CERAMICS
A POTTER'S HANDBOOK

Sixth Edition

CERAMICS
A POTTER'S HANDBOOK

Sixth Edition

Glenn C. Nelson

Richard Burkett
San Diego State University

WADSWORTH

THOMSON LEARNING

Australia • Canada • Mexico • Singapore • Spain • United Kingdom • United States

Acquisitions Editor: John Swanson
Developmental Editor: Stacey Sims
Editorial Assistant: Melinda Bonnell
Marketing Strategist: Mark Orr
Project Editor: Laura Hanna
Manufacturing Manager: Elaine Curda
Permissions Editor: Shirley Webster

Art Director: David Beard
Production Manager: Linda McMillan
Photo Researcher: Elsa Peterson Ltd.
Copy Editor: Charles Naylor
Cover Printer: LeHigh Press
Compositor: TechBooks
Printer: R.R. Donnelley

Printed in the United States of America
2 3 4 5 6 7 05 04 03 02

ISBN: 0-03-028937-8
Library of Congress Catalog Card Number:
2001096329

**For more information about our products,
contact us at:
Thomson Learning Academic
Resource Center
1-800-423-0563**

**For permission to use material from this
text, contact us by:
Phone: 1-800-730-2214
Fax: 1-800-730-2215
Web: http://www.thomsonrights.com**

Asia
Thomson Learning
60 Albert Street, #15-01
Albert Complex
Singapore 189969

Australia
Nelson Thomson Learning
102 Dodds Street
South Melbourne, Victoria 3205
Australia

Canada
Nelson Thomson Learning
1120 Birchmount Road
Toronto, Ontario M1K 5G4
Canada

Europe/Middle East/Africa
Thomson Learning
Berkshire House
168-173 High Holborn
London WC1 V7AA
United Kingdom

Latin America
Thomson Learning
Seneca, 53
Colonia Polanco
11560 Mexico, D.F.
Mexico

Spain
Paraninfo Thomson Learning
Calle/Magallanes, 25
28015 Madrid, Spain

This book is dedicated to my father, who taught me about science,
and to my mother, who always included art as a part of life.

The ceramics world has changed greatly in the nearly fifty years since Glenn Nelson began writing *Ceramics: A Potter's Handbook* as a small reference manual for his students in Minnesota. His was a pioneering effort in an era when there were few art galleries that handled the ceramic arts, not many suppliers of ceramic materials, and no textbooks that comprehensively covered the basics of making pottery and ceramic art. As a beginning potter in 1970, I found Nelson's book to be a wonderful resource. It was heartening to hear from so many other potters as I began this revision of *Ceramics: A Potter's Handbook,* that they too had fond memories of using this book as they started out in clay. I must thank Glenn Nelson for all his many years of diligent work in writing and revising *Ceramics.* I realize now what a monumental task that was. *Ceramics* is still chockfull of useful information, ideas, philosophy, history, and art. I've tried my best to preserve those qualities in this new edition and to merely add to it what I could to bring the information in the book into the current era.

Structure of the Book and Changes to the New Edition

The new edition begins with the basic material, clay, as this elemental and ancient medium is the core of all we do as ceramists. An understanding of the origin, composition, and types of clay is fundamental to understanding what humankind has done with clay in the millennia since the first person discovered that objects could be made from this substance. Chapters on the history of pottery and the ceramic arts follow and remain largely unchanged from the earlier edition, save for some rearranging of the text and a few other minor additions. A new fourth chapter brings the history of clay up to the end of the twentieth century, primarily through a portfolio of contemporary work in clay that illustrates the rich diversity of form and content typifying the past fifty years of art. A brief overview of this recent era focuses on how the ceramics world has changed and how it has often paralleled changes in the art world as a whole. This section replaces the section on the Professional Potter in the previous edition—a difficult decision, but one which I feel is for the best as it allows a larger portfolio of contemporary work. Quotes from ceramic artists about what motivates them and inspires them about clay are scattered through the captions that accompany the illustrations.

The chapter "Clay in the Studio" starts the studio practices section of the book. Chapters on the forming processes basic to ceramics follow, covering handbuilding, throwing, glazing and glaze formulation, and finally kilns and firing. All of these sections include all-new photographs of both the processes and contemporary ceramics to illustrate those processes. The chapters on glaze and glazes have been updated to reflect the removal of lead as a glaze ingredient from almost all glazes and the ever-growing focus on safe studio practices. Warnings for acutely toxic materials are more common now, but it is also important for young potters to understand that a lifetime of exposure to more subtle hazards in the workplace can greatly affect their health, and the warnings now reflect those concerns as well.

The section on glazes and calculations has been rewritten to try to make the difficult concepts surrounding ceramic chemicals and glazes more easily understood. At a time when ceramic raw materials (Gerstley borate, for example) keep disappearing from the marketplace and new ingredients must be found to make glazes, a basic knowledge of simple glaze chemistry can make the potter's life much happier. Even in an era where computers can calculate and recalculate glazes in a split second, a fundamental understanding of how glazes work is essential to using these new tools effectively.

Finally the section on kilns and firing covers that last, but ever so crucial, process in the transformation of clay from an expressively soft and plastic medium to one of the most long-lasting art materials known. Several sections of this chapter have been rewritten and expanded to include currently popular techniques such as soda firing.

Additions and updates have been made to the appendices, too, including new glaze and clay recipes, some useful calculations for ceramists, and a section on glues, adhesives, and ceramic repairs—a useful topic for a fragile art medium. The roster of ceramic suppliers is updated, with Web site and e-mail information included where available. Sources of ceramic information on the Internet are also listed, as this valuable resource has grown tremendously in the last few years.

Acknowledgments

I'd like to give my most heartfelt thanks to all the many, many people who have so patiently offered their help during this revision. First and foremost are all the potters and ceramists who have so generously offered photographs, recipes, information, and advice. I am grateful also to the following reviewers whose input guided this revision: Linda Arbuckle, University of Florida; Aurore Chabot, University of Arizona; Chris Dayman, Owensboro Community College; Gail Kendall, University of Nebraska—Lincoln; Robert Kibler, Glendale Community College; Mark Pharis, University of Minnesota. I would also like to thank my book team, now of Wadsworth Publishing. The team included John Swanson, acquisitions editor; Stacey Sims, senior development editor; Melinda Bonnell, editorial assistant; Shirley Webster, literary and picture rights editor; David Beard, art director; Laura Hanna, project editor; and Linda McMillan, production manager.

My family and friends have been a great support to me during this epic process—I must say I had no real idea what I was starting when I began the revision. Finally, I'd like to thank Richard Peeler, wherever you are, for introducing me to both the potter's art, and also to this book. I wish you could be here to see this new edition. And thanks again to Glenn Nelson: you set the standard.

Richard Burkett
San Diego, California

CONTENTS

Chapter 1

Clay is the remarkably common but unique substance that makes ceramics possible. It is the very essence of the ceramic arts. It is vitally important for the ceramist to understand it as a material.

Clay should not be confused with soil—a combination of clay, sand, humus (partially decayed vegetable matter), and various other minerals. Compared with other materials in the earth, soil forms an extremely thin outermost layer—varying from several inches to a foot (about 7 to 11 cm to .33 m) thick. There are, of course, large areas without soil, such as most desert and mountain regions. Between the soil proper and the rocky core of the earth rests a thicker layer of subsoil composed largely of clay mixed with sand and gravelly mineral deposits. Within this layer large beds of clay are found. In order to explain better the variety and nature of clay types, a brief description of the formation of this layer of subsoil is necessary.

FORMATION OF CLAY

As the earth cooled very slowly from its fiery origins, a rocky outer crust hardened, while internal pressures and volcanic eruptions pushed up mountainous areas. Gradually, water vapor formed, and an atmosphere evolved above the earth. The resulting rains and winds caused erosion, while extremes of heat and freezing temperatures led to expansion and contraction of the earth's surface. These combined forces fractured and crumbled the exposed rock. The initial composition of this rock varied greatly from place to place, so that the process of erosion had different effects and occurred in different manners over the surface of the earth. The two most important forces for the formation of clay beds were the melting and movement of the ice cover during the glacial ages and the organic acids released by the decay of vegetation.

Clay derives from the disintegration of feldspathic minerals commonly found in granite. Feldspars are made up of alkaline elements (sodium and potassium primarily) in molecular combination with alumina and silica. As these rocks decompose they are broken down into smaller combinations of alumina and silica particles as the alkalies in the rock are slowly leached from the stone. The most valuable clays for the potter consist mainly of the mineral kaolinite, which has an ideal formula of $Al_2O_3 \cdot 2SiO_2 \cdot 2H_2O$—a combination of one alumina, two silica, and two water molecules. Kaolinite particles (Fig. 1-1) are shaped like very thin plates less than 2 microns in size (1 micron is 0.001 millimeter or 0.00004 inch). Fine grains of sand are huge in comparison—0.02 inch (0.05 cm)

1-1 Kaolin particles (magnified several thousand times using an electron microscope) show the layered structure and generally hexagonal platelets that help to give clay its plastic qualities.

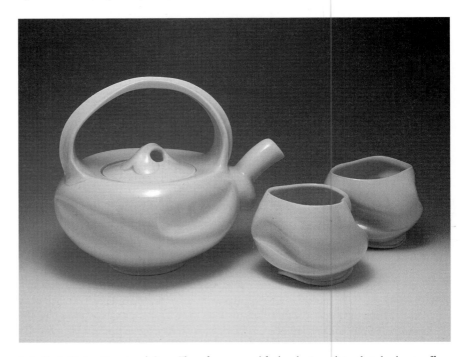

1-2 Chris Staley, Teapot and Cups. These forms exemplify the plastic qualities that clay has to offer. The smooth whiteness of porcelain is an ideal match to the expressive shape of these pots. Staley was first attracted to clay as an artistic medium because he "was amazed that something so fluid and amorphic could be transformed into powerful shapes."

in diameter. Unlike the granular structure of sand, kaolinite particles are flat and cling together like a deck of wet playing cards. These particles slide when wet and support one another in both wet and dry states, giving clay its most valuable quality, plasticity. Water molecules between the clay platelets both allow the platelets to slide past each other fluidly and also bind the platelets together through electrical interactions of the individual molecules involved.

Most clay found in the earth does not contain sufficient amounts of kaolinite to make it plastic, and nearly all clay has some impurities. These impurities and variations of the basic formula account for the different characteristics of the numerous types of clay (Fig. 1-2).

CLAYS FOR POTTERS AND SCULPTORS

Potters seldom use clays just as they come from the ground. The clays must be cleaned of rocks and roots, and even then are seldom ideal. Potters learned the advantages of adding other materials to their clays early in the history of ceramics. **Clay bodies** are what we call the mixture of different types of clay and other materials that are blended to make a workable clay. Porcelain (a blend of kaolin, feldspar and silica) is formulated in this way, as are most of the other types of clay used by ceramists (see Chapter 5, Clay in the Studio). Potters tend toward smoother more plastic clays which will flow and stretch when used on the potter's wheel. Sculptors often prefer coarser clays with more texture and less plasticity to minimize problems in drying and firing larger scale work.

The type of clays available to a local area often determined the type of wares made in a particular region before cheap transportation and commercially mined materials were available. In this way the incredible variations in our ceramic heritage have been somewhat determined by geology. The rich color of the earthenware clays commonly found on the earth's surface and fired in simple kilns can be seen in pottery around the world. Figure 1-3 shows the rich variety of surface found in the work of Jatumpamba potters in Ecuador. Workable stoneware clays are often located only in small pockets or below ground. The clays needed to make the fine hard whiteness of porcelain are more rare and, along with its need for high firing temperatures, made it available to only a few of the world's potters until relatively recent times.

The firing temperatures of naturally occurring clays have led to the descriptive terms **low-fire** (for earthenware temperature clays and glazes) and **high-fire** (for stoneware and porcelain clays and their glazes). More recently midrange clays have become popular, falling between these two in temperature and offering some of the more desirable properties of each (Fig. 1-4).

CLAY TYPES

As they are mined, clays can be classified as either residual or sedimentary. Residual clays have remained more or less at the site of the decomposed rock. They are less plastic than sedimentary clays, and because they have been subject to fewer erosive forces, have a much larger particle size. Sedimentary

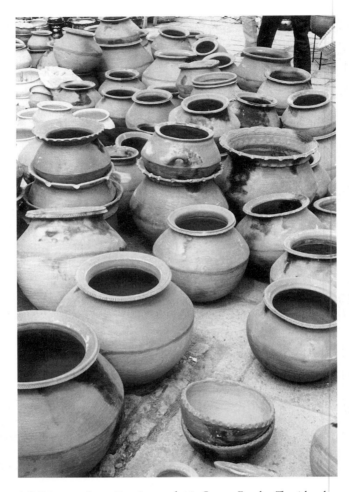

1-3 Jatumpamba pottery in a market in Cuenca, Ecuador. The rich red and black colors and markings of pottery made in the Ecuadorean village of Jatumpamba come largely from the local red clays used on the surface and the simple method of firing the work in an open fire.

clays are those that, by the action of wind or running water, have been transported far from the site of the parent rock. This action had considerable effect on the mixture and breakdown of the minerals, and therefore the particles are very fine and the clay more plastic (Figure 1-6).

The geological origins of a particular clay affect its firing temperature, color, and plasticity. These are critical properties to potters, who long ago learned to look for these qualities in their clays.

Kaolin

Kaolin is a very pure form of clay that is white in color and **vitrifies** (becomes nonporous and glass-like) only at very high temperatures. For these reasons, kaolin is seldom used alone but makes an important ingredient in all high-fire

1-4 Eddie Dominguez, *Art Cairn.* Earthenware clay is an ideal medium for sculptural works. In this piece primitive imagery is joined with rich textures and carving, modern symbols, and words to create a visual dialogue about art.

whiteware and porcelain bodies (Fig. 1-5). Kaolin also provides a source of alumina and silica for glazes.

The wide variety of kaolin types available illustrates the difficulty of classifying clays. In the United States the major commercial deposits are in the Southeast. North Carolina produces a residual kaolin with many coarse rock particles, while the deposits in South Carolina and Georgia are sedimentary. Florida deposits are even more plastic and are often termed ball kaolin or EPK (Edgar Plastic Kaolin from Edgar, Florida). No kaolin, however, is truly plastic in comparison with ball clay.

The kaolin beds in England are among the largest in the world. They are mined by hydraulic methods and require a complicated system of separating out the finer particles in huge settling tanks. Clays from the various mines are blended to produce kaolin of several consistent types. The fineness of particle size makes these clays suitable for casting or throwing bodies. The English type called Grolleg is one of the best kaolins for a plastic porcelain throwing body.

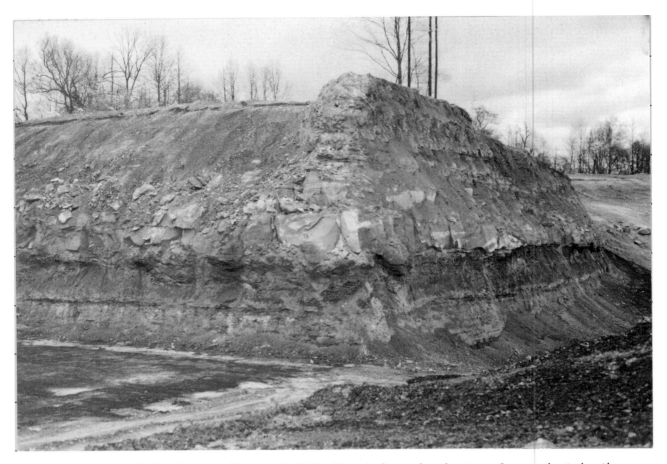

1-5 Clay mining in Oak Hill, Ohio. Clay is mined here at Cedar Heights Clays using heavy industrial equipment. Stoneware clays in the midwestern U.S. often are found in thick layers like this. Before the clay can be used it must be ground and processed.

Ball Clay

Ball clay, a sedimentary clay, is chemically similar to kaolin after firing. In its unfired state, however, the color ranges from a light tan to a dark gray because of the organic material present. Although weathered from a granite rock much like that which produced kaolin, the ball clay particles were deposited in swampy areas. Organic acids and gaseous compounds released from decaying vegetation served to break down the clay particles into even finer sizes than those of the sedimentary kaolins.

Ball clay imparts increased plasticity and dry strength when used as a body component. If a clay body contains 10 to 20 percent ball clay, it has greatly improved throwing qualities. Like kaolin, ball clay matures at a high temperature and can serve as a source of alumina and silica in recipes for **glaze** (a liquid suspension of ground minerals applied to fired ceramic ware) as well as a binding agent.

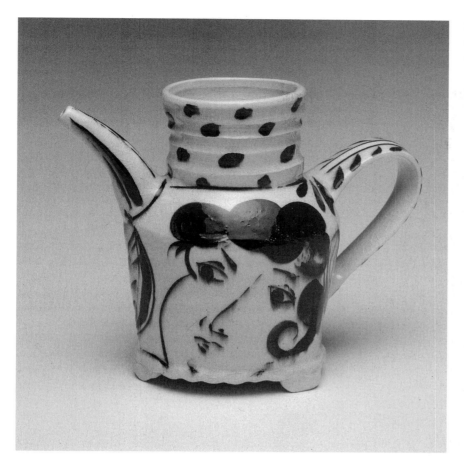

1-6 Gregg Pitts, Teapot (untitled). Porcelain clays provide a fine white surface for drawing and painterly expression on pottery.

Stoneware Clays

Stoneware clays are of particular interest to the potter because they are generally very plastic and fire in the middle range of temperatures, from about cone 5 to cone 10.* They are sedimentary clays which generally contain a mixture of clay minerals and are not a specific type of clay. Stoneware bodies are almost completely vitreous (Figure 1-7). Depending upon the atmospheric conditions of the firing, the color will vary from buff to gray. In the United States a wide variety of stoneware clays occur in scattered deposits from New York and New Jersey westward to Illinois and Missouri, as well as on the Pacific coast. Stoneware clays differ in composition. Compared with kaolin they contain many more impurities, such as calcium, feldspar, and iron—all of which lower the maturing temperature and impart color to the clay. Stoneware clays are sometimes thought of as a subcategory of fireclays.

*See temperature chart in the Appendix giving pyrometric cone equivalents in degrees Fahrenheit and Centigrade. Cones indicated in text refer to the Orton series. Note that Seger cones have a slightly different range.

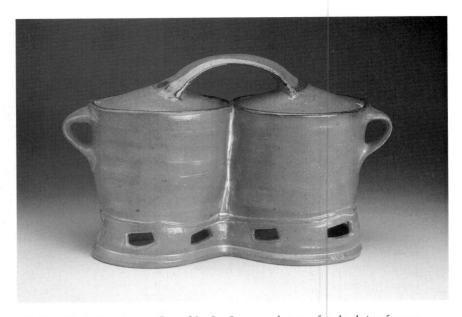

1-7 Steve Davis-Rosenbaum, Covered Jar Set. Stoneware clays are often the choice of potters because of their combination of plasticity in the raw stage with durability when fired. "The softness of the clay was enchanting to me at first, and then the realization that the possibilities were endless."

Fireclay

Fireclay is a high-firing clay commonly used to make the insulating brick and hard firebrick used to build kilns, and kiln furniture (the shelves and posts that hold pots inside a kiln). Its physical characteristics vary. Some fireclays have a fine plastic quality, while others are coarse and granular and more suitable for hand-building clay bodies than for throwing. Fireclays generally contain some iron but seldom have significant amounts of calcium or feldspar. The more plastic varieties, like some stoneware clays, often occur close to coal veins. They can be high in either flint or alumina and therefore have special industrial uses. Fireclays of one type or another are found throughout the United States, absent only from a few mountainous regions and the southeast and northeast coasts. Their availability and plasticity make fireclays a common component of stoneware bodies.

Earthenware Clays

Earthenware clays comprise a group of low-firing clays that mature at comparatively low temperatures ranging from cone 08 to cone 02 (Fig. 1-8). Sedimentary earthenware clays are most often found on or close to the Earth's surface. The ready availability and low firing temperature of earthenware clays has made them one of the most commonly used pottery clays over the history of ceramics. These naturally occurring earthenware clays typically contain a relatively high percentage of iron oxide, which, along with other impurities, serves as a flux (a substance that lowers the maturing temperature of the clay). The iron also gives fired earthenware its usual deep red-brown color.

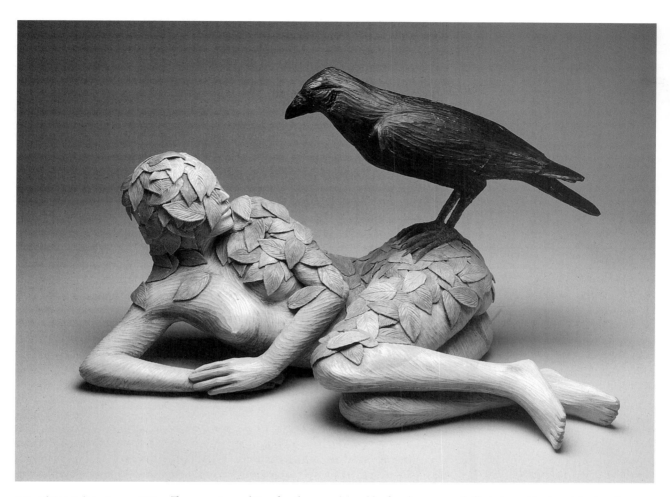

1-8 Adrian Arleo, *Annunciation.* The expressive qualities of earthenware clay and lowfire glazes are used effectively on this piece. Arleo has also incorporated non-ceramic materials to complete this work. She is interested in how gesture, expression, texture, and fragmentation of the figure can be used metaphorically to express such things as love, compassion, and spirituality. She also comments on the ceramic medium: "material and content stimulates an ongoing curiosity about what could come next. The possibilities seem endless."

The term earthenware is also used to describe any type of pottery fired to the typical temperature range of naturally occurring earthenware clays, whether or not the clay body used was actually an earthenware clay. The term **white earthenware** is often used to describe white clay bodies that are formulated to be fired in the earthenware range. These are usually created from kaolins or ball clays with enough added flux to make a rather dense, strong body when fired.

Naturally occurring earthenware clays may be rather fragile and quite porous when fired, but can often be made dense and strong by adding other fluxes to the earthenware body. Unlike stoneware bodies, the usual earthenware body, after firing, often has a porosity of between 5 and 15 percent. Terra cotta is a coarse-textured red earthenware clay that falls into this category. Because of the various fluxes and impurities it contains, most naturally occurring earthenware clay

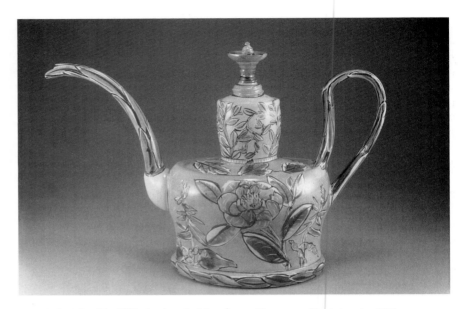

1-9 Linda Arbuckle, USA. *Southern Indulgence: coral bean, camellia, poison ivy,* 1990.
Earthenware, majolica glaze. Arbuckle skillfully uses majolica painting techniques to enrich the surface of
this teapot with floral embellishments that also relate to the artist's home in the southern United States.
She says, "The challenge of combining function, terra-cotta (which I see as a populist material), and a
presence in form and surface (which includes mark making and color) is endless and always new for me."

cannot be made vitreous like porcelain, for it deforms and often blisters at temperatures above 2100°F (1150°C).

Many potters have done considerable work in earthenware and have created clay bodies that are quite durable and strong. Some find its red-orange to red-brown color attractive; others use it as a base for bright, low-fire glazes. Majolica glazing techniques are particularly popular on earthenware clays (see Figure 1-9 and also Chapter 8). Industry's preference for purity and product control limit the large-scale use of earthenware largely to such things as building bricks, flowerpots, and tiles.

Earthenware clays of one type or another can be found in every part of the United States, although commercial deposits are abundant in the lower Great Lakes region. Many such clays, available commercially, are of a shale type. Shale deposits are clays laid down in prehistoric lake beds. Time, chemical reactions, and pressure from overlying material have served to cement these clay particles into shale—a hard, stratified material halfway between a clay and a rock. Shale clays are mined and ground into a powdered form similar to ordinary clay. The small lumps that remain can be troublesome if not screened out, for, like plaster, they will absorb moisture, expand, and rupture after firing. Lime in the clay will have a similar detrimental effect.

Slip Clay

Slip clays naturally contain sufficient fluxes to function as glazes without further addition. Although white and even blue slip clays exist, the most common are tan, brick red, or brown-black. Most slip clays fire in a middle range from

The history of ceramics is extremely diverse. Even a short look at the collections of museums such as the Victoria and Albert Museum in London, England, will stagger the mind with the quantity and variety of pottery that human culture has produced. The history of ceramics outlined in these chapters is decidedly condensed and touches only on a few of the many highlights of ceramic history. Further reading material is suggested in the bibliography found in the appendices.

Of all the remains left by ancient cultures, perhaps none have proved as valuable to the archaeologist and the student of history as the numerous artifacts made of fired clay. Items of wood, leather, and fabric that have survived more than a thousand years are rare, however carefully fashioned, except in unusual and fortuitous circumstances. Even bronze and iron are prone to disintegrate. Many types of stone when exposed to the weather will erode nearly as rapidly. Clay, which is usually abundant everywhere, has the unique property of being easily fashioned into a variety of forms. When fired in a kiln or even in a bonfire, it fuses into an amazingly hard and durable material.

This almost indestructible nature of fired clay has allowed us to surmise the existence of cultures that otherwise would be completely unknown. Birth, puberty, and death are the great traumatic experiences of human life. Although Western culture in the twentieth century has become a bit blasé about these transitions of life, our ancestors celebrated them with elaborate ritual. Death in particular was a frightening and mysterious event that required the propitiation of unknown forces. Belief in some sort of existence in the hereafter dates from the furthest reaches of time, for we find that Paleolithic peoples sprinkled their dead with red ocher as a symbol of life and buried them with their stone weapons and a supply of food. As early peoples developed the skill of pottery making, we find pottery included in these funerary offerings. A large portion of the ancient ceramics illustrated in this chapter comes from such grave sites and, for the most part, they were made especially for that purpose. The forms were often those in common use at that time, but made with greater attention to detail and more elaborate decoration. Reflecting the conservative nature of religious customs, the grave ware might also resemble an older style and could, for example, still be hand built although the ware made for daily use was wheel thrown. Often the grave offerings were overly elaborate and nonfunctional in design and were even decorated with fugitive, nonceramic colors, reflecting their one-time use.

Through changes in these pottery styles we can often trace the rise of ancient cultures, the beginnings of early trade routes, the dislocations caused by

war, and the restless migrations of peoples seeking a better land. Regardless of the initial development of a form or decoration, we find that if it is accepted by the populace at large it acquires, as it were, a life of its own and continues to be transmitted from parent to child as in most traditional crafts. Thus in various parts of the world we can see echoes of ancient forms and decorations that have survived for millennia.

As far as can be determined, the potter has been historically conservative in outlook and working habits. Throughout the ages the potter has often been an artisan of low social status, producing ware in direct response to the needs of the community. The pressures for individuality and the desire to be different, so prevalent among ceramists today, have no historical precedent as these are largely twentieth-century ideas. The technical nature of ceramics is such that a small change in methods or materials can well produce disastrous results. Therefore, for most of history, the craft of ceramics has changed slowly, even in the face of an improved technique. For example, although the potter's wheel was introduced into southern Germany, France, and England during the period of the Roman occupation and local potters learned to use it, they seem to have forgotten the technique after the Romans retreated to the Mediterranean area. We find no more wheel-thrown pottery until the seventh century in England. It gradually reappeared elsewhere as trade between northern and southern Europe increased during the Middle Ages.

Social and economic conditions have had a controlling influence on whether the potter's work was rigidly traditional or modified by outside influences. Early small, self-contained communities generally had a conservative tradition. Even as population grew, the first urban centers arose, and trade among communities expanded, an occasional imported jar doubtless had little effect on local potters. If competing trade among communities developed to any extent, however, then the local potters were forced to adapt the new shapes and/or decorations. It is likely that trade has had as an important effect on changing ceramic styles as have the dislocations caused by migrations, war, or the overthrow of established ruling classes.

ORIGINS OF POTTERY

Although early people were using crude stone tools in East Africa in the early Paleolithic period, as long as 2.6 million years ago, most of human cultural development has occurred much more recently, since the beginning of the Neolithic period after 10,000 B.C.

PALEOLITHIC AND NEOLITHIC CULTURES

The peoples of the Paleolithic period were wandering hunters. They also gathered wild seeds, tubers, and fruits. At the end of the Paleolithic period, about 10,000 B.C., the ice cap covering most of northern Europe, Asia, and North

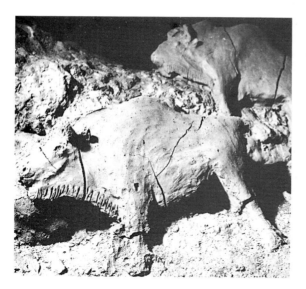

2-1 Bison, Tuc d'Audoubert, Ariege, France. After 15,000 B.C. Modeled clay, 25″ and 24″ (63.5 cm and 61 cm) long.

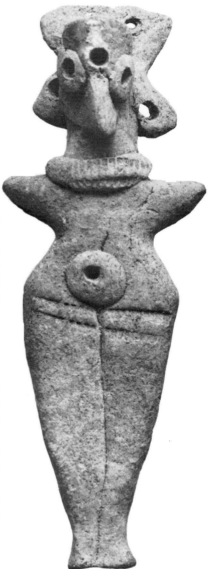

America receded, and much of northern Africa and western Asia became hot and dry. During the early Neolithic period, after about 7000 B.C., early communities began to settle down in fertile and temperate river valleys, first in western Asia and eastern Europe, later in Egypt, India, China, and Mexico. They deliberately planted seeds to produce a more dependable yield. Wild emmer and einkorn wheat from the upland valleys of Anatolia (now Turkey) and Iran are the source from which modern varieties of wheat are descended. These early farmers also domesticated wild goats and cattle. Dogs, of course, had long been hunting companions.

Long before these Neolithic developments of sedentary life, agriculture, and animal husbandry, Paleolithic cave paintings in Altamira, Spain, and the Dordogne Valley, France, about 25,000 to 15,000 B.C., reveal on the part of their creators a critical observation and graphic skill we can envy today. Numerous bone carvings also exist from Paleolithic times. Rock outcroppings in the caves were modeled with clay and painted to resemble animal forms (Fig. 2-1). Small, fired clay forms which are believed to be such fetishes, dating 26,000 and 28,000 years ago, have been found in the area formerly known as Czechoslovakia (see Fig. 6-1 in Chapter 6). Although we have no way of knowing their true purpose, these figures may have been used as fetishes in connection with hunting, planting, and harvesting ceremonies. They appear to have been fired by tossing them into a bonfire built in a primitive hearth-like kiln, perhaps as part of the ceremony. Such figurines, both fired and (more rarely) unfired, are found in all later Neolithic cultures. The Syrian votive statue in Figure 2-2 is representative of this type of cult image. From these early artistic achievements we can speculate that perhaps the economic changes of the Neolithic period were due less to an innate improvement in human capacity than to the effects of a changing climate.

2-2 Votive figure, Syria. 1400 B.C. Terracotta. Metropolitan Museum of Art, New York (gift of George D. Pratt, 1933).

The First Pottery

Neolithic families gathered wild and cultivated seeds and stored them in tightly woven baskets. Often the baskets were coated on the inside with clay to form a more effective container. Because the oldest pots in most Neolithic cultures have a basket-like or a corded texture (Fig. 2-3), many scholars have speculated that pottery making was first discovered by the accidental burning of a basket and the subsequent hardening of its clay lining. This is only theory, since some of the oldest known pots (the early Japanese **Jomon** ware discussed later in the chapter) were made by a fishing and shellfish-gathering culture that had not yet reached the agricultural stage.

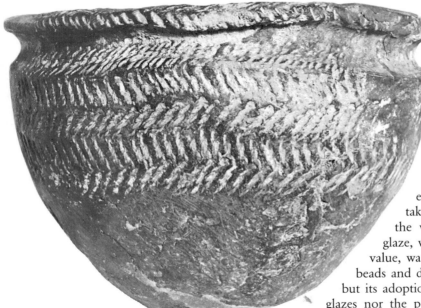

2-3 Pot, found in the Thames near Mortlake, England. Fired clay with cord impressions, height 5.25″ (13 cm). British Museum, London.

It is likely, however, that the earliest pottery in most cultures was probably made by women. As settlements grew, markets developed where a potter could trade wares for grain, leather, and other goods. With the introduction of the potter's wheel, it appears that the craft largely shifted to men. In many cultures where the potter's wheel is not used, pottery is still a tradition largely practiced by women.

Although the discovery of pottery by early Neolithic cultures seems to have taken place independently in many areas of the world, the discovery of glassy ceramic glaze, which had both practical and decorative value, was not universal. Glaze was first used on beads and decorative tiles in Egypt about 2700 B.C., but its adoption in the Middle East was slow. Neither glazes nor the potter's wheel developed in sub-Saharan Africa, Oceania, or the New World. Although high-fired stoneware and porcelain developed early in the Orient, because of the continued use of low-fire kilns and lack of interest in higher firing clays, these wares never developed in the Middle East and appeared in Europe only in relatively recent times. Thus ceramic development worldwide was very uneven; neglected in some areas, it made tremendous advances in others.

TECHNOLOGY AND THE EVOLUTION OF POTTERY

It is useful to know something about early kiln design in order to better understand the development of ceramic form and decoration, for the two are directly related. While many factors have influenced the form and surface of ceramic wares, including such factors as function, food, religion and ritual, technology has played a definite part in how pottery has evolved. Throughout history, each innovation in kiln design has greatly influenced ceramics, making new forms possible by removing technological limitations. Chapter 11 deals with the history and technology of kilns, and the reader is urged to refer to that chapter when unfamiliar terms and types of firing are encountered.

THE ANCIENT ORIENT

The Far East has a long ceramic tradition, dominated by China. The oldest known pottery, Japanese Jomon ware, dates prior to 10,000 B.C. Ware discovered in northern Thailand is thought to have been made as early as 7000 B.C. In China itself the earliest known pottery fragments date from before 4500 B.C.

China

Neolithic Period As elsewhere in the Neolithic period, the earliest Chinese pottery was black and round-bottomed and had an impressed-cord decoration. This ware gave way to a polished ware. As early as 4000 B.C., a highly developed, slip-decorated pottery appeared in the Yang-Shao cultures of Kansu Province in central China. The tall, rounded jars and graceful, flaring bowls of this ware were decorated with curvilinear plant and fish motifs in a black manganese or iron-red slip (Fig. 2-4). The sophisticated appearance of this early painted ware has baffled

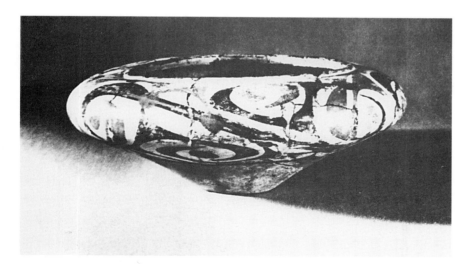

2-4 Yang-Shao ware bowl, Peihsien, Kiangsu Province, China. Neolithic (4000–3000 B.C.). Red-brown earthenware, painted; height 3.9″ (10 cm), diameter 7″ (18 cm).

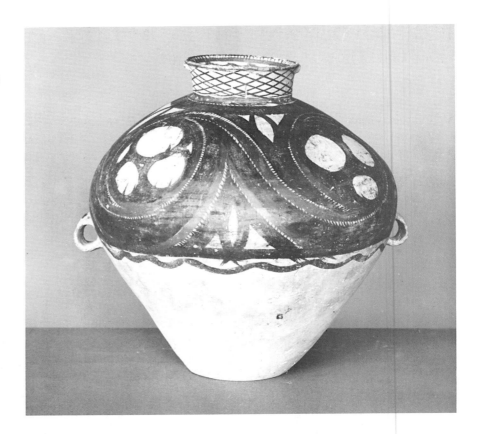

2-5 Yang-Shao ware oval jar, Pan Shan cemeteries. Neolithic (3000–2000 B.C.). Buff earthenware painted in black and red slip, height 15.25″ (38.73 cm). Victoria and Albert Museum, London (Crown Copyright).

many archaeologists. The thin, light red, burnished vessels were baked in an oxidizing fire to at least 1832°F (1000°C) and skillfully decorated. Normally one would expect to find an intermediate ware, between the polished ware and the Yang-Shao ware, that was more crudely made and decorated, but none has been discovered. Since slip-decorated ware appeared much earlier in the Middle East than in China, some authorities have claimed a diffusion from the Middle East.

Slightly later examples of Yang-Shao ware, about 2200 B.C., are oval jars with black and red double spirals from the Pan Shan cemeteries (Fig. 2-5). Typically they are oval with a small base, a large opening with a collar, and loops for tying down a cover. The Lung-Shan culture to the east in Shantung Province (2600–1700 B.C.) produced thin-walled, black, polished ware. The grooved and banded decoration and tall, flaring stems of this ware reveal the first use of the potter's wheel.

Shang Dynasty Later, in the Shang Period (c. 1523–1028 B.C.), white clay vases from An-Yang in Honan Province have intricate incised and stamped decorations similar to those on bronze funerary vessels made during the same period (Fig. 2-6). The smelting and casting of bronze was closely related to the development of higher-firing kilns and clay bodies. Although not common, some gray proto-stoneware was made. At first it was glazed accidentally with falling wood ash during firing. Later it was intentionally covered with a thin, yellow-green glaze.

right: **2-6 Cylindrical vase,** Anyang, Honan Province, China. Shang Dynasty (1766–1122 B.C.). Thrown earthenware with banded and incised decorations of metallic character, height 10″ (25 cm). Metropolitan Museum of Art, New York (Harris Brisband Dick Fund, 1950).

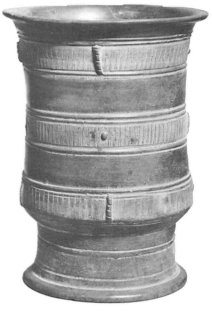

Chou and Chin Dynasties
The pottery of the Chou Dynasty (1027–256 B.C.) continued to have pressed and incised designs. The turmoil of the Warring States Period (481–221 B.C.) led to the rise of the first Chinese emperor, Ch'in Shih Huang-ti, who united northern and central China in 221 B.C. The earlier practice of burying the dead ruler with his attendants gave way to the more humane practice of providing him with ceramic figures of attendants, such as the thousands of life-size guardian warriors found near Shih Huang-ti's tomb in Hsi-An, Shensi Province, in 1974 (Fig. 2-7).

below: **2-7 Warrior with his horse** from the tomb of Ch'in Shi'n Huang-ti, Hsi-An, Shensi Province, China. Ch'in Dynasty (221–207 B.C.). Terra-cotta, life-size. Courtesy of the Cultural Relics Bureau, Peking, and the Metropolitan Museum of Art, New York.

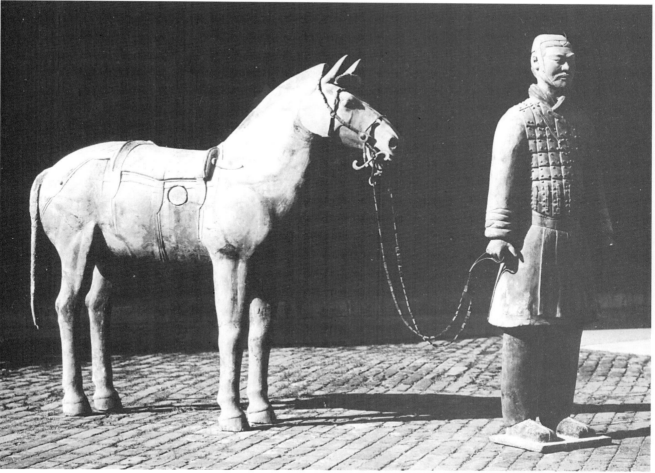

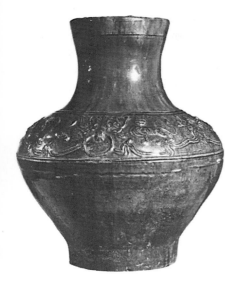

2-8 Vase, China. Han Dynasty (first–second century A.D.). Applied decorations and a runny green glaze, height 14.38″ (36.53 cm). Victoria and Albert Museum, London (Crown Copyright).

Han to T'ang Dynasties Under the Han Dynasty (206 B.C.–A.D. 220) trade and prosperity increased, and China gradually achieved a size and power comparable to those of the Roman Empire. The political and social order reflected the strict hierarchical relationships advocated by the sixth-century-B.C. philosopher Confucius. Pottery vessels replaced bronzes as preferred tomb offerings to the honored dead. Such earthenware vessels were often covered with a copper-green lead glaze (Fig. 2-8). Late in the period the ribbed decoration on large funeral jars was covered with a green feldspathic glaze fired at 2282°F (1250°C), although slip-decorated earthenware jars continued to be made.

During the Han, Six Dynasties (265–589), Sui (581–618), and T'ang (618–907) eras, the use of ceramic tomb sculpture continued but included small genre figures of musicians, jugglers, dancers, and especially dynamically prancing horses (Fig. 2-9). Late in the T'ang Dynasty polychrome clay slip decoration gave way to a lead glaze (Fig. 2-10). This brilliant, but running, yellow, brown, and green glaze was also applied to the typical earthenware jars and covered vases in a pattern of dots, chevrons, and rosettes. The Yueh kilns in Chekiang Province in the southeast, however, were developing **Yueh** ware, the first gray-green **celadon** glazes on refined bodies that some consider stoneware and others consider porcelain—inspired, perhaps, by jade carvings which the Chinese valued highly. In the north, a white porcelaneous ware called **Ting** ware was made in Ting-Chou, Hopei Province.

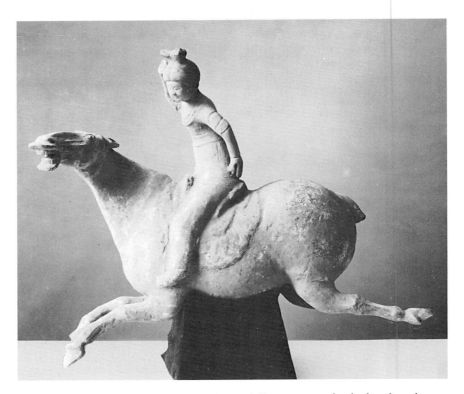

2-9 Horse and rider, China. T'ang Dynasty (618–907). Terra-cotta covered with white slip and traces of red, green, and blue paint, height 9″ (22.86 cm). Museum of Far Eastern Antiquities, Stockholm.

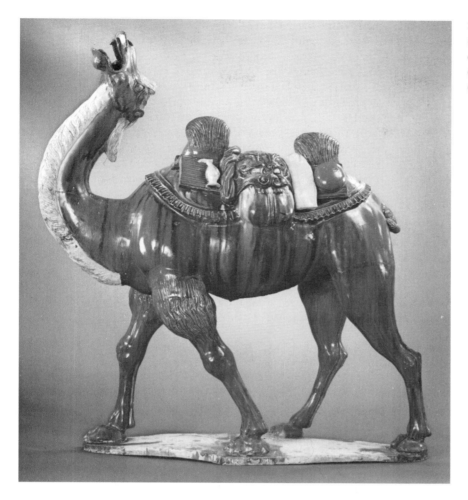

2-10 Camel, China. Sung Dynasty (A.D. 676–908). Lead glaze with polychrome decoration on terra-cotta, height 34.75″ (86.9 cm). Los Angeles County Museum (William Randolph Hearst Collection).

Korea

As China's neighbor to the northeast, Korea has always been affected by developments in China. Neolithic Korean pottery was a reddish earthenware for utilitarian purposes: bowls, flat-based vases with a straight neck, and large storage jars.

During the early historical period, Korea was divided into several warring kingdoms: Kokuryo (37 B.C.–A.D. 668) in the north, Paekche (18 B.C.–A.D. 663) in the southwest, and Old Silla (57 B.C.–A.D. 668) in the south. Eventually Silla, the most independent of the kingdoms, succeeded in uniting all of Korea (668–935). Kokuryo and Paekche produced earthenware showing Chinese influence. Silla made unglazed gray or red stoneware, particularly covered cups on a tall foot with cutout sections (Fig. 2-11). They were decorated with incised geometric patterns.

By the late seventh century Korea had adopted Buddhism from China, including the Buddhist custom of cremation of the dead. Thereafter, the most

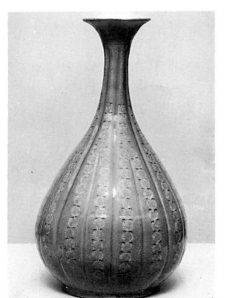

commonly found wares are cremation urns, consisting of a covered vase on a low foot with bands of stamped decoration. Later examples occasionally have a yellow-brown or olive glaze.

The golden age of Korean ceramics was the Koryo Period (918–1392). Although obviously influenced by Chinese Sung pottery, Korean potters were responsible for several unique innovations. The vase form in the shape of the stump of a flowering prunus (plum) tree and the tall, graceful bottle forms (Fig. 2-12) are refinements of the comparatively heavy Sung shapes. Experiments with glaze led to a delicate blue-green celadon color. This was especially remarkable since the ware was fired in immense, single-chamber, bank-climbing kilns (see Fig. 11-62, Chapter 11), where controlling the reduction atmosphere required great skill.

The variously formed bottles, vases, bowls, and covered jars were typically decorated with delicate floral patterns in the **mishima** inlay technique unique to Korea (Fig. 2-13). The design was first incised or stamped on a leather-hard stoneware body. The incisions were then filled with a porcelain slip or a dark clay or both. When the excess was scraped away, the decoration was revealed through the semitransparent celadon glaze.

Japan

The 1300-mile (2,200-km) island chain of Japan has been isolated from mainland Asia during most of its history. Pressures from an expanding China encouraged migration from China and Korea via Korea over a long period. Mainland influence has been very important in Japan, but, as a result of this isolation, changes in Japanese ceramics evolved very slowly. For instance, the black, cord-marked Jomon ware

above: **2-11 Covered stem cup** with pierced base, Korea. Old Silla Dynasty (57 B.C.–A.D. 668). Gray stoneware, height 9.25″ (23.25 cm). Seattle Art Museum (Eugene Fuller Memorial Collection).

left: **2-12 Graceful bottle**, Korea. Koryo Period (918–1392). Light stoneware with carved and inlayed mishima decoration, height 13″ (33 cm). Metropolitan Museum of Art, New York.

below: **2-13 "Sanggam" bowl**, Korea. Koryo Period, fourteenth century. Porcelain with inlayed mishima decoration under a pale celadon glaze, diameter 1.75″ (20 cm). Seattle Museum of Art (Eugene Fuller Memorial Collection).

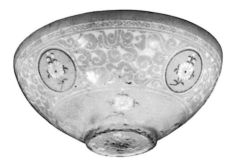

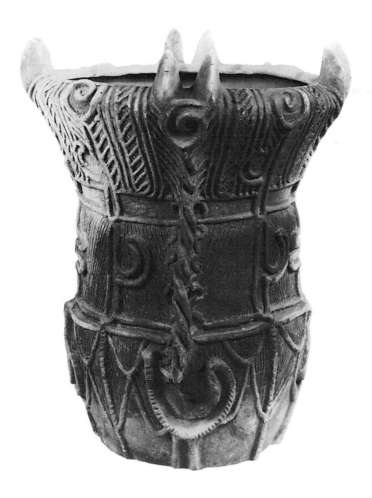

2-14 **Jar, Miyanomac,** Nagano, Japan. Middle Jomon Period, c. 2500 B.C. Earthenware with incised and applied decoration, height 23.4″ (59.5 cm). Tokyo National Museum (gift of Sugihara Sosuke).

(Fig. 2-14) of the Jomon Period (10,000 to 200 B.C.) survived until about 250 B.C., long after the Chinese were developing new forms (around 4000 B.C.). An interesting side note, given the recent history of male-dominated pottery in Japan, is that some scholars feel that it is quite likely that the Jomon potters were women, although this is impossible to know for certain. The pottery of the Yayoi Period (c. 200 B.C.–A.D. 200), unlike Jomon ware, was wheel thrown, simple in form, thinner, higher-fired, and decorated with incised, geometric bands.

Haniwa Period During the Haniwa Period (200–552), increased population, the introduction of bronze and iron, and the cultivation of rice led to prosperity, as evidenced by the huge burial mounds of feudal lords. Of special interest to the potter are the thousands of **Haniwa** figures, which encircled the mounds (Fig. 2-15). The first Haniwa were simple clay cylinders. Later ones were more elaborate representations of armored warriors, robed ladies, horses, and other attendant figures.

During the late Haniwa Period (after 400), many Korean potters, because of wars among the Silla and other Korean kingdoms, emigrated to Kyushu,

right: **2-16 Sue jar**, Obata, Kitaura-mura, Ibaraki, Japan. Heian Period, c. 1000. Stoneware with ash glaze, height 6.6" (25.8 cm). Tokyo National Museum.

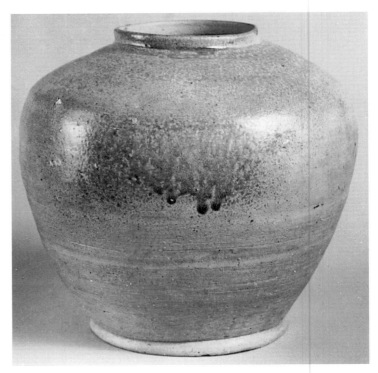

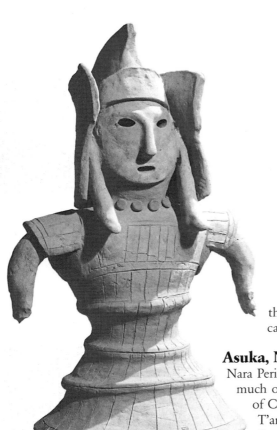

2-15 Haniwa warrior. Tochigi Prefecture, Japan. Haniwa Period (third–sixth century). Terra-cotta, height 22.88" (57.25 cm). Metropolitan Museum of Art, New York (gift of Mrs. John D. Rockefeller, III, 1958).

the southernmost island of Japan. There they produced a new ware called **Sue,** a gray stoneware with a runny green ash glaze (Fig. 2-16).

Asuka, Nara, and Heian Periods In the Asuka period (552–645), the Nara Period (645–794) and the early Heian Period (794–897), Japan adopted much of the civilization of T'ang China, including Buddhism and the use of Chinese characters to write the Japanese language. The Japanese made T'ang-influenced, lead-glazed earthenware pottery as well as the older Sue ware. Trade and other contact with China ceased during the turmoil of the closing years of the T'ang Dynasty (c. 906 A.D.). In the late Heian Period (897–1185), the isolated Japanese digested Chinese influences and revised them to suit Japanese taste.

THE AMERICAS

Pre-Columbian America

The Americas were first inhabited by bands of hunters and gatherers who migrated intermittently over the land bridge from Siberia to Alaska during the period 26,000 to 8000 B.C. Some of these bands settled down as farmers in fertile areas in what are now Mexico, Guatemala, Ecuador, and Peru. Their development may be roughly classified into the Preclassic (or Formative) Period (until 200 A.D.), the Classic Period (200–950), and the Postclassic Period (950 until the coming of the Spanish in the early sixteenth century).

2-17 **Olmec seated figure**, Las Bocas, Mexico, 1000 B.C.–A.D. 300. Earthenware with white slip and iron-red decoration, height 13.36″ (33.93 cm). Metropolitan Museum of Art, New York (The Michael C. Rockefeller Collection, bequest of Nelson A. Rockefeller, 1979).

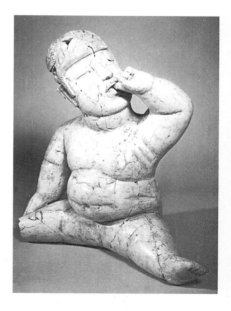

Mesoamerica

Advanced cultures developed in the Valley of Mexico, the east and west coasts of Mexico, southern Mexico, and northern Central America.

Olmec The first major Preclassic civilization in Mesoamerica was that of the Olmec (c. 800–400 B.C.), who inhabited the coast of the Gulf of Mexico and whose influence spread through a much wider area. At La Venta in Veracruz State and at other sites they built stepped, temple-crowned pyramids of brick faced with stucco or stone. They carved stone reliefs and freestanding figures, including huge heads, and clay figurines. Their sculpture is noted for its rounded forms and often pouting, baby-faced expression, as seen in the so-called jaguar-babies (Fig. 2-17).

Tlatilco Contemporary with the Olmec were farm villages in the Valley of Mexico such as Tlatilco, which produced thousands of small, often charming figurines (Fig. 2-18). Tlatilco also made burnished black or red earthenware with simple, incised designs. In addition to conventional bowl and bottle forms there were pots modeled in the form of birds or fish. This interest in modeled form

2-18 **Tlatilco figures**, Valley of Mexico, c. 1000–500 B.C. Terra-cotta; height of center figurine 3.75″ (9.5 cm). Metropolitan Museum of Art, New York.

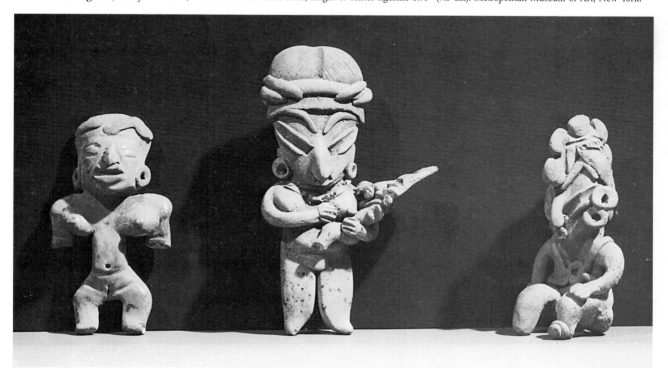

is characteristic of all Pre-Columbian pottery. The potter's wheel never developed in the New World.

Teotihuacán During the early Classic Period, Teotihuacán, which had previously absorbed Olmec civilization, was the most important center in the Valley of Mexico until A.D. 600. It was a large architectural complex planned for ceremonies of sacrifice to the gods conducted by priests. Structures included temple-pyramids decorated with stylized carving and painted stucco and residential quarters painted with murals of the gods or ceremonial scenes. The characteristic pottery of Teotihuacán, unique in Mexico, was a low, cylindrical ceremonial urn on three legs (Fig. 2-19). The brown body was often cut away and coated with red pigment to leave a stylized raised design. Reflecting temple decoration were a few unusual pieces whose fired clay bodies were covered with stucco painted in many colors.

Nayarit, Colima, and Jalisco In western Mexico the peoples of Nayarit, Colima, and Jalisco, unlike other Mesoamericans, had no temple-pyramids or powerful priesthood. They made pottery figurines, which, like

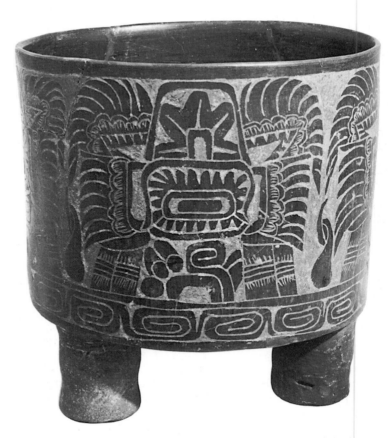

2-19 Teotihuacán tripod urn, Mexico, 200–600. Earthenware with incised and slip decoration, height 9.75″ (24.76 cm). Metropolitan Museum of Art, New York (bequest of Nelson A. Rockefeller, 1979).

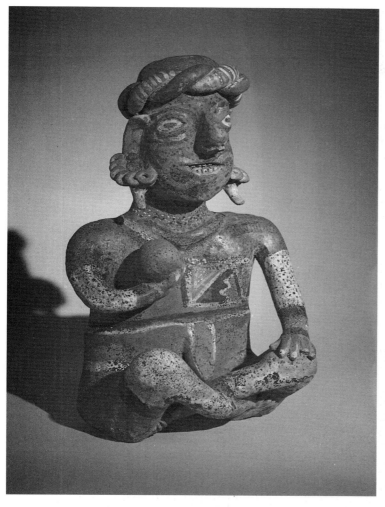

2-20 **Seated ball player.** Nayarit, Mexico. About A.D. 500. Burnished earthenware with polychrome slip decoration, height 13″ (33 cm). Minneapolis Institute of Art.

2-21 **Zapotec funeral urn,** Oaxaca, Mexico. c. 1000. Terra-cotta, in typical form of seated figure with elaborate headdress, height 6.5″ (16.51 cm). Collection I.B.M. Corporation, Armonk, New York.

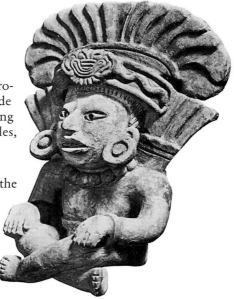

their Chinese counterparts, were intended to be buried in tombs to provide the dead with companionship in the life hereafter. Although made in regional styles, the figurines depict a relaxed, fun-loving people playing games or at rest (Fig. 2-20). There were also pots modeled like vegetables, dogs, or humans.

Zapotec and Mixtec In southern Mexico in the Valley of Oaxaca, the Zapotec developed a civilization centered in Monte Albán that reached its height during the Classic Period. The Zapotec built stone temple-pyramids and sculpted large, terra-cotta effigy urns, which depicted a stylized god or chieftain, seated, wearing a flamboyant feathered headdress (Fig. 2-21).

By 900, at the start of the Postclassic Period, the Mixtec had entered Oaxaca, possibly from the Gulf Coast, and taken over Monte Albán. They

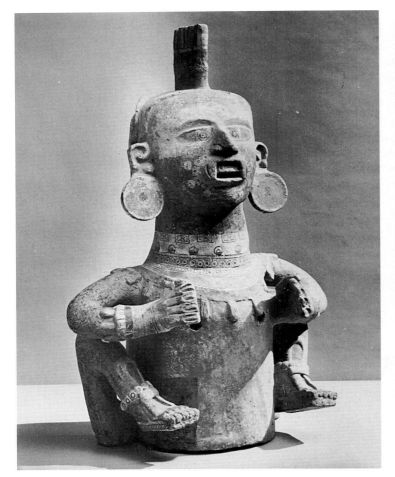

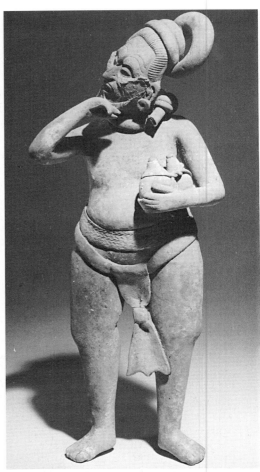

above left: **2-22 Mixtec xantile figure,** Puebla, Mexico, 1250–1500. Earthenware with trailed slip decoration, height 25.63″ (57 cm). Metropolitan Museum of Art, New York (The Michael C. Rockefeller Collection, gift of Nelson A. Rockefeller, 1978).

above right: **2-23 Mayan figure,** Jaina Island, Mexico, 900–1200. Terra-cotta, height 14.5″ (36.83 cm). Museum of the American Indian, New York (exchange from R. L. Stolper).

built their capital at Mitla, which also had previously belonged to the Zapotec. The Mixtec were excellent jewelers in gold and jade, as the finely detailed ornament on their pot-like, seated figurines shows (Fig. 2-22). Their love of intricate design is also reflected in the repetitive geometric decorations in yellow, red, orange, and black slip on their tripod and flared-pedestal bowls.

Maya The most advanced civilization of Mesoamerica was that of the Maya, whose numerous temple complexes such as Palenque, Tikal, Copán, and Chichén Itzá are still being discovered in Tabasco, Guatemala, Honduras, and Yucatán. Little is known of the Maya during the Preclassic Period. Mayan art of the Classic Period is serene and confident. Realistic, painted bas-reliefs adorn temple-pyramids and palaces. Ceramic figurines display a fluid, plastic quality (Fig. 2-23). The straight-sided bowls and footed vessels of the Maya perhaps show the influence of Teotihuacán (Fig. 2-24). They were decorated with incised hieroglyphs and patterns in polychromed slip resembling temple murals.

Neither the Toltec nor the Aztec, who dominated the Valley of Mexico and Yucatán in the Postclassic Period, attained the heights of the Maya.

North America

Diffusion Northward Influences from the culturally advanced people of Mesoamerica slowly diffused northward, including the skills of raising corn, building permanent structures, and making pottery. The Casas Grandes culture in northern Mexico made effigy jars in the shape of birds and other excellent pottery, both with bold slip decoration (Fig. 2-25). The Pueblo culture that built multistoried apartment dwellings in what is now the southwestern United States made fine ceremonial pottery decorated in slip-painted geometric designs. The people of the Mimbres Valley (New Mexico) made a distinctive ware that combined stylized patterns and realistic depictions of birds and animals in black on white slip (Fig. 2-26). Farther north in the Mississippi Valley and in the southeastern United States, the native culture erected large earthen temple-pyramids and burial mounds and made functional burnished black pottery with incised decoration (Fig. 2-27).

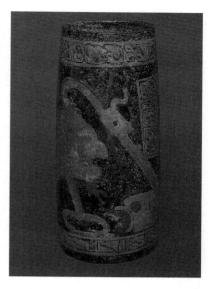

2-24 Painted Cylinder Vase *Long-beaked Cormorant with Fish.* Maya culture, late period c. 700–900 A.D. Clay, paint. Bowers Museum of Cultural Art.

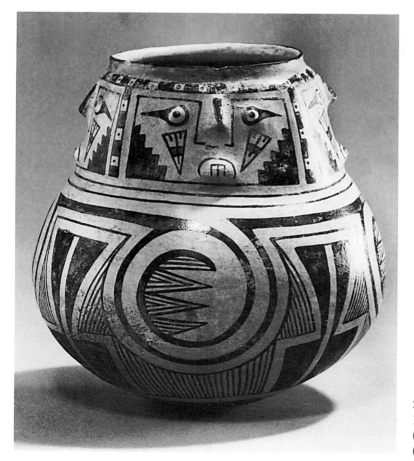

2-25 Casas Grandes effigy jar, Chihuahua, Mexico, 1300–1450. Earthenware with slip decoration, height 8.75″ (22.22 cm). Metropolitan Museum of Art, New York (bequest of Nelson A. Rockefeller, 1979).

2-26 Mimbres Culture bowl with image of a bat. This is a fine example of classic black-on-white Mimbres ware, 4.375″ × 11″ (11 × 27 cm). Earthenware with slip painting, 750–1100. Arizona State Museum.

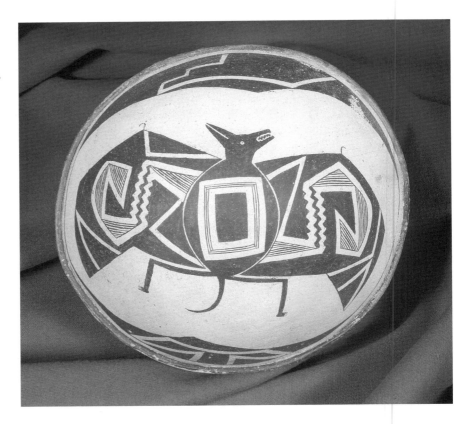

2-27 Native American effigy vessel in shape of a tortoise, Arkansas, U.S.A., 1200–1600. Blackware, 4.75 × 7.5 in. (12.25 × 19 cm). Museum of the American Indian, Smithsonian Institution.

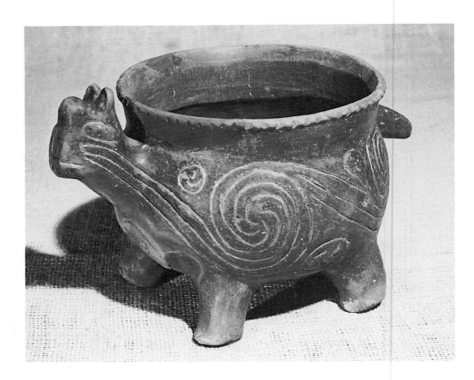

South America

In South America advanced cultures developed in the river valleys that crossed two main areas—the Pacific coast of what are now Ecuador and Peru and the Andean highlands of Peru and Bolivia. About 3000 B.C. people on the coast were beginning to raise corn and cotton. The first pottery, from the Colombian and Ecuadorian coast, was black or gray, round-bottomed, cord-impressed ware similar to Japanese Jomon ware and dated from 3000 to 2700 B.C.

Chavín By 1400 to 1000 B.C. during the Preclassic Period, the Chavín people of Chavín de Huantar and other centers in the north highlands and on the coast were building temple-pyramids, weaving textiles, working gold, and making pottery. Chavín pottery was burnished black ware in a bottle and jar form, usually decorated with a jaguar motif. The coastal Chavín at Cupisnique developed a unique form—the **stirrup-spout** bottle, which had a hollow, stirrup-shaped handle with a spout on top. Many were modeled in a great variety of human, animal, vegetable, and even house forms. Other, rounded vessels were decorated with incised patterns accentuated by stamping.

Mochica, Nazca, and Tiahuanaco During the Classic Period, beginning about A.D. 200, the Mochica on the north coast excelled in stirrup-spout bottles mold-modeled in the form of figures and portrait heads (Figs. 2-28 and 2-29). The breadth of imagery and artistic qualities of the sculptural pottery made by the Mochica rivals that of other great ceramic cultures worldwide. Stirrup jars were made in the form of a wide variety of animals, plants and human activity. Many of the pieces depict interactions between divine beings and humans, some of which would today be labeled explicitly erotic.

The Mochica also made smooth-surfaced stirrup-spout bottles and other pottery with delicately painted figures on white slip. About the same time, the people of the Nazca Valley on the south coast produced rounded and modeled grave pottery with double spouts and a strap handle and an emphasis on intricate painted polychrome decoration on slip (Fig. 2-30). Bisque molds were commonly used to produce spouts and elaborate vessel sections that were later joined. They were usually very light in weight with a uniform thickness, a remarkable achievement for hand-built ware.

In the early Postclassic Period, before 1000 A.D. the people of Tiahuanaco, who had developed a Classic civilization in the southern highlands, expanded west and north, overrunning the declining Mochica and Nazca civilizations. Characteristic Tiahuanaco pottery included flaring goblets, wide-rimmed bowls, and oval and modeled vessels with two spouts and a strap handle. They were decorated usually in black-outlined white on a red body or in polychrome slip. Stylized motifs included a feline form.

2-28 Mochica head jar, coastal Peru, c. 500. Terra-cotta with slip, height 8.63″ (21.89 cm). Art Institute of Chicago.

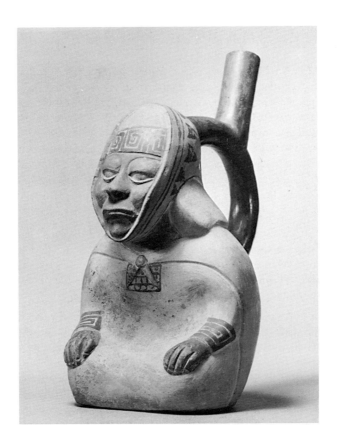

2-29 Mochica stirrup-spout effigy vessel, Peru, 500. Earthenware. In the form of a seated kerchiefed figure. Greek fret decor on headband and cuffs. Height 11″ (28 cm). Art Institute of Chicago (Buckingham Fund).

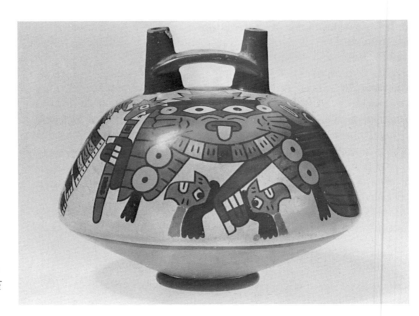

2-30 Nazca double spout vessel with bridge, Peru, 800. Earthenware, polychrome slip decoration showing deity with two trophy heads, height 5.51″ (14.12 cm). Art Institute of Chicago (Buckingham Fund).

THE ANCIENT MIDDLE EAST

Neolithic farmers of Mesopotamia (now Iraq), Palestine (Israel), Anatolia, (Turkey), Iran, and Egypt were making coiled pottery at an early date. Subsequently the rise and fall of a series of civilized peoples—notably Sumerians, Babylonians, Assyrians, and Persians—in western Asia and the exchange of influences between them and the various Egyptian dynasties in northeast Africa contributed to a rich complexity of art forms. Despite regional variations, certain characteristics remained constant. One is the use of repetitive patterns and symmetrical composition. Another is a preference for curved forms. A third is emphasis on bright color. Religious restrictions often banned the realistic representation of human form, which left these other areas as the main outlet for creative exploration. These characteristics were basic to Middle Eastern art and continued much later in the Islamic era.

Mesopotamia, Anatolia, and Iran

The oldest pottery found in the Middle East was made in the Neolithic village of Çatal Hüyük in southeast Anatolia about 6800 to 5700 B.C. The earliest wares were crude and soft with a dark burnished body. Later wares were red, covered with cream-colored slip and decorated with bands of zigzag and chevrons and circular motifs.

Slightly later in the sixth and fifth millennia B.C. Hassuna and Samarra in Mesopotamia were producing incised black ware and red-bodied painted ware. In the fifth millennium B.C. the peoples of Halaf, Arpachiyah, and Carchemesh, between Anatolia and Mesopotamia, were making large flat dishes covered with bands of intricate repeat motifs in lustrous brown, tan, red, white, and black slip. In the fourth millennium, Tepe Hissar and other centers in Iran were producing slip-painted ware thrown on the potter's wheel (Fig. 2-31). Geometric motifs were

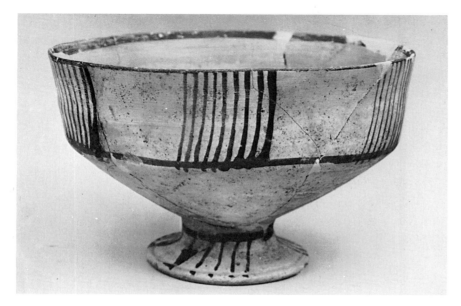

2-31 Small cup, Tepe Hissar, Iran, c. 3500 B.C. Wheel-thrown buff earthenware with brown slip decoration, height 4.38″ (11 cm). Metropolitan Museum of Art, New York (gift of Tehran Museum, 1939).

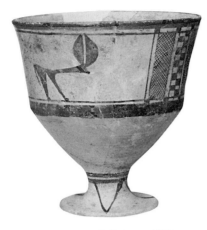

2-32 Footed cup, Sialk, Iran, c. 3000 B.C. Earthenware with slip decoration, height 7″ (17.7 cm). Metropolitan Museum of Art, New York (Rogers Fund, 1955).

combined with stylized flowers and animals, such as the graceful ibex on a footed cup from Sialk (Fig. 2-32). Middle Eastern love of color may be seen in the relief scenes of animals and court life, made of molded earthenware tiles covered with polychrome tin-lead glaze, that decorated the walls of cities and palaces of the Babylonians and Assyrians, who ruled Mesopotamia in the eighth, seventh, and sixth centuries B.C. (Fig. 2-33).

Egypt

The earliest pottery of Egypt was a crude, dark ware made in the Faiyum region of the lower Nile Valley during the Neolithic period, about 4500 B.C., later than that of the Sudan (7000 B.C.). More developed were the burnished red and black vases of the Badarian culture in northern Egypt (Fig. 2-34) made about 4000 to 3200 B.C. Because the pots were fired upside down in little more than a bonfire, the upper rims of the red clay pots were covered with ashes and in direct contact with the burning coals. This reduced the amount of oxygen and caused them to turn black, while the balance of the pot, exposed to the oxidizing effect of the air, retained its original red color. The Amratian culture to the south (c. 3600 B.C.) also made a red polished ware with white incised decorations of geometric, plant, and animal motifs. The Gerzean people of the Nile delta made a ware that indicates use of a better kiln and more control over the firing, as it had a light body with painted decorations in reddish brown slip depicting boats, birds, and hunting and religious scenes (Fig. 2-35).

2-33 Lion wall from palace of King Nebuchadnezzar II, Babylon, 605–562 B.C. Glazed brick, length 7′ 5.5″ (227 cm). Metropolitan Museum of Art, New York (Fletcher Fund, 1931).

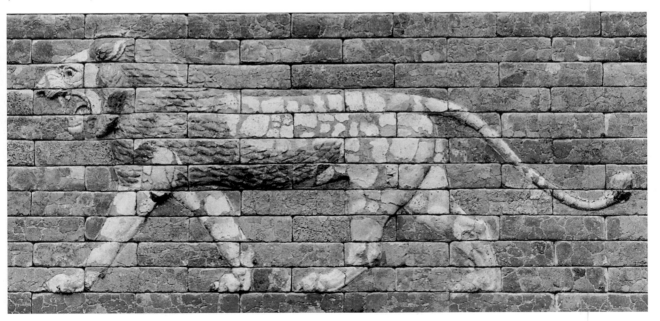

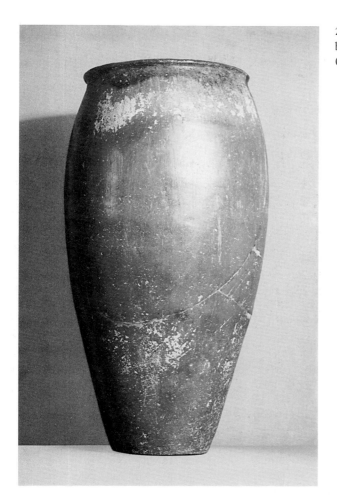

2-34 **Tall El Badari vase,** Egypt. Predynastic, before 3300 B.C. Red and black earthenware, height 21″ (53.3 cm). Victoria and Albert Museum (Crown Copyright).

2-35 **Gerzean vessel,** Egypt, c. 3300 B.C. Buff earthenware with brown slip decorations of ibexes, ostriches, and boats; height 7.75″ (19.69 cm). Metropolitan Museum of Art, New York (Rogers Fund, 1920).

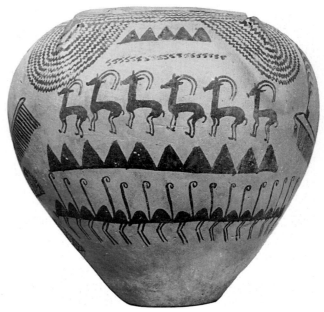

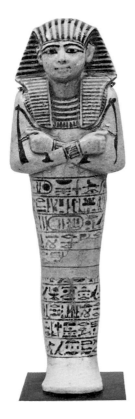

2-36 Faience Ushabti of King Seti I, Thebes, Egypt, 1313–1292 B.C. Ushabti are small mummy-like tomb objects thought to be useful to the dead in the afterlife. Height 11.75″ (29.4 cm). Metropolitan Museum of Art, New York (Carnavon Collection, gift of Edward S. Harkness, 1926).

At an early period the Egyptians developed a turquoise glaze called **faience.** It was made of silica (the chief ingredient of glass) and soda with some clay as a binder and copper or cobalt as a colorant. In drying, the water-soluble soda was drawn to the surface, and when fired it reacted with the silica to form a shiny alkaline glaze. This is similar to a relatively nonplastic self-glazing clay that today we refer to as **Egyptian paste.** It fused satisfactorily with sandy clay bodies common in Egypt, but flaked off the more plastic clay bodies common elsewhere in the Middle East. The turquoise tiles in the tomb of the Old Kingdom Pharaoh Djoser at Saqqara (c. 2600 B.C.) are the first evidence of faience. It was also used for beads, other jewelry, furniture inlay, and figurines (Figs. 2-36 and 2-37). It was not applied to pottery until the New Kingdom, about 1500 B.C.

In spite of the beauty of the early red and black vases, the decorated Gerzean ware, and the unusual turquoise faience, pottery as an art form did not prosper in Egypt. The agricultural wealth of the country flowed into the household of the Pharaoh, the priesthood, and the military caste. They preferred finely crafted vases of polished alabaster and other stone and vessels of silver and gold. Pottery in the dynastic era was primarily utilitarian.

below: **2-37 Hippopotamus** from the tomb of Senbi of Meir, Egypt, XII Dynasty (2000–1788 B.C.). Faience body with painted decoration of water plants; height 4.6″ (11 cm). Metropolitan Museum of Art, New York (Gift of Edward S. Harkness, 1917).

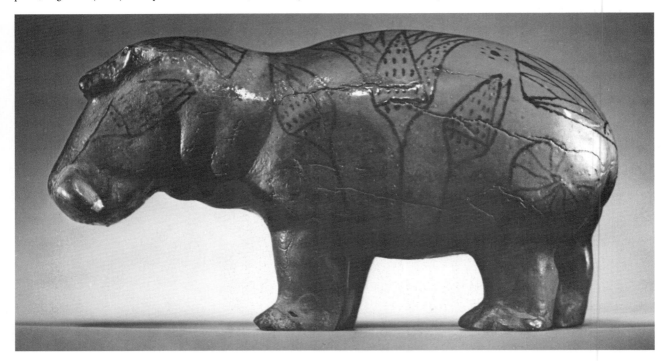

THE ANCIENT MEDITERRANEAN WORLD

Ceramics became a highly developed art form in the centers of civilization around the Mediterranean Sea, especially in Crete and Greece. Greek pottery was traded all over the ancient world.

Crete

Between 3000 and 2500 B.C. the Minoan civilization, named after the legendary King Minos, evolved on the island of Crete. Although it was influenced by the neighboring civilizations in Mesopotamia and Egypt, it was different from them. Without a dominant priesthood and protected from invaders by the sea and their navy, the Minoans developed a unique prosperity based on sea trade.

Neolithic Cretan pottery, like that elsewhere, was first a corded black ware, then a polished ware with simple crosshatched and dotted designs. Early Minoan pottery (2800–2000 B.C.) was wheel thrown and decorated with banded and geometric motifs in white over black slip. During the Middle Minoan period (2000–1550 B.C.), pottery forms became more graceful. Designs were curling plant and circular motifs in white, cream, and red on a dark body. These gradually gave way to dark designs on a light tan body.

In the closing years of this era and the early part of the Late Minoan era (1600–1500 B.C.), Minoan civilization reached its height and spread to islands in the Aegean Sea to the north and the Greek mainland. The flowing motifs of plant and sea life (particularly the octopus) were superbly suited to oval water bottles and rounded vase forms (Fig. 2-38). There were also huge palace storage jars for oil and wine. They stood nearly 6 feet (1.83 m) high and were decorated with bands of relief motifs (Fig. 2-39).

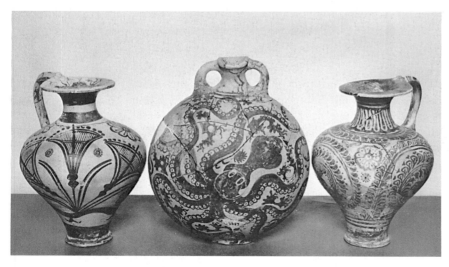

2-38 Minoan flask with two pots, Palaikastro, Crete, 1600–1500 B.C. Flowing decorations of sea and plant life in red and black slips on buff-colored clay. Herakleion Museum, Crete.

2-39 Pithos (storage jar), Knossos, Crete, c. 1450–1400 B.C. Earthenware storage jar with applied rope decoration, height 4′ (1.15 m). British Museum, London.

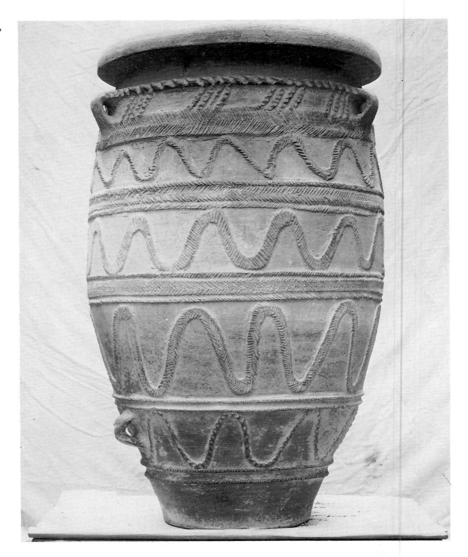

Remains of palaces at Knossos and other sites indicate a series of volcanic destructions and rebuildings. About 1450 B.C. as the result of a particularly violent eruption on the island of Thera (Santorini), huge tidal waves swept the populous north coast of Crete, palaces were destroyed, and a thick layer of volcanic ash covered the farmland. Also the island was invaded from the mainland. Crete never recovered its former glory.

Greece

Neolithic peoples were farming and making pottery in Greece in the sixth millennium B.C. About 2000 B.C., Greek-speaking tribes, including the Achaeans of Homeric legend, were invading Greece from the north. They built fortress-palaces on hilltops that became the centers of such later Greek city-states as Mycenae, Tiryns, Thebes, and Athens.

right: **2-40 Mycenaean stirrup jar,** Crete, 1200–1125 B.C. Earthenware decorated with stylized octopi, height 10.25″ (26 cm). Metropolitan Museum of Art, New York (Louisa Eldridge McBurney Gift Fund, 1953).

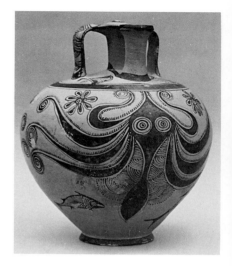

Mycenaean Period

By 1400 B.C. Mycenaean princes had expanded their power throughout the eastern Mediterranean, including Crete. Many Cretan craftsmen migrated to the mainland; thus much of the goldwork and pottery found in Mycenaean Greece has Minoan characteristics. Vases had a higher foot and were more rounded at the shoulder. Cups were high stemmed and delicately formed. Mycenaean potters subdued and conventionalized the more dynamic floral decoration of the Minoans and often used simple banded decoration (Fig. 2-40). Later they depicted scenes of warriors and horses somewhat crudely drawn, but a forecast of later Greek wares (Fig. 2-41). During the thirteenth century B.C., new waves of Greek-speaking peoples from the north, the Dorians, overthrew Mycenaean rule and initiated a period of artistic decline.

Geometric Style

About 1050 B.C. the pottery in the area around Athens improved. The forms, although based on those of Mycenaean cups, vases, and jars, were better thrown and higher fired. Decoration, bands or concentric circles in dark slip on a red body, was executed with care and precision. About 900 B.C., the **Geometric style** developed. Decoration was enlivened with rows of triangles, zigzags, meanders (keys), and swastikas (Fig. 2-42). Eventually

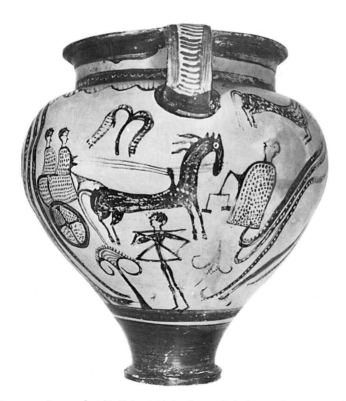

2-41 Mycenaean krater, found in Enkomi Alasia, Cyprus. Early fourteenth century B.C. The sketchy riders and chariots represent a great change from the earlier stylized plan decorations. Height 15.16″ (38.5 cm). Cyprus Museum, Nicosia, Cyprus.

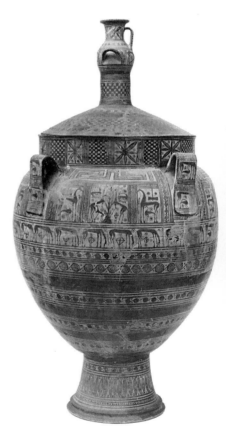

2-42 Funerary vase, Cyprus, eighth century B.C. Earthenware with paneled and banded decoration of horses, deer, waterfowl, and double axes in the Geometric style; height 46.88″ (117.5 cm). Metropolitan Museum of Art, New York (Cesnola Collection).

figurative elements were introduced. First came the horse, a prestige symbol, and later the chariot and driver, but all were drawn as stick-figures.

Oriental Style As the Greek city-states grew and population pressures on limited farmland increased, the Greeks founded colonies in the eastern Mediterranean and expanded trade with older civilizations of the Middle East. As a result Greeks encountered the fantasy of so-called Oriental art: winged monsters such as gorgons and sphinxes, often in a floral setting. In the late eighth and seventh centuries B.C., Corinth became a center of this **Oriental style.** Rhodes, Cyprus, and other islands close to Syria at the eastern end of the Mediterranean were also centers. They produced fine pottery on which floral borders replaced the old zigzags, and stylized birds, animals, and finally figures from the Homeric legends filled the central panel. An effective black-figure style, in which humans were painted in black slip on red ware, was used on a series of miniature vases (Fig. 2-43). Athenian potters at this time continued to stress the human figure, but in a sketchy outline style (Fig. 2-44).

Black-Figure Style Perhaps because pottery played an important part in burial rites, its forms had been codified. They included the tall wine jar, urn-shaped water jar, bowl, cup, pitcher, and bottle. The major area on each piece was devoted to a figure or group, at first representing heroes, gods, or episodes

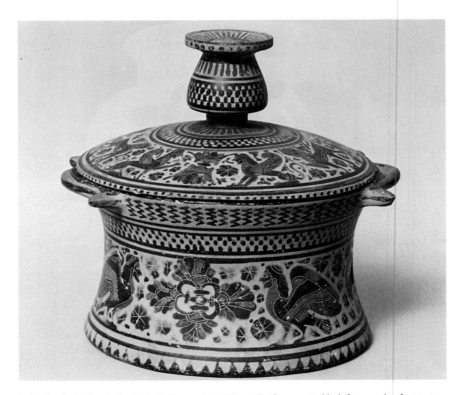

2-43 Pyxis (toilet jar), Corinth, Greece, 625–600 B.C. Earthenware in black-figure style of intricate banded decoration and fantastic animals, height 4.06″ (10.31 cm). Metropolitan Museum of Art, New York (Fletcher Fund, 1925).

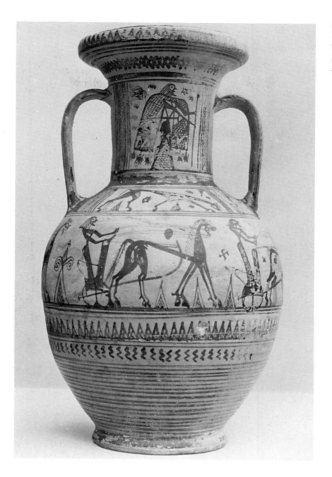

2-44 Dipylon amphora, Athens, Greece, eighth century B.C. Terra-cotta, height 11.69″ (29.22 cm). Metropolitan Museum of Art, New York (Rogers Fund, 1921).

from Homer, later athletic and domestic scenes (Fig. 2-45). These were done in the black-figure style, which Athenian potters had adopted from Corinth in the late seventh century B.C. It was striking, but because details had to be made by incising the black slip, it didn't take full advantage of the increasing skill of vase painters. Nonetheless, there are many fine examples of the skill of both potter and painter in this collaborative work.

Red-Figure Style After about 520 B.C. Athenian potters developed the **red-figure style,** in which the background was painted with black-firing slip and the figures reserved in the red of the unpainted clay body (Fig. 2-46). The so-called black slip glaze of the Greeks was not a true glaze, but rather was made of a finely decanted red clay slip called **terra sigillata.** When fired in a **reducing fire** (without oxygen) the entire pot became black. Changing the firing to oxidation at the end turned the porous, red clay body back to its original color while the painted slip remained black. Careful control of the firing was required to achieve this effect. With this powerful visual separation of red and black, details could now be added easily with fluid brush strokes. As the skill of the vase painters grew, they were tempted to create more and more extravagant effects. By this point, potters and painters had separated their tasks, each making best use of their respective skills. By the fourth century B.C., the powerful decorative qualities

2-45 **Stamnos, Greece,** 470–460 B.C. Earthenware in red-figure style. Metropolitan Museum of Art, New York (Rogers Fund, 1918).

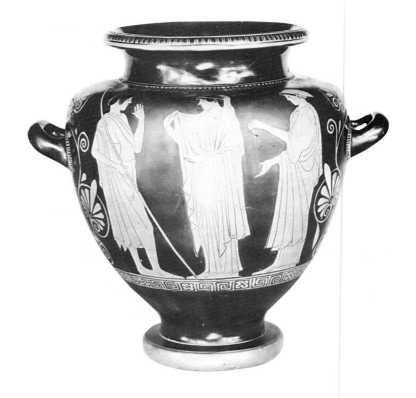

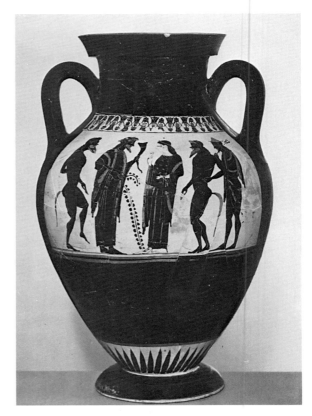

2-46 **Amphora, Greece,** sixth century B.C. Earthenware, decorated with panels of Dionysiac and marriage processions in the black-figure style. Metropolitan Museum of Art, New York (Rogers Fund).

of Hellenistic pottery were largely destroyed by attempts at realism that resulted in confused overlapping of forms, excessive foreshortening of figures, and eventually multicolored landscape elements.

Etruria

After Crete and Greece, the third major area of early civilizations in the Mediterranean is Italy. The Etruscans are thought to have come from Asia Minor to western Italy during the ninth century B.C. at about the same time that the Greeks were founding colonies in Sicily and southern Italy. Eventually the Etruscans established twelve loosely allied city-states in an area between present-day Rome and Florence. They mined and exported iron and copper and had considerable trade with the Greeks. Greek potters likely emigrated to Etruria.

Etruscan pottery was uneven in quality, for it absorbed many influences without assimilating them into a coherent whole. These influences included the polished black ware of the older Villanovan people of northern Italy (Fig. 2-47), the Oriental style, later Greek styles (Fig. 2-48), and their own embossed metalwork. Early Etruscan pottery had a red polished body and was often incised with bands or cross-hatching. More characteristic was polished black **bucchero** ware with incised, pressed, or molded decoration.

The Etruscans were most noted for their terra-cotta sculpture. Their temples were roofed with tiles that terminated along the eaves in elaborate gorgon heads. Large polychrome terra-cotta figures of gods topped the ridgepole, and high-relief figures filled the triangular pediment over the entrance. Unfortunately, these temples and their sculpture were almost completely destroyed by the Romans. Large ceramic sarcophagi have been found, however, in rock-cut tombs that escaped

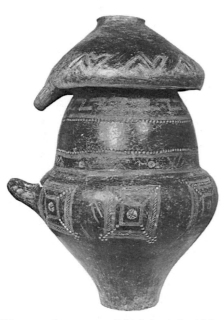

2-47 **Villanovan cinerary urn,** Vulci, Italy, ninth–eighth century B.C. Black polished earthenware. Villa Guilia Etruscan Museum, Rome.

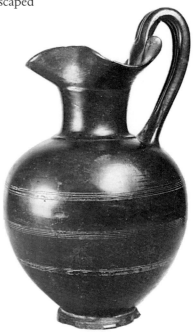

2-48 **Etruscan oenochoe** (wine pitcher), Chiusi, Italy, fifth century B.C. Black polished bucchero earthenware in the Greek style, 14 × 8 in. (35.5 × 20.3 cm). Art Institute of Chicago (gift of D. P. Armour and C. L. Hutchinson).

2-49 Etruscan urn in the form of a sarcophagus, Italy, third century B.C. Terra-cotta decorated with battle scene and reclining woman. Metropolitan Museum of Art, New York (Subscription, 1896).

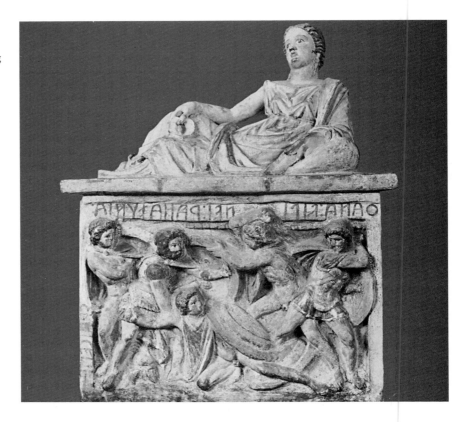

looting (Fig. 2-49). They are surmounted by portrait figures of the dead, the most famous of which is a reclining couple who seem to be in easy, animated conversation with their friends.

Rome

Shortly after 500 B.C. warlike Latin-speaking tribes around Rome began to expand north into Etruria and south into the Greek colonies. Neither the Greeks nor the Etruscans, often quarreling among themselves, put up a united front against the Latins. During the next two hundred years all Italy fell before the growing power of Rome, which eventually took over most of the empire of Alexander the Great in Greece and the Middle East, as well as the lands bordering the western Mediterranean.

Roman art combined Greek and Etruscan elements. Ornate late Greek, or Hellenistic, pottery was popular among the Romans, as was Etruscan bucchero ware. Although the Romans hired subject Etruscans to make ceramic sculpture for early Roman temples, the Romans eventually followed the Greek preference for marble sculpture. They continued the Etruscan interest in realistic portraiture, but expressed it in marble.

Roman conquests in Syria and Egypt eventually led to the use of the lead glazes that had developed in those regions (Fig. 2-50). The pottery style that is typically Roman is **terra sigillata** (Fig. 2-51). It is somewhat related to the Etruscan bucchero ware in that it has a raised sculptural decoration, but the body has a brick-red oxidized surface instead of a black, reduced one. Since the decoration was elaborate and detailed, the ware was often made in molds, one of which

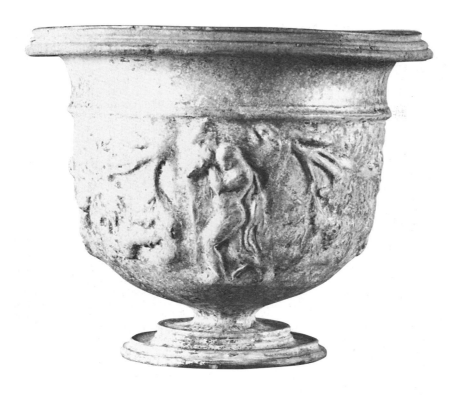

2-50 Footed bowl, Roman, first century A.D. Earthenware with sculptural relief and green lead glaze. Metropolitan Museum of Art, New York (Mr. and Mrs. Isaac D. Fletcher Collection, bequest of Isaac D. Fletcher, 1917).

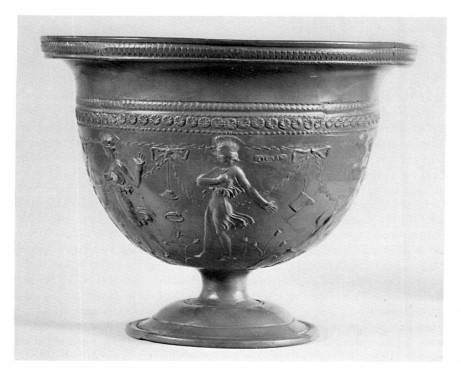

2-51 Terra sigillata footed bowl, Roman, c. 10 B.C.–A.D. 10. Molded red earthenware. Metropolitan Museum of Modern Art, New York (Rogers Fund, 1910).

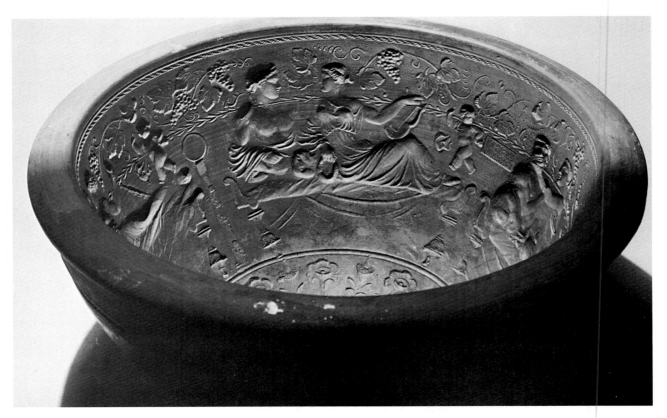

2-52 Arrentine mold with intricate relief,
Roman. Late first century B.C. Earthenware.
Metropolitan Museum of Art, New York
(Rogers Fund, 1919).

is shown in Figure 2-52. In general, however, the Romans neglected ceramics, giving greater attention and value to stone carving, metalwork, and architecture.

EUROPE

The development of European ceramics, in general, was often influenced from the cultures in the Middle East and the Orient. Farmers from western Asia migrated to the Danube Valley in eastern Europe, where small agricultural villages were settled shortly after 7000 B.C. Excavations during the 1970s at Vinca in Yugoslavia, Varna in Bulgaria, and other sites reveal pottery decorated with black graphite and artifacts made of gold and copper dated shortly after 5000 B.C. Clearly people were making ceramics in Europe at a very early point in its human occupation.

The Celts, Indo-European people from the east who spread over much of Europe from about 1800 to 400 B.C., were primarily farmers and skilled metalworkers. They traded with the Greeks and Etruscans south of the Alps for fine pottery. From the Romans, who colonized Gaul, the Rhineland, and Britain from the first century B.C. to the fifth century A.D., European potters learned such advanced techniques as the use of the wheel and lead glaze. The decline of Rome, however, accompanied by new waves of barbarian invaders from the east, caused pottery skills to be forgotten, not only in northern Europe, but even in Italy itself.

AFRICA

Our knowledge of African pottery suffers somewhat from the lack of data that formerly characterized the study of all aspects of ancient African cultures, although this is changing. Rock paintings and stone engravings from the fifth millennium B.C. to the second, which were first discovered in the mountains of the Sahara and central and southern Africa early in the twentieth century, reveal a gradual change from a hunting to a pastoral culture. As the climate gradually became drier and population increased, peoples migrated, generally from north to south and from west to east. Trade between the ancient African kingdoms of Kush (now Sudan) and Punt (Ethiopia and Somaliland) and Egypt exposed Africans to the developments of Middle Eastern civilizations. Iron making spread west to northern Nigeria, where the Nok people (900 B.C.–A.D. 200) worked in iron as early as the fifth century B.C. An extensive iron industry flourished at Meroë, capital of Kush, on the upper Nile in the first century A.D. The life-size terra-cotta heads and the fragments of figures made by the Nok about 500 B.C. have an impressive realism that is unique and give a hint of the accomplishments yet to come in Benin (Fig. 3-28, Chapter 3). Bronze casting, well-established along the Niger River between 600 and 950, spread south to Ife (Fig. 2-53) and Benin (now Nigeria).

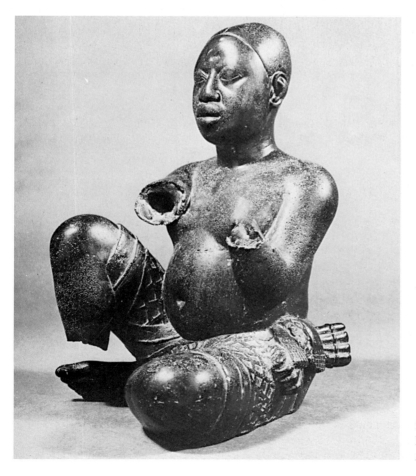

2-53 Ife figure, Tada, Nigeria. Tenth–eleventh century. Bronze, height 20.5″ (50.93 cm). Department of Antiquities, Lagos, Nigeria.

Chapter 3

A.D. ~1000 TO 1950

From the twelfth century, increased contact between the Orient, the Middle East, and the West led to many technical and stylistic changes in the ceramics of Europe and Asia, but did not affect those of Africa. The Spanish conquest and destruction of native cultures in the Americas introduced European forms and technology to the New World. The Industrial Revolution, which began in eighteenth-century Europe, led to a greatly increased but mechanical production, and to a decline in design. Contemporary modern handmade pottery developed largely in reaction to such industrially produced wares.

THE FAR EAST

China continued to play a major role in the history of ceramics, influencing not only Korea and Japan, as in previous centuries, but also the Islamic world and Europe.

China

Sung Dynasty During the Sung Dynasty (960–1279) Chinese innovations in porcelain and kilns were further expanded as potters achieved an unusual perfection of form and glaze. The white Ting ware continued, but farther south at Ching-te-chen, in Kiangsi Province, a true porcelain was developed. This Ch'ing-pai ware was high fired, translucent in thin areas, and covered with a bluish white glaze.

Celadons were of several types: gray-green **Kuan** (Imperial) ware in the north (Fig. 3-1) and blue-green **Lung-Ch'uan** ware in the south, resembling jade. Other porcelaneous bodies such as **Chun** ware had a pale blue or lavender-gray glaze splashed with purple. **Chien** tea bowls, made in Fukien Province, had a dark iron-brown glaze with silvery "oil spot" or "hare's fur" markings. They were called

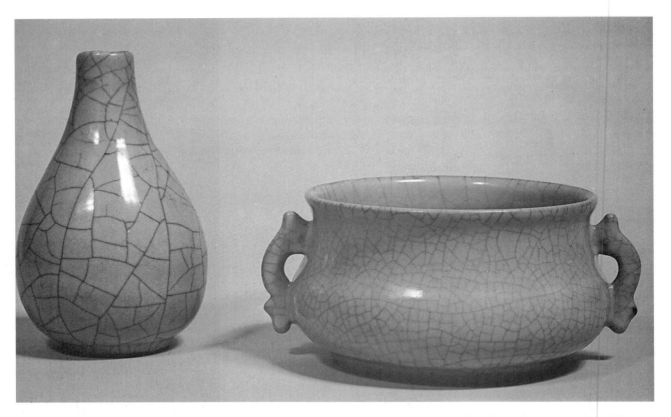

3-1 Vase and incense burner, China. Sung Dynasty (A.D. 960–1279). Kuan porcelain with a heavy crackled celadon glaze; vase height 5.13″ (13 cm), diameter of incense burner 6.13″ (15.5 cm). Cleveland Museum of Art.

Temmoku by the Japanese, who copied them. Strikingly handsome were tall **Tz'u-Chou** stoneware wine jars made in the north with incised or bold floral slip-painted patterns of brown-black over a cream slip (Fig. 3-2).

Despite the immense distances over desert and mountain terrain between China and the western world, Chinese military forces under the expansive Han Dynasty had gained control of the Silk Route between China and the eastern borders of the Roman Empire. During the T'ang Dynasty this overland trade to western Asia expanded, and maritime trade via the South China Sea was established with southeastern Asia and India. These contacts with the outside world were limited, however, and were interrupted during periods of domestic upheaval. This situation changed when Genghis Khan unified the nomadic Mongol tribes of central Asia in the late twelfth century. Fierce fighters and expert horsemen, the Mongols rapidly conquered an empire that stretched from Korea to Russia.

Yüan Dynasty The Mongol conquest of China was completed when Genghis Khan's grandson, Kublai Khan, conquered South China from the Sung and established the Yüan Dynasty (1280–1368). No longer a relatively isolated state, but part of a great foreign empire, China was much more open to foreign influence and in turn inspired non-Chinese civilizations.

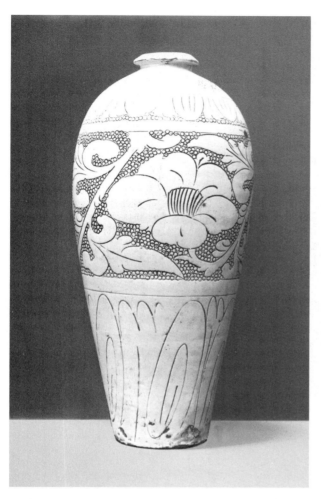

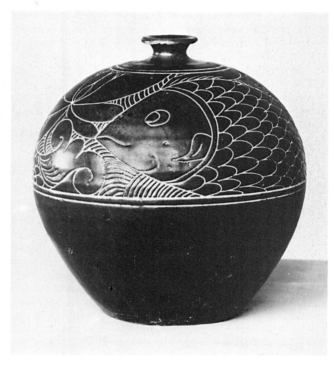

3-2 Tz'u-Chou vase, China. Sung Dynasty (11th century). Stoneware with vigorous sgraffito decoration, height 15.5″ (38.73 cm). Victoria and Albert Museum, London (Crown Copyright).

3-3 Tz'u-Chou ware bottle, China. Yüan Dynasty (1115–1234). Stoneware with dark brown glaze, height 9.63″ (24.4 cm). Victoria and Albert Museum, London (Crown Copyright).

The Mongol love for elaborate, overall decoration consisting of intertwining forms influenced the art of both China and the Middle East. Celadon ware continued to be made, but with ornate, more deeply carved designs. A good-quality cobalt was imported from the Middle East, which produced brilliant blue decoration on white porcelain instead of the brownish black previously obtained from inferior Chinese cobalt (Fig. 3-3).

Ming Dynasty Feuds among warlords and disastrous floods led to peasant uprisings and the founding of the Ming Dynasty (1368–1644), which gave imperial patronage to all the arts. In 1402 an official court factory was established at Ching-Te-Chên in Kiangsi Province. Its many potteries henceforth played the dominant role in Chinese ceramics.

White porcelain with blue underglaze decoration was in great favor during the Ming period. During the reign of Hsüan Tê (1426–1435) the blue-and-white

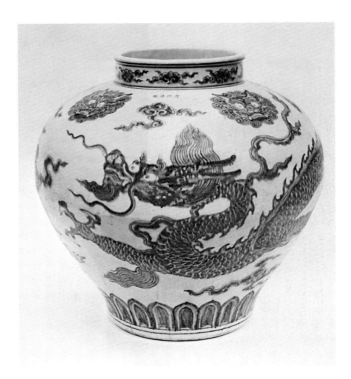

3-4 Jar, China. Ming Dynasty (1368–1644), Hsuan-Te Period (1426–1435). Porcelain with dragon decorations in underglaze Muhammadan blue. Metropolitan Museum of Art, New York (gift of Robert E. Tod, 1937).

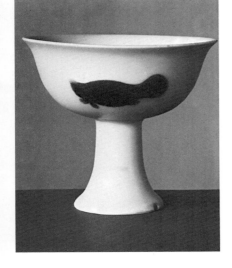

style, with its delicate animal and floral patterns, was at its height (Fig. 3-4). Copper-red (*sang-de-boeuf*) glazes, attempted during the Sung period, were perfected by Ming potters (Fig. 3-5). Meeting the court taste for luxury were **famille verte** ("green family") porcelains, decorated in low-fired overglaze enamels of dark purple, green, yellow, and later a strong red, which gradually replaced blue-and-white ware (Fig. 3-6).

Ch'ing Dynasty In the early seventeenth century, Ming China, weakened by rebellion, was taken over by Manchu tribes from the north, who established the Ch'ing Dynasty (1644–1912). The nomadic Manchus learned Chinese ways and continued the Chinese tradition of imperial patronage of the arts. In 1682 the imperial porcelain factories at Ching-Te-Chên, which had been largely destroyed during the Manchu conquest, were rebuilt and expanded. In addition to famille verte porcelains, a new **famille rose** ("rose family") porcelain was made, using colloidal gold in the glaze.

Unique to the Ch'ing period is an antiquarian mood in which many Sung and Ming pieces from the imperial collection were skillfully copied: celadons,

3-5 Stemmed cup, China. Ming Dynasty (1368–1644), Hsuan-Te Period (1426–1435). Porcelain; fish design, copper-red glaze. Foot thrown separately, height 3.63″ (8.5 cm). Victoria and Albert Museum, London (Crown Copyright).

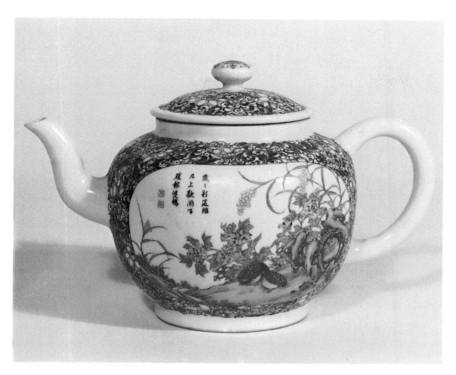

3-6 Teapot, China. Ch'ing Dynasty (1644–1912). Porcelain with famille verte decoration. National Palace Museum, Taipei.

ware glazed with copper-red, white Ting ware, and blue-and-white porcelain. Thus many pieces bearing a Sung or Ming mark are actually of Ch'ing origin. Wares made during the reign of Emperor K'ang Hsi (1672–1722) are particularly fine. Ch'ing potters produced quite a lot of work specifically for a huge export trade with the Portuguese and later the Dutch and English. Chinese efforts to satisfy European tastes, such as that for chinoiserie, led to a deterioration of standards of design.

Korea

Korea, like China, was affected by the Mongol invasion of the thirteenth century. From 1231 to 1260 most of Korea was occupied by the Mongols. This disruption caused great changes in the Korean pottery traditions and decline in craftsmanship from the Koryo Period. Celadons and ware decorated with mishima practically disappeared, although a few porcelains were made during the latter years of the Koryo Period.

The Yi Dynasty (1392–1910) is divided into two periods, separated by the Japanese occupation of 1592–1598. Characteristic of the early Yi period were stoneware, including **Punch'ung** ware (Fig. 3-7), a white slipware with vigorous sgraffito or iron-black brush work; a coarse, brushed slipware called **hakeme;** and a stamped mishima ware. Later, white porcelain with underglaze blue decoration became important (Fig. 3-8).

3-7 Punch'ung ware bottle, Korea. Yi Dynasty, sixteenth century. Stoneware with black iron brush decoration over a coarse white slip. Seattle Art Museum (gift of Mr. Frank Bayley to the Thomas D. Stimson Memorial Collection).

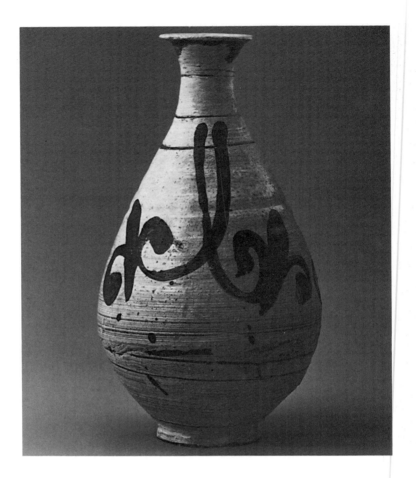

Japan

The later ceramic history of Japan was affected principally by the growing influence of Zen Buddhism, which encouraged the uniquely Japanese cult of tea.

Kamakura Period The Kamakura Period (1185–1333) was an era of renewed contacts with China. The Sung pottery imported during this time had a lasting effect on the Japanese. Seto, on the island of Honshu, became a major ceramic center. It produced a variety of vases, bottles, pitchers, and tea bowls incised or impressed with bold floral motifs and covered with a glaze that imitated Sung celadon.

Muromachi and Momoyama Periods Zen Buddhism, introduced to Japan from T'ang China, took hold in the twelfth century in the early Kamakura Period. As practiced by monks in Zen monasteries, it required long periods of meditation broken by a pause in which a cup of tea was served. During the Muromachi (1392–1573) and Momoyama (1573–1615) periods, the serving of tea became a codified ceremony and was adopted by the feudal nobility and then the rich merchant class. Most of the objects used in the ceremony—tea bowls, water container, cake trays, and flower vase—were ceramic.

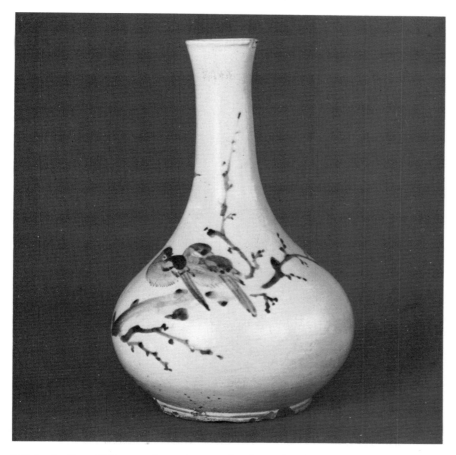

3-8 Bottle, Korea. Yi Dynasty, nineteenth century. Porcelain with underglaze blue decoration, height 7.5″ (19.05 cm). Victoria and Albert Museum, London (Crown Copyright).

In the Kamakura Period, as noted in Chapter 2, rare Sung bowls were imported from China for tea, but gradually they were thought not to be in keeping with the emphasis that Zen put on the natural, spontaneous, and simple. Eventually tea masters sought out the ordinary peasant earthenware made by the so-called six old kilns of Japan—Seto, Bizen, Shigaraki, Tamba, Tokoname, and Echizen. Later they also used the **Karatsu** ware made by Korean potters brought to Japan after the Japanese invasion of Korea. In the eyes of the tea masters the coarse imperfections of the clay, the careless touch of the potter's hand, and the accidental running of a glaze had a spontaneous quality associated with nature (Figs. 3-9 and 3-10).

Edo Period The cult of tea continued into the Edo Period (1603–1867), when it was served by such outstanding artists as Ogata Kenzan. Kenzan, who was primarily a decorative painter like his brother Korin, made tea bowls and other tea ware decorated with a free brush work and bold colors (Fig. 3-11) and in a style more Japanese than Chinese in feeling.

Porcelain was first made shortly after 1616 when kaolin was discovered by a Korean potter working for Lord Nabeshima near Arita on the island of Kyushu.

3-9 Oribe ware teapot, Japan. Momoyama Period (1573–1615). Stoneware with green and transparent glazes over a brown slip tortoise-shell decoration, height 7.63″ (19.25 cm). Seattle Art Museum (Eugene Fuller Memorial Collection).

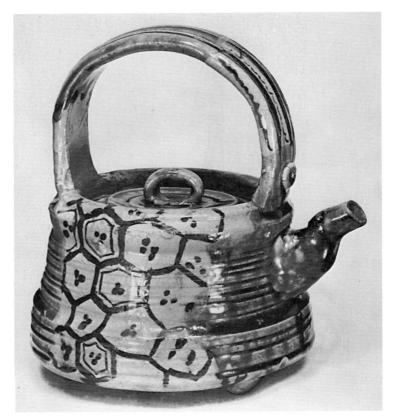

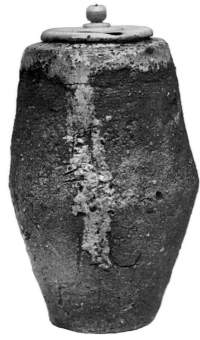

3-10 Tea jar, Shigaraki, Japan, nineteenth century. Coarse stoneware, height 3.5″ (8.8 cm). Metropolitan Museum of Art, New York (Fletcher Fund, 1925).

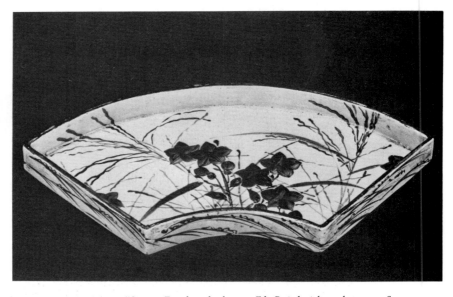

3-11 Ogata Kenzan, *Bellflowers.* Fan-shaped cake tray. Edo Period, eighteenth century. Stoneware with enameled decoration on a cream-colored glaze, length of sides 6.63″ (16.5 cm). Seattle Art Museum (Eugene Fuller Memorial Collection).

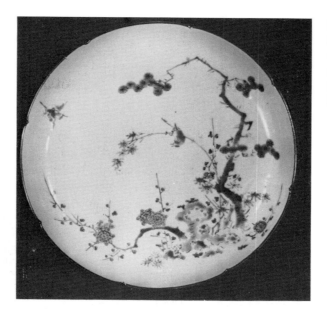

3-12 **Kakiemon ware plate,** Japan. *Pine, Bamboo, and Flowering Tree.* Edo Period, early eighteenth century. Porcelain with gold and enameled decoration, diameter 7.38″ (18.5 cm). Seattle Art Museum (Eugene Fuller Memorial Collection).

At first, potteries produced a Korean-inspired underglaze blue-and-white ware. Later, more colorful ware in Chinese style with dark blue underglaze and strong red overglaze enamel became popular. Chinese motifs were soon replaced by motifs from Japanese painting, textiles, and lacquerware. Such porcelain, however, soon became ornate, quite unlike the rustic tea ware. Produced in large amounts and exported from the port of Imari, this **Imari** ware, as it was known in the West, was in great demand in Europe.

In contrast to the vivid Imari ware were the small amounts of excellent porcelain produced by the potteries of the Kakiemon family and of Lord Nabeshima, also in Arita. **Kakiemon** enameled ware was in the Chinese tradition, but was painted with greater restraint and delicacy of color and brush stroke and with more openness of design Fig. 3-12). **Nabeshima** ware was delicately painted in motifs and style characteristic of Japanese painting (Fig. 3-13). **Kutani**

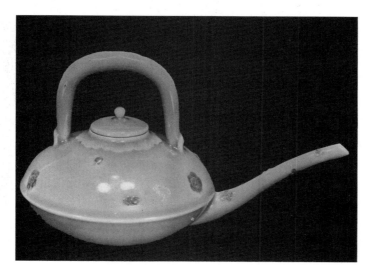

3-13 **Nabeshima ware teapot,** Japan. Edo Period, mid-eighteenth century. Porcelain with pale celadon glaze in a "plum blossom and buds" design, height 6″ (15 cm). Seattle Art Museum (gift of Mrs. Charles E. Stuart).

porcelain, from the Kutani potteries on the island of Honshu, was also Japanese in feeling, but had boldly brushed designs of birds, flowers, and landscapes in strong green, blue, yellow, and purple.

THE ISLAMIC WORLD

In the sixth century the prophet Muhammad founded a religion in the remote southern Arabian desert that became the dominant political and cultural force for a large part of the Old World. In the century after his death in 632, devout followers of Muhammad burst out of Arabia, conquering the Middle East and expanding east into India and west across North Africa into Spain. The Islamic civilization that they developed synthesized ancient art traditions of the conquered lands. Islamic culture also fostered mathematics and science, which undoubtedly influenced design. They developed the flowing, interlaced curves of symmetrical floral motifs known as **arabesques,** intricate geometric patterns and other detail, and vivid color.

Mesopotamia

Pottery of the seventh and eighth centuries in Mesopotamia was simple utilitarian earthenware often covered with a transparent lead glaze in brown, green, or blue-green (Fig. 3-14). Developments in pottery must be credited to the influence

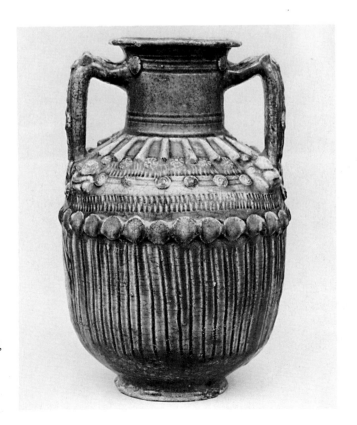

3-14 Amphora, Homs, Syria. Roman Period, A.D. first–third century. Earthenware with rope handles and applied decoration under a blue glaze. Metropolitan Museum of Art, New York (gift of John D. Rockefeller, 1938).

of Chinese ware, particularly porcelains, imported for the court of the Abbasid caliphs, who ruled from Baghdad and Samarra. These rulers encouraged local potters to imitate Chinese wares. In their efforts to do so, Mesopotamian potters, lacking the kaolin needed to make true porcelain, coated their earthenware with white slip. Such ware, incised with floral decorations and covered with a spotty, runny lead glaze in brown, green, and purple, showed the influence of T'ang pottery. As the pottery developed the slip was replaced by a thick white glaze, made opaque by adding tin to lead glaze, which served as a background for painted decoration. This Mesopotamian tin-lead-glazed earthenware was often breathtakingly elegant, but compared to Chinese porcelain somewhat less delicate.

Often the decoration was in luster glaze, the most unusual achievement of the Islamic potters of Mesopotamia (Fig. 3-15). Luster is a thin coating of metallic salts, which is fused by low firing onto a glazed surface as a form of decoration. During the eighth century it was used in Egypt on glass to produce the effect of gold. In the early ninth century, Mesopotamian potters adapted luster to earthenware. At first they used lusters of ruby red, green, brown, and yellow. In time they applied pale golden brown luster as a background in conjunction with polychrome decoration in blue, turquoise, manganese purple, and pale green.

The Old Testament injunction against making graven images for fear of idolatry was continued in Islamic tradition, although it pertained only to religious art. Intricate arabesques that suggest the complexity of life and the universe were favorite motifs on pottery and tiles used to enrich the interior

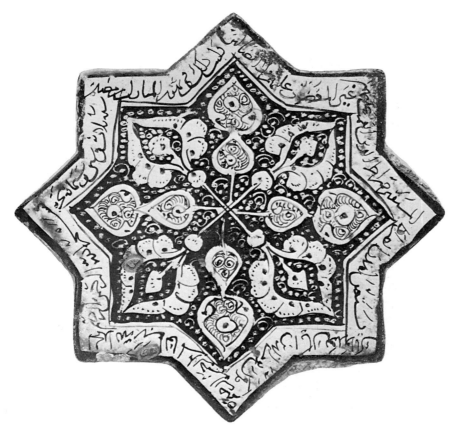

3-15 Wall tile, Kashan, Iran, thirteenth century. Tin-lead-glazed earthenware with luster decoration, diameter 5.75″ (14.5 cm). Metropolitan Museum of Art, New York (bequest of Edward C. Moore, 1891).

and occasionally the exterior of mosques. On pottery they often served as a background for stylized birds, animals, or human figures. Another common motif was koranic inscriptions in a bold, angular Kufic script, used alone or with other decoration.

Iran

Nomadic Turkish tribes from central Asia adopted Islam and established the Seljuk Empire in Iran and Mesopotamia in the eleventh century. Power shifted from the Abbasids in Mesopotamia to Cairo, Egypt, where Mesopotamian potters moved in search of patronage. Egypt then became a center of ceramic production.

After the fall of the rulers of Egypt in the twelfth century, many Egyptian potters settled in Iran. Consequently, Iranian potters in Rhages, Kashan, and other cities, who had previously made slip-painted, lead-glazed earthenware, began to use luster (Fig. 3-16). By about the twelfth century they had developed a soft-paste porcelain. Firing at a low temperature, this new body was composed of powdered silica sand and alkaline **frit** (melted, reground glaze) held together with a white clay. It was not very plastic, which limited them to rather simple dish, ewer, bowl, and vase forms. Such wares were coated with an alkaline glaze originally invented in Egypt.

Some Iranian pottery was decorated with Kufic inscriptions (Fig. 3-17). In contrast, other pieces bore delicate **minai** decoration, inspired by manuscript illustration, which revealed great interest in human life. Minai painting in polychrome enamel over opaque white or turquoise glaze, represented in miniature scenes of horsemen, court life, and romantic legends. It became popular in the late twelfth century. A third, quite different ware had bold decorations in

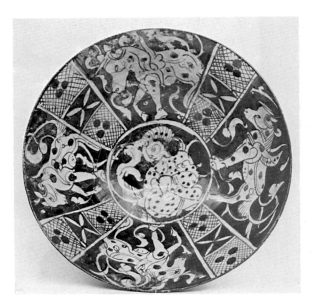

3-16 Bowl, Rhages, Iran, twelfth century. Earthenware with golden luster decoration. Metropolitan Museum of Art, New York (Rogers Fund 1920).

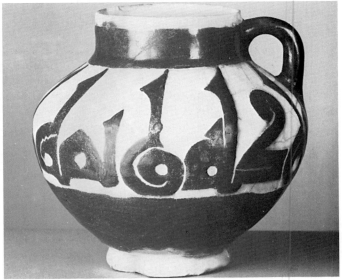

3-17 Tankard, Iran, twelfth century. The inscription reads, "Blessing to the owner." White earthenware with Kufic decoration in dark slip under a clear glaze, 5.75″ (14 cm). Victoria and Albert Museum, London (Crown Copyright).

dark slip or sgraffito of animals and floral patterns under a transparent turquoise glaze.

The Mongols, who invaded China in the thirteenth century, as previously noted, also conquered the Seljuks in Iran. As a result of their invasion, production of lusterware and minai ware ceased, except in Kashan. Gradually they were replaced by ware decorated with black brush work under a clear turquoise glaze (Fig. 3-18).

During the fourteenth century when both China and Iran were part of the Mongol Empire, contacts between the two countries were renewed. Designs from imported Chinese textiles and painting, such as clouds and dragons, were reflected in Iranian ceramics, although traditional Iranian bird and animal motifs with floral borders continued to be used. In the seventeenth century the luster technique was revived. Potters also produced a series of monochrome wares in Kerman and other cities, as well as fine earthenware and thin, soft-paste porcelain in blue and white (Fig. 3-19) or entirely in white with a pierced design in the body, which was filled and covered by a transparent glaze (Fig. 3-20).

Ottoman Empire

Many Seljuk Turkish tribes entered Anatolia (modern Turkey) from the eleventh through the thirteenth century. They built mosques enlivened by glazed tiles in the Iranian style. After the Mongol conquest of the Seljuks, one Turkish tribe, the Ottoman Turks, rose to prominence in Anatolia. In 1453 they conquered Constantinople, capital of the Byzantine Empire, which had succeeded Roman rule in the eastern Mediterranean and southeastern Europe. In the early sixteenth century, Syria and Egypt fell under Ottoman rule.

The Ottoman sultans imported Iranian potters to make tiles for new mosques in Bursa and Edirne. The tiles, in turquoise and blue on white, successfully combined Chinese and Iranian floral motifs. By the late fifteenth century, the potters of Iznik (formerly Nicaea) were making not only tiles, but also large dishes, jars, ewers, tall-footed bowls, and mosque lamps in white with blue decoration. Gradually they added green and purple decoration, and finally a brilliant iron-red. The most impressive examples of **Iznik** ware are large plates with a central floral spray—tulips, carnations, roses, or hyacinths—treated realistically (Fig. 3-21).

Spain

At the western end of the Islamic world, southern Spain prospered under Muslim (Moorish) rule from the eighth to the sixteenth century. Early **Hispano-Moresque** pottery of the tenth and eleventh centuries had stamped or slip-painted geometric motifs or koranic inscriptions.

The upheaval resulting from the thirteenth-century Mongol conquests in the Middle East benefited Spain as Iranian and other Middle Eastern potters, dispersed from their homelands, fled west. From them the Moorish and Christian potters of Málaga, Valencia, and nearby Manises learned the secrets of luster glazes. These lusters, composed of copper, silver, sulfur, red ocher, and vinegar,

3-18 Ewer, Sultanabad, Iran, thirteenth–fourteenth century. Earthenware body with decorations in a dark slip under a turquoise alkaline glaze, height 7.8" (19.8 cm). Art Institute of Chicago (Mr. and Mrs. Martin A. Ryerson Collection).

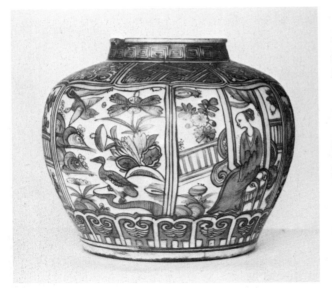

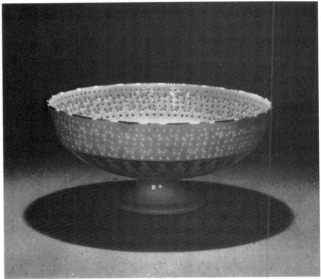

above left: **3-19 Jar,** Iran, sixteenth–seventeenth century. Copy in earthenware of a Chinese porcelain jar, height 7.5″ (19.05 cm). Victoria and Albert Museum, London (Crown Copyright).

above right: **3-20 Footed bowl,** Iran, seventeenth–eighteenth century. White earthenware with elaborate pierced decoration, diameter 8.5″ (21.59 cm). Victoria and Albert Museum, London (Crown Copyright).

were applied to earthenware covered with white tin glaze with a third low reduction firing only for the lusters. To save kiln space the large plates were placed on edge. The favorite colors were pale gold luster with details in blue. Decoration, on both front and back, reflected the arts of metal engraving and textiles in its overall patterns of stylized floral elements, chevrons, knotted ribbons, and koranic inscriptions (Figs. 3-22 and 3-23).

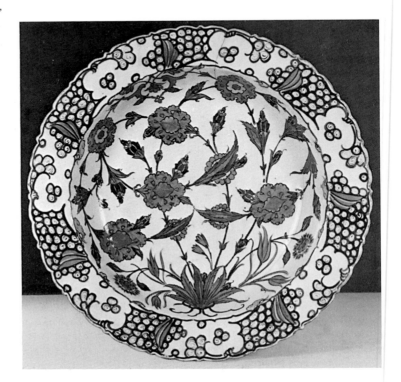

right: **3-21 Dish,** Iznik, Turkey, 1550–1560. Earthenware with tin-lead-glazed polychrome decoration, diameter 14.5″ (36.83 cm). Victoria and Albert Museum, London (Crown Copyright).

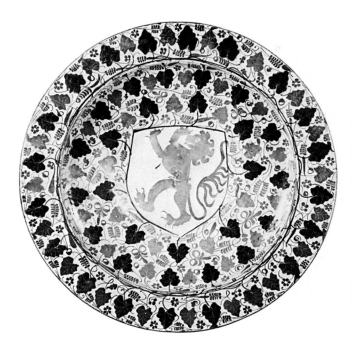

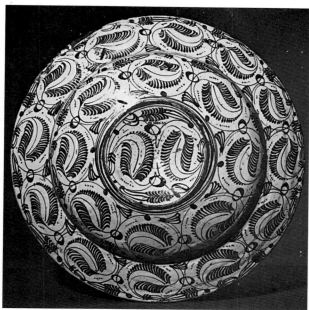

left: **3-22 Hispano-Moresque platter,** Spain, c. 1450. Earthenware with tin-lead glaze decoration in blue with golden luster, diameter 17.75" (45.08 cm). Victoria and Albert Museum, London (Crown Copyright).

above: **3-23 Bottom view** of platter in Figure 3-22 showing double foot and decoration.

As Gothic influences from France crept into Spain, more naturalistic foliage and even animals, birds, horsemen, and other humans appeared. Of particular interest are large sets of lusterware plated with a heraldic coat of arms surrounded by an intertwined floral border. Owning such plates became a symbol of prestige for many small feudal states, not only in northern Spain, but also in southern France and Italy where lusterware was in great demand.

Interested primarily in painted decoration, the Hispano-Moresque potters of the fourteenth and fifteenth centuries emphasized the flat painting surface of large platters or of the nearly cylindrical **albarelli,** or drug jars (Fig. 3-24). The graceful Alhambra vase with its wing-like handles was one of their innovations in form (Fig. 3-25).

Muslim influence waned as the Christians reconquered Spain. The last Moors and Jews, who were the chief farmers, craftsmen, and traders of Spain, were expelled when Granada fell to the Spanish monarchs Ferdinand and Isabella in 1492. The resulting damage to the Spanish economy was concealed for a while by the influx of gold and silver from Spanish conquests in the New World, but this treasure also made luster less appealing. Although attempts were made to shape plates with raised designs and bosses imitative of metalwork (Fig. 3-26), the association of lusterware with the Moors perhaps contributed to its decline.

Africa

Bronze casting reached its height in royal portrait heads of the rulers of Benin between 1575 and 1625. African sculptors also worked in stone and especially in wood, creating ceremonial and religious figures according to tribal traditions. Some, however, worked in terra-cotta. Since clay is commonly used to make studies in preparation for sculpture in other materials, it is not surprising that many large terra-cotta portrait heads have been found that have the same feeling for

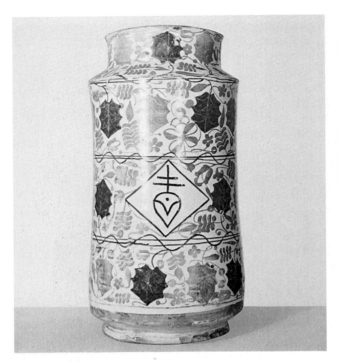

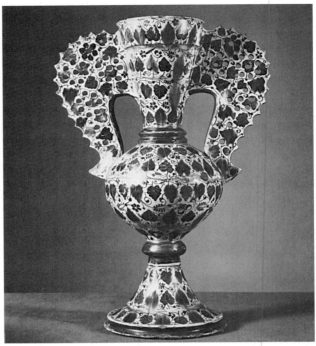

3-24 Hispano-Moresque drug jar, Spain, c. 1440. Earthenware with tin-lead glaze decoration in blue and opal luster, height 15.13″ (38.4 cm). Victoria and Albert Museum, London (Crown Copyright).

3-25 Hispano-Moresque vase, Valencia, Spain, c. 1470. Graceful wing-handled vase derived from the earlier more austere Alhambra style. Earthenware with tin-lead glaze decoration in blue and golden luster, height 20.75″ (52.70 cm). Victoria and Albert Museum, London (Crown Copyright).

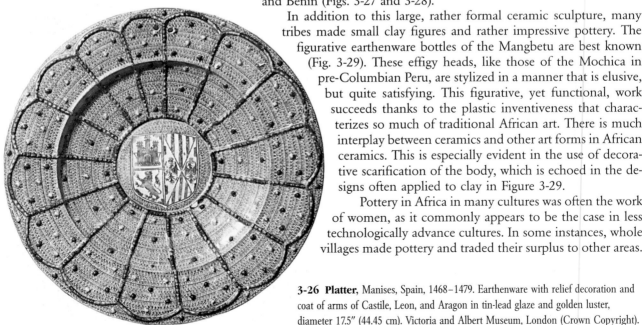

plastic form and personal expression that characterize the bronzes of Ife and Benin (Figs. 3-27 and 3-28).

In addition to this large, rather formal ceramic sculpture, many tribes made small clay figures and rather impressive pottery. The figurative earthenware bottles of the Mangbetu are best known (Fig. 3-29). These effigy heads, like those of the Mochica in pre-Columbian Peru, are stylized in a manner that is elusive, but quite satisfying. This figurative, yet functional, work succeeds thanks to the plastic inventiveness that characterizes so much of traditional African art. There is much interplay between ceramics and other art forms in African ceramics. This is especially evident in the use of decorative scarification of the body, which is echoed in the designs often applied to clay in Figure 3-29.

Pottery in Africa in many cultures was often the work of women, as it commonly appears to be the case in less technologically advance cultures. In some instances, whole villages made pottery and traded their surplus to other areas.

3-26 Platter, Manises, Spain, 1468–1479. Earthenware with relief decoration and coat of arms of Castile, Leon, and Aragon in tin-lead glaze and golden luster, diameter 17.5″ (44.45 cm). Victoria and Albert Museum, London (Crown Copyright).

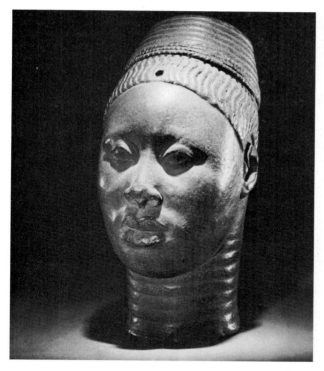

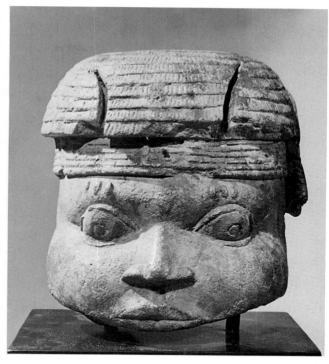

3-27 Cast of Ife head called Lajuwa, Nigeria, c. 1200–1300. Terracotta, height 13.11″ (33 cm), width 7.48″ (19.6 cm). American Museum of Natural History, New York, Cat. No. 90.2/249.

3-28 Benin head, Bini, Nigeria, 1560–1680. Terra-cotta, height 8.5″ (21.5 cm). Metropolitan Museum of Art, New York (The Michael C. Rockefeller Memorial Collection, bequest of Nelson A. Rockefeller, 1979).

right: **3-29 Mangbetu portrait bottle,** Congo, nineteenth–twentieth century. Terra-cotta, height 11.38″ (28 cm). Metropolitan Museum of Art, New York (bequest of Nelson A. Rockefeller, 1979).

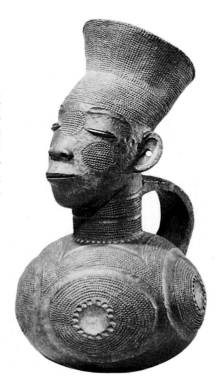

Except in a few Muslim-influenced regions in North Africa, all pottery was hand built in a combination coil and paddle technique. The gourd, so commonly used as a container, influenced many pottery forms. Large oval vases with collar rims served for food and water storage. Textural decorations were sometimes applied in a basket-like weave, sometimes mimicking scarification and other body decorations, or painted in iron oxides to produce a red or black design. Since most pottery was fired in an open pit with straw and twigs, it was not very hard; little early pottery has survived.

THE WEST

South America

Chimú In the late Postclassic Period, in the thirteenth century, the Chimú dominated the north coast from their great capital city of Chan Chan. By that time painted decoration on pottery had virtually disappeared. Old forms such as the Mochica stirrup-spout jars persisted, but the body usually was smoked black.

Inca In the early fifteenth century the Inca began to expand from the central highlands. By the arrival of the Spanish they ruled much of western South America from their capital at Cuzco. The most distinctive form of Inca pottery was the **aryballoid** jar with a pointed base, long neck, flaring collar, and low side handles (Fig. 3-30). Bands of triangular, crosshatched, and other geometrical motifs in polychrome slips embellished the forms. While Inca craftsmanship was more highly decorated than the earlier Chimú work, it seems more utilitarian than the much earlier sculptural pottery of the Mochica and the richly painted surfaces of the Nazca.

The Middle Ages

During the Middle Ages, contacts with the Byzantine Empire and the Islamic world encouraged Italian potters again to produce glazed ware. The simple earthenware bowls, jugs, amphoras, and pitchers of the seventh and eighth centuries had a runny yellowish or green lead glaze with **sgraffito** (scratched) decoration.

3-30 Inca aryballoid jar, Peru, c. 1438–1832. Earthenware with a dark slip geometric pattern, height 8.5″ (20.95 cm). Metropolitan Museum of Art, New York (The Michael C. Rockefeller Memorial Collection, gift of Nelson A. Rockefeller, 1961).

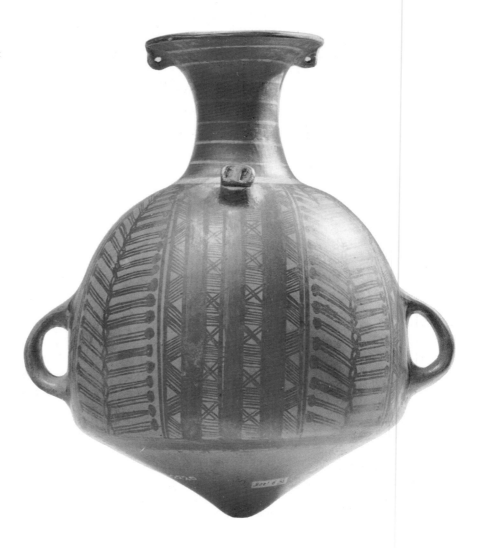

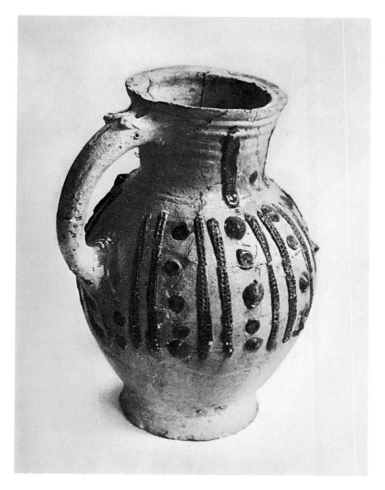

3-31 Jug, Rouen, Normandy. Late twelfth/thirteenth century. Thrown earthenware with applied clay and slip decoration under a thin yellow glaze, height 9.5″ (24.13 cm). The Museum of London.

France, farther from these advanced centers of civilization than Italy, was slower to recover lost skills. Green-glazed tiles may date from the ninth century, although glazes were not in widespread use until the thirteenth century (Fig. 3-31).

Britain was even more isolated by the departure of the Romans. By the tenth century, Anglo-Saxon trade with the Continent had resulted in only a limited revival of the potter's wheel and lead-glazed earthenware in England. In the late thirteenth and early fourteenth centuries, English potters became more innovative. The tall jug developed into a pitcher with a pinched-out lip and spiral patterns of clay applied under a green glaze. Finally faces appeared on the pitcher neck, the spout turned into an animal head (Fig. 3-32), and a few rare pieces had entire hunting scenes in relief.

Roman influences survived longer in the Rhineland, as seen in jugs with banded rouletted decoration. Increased trade with Italy reintroduced lead-glazed earthenware as early as 900, but it never assumed great importance. Improved kilns and an abundance of stoneware clays encouraged potters to fire higher and produce a more durable ware. By the early twelfth century they were producing a proto-stoneware, and by the late fourteenth century a true stoneware. Usually light gray in body, it was almost waterproof without a glaze.

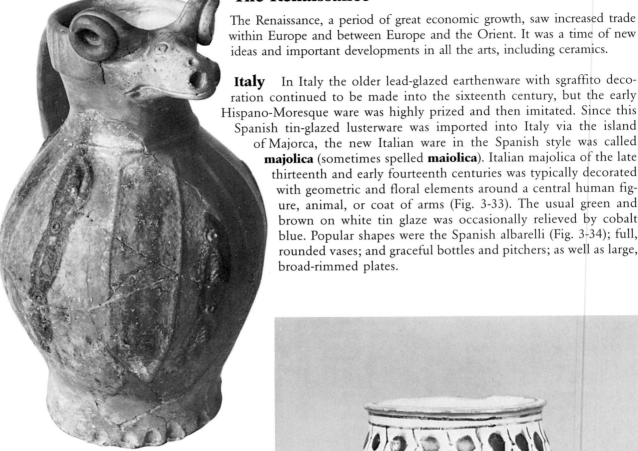

The Renaissance

The Renaissance, a period of great economic growth, saw increased trade within Europe and between Europe and the Orient. It was a time of new ideas and important developments in all the arts, including ceramics.

Italy In Italy the older lead-glazed earthenware with sgraffito decoration continued to be made into the sixteenth century, but the early Hispano-Moresque ware was highly prized and then imitated. Since this Spanish tin-glazed lusterware was imported into Italy via the island of Majorca, the new Italian ware in the Spanish style was called **majolica** (sometimes spelled **maiolica**). Italian majolica of the late thirteenth and early fourteenth centuries was typically decorated with geometric and floral elements around a central human figure, animal, or coat of arms (Fig. 3-33). The usual green and brown on white tin glaze was occasionally relieved by cobalt blue. Popular shapes were the Spanish albarelli (Fig. 3-34); full, rounded vases; and graceful bottles and pitchers; as well as large, broad-rimmed plates.

3-32 Jug, England. Late thirteenth/fourteenth century. Earthenware, ram's head spout with pinched foot, green stripes under a yellow lead glaze; height 14″ (35.56 cm). The Museum of London.

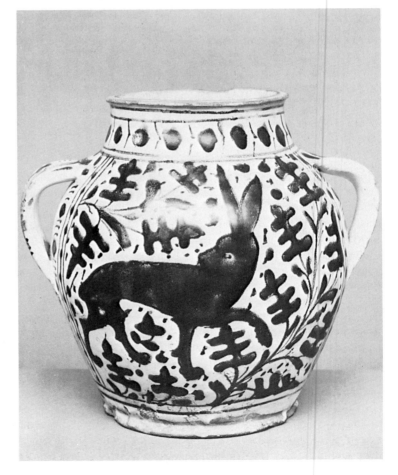

3-33 Drug jar, Tuscany, Italy. Mid-fifteenth century. Earthenware with majolica decoration of rabbit and flowers in blue, purple, and green tin-lead glaze; height 8.5″ (21.59 cm). Victoria and Albert Museum, London (Crown Copyright).

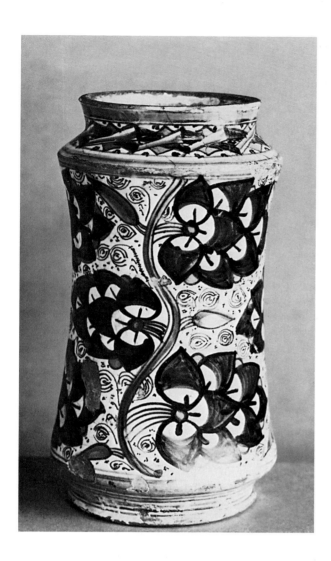

3-34 **Drug jar,** Caffaggiolo, Italy. Early sixteenth century. Earthenware with majolica decoration in tin-lead glaze, height 8.88″ (22.55 cm). Victoria and Albert Museum (Crown Copyright).

Early in the fifteenth century, Florence and Faenza produced a blue and brown majolica of stylized floral and animal motifs reflecting Byzantine and Oriental influences. These colors soon gave way to a wider palette including yellow, orange, and purple in the Iranian palmette and peacock feather motifs. Figures and portraits, which traditionally had been part of an overall decoration, became major design elements (Fig. 3-35). As the skill of pottery painters increased, they incorporated pictorial elements in their work; finally they copied complete panel paintings, including scenes from classical legends and the Bible, with perspective and atmospheric effects (Fig. 3-36). These subjects were often copied whole or piecemeal from works by the popular painters of the day. Although technically superior, this sixteenth- and seventeenth-century majolica lacked the union of form and decoration characteristic of earlier production.

Familiar with clay as a material for studies for sculpture, some of the many Renaissance sculptors were naturally intrigued with the marble-like effect of tin-glazed ceramics. The fifteenth-century Florentine sculptor Luca della Robbia

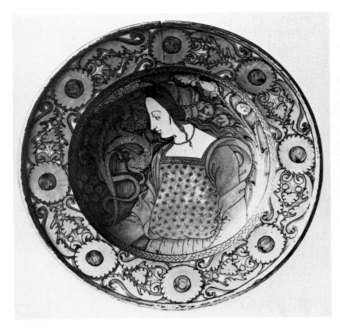

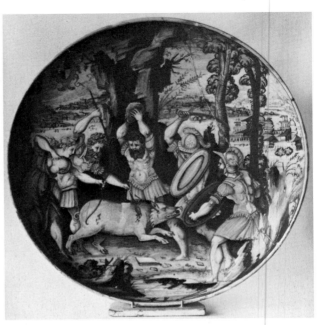

3-35 Platter, Deruta, Italy, c. 1520. Earthenware with majolica decoration of a young woman with a floral border in blue tin-lead glaze and golden luster, diameter 15.75″ (40 cm). Victoria and Albert Museum, London (Crown Copyright).

3-36 Plate, Urbino, Italy, c. 1542. Earthenware with majolica decoration of *The Calydonian Boar* in polychrome tin-lead glaze, diameter 10.75″ (27.3 cm). Victoria and Albert Museum, London (Crown Copyright).

produced subtly modeled terra-cotta madonnas glazed white against a pale blue background surrounded by an unobtrusive border of flowers and fruits; these relief plaques were remarkably popular decorations for churches and homes (Fig. 3-37).

France and The Netherlands In northern Europe tin-glazed earthenware became known as **faience** as a result of the popularity of the Italian majolica of Faenza. French faience potters imitated the blue-and-white porcelain of the Chinese, but none were as successful as the Dutch in Delft, who learned to throw thinner ware. Decoration became delicate until Delft potters were finally able to make reasonable copies in faience of the famous K'ang Hsi blue-and-white porcelain.

Chinese influence gradually gave way to European baroque influence in form and in landscapes, scenes, and decorative motifs copied from engravings and paintings. Eventually Dutch potters reproduced the colorful Japanese Imari ware and Chinese famille-verte ware. They also made glazed tiles. Tiles had long been made in Spain, Italy, and France to decorate churches and homes, but Dutch tiles were especially popular. Chiefly blue-and-white, they varied widely in motif, including flowers, ships, marine monsters, landscapes, and religious scenes.

England and Germany The majolica tradition was never significant in England. More important was slipware made chiefly during the seventeenth century in Staffordshire, usually to commemorate weddings and christenings. Trailed in dots and dashes or applied by stamping, the white clay slip made a striking

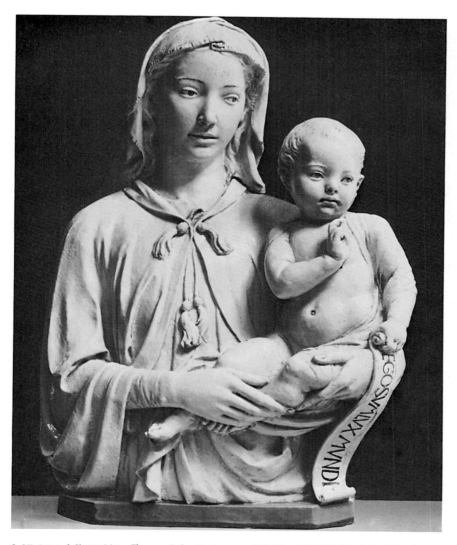

3-37 Luca della Robbia, Florence, Italy. *Madonna and Child,* c. 1450. Relief in tin-lead-glazed terracotta, white on pale blue background, height 31.25″ (79.38 cm). Metropolitan Museum of Art, New York.

contrast with the red or dark brown body. Slip-trailed plates decorated with feather brushing were also popular. More elaborate slip-trailed earthenware dishes, such as those by the potter Thomas Toft, displayed mermaids, pelicans, and coats of arms with a lattice border of trailed red and brown slip on a white ground covered with a clear or pale yellow lead glaze (Fig. 3-38).

Although German potters made peasant earthenware decorated with sgraffito or slip, the most important German ware was the salt-glazed stoneware that had evolved by the close of the fourteenth century. Lingering Roman influence can be seen in the pressed foliage designs on tankards and jugs, especially the full-bodied **bellarmine** jug with its bearded face (Fig. 3-39). By the sixteenth century, stoneware was also being made in the Beauvais region of France and in the seventeenth century in Staffordshire, England.

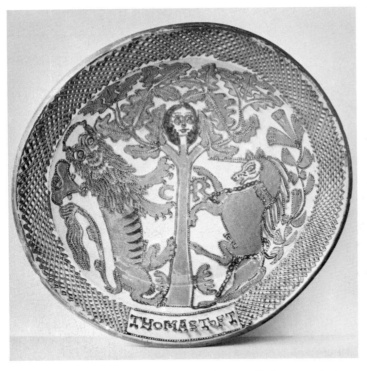

3-38 Thomas Toft, Staffordshire, England. Dish, c 1680. Earthenware with slip-trailed decoration in shades of brown on a yellow-tan body, diameter 17.5″ (43.81 cm). Metropolitan Museum of Art, New York (Rogers Fund, 1924).

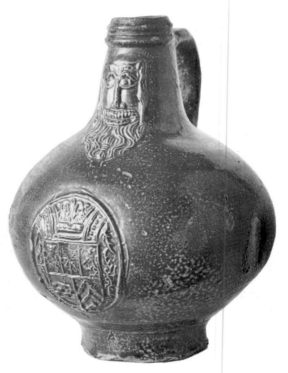

3-39 Bellarmine jar, Frecken, Germany. Early seventeenth century. Stoneware with impressed decoration under a mottled salt glaze, height 7.5″ (19.05 cm). Metropolitan Museum of Art, New York, (Rogers Fund, 1917).

The Eighteenth and Early Nineteenth Centuries

The Continent The outstanding development in eighteenth-century ceramics was the discovery of the way to make porcelain. The impetus came from the importation of blue-and-white porcelain from China and, later, of Imari ware from Japan. Tremendously popular, these Oriental porcelains sold at fantastic prices. In an attempt to imitate them, the Medici family of Florence in the late sixteenth century had sponsored the production of soft-paste porcelain using kaolinic clay, a white earthenware, silica, and soda. In the seventeenth and eighteenth centuries, factories at Rouen, St. Cloud, Sèvres, and other French cities produced soft-paste porcelain made of clay and frit. These wares were attractive but fragile.

In 1707, J. F. Böttger, a young German alchemist employed by Augustus the Strong, ruler of Saxony, in the course of subjecting local minerals to heat, developed a hard, red stoneware (Fig. 3-40). About 1710 he produced a true, or hard-paste, porcelain. Augustus thereupon established a porcelain factory at Meissen, where there were large deposits of kaolin. While at first the techniques

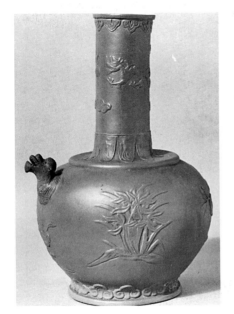

3-40 Flask, Meissen, Germany, c. 1710–1715. Early example of red stoneware by J. F. Böttger with impressed decoration. Metropolitan Museum of Art, New York (gift of Mrs. George B. McClellan, 1942).

3-41 Covered vase, Meissen, Germany, c. 1725–1730. Hard-paste porcelain with polychrome overglaze decoration in a Japanese style, height 16.5″ (41.91 cm). Metropolitan Museum of Art, New York (bequest of Alfred Duane Pell, 1925).

for making true porcelain were closely held secrets, the knowledge gradually spread across Europe. Later, factories were built in Vienna, Strasbourg, Nymphenburg, Copenhagen, and other cities. In the 1770s porcelain was being produced at royal factories in Sèvres and Limoges in France.

The wares of the various soft-paste and hard-paste porcelain factories were an innovation greatly desired in Europe in their attempts to imitate pottery from the Far East. The fine white surface, visual depth of glaze, and fired strength of true porcelain was in great demand. In style, potters at first copied Oriental pieces (Fig. 3-41). Then baroque, rococo, and neoclassical elements borrowed from other European arts crept in, including landscape scenes. Elaborate rococo figurines displayed the great skill of the potters in modeling and glazing.

These eighteenth- and early-nineteenth-century porcelains are treasured by twentieth-century museums and private collectors. They have been of less interest to present-day potters because their form and decoration did not grow out of regional ceramic traditions but was eclectic. Furthermore, through the use of plaster-of-paris molds, they reproduced shapes and decoration originating in metal and other non-ceramic materials (Fig. 3-42). Fittingly with the growing eclecticism of the late twentieth century, some modern ceramists such as Adrian Saxe of the United States are taking a fresh look at the social and artistic implications of these ornate works.

England While Continental potters led the way in the manufacture of porcelain, other developments in ceramics took place in England. The chief center was Staffordshire, which was well supplied with clay and with coal for the kilns. Staffordshire potters produced both salt-glazed stoneware and a new **creamware,** a light, durable earthenware used for dishes for the table. Creamware eventually superseded the softer slipware in England and, to some extent, faience and majolica on the Continent.

Although the Wedgwood family potteries produced immense amounts of creamware, they are best known for their unglazed black **basalt** ware and **jasper ware** of various pale colors. Both types of stoneware were used chiefly for display. Their shapes and relief decorations, molded or applied, were derived from an eclectic pastiche of classical forms. Popular pale blue jasper-ware vases with white figures in relief resembled glass cameos more than ceramics.

English potters also experimented with porcelain. By adding bone ash as a flux to soft-paste and hard-paste bodies, they produced a light, durable **bone china** fired at a somewhat lower temperature. Bone china was made at Chelsea, Worcester, and other potteries, notably that of Josiah Spode II, who developed the standard bone china formula. Spode (renamed Copeland), Minton, and other Staffordshire potteries also made **Parian** ware, a bisque porcelain that resembled marble.

3-42 Vase, Sèvres, France, c. 1785. Porcelain with sprigged classical motifs and a blue-and-white glaze, height 16″. Victoria and Albert Museum, London (Crown Copyright).
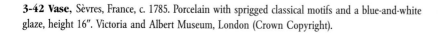

3-43 David Spinner, Bucks County, PA, USA. Pie plate, c. 1800. Red earthenware with sgraffito decoration, diameter 11.5″ (29.3 cm). Brooklyn Museum, New York (gift of Mrs. Hudlah Cart Lorimer in memory of George Burford Lorimer).

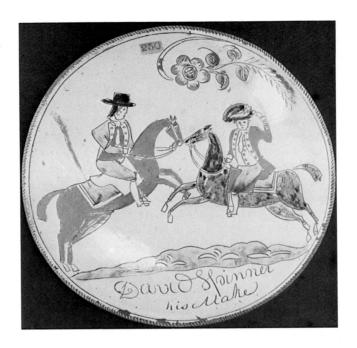

English potteries were quick to adopt the mass-production techniques of the Industrial Revolution. Steam-powered machinery, plaster-of-paris molds, and **jiggering** (shaping clay on a turning plaster mold by means of a metal template on a moving arm) made production more efficient and therefore cheaper. Transfer printing of designs from engraved metal plates speeded up decoration, but also led to the demise of most hand-painted ware.

America In colonial America the first pottery was a soft, lead-glazed red earthenware. That made by English colonists, if decorated at all, was in the English slipware tradition. Pottery made by German settlers in Pennsylvania was apt to imitate German slipware and sgraffito ware with figures and tulip and other floral designs (Fig. 3-43). Good stoneware clays were found in New Jersey and New York and later in Ohio. The first surviving stoneware was made in New Jersey in 1775. Gradually stoneware displaced the more fragile red earthenware.

Imports from abroad, especially English creamware, made it difficult for American earthenware potters working on a small scale to compete either in tableware or in decorative pieces. Stoneware potters, producing functional salt-glazed jugs and crocks for a local market (Fig. 3-44), were more successful. As these potters moved steadily westward with the homesteaders, the stoneware pottery produced became simplified in form and decoration when compared with the earliest stoneware produced on the East Coast by recent emigrant potters.

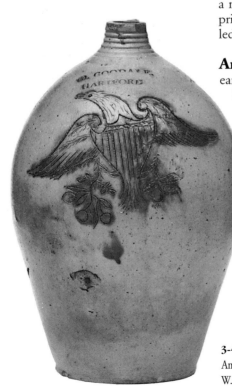

3-44 Daniel Goodale, Hartford, Conn. USA. Jug, c. 1818–1830. Stoneware, salt-glazed with incised American Eagle accented with cobalt; height 15″ (38.1 cm). Brooklyn Museum, New York (gift of Arthur W. Clement).

One of the most successful Eastern potteries was that in Bennington, Vermont. During the late eighteenth and nineteenth centuries, it first produced red earthenware, then stoneware, and finally a mottled-brown-glazed creamware called **Rockingham.** Bennington also used Parian ware copied from Minton and Copeland to make soft-paste porcelain figurines and elaborately modeled vases. Many had a blue background in imitation of Wedgwood jasper ware (Fig. 3-45). Although porcelain was made experimentally in New Jersey in 1826, it was not made commercially until after the Civil War.

The Late Nineteenth and Twentieth Centuries

Industrialization, beginning in eighteenth-century England, steadily increased thereafter in Europe, the United States, and later in Japan. In the process it nearly destroyed hand-thrown and hand-decorated ceramics. It forced individual potters into large factories where they performed a small, repetitive task in a huge mass-production enterprise controlled by an entrepreneur whose major interest was profit. Design decisions were no longer made by potters but by sales managers.

Preindustrial potters had worked basically within local traditions, reacting only slowly to new ideas and developments in other crafts such as metalwork. These local traditions succumbed to the immense popularity of imported ware. For example, Royal Copenhagen and Bing and Grøndahl in Denmark, Gustavsberg and Rostrand in Sweden, and Arabia in Finland were strongly influenced by the faience and porcelain of France and Germany. Commercial potteries in the United States, such as Bennington as previously noted, copied designs from abroad. The fact that until 1918 the china used in the White House was imported shows the pervasive influence of foreign wares.

Local traditions also suffered from the growing taste for extravagant display and the factory owners' desire for profit. In addition, the plastic quality of clay and the variety of glaze effects available made possible the manufacture of forms and decoration of variable quality and taste. On the positive side, the Industrial Revolution did make it possible for the masses to have affordable pottery and funded much technical research in ceramics in the early twentieth century.

Early Attempts at Reform
Gradually protest arose against this commercialized, industrialized ware. It began in mid-nineteenth-century England, when the writer John Ruskin, the writer and designer William Morris, and their followers, imbued with the Romantic ideal of return to the Middle Ages (Pre-Raphaelitism), tried to revive traditions of integrity in materials, design, and workmanship in the decorative arts. Although the Arts and Crafts movement they inspired faltered, Morris succeeded in drawing attention to their perception that the quality of nineteenth-century design was lacking. Later, the Art Nouveau movement of the 1890s and early 1900s in France, England, and the United States, and the related *Jugendstil* in Germany were other forms of reaction against the prevailing state of the decorative arts (Fig. 3-46).

Meanwhile individual potters such as Theodore Deck, Ernest Chaplet, and Auguste Delaherche in France (Fig. 3-47) and the Martin brothers and William de Morgan in England carried out experiments to rediscover the lost pottery secrets of earlier ages. They explored decorative techniques such as Islamic luster and Chinese copper-red glazes. The Victorian taste for ornate Ch'ing export porcelain was slow to die, but gradually an appreciation grew for the more

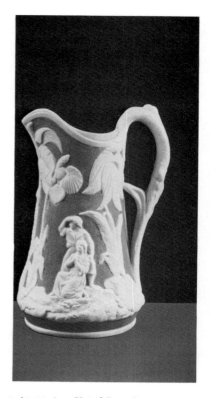

3-45 Pitcher, United States Pottery, Bennington, Vermont, USA, c. 1852–1858. Parian porcelain (Paul and Virginia design) in style copied from Wedgewood jasperware. Brooklyn Museum, New York (gift of Arthur W. Clement).

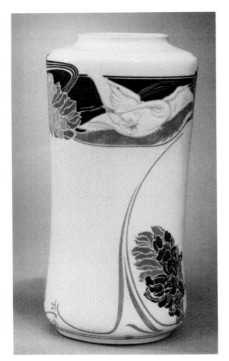

subtle wares of the Sung period as well as those of Korea and Japan. In the United States, the Art Nouveau movement and interest in Chinese ceramics played a part in giving new directions to potteries such as Rookwood in Cincinnati, Van Briggle in Colorado, and to early pottery enthusiasts such as Adelaide Robineau (Fig. 3-48). Taking the sinuous Art Nouveau form to an extreme, George Ohr produced an iconoclastic body of work that still appears

left: **3-46 Georges de Feure**, potted by E. Gerard, Limoges, France. Vase, c. 1898–1904. Porcelain with Art Nouveau design in green, lavender, and gray. Metropolitan Museum of Art, New York (Edward C. Moore, Jr. Gift Fund, 1926).

below left: **3-47 Auguste Dalaherche**, Beauvais, France. Vase, c. 1900. Stoneware showing Oriental influence. Metropolitan Museum of Art, New York (gift of Edward C. Moore, 1922).

below: **3-48 Adelaide Robineau**, USA. Vases. Late nineteenth/early twentieth century. Porcelain with crystalline glazes. Everson Museum of Art, Syracuse, NY.

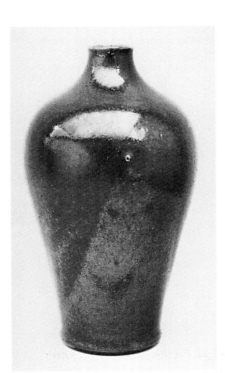

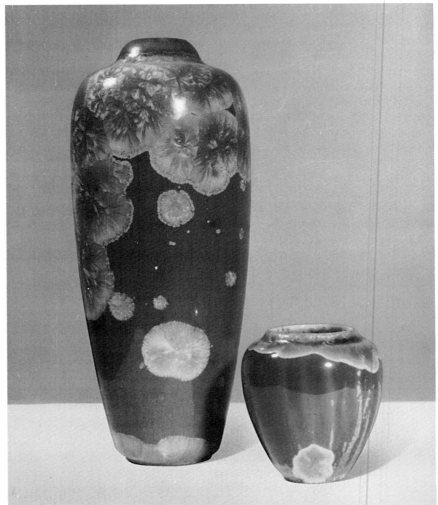

fairly modern. (Fig. 3-49) His unique forms, forgotten by a generation, have a playful quirkiness that many contemporary potters find appealing. His handling of the clay was remarkable, and he developed the ability to throw very thin forms with controlled areas of rippling.

Interest in Avant-garde Design In the early twentieth century in both Europe and the United States, some potters became more concerned with good design. In Europe this tendency was in large part the result of government-sponsored craft schools founded in England, Germany, Italy, and Scandinavia and of the Bauhaus, a school of design that flourished in Germany in the 1920s and early 1930s. These schools encouraged the production of furniture, glassware, textiles, and metalware, as well as ceramics, which were designed to be beautiful, functional, efficient to manufacture, and reasonable in cost. In Scandinavia, industry, the schools, and government officials made a combined effort to reach these goals, perhaps as a result of the prevailing socialist policies after World War II, which emphasized the well-being of the whole population.

When the Bauhaus was closed by the Nazi government, many of its faculty went to the United States, where they spread Bauhaus principles. Frans and Marguerite Wildenhain, former students at the Bauhaus, Maija Grotell from Finland, and Otto and Gertrude Natzler from Austria were among many émigrés who brought a fresh impetus to American ceramics. They built on a foundation already prepared by the English potter Charles Binns, who had become the first director of the New York College of Ceramics in Alfred, New York, in 1900. His work had been continued by his many students, such as Charles Harder and Arthur Baggs (Fig. 3-50), who laid the foundations for many ceramics programs later established in American colleges. *Keramic Studio* magazine, founded by ceramist Adelaide Robineau in 1899, played a helpful role.

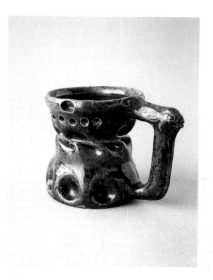

3-49 George Ohr, USA. Puzzle mug, c. 1895–1900. Exterior glazed rose with green and gunmetal flecks; "in-body" twist; dimples at base, 3.5 × 3 in. (8.9 × 7.6 cm). Stamped G. E. Ohr Biloxi. Ohr-O'Keefe Museum of Art.

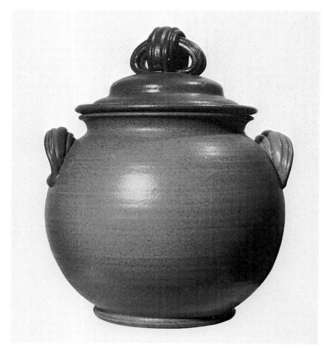

3-50 Arthur E. Baggs, USA. Jar, 1938. Salt-glazed stoneware. Everson Museum of Art, Syracuse, NY.

right: **3-51 Kenkichi Tomimoto,** Japan. Jar. Mid-twentieth century. Porcelain with a delicate pattern in gold and silver, height 7.5″ (19.05 cm). Japanese Embassy, Washington, DC.

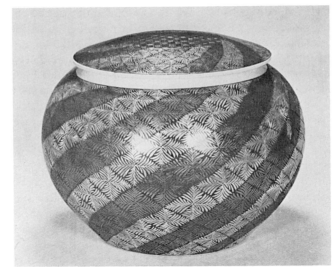

below left: **3-52 Bernard Leach,** Great Britain. Plate. Made during his stay in Japan, prior to 1920. Raku-fired earthenware with slip-trailed decoration, diameter 13.5″ (34.19 cm). Victoria and Albert Museum, London (Crown Copyright).

below right: **3-53 Bernard Leach,** Great Britain. Vase, 1931. Stoneware with form and brush decoration in an Oriental style, height 14″ (35.56 cm). Victoria and Albert Museum (Crown Copyright).

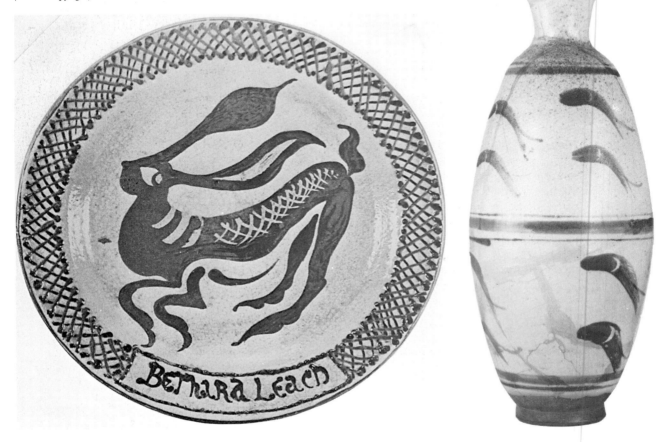

Interest in Traditional Techniques The twentieth century also saw a reawakening of interest throughout the world in the fundamentals of ceramics. Many people took up pottery as an avocation or taught pottery making in schools. Quite naturally, potters focused renewed attention on native pottery traditions that had been bypassed by the Industrial Revolution—majolica and lusterware in Italy and Spain, salt-glazed stoneware in Germany and the United States, Pueblo pottery in the southwestern United States, the many village potteries and ceramic traditions in Central and South America, African ceramics, and even Raku ware from Japan.

The Japanese potters Shoji Hamada and Kanjiro Kawai, together with Soetsu Yanagi, founder of the Mingei (folk art) Society in Japan, revived interest in traditional handmade pottery in the 1920s and 1930s. Their work and writings emphasized the strength found in the elegant simplicity and utility of traditional folk pottery. They influenced the architect Kenkichi Tomimoto, who made more individual pottery (Fig. 3-51) and founded the first Japanese college-level ceramics program.

In England, William Staite Murray and Bernard Leach, both of whom knew Shoji Hamada, led a revival in hand-thrown pottery. Murray made chiefly art pottery and taught at the Royal College of Art in London. Leach, who had studied ceramics in Japan before 1920, made functional ware. He encouraged understanding of Oriental folk pottery (Figs. 3-52 and 3-53) and rekindled interest in early English slipware. Through the many apprentices at his workshop in St. Ives, Cornwall, notably Michael Cardew in Britain (Fig. 3-54) and Warren Mackenzie in the United States (Chapter 7, Fig. 7-48), and through Leach's many books, he had great influence on ceramics in the English-speaking world.

In the United States on the West Coast in the 1930s Glen Lukens experimented with local minerals for glazes and encouraged his students in a wide range of projects. After World War II, Peter Voulkos, Daniel Rhodes, Laura Andreson, Robert Turner, Marguerite Wildenhain, Ted Randall, Gertrude and Otto Natzler, Sheldon Carey, Karl Martz, Vivika and Otto Heino, and a host of other potters continued to experiment with ceramic techniques and many helped to establish ceramics as an academic discipline in universities. A workshop/lecture tour throughout the United States by Hamada, Leach, and Yanagi in the 1950s ignited renewed interest in the folk pottery tradition. This new interest, coupled with the expansion of academic art programs and the growth of the avant garde in art, assured the future growth of ceramics. The tremendous growth of technical knowledge made by the ceramic industry during the early twentieth century provided additional impetus to the ceramics movement. The following chapter illustrates many of the diverse directions that ceramics has taken in recent years, and some of the issues, concepts, and content that surround the work.

3-54 Michael Cardew, Great Britain. Mid-twentieth century. Covered jar. Stoneware with incised decoration.

Chapter 4

1950 TO THE PRESENT

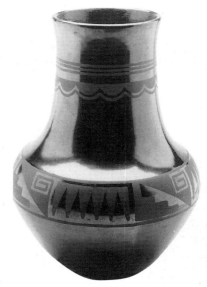

4-1 Maria & Julian Martinez, USA. San Ildefonso Pueblo vase, 1934–1943; earthenware, 11.5 × 8 in. (29 × 20 cm). This graceful form with its burnished surface and matte painted-slip decoration is typical of the pottery produced by Maria Martinez. Her husband, Julian, painted this vase. Everson Museum of Art.

Since the late 1900s the ceramics world has undergone many changes. The early part of the century saw a growing world awareness of the ceramics of other cultures (Fig. 4-1), and a burst of technical research and innovation spurred by the commercial ceramics industry. However, many of the aesthetic changes in ceramics have occurred since the 1950s. Artists in the postwar era were part of a culture that was searching for meaning in the wake of horrific world wars. Many artists turned aside from traditional "high art" media like painting and sculpture and found what they were looking for in clay. Some potters drew new inspiration from the modern age of industry and art (Fig. 4-2), while others worked to preserve the uniqueness of local pottery cultures from around the world. Potters like the remarkable Juan Quezada in the village of Juan Mata Ortiz, Mexico, looked at the pottery heritage of the nearby Casas Grandes valley and rediscovered many of the processes of the past (Fig. 4-3). Whatever their focus, twentieth-century ceramic artists broke the boundaries of tradition time and again by seeking new forms of expression and artistic content.

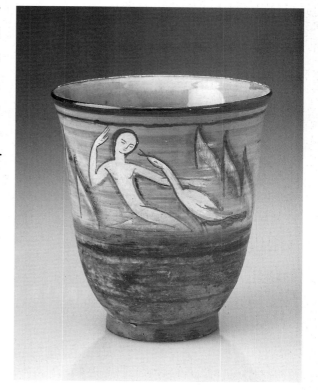

4-2 Maija Grottell, USA (born Finland). Vase, twentieth century. Stoneware, glazed, painted, 7-1/4 × 6-3/4 inches (18.9 × 17.1 cm). Schein-Joseph International Museum of Ceramic Art (gift of Winslow Anderson).

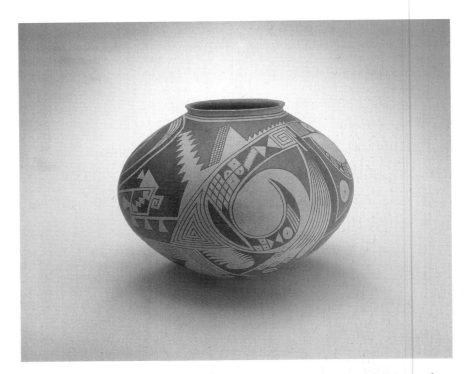

4-3 Juan Quezada, Mexico. Jar, 1978. Olla, 7.25 × 9.25 in. (18 × 24 cm). San Diego Museum of Man. Quezada rediscovered many of the processes that may have been used by the ancient Casas Grandes valley potters. He uses slips to create the decoration on these coiled and pinched pots. After burnishing, the work is dung-fired in an open firing, much as earlier potters in Casas Grandes may have fired their wares.

The second half of the twentieth century saw a renewed interest in ceramics and a tremendous growth in ceramics programs in higher education. By mid-century, the relatively small group of potters who were examining issues of craft and art, all the while trying to keep a traditional form of expression alive, had burgeoned into a huge and diverse legion of ceramists. Where few opportunities once existed to exhibit work, potters now traveled worldwide giving workshops and holding exhibitions. While much of the emphasis in the late 1950s was upon pottery making, largely due to the then recent visit of Leach, Hamada, and Yanagi in 1952–53, the growth of ceramics in the universities assured that ceramic expression would follow a diverse path. The breadth of expression in clay and glaze in recent years is unprecedented.

ABSTRACT EXPRESSIONISM AND CLAY

Contemporary ceramic art in all its forms owes much to a movement that rose to prominence in the 1950s: Abstract Expressionism. Peter Voulkos, along with a group of ceramists and other artists in Los Angeles, California, began to work in the direct, emotion- and instinct-based manner of the abstract

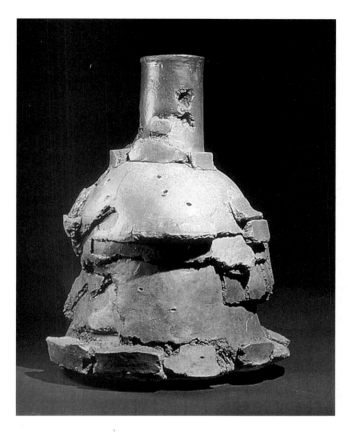

4-4 Peter Voulkos, USA. *Big Jupiter,* copyright Peter Voulkos, 1994; wood-fired stoneware, 40 × 30.5 × 27 in. (101 × 77 × 68 cm). "Clay's like anything else—if you treat it right, it'll treat you right. Personally, I like to work in wet, soft clay. I just throw it on the wheel and see if I can control it and see how it comes out. The point is, I like to handle materials that I can't always quite control. I just like to get a great big ball of soft wet clay in my hands. I like the feel of it . . . and I like the feel of it being a little too big and a little bit out-of-control—right on the edge. If I'm in perfect control, then I start contriving. No good."

expressionist painters of the era. Clay, with its wonderful plasticity and ability to respond immediately to the artist's touch, proved a perfect medium. The work Voulkos produced in this manner was a distinct deviation from the decorative functional pottery he had been making. Figure 4-4 shows a piece that is typical of Voulkos' work in this manner. The form is full of energy, quickly built from stacked thrown forms, with the slashes and punctures left as the evidence of the artist's expressive gestures. The excitement and new sense of artistic freedom generated by the abstract expressionist ceramists stimulated many new approaches to working with clay over the next three decades.

CERAMICS IN THE ART WORLD

As a result of the revival of interest in pottery traditions, innovative pottery design, and the adoption of ideas that run the breadth of the field of art, ceramics has come to be accepted as an art form. Many ceramists today work or have worked in other art media in addition to clay. Exhibitions of ceramics, rare in the early part of the twentieth century, are commonplace at the turn of the twenty-first century. Exhibitors, less focused solely on functional, wheel-thrown ware than potters were earlier in the century, are often more concerned with sculptural ceramics using any number of techniques adapted from both

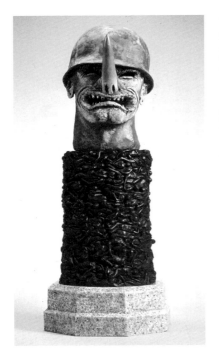

4-5 Robert Arneson, USA. *General Nuke*, 1985, granite, bronze, glazed ceramic, 74.25 × 32.5 × 37 in. (188.5 × 82.5 × 94 cm). Collection of the Hirshhorn Museum and Sculpture Garden, Washington, D.C.

the craft tradition and industry. Ceramists such as the late Robert Arneson (Fig. 4-5) largely rejected the pottery vessel in favor of more sculptural approaches to clay. Arneson often used clay as a medium to create highly effective social commentary.

Artists and philosophers have long discussed the intellectual basis of art, and ceramics is no stranger to this dialogue, but this search reached a fevered pitch in the twentieth century. Various trends in the world of painting and sculpture are echoed in the concerns of modern ceramists. Movements such as Dadaism, Cubism, Surrealism, Conceptual Art, Pop Art, Funk, Minimalism, Environmental Art, Feminism, and Postmodernism have all found their way into ceramics. Ceramics has been affected by a diversity of influences ranging from primitive art to modern industrial imagery, and processes such as mixed media or computer-aided graphics and design. The spread of ideas has been fueled by an eclectic world culture brought on by the high speed of modern communication. An increased focus on the content of the work and an ongoing dialogue with the art world as a whole have had a large effect on the shape of modern ceramic art.

The differences between avant-garde ceramists and potters with a more traditional craft approach are likely to continue. Both groups, however, have brought experimentation and vitality to an ancient art that was nearly stifled by the demands of industrialization and a mass market.

THE SEARCH FOR MEANING

In all this diversity it is difficult to focus on what makes the ceramics of the last half of the twentieth century unique. With such wildly varied forms, processes and styles of working as we see today, what is it that separates the artists using clay from those who simply manufacture and sell a ceramic product? One thing does stand out from the prolific explosion of styles and technical innovations of the past decades: the search for meaning. Whether functional pottery or figurative sculpture, abstract expressionist works or sculptural containers, ceramists increasingly trained in an academic setting have come to focus on the visual, emotional, and intellectual content of the work they produce. The innate human need to find meaning in the world around us is magnified by the impersonal nature of many of the industrially manufactured wares. Much of the ceramic art of the twentieth century finds its roots in these urges.

Following the distinctively modern urge to make all art unique, many ceramists have found it useful to carry on a "dialogue" with their work. The ceramist can develop what amounts to an ongoing conversational interaction between one's life and one's artwork, each informing the other in turn, always growing and changing. In carrying on such a dialogue, the artist takes a critical look at the process by which the work is made, and examines its purely compositional elements such as line, form, gesture, and scale. The dialogue also may involve investigations into the depths of psychological, social, and political meaning, and honest evaluations of the content of the work to see how well it succeeds in communicating the artist's intentions. The dialogue often extends to a careful look at the work of other artists, and at the world surrounding the artist, both natural and man-made.

For some the urge to explore pottery form and the implements of daily life is the focus. More sculptural pursuits hold the interest of others. Neither course is necessarily better and many ceramists fall somewhere in between. Ceramists now take full advantage of this wide range of options, following personal needs and preferences rather than any overriding tradition. Tradition is still a powerful force and inspiration, but now the potter has a choice of which traditions to adopt and which to discard.

The modern ceramist should strive to go far beyond merely replicating a learned form and style, as was often the expectation for the industrial potter of an earlier century. It takes a strong connection between heart and hand, and between mind and spirit, for art to flow from the clay in one's fingers. Content may range from the intensely personal to the most open of public statements, but it all comes from the same artistic struggle to find a purpose in what we make.

A CONTEMPORARY PORTFOLIO

The intent of the following pages is to let many contemporary ceramists speak for themselves about the issues surrounding their work and their involvement in clay, while providing a visual sampling of recent ceramics. Contemporary ceramic work is so extensive and diverse in scope that any survey of work is going to be only that, a tour of some of the highlights of the era. Given the breadth of expression in the twentieth century it would be largely impossible to define any clear boundaries that might divide, say, utilitarian ceramics from sculpture. The following black-and-white and color portfolio sections move generally from the more traditional functional wares to explorations of more purely sculptural form.

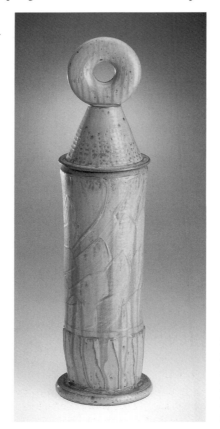

4-6 **Val Cushing**, USA. *Covered Jar #3,* 1993, high-fired stoneware with slip and satin matte glaze, 26.5 × 7 × 7 in. Cushing's masterful ability to throw allows him to combine a variety of thrown forms in this jar. His use of the large donut shape for the handle on the lid adds both whimsical, and industrial qualities.

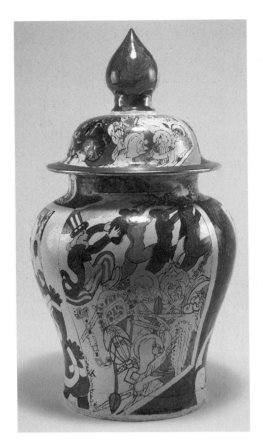

4-7 Michael Frimkess, USA. *Jumpin' at the Moon,* 1968, stoneware, low-fire lustre overglaze, 28.25 × 16 × 16 in. (71 × 40 × 40 cm). Frimkess takes the classic form of an oriental ginger jar and transforms it with contemporary imagery, playing historical references off often irreverent images of social satire. Williamson Gallery, Scripps College.

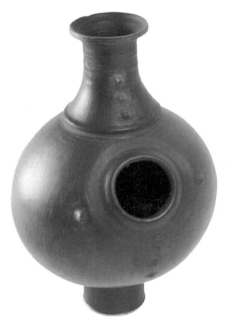

4-8 Winnie Owens-Hart, USA. *Small Smoked Water Drum,* 1994. Owens-Hart employs hand-building methods used by the traditional female potters of Ipetumodu to build these elegant vessels. The unglazed surface is burnished and then smoked to give it that lustrous black color typical of this type of ware. She says about her work, "Presently, clay has been in my life so long that I feel at peace and in union with the material (most of the time). Therefore, it is easily used to express my messages or act as a conduit to express my emotions."

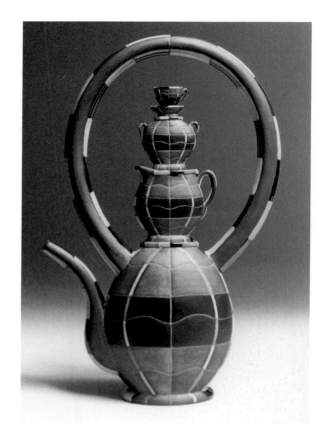

4-9 Gail Busch, USA. *Mercator Tea Set*, 1994, terra-cotta with terra sigilata and glaze, 10.5 × 6.5 × 2 in. (26 × 16 × 5 cm). "I enjoy looking at sculpture and non-pottery-oriented work in clay, but what inspires me is pottery. I believe that we don't make what we like the best, we make what we make the best. I am a representational artist and what I make are representations of pottery, referring to its history, and to its function and relation to daily human life."

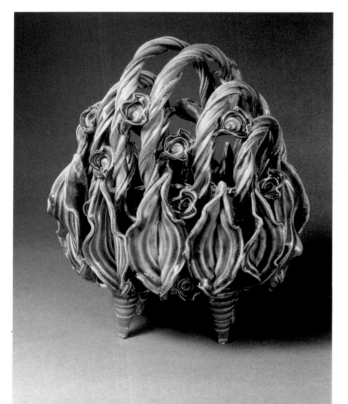

4-10 Lucy Breslin, USA. *Blue Leaves and Red Roses*, 14 × 19 × 15 in. (35 × 22 × 38 cm). Breslin's deft handling of the clay gives this organic form a vigorous, lively feel.

4-11 Phyllis Kloda, USA. *Balancing Act,* 1995, slip-cast earthenware, majolica and china paint, 21.5 × 16 × 12 in. (54.5 × 40.5 × 30.5 cm). Kloda's work often has a whimsical nature, largely from her inventive use of slip-cast vegetable parts. She says, "The object/pot must 'sing.' Content, form, surface, etc. all come together to form a well-orchestrated piece. Attention to those details is important—without that the intent falls short."

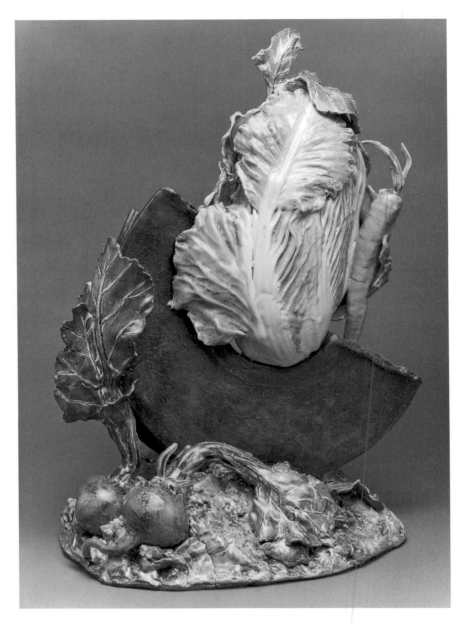

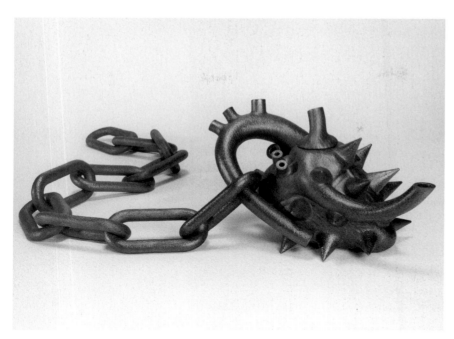

4-12 **Richard T. Notkin,** USA. *Heart Teapot: Mace II—Yixing Series,* 1998, stoneware, lustre, 6 × 40 × 6.25 in. (15 × 101 × 15 cm). "As the poet economizes words, I have developed a similar means of expression in the ceramic arts through the conservation of materials. I believe that the aesthetic impact of a work of art is not proportional to its size, but to its content. It is not the objects created which are of prime importance, but the lives of people who may be touched in significant ways."

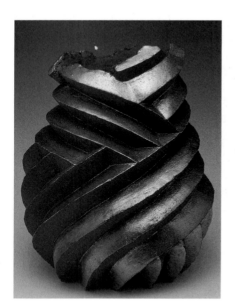

4-13 **Emiko Onodera,** Japan. *Vase for Katharsis,* 1994, clay, 13 × 9 × 8 in. (35 × 23 × 22 cm).

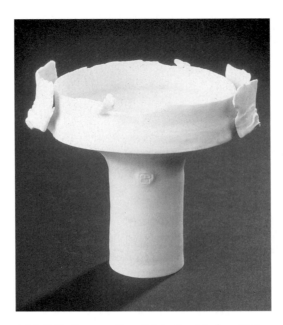

4-14 Colin Pearson, Great Britain. Porcelain form, 1993.
Thrown porcelain, nepheline syenate/barium/lithium glaze,
electric kiln fired to 1200°C, 6 × 6.5 in. (15 × 16.5 cm).

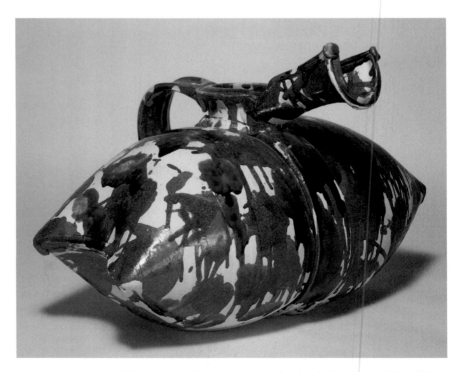

4-15 Betty Woodman, USA. *Pitcher,* 1978, earthenware, low-fire glazed, 15 × 22 × 15.25 in. (38 ×
55 × 38 cm). Williamson Gallery, Scripps College. Woodman's work almost always has historical
references; for example, Middle Eastern in the form of this pitcher, and the colorful Chinese lead glazes
from late in the Tang dynasty.

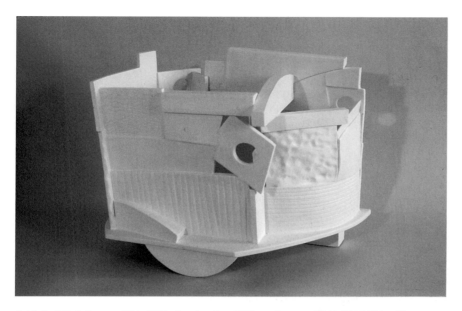

4-16 Judith Salomon, USA. *White Construction*, 1993, earthenware, 20 × 15 × 12 in. (50 × 38 × 30 cm). Salomon casts slabs from white earthenware clay, then uses these to hand-build her energetic, highly visual work. She says, "When I look around my world, I transform my views into vessels."

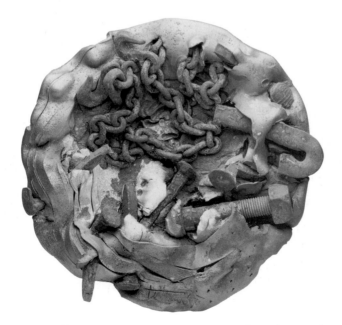

4-17 Neil Tetkowski, USA. *Earth in Chains*, 1994, 20 in. (50 cm). The combination of vigorously handled clay and industrial castoffs combines for a powerful statement on contemporary life. Here the potter's wheel is used as a tool to create platter-like forms as a starting point for sculpture.

4-18 Yoonchung P. Kim, USA. *Stacked Pang-Ee with Vase,* 1994, stoneware and earthenware, 29 × 14 × 14 in. (73 × 35 × 35 cm). "The simple and unpretentious white wares from 17th and 18th century Korean Ceramics Exhibition attracted me first to clay. All the pieces in the exhibition were white wares, looking as if they were multiple images of a full moon. They were many different shades of white with imperfect round shapes. Unlike the perfect celadon wares of the 11th to 12th century, these pieces showed the process of ceramics, imperfection, and unpretentiousness.

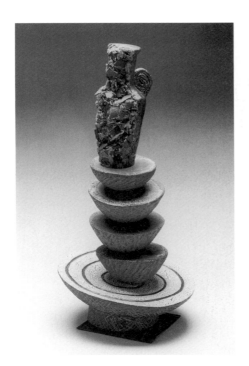

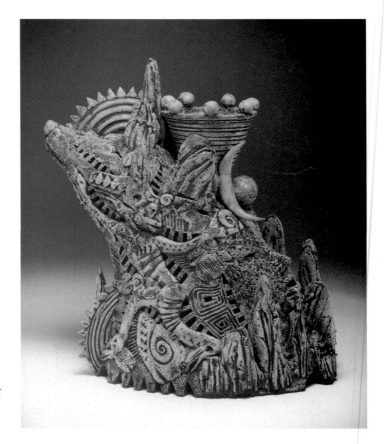

4-19 Andy Nasisse, USA. *Petrified Rock,* 1993, ceramic, low fire, 29 × 24 × 13 in. (73 × 60 × 33 cm). This richly textured sculptural form responds well to the choice of glazes which emphasize the edges and relief qualities of the surface.

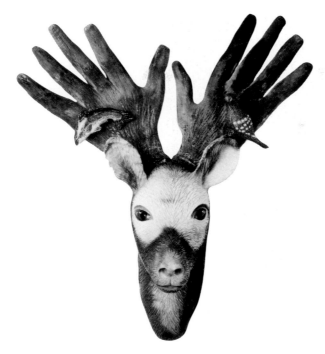

4-20 James Ibur, USA. *Stream,* 1994, smoked stoneware, 24 × 20 × 14 in. (60 × 50 × 35 cm). "I am thrilled when a piece continues to not only impact me initially by the harmonious interplay of design, content, and surface, etc., but really when it continues to reveal itself over repeated visits. It functions as a kind of unfolding mystery that I find greatly appealing."

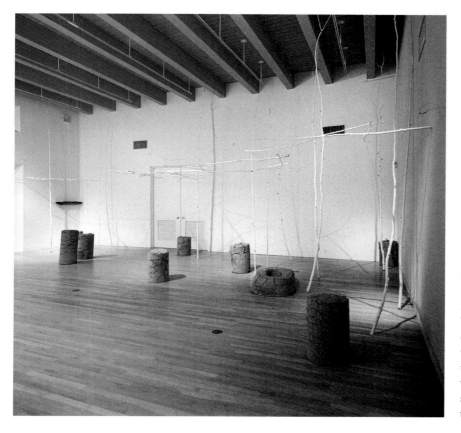

4-21 Bill Gilbert, USA. *Nullarbor,* 1990, adobe, wood. Gilbert uses adobe to build large, seemingly simple ceramic structures. These are combined here (after firing) with other media in a large-scale installation. He was first attracted to clay by "the opportunity to establish a more humble and direct dialog with the earth at a time when our culture seemed lost in a destructive worship of technology and power."

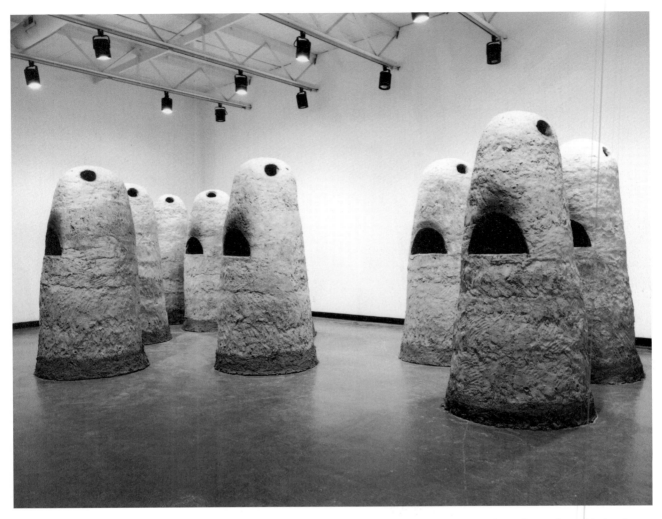

4-22 Life in General (Brook, Rose, Cooper and Sheperd LeVan), USA. *Digits,* 1993; adobe, 84 in. (213 cm). Installation of ten adobe bread ovens aligned in the form of the word "god" in braille at California State University-Long Beach. Participants in this group work built the ovens and made 35 sets of porcelain dinnerware. On August 18, 1993, bread was baked in the ovens and 35 people participated in a potluck dinner. Afterwards, the ovens were installed in the gallery. "Many traditional cultures see the earth, their specific architectures, potteries, and graves as personifications of the individual and collective self. This connection of earthen volume and vessel with the spirit-self or psyche calls up countless levels of meaning. As we work to address our current psychologically impoverished situation in the Western developed world, we find making with earthen materials particularly rich territory for the reconnection of or care of the self."

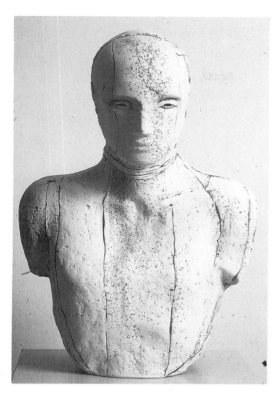

4-23 Christie Brown, Great Britain. Decorative Human Form (Bust from the Gruppe Series 6), 1999. Ceramic, handbuilt, press molding, 23 × 16.5 in. (58 × 42 cm).

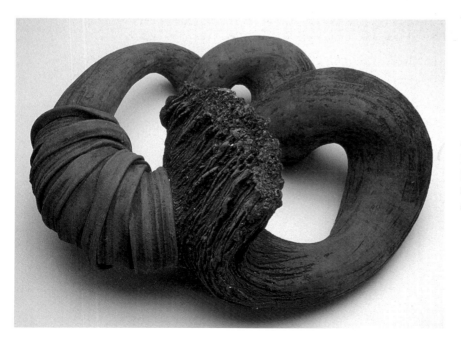

4-24 Syd Carpenter, USA. *Broom Lore,* 1997. Fired clay, oxides, slip, 7 × 15 × 15 in. (18 × 38 × 38 cm). Carpenter's work is strongly sculptural, with organic forms that are evocative in their twisting, turning growth.

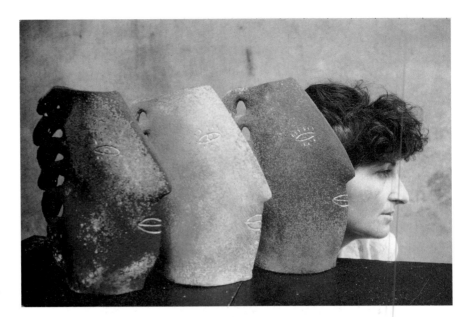

4-25 Daniella Chinellato, Italy. Vases. "I am not interested in the everday reality of things, but in the idea of them, their archetypical meanings, the image that they assume inside me. I let things mix together: childhood memories in the Venetian countryside, westerns, travel experiences, and a classical Roman culture."

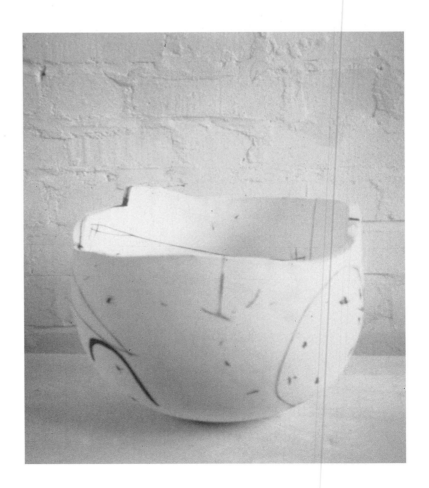

4-26 Gordon Baldwin, Great Britain. Bowl, 1991. Fired clay, engobes, oxides, stains, 16 in. (41 cm).

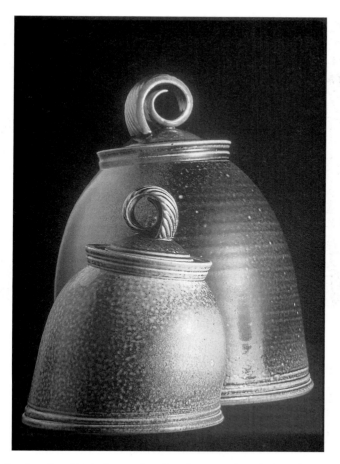

4-27 Jane Hamlyn, Great Britain. Leaning Jars, 2000. Stoneware clay, salt glaze, thrown, altered, 11.5 × 8 × 8 in. (29 × 20 × 20 cm). Salt glazing allows Hamlyn to use delicate combinations of slip and impressed and incised decoration on her pottery. This type of firing enhances small surface details and marks. She is a master of alteration of thrown forms, to which she adds handles and feet as appropriate to the pot.

Chapter 5

Clay is the basis of everything that the potter makes, yet seldom do we use clay straight from the ground. While Chapter 1 described the types of clay that occur in nature, this chapter covers the kinds of clay bodies and some of the basic techniques used in working with clay in the studio, and concludes with some basic health and safety considerations for the ceramist.

CLAY BODIES

An earthenware, stoneware, or porcelain body that is completely satisfactory for the potter seldom occurs in nature. The clay may not be plastic enough, may have an undesirable color, or may not fire at the proper temperature. Even clays dug in the same location will vary slightly in chemical and physical qualities. Thus, it is usually necessary to mix clays in order to achieve a workable clay body (Fig. 5-1).

In making up a clay body, you will generally begin with a clay that is available at a reasonable price and has no major faults, such as an excessive amount of sand or grit. Clays for general pottery use should be at least moderately plastic. The plasticity can be improved by additions of ball clay or bentonite. In rare cases, a clay may be so fine and plastic that it will not dry easily without cracking or warping. In this event, you can add a less plastic clay, silica sand, or a fine **grog** (crushed, fired clay)—to **open up** the clay body and make it more porous so it will dry uniformly. This treatment is often necessary to make an extremely fine, or **fat,** clay throw and stand up better. Some ceramists add coarse grog to a clay body for the rough, textured effects it creates. Others prefer a very smooth body with little grog that allows fine detail or carving on the surface.

Occasionally, a clay will lack sufficient fluxes to fire dense and strong enough at the desired temperature. When this occurs, inexpensive materials containing fluxes—such as feldspar, talc, dolomite, nepheline syenite, or bone ash depending on the temperature or effect desired—are usually added. In some cases a small amount of lower-firing clay can be added, which has the advantage of not lowering the plasticity like the nonplastic materials just mentioned will, but most naturally occurring earthenware clays will also add iron oxide which changes the fired color. If, on the other hand, there is too large a proportion of fluxes and the clay body deforms at a relatively low temperature, you must either begin

5-1 Mixing clay in a Soldner mixer. Modern clay mixers make the task of mixing clay for the studio a much easier job. Note the use of a dust mask rated for the fine particle size of clay dust.

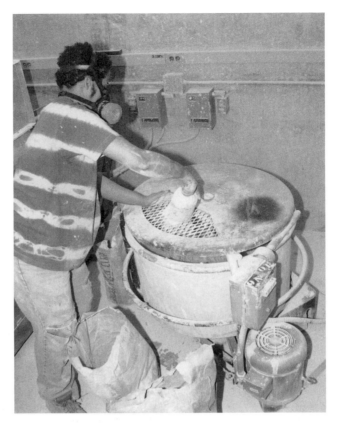

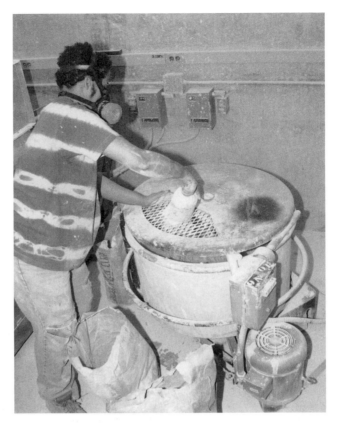

SAFETY CAUTION
Fine clay dust can be a health hazard. Proper clay-mixing procedures and the judicious use of safety equipment such as an OSHA-recommended dust mask will minimize this hazard. See the section on health and safety later in this chapter.

again with a different clay or add clays that are higher in alumina or in both silica and alumina. Either a Florida kaolin or a plastic fireclay of high maturing temperature will work for this purpose.

PROPERTIES OF CLAY BODIES

Before a new clay or clay body is purchased or used, a few simple tests should be made to determine its various characteristics.

Plasticity

Plasticity is essential to a clay body. A standard, simple test for plasticity is to loop a pencil-size roll of wet clay around your finger. Be sure the clay is of working consistency and not too dry or too soft. If the coil cracks excessively, the clay is probably not very plastic and not suitable for forming. The ultimate test, however, is to work with the clay to determine if it throws without sagging and joins without cracking. Check the drying properties, too, as too much plasticity may lead to problems with drying cracks from excessive shrinkage. In comparing bodies, make sure that all samples have been aged for equal lengths of time

and equally processed. It often takes a few days to weeks for clay bodies mixed directly from dry powdered clay to develop a good working plasticity.

Even a satisfactory clay body may be markedly improved by aging it for several weeks in a plastic state. Aging allows the microscopic platelets of clay to become completely wet, causing them to cling together and yet allowing them to slide past each other. If clay is aged for several months, a slight chemical breakdown occurs, much like the original clay formation process. A small amount of clay can be aged in a heavy plastic bag or plastic garbage can. For larger quantities a plastic-lined box, concrete vault, or even an old refrigerator can be used. (According to legend, ancient Chinese potters prepared huge quantities of clay that were stored in pits and covered with moist straw. Each generation of potters used the clay prepared by the previous one.)

Wedging, a process by which the clay is kneaded by hand to remove air pockets, has considerable effect in increasing plasticity. In a coarse clay, the realignment of particles by wedging can also prove beneficial (see the section on wedging later in this chapter). Wedging the clay a day or so ahead of time, then again immediately before use, may greatly improve the workability of freshly made clays for throwing.

Water of plasticity refers to the amount of water needed to bring a dry, powdered clay into a plastic state. The finer the particle size, the more plastic a clay is likely to be and the more water it will absorb.

Bentonite may be added in small amounts to clay bodies as a plasticizer. It has the finest particle size of any clay known and is one of the most plastic clays available. When used in nonplastic (short) clays, 1 part bentonite is equal to 5 parts ball clay. The extreme plasticity of bentonite limits its use to a maximum of about 4 to 5 percent in clay bodies. Bentonite becomes quite gummy and lumpy when mixed alone with water. Either the bentonite should be added to the dry clay body and thoroughly mixed dry (avoid creating a dust hazard by mixing in a tightly sealed container), or it can be added wet by slaking the bentonite completely in a small quantity of warm water and then blunging it before adding it to the batch in the clay mixer. An old blender may be useful for blunging small amounts of bentonite and water.

Porosity

The porosity of a fired clay body is directly related to the hardness and **vitrification** of the clay. A completely **vitrified** clay has no porosity. To make a quick porosity test, carefully weigh an unglazed fired-clay sample on an accurate gram scale. Boil the sample in water for an hour or so, then let it soak overnight in the water. In the morning wipe the sample clean of all surface water and immediately weigh it a second time. The percentage gain in weight will be the porosity of the clay body.

Most bodies used by the hand potter can be fired with a variation of at least 50°F (28°C) from the optimum firing temperature without proving unsuitable. This is only a cone or two variation from the norm. As a general rule, fired clay bodies fall within the following porosity ranges: earthenware, 4 to 10 percent (although some are less porous); stoneware, 1 to 6 percent; porcelain, 0 to 3 percent. A higher firing will reduce the porosity, but normally a specific firing temperature will have been chosen. Adjustments in the amount of flux in the body will affect the firing temperature and relative porosity. Some clay bodies (especially earthenware bodies) will bloat if fired to near vitrification due to the release of

gases as materials in the clay body melt. The degree of vitrification will also have an effect on glazes, both in the way they melt on the body and how well they fit the clay body.

Shrinkage

Shrinkage of the clay body occurs first as the clay form dries in the air and again when glaze fired to maturity. Most clays will not shrink noticeably during bisque firing, unless the bisque is quite high. The more plastic clays will always shrink the most. Clays with high shrinkage are more likely to have problems with warping and cracking during drying and firing. Highly vitrified clays will shrink more in the glaze firing than will more refractory, porous clays. The test for shrinkage is quite simple.

Shrinkage Testing

◆ First, roll out a plastic clay slab about 15 cm long. Draw a 10 cm line on it as illustrated. Be very careful not to move or stretch the wet slab after the line has been drawn (Fig. 5-2). Make shrinkage tests for all the temperatures to which you typically fire.

◆ When the slab is totally dry, take a second measurement of the 10-cm line. Record this length in your notes and scratch the number carefully on the back of the slab as the dry length to calculate drying shrinkage.

◆ Make another measurement after firing to the final temperature to calculate the firing shrinkage.

◆ For the most accurate assessment of clay shrinkage, do several tests and average the results.

Once one knows the shrinkage of the clay, it's simple to calculate the finished size of a piece from the wet size, or vice versa. Here is the math:

$$\text{wet size} \times (100 - \text{percentage shrinkage})/100 = \text{finished size}$$

$$(\text{finished size}/(100 - \text{percentage shrinkage})) \times 100 = \text{wet size}$$

For example, a 9-inch-diameter pot made from clay that shrinks 13 percent when glaze fired would give this final diameter:

$$(9 \times (100 - 13))/100 = 7.8 \text{ inches fired size}$$

5-2 Shrinkage Test Tile Care should be taken to mark the tile accurately at 10 cm. Be especially careful not to bend or stretch the tile after marking.

Or using the same clay shrinkage and desiring a piece with a fired diameter of 6 inches, the following calculation will give the wet size:

$$(6/(100 - 13)) \times 100 = 6.9 \text{ inches wet}$$

One can use the same math for calculating the size of a wet pot from the dry size by using the drying shrinkage instead of the firing shrinkage.

Clay shrinkage rates generally range from 5 to 10 percent in the drying stage, with an additional 5 to 12 percent shrinkage during firings. Thus, you can expect a total shrinkage of at least 13 percent (typical for stoneware) and an extreme of 24 percent, with a median of 12 to 15 percent between the wet clay and the final glazed ware. These average shrinkage rates apply to plastic throwing clays.

Porous earthenware clays, sculpture bodies, or underfired stoneware clays may have much lower overall shrinkage. The addition of large amounts of grog as is often found in hand-building or raku bodies will lower shrinkage both in drying and firing, and may weaken the clay body somewhat after firing. Special whiteware bodies using spodumene in place of feldspar and only small amounts of clay have a greatly reduced shrinkage and can even be compounded to develop a slight expansion in firing. Wollastonite as a replacement for silica and flux in a body will also decrease firing shrinkage.

Fired Color The color of the fired clay is often an important factor in itself, and also in its influence on glaze color. Glazes may appear quite different on light and dark clay bodies. Naturally occurring clays may have a limited color range, usually produced by varying amounts of iron oxide in the clay. Fired clay color can be modified by blending clays from different sources, using purer clays to lighten the clay, or adding darker-firing clays or colorants such as iron oxide or ocher to darken the clay. Using a natural clay that provides iron oxide is usually preferred to the addition of pure iron oxide, as a smoother, more uniform color usually results. Colors outside the naturally occurring earth tones may be produced by adding other colorants or ceramic stains (see next section). It is sometimes difficult to make a clay that has all the characteristics one might want. Often one has to balance the need for a particular color against limitations in plasticity, shrinkage, porosity, firing temperature, or safety of use.

BASIC CLAY BODIES

Earthenware Bodies

Many earthenware bodies are characterized by their deep reddish brown color (caused by the high iron content) and often somewhat high porosity that results from their lower firing range. These qualities make earthenware popular with sculptors and hand-builders, but a fine-grained, plastic earthenware with good fired strength makes a fine throwing body for pottery. By adding fluxes like talc or a frit to the clay body, dense, more vitreous earthenware bodies can be made. This greater density will often impart greater fired strength to the clay, as well. However, excessive vitrification of many earthenware bodies may lead to bloating.

White earthenware clay rarely occurs in nature. Low-fire white clay bodies often contain large amounts of talc (typically 50 percent) along with kaolin or ball clay to reduce their firing temperatures to between cone 08 and cone 04. The bright and even color of these bodies provides a good base for high-contrast, low-fire decorative effects, such as decals, lusters, and the bright, primary colors possible with low-fire glazes and slips. These so-called "ball-talc" white earthenware bodies are generally quite good for hand-building. Because of the rising cost of fuel, many ceramists are also adapting traditional stoneware and porcelain techniques to low-fire bodies.

Stoneware Bodies

There is little chemical difference between a stoneware and a porcelain body, except for the presence of small quantities of iron and other impurities that color the stoneware and reduce its firing range to between cone 6 and cone 10. Stoneware clays usually have a somewhat coarser texture, but are generally much more plastic than porcelain and are easier to use for most throwing and hand-building techniques (Fig. 5-3). Many potters are attracted to stoneware for the

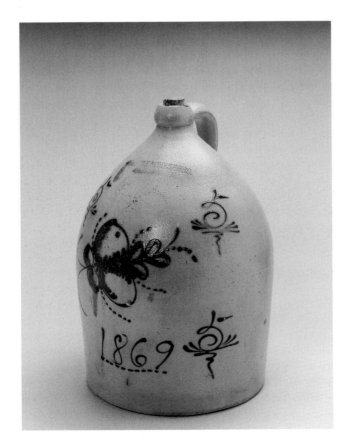

5-3 Hubbell and Chesebro, USA. Jug, 1869, salt-glazed stoneware, 18.25 × 12.5 in. (46 × 31 cm). Everson Museum of Art.

range of clay body color that can be obtained in a gas kiln under **reducing** conditions (firing with an excess of fuel and very little free oxygen in the kiln). Colors from a very light buff to orange-tan to a dark, nearly black-brown are possible in reduction-fired stoneware.

Most stoneware bodies contain grog or silica sand to make the clay stronger and more versatile in its plastic state, although an excess of either may weaken the clay after firing. These materials add to the coarse texture of the body. Feldspar may be added to lower the firing temperature somewhat, and to develop a stronger, more vitreous body. Potash feldspars are usually the preferred type for this purpose. Feldspar has the additional advantage of forming a glass with some of the free silica in the body which might otherwise be converted to **cristobalite,** a high expansion form of silica. Cristobalite can cause thermal shock problems and **dunting** (shattering of the ware). Nepheline syenite, a material similar to feldspar, may be added instead when making a stoneware-type body for firing in the cone 4–6 range. Some batches of nepheline syenite and soda spar, however, may release enough soda into the clay to partially deflocculate the clay, lowering its plasticity.

China Bodies

The term **chinaware** is used rather loosely to designate a white body usually fired between cones 4 and 8. Some types, such as restaurant china, are very hard and durable. They should not, however, be confused with the even harder and often more translucent porcelain bodies fired at cone 10 to cone 16.

Bone china resembles porcelain, except that bone ash has been added to the body as a flux to increase translucency and to reduce the temperature needed for maturity to about cone 6. Like porcelain, bone china is very hard, white, and translucent when thin. Its greatest faults are a tendency to warp in firing and the lack of sufficient plasticity for throwing. Bone china is usually formed by handbuilding or slip casting.

Porcelain Bodies

The highest-firing category of traditional ceramic wares, porcelain bodies, are characterized by a smooth texture, uniform white color, and the ability to accept fine detail (Fig. 5-4). Most porcelains are somewhat nonplastic when compared to stoneware. Porcelain is a term that is often used loosely for dense whiteware bodies. Porcelains usually fire between cone 8 and cone 12 to an extremely hard, vitreous ware. True porcelains are also nearly vitreous after firing and often somewhat translucent when thin, while white stoneware is somewhat rougher in texture and never translucent.

These qualities make porcelain ideal for commercial products shaped mechanically by casting or jiggering. Many hand potters have become interested in exploiting these same effects, and therefore porcelain bodies with greater plasticity and slightly lower maturing temperatures (cone 6 to cone 10) have been developed. Porcelain bodies are compounded principally from kaolin, feldspar, and flint. Plastic Florida or English kaolins are often chosen to make the porcelain easier to throw. For increased plasticity some ball clay is generally added, often resulting in a higher drying shrinkage and a grayer color with lowered translucence due to iron and titanium oxides in the ball clay. In a throwing body, the ball clay is typically used for as much as 25 percent of the body. Bentonite

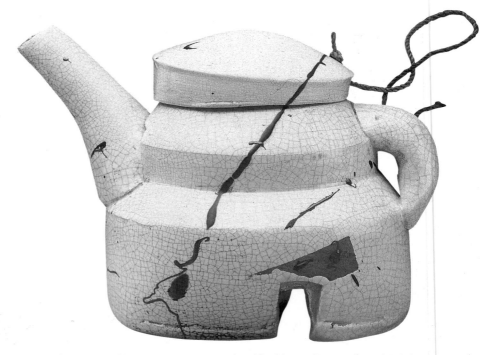

5-4 Jeri Au, USA. *Tibetan Teapot II,* porcelain. The delicate whiteness of porcelain is important to the success of this teapot with its crisp edges and gestural decoration.

may also be added up to 5 percent, again with higher drying shrinkage the result. Choosing a ball clay and bentonite, which are fairly pure and contain very little iron oxide and titanium dioxide, will keep the clay body whiter and more translucent. For larger work, molochite (porcelain grog) can be added to lower drying shrinkage while retaining the smooth white surface after firing. (See the appendices for suggested clay bodies.)

SPECIAL CLAY BODIES

Raku Bodies

The composition of raku bodies are often quite different from those for normal firing, because of the speed of the raku firing process. The ware is placed in a hot kiln, and, when the glaze becomes molten, it is removed and cooled very quickly. In order to withstand these radical temperature changes, the ware must be somewhat porous. Thinner, more open ware that heats quickly and evenly has a better chance for survival in raku firings. The typical raku body is a stoneware clay containing at least 20 percent grog. When used in raku firing, stoneware clays are underfired and quite porous, never coming close to their maximum firing temperature. Thicker ware may need somewhat greater amounts of grog. Bisque firing to only about cone 010-08 will often help large and thick

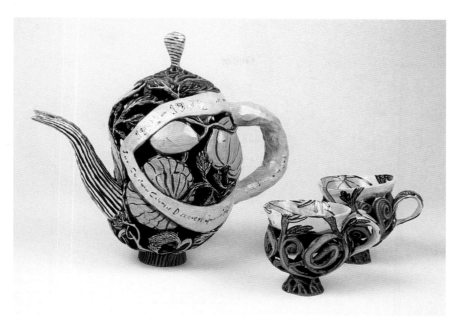

Plate 1 Deirdre Daw, USA. *Christopher Columbus Invades America Series: C. C. Discovers Indigenous Vegetables*, 1991. "The history and tradition of clay is an endless source of inspiration and a connection to past traditions and trains of thought."

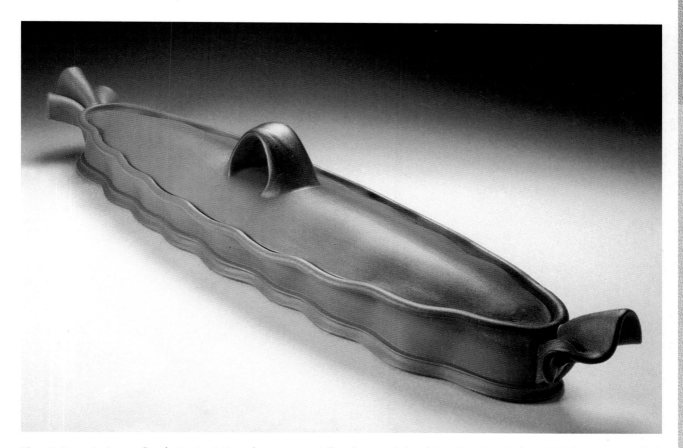

Plate 2 Bruce Cochrane, Canada. *Serving Dish*, earthenware, terra sigillata, thrown and altered, 4 × 20 × 5 in. Cochrane's lidded containers are fluid alterations of wheel-thrown forms. He says he was first attracted to clay by "the ability to create volume from a solid lump of earth, then make it permanent through heat and actually interact with the object on a functional level. I was also seduced by a throwing demonstration in a shopping mall. The process of throwing is as exciting today as it was twenty years ago."

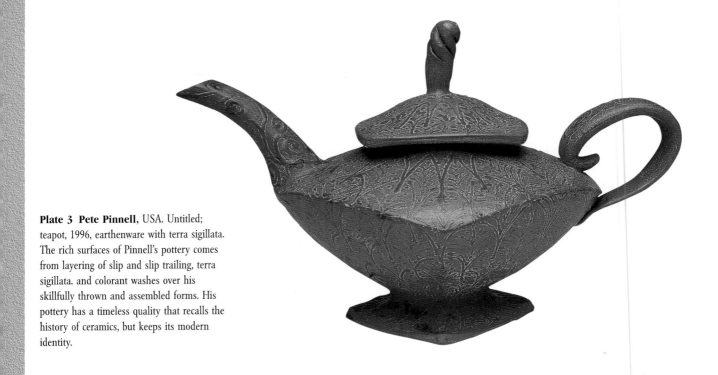

Plate 3 Pete Pinnell, USA. Untitled; teapot, 1996, earthenware with terra sigillata. The rich surfaces of Pinnell's pottery comes from layering of slip and slip trailing, terra sigillata. and colorant washes over his skillfully thrown and assembled forms. His pottery has a timeless quality that recalls the history of ceramics, but keeps its modern identity.

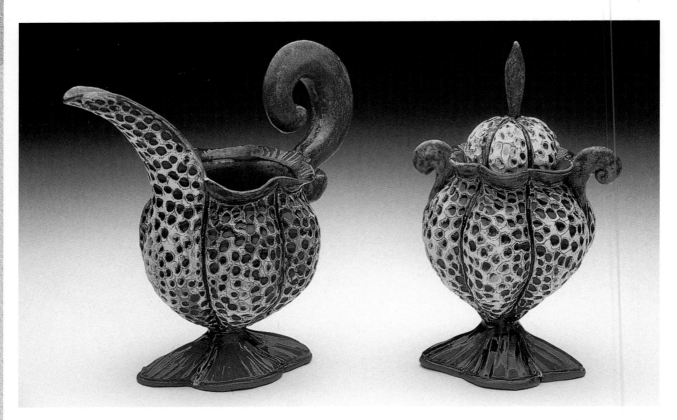

Plate 4 Jenny Lou Sherburne. USA. *Cream and Sugar Set,* 1992, earthenware, 8 × 7 × 4 in. (20 × 17 × 10 cm). "In a very real sense, my work is a survival technique. Functional pottery provides me with a framework within which I can listen, question, express, and communicate. When I squeeze the clay, it eases out of my fingers and extends itself. I have often forgotten how plastic it could be. In rediscovering the plasticity of the clay, I've reactivated the plasticity of my own perceptions and responses. Just like the clay, reality is malleable; our world is what we make it."

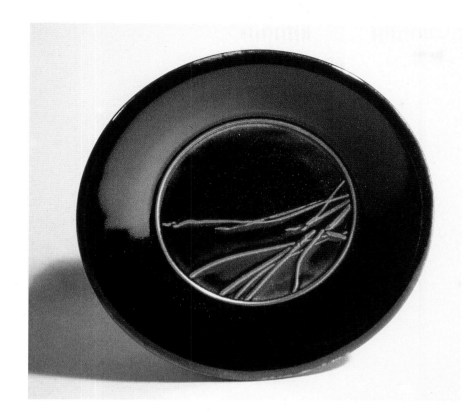

Plate 5 Ron Roy, Canada. *Reflections*
series platter, 1993, porcelain, 13.5 in. (34 cm).
Ron Roy is a master of temmoku glazes. He
applies slip for the decoration to the
greenware. After bisque he applies one coat of
glaze, waxes the center to keep the glaze thin
enough to break brown over the texture,
and applies another coat of glaze to the rim to
ensure that it will fire a rich black.

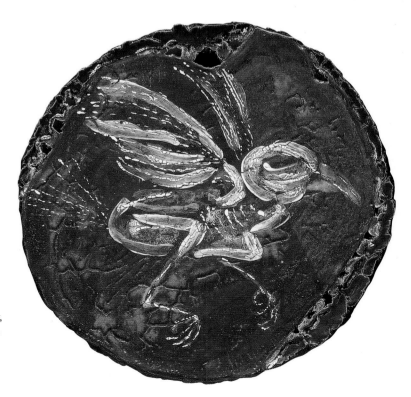

Plate 6 David L. Gamble, USA. *Plate*, clay,
multiple firings, 23 in. (58 cm). The artist uses
slip and glazes applied through multiple
firings to build up the richly textured surface
of this piece.

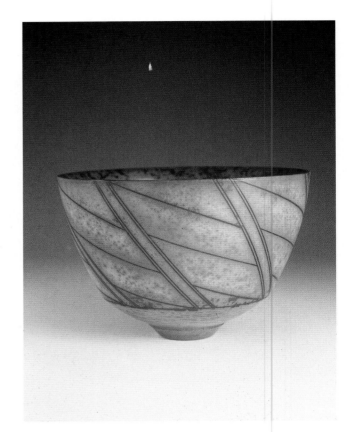

Plate 7 Duncan Ross, Great Britain. Bowl, 1999. Thrown earthenware with terra sigillata slip, smoke fired, 5.5 in. (14 cm). This bowl has an elegant beauty, yet a timeless quality that blends modern elements with hints of the rich heritage of ceramics. The artist's use of terra sigillata and saggar firing results in the rich red browns bordered by black.

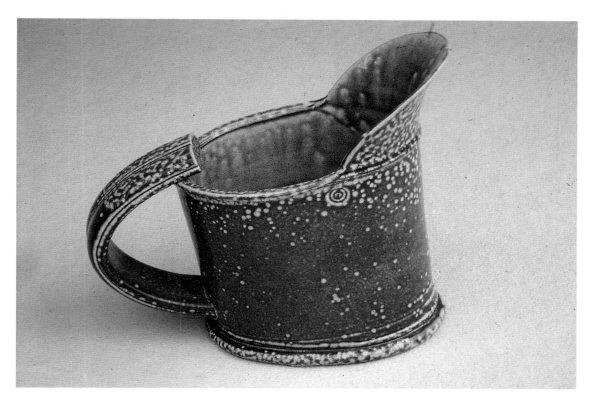

Plate 8 Walter Keeler, Great Britain. Oval jug, 1988. Salt-glazed thrown stoneware with extruded handle, chrome cobalt pigment, 4.5 in. (11 cm). Keeler is one of the most inventive British functional potters. His work, while perfectly functional, has a fresh quality that is the result of deft handling of the clay and the salt glaze which reveals all the surface details.

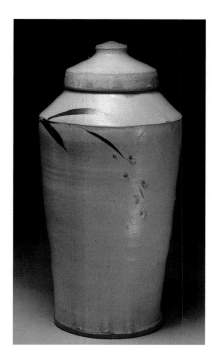

Plate 9 Rock Creek Pottery–Will Ruggles/Douglas Rankin, USA. Covered jar, 2001. Wood-fired stoneware, 15.25 in. (39 cm).

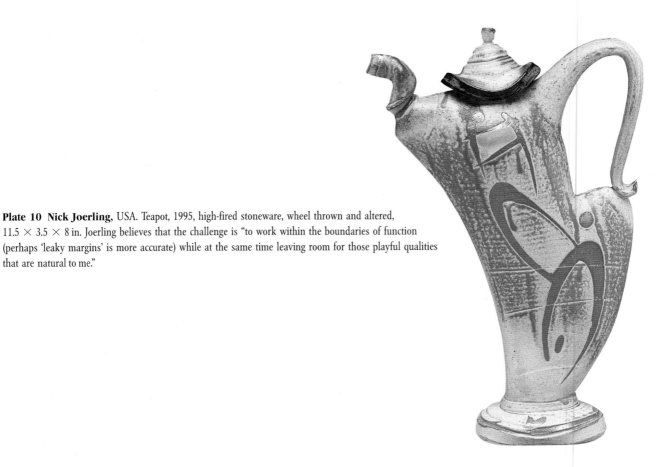

Plate 10 Nick Joerling, USA. Teapot, 1995, high-fired stoneware, wheel thrown and altered, 11.5 × 3.5 × 8 in. Joerling believes that the challenge is "to work within the boundaries of function (perhaps 'leaky margins' is more accurate) while at the same time leaving room for those playful qualities that are natural to me."

Plate 11 John Chalke, Canada. Wood-fired plate, 1994, trailed slip, decomposed granite wedged into clay, 18.5 in. (46 cm). The effects of wood firing–the ash and flame that leave their marks on the clay–play an important part in the richness of the surface of this platter. The central marks are left by the stacking of other pieces on top of this plate during the firing. He speaks of his attraction to clay, "It cracks, shivers. It shrinks. I can't say it's ever been easy. Sometimes I really wonder why I bother. Kilns never fire evenly, ceramic materials change on you and cones misbehave."

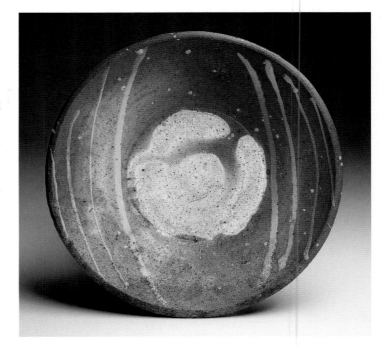

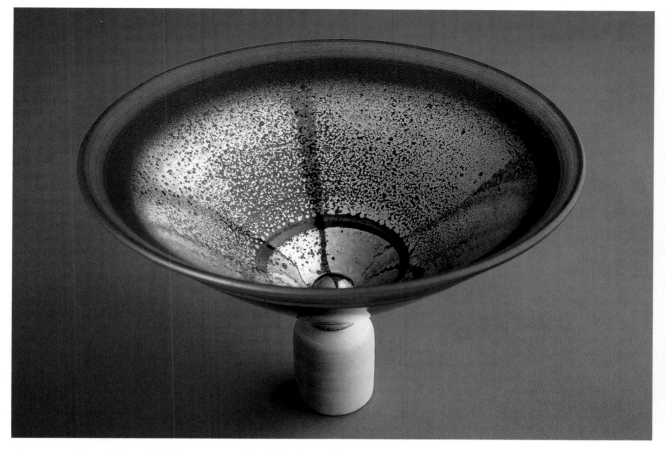

Plate 12 Derek Smith, Australia. Chalice, 1996, Porcelain, black glaze, sandblasted, with gold and platinum luster.

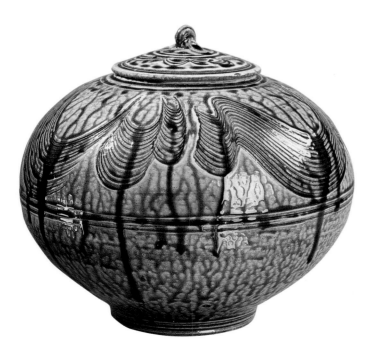

Plate 13 Les Miley, USA. Lidded Jar, 1991, salt-glazed c/10 stoneware, combed porcelain slip with wood ash. Salt glazing perfectly complements the fluid slip combing on this almost spherical pot. The almost tightly inflated qualities of this wheel-thrown form create a lot of visual tension and make a perfect canvas for the combed decoration.

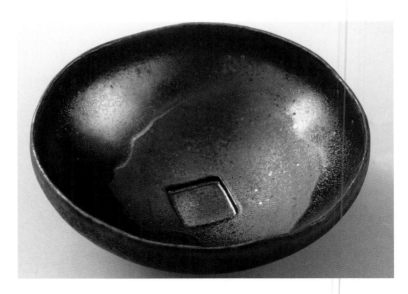

Plate 14 David Shaner, USA. *Hand-formed Bowl,* 1994, reduction-fired stoneware, 5 × 14 × 14 in. (15 × 37.5 × 37.5 cm).

Plate 15 Magdalene Odundo, Great Britain. Vase, 1988. Handbuilt clay, burnished, reduced and oxidized, 17.5 in. (45 cm). The swelling, highly burnished forms that Odundo makes have strong roots in her African heritage. Although they have historical precedents, her vases are distinctly modern in many aspects.

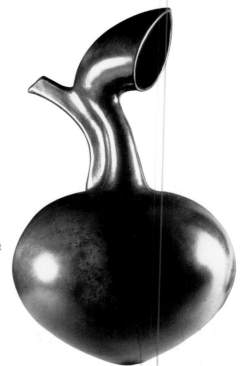

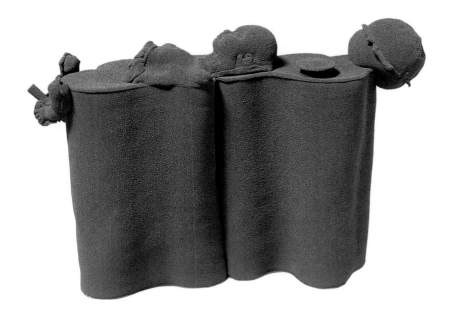

Plate 16 Philip Cornelius, USA. *The Orange Grove on a Blue Night,* 1992, porcelain, 11 × 14 × 4 in. (27 × 35 × 10 cm). Cornelius often works with the teapot as a basic starting point for form, although the final result is a sculptural statement. His work often combines thin porcelain slabs and slip-cast forms. "For me the clay is the best medium because it is so common. If your piece is to have any merit (value), it must come from within the maker. It is the obligation of the maker to imbue the clay with value."

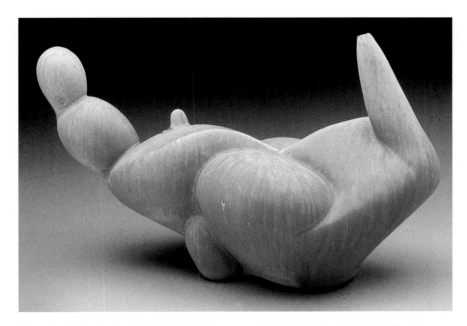

Plate 17 Chris Gustin, USA. *#95-25,* 1995, stoneware, 10 × 15 × 8 in. (25 × 38 × 20 cm). Gustin's pieces have an exciting tension balance and gesture. He says about his work, "Constantly fighting gravity, clay offers me numerous technical challenges to overcome and master. If you can change one thing, then everything changes. Temperature, atmosphere, formula, scale, tool, building method: there is so much to know, and even when I think I have it, there is always a new twist that forces me to start at the beginning again."

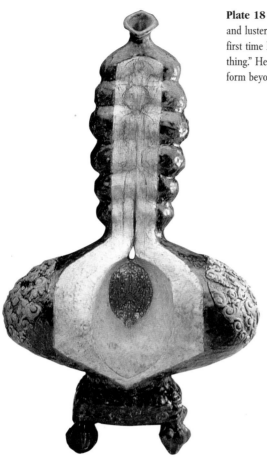

Plate 18 Kate Blacklock, USA. *Blue Ribbed Pedestal Vessel,* 1994, earthenware, glaze and luster, 29 × 16 × 9 in. (73 × 40 × 22 cm). Blacklock was attracted to clay. "The first time I saw a potter throwing a pot on the wheel . . . I wanted to learn this magical thing." Her alterations of the thrown form and use of glaze and luster take this vase-like form beyond mere function.

Plate 19 Wesley Anderegg, USA. *Group cups and saucers,* 1995, earthenware, 6 × 6 × 4 in. (15 × 15 × 10 cm). Anderegg combines function with sculptural wit in these pieces, while carefully avoiding the stereotypes of cups with faces on the sides. The expressive painting adds a lot to the evocative emotion-filled visages.

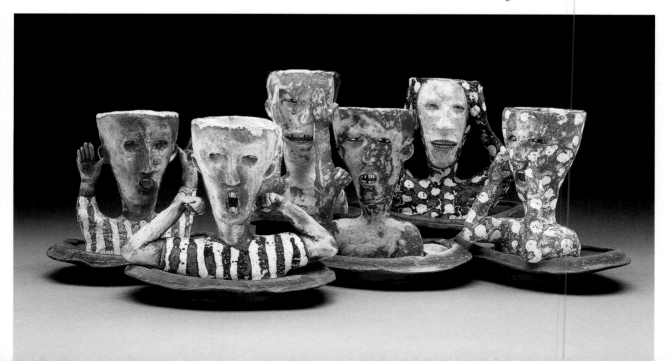

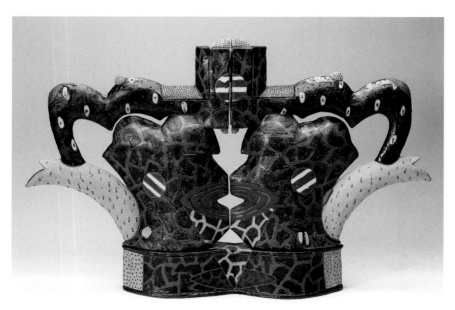

Plate 20 John Rohlfing, USA. *Diptych Teapot*, 1994, earthenware, 18.5 × 28 in. (46 × 71 cm). Rohlfing uses negative space and selection of forms effectively in this playfully painted double teapot.

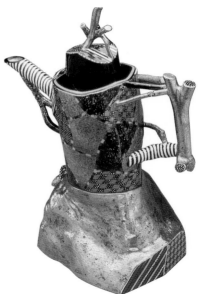

Plate 21 Ralph Bacerra, USA. Untitled teapot, 1989, whiteware, glazes, lusters, 17 in. (43.2 cm).

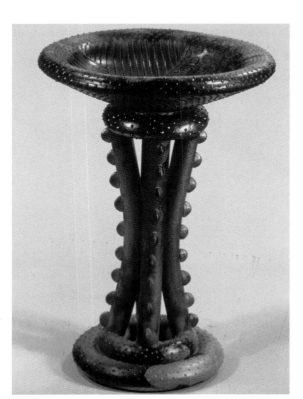

Plate 22 David MacDonald, USA. *Ceremonial Bowl*, 1990, earthenware, pit-fired, 36 × 20 in. (91 × 51 cm). MacDonald draws inspiration for his work from the rich heritage of African art, but wants his work to be seen as a more universal part of the human spirit. The lush coloration of the terra sigillata which covers this piece is the result of the direct flame and fuel contact that occurs in pit firing.

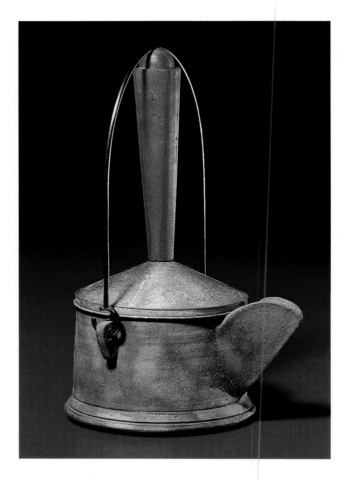

Plate 23 John Goodheart, USA. *Bucket 2,* 1994, clay, copper, wood,
10 × 5 × 5 in. (25 × 12 × 12 cm). "I respect the traditions and humility
of craftsmen as well as the beauty inherent in daily rituals. What I do in
the studio is a more intense and focused reflection of how I live each day.
I have grown to appreciate the ordinary as well as the heroic. This is why
I have continued to make pots for almost forty years."

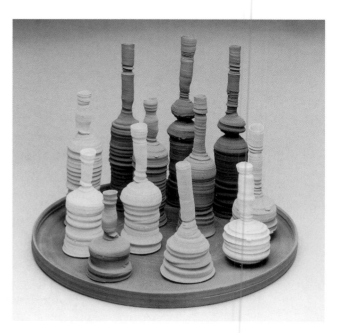

Plate 24 James Makins, USA. *Junihitoe,*
1992, porcelain, 19 in. (50 cm). Everson
Museum of Art.

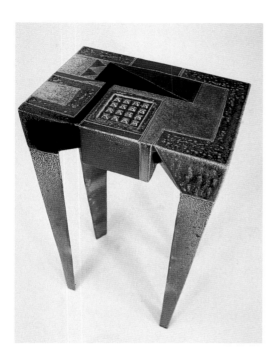

Plate 25 Robert Winokur, USA. *Table with Grid Inset*, 1984, salt glaze stoneware, blue wood ash glaze, slips and engobes, 30 × 10 × 14 in. (76.2 × 25.4 × 35.5 cm).

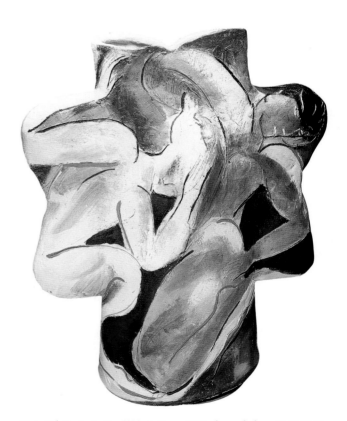

Plate 26 Rudy Autio, USA. *Antigua*, 1994, clay and glaze, 34 × 27 × 17 in. (86 × 68 × 43 cm). "Clay provides endless potential for all the things one can do with it—sculpture, painting, design—plus a challenging technical side always interesting for the tinkerer. While I focus on clay as a ceramist—(it is my career)—I don't go goofy for it in any special way. Any art media is limitless, really. Painting, sculpture, dance, video all are endlessly challenging and provide limitless potential."

Plate 27 Ron Nagle, USA. Untitled, 1991, earthenware, low-fire glazes and multifired china paint, 3.25 × 4 × 3.25 in. (8 × 10 × 8 cm).

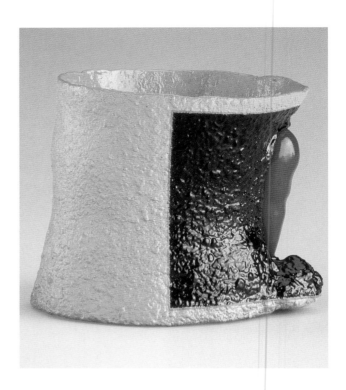

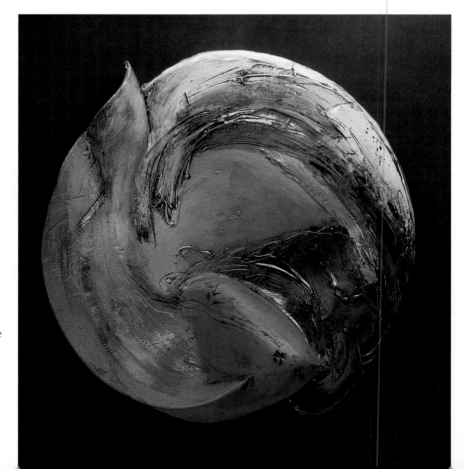

Plate 28 Susanne G. Stephenson, USA. *Dusk II*, 1994, terra cotta, thrown, hand-built, thick slips and color-vitreous engobes. "For me the canvas is rigid and confining. I am not interested in creating an illusion of space. The physical gesture of the form in conjunction with the freely applied thick colored slips are the means of my expression."

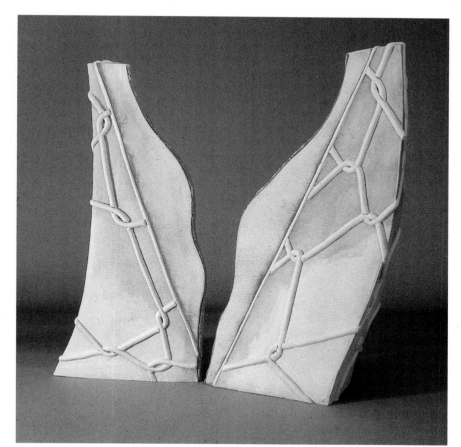

Plate 29 Donna Nicholas, USA. *Gyre XIII*, 1994, low-fire clay and glaze, 27 × 25 × 9 in. (68 × 63 × 22 cm). Nicholas says, "I begin my pieces with full-scale drawings. I like the broad gesture in a large drawing to establish the gestures of the forms and the all-important shape of the negative space."

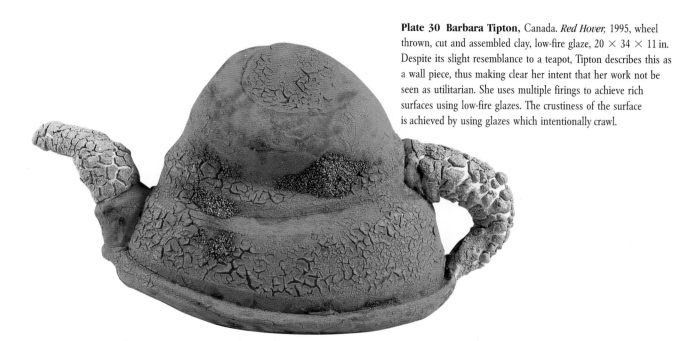

Plate 30 Barbara Tipton, Canada. *Red Hover,* 1995, wheel thrown, cut and assembled clay, low-fire glaze, 20 × 34 × 11 in. Despite its slight resemblance to a teapot, Tipton describes this as a wall piece, thus making clear her intent that her work not be seen as utilitarian. She uses multiple firings to achieve rich surfaces using low-fire glazes. The crustiness of the surface is achieved by using glazes which intentionally crawl.

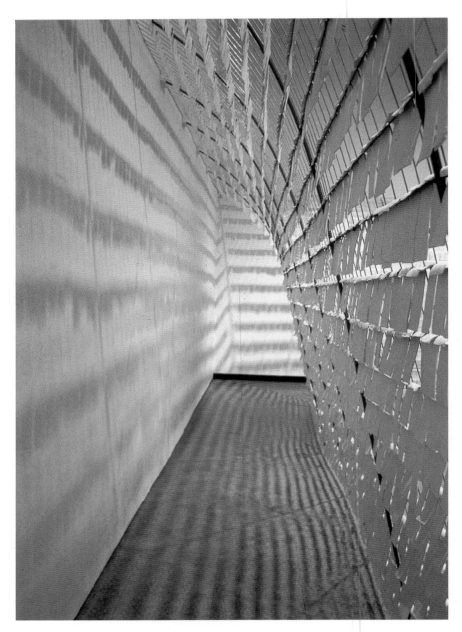

Plate 31 Berry Matthews, USA. *White Space* (view of corridor along wall), 1993, clay, wire, 84 ×
240 × 276 in. (213 × 609 × 701 cm). Matthews's sculpture installation contrasts a relatively simple
overall form with an exceedingly complex structure made up of about 12,000 small pieces of porcelain
hung on wire fencing. The work transforms the gallery space, breaking up the light and rustling slightly
as one moves through the structure. The fragility of the thin clay slabs adds an element of risk to the
viewing experience.

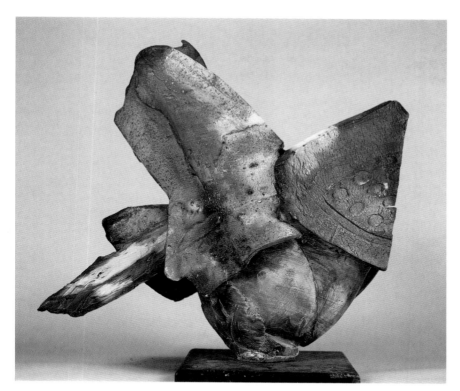

Plate 32 Paul Soldner, USA. Untitled; low temperature soda fired, thrown and altered, unglazed, 27.5 × 23 × 15.5 in. Soldner feels ceramics probably doesn't offer him things that couldn't be found in other media, but he is interested in the complexity of material and process, the flexibility of the medium, and the fact that there is always so much to learn. "My work is mostly experimental, intuitive invention, based on random components and decision-making selection. It also uses the figure as a reflection of contemporary life, abstracted, and concerned with pushing the possibilities of the technical processes."

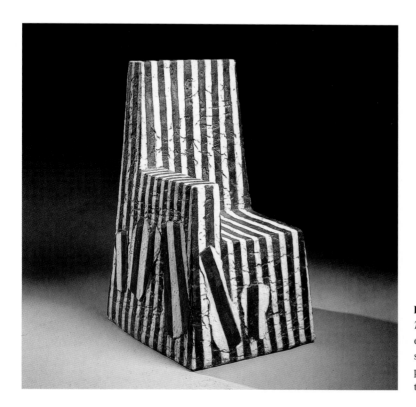

Plate 33 Betty Engholm, Denmark. *Throne,* clay. This full-size hand-built chair is enlivened by the bold vertical black and white stripes. Note how the fragmental striped pieces work with the asymmetry of the form to break up the even repetition of the stripes.

Plate 34 Paula Winokur, USA. *Markers,* 1995, unglazed porcelain, 96 × 12 × 10 in. (243 × 30 × 25 cm).

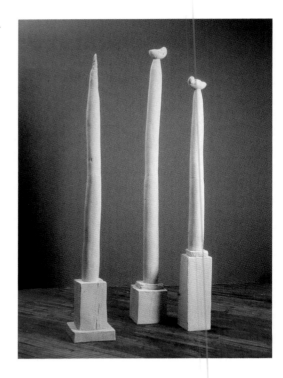

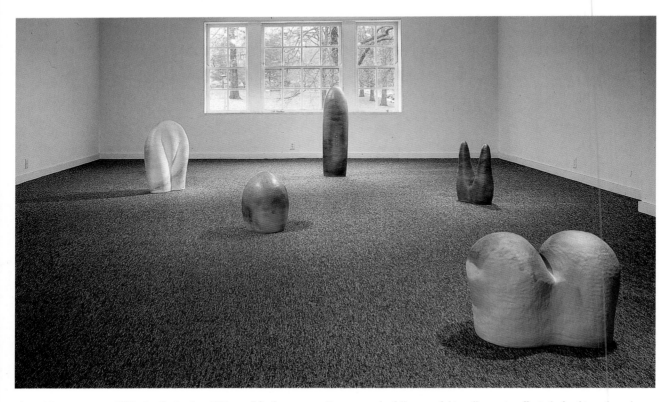

Plate 35 Eva Kwong, USA. *Fertile Garden,* 1985, wood-fired stoneware. Kwong uses the full space of this gallery quite effectively for this sculptural installation, transforming it into an indoor garden. The use of wood firing for the ware results in pleasantly earthy tones that befit the natural theme.

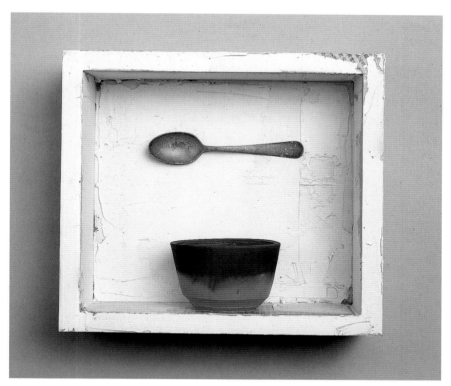

left: **Plate 36 Nancy Selvin**, USA. *Still Life*, clay bowl, spoon, wood, plaster. Selvin's still lifes carry a lot of information using a few simple elements. The use of common home construction materials for the box that holds the clay bowl and found spoon helps to anchor its domestic setting. She says clay "provides 4,000 years of history and domestic form from which I can work."

below: **Plate 37 John H. Stephenson**, USA. *Core #22*, 1994; low-fire terra-cotta ceramic sculpture, 18.5 × 22 × 29 in. (46 × 55 × 73 cm). "I handle work for two dimensions in a much different way than I do work for three dimensions. Roughly, one is to be viewed from one position or distance while the other is to be moved around in real space."

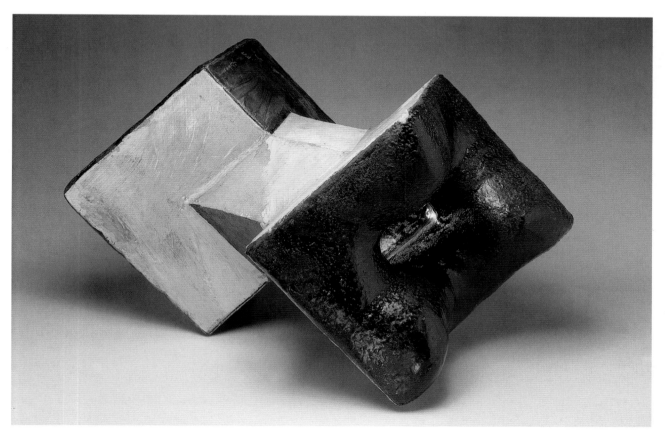

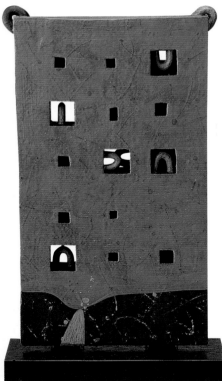

Plate 38 Hiroaki Taimei Morino, Japan. *Sculpture,* 1992, slab construction, stoneware, iron red, green, and black glaze. The strong architectural references in this work contrast with the organic forms that move through the openings. In talking about his work, Morino speaks of the "mysterious process in which clay, glaze, and fire work together beyond human power."

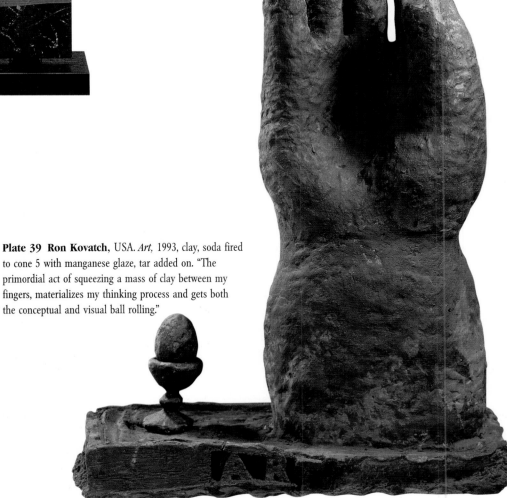

Plate 39 Ron Kovatch, USA. *Art,* 1993, clay, soda fired to cone 5 with manganese glaze, tar added on. "The primordial act of squeezing a mass of clay between my fingers, materializes my thinking process and gets both the conceptual and visual ball rolling."

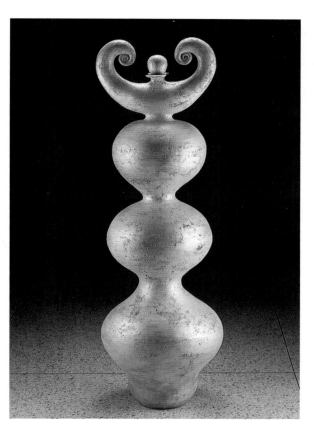

Plate 40 Amara Geffen, USA. *Luna's Triumph,* 1994, glazed and painted earthenware, 56 × 17 × 17 in. (142 × 43 × 43 cm). Geffen's vessels often have a mythical quality and elements of classical forms. "The first thing that attracted me to clay was the level of concentration and focus it required. To work with clay you must be fully awake—you cannot work on "autopilot." Also, there is no end to what you can learn and discover. Working with clay means there is always something new to become aware of."

Plate 41 Gregory Zeorlin, USA. *Garden Mantel,* 1991, earthenware, 16 × 15 × 8.5 in. (40 × 38 × 21 cm). Zeorlin combines a complex group of pottery, architectonic, and organic forms into a unified composition through the use of color and careful placement.

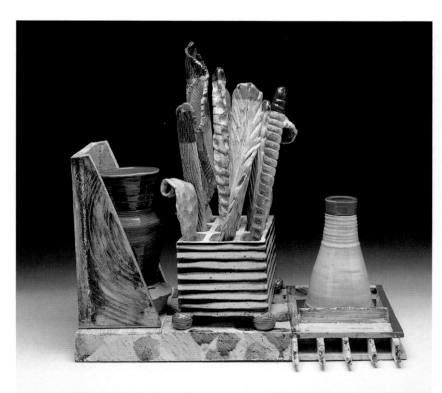

Plate 42 Leslie Lee, USA. *Social Faces,* 1994, painted paperclay, 27 in. (68 cm). "Clay is a whole-body experience for me. I work in other media also, but nothing seduces me and calls me back like clay. The smell of the dry material being wetted and mixed is very sweet after lugging heavy, dusty bags. The finished clay is smooth and cool to the touch. It requires big body action for wedging, rolling, slapping down. It invited meticulous finger work for carving, sculpting, texturing. And then there's the fire: the heat, the acrid transformation of mud to stone.

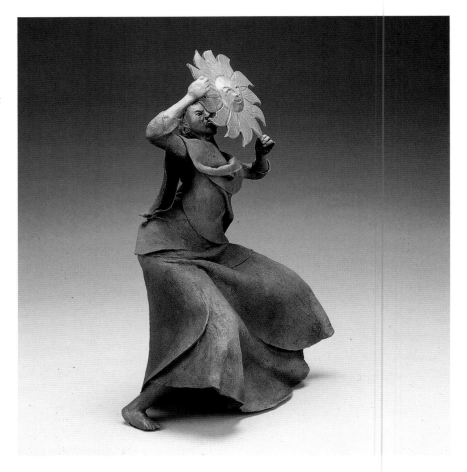

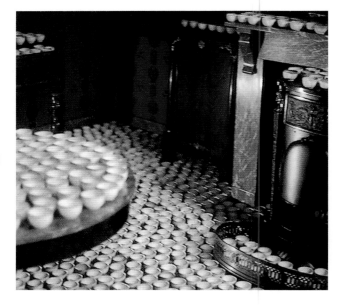

Plate 43 Piet Stockmans, Belgium. *Exhibition 1986.* Museum voor Sierkunst, Ghent, 1986, porcelain. Stockmans' installations, like this one which uses hundreds of small bowls, transform interior space through the sheer obsessiveness of the numbers of objects that cover almost all the level surfaces.

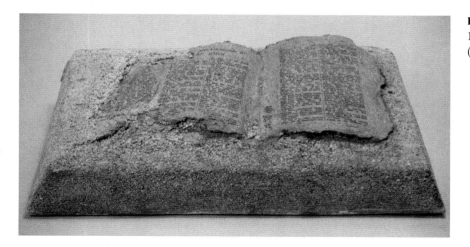

Plate 44 **Takako Araki,** Japan. *Sand Bible,* 1983, stoneware, sand, 6 × 18 × 25 in. (15 × 45 × 63 cm).

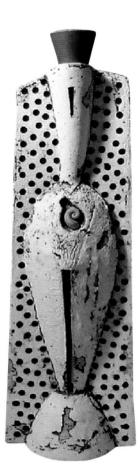

Plate 45 **Trudy Golley,** Canada. *Karyatid,* 1999. Midrange stoneware (cone 6) fired in oxidation, high barium/copper glaze, 23 × 7 × 5.5 in. (58 × 17 × 14 cm).

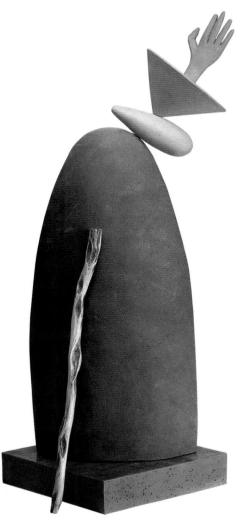

Plate 46 **Curtis Hoard,** USA. *Figure with Walking Stick,* 1994, earthenware, hand-built, cone 02, 67 × 24 × 28 in. (170 × 60 × 71 cm). "Clay, as an artistic medium, is all-inclusive. The idea of being sculptor and painter at the same time opens possibilities that other media don't provide."

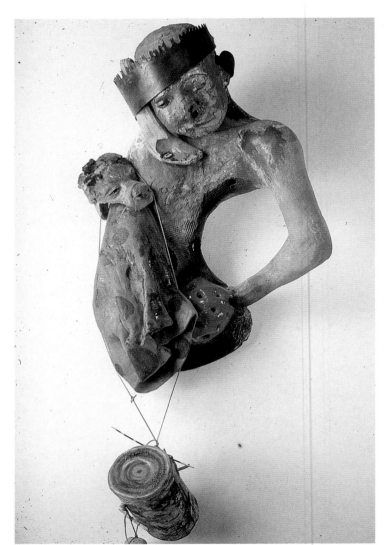

Plate 47 Arthur Gonzalez, USA. *At Heart Level,* 1992, clay, steel, wood, 26 × 67 × 13 in. (66 × 170 × 33 cm). "For me a really good work in clay is one that doesn't rely on traditional clichés in clay. I hate work that talks only about technical razzle-dazzle. Clay's propensity for fooling the eye is long understood. Clay needs to look at a bigger picture. Clay needs to see the needs of the art world and ask itself, 'How can I contribute to these needs?' Clay needs to not be self-referential, but be self-assured enough to look out to larger needs."

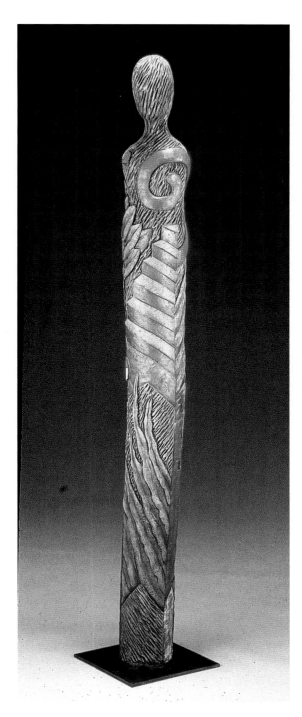

Plate 48 Christine Federighi, USA. *Blue House Below,* 1994, clay, 72 × 8 × 9 in. (182 × 20 × 22 cm). Federighi's work is quite tall, so firing is accomplished by stacking two sectional electric kilns, one on top of the other. To secure the work after firing it is placed over a rod or armature which is attached to a base. Although in the past she has worked with colored terra sigillatas, she now prefers to paint her pieces with oils after firing.

Plate 49 Gina Bobrowski, USA. *Sighting the Distant Shore*, 1994–1995, multi-fired ceramic, fired mixed media, found objects, 53 × 30 × 31 in. (135 × 76 × 79 cm). "It's important to try to approach everything with open senses and no preconceptions. When the work communicates clearly, clearly enough and mysteriously enough, I will not initially be all that aware of what it's made of. I'll just want to be around it for a long time. I am inspired by works that resonate, both in their relevance to the bigger world of human experience and in their capacity to become language."

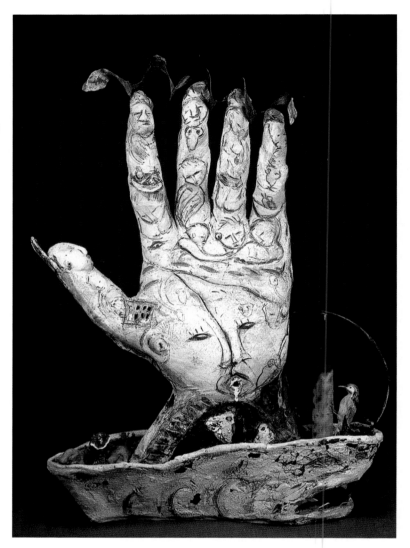

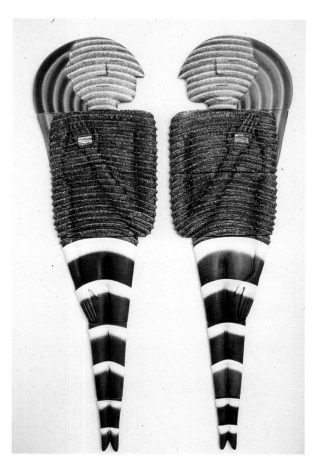

Plate 50 Nancy Carman, USA. *Guardian Figures: Earth/Water,* 1991–92, white earthenware, 96 × 27.5 × 4 in. (243 × 69 × 10 cm). Carman's work varies in scale from these larger than life-size figures to much more intimate sculpture. She is thrilled by "an object that surprises me, that resonates on some (deep) inner level, that delights me with its ingenuity, that gives me another take on my worldview. The route to these experiences and insights may be an acute sense of craft and process, but not necessarily."

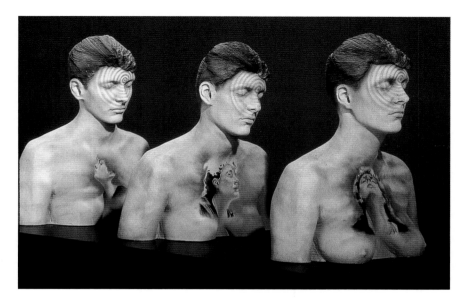

Plate 51 Nan Smith, USA. *Guide* (detail), 1991, airbrushed glazed earthenware, gypsum cement, 84 × 22 × 60 in. Smith often works in large-scale installations which include life-size figures. The work here is part of one of these installations. Her mold-making abilities allow her to replicate real objects in clay with striking clarity. She transforms these real objects through clay's "infinite potential to synthesize two-dimensional surface information with three-dimensional form."

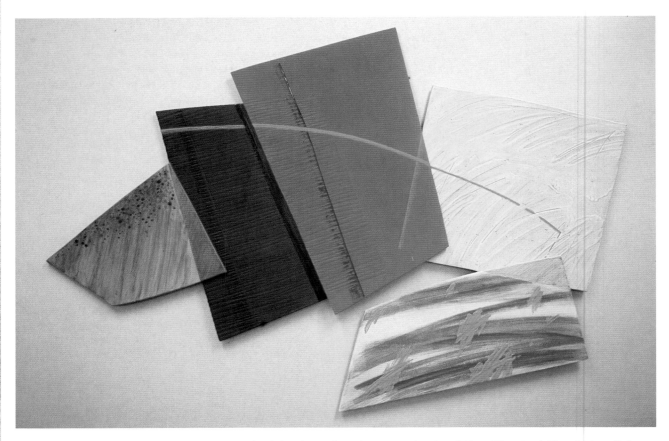

Plate 52 Jeanne Otis, USA. *Calendula Hour,* 1993, colored slip, glaze and overglaze, 50 × 76 × 2 in. (127 × 193 × 5 cm). The color is applied as an overglaze (frit and stain) on top of an opaque white glaze. Otis describes her work in clay as "a continuous dialogue with color." She adopts a painterly manner in handling the abstract imagery and goes on to say that the "current focus using glazes and underglazes in a finger-painting manner is a direct response to the ceramic materials and their color quality in the wet state."

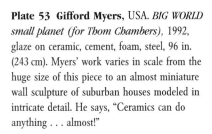

Plate 53 Gifford Myers, USA. *BIG WORLD small planet (for Thom Chambers),* 1992, glaze on ceramic, cement, foam, steel, 96 in. (243 cm). Myers' work varies in scale from the huge size of this piece to an almost miniature wall sculpture of suburban houses modeled in intricate detail. He says, "Ceramics can do anything . . . almost!"

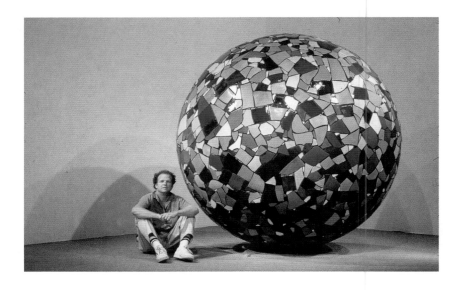

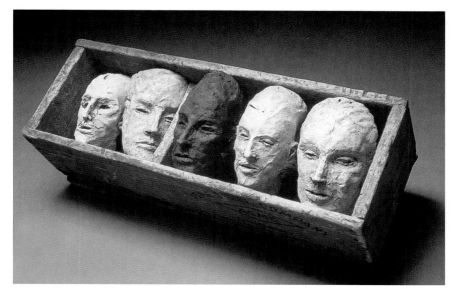

Plate 54 Judy Moonelis, USA. *Heads in a Box*, 1993, ceramic, wood, encaustic, 10 × 23 × 12 in. (25 × 58 × 30 cm). Moonelis' work almost always incorporates both powerfully modeled figurative elements and intensely personal content. The intensely visual qualities of her work ensure that it carries a strongly evocative message to the viewer.

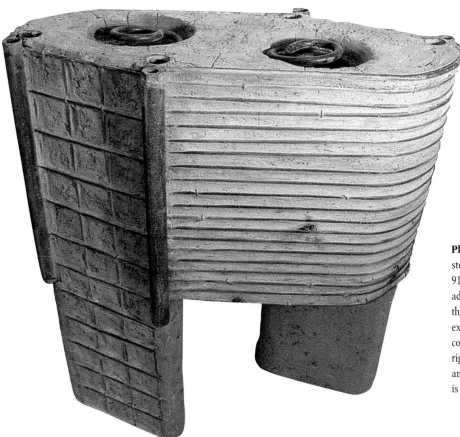

Plate 55 Joyce Kohl, USA. *Twins*, 1993, stell and adobe, 48 × 36 × 30 in. (121 × 91 × 76 cm). Many contemporary artists have adopted non-fired clay processes like adobe as they allow the evocative qualities of clay to be extended to much larger forms. Here Kohl combines it with steel, which both forms a rigid and strong structure to hold the adobe, and also adds its own evocative qualities as it is allowed to rust and discolor.

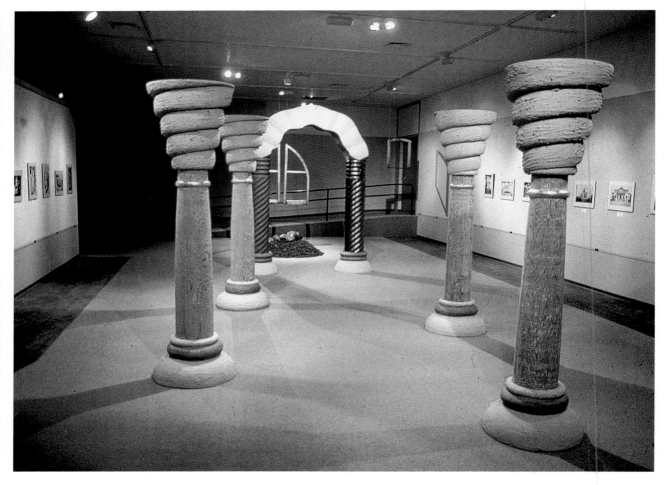

Plate 56 Robert W. Harrison, USA. *Art 'n' Architecture,* 1992, turned wood, carved Styrofoam elements, powder-coated steel. This is a site-specific installation at the Holter Museum of Art, Helena, Montana. Harrison often makes use of a variety of media which is combined with the clay portion of his work. This allows him to more easily work on a larger, architectural scale.

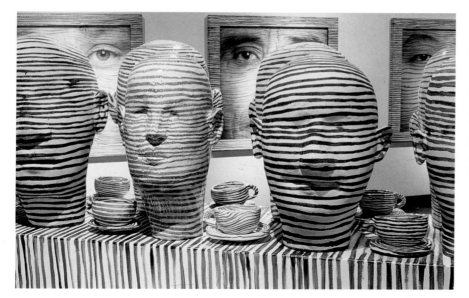

Plate 57 Tre Arenz, USA. *Sameness–Touch* (detail with photos), 1995, clay, wood, paint, 24 × 56 × 156 in. (60 × 142 × 396 cm). Detail of her *Sameness* installation (which includes the photographs behind the heads). Arenz explores issues of identity and culture through the use of familiar images. The clay forms (heads and cups) are made by a combination of pinching and coiling, and placed on a wooden table—all striped in a similar, yet always varying fashion.

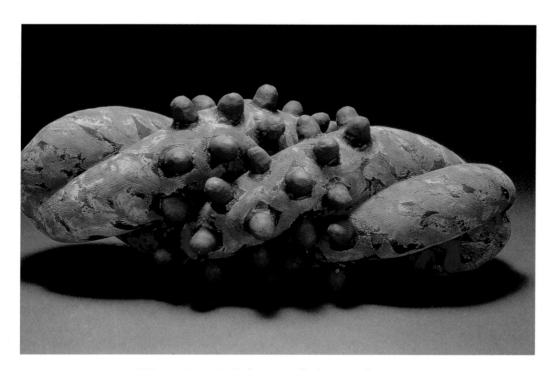

Plate 58 Gary Erickson, USA. *Dualidad,* 1996. Earthenware, coil-built, terra sigillata, cone texture glaze, 13 × 19 × 21 in. (33 × 48 × 53 cm). "I get excited by work that communicates at many different levels. There is so much work being made contemporarily that has a high "WOW" factor (usually technical skill or color use.) After thirty seconds it wears off, you know it all, and move on. That initial impact is important whether it comes from color, surface, or form."

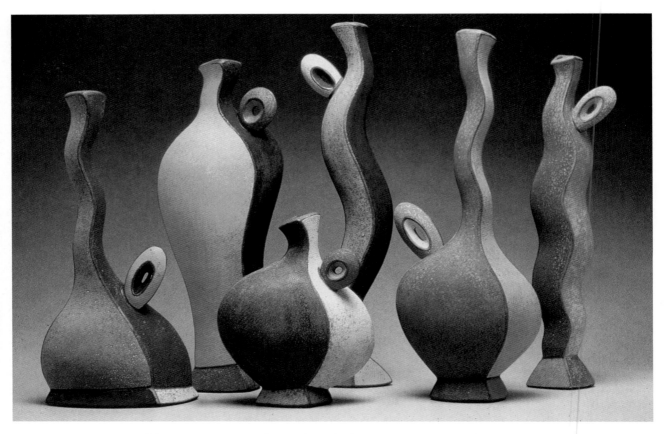

Plate 59 Michael Sherrill, USA. *Wavy Bottles,* 1995, earthenware, largest bottle, 31 × 6 in. (78 × 15 cm). These vase forms are made through combinations of hand building, extrusion, and throwing. The result is a still life constructed from vases. His colorful matte glazes work to further enliven these expressive pots. He says, "I am still working in clay because I feel that I am maturing in it as an artist and that I am working with a medium that does not corner me or inhibit me."

work survive the rapid raku firing, due to the added porosity of the ware. The rapid and often uneven heating of a raku firing causes stress on the ware. All clay and glaze is subject to slight expansion on heating and contraction on cooling. The amount of expansion and contraction is known as the coefficient of **thermal expansion.** As the glaze cools quickly on the surface of the raku pot, it contracts faster than the clay and pulls apart in thin cracks called **crazing.** These cracks in the glaze are usually penetrated by the smoke and carbon of the post-firing reduction, leaving some of them a smoky gray. This is a popular effect against a white raku glaze.

Raku pottery remains rather porous even after the final glaze firing and this along with its usual heavily crazed glaze limits its usefulness as a container for liquids. (See Chapter 11 for firing techniques and the Appendix for a raku body formula.)

Sculpture Bodies

Problems often arise in constructing large, thick-walled sculptural forms in clay. The most serious of these are a tendency for vertical walls or horizontal spans to sag and the danger that thick areas will crack during drying or firing. To minimize these problems sculpture bodies are often formulated to be underfired, at least when compared to stoneware or other pottery clays. This means that they could actually be fired to much higher temperatures without melting. Adding coarser plastic fireclays to a sculpture body may improve its usefulness for large work. The addition of grog to a sculpture body will help the clay to **stand up,** or support itself without collapsing. If grog is added to the clay in amounts of 20 to 30 percent of the body, it will reduce shrinkage and some of the strains that develop in sections of clay of varying thickness. For the lowest shrinkage it is important to use a blend of particle sizes of grog, from the finest to very coarse. While it's much easier to add grog to the clay while first mixing it, it can also be easily wedged into already prepared clay if only a small amount of clay is needed.

Another possible addition to the sculpture body is nylon fiber. Chopped nylon fiber can be wedged into the clay to increase its plastic strength. Good ventilation is needed when bisque firing this clay, as the nylon burns out of the clay. Adding chopped nylon fiber to the clay is a safer alternative to fiberglass which has been used in the past. Glass fiber can be highly irritating to the skin. However, since glass fiber consists mainly of silica, it melts into the body during firing with no other firing hazards. When slabs of unusual stability are needed, some potters sandwich a mesh between layers of clay. Nylon net can be used between slabs, as can any other open mesh fabric that allows the two slabs fully to connect through the mesh. The slab and netting sandwich is usually rolled to join the layers firmly together. *Do not* recycle clays containing additives like fiberglass and nylon with other clay, and *do not* run these materials through clay processing machinery like pug mills where the fiber is likely to get caught up in the moving parts.

⚠️ **SAFETY CAUTION**
Fiberglass is an irritating material and should be handled with care. Follow manufacturer's directions and health warnings. Chopped nylon fiber is much safer to work with in the raw clay, but may not provide the same fired result. Fumes from burning nylon or plastic fibers may be hazardous. Good kiln ventilation is required.

Ovenware and Flameware Bodies

Most fired earthenware and stoneware clay bodies can be used for cooking in an oven at up to 400°F (204.44°C), provided the walls and bottom are of uniform

thickness and a properly fitting, uncrazed glaze, if any, coats both inside and outside. This helps the pot to heat and cool evenly and withstand the resulting expansion and contraction. Another general precaution with ovenware is to place it in a cool oven and let it heat up slowly; once it is hot, never expose it to rapid cooling such as plunging it into a sink full of water.

A ceramic body can be formulated to control the effects of **quartz inversion** (see section on quartz inversion in Chapter 11, p. 255) and also to make it more resistant to heat shock at lower temperatures. The body should be stoneware or fireclay and should first be tested to determine its chemical composition. Depending upon the alumina–silica ratio and fluxes present, a 15 to 20 percent addition of spodumene, wollastonite, or petalite will reduce the possibility of cracking. (Because of the difficulty in obtaining petalite, 3 parts spodumene and 1 part feldspar can be substituted for 4 parts petalite.) A combination of pyrophyllite and talc to replace part of the feldspar in the body may also cut down on thermal expansion. New glazes will probably have to be formulated to fit this lower thermal expansion clay.

A direct flameware body is similar to ovenware except that the petalite may comprise as much as 50 percent of the body, the balance being ball clay, stoneware, or fireclay. A small amount of feldspar will combine with any free silica that may remain. Firing temperatures should be to cone 10 or above, but the body should retain a porosity of 3 to 4 percent. Glazes must be specially formulated to match the extremely low thermal expansion of flameware.

Casting Slips

Clay in liquid form to be poured into molds is called casting slip. This form of clay is widely used by both artists and industry to quickly produce multiples of objects. The clay body in a casting slip must be **deflocculated** to cause the clay to liquefy while having only slightly more water added than plastic clay used for throwing. White clay bodies like porcelain and white earthenware are commonly used for casting slip, although most clays can be deflocculated. However, some red earthenware clays may be difficult to make into successful casting slips.

Deflocculation occurs when the electrical attraction of the tiny clay platelets is changed, usually by the addition of a small number of sodium ions to the water which is mixed with the clay. This causes the clay platelets to move apart slightly and flow more easily, becoming a liquid slip. Because the clay contains roughly the same amount of water, it will have a similar shrinkage as plastic clay. This allows casting slip to be poured into molds without many problems of cracking and high shrinkage. If the clay was not deflocculated and merely made liquid by adding more and more water when it was mixed, then it would shrink excessively in drying and crack severely.

While it is beyond the scope of this book to go into the details of casting slips, it may be useful for the potter to make a deflocculated slip at some point. Only a small amount of deflocculant is needed, usually in the range of 0.25–0.5 percent of the dry weight of clay body. The actual amount used must be determined by careful testing and varies from clay to clay. A mixture of sodium silicate and soda ash has traditionally been used as a deflocculant, but commercial deflocculants like Darvan are now more commonly used. These commercial deflocculants usually do a better job of deflocculating the clay, and cause less damage to plaster molds. Adding about 0.05 percent soda ash with Darvan may

lessen the amount of Darvan needed to deflocculate the clay. Impurities in the water used may affect the defloculation (for instance, hard water), and some potters use distilled water for small batches of slip when dependable workability is critical. When clay slip is properly deflocculated it has a stringy, syrupy quality and relatively low drying shrinkage.

The mixing process is somewhat different than that typically used for mixing plastic clay. First, hot water (hot tap water, not boiling) is measured in the proper amount for the amount of dry clay to be added. The deflocculant is added to the hot water first and thoroughly mixed. Then the powdered clays are added while the slip is constantly stirred. Finally, any nonplastic materials are stirred into the slip. The defloculation process takes some time, but the hot water helps to slake the dry clay faster and hasten the process. Casting slip must usually be aged for a few days, as well, before it gains its optimum casting properties. Casting slips tend to gel when allowed to stand unstirred, so the slip must either be kept in constant motion, or stirred well right before use. The consistency of the slip is often critical, too. Most ceramists who are slip casting keep careful track of the specific gravity of their slip, adjusting the amount of water added to keep the slip at a constant density. (See the appendices for specific gravity calculations.)

Colorants in Clay Bodies

Depending upon firing conditions, most earthenware and stoneware bodies range in color from a light tan through buff and orange-red to a deep reddish brown. The warm, earthy tones result from the different amounts of iron oxide present in the clay. These hues can be made darker by adding either red or black iron oxide, or if possible, by adding iron-bearing clays. Some potters in the past have added manganese dioxide to make a nearly black clay, but the toxicity of manganese dioxide precludes this use in most cases. Commercially available body stains may offer a safer, but more expensive method for coloring clay. Be sure to use stains made specifically for clay bodies, as some of the commercial stains meant for glazes are not suitable for coloring clays. If the colorants are finely ground, they will create an even tone; colorants with a coarse particle size yield a more speckled effect. Always make tests when adding colorants. For instance, too much iron oxide may lower the melting temperature of the body. A large quantity of red iron oxide will also cause the clay to stain whatever comes in contact with it during the forming process.

Pure white bodies are characteristic of porcelain in the high-firing range and white earthenware in the lower temperatures. It is possible to add oxides to these bodies to produce green, blue, yellow, or even lavender clays. While some raw colorants may be used, commercially manufactured body stains are available in many colors and may be safer to handle as a clay body. Body stains are made especially for use in clay bodies and slip, although many glaze stains will also work as body stains.

To minimize dust hazards, the oxides should be added to clay as a watery slurry, and the batch mixed well to blend the colorant with the clay. Make the colored clay first into a slip, then add the colorant slurry and **blunge** it until thoroughly mixed. The slip can be screened if needed. The colored slip is then dried to usable consistency on plaster slabs. See the appendices for colorants and their properties.

Common Problems with Clay Bodies

Some clays, especially earthenware clays of glacial origin, vary greatly in composition from batch to batch. They may contain soluble materials, usually sulfates, which are drawn to the surface during drying. When the clay is fired, a whitish film appears on the surface. This is often known as **scumming.** Highly mineralized water supplies may also contribute to this problem. This defect can be eliminated by an addition to the clay body of up to 1 percent barium carbonate which reacts with the soluble sulfates in the clay to render them insoluble. This reaction also forms barium sulfate, an insoluble, much less hazardous form of barium. Barium adds a possible hazard to the clay (see the Safety Caution box) but unfortunately no other alternative exists to stop scumming other than to find a source of clay which is free from scumming. The use of demineralized water when mixing the clay may also help to lessen scumming.

Another problem occurs when clay contains small chunks of lime or shale. These contaminants can cause pieces of clay to pop off the ware after bisque firing. These defects are sometimes referred to as **lime pops.** Usually the chunk of lime is visible as a small white dot in the center of the lime pop. The only solution is to find a lime- or shale-free clay body. Contamination of clay with small chunks of plaster is another cause of this annoying problem. Careful studio use of plaster is advised.

Clay bodies can also suffer from unwanted partial deflocculation due to alkalies (primarily sodium compounds) leaching from frits, nepheline syenite, or other materials added to flux the clay. This will appear as lowered plasticity, often with a rubbery feel when throwing. In severe cases clay freshly mixed to a perfect working consistency may turn to a soft mush overnight. The best cure is to formulate the clay with a flux-containing material that will not leach or that leaches less. Adding a cup (0.24 l) or so of vinegar to every 100 lbs (45.4 kg) of the clay as it is mixed may provide short-term relief from mild cases of this problem.

Further information on firing faults of clay bodies can be found in Chapter 11, Kilns and Firing.

Clay Prospecting and Preparation

Suitable pottery clay can be found in most sections of the United States and indeed the world. Clay is a very common material on the surface of the earth. Digging and preparing your own clay is quite labor-intensive and is unlikely to be a sensible economic proposition for most potters, but it can be rewarding in other ways (Fig. 5-5). If you are teaching in a summer camp, for example, a hike can easily be turned into a prospecting trip. For the few hundred pounds (about 90 to 180 kg) of clay which you may want to obtain, you should look to the accidents of nature to reveal the clay bed. A riverbank, a road cut, or even a building excavation site will often expose a deep bed of clay that is free of surface contamination. If the clay contains too much sand or gravel it may not be worth the trouble. A few tree roots will not disqualify a clay, but any admixture of surface soil, lime, or humus will make it unusable.

On the first prospecting trip take samples of a few pounds (one or two kg) of clay from several locations. Dry the samples, and while wearing a suitable dust mask, pound them into a coarse powder. Then soak the samples in separate containers of water to soften the clay, a process known as **slaking.** Let these

5-5 Dora Gualinga, Quechua potter, Ecuador. Dora Gualinga gathers clay using a palm leaf as a container. Her clay comes from a small spot near the village gardens in the Amazonian region of Ecuador. Potters have looked to local sources of clays in this way for thousands of years; only relatively recently have purified industrial clay and minerals been available to potters.

sit at least overnight, then carefully drain off any excess water at the top. Passing the resultant clay slip (liquid clay) through a 30-mesh sieve is usually sufficient to remove coarse impurities. If the clay proves too sandy or coarse, let the heavier particles settle for a few minutes after stirring, and then pour off the thinner slip. Pour this slip onto **drying bats** (plaster slabs with a depression in the center) until the clay has dried enough to wedge. Make tests for plasticity, porosity, firing temperature, and shrinkage. If you are firing to temperatures well above earthenware, your first fired test should be in a small bisque bowl or cup in case the clay melts completely.

The clay may fail simple plasticity tests due to excessive sand. (See earlier section on plasticity.) Sand can be removed by adding extra water to the body when it is a slip and allowing the sand to settle out. However, this procedure may require more effort than it is worth. If the base clay has possibilities but is only moderately plastic, an addition of 15–20 percent ball clay or 3–5 percent bentonite, or both, will improve the body. Some bodies contain up to 40 percent ball clay, but because ball clay absorbs a large quantity of water, the shrinkage rate increases.

In most localities, surface clay is likely to be of an earthenware type. The samples should also be tested as possible slip glazes. It is surprising how many pockets of glacial clay (fine grained clay that has been moved and sorted by glaciers) work nicely as glazes, either alone or with a small amount of flux added. In some areas, the riverbank clay may be of a stoneware or fireclay type. All in all, clay prospecting can be profitable, but it is mostly fun. In this era of highly processed goods, starting out from "scratch" gives a rare feeling of satisfaction.

Mixing one's own clay in the studio can be done a number of different ways. The simplest for small batches and tests is the method described above for mixing clay found by prospecting. Clay mixed as slip in five-gallon (or larger) plastic buckets, then dried on plaster bats is sufficient for small production needs and testing. Clay mixed first as slip like this is often more plastic than clay mixed directly to working consistency. Even with machine-mixed clay, if the plastic clays can be added first to the water to allow them to slake more completely, the result is usually more workable clay.

Mixing larger amounts of clay entirely by hand is very labor-intensive. Studio clay mixers of various sizes and designs are commercially available and will quickly mix enough clay for studio production. Some potters have found used commercial bread dough mixers work well for clay mixing. Small studio-sized de-airing pug mills, while somewhat expensive, can be a big help in preparing workable, plastic clay and minimizing time spent wedging. Good ventilation and a proper dust mask are necessities for mixing plastic clay from its commercially available powdered form.

Commercial Clay Production

The commercial mining of clay is worth mentioning briefly. Even though the amount of clay used by potters represents only a very tiny fraction of the clay mining business, potters depend on commercial sources for clay. Millions of tons of clay are mined each year for a great variety of industrial purposes—building bricks, refractory liners for steel furnaces, insulating materials, Portland cement, and bathroom fixtures. Especially fine kaolin clays are used for coating printing papers to make glossy paper, while other clays serve as extenders or fillers in paint and insecticides, and are even used in some medicines.

Depending upon how close to the earth's surface a clay is located, there are basically three different methods for mining clay. High iron-content clays, usually earthenware clay used primarily for tiles and bricks, occur close to the surface and are usually extracted with a power shovel. Impurities are sieved out after drying and a coarse grinding. Shale clays, found at deeper levels, require blasting techniques, followed by grinding and sieving. Shale clays are then often blended with more plastic clays.

Fireclay is often found close to coal beds and is mined either in an open pit or in a traditional shaft. In some commercial processing of fireclays, the coarsely ground particles of fireclay are mixed with water, causing the larger particles to settle. After drying, a fine dust is produced by air-floating, separating particles by size using air pressure. Because most fireclays are primarily used for other commercial purposes besides pottery, their purity and dependability for studio use varies greatly. New batches of fireclay should be tested carefully. Kaolins are found in localized deposits, and are somewhat rarer than most other clays. In some cases clays are washed from their location in the earth with high-pressure jets of water, and the resulting river of slip collected, screened and dried.

BASIC STUDIO PROCESSES: WEDGING, JOINING, AND DRYING

To make objects from clay successfully, careful attention to all parts of the process is required. Wedging, joining, and drying are basic to all the forming procedures outlined in later chapters.

Wedging

Wedging (Figs. 5-6 to 5-16) is one of the most important parts of clay preparation. Unless the clay is properly wedged, the beginner will find processes such as throwing to be difficult or even impossible. The clay is kneaded to force out air bubbles, to align coarse particles, and to develop a homogeneous consistency. Well-wedged clay will seem more plastic and generally be less prone to drying cracks and other faults.

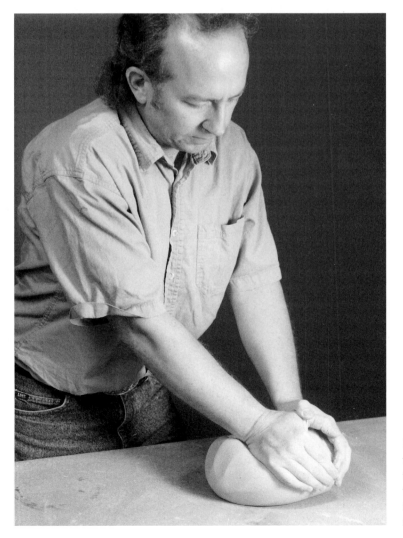

5-6 Wedging and wedging table. The wedging process involves repeated kneading of the clay to remove lumps and air pockets. The wedging table should be low enough to use the full weight of the upper body to help move the clay.

5-7 Wedging–spiral technique. Wedging starts with the clay lump in an upright position, with the left hand on top, and the right hand at a 90-degree angle to the left, on upper side of the clay. It may help to pat the clay into a large thick cone to start.

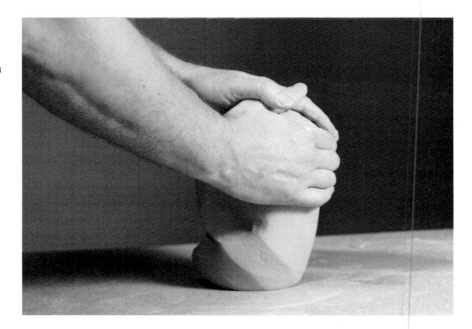

5-8 Wedging–spiral technique. The clay is pressed downward with a rolling motion, causing the clay to fold slightly at the bottom.

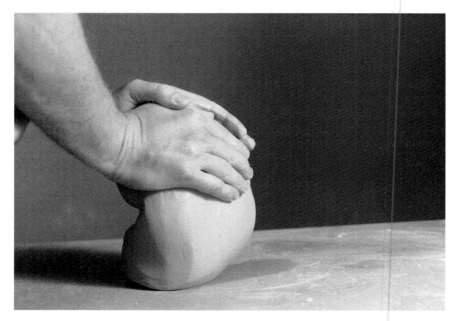

The potter typically starts wedging with a 5- to 10-pound (2.27–4.54-kg) ball of clay; the larger the clay mass, the greater the physical strength required. The clay should be just slightly softer than desired for forming, because some moisture is lost in the wedging process. A plaster wedging table provides an absorbent surface. The wedging table should be at a conveniently low height so that one's body weight can be used to advantage in the process. The plaster surface should be scraped often to prevent the clay particles from clogging the plaster and making the clay stick. Scrape the clay from the plaster carefully, as any plaster chips

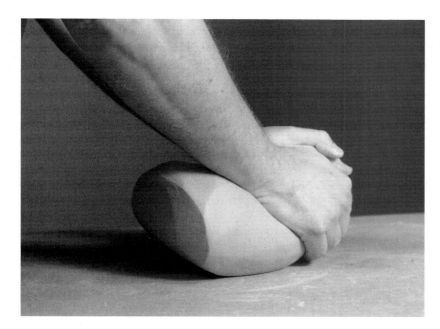

5-9 Wedging–spiral technique. As the clay is pressed down, allow it to roll forward on the table so that the bottom part of the clay (at left) rocks up slightly.

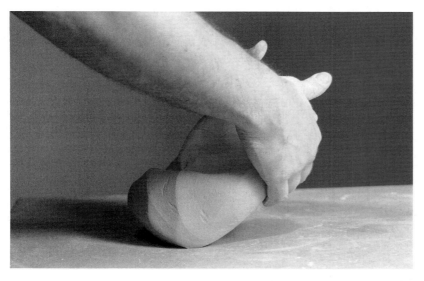

5-10 Wedging–spiral technique. The clay mass is lifted up to stand again on its end.

that get into the clay may cause lime pops in the bisqueware. Using a wooden scraper will help avoid digging into the plaster. Very smoothly finished concrete is another alternative for a wedging table. Concrete is not as absorbent, but at times this is an advantage. Canvas-covered plywood or plaster is also popular with some potters, but tends be dustier to use as the clay dries in the weave of the fabric.

The clay mass is wedged with firm pressure from the heel of the hand to compress the clay. A rocking motion with a slight twist keeps the clay from flattening on the table. This pressing, rocking, and twisting will create a corkscrew effect, eventually bringing all portions of the clay into contact with the surface and bursting trapped air bubbles (see Fig. 5-15). A comfortable and effective

5-11 Wedging—spiral technique. At the end of the lift the clay is rotated clockwise about one-quarter turn.

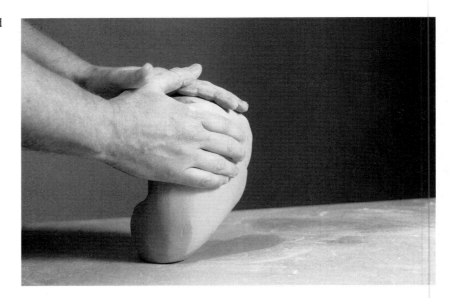

5-12 Wedging—spiral technique. Again the clay is pressed down and forward on the wedging table to repeat the process. Proper wedging usually requires about 40–50 or more repetitions or "turns" to achieve an even consistency.

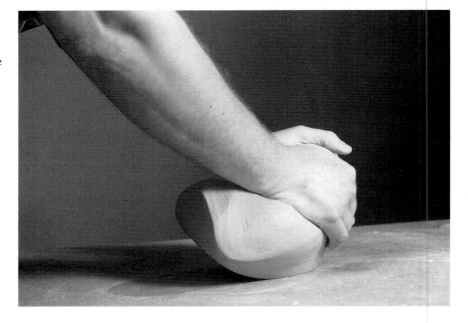

wedging rhythm will evolve only after practice. Beginning students tend to flatten and fold the clay, thus adding rather than removing air pockets.

A wire strung from a post at the rear of the table to a front corner will help to cut the mass of well-wedged clay into smaller pieces. The wire also aids in mixing a too-stiff mass of clay with a softer body. Both soft and hard clays are cut into thin slices and thrown onto the table, alternating the soft and hard pieces. This cutting and throwing operation is repeated several times, each time cutting at a different angle through the layers. The clay is then wedged in the usual manner to obtain a uniform consistency.

Depending upon the type of work being done, it may be useful to wedge **grog** into the clay body. Grog (fired clay crushed to fine particles) helps plastic

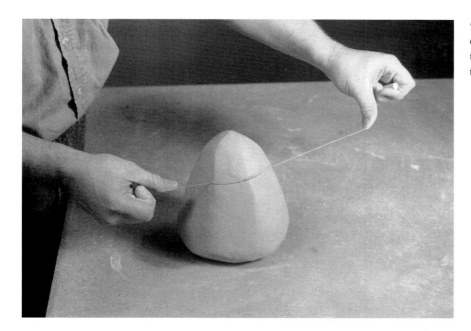

5-13 Wedging–spiral technique. The clay can be cut apart with a tightly stretched wire to check for air pockets or inconsistencies in the texture.

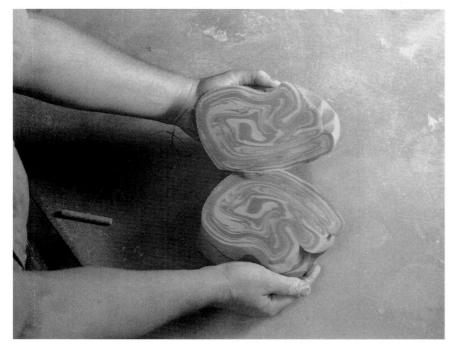

5-14 Wedging–spiral technique. Here the two chunks of different colored clays have been wedged together to show how the wedging process folds and blends the clay.

clay to stand up, prevents sagging, and lessens the chances of thick walls cracking. In drying, the clay pulls away slightly from the grog. This opens air channels, causes a more even exposure of the clay to the air, and lessens the danger of cracks occurring.

For throwing and for delicate sculptural work a minimum of fine grog is necessary; for large sculptural pieces as much as 20 to 30 percent of a mix of fine, medium, and coarse grog (mesh sizes 12 to 8) will be needed. In adding

5-15 Wedging–spiral technique. The clay should look somewhat like this after wedging. The shape resembles a conch shell. You can see the folds in the clay from repeated turns and the indentation from the last turn made by the right hand.

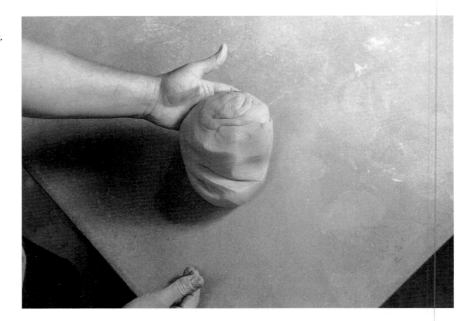

5-16 Wedging–spiral technique. After wedging is complete, chunks of clay can be cut off with a wire and patted into balls of convenient sizes for throwing.

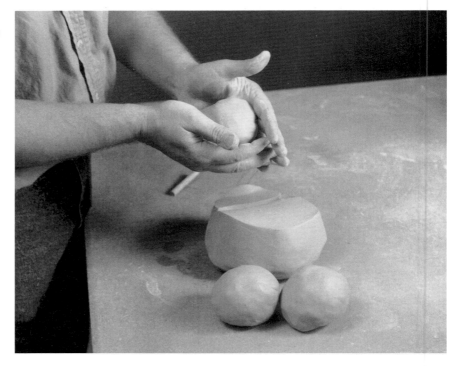

grog it is important to add a blend of fine, medium, and coarse grogs to maintain as much plasticity and strength as possible while reducing shrinkage. Adding only one size of grog may not achieve the desired effect.

Grog should be wedged into the body in small quantities at a time. Thin layers of the type of grog needed are dusted onto the surface and wedged until they are evenly distributed throughout the body. Then more grog is added until the

body seems right. Larger amounts of grog can be quickly added by dusting slices of clay with grog, pressing the layers together, and then wedging the entire mass.

Unusual effects are achieved by adding colored grog to a contrasting clay body. Small amounts of colored grog can be made by forcing plastic clay of the desired hue through a coarse screen. One could use an extruder for this purpose. The string-like strips of clay are allowed to dry and are bisque fired. The fired pieces are pounded with a mallet to crush them into small particles. The resulting grog can be put through a sieve to obtain a more uniform particle size if desired.

Joining Clay

One of the most basic processes in clay work is to attach two pieces of clay together. Clay can be joined at any stage between wet and leather-hard, but most often these attachments are made as the clay stiffens to the leather-hard stage. It is important that both of the parts being joined be of the same degree of wetness so that their drying shrinkage is identical. If two different clay bodies are being joined, it is very important that they have the same drying and firing shrinkage or they will crack apart.

Fully wet, plastic clay may often be joined by simply pressing the two parts firmly together. However, often more effort is needed to make a strong connection that will not crack. Joining a large wet piece of clay to a drier one is only asking for cracks, although many clays tolerate a little difference in wetness. Dry clay which is well past the leather-hard stage is impossible to join successfully using ordinary techniques.

Clay parts are usually attached by first **scoring** the surfaces to be joined with a needle tool, fork or serrated rib (Fig. 5-17). Score the surface fairly deeply if possible. This breaks up the alignment of the clay particles on the smooth surface and allows the two parts to be mechanically joined by interlocking grooves. The scored surfaces are then coated with a layer of thick slip made from the same clay being joined and pressed firmly together. If the clay is somewhat on the dry side of leather-hard, a second scoring and slipping (and maybe even a third) is advised to soften the clay in the area of the joint. If you're working on the wheel, the easiest way to get slip that matches your clay is to save slip from the throwing bucket. Another way to make slip quickly is to slake a few dry trimming scraps in warm water in a cup *without stirring*, then pour off the excess water. The resulting slip should be ideal for use. If you don't have dry clay scraps, you can quickly make small quantities of slip for joining by shredding a number of small pieces of your wet clay in a cup, adding a small bit of water, and repeatedly mashing the clay into the water with an old fork until it is of a smooth consistency. Slip can be made on the site of the joint in a similar manner, by first scoring, then applying a small amount of water, followed by more scoring. This is repeated until a thick slip is formed on the surface of the clay.

A strong joint comes from both the bonding of the slip and from the pressure of firmly intermeshing the two scored clay parts. This intermingling of the clay from the two parts greatly strengthens the connection. Be careful not to trap air pockets in the joint, as these will severely weaken it. Slip should squeeze out of the joint slightly when it is forced together. You can use two pieces of heavy foam rubber or in some cases smooth cloth to press on the two sides of the joint to avoid fingerprints on the clay when joining.

5-17 Joining two pieces of clay. The knob and lid being joined here are the same dampness, leather-hard clay. The edges to be joined have been deeply scored and coated with clay slip of the same type as the clay being used. The two parts are then pressed firmly together, assuring a firm mechanical bond.

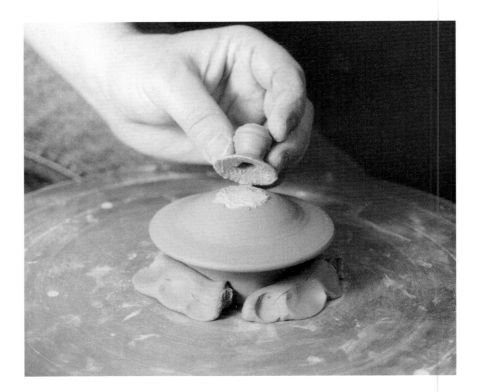

Where possible, a small reinforcing coil of clay should be added to the joint. Keep this coil small and inconspicuous, but if at all possible work it well into both sides of the joint, then smooth. Any slip that oozes out of the joint can be cleaned up after it dries to nearly leather-hard and the attachment is firm. Dry complex pieces slowly so that the thicker areas of the joints dry at the same rate as the rest of the piece.

Drying

Clays vary tremendously in their ability to dry evenly without cracking or warping. Small pieces made from coarser, more open clays with a lot of grog may often be dried casually and quickly. Larger work, work with lots of thick and thin sections, pots with handles or similar attachments, or work made from fine-grained clay must be dried more carefully and evenly. Uniform drying, with all parts losing moisture at the same rate, is much more important than the actual speed of drying. In most studios, however, the only way to have even drying is to dry the work slowly. This is usually accomplished by keeping the work loosely covered with plastic sheeting. Removing the plastic for short periods, or even just turning it inside out to let the accumulated moisture evaporate, will speed the drying process. A **damp closet** or **damp box** which maintains high humidity will make slow, even drying easier.

Uneven drying causes part of the piece to shrink faster as it dries, stressing the ware. This can easily lead to warping and cracking. Rims, handles and similar thin and exposed parts are particularly prone to quick drying and cracking.

Drying Tips

◆ Avoid placing work where there is a strong draft which might dry one side of a piece faster.

◆ Place a paper bag or newspaper tent over a piece to protect it from drafts yet still allow water to evaporate rather quickly.

◆ Wrap small pieces of plastic sheeting around handles or other thinner parts to let them dry at the same rate as thicker areas.

◆ Coat thin or delicate parts with wax emulsion to keep them from drying too quickly. The wax will burn out in the bisque.

◆ Place the work on two or more thin slats of wood to allow air to move under the piece and dry the bottom evenly.

◆ Turn the pieces upside down or on their side as soon as this is safely possible to allow the undersides to dry.

◆ Keep the work warm. Clay dries much more evenly when warm than if it is cold. The water in clay moves very slowly through the cold clay, leaving the interior damp as the surface dries.

◆ Work can be dried relatively quickly if it can first be gently heated to about 150°F (66°C) in a humid environment, and then the humidity is gradually lowered while the temperature is held constant. This is the key to wet-firing work in a gas kiln. Controlled forced drying must be done *very* carefully to keep steam from forming and blowing up the work, but may actually result in much stronger greenware.

◆ Dry flat slabs such as tiles slowly between layers of board or drywall to help keep them from warping. Take great care to keep the gypsum interior of the drywall out of the clay—it can cause lime pops.

◆ To keep work wet longer, wrap it in one layer of plastic sheeting, then spray down the outside of this wrap with water and tightly cover with another layer of plastic. This creates a high humidity layer that will greatly slow drying.

◆ Use damp towels on the clay only with great care, as too much moisture applied directly to the clay can lead to cracking.

Recycling Clay

One of clay's finer properties is that it may be used over and over in the plastic state until it is finally fired. Dry clay trimmings, scraps, and failures can be slaked down in a bucket or plastic garbage can and easily reprocessed to plastic clay. Wet clay and trimming scraps can be added directly to the slop. Larger chunks of leather-hard clay should be allowed to dry completely first and be broken up, or they will remain leather-hard lumps in the scrap bucket. Recycling can be done in small quantities by simply drying the clay slop on large plaster bats until it is of usable consistency. Larger quantities may call for the use of clay mixing equipment and the addition of dry powdered clay. Reprocessed clay is often quite plastic and workable thanks to its extended soaking time in the slop barrel.

For reprocessed clay to be as good as new the potter has to take care to keep foreign materials out of the slop bucket. It's also a good idea to make sure that the clays mixed in the slop barrel are of compatible temperatures in firing. Mixing low-fire and stoneware clays may result in disasters in the kiln if fired to

stoneware temperatures. Don't recycle deflocculated casting clays along with plastic clay for throwing, or the partial deflocculation that will result will ruin the plasticity of the throwing body. Different colored clays of the same temperature may usually be mixed if the color of the recycled clay is unimportant.

HEALTH AND SAFETY

The potter should consider the potential for a lifetime of exposure to the dust, chemicals, hot kilns, and other hazards of the studio. While most ceramic processes offer only a few immediate hazards, the slow accumulation of damage over years of exposure may take its toll. Protecting the potter's most basic tools, one's hands and eyes, should always be a foremost concern.

It is important to know the potential hazards of the materials with which you work. Health information on hazardous materials in the United States is available from *Material Safety Data Sheets* (MSDS) which can be obtained from the manufacturer or supplier. The MSDS provide detailed descriptions of hazards, but may be difficult to read without training (see the section on MSDS in the appendices). The many glaze chemicals traditionally used by potters, for instance, include quite a few that are relatively safe, and others that may be irritating, **toxic** (potentially poisonous), **carcinogenic** (possibly causing cancer), **teratogenic** (capable of causing birth defects), or **mutagenic** (capable of causing genetic mutations). Risks are typically based on the danger to healthy male workers, therefore women (especially if pregnant), children, the elderly or infirm may have to take more stringent precautions. Length and type of exposure to hazards are vitally significant in assessing any dangers. Giving oneself time away from hazardous chemicals may, in some cases, allow the body to rid itself of some of its hazardous burden, but this is certainly not the case with all materials. It is also important to know what type of contact is dangerous, whether the hazards lie with skin contact, ingestion, or inhalation of the material.

Clay workers have traditionally been subject to **silicosis,** a potentially deadly lung disease caused by breathing in fine silica particles which are present in many ceramic raw materials, including most clay dusts. Silicosis is the permanent scarring of lung tissue by sharp particles of silica. The particles that can cause silicosis are in the submicron range in size—small enough to be invisible when floating as dust in the air. Each exposure contributes to the cumulative effect. While silicosis usually requires years of exposure to silica dust hazards, prevention is the only cure.

The length of time of exposure is a key factor with many potential health hazards. Care should be taken to keep clay-working areas isolated from family areas if the studio is located in a home, so that you and your family are not exposed to the typical studio hazards of dust and kiln fumes continuously day and night. Avoid bringing clay dust into living areas on shoes or clothes. Don't eat or drink in areas where there are glazes and chemicals. Never store hazardous materials in unlabeled food containers, as they could be mistaken for food.

When working with powdered clay, spraying glazes, or cleaning the studio, be sure to wear a protective dust mask which is OSHA-certified for dust and mists. The cheapest disposable dust masks often don't stop the finest particles which are the most dangerous. Be sure the mask fits properly and seals to the face (Fig. 5-18). Most face-type masks can't be reliably worn over beards, so an

5-18 **Dust mask** being worn properly. Use a properly fitted dust mask that will remove fine dusts and mists when mixing clay and glazes. The one shown has replaceable filters which should be checked at each use. Note that there are two elastic straps around the head to maintain a tight seal against the face without extreme tension.

air filtering system that covers the entire head will be needed. As some types of dust masks have the potential to restrict breathing, these should be worn only on the advice of a doctor, especially if you have any type of other health problems. The filters for dust and mists will *not* stop solvent vapors. Filter masks made specifically for solvents must be worn in this case. Great care should also be taken when using flammable solvents, as hot kilns and open flame are often present in ceramic studios. Use of a well-designed spray booth, coupled with wearing a suitable dust mask, can greatly minimize the risks of spraying glazes.

Maintain good ventilation and clean work areas. The use of oil-based sweeping compound may help somewhat to keep clay dust from flying when sweeping up dusty studio floors, but wet cleaning methods are often safer. In general, avoid sweeping if at all possible, and use wet-mop cleaning or sponging to pick up clay dust. The use of ordinary vacuum cleaners or shop vacuums will only increase the dust hazard, as the finest and most dangerous particles go right through the typical filters, hanging in the air for hours afterward and gradually becoming more concentrated in the studio environment. Special vacuums with HEPA filters for fine dust are available, but are somewhat expensive. Air cleaning

systems are also available in studio-sized models, and these may help to cut down on dust hazards.

Dermatitis, an inflammation of the skin, occurs in rare instances from handling wet clay. It is an allergic reaction. If it occurs, unfortunately you have little choice but to give up potting, although you might try wearing thin rubber gloves or using some type of barrier cream that protects the skin from direct contact with the clay. Consult with your physician for recommendations.

Various glaze chemicals are also toxic or harmful, as are many of the gases given off during firing. For specific cautions concerning these and other health problems related to ceramic materials see the chapters on decorating, glazing, and firing (Chapters 8, 9, and 11) or consult the MSDS for the specific materials. Handle glaze chemicals carefully and know *before use* of any hazards associated with them, in both their raw, unfired and fired states. It's almost impossible to keep one's hands completely free of glaze when glazing, so rubber gloves and other safety equipment may be required if there are hazardous materials in the recipe. Be careful to dispose of waste glaze materials in an environmentally conscious way. Recycling waste glaze mixtures as a "scrap" glaze is one way to make use of glaze remnants. Sorting these by firing temperature and color may help scrap glazes to have a greater dependability and useful color. Even then it's still a good idea not to use scrap glazes on food wares unless you're sure the ingredients make a food-safe glaze.

Kilns offer their own hazards, primarily due to the intense heat generated and the gasses given off during firing. Good ventilation for all types of kilns is a necessity. There are several types of powered vents available for electric kilns that will remove kiln fumes from the room. Gas kilns require adherence to commercial and fire codes, especially if located indoors. Kilns always should be located well away from combustible materials.

Insulated gloves are advised when working around hot surfaces and checking cones. The light emitted by a high temperature kiln contains a substantial amount of infrared light which could possibly damage the eye over the course of a lifetime, although the likely exposure when firing a ceramic kiln is brief. Only relatively small amounts of ultraviolet light are emitted from the very highest temperature ceramic firings. While the short exposure to infrared light from a quick check of the cones offers little danger, the use of special colored kiln glasses or one of the lighter shades of welding goggles will help to protect your eyes from heat hazards and often make it easier to see the cones, too. Leather welding jackets and chaps, along with gloves and a face mask, will help protect one from the heat and fire hazards of raku firing (Fig. 5-19). Aluminized fire gear can sometimes be obtained as surplus and will help the serious raku potter to stay cool.

The use of face and eye protection and leather gloves when grinding or chipping kiln shelves, cutting brick, and the like is another vital necessity when working with kilns. Small bits of glaze left on kiln shelves can be razor sharp.

One last hazard that faces many ceramists is muscle strain. The potter's art is filled with heavy items: bags of clay, kiln shelves, large pots, and heavy sculpture. Careful lifting, buying supplies in smaller sizes, and the use of lifting aids or the help of an assistant will lessen the chance of debilitating strain on the body. Back strain from constantly bending over a potter's wheel can be lessened by moving around and changing one's position occasionally. Some potters prefer to throw from a standing position, but even that may have its repercussions over a lifetime. Try to avoid repetitive stress to your body. Medical advice should be sought if chronic pain ensues.

5-19 Raku firing with proper safety gear.

Many art-related health resources, including MSDS and information on toxic materials, and environmental and workplace laws, are available on the World Wide Web (see appendices for references). For specific information on arts hazards, also consult your local environmental health specialist or some of these sources:

Alexander, W. C. "Ceramic Toxicology" in Gerry Williams, Peter Sabin, and Sarah Bodine, eds., *Studio Potter's Book* (Warner, N.H.: Daniel Clark Books, 1978).

McCann, Michael. *Artist Beware*, 2nd ed. (New York: Watson-Guptill, 1992).

McCann, Michael. *Health Hazards Manual for Artists*, 4th ed., (Lyons and Burford, 1994).

Rossol, Monona. *Keeping Claywork Safe and Legal* (an NCECA publication, 1993).

"The Impact of Hazards in the Arts on Female Workers," *Preventive Medicine* 6 (1979): 338–348.

Art Hazards Newsletter (Center for Occupational Hazards, 5 Beekman St., New York, N.Y. 10030).

Chapter 6

Hand-building with clay is one of the oldest craft activities known. Potters use these techniques today in almost the same manner as they were used 10,000 or 12,000 years ago. It is likely that small figurines and animals were modeled long before the first pots were made. Few of these unfired figures have survived, but some have been found among the remains of several ancient cultures. The earliest of these small clay figures were made between 26,000 and 28,000 years ago.

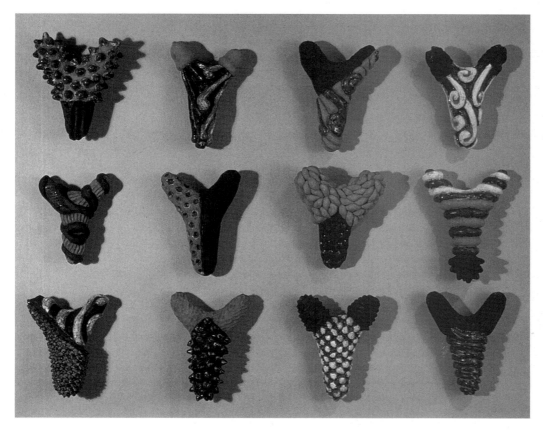

6-1 **Priscilla Hollingsworth**, USA; *12 Y Forms, Wallpiece*, 1991. The multiple pieces exhibit a modern fetish-like quality through their small size, use of repetitive form, and evocative surfaces.

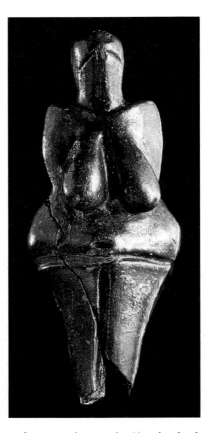

6-2 **Dolni Vestonice female** figurine, earthenware clay. Note that the glossy surface is due to preservation treatments. The original figure would have been bare clay, fired to a low temperature in a simple kiln.

Throughout the history of ceramics, hand-building techniques have been used to make both functional and sculptural forms. In skilled hands, pinching and coiling produce remarkably symmetrical pots. Even after the introduction of the potter's wheel, many cultures continued to prefer the flexibility of these hand-building methods. Contemporary artists value the ability to make almost any form imaginable using hand-building techniques.

PINCHING

Pinching requires only properly prepared, plastic clay and the fingers. Small sculptural pieces can be pinched from one large mass of clay or built up from many smaller pieces. Remarkably expressive forms can be made with this simple hand-building method, provided certain basic guidelines are kept in mind.

Small cracks that appear during pinching can be smoothed over, but large cracks are likely to reappear during drying and firing. If the clay becomes too dry and cracks excessively, it is best to moisten it, rewedge it, and begin again. Working quickly and keeping the fingers ever so slightly damp (but not wet) may help to keep the clay workable. If too much water is added the clay will become sticky, soft, and impossible to work. Also important to pinching (and to most hand-building methods) is manipulating the clay with gentle, even pressure. When clay is stretched or pulled it often cracks or tears, but if the potter can skillfully move the clay by squeezing and compressing it between the fingers with small repetitive movements, cracking will be kept to a minimum and the clay will be stronger as a result.

A pinch pot is a good starting point for beginning potters. Making a simple bowl shape will help familiarize one with the qualities of clay. The basic steps are illustrated in Figures 6-3 through 6-11. The potter starts with a small

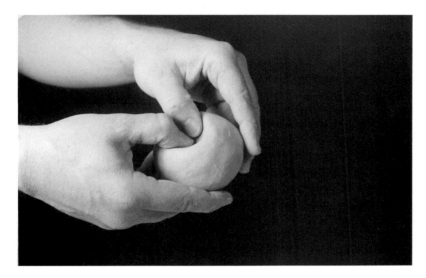

6-3 A good way to start a pinched form is to use your thumbs to find the center of a small, well-wedged ball of clay, rotating the ball of clay slowly in your hands as your thumbs gradually make a deeper and deeper indention.

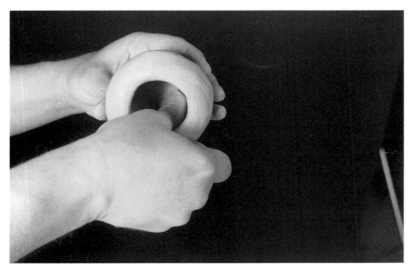

6-4 As the opening made with the thumbs becomes larger, use one thumb inside and a finger or two outside, pinching the clay down (away from the opening) and out. Gradually work the clay, turning it with every pinch, expanding the bottom of the form out. Try to keep the opening a constant size, just big enough to be able to work with your thumb inside. In this photo, the left hand supports and turns the form, while the right pinches.

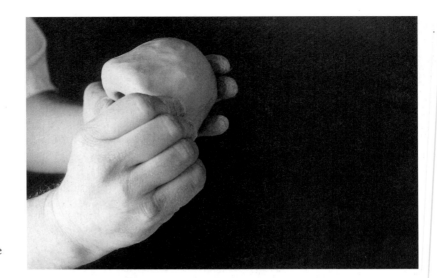

6-5 As the bottom is expanded outward, the rim is left thicker. This extra clay will be used to shape the top of the form and rim.

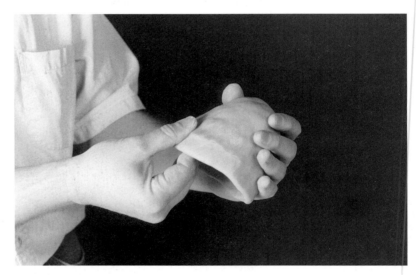

6-6 Pinching The sides and rim can be pinched after the bottom is shaped and thinned to near the final thickness. Note the repetitive marks left by pinching the same amount over and over as the form is turned. Be careful to pull the clay toward the rim with each pinch instead of just squeezing the clay thinner if you want to make a deeper bowl shape or a form with a small opening.

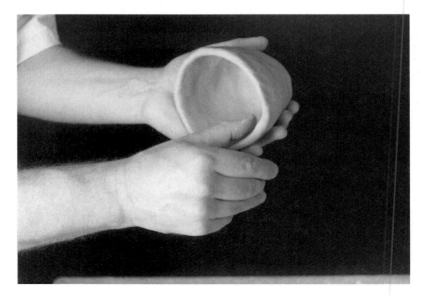

6-7 Pinching You can use the side of your thumb like a rib, moving it sideways to smooth the inside while supporting the outside with your other hand.

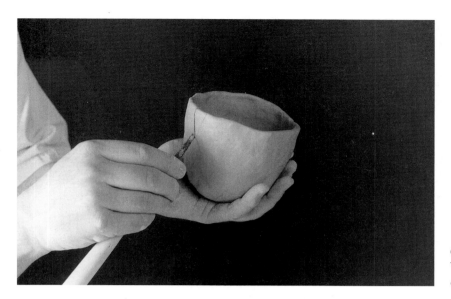

6-8 If the rim gets too wide, small V-shaped darts can be cut out and the sides of the dart overlapped.

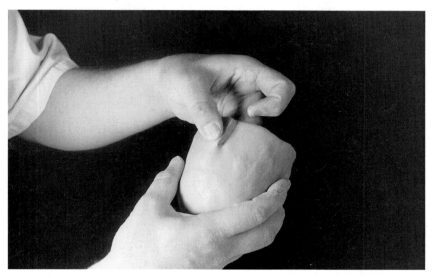

6-9 After the darts are overlapped, the clay is pinched together firmly and shaped. If the clay is getting slightly dry, the edges of the join should be scored and lightly slipped to make sure the two sides bond.

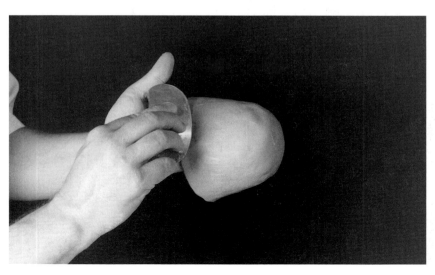

6-10 Pinching The outside of a pinched form can be smoothed with a flexible rib, or with your thumb. You may need to let the form dry until it is slightly stiffer (not quite leather hard) to scrape the surface quite smooth.

6-11 You can smooth the rim with a piece of wet leather chamois or soft cloth folded over the rim and held between the fingers as the other hand turns the pot.

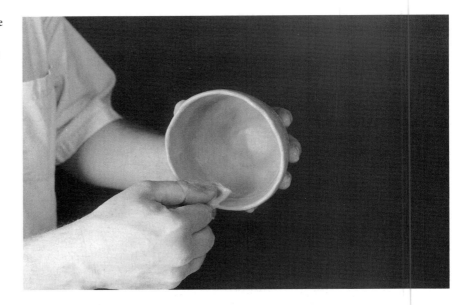

ball of wedged clay, the size of a tennis ball or slightly larger. A depression is made in the center with the thumbs. Then the ball of clay, held in one hand, is squeezed between the thumb and forefinger of the other hand. Expand the form from the bottom out by pressing down and out against the bottom of the form with the thumb, while pinching slightly using an upwards sliding motion with the fingers. Pressing outward from the inside or simply squeezing the clay between the fingers makes a wider form. Try to keep the rim and opening just large enough for the thumb to work inside the form. Keep the rim slightly thicker to help keep the rim from cracking. Once the bottom of the pinched bowl is thinned enough, the thicker rim may be expanded or shaped as desired.

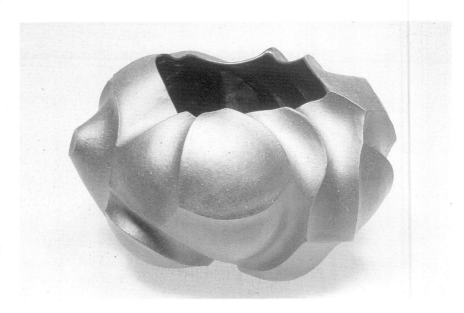

6-12 Tia Pesso Powell, USA. *Chameleon Eye Bowl*, 3.4 × 5.6 × 5.5 in. (8.6 × 14.2 × 13.9 cm). Stoneware. Powell's small pinched bowl illustrates the expressive possibilities of even simple pressure like pinching.

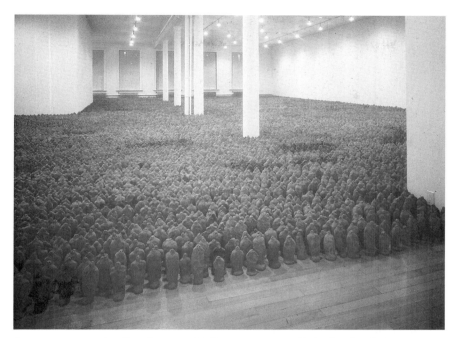

6-13 Antony Gormley, Great Britain; *Field*, 1991, terra cotta, variable heights. Gormley's *Field* uses 35,000 pinched terra cotta figures which vary from 3 to 10 inches in height. The huge number of similar but distinct forms speaks to us about the human condition in a crowded world, and causes one to consider both our common heritage and our individualtiy. Gormley worked with a family of potters in Mexico to produce this great quantity of figures.

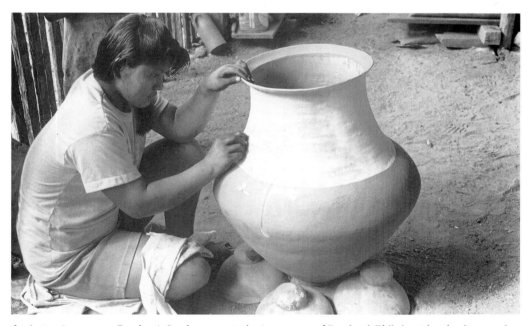

6-14 Quechua potter, Ecuador. A Quechua potter in the Amazon area of Ecuador skillfully burnishes the slip-covered surface of a large coil-built jar which will be used for fermenting a local beverage. These pots are made entirely without use of a wheel.

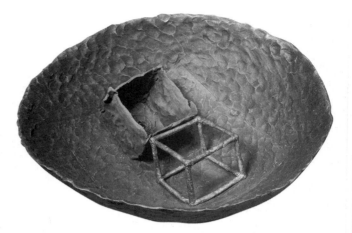

6-15 Christina Bertoni, USA; Untitled Oceanos Series, 1986, earthenware, paint, 17 in. (43 cm). Bertoni's bowl-like sculpture makes good use of lively pinched texture.

When the walls are of uniform thickness, the rim can be cut or smoothed with a damp piece of leather or soft cloth. Once this basic form is established, there are many decorative possibilities—pinched additions, incised lines, or the addition of surface textures by adding or cutting away clay. Many potters find that leaving visible evidence of the process energizes the form with the lively texture of repetitive fingerprints.

By pressing other surfaces or tools into the clay, textures can be made which are derivative of natural objects or invented, abstract surfaces. A foot may be added to containers as a simple coil or ridge of clay joined to the bottom, or individually modeled pieces can be added to make tripod feet. Historically, cooking vessels had tripod feet to elevate them above hot coals. An added foot may serve both functionally, and visually to elevate an otherwise plain form. Potters need to consider all aspects of their work, including the space underneath it.

COILING

Coiling is done by rolling out coils or ropes of clay to a desired thickness, then building a form by attaching coil after coil of clay. Potters traditionally rolled these by hand either in the air as illustrated (Fig. 6-16) or on a flat surface (Fig. 6-17), but now an extruder is often used to create very even coils in round or flattened shapes. Coils should be kept moist so that they stick tightly together during the joining process. Often these coils are joined to a flat or rounded base and gradually shaped to build up the desired form. If coils are used instead of slabs for the flat base of a form, the base may be more likely to crack. When adding coils to a slab base always add the coils on *top* of the slab, not around the outside of the slab. This will minimize cracking at the junction of the slab and coils as the weight of the entire form helps to hold the parts together. The joint between a slab and the first coil should always be scored, slipped, and carefully worked together.

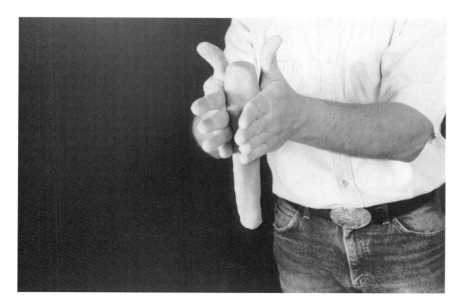

6-16 Coils can be rolled in the air. This is a very quick process and deosn't dry out the coils as much as rolling them on a tabletop or board. The key is to move the hands so that they seem to rotate in opposite directions, pivoting around the center of the hand. The clay coil should rotate, but otherwise should be almost stationary in the air and not flop back and forth.

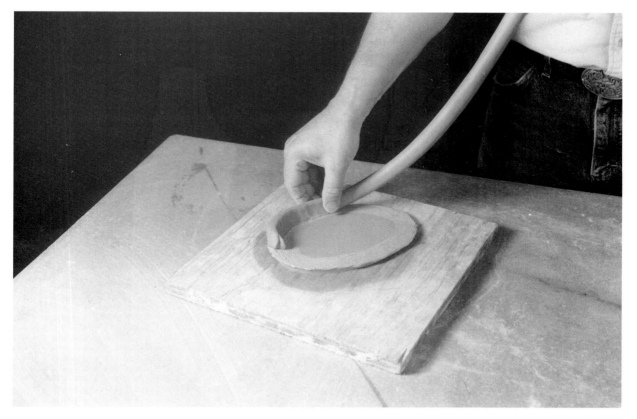

6-17 Coils are attached on TOP of a slab base. Never attach the first coil around the outside edge of the slab, as this often leads to cracks where the coil is attached.

If the clay used for coiling is of the proper consistency, and the potter works quickly, little or no slip will need to be added between the coils. If the clay is too stiff, the seams between coils will easily separate when the most recently added coil is pulled away. In this case each layer of coils should be lightly scored and slipped before the next is added. Adding too much slip to joints will soften the form, leading to weakness or even its possible collapse. Use a toothbrush or other stiff brush dipped in slip to quickly scuff up each layer of coils while applying a thin coat of slip. Some ceramists build with flattened coils (almost like long slabs) attached edge to edge. It is especially important in this case to score and slip.

The coils should be pressed together firmly and the join marks smoothed on the inside with a vertical wiping motion. Many ceramists use a pinching motion between thumb and finger or between the fingers of both hands to join the coils together in an overlapping manner (Fig. 6-20). This creates the strongest bond between the coils and lessens the likelihood of cracking during drying and firing. Unless the decorative effect of the coils is desired, the coils should also be joined on the outside for greatest strength. If a more refined form is desired, the surface can be finished with a wooden tool or metal scraper when the clay has begun to dry. Disposable woodworking tools like a SurForm™ rasp (which works like a grater) make refining the form easier (Fig. 6-21). Once a visually strong overall form is obtained, the surface can be incised or clay added to enhance the surface or create textures. Coils can also be added to the rims of thrown or slab forms, provided the clay has set up enough so that it will not sag. When coils are joined to an almost leather-hard surface—still moist but dry enough to

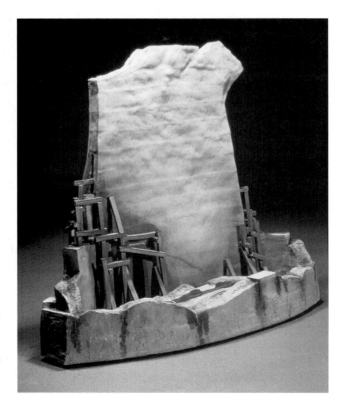

6-18 Joanne Hayakawa, *Future Structure,* 1990; 34 in. (86 cm). The seams of the flattened coils Hayakawa uses to form the torso-like section of this piece are left to add a sense of the process and a layered, geologic feel to the form.

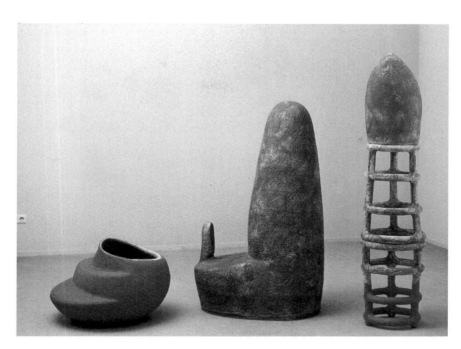

6-19 Scott Chamberlin, USA; *Scabra,* 1993 glazed ceramic 84 × 108 × 36 in. (213 × 274 × 91 cm). Chamberlin uses coils as a way to build large sculptural works. The seams between coils and the finger-pinching marks are quite visible on the surface. They add to the organic qualities of the forms, which derive some of their inspiration from topiary.

6-20 Pinching coils together Coils should be overlapped in a shingle-like fashion for maximum strength. Two colors of clay have been used here to show how pinching down on the outside and up on the inside creates this overlap. Thinning the walls by further pinching and paddling increases the strength of this bond.

6-21 Refine the surface of a coil-built piece quickly by using a Surform tool to shave away excess clay. This is best done at the leather-hard stage.

hold its shape without distortion—the edge must first be scored and coated with slip. Such complex forms should be dried very slowly and evenly.

Coils may also be connected to create an openwork form or coiled in a variety of different directions to create sculptural forms or decorative effects (Fig. 6-22 Wladyslaw Garnik). When creating openwork or similar extremely delicate forms, thought must be given to the fragile nature of clay, especially in its dry, unfired state (Figs. 6-23–6-35). Delicate forms may be built directly on a spare kiln shelf to facilitate moving the piece to the kiln. Two or three sheets of newspaper between the piece and the kiln shelf will help to keep the piece from sticking to the kiln shelf. The newspaper is left to burn out in the firing. Large or heavy pieces may also benefit from a sprinkling of fine grog on the kiln shelf before the newspaper is placed and clay work begun. The grog allows the piece to slide more easily as it shrinks in drying and firing.

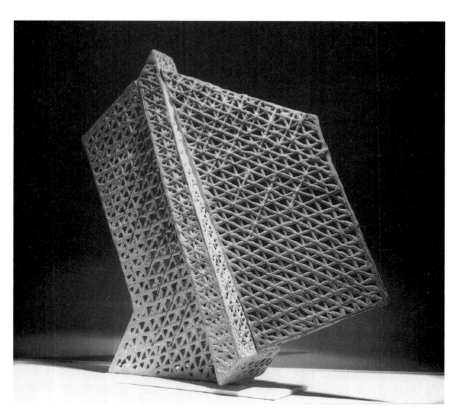

6-22 **Wladyslaw Garnik,** Poland. Bateau colored porcelain, fired to cone 14–18 in. (45 cm). Made from coils of colored porcelain.

below: 6-23 **In this series** of photos, a coil-built vase is started on a slab base, then refined bit by bit as the form grows upward. Note how the thick coils have been overlapped and pinched together. The coils are being worked together on the inside in this photo. The inside hand pulls the clay gently up while the outside hand supports the form.

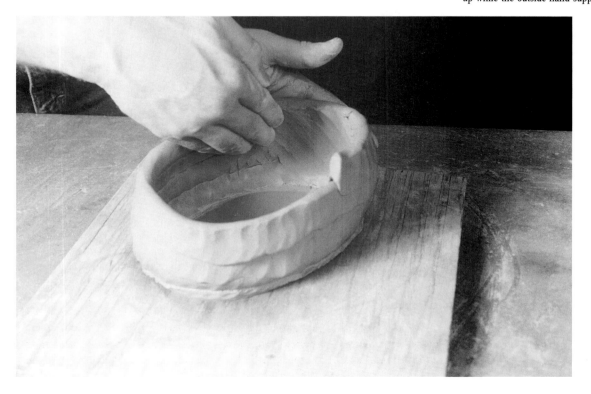

6-24 More coils are added after the first few layers are smoothed together. Notice that the coil is held in the air until it is joined by pinching. This helps to control the shape. If the coil were laid on the rim all the way around in the shape desired, then pinched thinner, the form would become quickly wider as the clay is thinned.

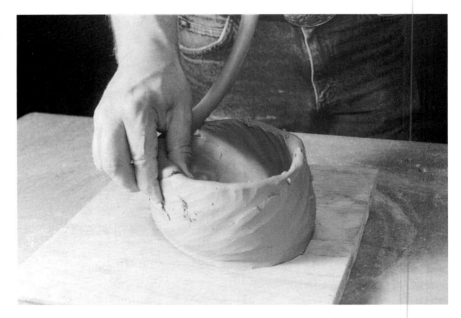

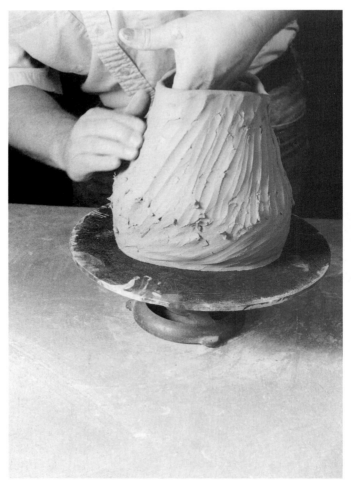

6-25 As the coils are added, they are worked together by pulling the clay down on the outside, and up on the inside, which further increases the angled overlap of the coils. The form can be shaped some during this process, too.

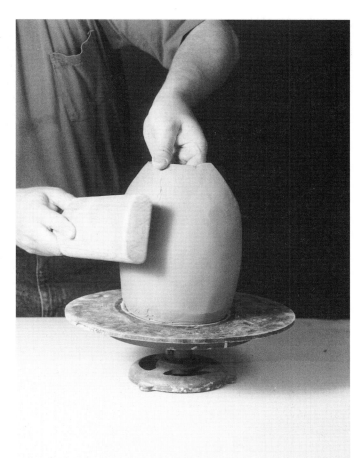

6-26 Paddling the form with a wooden tool helps to refine the form while the clay is still wet enough to move without cracking. Keep a hand inside for support. A round stone or tool can also be used inside as an anvil to help thin and shape the sides.

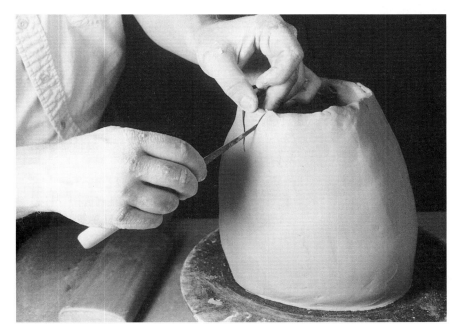

6-27 If the form gets too large from the paddling and smoothing, triangular darts can be cut from the rim and the sides of the cut overlapped to make the top of the form narrower.

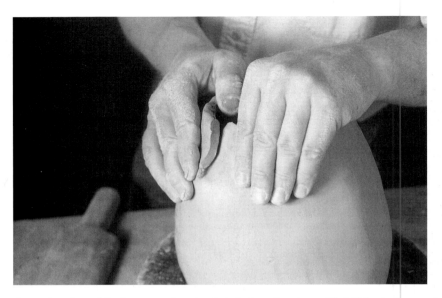

6-28 The edges of the dart are overlapped and pinched together, then paddled. If the clay is not soft enough to stick together securely, the edges of the dart should be scored and slipped before pinching them together.

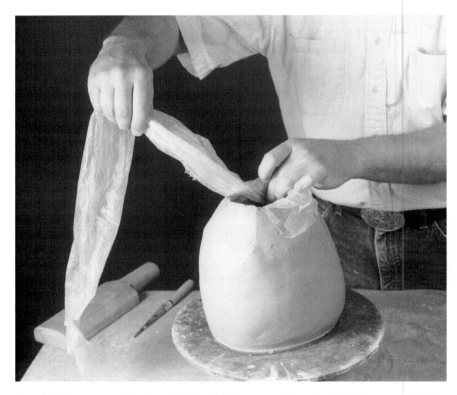

6-29 The form may need to dry and stiffen slightly at stages during the coil-building process. This is necessary to keep the form from collapsing as new soft clay is added. Keep the edge covered with strips of plastic so that more coils can be added at the top. Fold the strip lengthwise so that both the inside and outside of the edge are well covered.

6-30 After it has stiffened slightly, the bottom section is smoothed and refined before adding more coils to the top of the form. If the form has been drying, score and slip the top edge to ensure a good bond before adding a new coil.

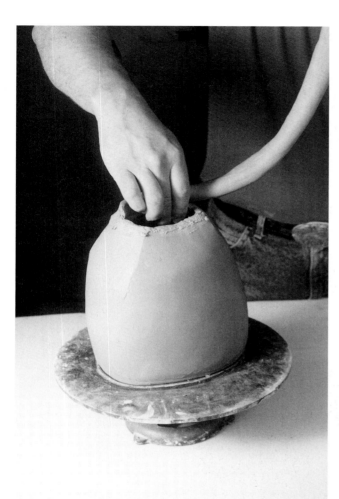

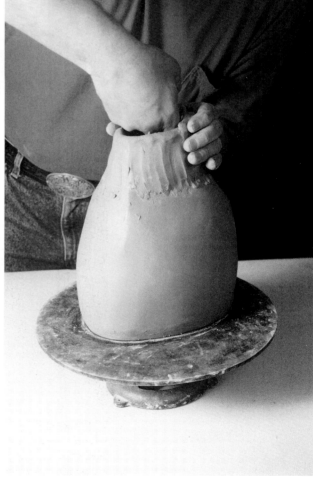

6-31 More coils have been added to the rim to raise the height of the form without altering the stiffer clay at the bottom.

6-32 The form is continually refined as work progresses. To form a flattened top on this vase-like pot, the last coil is added by pinching it inward.

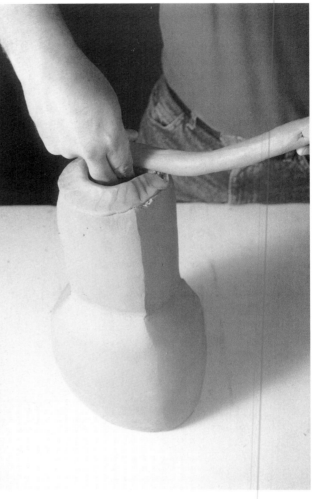

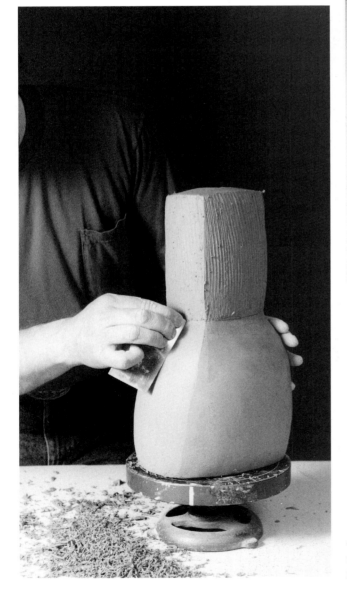

6-33 As the pot nears the leather-hard stage, a metal scraper can be used to further refine the form. Texture can be added to or carved into the form at this stage, once the overall shape has been achieved.

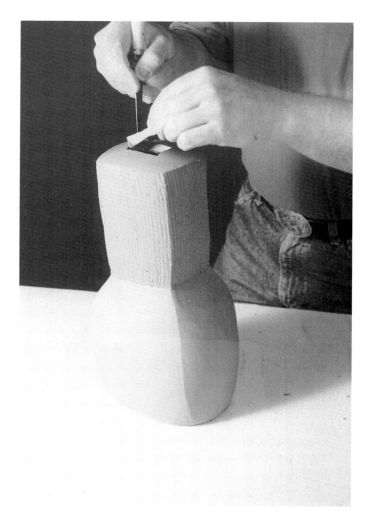

6-34 The opening at the top can be trimmed with a fettling knife or any small, sharp blade.

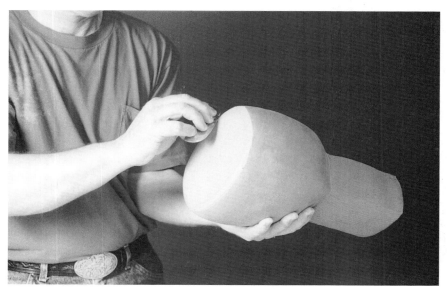

6-35 Once the form is leather hard, it can be picked up, and the bottom scraped smooth. Feet, handles, or other attachments can be added at this point, if desired.

Thick Coil and Paddle

The size of many ancient pots amazes the modern potter. In the typical process used for thousands of years, thick coils are joined, then thinned and shaped by beating a paddle against a rounded wooden anvil or large smooth stone held inside. In Figure 6-36 an Ecuadorian potter from the village of Jatumpamba uses two fired clay mallets (one inside, one outside) to thin the walls of her large pot. The mallets are kept soaking wet to keep them from sticking. Wooden paddles are often used dry. Wrapping a wooden paddle with cord or covering it with fabric may reduce the tendency of clay to stick to its surface as well as impart a texture on the clay surface.

When constructing a large, vertical piece, the potter should begin with a form that is taller and narrower than the ultimate goal, because paddling will stretch the clay wider. The vibration of this forming method sometimes causes the clay to settle, so it must be done with care. If sagging occurs, the pot will have to be left to dry and stiffen slightly before forming continues. Carefully burning a crumpled piece or two of newspaper inside a large pot will dry the clay more quickly. (*Caution:* don't start open fires indoors!) Quechua potters in the humid Amazon region of Ecuador sometimes hold a burning ember inside

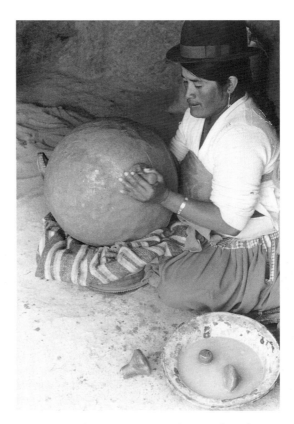

6-36 Jatumpamba potters, Ecuador. Women potters in the tiny village of Jatumpamba in the Ecuadorian Andes use bisqued clay mallets to thin the clay. A convex mallet is used inside, and a mallet with a concave face is used outside the form. The mallets are kept wet during use. The mallets this potter uses are in the bottom right corner of the photo, some in water.

a coil-built pot to warm and dry it so that more coils can be added. Warming the pot by placing it briefly in the sun or by blowing warm air inside may be a safer method to do this. If more coils are to be added, be sure to keep the rim soft by covering it with plastic.

Coiling Sculptural Work

Coil construction is the basic technique for much sculpture, especially when used in combination with pinching and slabs. For very large sculpture, adding extra thickness during coil construction both supports the large forms and makes them more resistant to vandalism when installed in public areas. Building an internal grid-like bracing of coils as the piece is constructed will also strengthen large forms. Very large forms can sometimes be built inside a large kiln (or on a car kiln) where they can be fired without having to be moved. A ladder can be used to coil very tall forms.

Problems in Coil Construction Problems that arise in coil construction often can be attributed to one or more of the following:

◆ Coils which are too thick (form is too heavy) or thin (form is too fragile) for the overall size of the piece

◆ Clay that is either too soft and sticky (form sags easily) or too stiff to join properly

◆ Coils added too rapidly so that the lower walls sag and thicken

◆ Forms which are too horizontal or have too flat an underside curve (Wet clay cannot support too wide a shape. Thin, wide unsupported forms may also sag during firing.)

◆ Coiling the flat base of a piece instead of using a slab for the base (bottom cracks)

◆ Adding the first coil around the outside of the base slab instead of on top (bottom cracks)

◆ Lack of planning and inattentiveness to the shape, resulting in a shapeless, lumpy or generic organic form

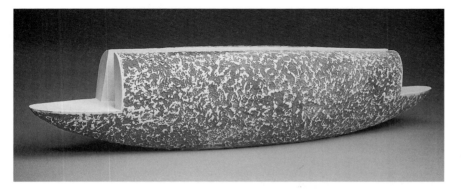

6-37 Sally Brogden, USA. Untitled 91-10. Clay, 45 × 7 × 8.5 in. (114 × 18 × 21.5 cm). Brogden combines the qualities of abstract sculpture and container. Note how the strong texture emphasizes the interior space and contrasts with the crispness of the apparently cut ends of the form.

Slab Construction

Slabs are sheets or slices of clay that are flattened to the desired thickness, often with a rolling pin. These slabs can then be wrapped, folded, or cut and joined together. The illustrations show the great variety of forms possible with slab techniques. Although beginning students tend to make slabs into square or rectangular box-like shapes, there is just as much potential for almost any other shape. When used in combination with modeled, coiled, or thrown sections, and a painterly approach to glazing, slab construction has many more possibilities.

To make a number of small slabs, one can start with a large block of wedged clay and cut off slab-like sections with a wire. These cut sections should be just a bit thicker than needed, and are then rolled out to the desired thickness on a canvas or heavy cloth. Rolling the clay out diagonally toward each corner will preserve the square form, if desired. Turning the slab over after two or three strokes of the rolling pin will keep the piece an even thickness. Flip both canvas and clay onto another cloth, then peel the canvas off the clay. This keeps the slab flat and intact. Turning the slab over releases it from the surface so that it can stretch easily with the next roll.

Fabric or other flat textured objects can be placed between the slab and rolling pin to produce interesting textures. Choose textures carefully to ensure that they are appropriate to the form and content of the work. A smooth surface is often better than an inappropriate fabric texture. A twisted wire or stretched-out small spring can be used to slice textured slabs from a well-wedged block of clay.

A quick way to make larger slabs is to throw them out. A flattened chunk of well-wedged clay is thrown down so that the clay hits the table with a glancing blow, stretching as it hits. By repeatedly throwing the clay slab and turning it each time, a remarkably even slab can be formed. However, if the clay is thrown straight down on the table it will stick. Rolling the slab with a rolling pin will even out any inconsistencies and compress the clay for maximum strength.

Very large, thick slabs can be made by slamming chunks of clay together on a table or floor covered with three or four layers of newspaper or a thick sprinkling of grog. The surface of the slab can then be compressed and leveled by pounding with a wooden paddle or even by walking on the slab. Such slabs often have an expressive texture left from the forming process. Care should be taken to keep contaminating materials like plaster or stones out of the clay when making such slabs on the floor. Newspaper adhering to the backs of slabs should be scraped off where the clay is to be joined. Any remaining newspaper will burn off in the kiln.

Those working extensively with slabs might want to purchase a commercially manufactured slab roller. This machine often consists of one or two metal rollers in an etching press arrangement that compress the clay between two pieces of canvas as the clay and canvas moves past the rollers. The even slab thickness produced by a slab roller is best for many forms, but remember that hand-rolled slabs with tapering thickness may be more appropriate and stronger for some shapes. Hand-rolling a tapered slab with a fairly thin edge and thicker midsection can offer strength, along with the delicately graceful appearance of a thin slab, something slab-rolling machines can't do.

Tips for Successful Slab Building:

- Slabs made using a slab roller can be made stronger and less likely to crack or shrink unevenly by rerolling them gently with a rolling pin perpendicular to the direction they were originally rolled. Hand-roll them

on both sides in several different directions to even out the compression and stretch of the clay.

◆ If flat slabs are desired for rectilinear forms or tiles, care should be taken to keep the slabs absolutely flat during the forming process to avoid problems with plastic memory and subsequent warping during drying and firing. Even rolling is also key here.

◆ Use slabs that are soft or stiff enough for the type of forms being constructed. Stiffer slabs will be easier to keep flat, softer slabs will bend without cracking. Carefully judging the appropriate workability of the clay is a key to many ceramic processes.

◆ Allow clay to stiffen as somewhat larger slabs than needed, then cut the slabs into shapes just before use, trimming off any overly dry edges.

◆ Soft slabs can be shaped to leather-hard forms without attaching. Then let them stiffen to the same wetness as the form to which they will be attached, covering with plastic as needed (often overnight or longer). Score, slip and attach them only after all the parts have dried to the same leather-hard state.

◆ Score deeply, slip, and reinforce all joints.

◆ Use firm pressure to force joints together for a strong mechanical bond.

◆ Dry complex slab pieces slowly to avoid cracking, especially if slabs of differing thickness are used.

Forming Soft Slabs

Slab forms can be constructed from soft freshly made slabs, or the slabs can be stiffened by drying them on flat boards. Soft slabs can be cut, bent, stretched, folded, and rolled into many wonderful shapes, offering the potter a lot of freedom with form. Textures can be added while the slabs are still flat, or applied after they are formed, depending on the way the texture is produced. Gently curved pieces like Mark Pharis' *Soy Bottle* are freely formed from soft slabs of clay, giving them an animated feel (Fig. 6-38).

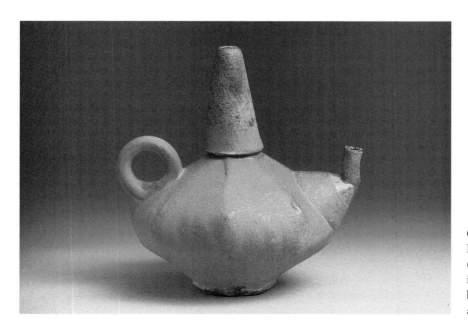

6-38 Mark Pharis, USA; *Soy Bottle*, 1999. Earthenware, hand built from slabs, 7.5 × 7 × 6 in. (19 × 18 × 15 cm). This pouring form is slab built from soft slabs. The visible joints become an important part of the design and add energy to the form and surface.

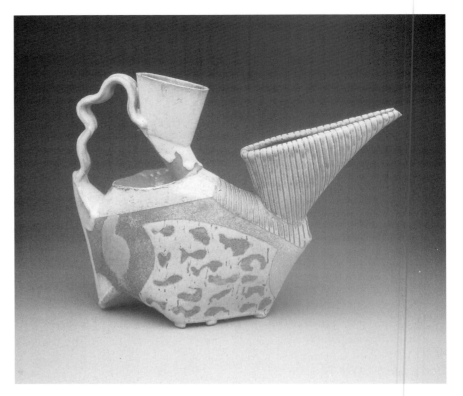

6-39 John Gill, USA; *Ewer.* Gill's Ewers, formed from cut and folded soft slabs, provide a playful foundation for his painterly approach to decoration using colored slips and glazes.

Simple forms or molds are often useful to shape slabs and support them until they are dry enough to assemble. Such forms can be as rudimentary as a folded piece of cardboard, or a solid clay shape wrapped in thin plastic and covered with one or two layers of newsprint or cloth to keep the slab from adhering to the clay support. More complex molds may be made from plaster. If the slabs are draped over a mold, they should be soft enough to be quite plastic. If the slabs are to be formed into a vertical shape, the pieces should be allowed to dry slightly so that they can support themselves. Slabs for this type of construction should not be allowed to dry too much, however, for they may crack as they are folded or bent into shape. Large curved, abstract shapes can be made by placing slabs in a canvas sling extended between the backs of two or more weighted chairs.

As in other techniques, the edges that are joined should be deeply scored and coated with slip so that they will bond together. Good joining techniques will help to prevent the slabs from coming apart during the shrinkage of the drying and firing processes. Sharp angles and joints should be reinforced with a small coil of moist clay on the interior seam. Knitting the joined edges together with a pointed tool, followed by the addition of a small coil of soft clay on the outside seam will add even more strength. A scraper or SurForm™ tool may be used to true up the visible seams after the joints have dried to a leather-hard state. Long horizontal spans may need to be reinforced with interior clay partitions to support the slab and prevent it from sagging.

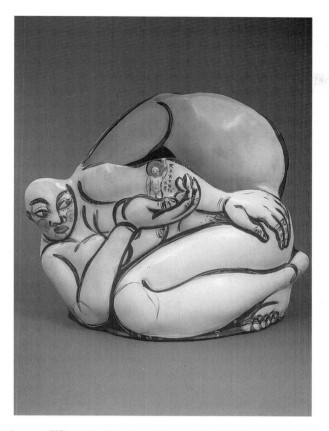

6-40 Akio Takamori, USA; *Birth of Buddha*, 1995 porcelain, 25 × 32 × 11 in. (63 × 81 × 27 cm).
Takamori creates his form with two almost identical slabs of porcelain, one for each side. The slabs are
hand-formed to give them contours, then after stiffening slightly they are joined on a base slab to form
the vessel. He adds the details in a loose drawing style using under- and overglazes, and sgraffito. This
piece is lightly salt-glazed to preserve the delicacy of the drawing, with lowfire color added sparingly in a
separate firing as needed.

Akio Takamori uses slabs to create lively figurative vessels without the use
of molds. Takamori cuts out the rough shape of the vessel from two soft slabs,
often using a simple paper pattern for each half. The forms are shaped by gen-
tly reaching under each slab as it lies on the canvas-covered table, and then push-
ing up areas where volume is needed. Props are made from crushed newspaper
as needed to support the shaped slab until it stiffens slightly. When the slabs
have stiffened enough to just hold their shape when moved, Takamori joins the
two halves of the container onto a slab base. The black slip drawings are added
to the leather-hard clay after all finishing work is done on the form.

Clay slabs can be manipulated to create endless surface textures and sculp-
tural effects. Some potters choose to shape the plastic slabs just enough to sug-
gest a form, but leave the method undisguised. A clay basket form, for exam-
ple, draws much of its visual impact from the rawness of stretched, cracked slabs
and a direct approach to assembling the parts. Surfaces like this can be made by
quickly drying only one surface of a slab, then gently stretching it. This causes
the drier layer of clay to crack. Slabs can be stretched using the throwing-out

6-41 Marilyn Levine, USA. *Two-Tone Bag*, 1974 stoneware with nylon fiber, engobe, and lusters, 9 × 14.5 × 10 in. (22 × 36 × 25 cm). Los Angeles County Museum of Art. Levine skillfully uses the ability of clay to look like other materials, in this case old leather. She captures the intimate character of this well-used bag, which in turn tells us about its owner.

process. Other artists like Marilyn Levine use the wonderfully plastic qualities of clay to imitate other materials (Fig. 6-41). Levine adds chopped nylon fiber to stoneware clay to give it more fabric-like strength. This allows her to work with the clay more like one would handle leather. Levine controls drying by covering the slabs with a layer of thin plastic. The slab-plastic lamination is cut with scissors to conform to a paper pattern. A roulette wheel is used to imitate the stitching common on leather articles. The sections, still covered with plastic, are joined (first removing any plastic from the joined areas) and held together with masking tape while drying.

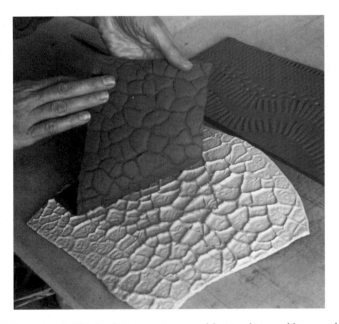

6-42 Sandi Pierantozzi, USA. Sandi Pierantozzi presses slabs into plaster and bisque molds to create highly textured clay slabs.

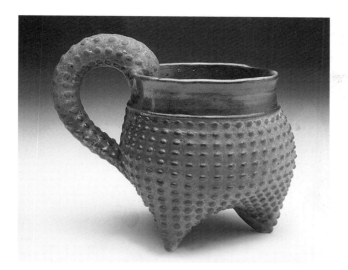

6-43 Sandi Pierantozzi, USA; *Nub Cup* stoneware, wood fired, 5 in. (12 cm). Hand built from textured clay slabs, it's obvious that Pierantozzi has taken great care to preserve the surface texture when slab-building this cup.

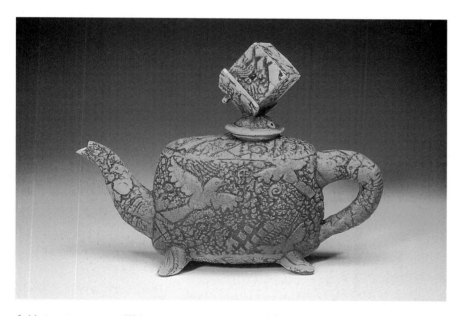

6-44 Dennis Meiners, USA; *HouseBird Teapot,* 2000. High-fired stoneware, 11 × 6 in. (28 × 15 cm). All pre-textured slabs; handle is hollow. Matte barium blue glaze blushed pink in reduction atmosphere.

Other artists use slabs in a variety of creative ways. After first joining slabs and chunks of colored clays into a larger loaf of clay, Thomas Hoadley cuts patterned slabs from the loaf and combines them into bowls like the one in Figure 6-46. This technique is sometimes called **nerikome** or **millefiore.**

Many ceramic artists draw heavily on the techniques and aesthetics of other art forms in making their work. Clay slabs lend themselves quite well to the

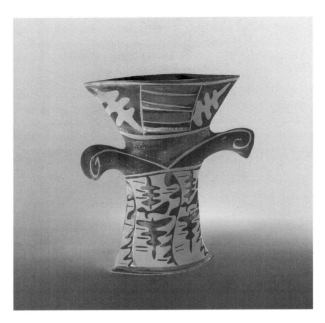

6-45 Kate Inskeep, USA; *Oak Vessel* slab built porcelain, 17 × 16 × 6 in. (43 × 40 × 15 cm). Vessels like this can be formed from two almost identical slabs which are shaped slightly, then joined at the edges. A slab of clay is added at the base last to close off the bottom.

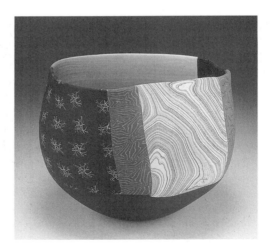

6-46 Thomas Hoadley, USA. Untitled vessel, 1998. Colored porcelain, hand built using Nerikomi technique, 7.75 × 7 × 7 in. (14 × 17 × 17 cm). The intricate visual texture of the bowl is formed from colored clays layered in patterned blocks, sliced into slabs, and assembled.

incorporation of graphic arts processes such as silk screen printing. Les Lawrence casts the richly decorated slabs he uses to assemble forms like the teapot he's making in Figures 6-47 through 6-56. The cast slabs can be made quite thin and strong. Techniques like this, combining the processes of printmaking and ceramics, are increasingly popular.

6-47 Les Lawrence, USA. Photo silkscreen and slip-cast porcelain slabs are used to build a teapot. Lawrence first silkscreens images onto a very smooth, flat, plaster slab. He uses a mixture of commercial black underglaze and gum arabic instead of ink, and sponges it through the screen. He combines multiple images in unique ways for each piece. He has silkscreens made with many images on each screen to save space.

below left: **6-48 He then draws** back into the black underglaze image by carefully scratching through the soft coating of underglaze on the plaster. He will eventually cover the whole plaster slab with images.

below: **6-49 When the screened** image is complete, Lawrence pours porcelain casting slip over the slab and quickly tilts the slab to get an even coating over the whole surface.

6-50 **After allowing** time for the slab to dry and stiffen somewhat, he uses compressed air from a nozzle to help release the slab from the plaster while it is still slightly softer than leather hard. The slab edges have already been trimmed to help release it from the plaster and to prevent edge cracking.

6-52 **The sides** of the teapot, made from two identically shaped slabs, are joined on two opposite sides with a little casting slip. Lawrence works quickly with the slabs while they are still somewhat soft and plastic. Scoring is not needed when using cast slabs in this manner.

6-51 **The slab** is flipped after it is released from the slab so that he can decide what parts of the images to use. The slab is then cut into sections for assembly into a teapot.

6-53 **The two** attached slabs are gently spread apart with a chopstick, much like opening an envelope.

6-54 **After attaching** another slab as a base, Lawrence begins to shape and attach the other parts of the teapot. Here he is adding the top, using a chopstick to help shape the form from the inside.

Stiffened Slabs

Slabs can also be handled in a more rigid state, almost like working with wood, if the clay slab is allowed to stiffen almost to the leather-hard stage before the form is assembled. Slabs should be dried to their working stiffness before the final pieces needed are cut, as the edges of the slabs have a tendency to dry more rapidly and may have to be trimmed off. Some potters make a stack that alternates wooden boards and slabs to dry slabs evenly, allowing the unpainted wood to draw moisture from the slabs overnight. Planning is needed to have ample stiffened slabs prepared.

Simple shapes built from stiff slabs may be formed by cutting and fitting slabs one at a time. Many artists use this intuitive method for all their work. More complex shapes may be more easily constructed by first making a paper

6-55 The spout is attached. It was formed by rolling a thin slab around a dowel.

6-56 The teapot is nearing completion, with the base trimmed, and a lid and handle added. All parts have been made from the printed cast slab. The handle is made from two thicknesses of slabs to make it stronger. Lawrence is starting to add stainless steel nails to the teapot to resemble rivets holding the slabs together. These nails are cut very short, and inserted into pre-drilled holes. Stainless steel can withstand the high temperatures of ceramic firing, but turns matte black.

or cardboard mockup that is then used as a pattern for cutting the parts needed from the clay slabs. Both sides of all joints should be scored and a thick clay slip applied before the parts are pressed together to join them. When possible, a small coil of clay should be pressed into the inside of the joint to reinforce it. If the outside is to be scraped and smoothed, then knitting the edges of the joined slabs together with the point of a small tool before smoothing will greatly strengthen the bond (Figs. 6-57 through 6-65 photo series on building with stiff

6-57 Stiff slab construction Slabs of clay are rolled out to a uniform thickness and left slightly larger than needed. They can be dried evenly by placing them on flat boards, which are stacked up like a board-on-clay sandwich, and covered with plastic for a day or so.

6-58 After the slabs have stiffened to about leather hard, they can be cut the exact sizes needed and assembled. A carpenter's framing square is useful when building rectangular forms.

6-59 The edges of both of the slabs which are to be joined are scored deeply and coated with thick slip.

6-60 As the slabs are assembled, props like this brick may be needed to hold the slabs temporarily in place.

slabs). Avoid adding water or wetting the joints excessively when finishing them, as this may encourage cracking by causing the clay to first expand with the extra water, then shrink more than the surrounding clay. Instead, dampen wooden or metal tools slightly to make them slide across the clay more easily. Artists may find leaving the joints raw and visible appropriate to some pieces. Patrick Siler uses this to good effect in his *Jivin' Man Jim #2* (Fig. 6-66).

6-61 Firm pressure is needed to ensure that the scored, slipped edges intermesh and bond.

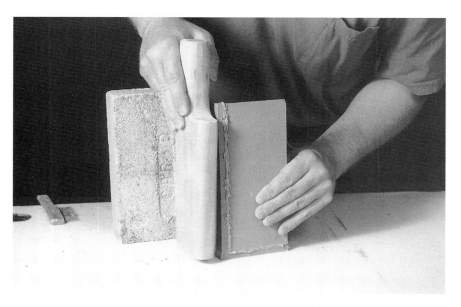

6-62 Use a wooden paddle to put even pressure on the joint and still keep it flat.

More exacting forms may require greater precision in joining and trimming joined slabs. Pieces like Kathryn Sharbaugh's *For the Record* teapot (Fig. 6-67) depend on clarity of form and carefully trimmed edges. Planing the joints flat can be done with a knife, scraper or a disposable woodworking tool such as a SurForm™ rasp.

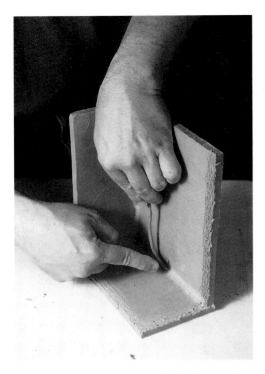

6-63 Whenever possible, work a small coil of clay into the joint to reinforce it. This can often be done right after joining, using the slip which has squeezed from the seam to help bond the coil to the sides.

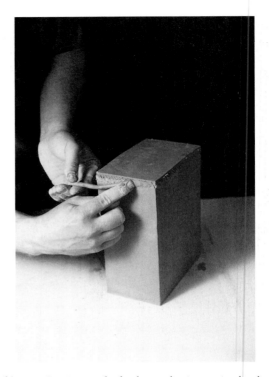

6-64 Outside joints can be deeply scored, using a pointed tool and a small coil added for strength. The added clay is smoothed into the surface with a rib and later trimmed or scraped flush with the sides.

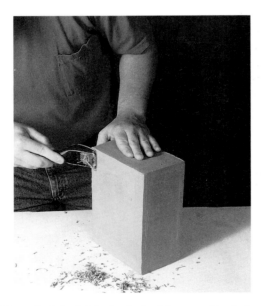

6-65 Let the joined slabs dry slowly while wrapped in plastic. After the entire form, including the joints, is leather hard, the joints can be trimmed flush to the sides. Here a SurForm tool (a type of woodworking rasp) is being used to plane down the joints to make them invisible.

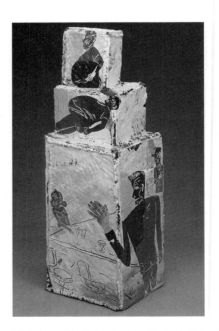

6-66 Patrick Siler, USA; *Jivin' Man Jim #2,* 1989; 46 × 16 × 16 in. (116 × 40 × 40 cm). Siler uses quickly assembled clay slabs with stenciled slip drawings to enliven this simple house form. The construction techniques used are appropriate to the style of images.

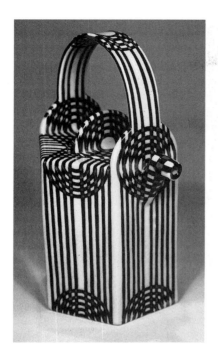

6-67 **Kathryn Sharbaugh**, USA; *For the Record,* 1993; slab-built porcelain with underglaze fired to cone 10 oxidation, 9 in. (22 cm). Sharbaugh's precise geometric patterning on her teapots demands that the forms be carefully constructed and all joints smoothed. Note how parts like the handle and knob on the lid have been shaped to work with the patterning.

MOLDS

The use of molds to form clay is an ancient technique that is much used in modern commercial production and also quite useful to the artist. Molds offer both benefits and drawbacks to the artist-potter. By using molds the artist can quickly produce variations of a particular form, as well as make complex forms that are thin enough to be easily fired. The main drawback to using molds is that experimentation and creativity may be stymied by dependence on a particular form. It is up to the potter to use molds creatively and effectively. Many artists use molds as a starting point to speed the production of forms that are then altered or combined into more complex works. Virginia Scotchie uses a variety of press molds in Figure 6-68 to produce the ceramic spheres for her installation sculpture *Scatter.* Molds are also useful to preserve surface textures on the slabs pressed into the mold as seen in Figure 6-42. Molds for ceramics are often made of plaster, as its absorbent surface helps to dry and release the wet clay. Many other materials, such as Styrofoam, cardboard, wood, or found objects, can be used for molds, especially if the mold is only needed once or twice.

Hump and Press Molds

A mold can be almost any shape, and the technique of molding can sometimes produce a finished form in practically a single step. More often, artists use molds as a starting point for even more complex forms.

For a **hump mold,** a slab of clay is draped over a convex form—a stone, mound of clay, gourd, kitchen bowl, beach ball, or plaster form made for the purpose. The slab is pressed to conform to the mold, and the excess clay is trimmed away. If the mold is not absorbent plaster, strips of wet newspaper, paper toweling, or plastic can be laid over the mold to prevent the clay from

6-68 Virginia Scotchie, USA; *Scatter* (in progress), 1995. The artist is in her studio press-molding clay spheres for a large installation piece.

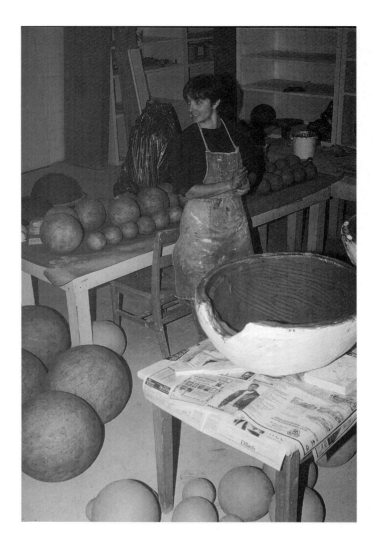

sticking to the form (Fig. 6-69). After drying slightly—enough to maintain the shape without distorting—the clay is removed from the mold. If left on the form too long, the clay will often crack as it dries and contracts around the mold unless the mold is rather flat.

A convex form can also be covered with coils of plastic clay. The coils should be smoothed together with a tool or the fingers so they will not crack apart when drying. Coils and slabs can be joined over a preexisting shape, provided the seams are well sealed. This will create alternating smooth and rough textures. Join marks are smoothed on the exterior, so that any design will be seen on the inside surface. Another possibility is a completely round, closed form that results from joining plastic slabs around a heavy balloon. When the clay is leather hard, the balloon should be punctured to permit the clay to contract. The rubber will burn out during the firing. The firing should proceed slowly, however, to allow the moisture to escape through the puncture hole instead of turning to steam and causing the pot to explode.

A **press mold** is a concave form—the inside of a bowl or plate, an opening carved into wood or foam, or a plaster mold—into which slabs or coils of plastic

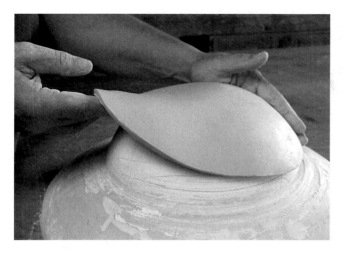

6-69 Hump molding.

clay are shaped. The procedure is the same as for hump molds, except that the slabs or coils are pressed into a form rather than draped over it (see Figure 6-69). In this method the smoothing and joining of coils and slabs is done on the inside surface, and any design left from the process will appear on the exterior.

Rounded forms can be constructed by joining two semicircular sections press-molded in a bowl shape. Both halves must have a similar moisture content when joined. The edges should be scored and coated with slip and carefully worked together on the joint. Once joined, the piece should dry very slowly to prevent cracking along the seam. Be sure to provide at least a small hole to allow air inside the form to escape as the form shrinks.

Commercially, some very complicated forming machines are used to press-mold plates, bowls, cups, and similar vessels. Such commercial production is very fast: several thousand pieces per day. Studio potters can hardly expect to compete by making prosaic types of functional ware. Their work must be unique in both form and decoration if it is to command the higher prices they must charge.

Slip Casting

Another possibility for hand-building with molds is casting. Although casting is a commonly used commercial production technique, studio potters have found it useful for creating complex shapes and forms that are not easily thrown. Slip casting consists of pouring deflocculated slip into a plaster mold. Depending upon the complexity of the piece, the plaster mold may consist of one to five or more parts. In order for the slip clay to dry and shrink away from the plaster mold without cracking, it is best if the form is of a fairly smooth texture without deep crevices and undercuts.

Molds for slip casting must be carefully made to be equally absorbent in all sections. This can be done by maintaining a consistent wall thickness of plaster (usually about 1 inch [2.54 cm]), and by using the same ratio of water to plaster for all parts the mold. Badly made molds may cast one side thicker than the other and have similar flaws that can lead to cracking as the cast form dries. Multiple part slip casting molds must also fit tightly together, as the weight of liquid clay slip in the molds will cause slip to flow out of even the smallest gap

6-70 Adrian Saxe, USA. The artist in his studio with a partly completed slip casting mold for one of his gourd-based pieces.

between the mold parts. Adrian Saxe makes beautiful molds of gourds for his series of sculptural vessels, as can be seen in Figure 6-70.

When the newly made plaster mold sections have dried, they are scraped clean on the outside to avoid the possibility of plaster chips getting in the clay. Then the sections are clamped together for the casting. A specially prepared **deflocculated** slip (See Chapter 5) is poured into the mold. Plaster draws the moisture from the slip and causes the clay slip that is in contact with the surface of the plaster to harden, or set up in much the same way as a glaze coats absorbent bisqueware when it is dipped into the glaze bucket. When a sufficient thickness of stiff slip has formed on the inside of the mold (this usually takes about 5–20 minutes depending on the thickness desired and the absorbency of the mold) the excess liquid slip is poured or drained from the mold. As casting slip is thixotropic and flows slowly after it has been sitting undisturbed, the molds must be allowed enough time to drain upside down, usually twenty minutes or more.

The casting is allowed to stiffen and dry further in the mold before it is removed. Slip-cast pieces may be eggshell thin or quite thick depending on the complexity of the mold and the qualities of the slip used, but typically are 1/8 to 1/4 inch in thickness. The cast form is removed from the mold when it is leather hard. Multiple castings can be joined together by fitting them carefully

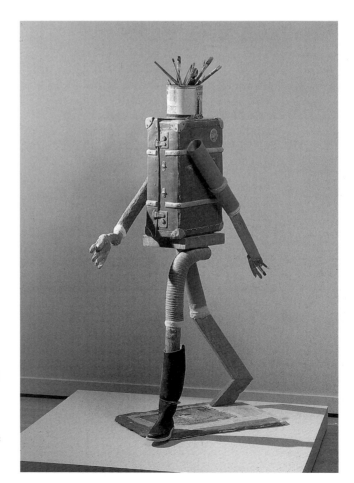

6-71 Richard Shaw, USA; *Traveling,* 1993 porcelain with decal overglaze, 68 × 41 × 21 in. (172 × 104 × 53 cm). Shaw's whimsical use of found objects cast in porcelain challenge the viewer to consider the meaning of the transformed objects in the context of the whole sculpture.

together, then painting a little casting slip on the surfaces to be joined. The surface of the casting may be scraped or sanded when dry to remove the join marks or seam lines left from the mold sections.

Many artists, such as Richard Shaw (Fig. 6-71), use slip casting to replicate found objects that are then recombined in sculptural forms or **trompe l'oeil** compositions. By using ceramic versions instead of the actual objects, the viewer of such art is asked to consider the meaning of the whole sculpture over the more familiar qualities of the real items.

Styrofoam for Molds and Models

Nino Caruso, an Italian ceramist known for his architectural modular reliefs (Fig. 6-73), has often used styrofoam as a model material to make molds. Styrofoam has a very dense consistency but is still lightweight and convenient to handle. Blocks of styrofoam can be cut with a taut, hot wire. The wire is placed in an arrangement like a band saw, but the wire makes a sharper cut and leaves a smoother surface than a saw blade.

The various segments of the pattern are joined with cement to make the model, which is then coated with shellac to fill all the air pockets and repel the plaster. This model serves as the form for making the plaster mold for slip casting.

Styrofoam may also be used to make quick press molds and hump molds. Shapes may be cut from sheets of foam using a sharp knife or small saw blade. Stiffer denser foam can even be sanded lightly to smooth it. Clay slabs can be pressed into these molds and allowed to stiffen. If the sides of the mold are slightly angled the clay can be easily removed from the mold when it has firmed up.

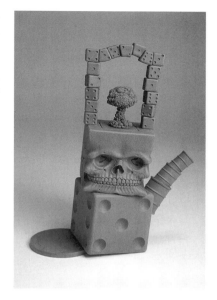

6-72 Richard Notkin, USA; *Cube Skull Teapot* (variation #19), 1992 stoneware 8.5 × 6.75 × 3 in. (21 × 17 × 7 cm). This teapot in the Yxing Series is assembled from several parts slip-cast in molds from Notkin's own original models. Notkin found part of his inspiration for this series in both the technical and compositional qualities of Chinese Yxing ware. Notkin uses the functional teapot, a common everyday item for many people, as a format for social commentary.

6-73 Nino Caruso, Italy; *Itinerary,* 1991, terra cotta. Caruso's architectural work often uses modular elements, as can be seen in this photograph. The installataion is in an exhibition in the XVI Fortress of Perugia, Italy.

Rigid styrofoam in varying thickness is easily obtained at most building supply stores. Different grades and densities of styrofoam board are available. The type of styrofoam made from many small beads of foam compressed together is only marginally useful with clay as it can't be sanded. The denser, more fine-grained styrofoam can be cut smoother and sanded, and offers more strength and rigidity.

Air-Release Press Molding

Many small production studios are using a combination of a hydraulic press and air-release plaster molds to speed production. This is a complex operation, so only a brief description of the process will be given here. Fairly stiff plastic clay is laid into the lower half of a two-part mold, then the press is activated to force the two parts together. The clay is spread throughout the mold by the tremendous pressure of the hydraulic press. Any excess clay is squeezed out and trimmed automatically as the mold halves come together. As the press is opened, air pressure is applied within the porous plaster mold and the clay releases immediately. Special mold-making techniques are needed to make the mold porous for the air release, and yet still strong enough to withstand the high pressures of this process. Like any molding process, the potter needs to carefully balance the production advantages with the artistic limitations of such industrial methods.

MODELING

Modeling directly in clay preserves the texture of the material and the feeling of immediacy derived from manipulating hands and tools. Since time immemorial sculptors have modeled solid clay studies, made plaster casts and created a finished product in stone or metal. Usually, the final piece does not resemble the original clay sketch, which would have been too difficult to fire. Solid masses of clay are apt to explode in the kiln, so when fired clay is the desired final form of a solid-modeled form, the sculpture is often hollowed or cut into sections to allow firing. And, of course, a plaster mold can be taken from the original solid modeled form, and a thinner clay replica can be pressed or cast in that mold. This is a common use of molds.

Traditional Modeling Method

Over the years sculptors developed methods of modeling that permitted the original study to become the permanent record. If the study is on a small scale and the clay walls are less than 1 inch (2.54 cm) thick, firing will not present a problem. If an armature can be used (see next section), and removed before the clay dries, this may allow one to model larger pieces and maintain a reasonable clay thickness. For larger pieces, it is usually necessary to hollow out the excess clay inside unless very porous, groggy clay and very long firing times are used. Flat or low forms may allow hollowing from the underside. Taller or closed shapes may require that the piece be cut in half with a fine wire while the clay is still fairly plastic. Cutting through smooth areas with little texture will make reassembly easier. With a wire loop tool the walls are trimmed to a thickness of 0.5 to 1 inch (2.54 cm). Some care should be taken not to distort the two halves so that they will fit back together exactly. When both halves have been hollowed, the cut edges are scored and coated with slip. The two sections are pressed together,

and any surface defects are touched up with the fingers or a tool. This same technique can be used on a smaller scale to model expressive spouts for teapots or ewers from solid clay. These are then hollowed out and rejoined when the clay is slightly softer than leather hard.

Large sculpture should dry under plastic and be exposed to air slowly. This will ensure an even drying of the thick areas. The kiln firing should also proceed slowly. It is common practice to leave the kiln on very low heat with the door ajar for at least twelve hours before the actual firing begins to assure that the pieces are completely dry. (See Chapter 11, Kilns and Firing.)

Expressively modeled clay often needs no further embellishment, but colored engobes and glazes may be effectively used to enhance the surface and form. Care should be taken to make sure such surface treatment works effectively with the form. Color, pattern, and texture skillfully applied can be used to accentuate parts of a form, or applied overall to minimize variations (sort of a camouflage treatment) or unify the whole. A painterly approach vigorously applied to minimal form can add movement and energy to an otherwise static shape. Likewise, a thoughtless surface treatment can hide or obliterate a wonderful form. (See Chapter 8, for more information on surface design.)

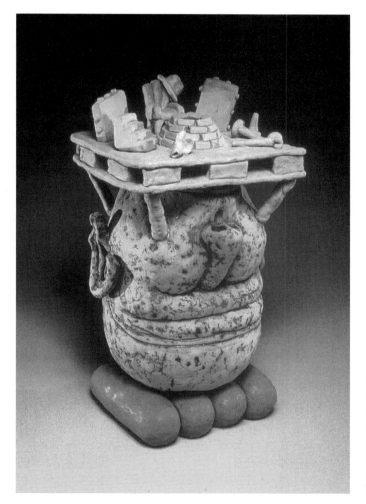

6-74 Allan Rosenbaum, USA; *The Source*, 1994 glazed ceramic 23 × 12 × 12 in. (58 × 30 × 30 cm). Rosenbaum skillfully uses bare red earthenware clay along with colored slip and glaze to obtain rich contrasts in color and surface on this vigorously modeled piece that uses a variety of hand-building techniques.

Building Complex Forms

More complicated pieces can also be cut apart, hollowed out and then joined, but problems are apt to arise from the rejoining of too many parts. It is often simpler to construct the different parts from hollow sections initially and then join them together. The clay must be plastic enough during the joining process so the joins can be smoothed over. Some artists choose to leave the joints and other evidence of the process visible for effect, but this requires careful craftsmanship to assure that the joints don't crack as the piece dries.

Sagging during firing is always a problem with sculptural projections that lack support. In figurative sculpture, heads especially are apt to tilt when the weight of the head puts pressure on the forward thrust of the neck. Clay tube supports can be made for the projections when both are leather hard, so that they will shrink at the same rate during both drying and firing. Small holes in several places will allow moisture and combustion gasses to escape during firing.

Armatures and Internal Supports

Often, complicated sculptural forms will need some kind of interior support in addition to the exterior support to prevent sagging during drying and firing. Clay partitions that shrink with the form in drying and firing are the most practical solution, provided ample air passages are left. Support partitions can be in the form of an internal grid work, or if less strength is needed, simple slab or pinched struts on the inside of walls, much like the stud walls of a house. These can be built inside the piece as it is formed or stiff slabs can be added at the leather-hard stage. Metal rods and wire can be used temporarily, but these must be removed before major shrinkage occurs to avoid cracking the piece. Wrapping removable metal or wood supports with soft foam may allow them to be left inside the work longer as the clay shrinks.

Other possibilities for armatures include the use of crushed and wrapped newspaper, held together by a little masking tape. The newspaper can be wrapped around a steel or wood upright to stabilize larger forms. Quite a bit of the newspaper should be crushed into loose shapes, then added to the armature. This will assure that the newspaper can be compressed as the clay shrinks and dries. Foam may also be used as part of such armatures. If possible, the newspaper should be removed as the form becomes leather hard to allow more even drying. However, if sufficient drying time is allowed (add a week or two more for drying larger forms) the newspaper may be burned out in the kiln. However, damp newspaper can hold moisture for a very long time, so it's best if you can remove it. Foam should always be removed, as the chemicals given off by burning plastics are often toxic.

⚠️ **SAFETY CAUTION**

Don't burn plastics or foam in the kiln. The gases given off by many plastics as they are heated can be dangerous or toxic.

Cloth bags or sacks may be filled with perlite, vermiculite, or styrofoam packing pellets to make an armature for complex or nearly closed forms. Sand-filled bags are a possibility, but will not allow for clay shrinkage and will be quite heavy. Cloth forms may be stitched into almost any shape. Soft clay slabs may be wrapped around these temporary armatures, and the joints smoothed.

When the form has stiffened sufficiently to be self-supporting, a small opening can be made in the cloth sack and the contents drained out to allow the clay to finish shrinking. The smaller the filling material, the smaller the hole needed to drain the form. It may even be possible to carefully pull the cloth out through the same hole. If the cloth is left to burn out, be sure to use cotton or other natural fibers to avoid the possibility of toxic gasses from burning artificial fibers.

COMBINED TECHNIQUES

Once the basic hand-building methods have been mastered and the potter is familiar with the possibilities of each, it will become clear that many forms can be constructed only by combining the different techniques. Pinched and modeled shapes often require coiled additions. Slabs and coils reinforce each other structurally as well as aesthetically. Each method has structural advantages and limitations. If pinching a lump of clay does not produce the desired form, then perhaps a coil should be added to the rim, or a slab joined to the coil. Forms made from thick soft slabs, or even thick wheel-thrown forms, may be pinched, stretched, and altered into new shapes. The potter discovers by experimentation how far plastic clay can be stretched and manipulated. Overly thin walls will sag, and walls that are far too thick are likely to explode in the kiln. Figure 6-74 and the many illustrations in the portfolio section of Chapter 4 (for example, Plate 57 Tre Arenz's *Sameness—Touch*) show the freedom of design that is possible when hand-building techniques are combined imaginatively to create both functional and sculptural forms.

The challenge for the beginning hand-builder is to create strong forms. It hardly matters whether these are sculpture or useful containers from a pottery tradition. Clay is a largely shapeless material and the tendency for the beginner is to make generically organic, lumpy, shapeless forms. Balancing a playful sense of discovery with one's intent and ideas helps to keep the forms strong and the work interesting.

SPECIAL HAND-BUILDING TECHNIQUES

Ceramists have developed a number of special techniques to achieve the forms they desire. Inventiveness and experimentation go hand-in-hand with skilled craft to enable artistic visions to become reality.

Extruded Forms

Extruded Coils Many potters use clay extruders to save time in producing small coils in quantity for constructing or decorating pots and for creating fanciful strap handles. To make small coils the barrel of the extruder should not be too large in diameter because the pressure required to extrude the clay through it would be too great. Several small coils may even be extruded at once. With dies that produce extrusions with hollow centers many vessel and sculptural forms are possible. Spouts such as those on Harris Deller's *Curvilinear Teapot with Concentric Arcs and Passive Spout* (Fig. 8-22) or Mark Pharis' *Soy Jars* (Fig. 6-38) make good use of extruded forms.

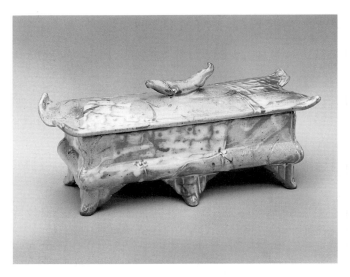

6-75 John Glick, USA; *Lidded Box,* 1994, stoneware, reduction fired to cone 10 w/ multiple glazes 4.5 × 12 × 4.5 in. (11 × 30 × 11 cm). Glick uses extrusions as a basic building block for many of his hand-built pieces like this lidded container. His work is known for its richly embellished surfaces created by layers of slips and multiple glazes.

Extruded Slabs Depending on the shape of the die used, many forms other than the coil may also be extruded, such as the slab forms designed by John Glick to produce the rectangular covered box illustrated in Figure 6-75.

There are certain advantages to the extruded slab form. As a result of the process, the clay has a denser and better aligned composition, which is less apt to warp in drying and firing. Also, flanges and lips can be produced as part of the basic form.

To produce extruded slab forms, the potter makes a sketch of the projected work and a scale drawing of the forms to be extruded. The dies can be constructed of wood, metal, or even fired clay, but for ease of forming, a die of 0.5-inch (1.27 cm) dense polyethylene (available cheaply in the form of kitchen cutting boards) works very well. It must be carefully smoothed and the edges beveled slightly to produce a clean, even surface. Polyethylene is quite easy to cut and work, and once the die shape is refined, the edges can be flame polished to a glassy smoothness by melting them quickly with a torch. Long-lasting precision dies can be commercially laser cut from stainless steel for more production-oriented use.

Several models of commercial extruders are available or an extruder can be improvised. The handle should be of sufficient size to exert a substantial amount of pressure on the clay. The extruder should be securely mounted on a sturdy table or wall.

The clay must have been aged and wedged. Nonplastic clays or poorly wedged clays will often cause holes or cracks to form in the extrusion as it leaves the die. Grog, if added, should be of a small size. Extrusions of up to 36 inches (91.4 cm) or longer are possible. They should be laid out carefully on a table and allowed to dry before assembling.

For further information on extruding forms, see John Glick's article in Vol. 17, No. 1 of *Studio Potter,* pp. 55–61.

EXPERIMENTAL METHODS

A thixotropic clay body is one which flows when it is moved but becomes semi-rigid when still. Potters have developed clay bodies that have thixotropic properties, allowing them to achieve some interesting effects of fluidity and apparent motion. However, the properties of thixotropic clay make it somewhat difficult to handle, due to unusual sagging and shrinking rates. Thixotropic clay might be used experimentally for a piece that requires fluid or rope-like forms.

Fabric or cotton gauze may be dipped in deflocculated casting slip and applied to armatures or clay forms to build up evocative surfaces with a resemblance to cloth. Open-weave cotton or other natural fiber works best, as the slip will fill the pores of the material creating a stronger form when fired. Sheets of paper or tightly woven cloth dipped in slip will result in *very* fragile forms after the layer of fabric burns away and leaves thin, delicate layers of clay. More slip can be painted or sprayed on the dipped forms before firing to build up greater thicknesses, but they will still be fairly fragile. While not suitable for functional work, such easily broken forms may be appropriate for small sculpture.

A similar method uses casting slip to which large amounts of paper pulp or shredded paper has been added. Up to 25–30% paper can be added without losing too much of the plastic qualities of clay. This clay-paper mix can be worked more like wet paper. The paper pulp acts to reduce the already low drying shrinkage of the casting slip. The paper and clay mixture may be pressed into molds or formed on a screen like paper. The clay-paper mix may also be applied over

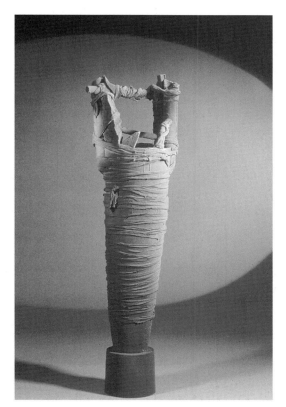

6-76 Sandra Black, Australia; *Timewell,* 1990, slip-cast, draped, and assembled bone china with airbrushed colored slips 28 × 8 in. (71 × 20 cm). Black uses a slip-soaked cloth to create a bound feeling to her work *Timewell.* The basic form is slip cast from bone china, then the handle-like form and wrappings are added.

crushed newspaper armatures, one coat at a time, until the clay is strong enough for the size of the form. Each new layer of clay-paper slip should be applied after the previous coat has become leather hard. Shrinkage is typically so low that any drying cracks may be patched with the same mixture used to form the piece, very much like working with papier-mâché. When fired the paper burns out, leaving a somewhat fragile, but lightweight clay form. A casting slip/paper mixture can even be used with some success to fix broken greenware, and sometimes even bisque. Rosette Gault has done much work investigating the possibilities of paper pulp and clay mixtures. She uses it for sculptural works like that in Figure 6-77. See the bibliography for Rosette Gault's book on paper clay.

Sawdust and planer shavings from a woodworking shop may be mixed with plastic earthenware clay to make a lower-shrinkage clay body for hand-building thick sections or solid forms. These may be up to 4 to 6 inches in thickness if enough wood shavings are included. The coarse nature of planer shavings can add interesting texture to hand-built work, both during construction and after the wood burns away, leaving a porous structure to the clay. As many as three to five 5-gallon buckets of planer shavings can be added to a 200-pound batch of clay. For small batches, dampened wood shavings can be wedged into soft clay a little at a time, working in as much as possible until the clay starts to become nonplastic. Care should be taken to use only nontoxic wood like pine, fir, or poplar, carefully avoiding treated lumber products and exotic woods. Dampening the wood shavings slightly before adding them to the clay will help them mix with the clay.

Other organic materials (walnut hulls, beans, rice, noodles, straw, etc.) may be tried as burn-out texture additives to clay in a manner similar to sawdust, but tests should be made before constructing the actual work. Some materials, such as birdseed that contains millet, may cause the clay to fall apart after firing. Many organic materials swell when wetted, so presoaking the material to expand it before mixing with the clay may help to avoid cracking.

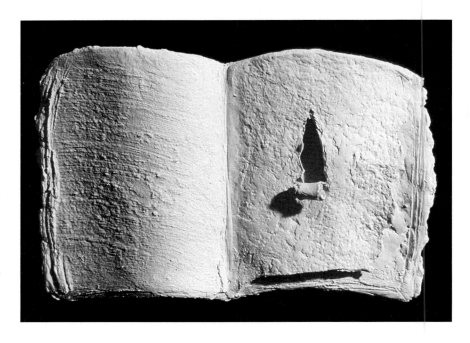

6-77 **Rosette Gault,** USA; *Journal,* 1992, paper clay (clay with paper pulp added), 8 in. (20 cm). Gault puts a large amount of paper pulp in clay slip. This allows her to make work that can be fired, but has some of the properties of cast paper and some of the plasticity of clay. Paper clay's properties make it very suitable for sculptural work. Gault holds a patent for inventions related to paper clay.

⚠️ **SAFETY CAUTION**

Clay containing organic materials should be used and dried quickly (the same day is best) before the organic materials have a chance to rot or grow molds. *Don't recycle this clay.* Make only as much as you can use.

Firing of work containing organic matter should be done only in gas kilns in a well-ventilated space. Firings should proceed VERY slowly, especially below 1000° F, to allow ample time for the organic material to completely burn out of the clay. Firing pieces with very thick sections may require several days. Avoid adding plastics or other materials to the clay that will produce toxic gasses during firing.

Some artists have added stainless steel turnings and industrial parts to a thick slip which is applied over clay forms. After firing the pieces can be sandblasted to remove some of the slip and expose the stainless steel nuts, bolts and turnings in the clay. Stainless steel will withstand temperatures of cone 6 to 8 or higher if completely embedded in the clay. Most other common metals will melt or oxidize completely at higher firing temperatures so be certain of the type of metal you are using. Metals like copper will melt at temperatures not much above a low bisque firing (cone 08–06), often ruining both the work and expensive kiln shelves.

On a small scale, thin stainless steel rod (1/16 inch [0.159 cm]) can be used to fasten small parts to a larger sculptural form. Welding supply stores are a good source of stainless rod. Small stainless steel nails might also be used. Small chunks or clay shapes can be pinned to the main clay structure at the greenware stage and fired in place. Nichrome or element wire may be used in similar fashion at low fire temperatures. Other metals should not be used in this structural manner as they will soften or melt during the firing.

Completely covering the stainless steel with clay is the best was to protect it in the kiln, but as clay shrinks during both firing and drying this is likely to cause cracking in the clay if the stainless steel parts are very large. Larger stainless steel armatures may be used if a clay body of very low shrinkage is devised. Such clay bodies are not very plastic, which limits the types of forming that can be done. Stainless steel screen or mesh may also be useful as a supporting structure for low-shrinkage clay bodies. Paper-pulp-filled deflocculated clay slip with the consistency of papier-mâché might be a good choice to use over a metal armature (see the earlier section on paper clay, under Experimental Methods).

TECHNIQUES FOR ARCHITECTURAL USE

Ceramic murals and architectural reliefs differ from previously discussed forms because their large size requires that they be constructed of many units. They are discussed here because they are formed primarily by hand-building techniques.

The ceramic mural can be highly sculptural with deeply modeled relief, or composed of primarily flat tiles. The challenge of working on a large scale while still being able to fire small units has led many ceramists to this format. While tile pieces can often be made piece-by-piece and assembled later, reliefs are often most effective if modeled all at once and then cut into sections. A slant board, a rigid panel which slopes slightly backward, is often used so that the modeling may be done in a nearly vertical orientation. The shrinkage of the clay should be calculated and the slant board built large enough to accommodate this. A ledge at the bottom of the slant board keeps the clay from sliding off the board.

After modeling is completed, the relief is cut into sections. Care should be taken so that the cuts used to section the work don't detract from or destroy the image. Sometimes the sections can be divided in a way that partially hides the cuts. Other times a simple, unobtrusive grid pattern is the best choice for sectioning a large work. Thicker sections should be hollowed out after the clay has dried enough to be handled without distorting the sections. Each section can be placed on soft foam while the back is being hollowed. Hollowing the section by cutting grooves in the back will leave support and a surface for attachment of each tile after firing.

Tile can also be used in more sculptural ways. Many artists have used glazed ceramic tile over armatures of various kinds, from fired clay forms, to cement, wood, or steel.

Bruce Howdle makes large-scale ceramic murals by first modeling them on a slant wall, carefully taking into account the shrinkage of the clay so the mural will be the proper size when it is fired. In Figure 6-83 he can be seen working on one of his murals. He works quickly on these murals, building up the clay on the slant board and modeling it while it is still moist. Later the mural was cut up into hundreds of pieces which were hollowed out, reassembled to check and refine the surface, then fired after drying for two months.

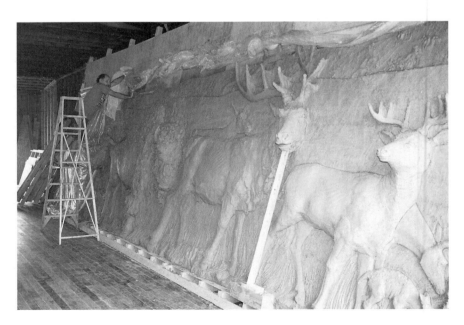

6-78 Bruce Howdle, USA; clay tile mural in progress, 1994, clay. Howdle's clay murals are executed on a grand scale befitting themes such as the European exploration and settlement of the American West. They are constructed on a slant board so as to be able to both see the forms in their final orientation and to be able to work the whole surface. The clay will be cut apart into separate smaller tiles after it has stiffened slightly.

LARGE-SCALE SCULPTURE

Sculpture weighing 50 to 100 pounds or more requires a different approach to building, moving, and firing the work. Lifting large work has given many a potter a strained back. From the start of the piece, the potter must plan how it will be moved into the kiln, and whether it will fit into the kiln in one piece or must be fired in sections. Heavy pieces can often be constructed on a rolling cart or dolly. If the dolly is built so that the top of the dolly matches the height of the kiln floor, the piece can be slid into the kiln. Large sculptural forms can be built on a piece of plywood or fiberboard. The plywood, with the sculpture atop it, can be slid from the top of the dolly into the kiln and allowed to burn out during the firing. A few dowels for rollers or a layer of sand or grog between the board and dolly will allow the sculpture to slide into the kiln more easily. Grog on the kiln floor will do the same within the kiln. Those fortunate enough to have a car kiln or a small hand forklift may find loading such large pieces easier. In Figure 6-79 Graham Marks is shown with one of his large works being lifted from the kiln with an overhead hoist and a sling. The artist doing such large work often needs to be inventive in finding ways to move heavy pieces of fragile clay. See Chapter 11, Kilns and Firing, for more information about firing large pieces.

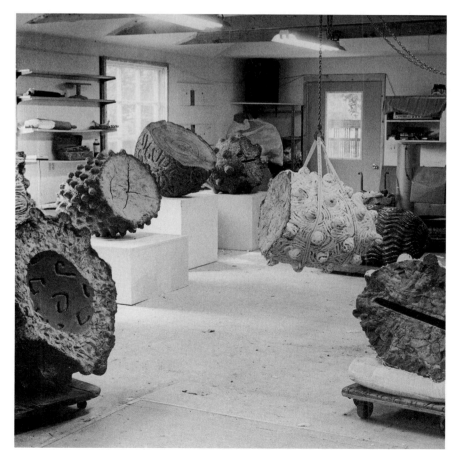

6-79 Graham Marks, USA. An overhead hoist and sling make it possible to move heavy work without injury. Marks' work, while hollow between the interior and exterior walls, is still quite heavy. The pieces are created and fired on the flatter end, then turned on their sides for exhibition.

Chapter 7

The introduction of the potter's wheel was a technical advance that gave a great impetus to ceramics. Before the development of the wheel, a simple turning device had aided potters in trimming and refining hand-built pots. This evolved into a weighted wheel head turning on a peg in the ground. At first, the primitive wheel served only as a convenient way to turn a pot while adding plastic coils and to give a final finish to the lip. This method is still used by many potters, including many of the Native American cultures. Remarkably symmetrical jars can be made by rotating a coiled pot on a **platos**—one shallow bowl resting on top of another inverted shallow bowl. Some cultures use a curved section of gourd for this purpose.

Although pots with wheel-turned feet dated as early as 3500 B.C. have been found in eastern Anatolia and northern Iran, it was not until about 3000 B.C. that small pots were thrown entirely on the wheel. By this time, improved agricultural methods and more prosperous villages led to the barter of goods. The crafts of the metalsmith, weaver, miller, and leather-worker, as well as the potter, developed for this market. Often an entire family engaged in pottery making and traded their wares for other goods. The potter's wheel was an essential tool, because it provided a more efficient method of making small and moderate-size pots. Larger pieces were still coiled or made by a combination of techniques.

More recently artists have considered the potter's wheel to be a useful tool for creating certain types of round shapes—merely one of many clay-forming tools available today. Whether one works to create functional pots or abstract sculpture, the ability to throw will be an asset to any artist working in clay.

THROWING ON THE WHEEL

The overriding advantage of the wheel is that one can make perfectly symmetrical rounded forms in a short time. Most student potters have greater initial success with coiling or slab techniques, but all are eager to try their luck on the potter's wheel. It is fascinating to watch an experienced potter take a

ball of plastic clay and produce a form that evolves and changes shape in a seemingly miraculous fashion. Developing skill at throwing on the wheel, however, demands much practice and an understanding of the proper sequence of operations.

A student should choose a single form, preferably a cylinder, and throw it over and over again. When throwing a different shape each time, the student learns nothing from previous errors and misses the most natural method of developing form and design. It is important to learn how to center the ball of clay and bring it up into a cylinder quickly, before the clay begins to soften and sag from the water. Gradually, the potter gains a sense of how far to push the clay—how thin the walls can be and how wide a curve can open before the clay becomes distorted and collapses. With practice the potter learns to throw taller and thinner shapes from the same amount of clay. A greater ease and freedom in handling the clay ultimately brings a dynamic quality to throwing.

There is little point for the beginner to make detailed drawings of an ideal pot, but gestural sketches to suggest proportion and overall shape may help the beginning potter to stay focused on the form at hand. Until he or she gains a feeling for the clay and a knowledge of possible forms, there is likely to be no relationship between the drawing and the pot. The final details should grow out of the actual process of throwing. Plastic clay has a quality all its own and imposes certain restrictions on the potter. Thus, there are certain forms and decorations that seem natural to clay, expressing a fluidity difficult to achieve with other media.

Selecting a Wheel

A suitable wheel is even more important for the beginner than for the experienced potter. The potter who throws for many hours every day really needs an electric wheel, but the beginner may find a kick wheel is preferable. During the critical moments in throwing, one instinctively stops kicking, thus slowing the speed of the wheel. A beginner on a power wheel may actually increase the speed at a moment of crisis, causing centrifugal force to tear the pot apart. On the other hand, centering on an electric wheel is generally much easier. Ultimately, the type of wheel used is a personal choice.

The wheel should have a rigid frame that is free of vibration. Its seat must be comfortable and adjustable for both height and distance from the wheel head. On a foot-powered wheel, kicking should be an easy motion, not tiring or awkward, and the footrest must be in a convenient location. If the student is throwing on an electric wheel, the seat should be adjusted to a comfortable height and brought as close to the wheel head as possible. Most electric wheels manufactured today are very low. Depending upon the height of the potter it may be desirable to elevate the wheel slightly to avoid back strain from hours spent in a bent-over position.

On a power wheel the speed control activated by foot (or on some older wheels by the knee) should allow easy operation from either a standing or a sitting position. Excessive speed in the wheel is not necessary or even desirable; 80 to 100 rpm is sufficient for centering, and even slower speeds may be desirable for throwing. The most critical factor is the torque transmitted through the reduction gears from the motor. A motor of at least 1/3 horsepower is essential for potters throwing large pieces, since the pressure needed to center a clay ball of 25 pounds (11.34 kg) or more may actually stop a 1/4-horsepower unit.

Preparing to Throw

A bowl of water and a few simple tools should be placed in easy reach. The following are the essentials:

◆ a small sponge to apply water and remove excess slip and water from inside the pot, plus a sponge attached to a long dowel if desired

◆ a small piece of leather to compress and smooth rims

◆ a pin tool (or needle attached to a dowel) to remove uneven rims, pop air bubbles, or gauge the thickness of bottoms

◆ a rib, of metal or wood, to aid in refining the form

◆ a fine, double-twisted wire to cut the finished pot off the wheel head

◆ a wooden potter's knife to trim up bottom

Composition board, plywood, or plaster bats will prevent thin pots from sagging or becoming distorted when removed from the wheel. Plaster bats were once preferred, but must be used with great care to avoid getting chips of plaster in the clay. Bats are essential for large pieces and very wide bowl shapes. Some wheel heads are equipped with removable metal pins that can be inserted into corresponding holes in the bats. Otherwise, wooden bats can be attached with soft clay or plaster bats with slip (Fig. 7-1).

From clay that has been thoroughly wedged (see Chapter 5), pieces are cut that can be held comfortably in one hand. A good test is to try to cover the whole ball using both hands. A comfortable size for beginning practice is when

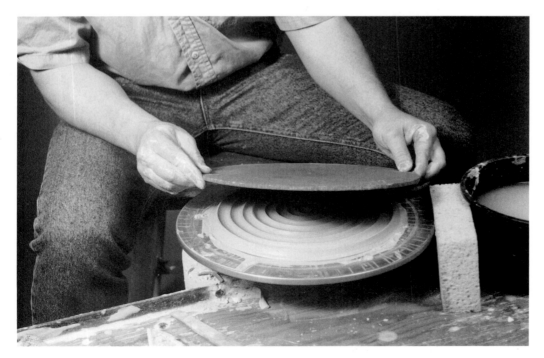

7-1 Attaching a bat A bat is attached to the wheel head using a pad of clay that has been thrown for that purpose. A slight amount of pressure in the center of the bat should affix it to the wheel. After the pot is thrown on the bat, the bat can be pried up from the wheelhead or cut loose using a wire held up against the underside of the bat.

the hands can just barely cover the clay ball—one to one and a half pounds (0.46 kg)—about the size of a small grapefruit or softball. If the clay ball is too small, it will be hard to manipulate; if too large, it will be difficult to center. The pieces are patted into balls, and all those that are not to be used immediately are covered with plastic. Even a slight drying of the surface will lessen the throwing qualities of the clay.

The consistency of the clay is very important when the student is learning to throw. It should be soft enough to be wedged and centered easily, but not too soft to stand up or hold its shape as it is thrown. If a pencil-sized coil of moist clay cracks when wound around the finger, the clay is not suitable for throwing. Clay that is too hard can be very frustrating, for it is difficult to wedge and center. In this situation, softer clay should be wedged into it.

Centering

The first step in throwing is **centering** the clay, or forcing it onto the exact center of the wheel head, as illustrated in Figures 7-2 and 7-3.

◆ If the wheel head or bat is dry, moisten it *very* slightly for better adhesion.

◆ Press the clay ball down in the center of the wheel head. Pat it gently on to center if it seems a bit off.

◆ Start the wheel turning briskly.

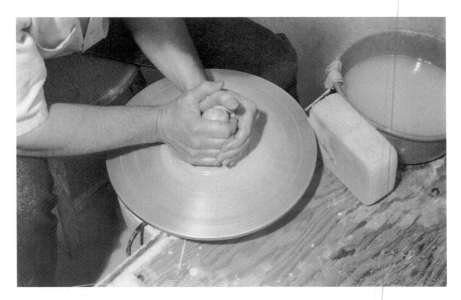

7-2 Basic centering techniques—wheel wedging. Centering the clay is one of the most important steps to successful throwing. Here the clay is compressed inward and up with the heel of the left hand pushing on the clay and the left elbow firmly braced against the hip. The right hand pulls inward from the side opposite the potter. Use plenty of water for lubrication and keep the wheel speed fast in a counterclockwise direction. Start pressing on the clay at the bottom, near the wheel head, and gradually change the pressure and angle of the hands to form a blunt cone. Any unevennness in the clay will be pushed to the point of the cone and dissappear. It is very important that both hands work together with the elbows braced firmly on the body. Note that this forms a triangle between the two arms and the body—a very strong, rigid shape.

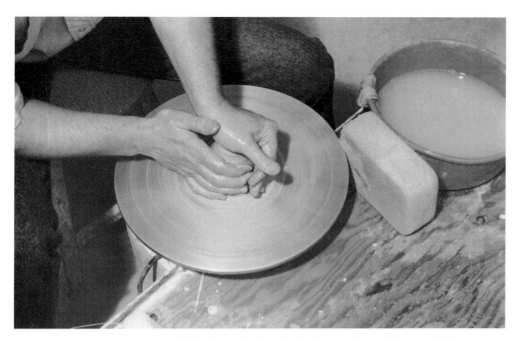

7-3 Basic centering techniques—wheel wedging. After the clay has been raised into a blunt conical shape, it can be pushed back down into a hemispherical shape using the left hand to push down. The right hand helps to push and steady. As the clay starts to flatten on top and mushroom out slightly, pressure is changed gradually to the sides to round off the lump. The pressure on the right hand, pulling inward with the fingers, becomes greater to help the clay become rounded. These first two steps are repeated a few tiems until the clay is centered—no wobbling. With a little practice these two steps become a fluid continuous motion.

◆ Dip your hands in water and wet the clay.

◆ With both hands apply pressure downward on the clay to seal it to the wheel and force it into a rounded beehive form.

◆ Depending upon your preference, brace either your left or right elbow on your thigh and force the clay toward the center with the heel of your hand, using the other hand to pull the clay back toward you to even out minor irregularities. If you feel your arm being moved by the clay, try to press your hip or side firmly against your elbow to stabilize your arm.

◆ Wheel wedge the clay to help center it, bringing it up into a cone then back into a rounded beehive shape several times (Fig. 7-3).

◆ Try to keep the form rounded and avoid sharp or squared-off forms, as these will tend to make for problems in centering. Especially avoid forming a depression in the top of the clay as it is being brought up during centering.

◆ When the beehive form is centered, flatten the form slightly and make a depression in the center with your thumbs.

◆ Add a little water and enlarge the depression.

The student is now ready to begin throwing the desired form. No more water should be used than necessary. While throwing, the hands should not be washed off but rather stripped of the slurry, which is used as a lubricant.

THROWING SPECIFIC FORMS

Many thrown forms evolve from a cylinder. The pottery by Karl Kuhns and Debbie Parker shown in Figure 7-14 evolved from basic cylinder forms. Bowls and bottles, for instance, evolve from a low, thick cylinder. Unless the potter can throw a perfectly uniform cylinder, it is useless to try to develop the form further. If the three basic variations below can be mastered, almost any form can then be made.

Throwing requires a very steady hand. Bracing one's arms against the body will greatly help with this. More than anything else, though, throwing requires that each time one touches the clay pressure must be applied slowly and steadily. One must avoid sudden movements. Quickly grabbing *or* letting go of the clay will rapidly cause the pot to become off-center. Avoid panic, concentrate on your actions right down to your fingertips, and count to ten if necessary when first applying pressure on the clay or letting go of it.

The Cylinder

The general procedure for throwing a cylinder is illustrated in Figures 7-4 through 7-13.

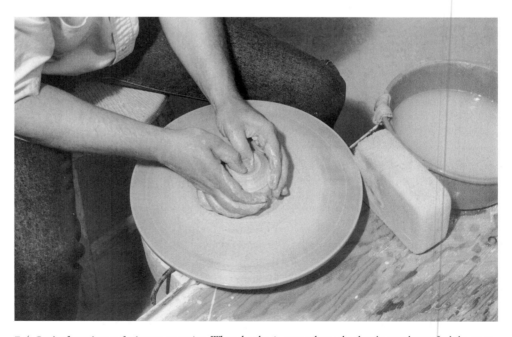

7-4 Basic throwing techniques—centering. When the clay is centered, use the thumbs together to find the exact center of the clay. Keep the hands loosely around the sides of the clay to help steady yourself. Note that the arms are still in the triangular shape, well braced against the body. The thumbs can continue pressing down together, with lots of water for lubrication, stopping about 3/8 inch from the wheel head. It's important to keep the thumbs together, gradually turning them nail to nail, so that they can follow the path of least resistance down the center of the spinning clay.

◆ After you have centered the clay and formed a slight depression in the exact center, open up the clay by pulling it toward you with your left hand inside the form and your right hand both steadying the left and compressing the rim.

◆ Develop a slightly rounded bottom not more than 0.5 inch (1.91 cm) thick. Sponge out excess water so the base does not become too soft.

◆ Use only the fingertips to throw small forms, the knuckles for larger ones. Several possible hand positions are shown. Use the position that is most comfortable and effective for you.

◆ With a firm support from the inside fingertips, pull the clay upward with the outside hand. The clay should not flare out at the base, but rather be forced in and pulled up. Most of the pressure on the clay should be from the outside fingertips or knuckles.

◆ Should the cylinder flare outward, encircle first the top of the form with the thumbs and middle fingers of both hands and compress it into a smaller diameter, then compress the rest. Eventually you should be able to throw a 12-inch (30.48-cm) cylinder with five or six pulls from bottom to top. This will require at least three pounds (1.4 kg) of clay.

◆ If the clay begins to sag, ball it up, dry it back to a plastic state, and rewedge it. It is a waste of time to fuss with a wobbly pot.

◆ A slight unevenness usually occurs at the rim. This can be compressed with the side of a finger after each pull as shown. If it gets too uneven, cut off a segment with a needle-like tool. Moisten and finish the rim with a wet strip of glove leather or chamois.

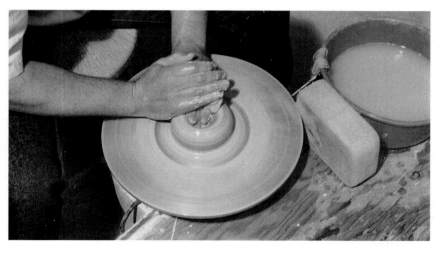

7-5 Basic throwing techniques–opening. It's important that the hands always work together on one place on the clay, never separately. Keep the hands and the clay quite wet. In this step the clay is stretched open by placing the fingers of the left hand inside the opening made with the thumbs, and the right thumb outside. The right hand wraps across the left, with the side of the right hand on the rim of the clay. The arms are still braced firmly against the body. Gradually pull back toward yourself, gently pulling the clay out into a larger ring leaving about 3/8 inch of clay on the bottom. The side of the right hand should press down gently on the rim of clay, forcing the clay to flow down and out across the wheel head. Clay moves most fluidly when it is under compression.

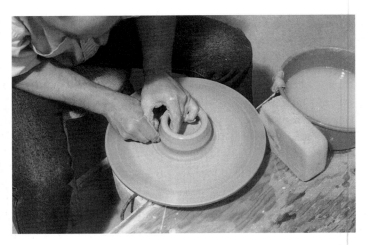

7-6 Basic throwing techniques—raising sides. After the clay has been opened into a thick ring, push it back toward the center slightly to compress the clay and to assure that it is still on center. To raise the sides, the hands are once again used together. Note the interlocking grip above, with the thumb of the left hand placed in between the thumb and forefinger of the right hand. The tips of the two forefingers should be aligned like the points of calipers. The thumb of the right hand is firmly gripped against the fingers, which give greater strength to that hand to move the clay. The elbows are still braced against the body. Start by making a finger-sized groove at the outside base of the ring of clay with the right forefinger, with the left hand inside to provide backup against the pressure. Maintain finger pressure and slowly make this groove spiral upward.

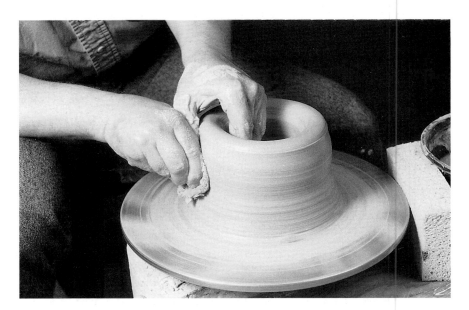

7-7 Basic throwing techniques—raising sides. An alternate grip for throwing is to use the forefinger knuckle of the right hand to press against the clay. For larger forms like this, using a small sponge between the knuckle and the clay may be helpful.

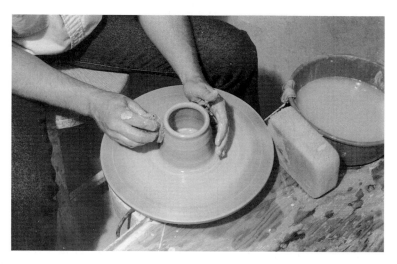

7-8 Basic throwing techniques—raising sides. This is what your cylinder should look like after a first pull or two. Keep the surface just barely wet by squeezing a small, wet sponge gently almost against the side of the pot, coating the surface of the clay evenly with water. Don't press the sponge against the clay, as this will wipe off the coating of slip that helps to lubricate your fingers, and with grog-filled clays make the surface very rough. Use water mainly on the outside, with a little water occasionally inside if the surface gets dry or sticky.

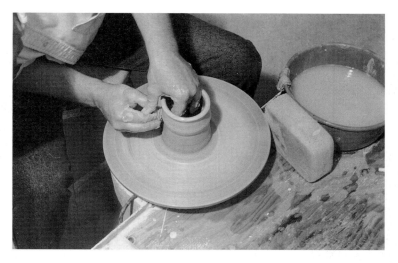

7-9 Basic throwing techniques—raising sides. As the form gets taller and the clay thinner you'll need to adjust your grip slightly. Here the thumb of the left hand just touches the fingers of the right hand, maintaining contact between the two hands so that they work together. Note that as the clay gets thinner, the ripple in the side caused by the inward pressure of the right hand becomes more visible. Gradually reduce the pressure against the clay as your hands move from the bottom to the top. Stop just below the rim, leaving the slightly thickened rim visible above. Note that the hands are at about 4 or 5 o'clock from the potter's perspective.

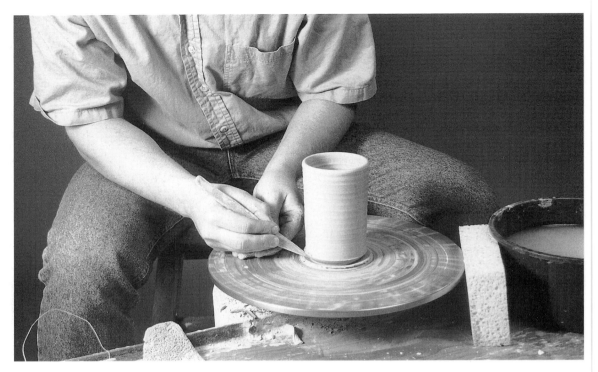

7-10 Basic throwing techniques – finishing. When the clay is evenly thinned to about 1/8- to 1/4-inch thickness and the cylinder is complete, trim off the extra clay at the base using a wooden potter's knife. Place the point against the clay about 1/4 inch above the wheel head, then slowly press the point downward at about a 45-degree angle until it hits the wheel head.

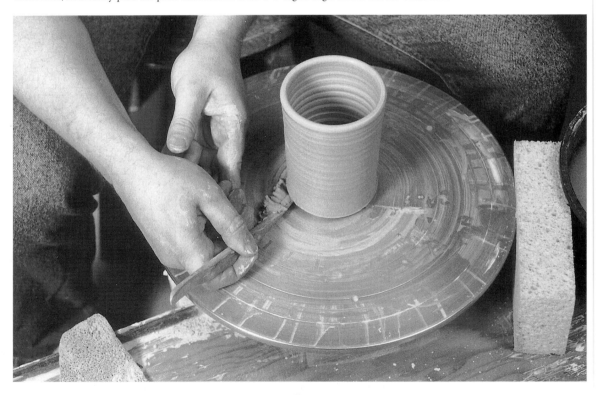

7-11 Basic throwing techniques – finishing. The clay trimmed off by undercutting the cylinder can be scraped away using the wooden potter's knife.

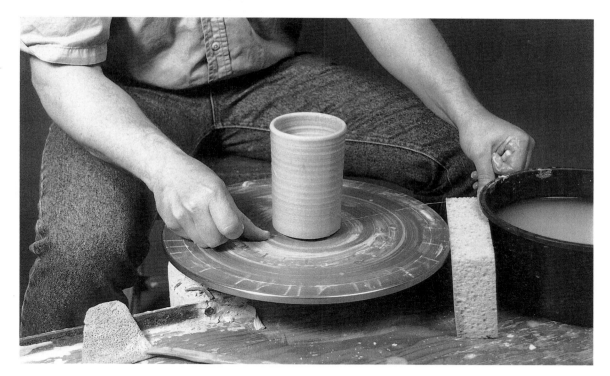

7-12 Basic throwing techniques—cutting off. The cut-off wire is stretched tightly between the hands and held against the wheel head with the right thumb. Pull the wire under the pot as it turns slowly, taking care that the wire stays tightly against the wheel head. You can squeeze a little water from your sponge onto the wheel head and into the groove at the base of the pot before cutting. This helps to easily slide the pot off the wheel.

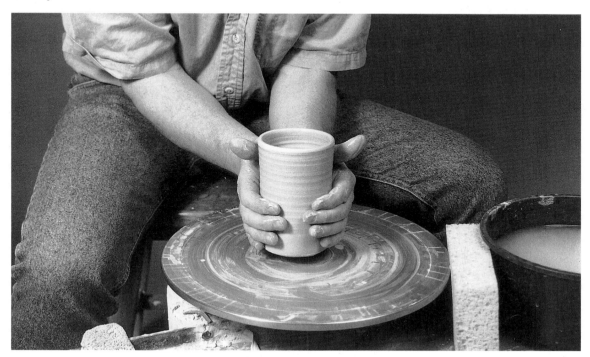

7-13 Basic throwing techniques—lifting from wheel. After being cut off with a wire, the cylinder is gently lifted off the wheel and placed on a ware board. Squeeze the pot gently at the very base with your two little fingers, give it a slight rotation to break it loose from the wheel head, and lift. If the hands are cleaned of slip, there should be no finger marks left on the pot from this step.

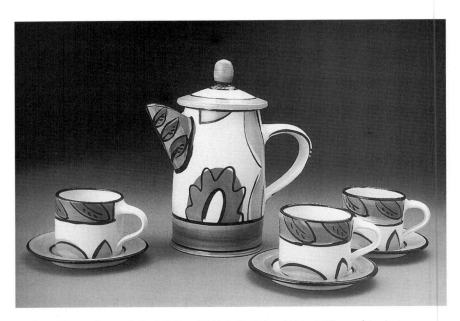

7-14 Debbie Parker and Karl Kuhns, USA; *Coffee Pot and Cups,* 1993, porcelain. A strong, simple handle is an essential element of these cups and coffee pot. Parker and Kuhns work together as a husband-and-wife team. They say, "We love to make pots that people can use every day. Collaboration has allowed us to highlight our individual strength in a shared vision—spirited pots that will invite use and serve well functionally and visually."

Whenever possible while throwing, the elbow should be braced on one's side for greater control. Larger forms, like the cylinder Yoshiro Ikeda is throwing in Figure 7-15, require that the potter find well-braced positions to be able to control the clay. If the potter is left-handed, he or she may want to try holding the hands in a reverse form, but only if the wheel direction is also reversed. The usual electric wheel turns in a counterclockwise direction. Therefore, to throw in this fashion a left-handed potter needs to reverse the wheel to rotate in a clockwise direction. A few electric wheels are available which can change direction.

Throwing Tips Watch out for these possible problems in throwing:

◆ Clay that is too stiff, too soft, poorly wedged, or left unwrapped to dry unevenly.

◆ Opening the clay before it is properly centered.

◆ Grabbing or letting go of the clay too quickly, leaving uneven spots in the clay wall.

◆ Greater pressure with one thumb than the other when opening the centered ball of clay, making the walls uneven.

◆ Applying too much water so that the clay becomes too soft.

◆ Unsteady pressure on the pot, making the pot wobble.

◆ Excessive pressure from both the inside and the outside fingers, causing a thin spot in the walls.

◆ Throwing too slowly and overworking the clay, causing the pot to sag.

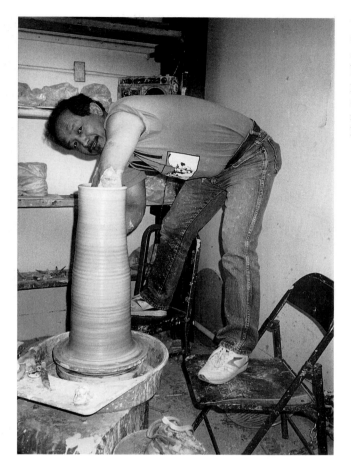

7-15 **Yoshiro Ikeda,** USA. Here Ikeda throws a large cylinder from 40 pounds of clay, and gets up on a couple of chairs to be able to reach down to the bottom of the pot. While a more stable footing would be adviseable for safety, throwing larger forms may call for improvisation of technique to handle the large amount of clay.

◆ Don't allow throwing water to collect in the bottom of the pot, making the clay soft and the pot difficult to remove from the wheel, a practice that also creates a tendency for the pot to crack during drying.

The Bowl and Open Forms

Throwing a small bowl presents few problems. The essential fact to remember is that the potter does not develop the desired form and then merely make it thinner and larger. Clay tends to sag as it is pulled outward; therefore, the potter must begin with a form that is higher and narrower than the finished piece. Also, because the clay wall becomes thinner when it is expanded to form the bowl shape, one must start with a slightly thicker rim than is desired for the final form of the bowl (Figs. 7-16 through 7-19).

◆ Start with a low cylinder shape with a rounded bottom. The smoothly curving interior of a bowl is a lovely space. Try not to let the interior of the bowl become too flattened with sharp inside corners.

◆ Gradually expand the bowl outward, concentrating on the form of the interior and rim. The outside bottom will be trimmed later to match the inside.

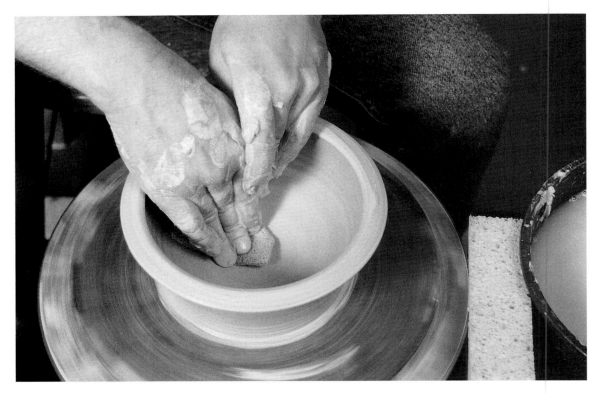

7-16 Bowls are thrown a bit differently than cylinders, with the bottom opened as a rounded curve rather than the flat base of the cylinder. As you pull out the clay to open it, let your hands rise up slightly. Bowls are often prone to S-cracks in the bottom, so prevent water from puddling in the bottom, as absorbed water will cause the clay to shrink more. An additional help for this problem, shown above, is to press firmly on the clay near the base and press it back in toward the center, being careful to retain the curvature of the bowl. Do this step just after opening while the bowl is still quite thick.

7-17 A potter's rib is a very useful tool for making bowls. Choose one with curves that match the size and scale of the bowl you are making. Wooden ribs often work best inside, but flexible metal ribs like the one in Figure 7-16 are good for giving a smooth contour to the outside of bowls. Here a sponge is being used in the left hand inside the bowl to minimize finger marks. It is always the potter's choice to smooth the surface with a rib, or to leave finger marks and other evidence of the throwing process.

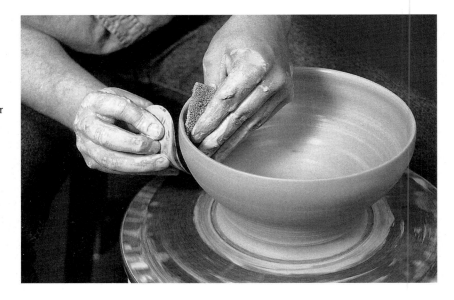

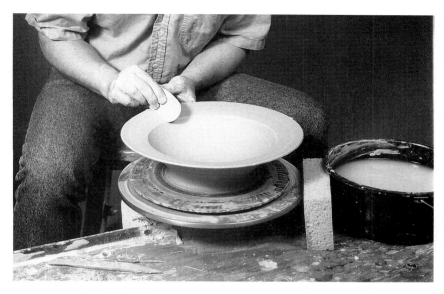

7-18 A rib is also useful for defining the rim of a bowl.

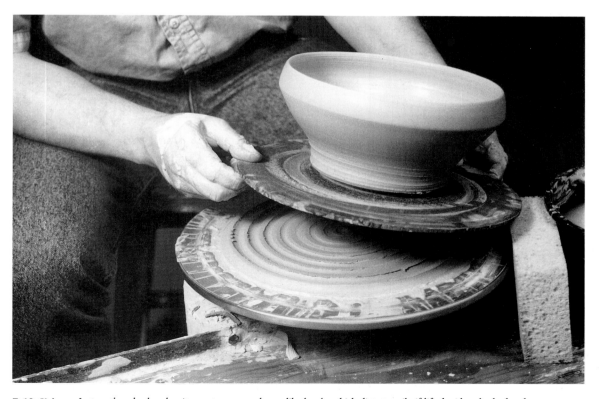

7-19 Using a bat on the wheel makes it easy to remove shapes like bowls, which distort easily if lifted with only the hands.

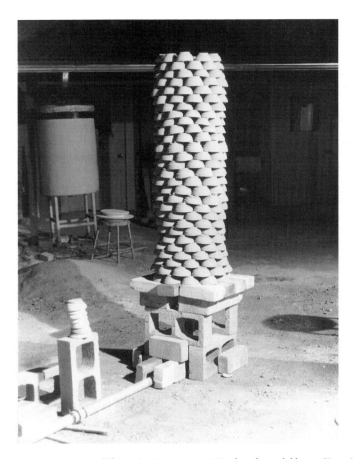

7-20 Louis Katz, USA; *Cylindrical Scove,* 1990, clay, charcoal, blower, 72 × 24 × 24 in. (182 × 60 × 60 cm). Katz threw 280 bowls, then stacked them in the fashion of a scove kiln where the kiln itself is made out of the ware to be fired. The interior was filled with charcoal briquets which provided the fuel. The pipe underneath provided air to aid in combustion. The act of firing this piece is a primary part of the content of the work.

◆ A rib will help to get a smoother curve to the inside of the bowl.

◆ Take care to keep excess water sponged out of the bottom of the bowl.

◆ Compress the bottom of the bowl by throwing the clay back toward the center after the first opening pulls are made. These last two items will greatly reduce the tendency of bowls to have S-cracks in the bottom.

Larger Pots

All the typical throwing problems are magnified when the potter wants to throw a really large bowl or other large form. One thing to always keep in mind is that as circular objects like plates double in size, they have four times the area and therefore it will take at *least* four times as much clay. A plate with three times the diameter will take at *least* nine times as much clay, probably more. With bowls the increase is greater, perhaps needing as much as six to

eight times the amount of clay as the diameter doubles. The other aspect of throwing that is related to this is the speed at which the clay moves through your fingers at the rim. The clay speed at the rim increases proportionally as the diameter increases, if the wheel speed is kept the same. This means that for larger diameter pots you'll want to slow down the wheel as the form increases in size.

Tips for Throwing Larger Bowls

◆ Wedge 10–15 pound (4.5–6.8 kg) batches of clay separately and then join them together to form a 20- to 30-pound (9.1–13.6 kg) or bigger ball. Only a little wedging will then be needed for the larger ball of clay.

◆ Pat the large ball of clay onto roughly the center on the wheel as the wheel turns slowly, then center as usual.

◆ Centering large amounts of clay may require a different stance to use your body weight to help steady the clay and better bracing of your arms against your body.

◆ After centering and opening the clay, form a low, thick cylinder.

◆ Pull this cylinder up quickly into a tall bowl shape.

◆ Leave the rim and side walls thick enough to expand to the desired diameter. Remember that the clay will get *much* thinner when expanded.

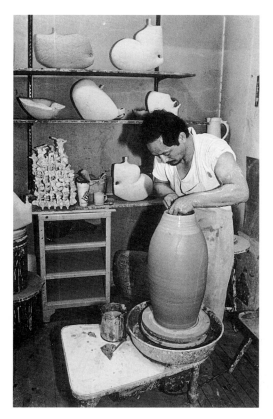

7-21 Yoshiro Ikeda, USA. The top of a larger bottle form is closed slowly, as the potter demonstrates here. Ikeda keeps the main surface of the pot fairly dry when throwing this large form. Water is applied only to the upper section where he is working. This helps to keep the clay from becoming overly soft and prevents the collapse of the large pot.

- Compress the bottom of the piece by pressing back toward the center. S-cracks are much more likely on larger pieces and this will greatly help to prevent them.

- It is often difficult in a bowl of this size to end up with sufficient clay to form an adequate rim, which strengthens the form and helps to reduce the tendency to warp in drying and firing. One solution is to join a thick coil to the rim after the bowl has stiffened somewhat. This coil extends the size of the pot and enlarges the rim to form a focal point for the visual movement of the large, rounded bowl form.

- Finally, cut the bowl off the bat with a double-twisted wire. Don't use water under the form when cutting it off, as you would with a pot thrown directly on the wheel head. Do not remove the bowl from the bat until it has dried to a nearly leather-hard state. If you don't separate the base from the bat by the rough cut of the wire, the foot of the bowl is more likely to crack in drying.

The Bottle and Closed Forms

The bottle is an intriguing project, not only for its technical problems in throwing, but for its design considerations. Whereas the bowl is a relatively simple form evolving from a low, thick cylinder into a curved shape and emphasizes its rather open interior, the bottle usually has a full, swelling body, a feeling of upward movement, and a more mysterious interior. Infinite variations between foot, body, neck, and rim are possible. Figures 4-40, 4-66, 8-12 and 8-16 show only a few of the many possibilities. Steps in closing the neck of the bottle form are illustrated in Figures 7-22 through 7-24.

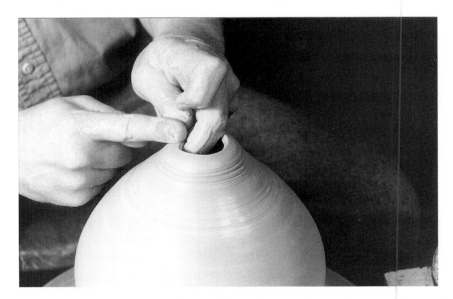

7-22 Throwing closed forms The clay is pushed inward to narrow the top of a pot to make a closed form such as a bottle or vase. The opening is kept as narrow as possible (just enough room to put the left hand inside) during the entire throwing process. When the sides are finished, the top is carefully narrowed in a series of steps. First the clay is pushed inward, with a finger inside the form for support. These forms are also useful as a starting point for sculpture where the form may be closed completely.

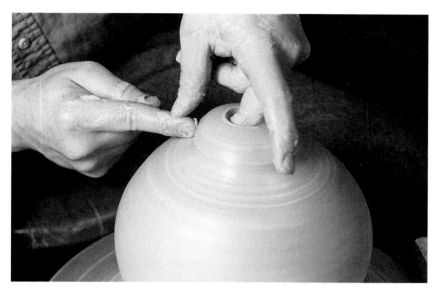

7-23 Throwing closed forms More clay is brought up toward the top as the clay is pushed down and in, supported carefully inside throughout the process. Note how the thumb of the left hand helps to steady the forefinger of the right hand which is doing most of the work.

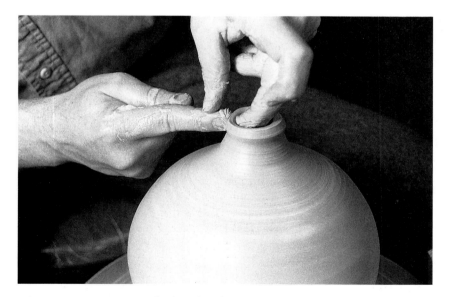

7-24 Throwing closed forms The clay is brought up into a neck-like shape. At this point the clay can be pushed in again with another series of these steps to close the form, or if a vase is desired the neck and rim can be finished. If the shoulder of the form starts to collapse slightly, blow a quick puff of air into the small opening to reinflate the form.

Tips on Throwing Closed Bottle Forms

◆ Begin the form with the basic cylinder as previously described, leaving it a little thicker from the middle to near the base since it will be flared out to form the round body of the bottle.

◆ Flare out the midsection of the cylinder with the fingertips or preferably with a flexible steel scraper or a wooden rib on the outside of the form. Keep the clay wall compressed, even while expanding the form, and it will be less likely to sag.

◆ Try to keep the opening at the top just large enough to allow your hand inside.

◆ Keep the points of pressure on the clay relatively small (just a fingertip inside and out). You may want to work the clay in a drier state with a lighter touch. Using less water helps to keep the form from sagging.

◆ After you have expanded the body, neck-in (narrow) the top, using an inward movement of the encircled fingers at the very top, which also thickens the rim a little. Always start by necking-in the rim first, then the clay below it. Care must be taken not to twist or collapse the clay (and the clay must be very evenly thrown).

◆ Carefully pull up the top so that it is again more vertical, using the fingertips and being careful not to enlarge the opening. Next neck-in the opening again (see the illustrations). After repeating this process several times to bring the pot to the shape you desire, finish the rim with a piece of leather chamois.

◆ Remove excess clay from the base and cut the bottle from the bat with a fine, twisted wire.

The final bottle or vase should not be expected to be taller than the original cylinder. Although the necking-in of the top section thickens the clay and allows it to be pulled up farther, the inevitable vibration of throwing causes the clay to settle. Truly round forms will need to be trimmed at the bottom. A chuck is useful to hold the pot for trimming bottles and other pottery forms with narrow necks (see Figure 7-37).

Multiple-Section Forms

There are limits for most people to the potential size of forms thrown from one section of clay. Most students can comfortably center only about 20 pounds (9.1 kg) of clay at a time, and 50 pounds (22.7 kg) is certainly the maximum for most potters. It is foolish to try to stretch clay beyond its natural capacity. Trying to make the walls ever taller always leads to excessive thinness and may cause the form to flop.

Many potters find it more convenient to throw an extremely tall or large shape in sections. The sections should be allowed to dry to a leather-hard state and then are joined. The Greeks used this method for their funerary jars, which often stood more than 4 feet (1.22 m) tall (see Figure 2-42).

If a smaller pot consists of different angular shapes, such as a teapot, it too can be thrown in multiple sections. This sectional approach also is good when one wants to alter forms to intentionally out-of-round shapes, for instance when squaring the body of a pot, but keeping the rim very round.

The Multiple-Section Pot

The pot by Don Reitz in Figure 7-25 is more than 34 inches (86 cm) tall and consists of five separately thrown sections. By throwing in sections Reitz can have more control over the overall form, as well as creating powerful transitions

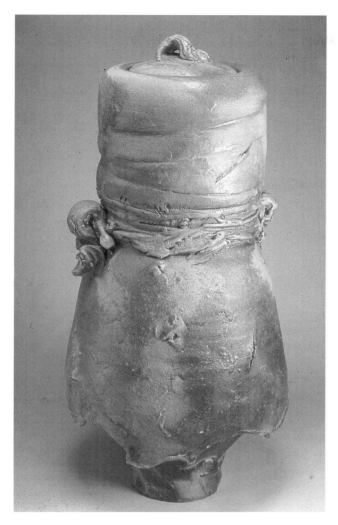

7-25 Don Reitz, USA; Celebration Vessel, 1997. Wood-fired stoneware, 49 × 20 in. (124.5 × 50.8 cm). Reitz creates his monumental pots by throwing them in sections. This piece was assembled from four or five thrown sections. Preplanning, careful measurement of diameters, and attention to form assure that the overall form will go together as planned. Reitz is careful that these requirements don't get in the way of the expressive qualities of the clay and throwing process. Wood firing this pot preserved the intimate surface details.

between each section and the textures and marks left from forming them on the wheel. Some general guidelines will help the beginner attempting a multiple-section pot.

- ◆ Make a rough sketch of the final form, deciding upon the number of pieces, how they will be thrown, including the approximate heights and diameters, and how they will be joined.

- ◆ Throw the sections from one clay body, wedge and prepare the clay at the same time, and keep unthrown clay covered with plastic.

- ◆ Throw the pieces in a rapid sequence so they will be of the same consistency as they dry.

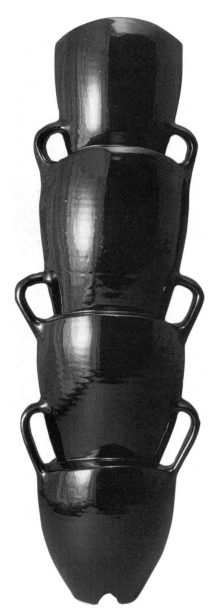

7-26 Michelle Coakes, USA; *Empire Vase*, 1993, earthenware, 22 × 7 × 4 in. (55 × 17 × 10 cm). Coakes uses thrown forms to build this sculptural vase. The delicate handles add a nice counterpoint to the solidity of the main form. The smooth surface has an elegant tactility. She says of what drew her to work with clay, "I just had to touch it—then I was hooked."

◆ Cover the rims of each section with plastic after they have stiffened slightly to promote an even drying. Smaller parts may be placed inside larger ones for slow and more even drying before assembly.

◆ Join the top of one section to the top of another and bottoms to bottoms, if at all possible, to ensure a similar moisture content.

◆ *Never* join a flat bottom to another flat bottom. Always cut out at least one of the bottoms (leaving it as a thickened rim of clay) to make a stronger attachment.

◆ Score all joints, and thoroughly coat them with thick slip before assembling. Some potters throw the rims to be connected so that they will interlock (one rim a V shape, the other a groove) for a stronger joint.

◆ Make curves round and uniform as in a bridge arch for strength. Any near-horizontal flatness, especially near the bottom of the form, may cause the form to collapse. Remember also that the parts near the bottom have to hold the weight of the entire form.

◆ Cover the assembled form tightly with plastic for three or four days, then dry slowly. This will equalize the wetness and shrinkage of the different parts and help to prevent cracking.

◆ Some forms may be easier to trim *before* assembling the parts.

More Throwing Tips

Most large pots and wide bowls must be thrown on a bat, but many pieces can be thrown conveniently right on the wheel head. These can be cut from the wheel with a wire or string, then lifted off with a slight twisting motion of the first two fingers of both hands (Fig. 7-27). A thicker base and a finger-sized undercut with a wooden tool will provide an easier grip and will lessen the tendency of the pot to become distorted, although many potters use this distortion in an artistic fashion. Lightly adhering a sheet of newspaper to the rim of a large bowl or vase before removing it from the wheel will help to keep the shape round. Let the newspaper dry loose rather than peeling it off while the pot is still wet.

A hinged, adjustable pointer is a traditional guide for throwing pots of uniform height and/or diameter. Other simple gauges and measuring sticks may also be helpful in making parts which need to fit together or be a specific size.

Throwing Off the Hump

Small pieces such as lids, cups, bowls, or bottles can be thrown off the **hump** (a larger mass of clay). This method can be much faster when a great many pots of the same size are being thrown at the same time, for it is easier than centering each as a separate ball of clay. Care must be taken when throwing off the hump to compress the inside bottoms of the pots. Wheel wedging the clay at the top of the hump four or five times before opening each pot will also help to prevent S-cracking. To remove the thrown form from the larger mass of clay, a groove is cut at the bottom, one end of a string is allowed to wind a turn or two into the groove, and is then pulled through the bottom with the wheel revolving slowly. A needle tool can be used to cut off very small pots thrown off the hump (Fig. 7-28).

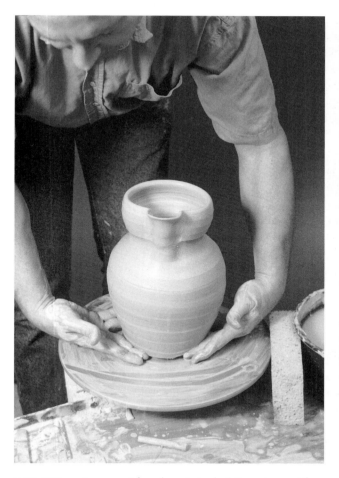

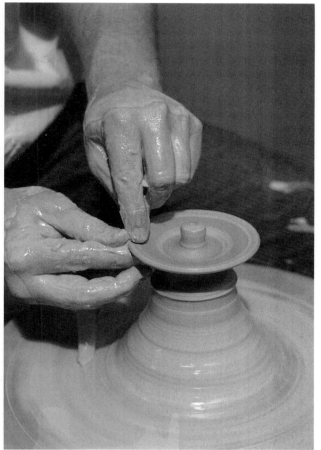

7-27 Lifting a larger pot from the potter's wheel. Removing a pot from the wheel is easier if the bottom is first cleaned up using the wooden potter's knife. The piece is then undercut with a wire and the pot is picked up or slid to a ware board. The beveled cut at the base provides a grip for the fingers. If you choose to slide the piece onto a board, wet the wheel head and be sure to lightly dampen the board first to allow the piece to slide easily.

7-28 Throwing off the hump Throwing off the hump is a useful skill for making smaller pots or parts like lids or spouts. As each small part is thrown it is cut off the mound of clay with a wire, string, or needle tool. The mass of clay is roughly centered, then a small amount of clay at the top of the lump is wheel wedged and carefully centered. Only enough clay for the size of pot needed is centered, with the rest of the clay below left largely uncentered until it is needed.

Trimming

Trimming removes excess clay from the bottom of a pot, refines the form and leaves it lighter and less likely to crack. If desired, trimming can give the pot a **foot**—a ridge of clay at the base to add stability and serve as a design accent. Some pots can be trimmed during the throwing stage or thrown sufficiently thin, and the mark of the cutting wire left as it is.

Most often, trimming or **tooling** is done when the pots have dried to the leather-hard stage. If the pot becomes too dry, there is a danger of cracking; if too soft, it will sag. A pot that becomes a bit too dry after throwing can be restored to a leather-hard state by spraying it with a plant mister both inside and out. This should be done several times to ensure an even absorption of water.

One can also dip small forms quickly in warm water, then lightly shake off the excess water. This works well for rims that have dried a bit too quickly. Plaster throwing bats will absorb the excess moisture and prevent the bottom from becoming too soft. A pot that has become completely dry, however, should be discarded; it will take less time to throw a new one than to reclaim the old. Laying a sheet of newsprint or thin plastic over bowl and plate rims also helps them to dry more slowly and evenly.

If thrown on bats, pots should be cut through underneath the bottom with a wire to allow the clay to contract evenly. Plates, platters, and wide bowls should be inverted on a wooden bat after they have stiffened slightly to allow the thicker bottom to dry. This will also prevent the rims from drying too quickly and thus reduce the chances of warping and cracking.

When the pot is leather-hard, the potter should carefully observe its inside shape and judge its thickness to determine how much clay needs to be removed. If unsure, you can insert a pin tool through the clay wall to judge the thickness (Figs. 7-29 through 7-37).

Trimming Tips

◆ Place the pot upside down on the wheel and center it. A tall vase or bottle can be placed inside a wide-mouthed heavy plastic or ceramic jar or chuck that has been centered and secured to the wheel.

◆ Press a roll of clay around the circumference, and attach the pot (or the supporting jar) securely to the wheel. Avoid using random lumps of clay, for these place a strain on thin rims and cause cracks.

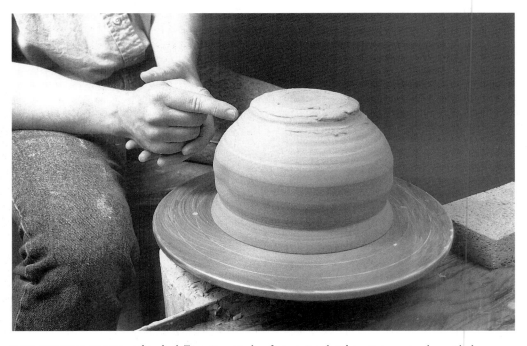

7-29 Trimming pottery on the wheel. Trimming or tooling first requires that the potter re-center the upside-down leather-hard pot on the wheel. This can be done by starting the wheel, holding a finger or tool steady to see where the pot is most off center, and stopping the wheel to move the pot sideways slightly in the direction indicated.

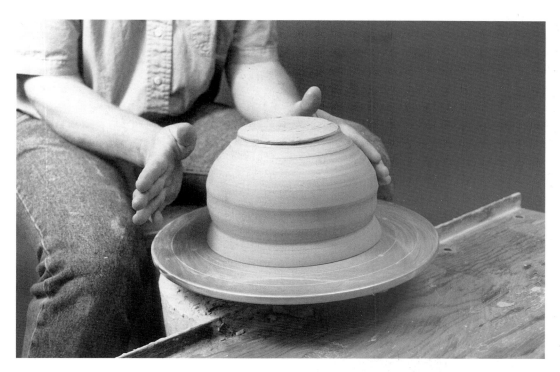

7-30 Trimming pottery on the wheel. Tap centering is a faster process of re-centering ware to be trimmed. As the wheel turns slowly, the left hand gauges where the pot is off center, and then after a split-second delay, the right hand gives the pot a light tap to move it sideways. It takes a little practice to learn the wheel speed and rhythm that best suits your reaction time. Use a coffee can filled with sand to practice.

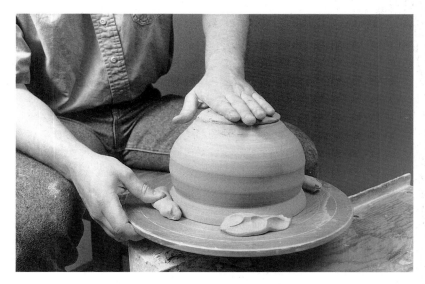

7-31 Trimming pottery on the wheel. Once the pot is centered on the wheel head, it must be firmly held in place during trimming. Thick coils of soft plastic clay are added as chunks to hold the bowl. Hold the pot down against the wheel to keep it on center, place a coil of clay against the rim, and then press the coil down against the wheel head to stick it. Don't press the plastic clay hard against the rim or it may distort the rim.

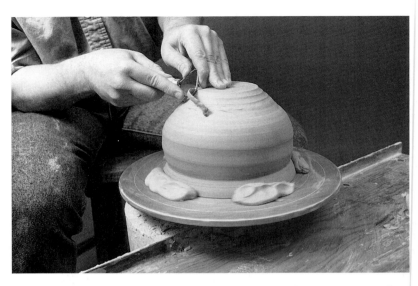

7-32 Trimming pottery on the wheel. The clay is shaved away a little at a time using a loop tool. Hold the tool firmly at about a 45-degree angle to the clay surface so that the tool peels off a continuous strip of clay as the pot turns. Start trimming using a small diameter loop tool or the small corner of a large trimming tool, taking little cuts until the surface is leveled. Then use the broader edge of the tool if a smooth surface is desired. Hold the pot down on the wheel head with the left hand. Brace yourself for stability just as when throwing.

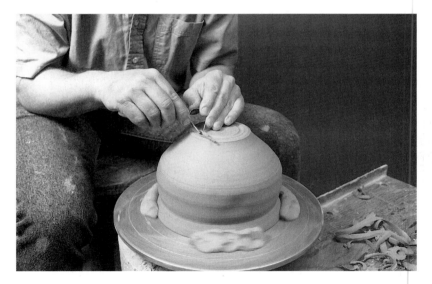

7-33 Trimming pottery on the wheel. After the outside is trimmed to match the inside shape of the bowl, the foot is cut. The size of the foot rim should be carefully considered to complement the form of the pot. First cut a groove to mark the width of the foot, then trim out the center.

◆ With the wheel turning at a moderate speed, apply the trimming tool to the pot and shape the bottom. Trimming too slowly leads to uneven trimming (see Figure 7-32).

◆ Begin by reducing the diameter of the base, where most of the clay tends to be. Trimming will help to control a foot that is too wide.

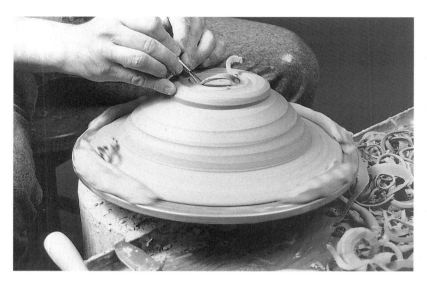

7-34 Trimming pottery on the wheel. Make the foot robust enough to hold the weight of the pot. A well-designed foot can elevate and accentuate the pot, or be a subtle underpinning to the form.

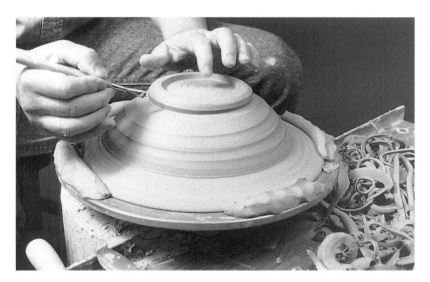

7-35 Trimming pottery on the wheel. Judging the thickness of the bottom when trimming takes some practice. Some potters tap on the bottom to hear the change in sound as the bottom gets thinner and more drum-like. Taking a careful look at the shape of the inside of the pot before trimming is equally important!

◆ Trim the outside to match the interior curves of the form as much as possible. Obviously some variations in detail between interior and exterior surfaces may be desirable.

◆ Trim the outside of the form first, then finish by trimming out the interior of the foot after the final outside diameter has been determined (Fig. 7-33).

In trimming, the potter tries to maintain the same fluid motion as in throwing, so that the foot seems like a natural extension of the pot. The inside

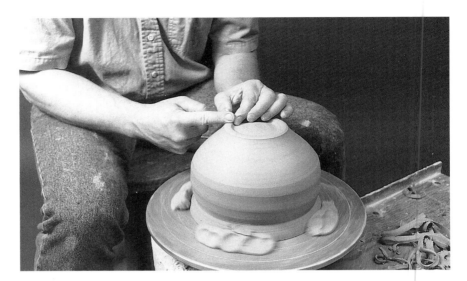

7-36 Trimming pottery on the wheel. The foot of the pot can be rounded and smoothed after trimming by pressing the side of the finger firmly against the clay. Use a very small amound of water if needed to help smooth the foot. A rib can be used if the clay is too dry or too groggy.

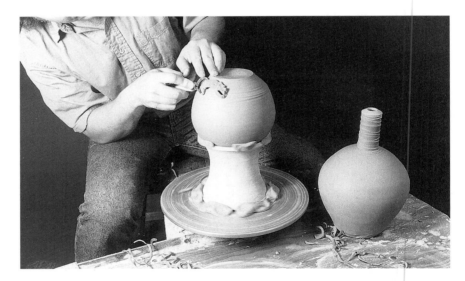

7-37 Trimming using a chuck A bisque-fired clay chuck (the cooling tower shape under this long-necked round bottle being trimmed) is useful for trimming shapes that otherwise would be impossible to turn upside down on the wheel for trimming. A number of variations in shapes and sizes of chucks can be quickly thrown on the wheel. Make the chucks thick and sturdy enough to withstand repeated use. Clay chucks like this can be used as leather-hard clay or even when dry, but are stronger when bisque fired.

curve of the foot should repeat the curve of the exterior. It is interesting to note that while Japanese potters throw with the wheel turning in a clock-wise direction, they trim pots turning in a counterclockwise motion. This makes the trimming marks blend into the throwing rings without changing the surface texture.

Although the height and contour of a foot depend on the overall design, the base edge should have a slight bevel to make it less susceptible to chipping. An outward taper of the foot will give the pot both an actual and a visual stability. It's important that the style of foot used is fitting to the overall form of the pot. Especially wide shapes such as platters may need a second interior foot to support the large expanse of clay and prevent sagging. Tall pedestal-type feet can be thrown separately, tooled, and then joined to bowl or cup shapes when the clay is leather hard. Carved or hand-cut feet are an alternative to trimming circular feet on the potter's wheel. Hand-built feet can also be applied to the tooled bottom at the leather-hard stage. After firing, the bottoms of tooled pots can be ground if desired to remove any roughness and prevent scratching of furniture.

APPENDAGES

A basic form can be given various appendages to make it more functional or add visual interest. These include handles, spouts, extended rims, and lids. Any appendage attached to a thrown pot should be the same moisture content so that in drying the two parts will shrink at the same rate. This makes the join stronger, and less apt to separate and crack as it dries.

Handles

Handles are joined to a form after it has been trimmed and while it is still leather hard. The series of photos in Figures 7-38 through 7-45 show the steps of pulling a few types of handles.

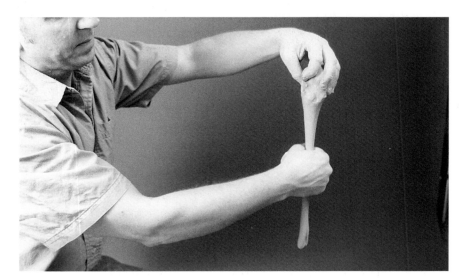

7-38 Pulling a handle Pulled handles are formed by lightly squeezing the clay between the thumb and forefinger as the hand is moved down the thick coil of plastic clay. Keep the hand doing the pulling quite wet to let it slide easily over the clay.

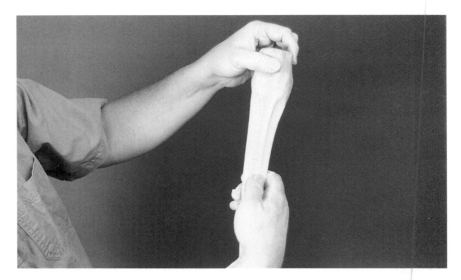

7-39 Pulling a handle Another view of an almost completed pulled handle shows how the thumb can be used to put decorative grooves in the handle.

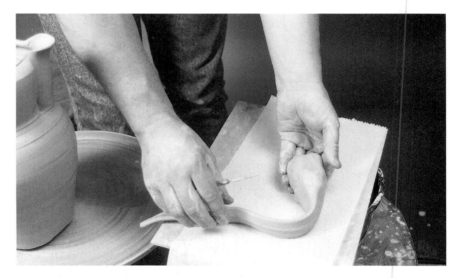

7-40 Pulling a handle After the handle is pulled it may be useful to let it dry slightly. You can lay the handle on its side on a clean piece of paper, shaping it farily closely to the needed shape. After the clay stiffens a bit it may be impossible to make the sharp bends needed in the handle without it cracking. Cut off the large chunk of clay from which the handle was pulled, but leave some extra clay on both ends of the handle so that it can be cut and fitted to the pot.

Handle-Pulling Tips

◆ Wedge clay that is approximately throwing consistency (you may like it slightly stiffer or slightly softer), and roll it into a thick carrot-like taper.

◆ Hold the butt end in the left hand, wet the right hand, and pull the clay firmly but gently in a swift, downward motion.

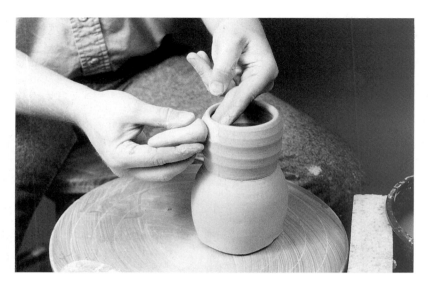

7-41 Pulling a handle Handles can also be pulled directly from the form. A small cone-shaped lug of clay is first attached at the top of the handle. The pot must be quite firm, but still soft enough to allow the attachment of wet clay without cracking as it dries—not quite leather hard is ideal.

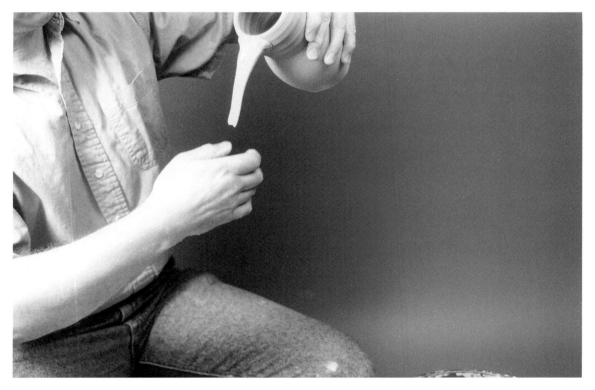

7-42 Pulling a handle The handle is then pulled directly from the pot. Many potters feel that this gives a more integrated feel to the handle.

7-43 Pulling a handle The handle is then bent in a pleasing shape that works with the pot and attached at the bottom. Pinch off any excess in length.

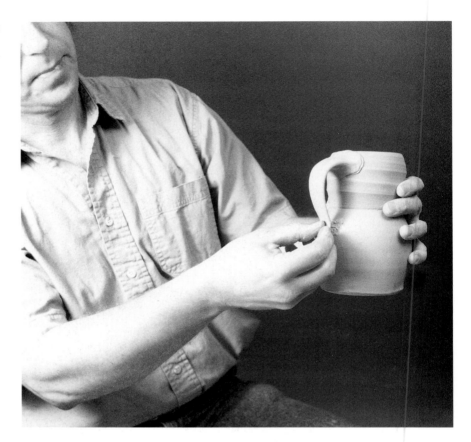

◆ Pull the clay three or four times, wetting the hand each time and turning the mass of clay.

◆ Apply even pressure that is lighter toward the end of the elongated strip.

◆ If the thickness is erratic, cut off the uneven part, because it will weaken the handle.

◆ Pressure with the thumb against the fingers during the pulling motion can be used to make a more comfortable handle (see Figure 7-39). More ornate handles can be made by varying the thumb position while pulling.

◆ Score and apply slip to the two points of attachment on the pot.

◆ Pinch or cut the butt end of the handle, and press it firmly against the upper section of the pot, smoothing the clay to strengthen the join.

◆ Correct the curve, and fasten the bottom of the handle to the score marks.

◆ Look critically at the negative space created between the handle and the pot and adjust the curve of the handle as needed, but try not to overwork the handle.

Handles for cups and other small objects can be made by attaching the thicker end of a roughly formed handle to the upper score mark and pulling the handle directly on the pot (Figs. 7-41 through 7-43). Small knobs of clay

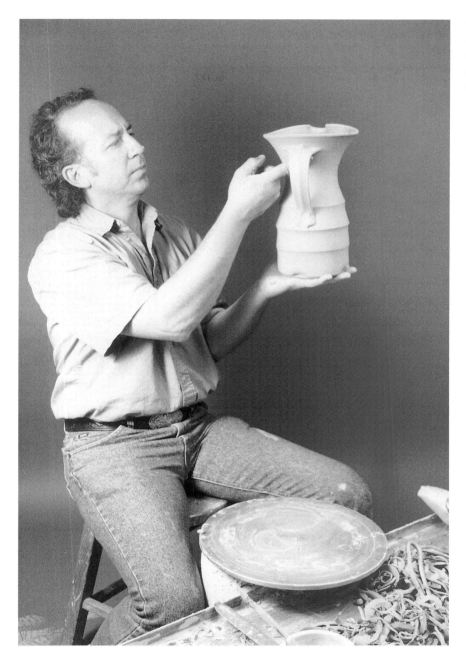

7-44 Pulling a handle After the handle is attached, it's necessary to look at its shape carefully, and make any necessary adjustments. Handles should fit aesthetically with the pot.

can be placed on the upper ridge for a thumb rest, but avoid adding unnecessary "gum wad" like additions of clay which don't really function in a visual or utilitarian way. Decorative handles made of coils, pinched forms, or slabs of clay are also possible.

Whichever method is used, after the joining is completed the ware should be placed in a damp room or covered with plastic to allow a slow and even drying. This will prevent the small diameter of the handle from drying and contracting faster than the body of the pot, causing cracks to develop.

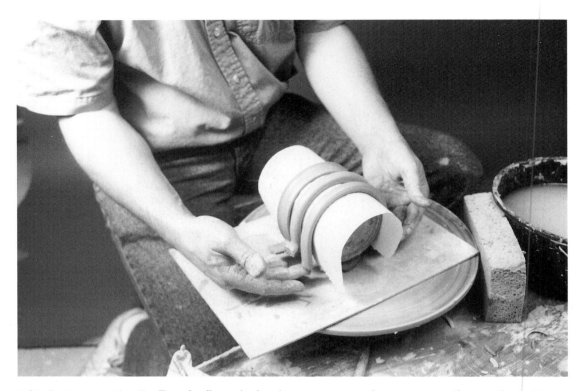

7-45 Shaping teapot handles Teapot handles can be shaped over a can or piece of pottery to get a uniform round curve. Note the piece of paper between the handles and the coffee can to keep them from sticking.

The beginner may have to pull many handles in order to achieve one that looks and fits well on a pot. At first it may help to let the handle dry slightly after pulling. The handle can be bent to approximate shape and laid on its side on a piece of paper, or left attached to the larger chunk of clay and allowed to bend in a graceful curve. The joining process is easier if the surface of the handle is not wet with slip.

When a high, rising handle, as for a teapot, is needed, the potter may prefer to purchase a ready-made one of cane. In this event, a lug (small thick coil) of clay is attached to two sides to accept the handle. The lugs should be joined, with scoring and slip, in the usual manner. Handles made from other materials may also be attached in a similar manner if they will support the weight of the pot. A conventional pulled or hand-built handle can also be used on a teapot. These can be placed over a coffee can or other curved form to hold their shape until they are stiff enough to attach (Fig. 7-45).

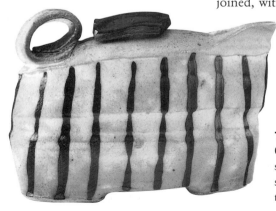

7-46 Linda Christianson; *Teapot,* 1995, wood-fired stoneware, 8 in (20 cm). Christianson is known for her lively pulled handles. Many of them are quite wide, and sometimes placed in unexpected positions, such as the one on this teapot. She says, "It surprises me that after nearly twenty years of making pots, it is still a thrill and challenge to make a cup and pull a handle."

Spouts and Pouring Vessels

Pitcher spouts are often made soon after the pot has been thrown, while the clay is still soft (Figs. 7-47 through 7-49).

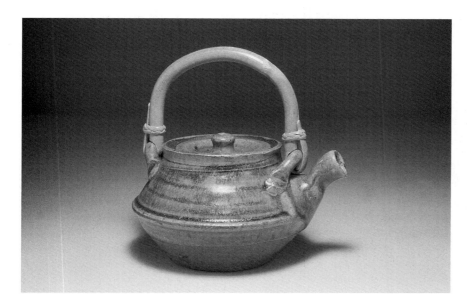

7-47 Warren MacKenzie, USA; teapot, 1989, stoneware, 9 in. (22 cm). The bamboo handle on this classic teapot is attached by strong clay lugs. Note the wonderful curve added to the spout right after it was thrown.

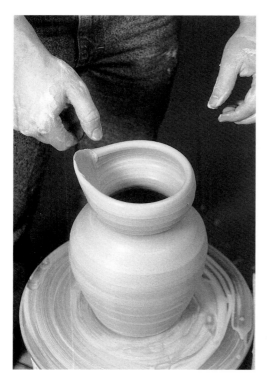

7-48 Pulling a pitcher spout A variety of ways of making pitcher spouts is shown in this series of photos. In this photo the spout is being pulled from a thick rim. Some potters will also add a small coil of clay to the rim to be able to pull the spout higher.

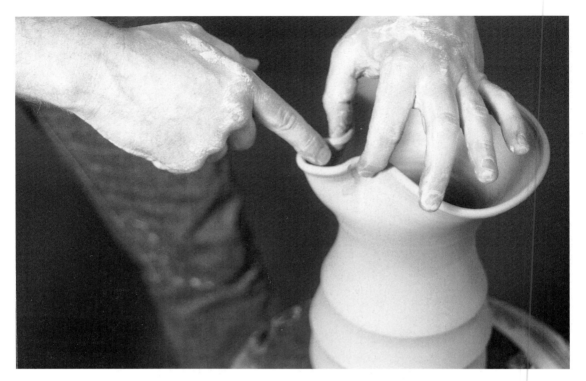

7-49 Pulling a pitcher spout Another variation in pitcher spouts is to throw a form with a flaring rim, then fold the rim in while holding the spout opening steady with a finger. This maintains a roughly circular shape to the top of the pitcher. The spout is then smoothed, pulled, and shaped for proper function. Many other types of spouts are possible.

Tips for Pitcher Spouts

◆ Place the thumb and index finger against the rim to act as a support.

◆ Form the spout with a wiping motion of the index finger of the other hand while pushing gently in toward the center with thumb and finger. This keeps the overall shape of the top round.

◆ Keep the width of the spout in proportion to the size of the pitcher. Tiny spouts on a large pitcher will not usually pour well.

◆ If the wiping motion is continuous and the edge sharp, the pitcher will not drip. Don't let the spout get too thin and fragile, but keep it more of a 70- to 90-degree angle.

◆ Spouts can also be pulled somewhat like a handle from a rim that is left slightly thicker than normal.

◆ A spout need not be an extension of the rim. It may also be formed from a tongue-shaped slab of clay that is folded into a U-shape and attached to the rim (see Figures 7-50 and 7-67).

A teapot spout is thrown at the same time as the pot and the lid, so that all will shrink at the same rate. This kind of spout is more complicated because there are many functional and aesthetic considerations. The spout must be long

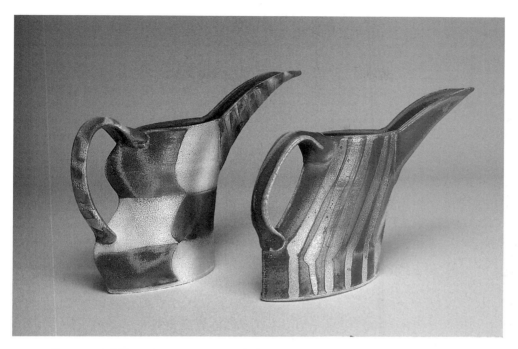

7-50 Jeff Oestreich, USA; *Beaked Pitchers,* 1994, salt-glazed stoneware, 8 × 8 × 3 in. (20 × 20 × 7 cm).
Thrown and heavily altered, these small pitchers feature an added spout which extends beak-like from the thrown
form. Oestreich cuts and reassembles the thrown shape to create the assymetrical profile of the body of the pitcher,
then adds the spout, which is made from a tongue-like slab of clay.

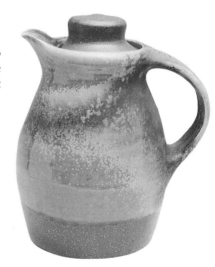

enough to reach above the rim of the teapot, or else the pot cannot be filled to
the top. The base should be broad and low on the pot so as not to become
clogged with tea leaves. Spouts pour best when they taper to their smallest
diameter right near the opening.

Tips for Teapot and Ewer Spouts

◆ Often the spout can be stored temporarily inside the teapot while waiting
for it to be assembled. This keeps all the parts equally moist.

◆ Cut and fit the spout to get a pleasing angle and connection to the pot. Be
careful to have the opening of the spout at about the same level as the lid
opening, so that the vessel can be filled completely.

◆ Once the placement has been established, trace the outline of the base of
the spout on the pot.

◆ With the point of a fettling knife or other hole-making tool, make as many
strainer holes as the space will permit in the portion of the pot wall to be
covered by the spout. Thinning the section of the pot wall inside the spout
will make it easier to glaze without clogging small strainer holes.

◆ Wait until the clay has dried to brush away any rough burrs, for otherwise
they will stick in the holes.

7-51 Clary Illian, USA; *Lidded Pitcher,*
1994, salt-fired stoneware, 14 in. (35 cm).
Illian's beautifully functional ware features
strong visual lines that perfectly complement
its use. Note she has pulled the spout to a
delicate edge, and the handle springs from the
lip in a graceful arc.

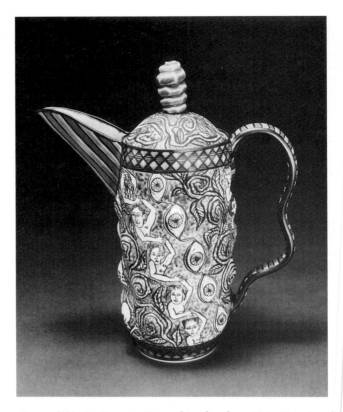

7-52 George Bowes, USA; *Resilience*, 1990, porcelain, slip, glazes, 12 × 11 × 6 in. (30 × 27 × 15 cm). The oversized slab spout on this pot is balanced by the lyrical curving line of the handle. The form has been altered while wet to create the knobby surface on the sides, which then provides a ground for Bowes' complex painting. Bowes uses a method similar to classic majolica painting to get the intricate patterning of the surface of this piece. Bowes says, "Functional ceramic objects, as a result of their respective uses, are intricately entwined with our daily lives. When viewing or using a piece of this nature, there is no way to divorce one's self from the associations of daily routine. I believe this sets up the perfect format to discuss ideas and opinions of what it means to be a participant in today's world."

◆ Join the spout to the pot while they are both still slightly softer than leather hard. At this point the base can be pinched into a graceful curve. Score both parts well where they will attach, coat them with slip, and press them firmly together.

◆ Make the pouring lip sharp in profile to prevent dripping. If the clay is too hard to manipulate, you can usually cut a sharper edge on the lip.

Other options for spouts include extruded clay tubes, modeled forms which are cut in half, then hollowed and rejoined, press-molded spouts (Fig. 7-53), and pulled spouts. Spouts like the one on Randy Johnston's teapot (Fig. 9-4) can be made by cutting the shape of the spout from heavy cardboard and pressing a slab gently into the opening. Make one pressing from either side to make the right and left sides of the spout.

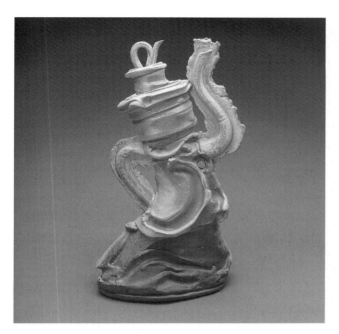

7-53 Brad Schwieger, USA; *Soda-Fired Teapot,* 1994, stoneware. The plastic qualities of the clay are exploited to the fullest in Schwieger's work. The thickly thrown body is gouged and poked to create line, much as one would draw expressively on paper. Notice how the flanges from forming the press-molded handle and spout are left intact. Soda firing this piece preserves all the details of process that the artist so obviously loves.

7-54 Making pots with lids This series of photos shows some ways to throw a variety of lids. A steady hand and practiced throwing ability is needed to make lids that fit and function well. Here the galley or ledge which will support the lid is being formed from a rim which was left quite thick. A rib is being used to define the shape, but this shape could also be made more rounded using only the fingers. Note how the clay is carefully supported inside and out by the fingertips.

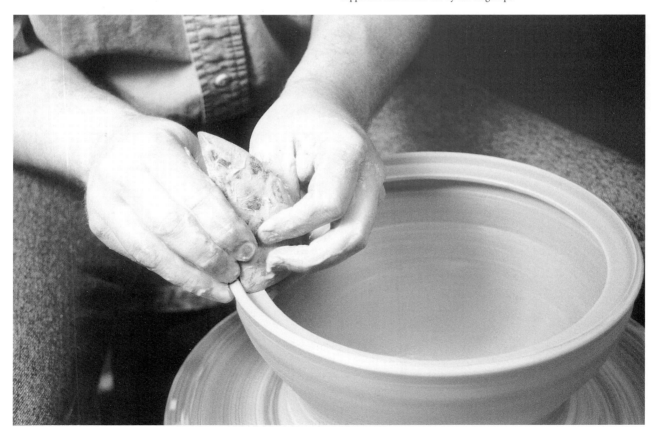

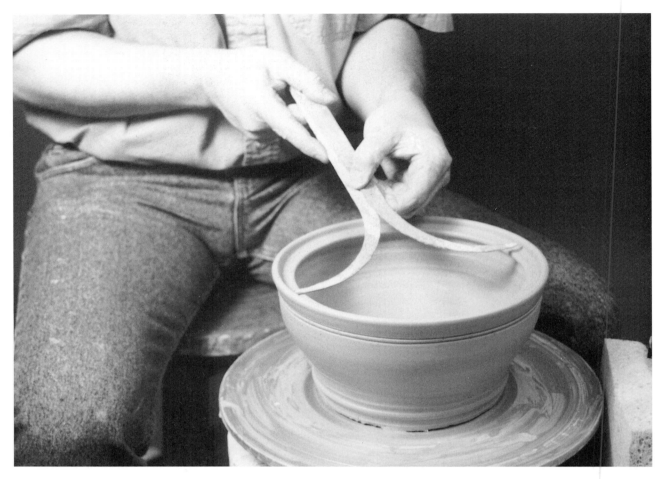

7-55 Making pots with lids Calipers are useful for accurately measuring the widest part of the lid opening. A ruler could also be used if care is taken to measure accurately right after throwing the form.

Lids

There are many different ways of making covers for pots. All, however, are thrown at the same time as the pot and are measured accurately with calipers to ensure a tight fit. A lid should conform to the shape of the pot and complement its lines. Care must be taken when removing a lid from the wheel or bat and during trimming. If the lid is distorted while it is still soft, it will most likely warp as it dries and not fit correctly. It is quite difficult to make a lid for a pot that is too dry. If the potter cannot calculate the different shrinkage rates, the lid will not fit the pot.

One of the simplest types of lid is a flat disk with a knob thrown on top. If small, it can be thrown off the hump, but a wide lid should be thrown on a bat. Very wide, flat lids or lids that are too thin may slump in the center during firing. The vessel must have a depressed inner flange to support the flat lid.

Casseroles or teapots should have an inner flange below the pot rim to hold the lid. This prevents moisture and escaping steam from running down the sides of the pot. In throwing the pot, the rim is kept a little thicker than usual.

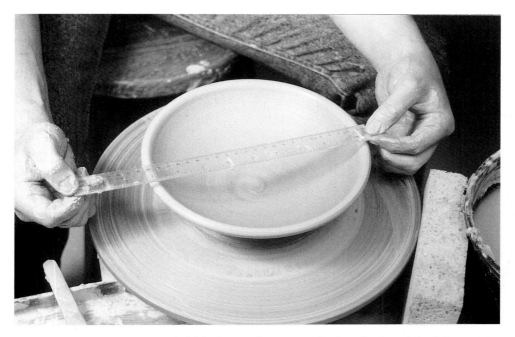

7-56 Making pots with lids Here the lid for the pot is being measured with a ruler. A simple bowl shape is made, which will be turned upside down and trimmed when it is leather hard. A knob or handle will be added after trimming to allow lifting the lid.

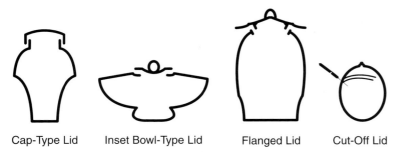

Cap-Type Lid Inset Bowl-Type Lid Flanged Lid Cut-Off Lid

7-57 A variety of lids are pictured here along with the type of container and rim needed to make them fit.

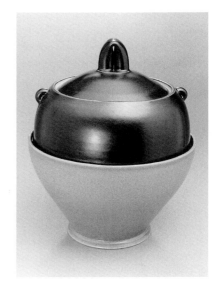

7-58 Lee Rexrode, USA; *Black Jar (nesting)*, 1994, shino glaze on porcelain, 11 in. (27 cm). This lidded jar has the appearance of being nested inside a bowl. Rexrode split the rim while throwing, creating a false lip around the belly of the pot. Glazing the two sections with contrasting values completes the illusion. Note the placement of the beautifully proportioned handles. Rexrode writes, "In addition to its visual appearance, tactile qualities of texture, weight, and balance are important to my utilitarian work. Our sense of touch plays a vital role in our perception of pots because our fingers communicate feelings that the eye alone cannot."

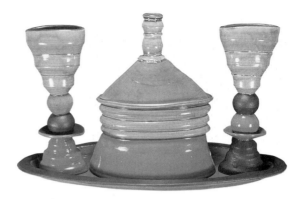

7-59 Jane Dillon, USA; *Jar, Two Cups, Tray,* 1994, terra cotta, 18 × 24 × 12 in. (45 × 60 × 30 cm). Dillon's playful combination of thrown forms and bright colors gives this set a toy-like quality. She plays the combination of geometric forms and angular surfaces against each other in a sculptural way that adds to the more functional aspects of the piece. She says, "Forms should push out volume and show the mark of the maker's hand. Glaze should move and flow as it melts, then freeze; recording the movement."

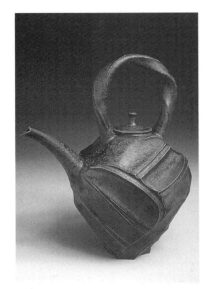

7-60 Jim Connell, USA; *Copper Carbon Trap Teapot,* 1994, stoneware, 15 × 10 × 8 in. (38 × 25 × 20 cm). Deep carving into the surface of this functional teapot gives dynamic interest to the main body of the form. Connell contrasts that with the cleanly thrown spout and lid, and the arching handle with a twist. The surface of the glaze has been sandblasted after firing to give it a soft, satin patina.

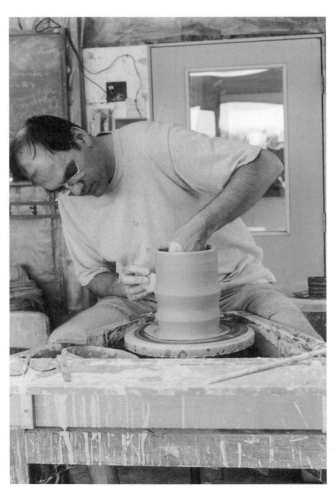

7-61 Jeff Oestreich, USA. Oestreich throws the body of one of his oval beaked pitchers. The form starts as a cylindrical shape with no bottom. Here he adds the angular facets to the sides.

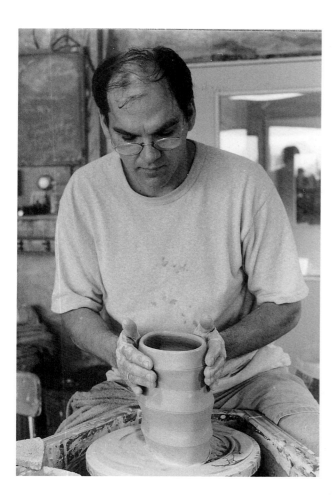

7-62 Jeff Oestreich, USA. After the form is thrown and cut loose from the wheel head, Oestreich gently pushes it into an oval with his hands.

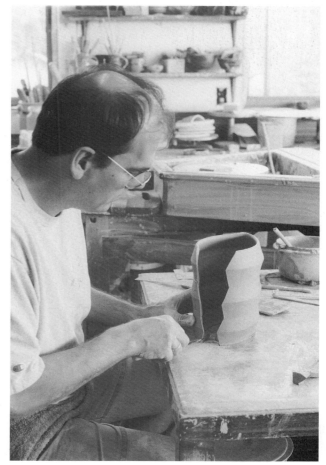

7-63 Jeff Oestreich, USA. After letting the pitcher body dry to nearly leather hard, Oestreich makes V-shaped cuts on both ends of the oval, one with the wide part of the V at the top, the other at the bottom. When the sides are put back together, the pitcher will be slanted.

7-64 Jeff Oestreich, USA. The two sides are carefully scored, slipped, joined.

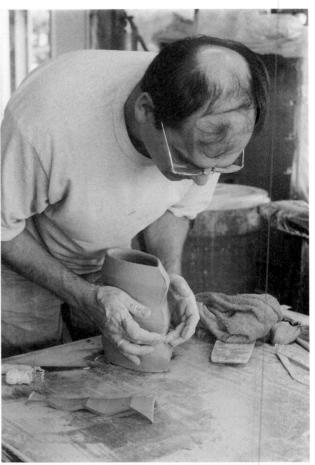

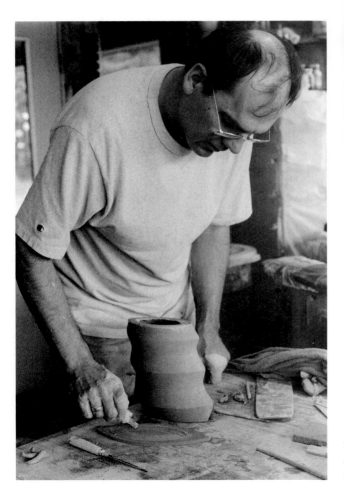

7-65 Jeff Oestreich, USA. The bottom of the pitcher body is made level after the sides are joined by cutting under it with a thin wire. Once this is done, the body is joined to a slab to close off the bottom.

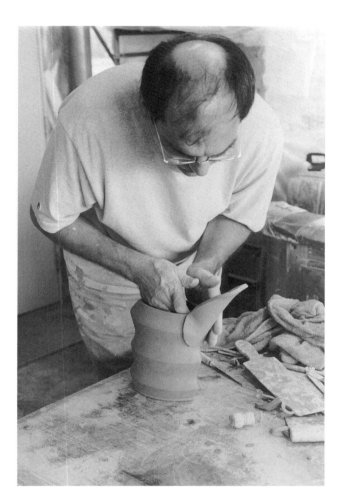

7-66 Jeff Oestreich, USA. A slab spout is added to the pitcher body. Oestreich describes the piece of clay used to make the spout as being, "the shape of a cow's tongue." He will reshape and refine the spout after it is firmly attached.

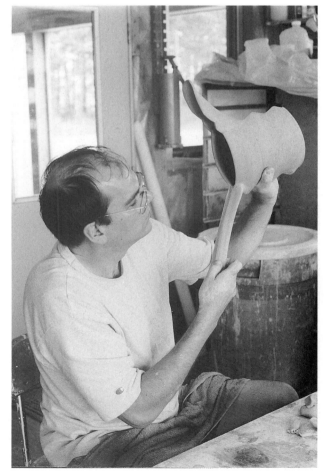

7-67 Jeff Oestreich, USA. The last step is to add a handle, which Oestreich pulls from a lug of clay attached to the pitcher. The finished spout can be seen at the top.

Then, with the finger, the rim is split and a portion is depressed to form the inner retaining ring. The rim is finished with a soft leather rib.

A domed or slightly rounded lid is thrown like a simple bowl. The rim is thick enough to allow an inner retaining ring to fit inside the top of the pot. When leather hard, the lid is inverted and the top tooled. A knob can be thrown on the lid or thrown separately and attached with slip. Knobs can also be made of pulled handles, coils, or modeled forms attached to the lid.

Another kind of lid is actually a shallow bowl that conforms to the slightly flared rim of the pot it covers. The knob is thrown on the lid at the same time. Later, the bottom is trimmed of excess clay. This method works especially well when a great number of lids are being thrown, because they can be thrown off the hump, the tooling process is faster, and there is a wider margin of error in the fit.

Once students understand the basics of making a lid, they can explore a great variety of shapes (Fig. 7-57). There are also many possibilities besides thrown clay. For example, corks make very tight-fitting lids and provide an interesting contrast to clay. Turned wood lids are sometimes a fitting alternative to clay.

THE TEAPOT

The teapot offers an unusual challenge to the potter, since it generally consists of four separate parts that must be combined to form a unified whole that is both functional and pleasing in design. However fanciful the conception, or exotic the form, the truly functional teapot should have a well-balanced handle, an efficient pouring spout, a lid that will not fall off when pouring, and a body appropriate for holding the tea and retaining heat.

The flange on the teapot lid is often made deep to prevent its being dislodged when the tea is poured. A small hole should be made in the lid to let air enter the teapot as tea is poured out. After a slight drying the vessel and lid are trimmed. The spout is usually kept a bit softer, since after trimming it will be pinched out to flare into the vessel form. As previously noted, the spout level must reach the vessel rim and the strainer holes be cut as low as possible for best pouring. To prevent dripping, the rounded rim of the spout is cut at an angle. Due to the torque of the spout during throwing, the clay will often unwind in a clockwise direction in drying and firing. A thrown spout is therefore cut at a slight angle in the opposite direction. When looking at the spout straight on the angle is cut about 10 degrees in a counterclockwise direction from what is desired after firing. Finally the handle is pulled and joined. The curves and angles of the lid, spout, and handle should all form a pleasing whole.

ALTERING THROWN FORMS

Potters often choose to use throwing as a starting point for more complex forms. The potter's wheel is very good for making round, thin-walled forms with radial symmetry, but often our ideas go beyond those restrictions. Thrown parts can be distorted, paddled, pushed, pulled and even cut apart and reassembled to create new shapes. Working with the clay at just the right wetness

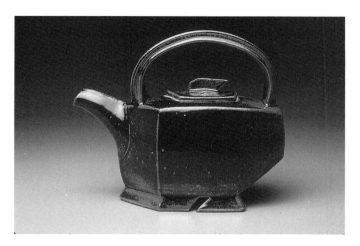

7-68 Jeff Oestreich, USA; *Teapot,* 1992, stoneware, 10 × 10 × 5 in. (25 × 25 × 12 cm). Oestreich's teapots are always notable in their unique stance. Note how he has carefully considered all aspects of the pot from top to bottom, handle to foot. The small cut in the foot draws the eye to focus on that often-ignored part of the form. Paddling and cutting the body of the pot gives a geometric shape to the original thrown form.

is always the key. Major distortions have to be made while the clay is still quite soft, sometimes right after throwing. Paddling needs soft clay, but clay that isn't too sticky and wet. Cutting and reassembling requires clay that is carefully and evenly dried to nearly leather hard. Jeff Oestreich's teapot shown in Figure 7-68 began as a thrown form and was heavily altered by paddling and cutting.

In Figures 7-61 through 7-67 Jeff Oestreich is shown assembling a pitcher which has been altered from the original thrown form by distorting, cutting, and reassembling. Several other teapots and pouring vessels by a variety of artists are also shown, which all use thrown parts in creative ways.

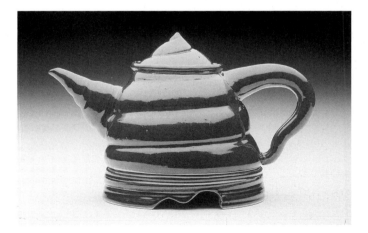

7-69 Susan Crowell, USA; *Teapot with Trivet,* 1992, porcelain, 12 in. (30 cm). Crowell's teapot makes good use of the type of refined yet energetic form possible on the wheel, using spiraling lines that reflect the process. The vertical thrust of the upward spiral is intersected by the line of the rather robust handle and spout.

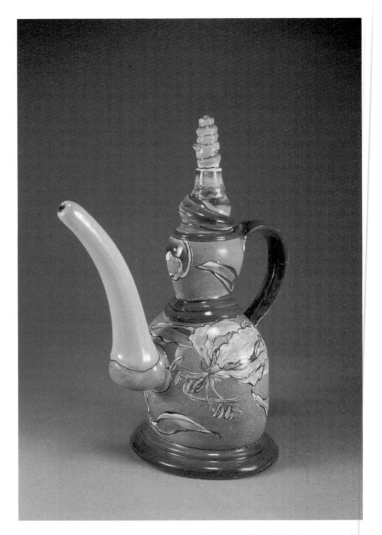

7-70 Linda Arbuckle, USA; *T-pot: Glory,* 1994, earthenware with majolica glaze, 10.5 × 9 × 6 in.
(26 × 22 × 15 cm). Arbuckle makes effective use of the techniques of majolica painting to combine
bright color, playful forms, and floral elements into a functional form (see Appendix for details of majolica
glazes). She says about her choice to make functional pottery, "Because I want to make pottery people
contact and handle in daily life, I choose certain limits. Other people may explore darker themes in their
work. I know these exist and are valid areas for expression, and I'm interested in entertaining these ideas
in other artists' work. On the other hand, I don't want violence and death with my toast in the morning,
so function limits content as well as form and surface for me."

As mentioned in Chapter 6, many forms can be created only by combin-
ing techniques. Many potters find that the while the wheel is a wonderful tool,
it does limit the kind of forms that can be made.

Slightly ovoid forms may be made by paddling the slightly soft thrown form
after it is firm enough to handle safely. More often extreme alterations of shape
can be best accomplished by distorting the form immediately after it is thrown,
then further refining the shape as the piece nears leather-hard consistency. Such

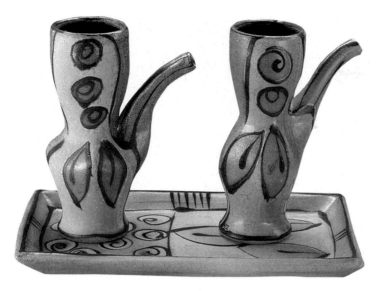

7-71 Suze Lindsay, USA; *Oil & Vinegar,* 1995, salt-fired stoneware, 6 × 4.5 in. (15 × 11 cm). Note how the spouts have been made and attached so that they seem to really flow from the main body of these forms. The immediacy of slip painting on the raw clay surface of these pieces helps to keep the decoration on these pieces fresh and lively. This is an ideal surface treatment for work that will be salt fired.

reshaped thrown containers are often thrown without a bottom, but on a bat so they can be easily moved without unwanted distortions. A slab (wheel thrown or rolled out) of the same type of clay is allowed to dry to the same consistency as the thrown sides. Often even drying is best accomplished by placing the sides on the slab (but not joined) when they can be safely moved, and wrapping the two tightly with plastic for a few days. The two parts, sides and bottom, are attached only after they are exactly the same dampness. Trimming and smoothing of the slab edges can be done by hand, using a sponge or wet piece of leather for the final smoothing.

Hand-built and sculptural additions to thrown shapes often provide a pleasing contrast to the more mechanically perfect forms made on the wheel. Parts may be cut away and replaced by other hand-built or thrown forms. Soft thrown forms may be manipulated from both the inside and outside to alter them into new shapes that may have little resemblance to the symmetrical forms made on the wheel. Thickly thrown forms may be cut, carved, trimmed, or paddled into new shapes. The potter's wheel is but one more tool available to the artist. The potter should always keep an open mind to the countless possibilities in form and process.

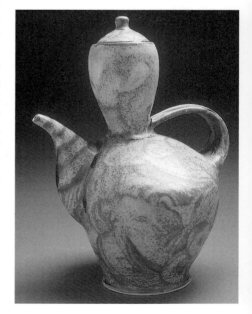

7-72 Peter Beasecker, USA; *Coffee Pot,* 1994, porcelain, 12 × 9 in. (30.5 × 23 cm). Beasecker combines simple thrown forms to make complex and eccentric vessels. The off-center vertical upper section balances the more horizontal movements of the spout and handle. Note how the gently curving spout echoes the curves of other parts of the piece.

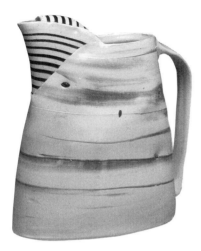

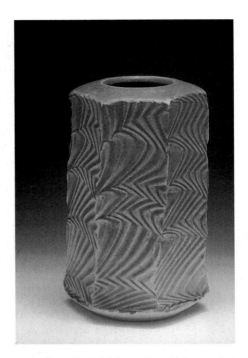

above: 7-73 **Sandy Simon**; *Toucan Pitcher,* 1986, 9.5 in. (24 cm). This oval pitcher gets much of its whimsical nature from the addition of the striped, slab-built spout that has been inserted in a cut in the front of the pitcher.

above right: 7-74 **Ginny Marsh**, USA; vase, 1994, porcelain, 9 in. (22 cm). The subtle colorations of reduction-fired glaze provide a gentle contrast to the energetic surfaces of the wire-cut sides of this vase. By throwing a thick-sided cylinder, Marsh can cut deep facets into the sides of the piece using a kinky wire.

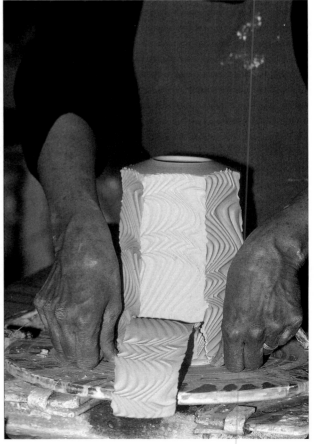

7-75 **Ginny Marsh**, USA. Marsh uses a kinky wire to create highly textured facets on a porcelain vase. The opening and top are carefully left simple and round in contrast to the exuberance of the sides. She says, "I wrap a Kemper K-35 wire around a brazing rod, rather irregularly, and then slide if off" to create the kinky wire used to cut the sides. Changing the direction that the wire is pulled creates the varying texture.

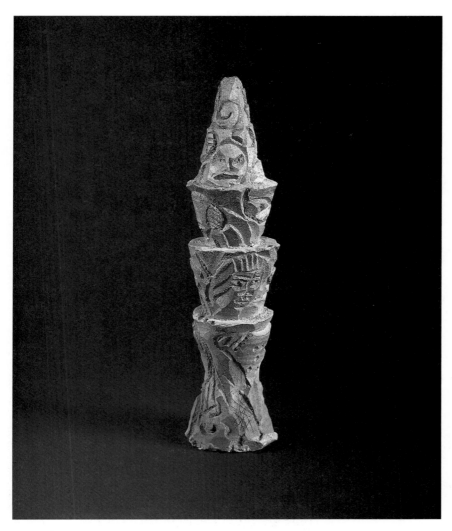

7-76 Kirk Mangus, USA; *Ziggurat,* 1985, wood-fired stoneware, 36 × 12 × 12 in. (91 × 30 × 30 cm). Combined thickly thrown forms provide a starting point for Mangus' energetic drawing and carving, which often includes figurative images like those on this piece. The subtle surface effects of wood firing preserve the freshness of his mark making.

Chapter 8

The character and shape of a piece will often suggest an appropriate type of decoration or surface treatment. There are many methods of embellishment, including manipulation of the clay itself and the use of colored clay bodies, slips, and glazes. You, as the artist, must decide whether the form needs the simple coloration of a single glaze, more complex decorative patterning, narrative drawings, or any of a world of other approaches. The potter should keep in mind that a wonderful surface won't rescue weak forms, and good form can be obscured by poor decoration. Surface treatment may harmoniously meld with the form or build visual tension by contrast. There is never only one method suitable for a particular shape.

THE CERAMIC SURFACE

The potter should consider during the forming stages how a piece will be embellished, because some types of decoration are undertaken while the clay is still plastic. Often, freely thrown or complex hand-built forms are complete in themselves, and some may need only a coating of a single glaze. Other, simpler shapes may benefit from plastic additions or a painted design in slip or underglaze. Experienced potters often think of the clay much as a painter might consider a blank canvas, a starting point over which the ceramist may apply slip and engobe, glaze and colorants, and perhaps even overglaze and luster, building the surface layer by layer, firing after firing. Planning the decoration and glazes for a form while it is being made will help to create a more unified result.

When faced with the many potential glaze colors, textures, and methods of application, the novice potter often tends to try a little of everything on one pot. The result usually resembles a discarded paint can, devoid of accidental charm. With experience it is often possible to use a single stroke of color or

a single glaze and produce a free and fluid effect or to allow a heavy application of glaze to make its own design. Other works may require multiple firings over a wide range of temperatures to achieve an evocative surface which is built up layer by layer.

Clay in the Plastic State

Texture and line can be incorporated into a form while the clay is still soft as in this piece by Mark Messenger (Fig. 8-1). In a wheel-thrown piece, deep throwing rings, pinched depressions, or modeled designs will provide decorative accents. After removal from the wheel, the form can be modeled even more, although care must be taken not to stretch the clay too much, or it might collapse.

In the hand-building process there are many possibilities for decoration. Coils or slabs can be pinched together or modeled into an endless variety of shapes for both functional and sculptural purposes. Chuck Johnson uses little or no glaze on his work to allow the richly expressive qualities of the clay to be seen (Fig. 8-2). The complex surfaces of Marc Leuthold's work require no glaze at all (Fig. 8-3).

8-1 Mark Messenger, USA; *Pyre,* 1993, earthenware, 23 × 10 × 12 in. (58 × 25 × 30 cm). Washes of underglaze and glaze give a delicate color to the textured surface of the clay and help to emphasize the depth of forms. Further richness is given to the surface by the use of multiple firings to apply layers of glaze and color, including glazes that intentionally crawl to give peeling, scaly surfaces that evoke images of age. Many of these forms started as simple wheel-thrown shapes that were modified and shaped while still soft.

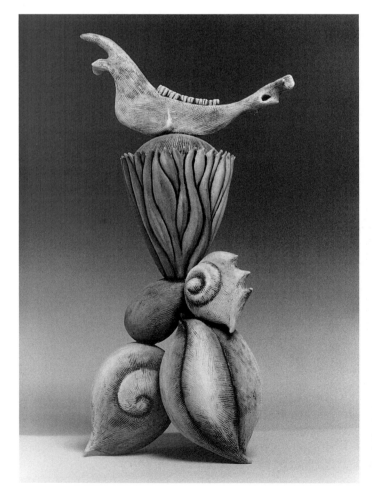

Colored clay bodies offer one of the most basic means of decoration in both throwing and hand building. Colorant oxides or **body stains** are best added wet to a slip made from the clay body ingredients. Some glaze stains may also work in clay bodies. The batch should be thoroughly **blunged** (mixed in a liquid state) and then dried until it reaches wedging consistency. Naturally occurring colored clays may also be used. (See the Appendix for amounts of colorants added to bodies.) Some of the possibilities for colored clays include neriage, millefiore, Egyptian paste, and marbling.

Neriage The neriage technique uses colored clays pieced together in molds. Shaped segments of plastic clay are joined in a concave mold to make a pattern identical on both the interior and exterior surfaces of the pot. The contrasting clay pieces can be strips, coils, or small slabs. They must be joined well and allowed to dry slowly (see Figures 4-48 and 6-49).

⚠ **SAFETY CAUTION**
Be careful to use nontoxic or otherwise nonhazardous colorants when making clays that you'll be forming with your bare hands. Stains may offer a safer alternative to raw oxide colorants. Consult manufacturers' recommendations on Material Safety Data Sheets for the safety of specific colorants and stains in contact with the skin.

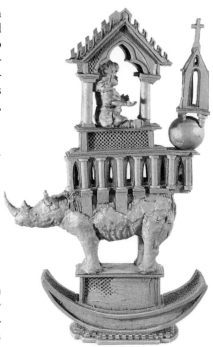

8-2 Chuck Johnson, USA; *Rhino Stele*, 1995, cone 1 gas-fired ceramics, 38 × 24 × 12 in. (96 × 60 × 30 cm). A wide variety of forming techniques have been used on this large sculpture. The expressive qualities of the raw clay have been preserved by using little glaze on the surface.

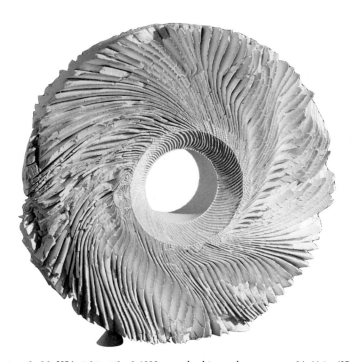

8-3 Marc Leuthold, USA. *White Wheel*, 1995, carved, white earthenware cone 04, 11 in. (27 cm). Sculptural forms like this can be more powerful left unglazed so that the richly textured surface is left unaltered.

Millefiore The millefiore technique, which also uses colored clays in molds, is a more complicated procedure evolved from glass making. The different-colored clays are rolled into slabs, then layered in "loaves" or long rectangles that show the colored design in cross section. The loaf is sliced through to make a slab, then this slab is joined with other slabs and small pieces of clay in a plaster mold. Needless to say, the decorative possibilities with this technique are great, for the colored clays combined with glazes, lusters, or decals can create an ornate design.

Egyptian Paste Another technique in which both decoration and glazes are combined in a plastic clay is Egyptian paste. The paste has colorants and glaze-forming materials incorporated into the body in a soluble form. The actual clay content is very low—no more than about 20 percent of the body—with the major portion being nonplastic materials such as flint. As the clay dries, sodium is deposited on the surface and combines with the flint and colorants to create a glaze. Developed by the Egyptians before 3000 B.C., this paste was the earliest form of glaze known. It is most often seen in turquoise-colored beads and small, modeled figurines (see Figure 2-37).

Egyptian paste is highly nonplastic and suitable mainly for simple hand-built forms and beads. Another limitation is that excessive handling will remove the surface coating of sodium. Because fingerprints on the paste will leave unglazed patches, pieces should be dried and fired on stilts, or, for small objects such as beads, strung on Nichrome wire. When completely dry, the finished piece can be once fired to cone 08 to 07, depending upon the formula. (See Appendix for an Egyptian paste body.)

Marbling The ancient technique of marbling to make clay look like stone became popular in Europe during the eighteenth century and was termed **agateware** by the English. Slabs of different-colored clays are placed on top of each other and wedged just enough to remove air pockets. Two or three lumps of differently colored clay may also by slammed together into a block. The mass is then thrown in the normal manner, with the layers creating color striations.

Leather-hard Clay

The term **leather hard** refers to clay that has dried enough to be handled without becoming distorted, but which contains sufficient moisture to permit joins to be made and slips applied without cracking. Incising, carving, and stamping are most conveniently done at this stage, because the clay cuts cleanly and does not stick to the tool.

Thrown forms that have dried enough to be slightly firm (the surface is no longer soft and sticky) can be paddled to flatten the sides. If the walls are very thick, they can be cut with a fettling knife or wire, and then carved. Elaborate handles joined to thrown or hand-built forms can serve as decoration and a design accent.

Incising The technique of incising consists of carving lines with a tool or knife into a clay surface. These lines can be deep cuts providing a strong accent or shallow ones following the contour of the pot. The ewer by Bobby Silverman uses this technique to great effect (Fig. 8-4).

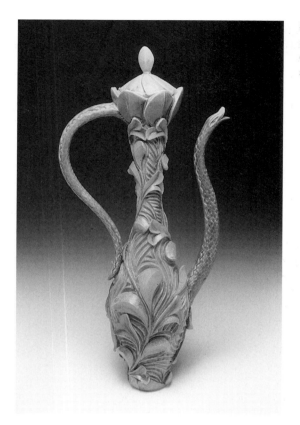

8-4 Bobby Silverman, USA; *Ewer,* 1990, wood-fired porcelain. The deeply carved surface of this ewer demands a strong but simple underlying form and glazes that don't obscure the delicate edges. Wood firing works well to maintain these details and still add variety and subtle texture to the piece.

Stamping One of the oldest decorative techniques for ceramic objects is stamping (Fig. 8-5). Many Neolithic pots have impressed designs of weaves, cords, or basket patterns. These devices are still used today to provide interesting textural decoration. Other possibilities for stamps include shells, leaves, pebbles, and an infinite variety of found objects.

 Potters also carve stamps out of clay and bisque-fire them for increased durability and to prevent their sticking to wet clay. Stamps should be applied with a fair amount of pressure to make a clear impression. If a vertical wall is being stamped, the wall must be supported on the opposite side with the hand. The moisture content of the clay is important. The clay should be somewhat softer than leather hard. If it is too dry, the clay may crack; if too wet, the stamp may stick.

 Rolled stamp decoration has the advantage of greater speed in application, but generally produces a less complex design. Applied clay pressed with a finger or a stamp will create a raised pattern and a more ornate, textured effect.

Sprigging Applying relief designs with slip onto a leather-hard surface is called sprigging (Fig. 8-6). Perhaps the best-known examples of sprig designs are the Wedgwood cameos and vases (see Figure 3-45). Sprigs can be formed individually of leather-hard clay, but generally they are made in plaster or bisqued clay molds. First, plastic clay is pressed into the mold. When it begins to dry and shrink away from the form, it is removed, scored and slipped, and then

8-5 Lana Wilson, USA; *Artifact Teapot* 6, 1995, white stoneware with black and red engobes, 12 × 6 × 4 in. (30 × 15 × 10 cm). Wilson uses stamping along with other textures to develop a rich and dynamic surface to this teapot form. The red and black engobes are carefully applied to emphasize the textures. Wilson has based the designs of many of the stamps she uses on 1930s hobo signs.

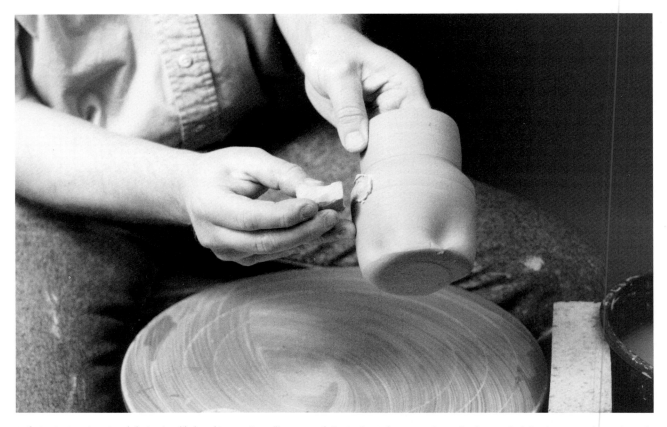

8-6 Sprigging A sprigged design is added to this cup. A small amount of plastic clay is first pressed into the design which has been carved into the end of a bisque clay stamp. This is then pressed onto the surface of the damp clay pot, transferring the design as a raised image.

8-7 Birgit Krogh, Denmark; *Tile*, 1994, 7.25 × 7.25 in. (18 × 18 cm). Krogh uses sgraffito line hilighted by dark colorants, and thick white slip to enliven the flat surface of this tile.

pressed onto the pot's surface. Use a piece of soft foam to press the sprig against the piece without damaging it. If a sprig is too large, it is apt to shrink away from the pot. It is better to build up designs from smaller units. Small sprigs may often be applied immediately to the pot.

Slip Decoration Slip can be applied to leather-hard clay in many ways. For decorative purposes, oxides are added to the liquid slip to produce colors. Slip can be brushed over the entire surface of a pot, painted on in designs, or applied in bands. Once the coating has dried, lines can be scratched through to the clay beneath, as in Figure 8-7. This technique is called **sgraffito.** The incising should not be done when the slip is completely dry because it may chip or flake off. On the other hand, if the slip is too wet, the design will smudge. The rough edges should not be brushed away until the slip has dried completely because this, too, will smudge the design (Fig. 8-8).

Paper stencils can be cut from newsprint, blotter paper, or paper toweling. These stencils are dampened and applied to the surface of the ware, then slip is applied over the clay surface. When the slip has dried to leather-hard consistency the stencils can be carefully peeled up. The result is a strongly graphic image (Fig. 8-9). Several layers of these stencils can be made and applied, resulting in

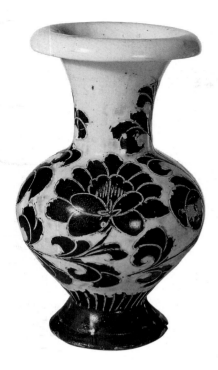

8-8 **Unknown Chinese potter;** Tz'u-chou type vase, 11th–12th century A.D.–Northern Sung Dynasty; stoneware with slip, 8 in. (20 cm). The floral design on this vase has been carved through a layer of black slip to reveal the lighter colored clay underneath. Victoria and Albert Museum.

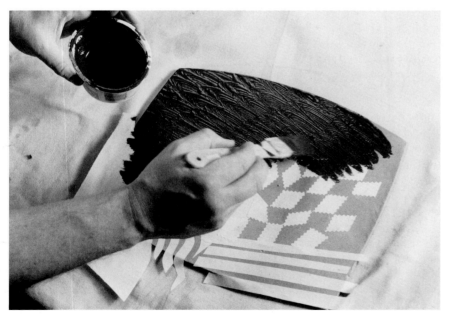

8-9 **Paper stencil** used with slip. Slip is painted over stencils cut from newsprint. The paper stencils are attached to the leather-hard clay by dampening the paper and smoothing it onto the clay surface. The stencils are removed when the slip has dried to leather-hard consistency, revealing the clay or slip surface below. Multiple layers of stenciled slip can be applied in this manner.

multiple colored images in slip. Masking tape or other removable adhesive may be used as the clay gets drier.

Slip Trailing Applying slip with a syringe or squeeze bottle is called slip trailing. The line created by this method is very fluid and shows a slight relief

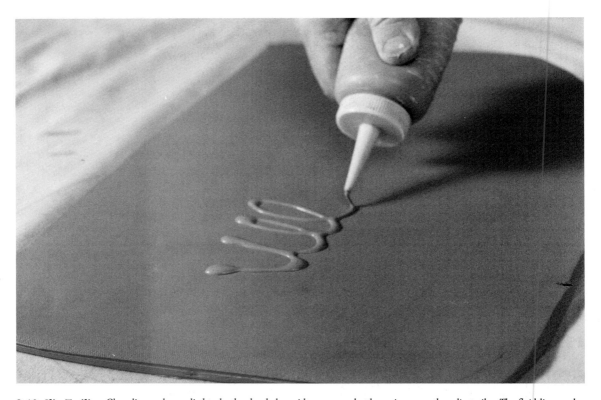

8-10 Slip Trailing Clay slip can be applied to leather-hard clay with a squeeze bottle, syringe, or other slip trailer. The fluid line made with this type of application takes some practice to control, but gives a beautifully raised line. Mistakes can be erased by scraping with a metal rib after the slip dries to a leather-hard state.

effect, as in Figure 8-10 (see also Figure 4-33). Slip trailing can also be used to create surfaces with raised patterning, as shown in the photos of Peter Pinnell decorating one of his cups. The cup will later have terra sigillata and an oxide wash over the slip trailing, giving a patinaed effect (Figs. 8-11 and 8-12).

A variation of slip trailing is combed or feathered slipware, a technique popular in Europe, especially England, from the fifteenth through the eighteenth century. The procedure is unusual and can be applied only to wide, shallow shapes. In this method, slip is trailed in parallel lines across the entire surface. Then the piece is lifted a few inches off the table and dropped. The impact flattens the lines, causing them almost to touch each other. A feather or comb brushed gently across the surface at right angles to the lines creates a delicate pattern. If desired, the slip-trailing technique can be used on a clay slab, and the slab can later be draped over a mold for shaping.

Slip Transfers Slip trailing, painting and feathering techniques can be done on another surface and transferred to the leather-hard clay. Slips can be painted or silk-screened onto newsprint or tightly woven cotton material. After the slip-coated paper dries to leather-hard consistency, the slip can be transferred to the surface of the ware by pressing it into freshly applied slip on the pot. Press the paper gently to rub out air bubbles and get good adhesion of the transfer.

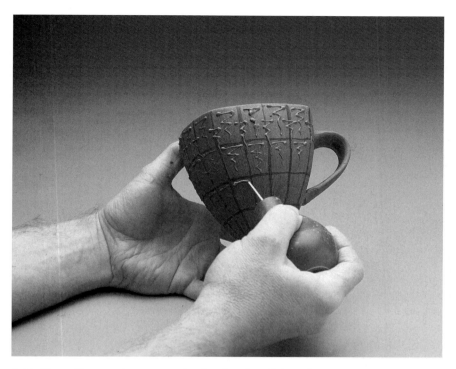

8-11 Slip trailing–creating a patterned surface. Peter Pinnell slip trails an intricate pattern on a cup. Notice the grid lines painted on the leather-hard cup with green food coloring, which enable the artist to create repetitive patterns over the surface of the form.

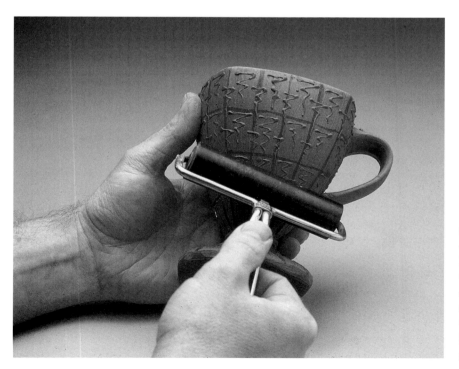

8-12 Slip trailing–rolling lines flat. After the slip-trailed lines have dried to almost leather hard, Pinnell flattens them slightly with a rubber printing brayer. After the cup dries a bit more, he'll brush a few coats of terra sigillata and buff the surface lightly while it's still damp. After bisque firing, Pinnell will wipe a stain on over the textured surface, glaze the inside, and refire.

8-13 Richard Shaw, USA; *Goose Plate*, 1979, porcelain with decal overglazes, 11 in. (27 cm). The peeling layers of slip on the surface of this platter give it the feeling of age and weathering.

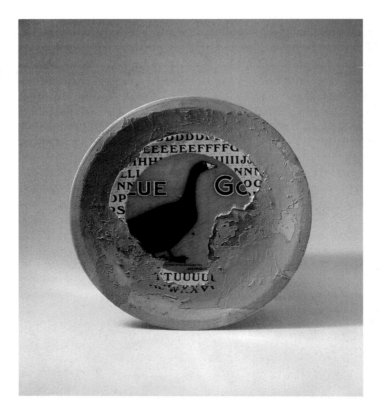

Any areas that don't adhere will peel away like peeling paint when the paper is removed. This can be an interesting effect in itself. Richard Shaw uses this transfer technique effectively in his *Goose Plate* in Figure 8-13. Slip feathering can be done on a nonabsorbent surface and then picked up by laying a piece of newsprint or other absorbent paper gently on the slip and transferred as above.

Inlay Decoration The early and widespread use of incised lines and slip decoration eventually led to a combination of these techniques. One of the simplest methods is to apply a dark-colored slip to incised lines in a lighter clay body. After the slip has dried slightly, the surface is wiped clean with a scraper, further defining the color contrast. Smooth grog-free porcelain bodies make it easier to get a crisp smooth line.

Mishima In mishima, an inlay technique of Korean origin, incised lines are filled with clay of a contrasting color. Often several colors are used. When partially dry the surface is scraped flush (see Fig. 8-14).

Clay in the Dry State

When a clay body has dried completely it is known as *greenware*. Decorative possibilities become more limited because of the fragility of clay in this state.

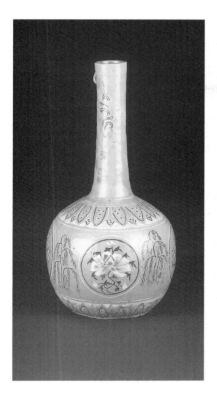

8-14 Unknown Korean potter; Vase, 13th century A.D.–Koryo dynasty stoneware, 13.6 × 6.7 in. (34 × 17 cm). The delicate line quality of inlaid clay or mishima gives this vase much of its character. The potter has used both a black and a white slip, which contrast nicely with the grayness of the typical stoneware body under the light celadon glaze. Touches of copper red have been added to the white petals of the flower. Victoria and Albert Museum.

Greenware is likely to crack and break when knocked or held by the rim. Provided the ware is handled gently, however, there are some decorating techniques possible on dry clay bodies.

Engobes and Oxides Dry clay may be brushed with engobes and oxides to create colored designs and patterns (Fig. 8-15). Most commercial underglazes fall into the category of engobes. An engobe is a slip that has a reduced clay content to lessen contraction problems, although the terms slip and engobe are often used interchangeably. Usually, half the clay is replaced by feldspar, silica, and a flux, and a small percentage of such plasticizers as bentonite or macaloid can also be added. Coloring oxides and stains are also painted on raw clay, but too thick an application will flake off or cause faulty adhesion of the glaze. Adding 10–15 percent ball clay and a small amount of flux or feldspar to the colorant and water mixture will help to seal the color to the body and make it less susceptible to flaking during the glaze firing.

Burnishing Fine-grained slips or clay bodies may be burnished with a polished piece of agate or even the back of a stainless steel spoon, but usually

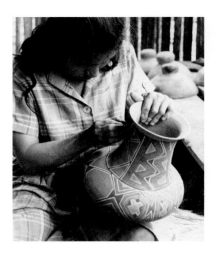

8-15 Quechua potter painting a jar, Ecuador. Colored mineral and clay pigments are applied with tiny human hair brushes to create these beautifully intricately patterned pieces. The pot will later be fired just once in an open bonfire, then covered with a clear tree-sap resin while still hot. No glaze is used.

don't achieve the smooth lustrous sheen of a good terra sigillata (below). Burnished surfaces may need to be fired to a temperature somewhat lower than typical bisques to maintain the maximum shine. They are often fired in the cone 014–010 range. Burnishing may not be successful on clays that have problems with scumming due to soluble salts in the clay that accumulate on the surface during drying. The scumming will dull the burnished surface, and will often be evident before the piece is fired. Adding 1/4 to 1/2 percent barium carbonate (toxic) to the clay body when mixing is one solution, as this blocks the scumming. Better yet, find a clay body that is not prone to scumming.

Terra Sigillata Roman terra sigillata relief ware, black Etruscan bucchero pottery, and the so-called black varnish of the Greek red-and-black ware and some Pueblo pottery all had essentially the same semi-glaze finish. These are not actually glazes, but rather slips made of extremely fine-particled clay, fired to low temperatures so that the surface is somewhat easily scratched and not completely waterproof. However, the unusual decorative qualities of the soft black and red colors have made terra sigillata ware popular with modern studio potters.

Terra sigillata coated surfaces are often the final surface of a pot and are used without a covering of glaze. Terra sigillata is made from the finest particles of clay and will give a low sheen on a smooth clay surface after only a small amount of buffing. For the best shine, the clay surface must be quite smooth and ideally made from a smooth fine-grained clay or slip. It must be applied thinly, with a consistency like that of milk, to avoid peeling later on. Terra sigillatas can be colored with stains or colorants, but the best ones are often made from naturally colored clays. Terra sigillatas should be buffed to a shine before firing by polishing with a soft cloth, chamois, or piece of the crinkly type of plastic grocery bags. Terra sigillata can usually be fired somewhat hotter than a burnished slip surface and still keep its shine, especially when applied to a fine-grained clay body or over a smooth slip. Firing terra sigillata to cone 04 is fairly normal, and a dull sheen may remain up to cone 6 or higher. These surfaces are popular for pit-fired and low temperature saggar-fired pieces. While a good terra sigillata should seal the clay surface, the fired ware can also be given a protective seal of wax or other sealer to enhance the sheen.

To prepare the classic slip, a low-firing, high-iron-content earthenware clay (many other clays will also work) in a dry state is mixed with a large quantity of water. Adding 3 or 4 percent soda ash to the water is necessary to deflocculate the clay. Thorough blunging is important to allow the clay particles to get fully wetted and separated. A large plastic garbage can makes a good container. The slip should be allowed to settle for about twelve to twenty-four hours undisturbed, and then any clear water on the surface should be siphoned off. The thin upper portion of slip should be siphoned off next and saved, as this is the terra sigillata. Be very careful to leave all the coarser clay that has settled to the bottom, which should be discarded, not recycled. Repeating the settling process with the terra sigillata will give an even finer-particled clay slip. The slip is then allowed to evaporate until it reaches the consistency of thin milk, a specific gravity of about 1.1 to 1.15.

Terra sigillata should be applied when the clay body is leather hard in several successive thin coats, gradually building up the surface. This reduces the risk of flaking that can result from the different shrinkage rates of the body and the glaze. The terra sigillata can be sprayed on to form an overall coating or brushed

on to create a pattern. Terra sigillatas normally need only a buffing, as described earlier, but for a glassier surface, the terra sigillata can be burnished with a hardwood or bone tool, but this is generally not needed if a good terra sigillata has been made.

The firing technique is an important factor with the terra sigillata. If the atmosphere is oxidizing, the color will be a soft, semigloss red; in a heavy reducing fire or raku firing, the color may be black. Contemporary potters have successfully made colored terra sigillatas from a variety of clays and colorants. (See the Appendix.)

Wax Resist Decoration by the wax-resist method is generally used in conjunction with coloring oxides and glazes, and occasionally slips or engobes. A brushed-wax design repels the applied stain or glaze, and the applied color fills the negative space between the wax (Figs. 8-16 through 8-18). Lines incised through a band or panel of wax will absorb the stain or glaze application and produce a decoration of contrasting color. The wax may be hot paraffin or a safer and more convenient water-soluble wax emulsion which can be applied cold. The hot wax

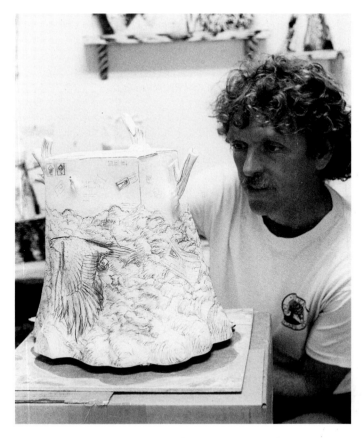

8-16 Jeff Irwin, USA; *Second Day Air,* 1995, earthenware, vitreous engobe, 13 × 11 × 11 in. (33 × 27 × 27 cm). Irwin begins by drawing the design lightly on the white slip-covered surface of the clay with a pencil. He is just starting to apply the wax resist over this drawing wherever white is to appear in the final result.

8-17 Jeff Irwin, USA; *Second Day Air*, 1995, earthenware, vitreous engobe, 13 × 11 × 11 in. (33 × 27 × 27 cm). A vitreous black engobe has been applied over the wax-resist drawing. The white areas are the ones which have been waxed. Some cleanup is needed on the waxed areas to remove small droplets of black engobe which adhere to the wax.

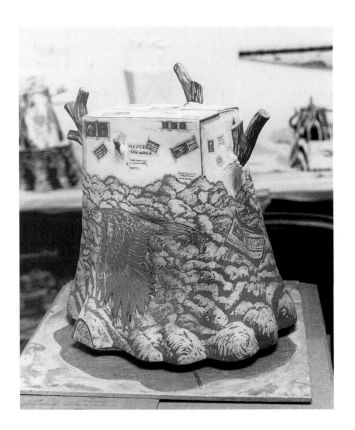

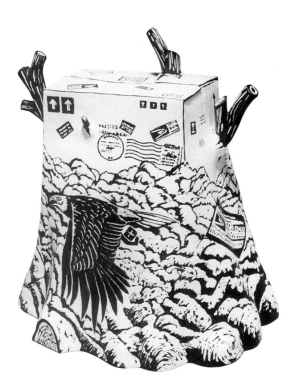

8-18 Jeff Irwin, USA; *Second Day Air*, 1995, earthenware, vitreous engobe, 13 × 11 × 11 in. (33 × 27 × 27 cm).

is less apt to pick up specks of color or glaze and solidifies quickly, but great care must be taken to keep the mixture from overheating and catching fire. The wax emulsion must be allowed to dry thoroughly to successfully resist the colorants. Both kinds of wax are burned away in the kiln long before glazes melt.

Always heat paraffin in a container placed in boiling water to avoid over-heating and the chance of fire. Some potters have used beeswax thinned with a solvent, but great care must be used to avoid fires. Provide adequate ventilation and protection from breathing wax and solvent vapors.

⚠ SAFETY CAUTION
Be careful not to overheat the wax if using paraffin or other hot wax. Wax should always be melted in a hot water bath so that it is kept at temperatures under 212° F (100° C).

Latex frisket A variety of brands of removable frisket are available which work in many ways like wax-resist methods, but are easily removable from the clay surface. Most are water-based rubber latex emulsions which can be brushed easily onto the clay. The frisket, like wax emulsion, must be allowed to dry completely before it will act as a resist. Working a small drop of liquid soap onto the bristles of one's brush before using it with latex frisket will make cleanup much easier. Be careful not to let the latex dry in the brush, as it sets rapidly. Latex must be peeled off the surface before firing.

Slip Glazes Glazes with a high clay content, such as a slip glaze, can sometimes be applied to leather-hard or dry ware which is then fired only once. This can be a great labor saver for the potter. A single firing also promotes a good union between the clay body and the glaze, because the two shrink and fuse simultaneously.

Glaze recipes for bisque ware can sometimes be adapted for single fire glazing like this by substituting a more plastic clay such as ball clay for the kaolin in a glaze, or by adding bentonite up to 5 percent or so to increase the drying shrinkage of the glaze to fit the clay. Much experimentation may be needed to get a once-fired glaze that works with your particular clay (Fig. 8-19). The ware must be of a uniform thickness and the glaze applied quickly to prevent excessive absorption or the greenware may crack. Clays with high dry strength and density are better adapted to this than others because they absorb as little water as possible and withstand the stress. Such clays may survive glazing when dry, but many clays must be glazed while leather hard to avoid cracking the greenware. It is best to experiment at first on simple smaller objects such as tiles or small simple thrown shapes.

There are, however, several major disadvantages to the combined firing. The great risk of once firing is that if any greenware explodes in the kiln for any reason, the shards will land on the other glazed pieces and fuse to the glaze as it melts. Because of its fragility, the dry raw-clay vessel may be broken in handling. Expansions caused by the moisture absorbed into the dry clay may cause the vessel to crack. In general, only when the body of a piece is rather thick and uniform can glaze be poured safely. Other pieces should be sprayed, since the glaze, with its troublesome moisture content, can then be applied at

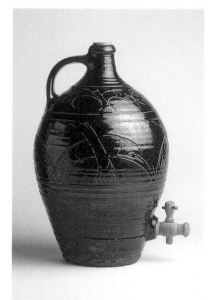

8-19 Michael Cardew, Great Britain. *Cider Jar,* 1938, earthenware with black slip, 17.8 × 10.8 in. (45 × 27 cm). In this type of ware, the black slip glaze is applied to the unfired ware, and the design incised through the raw glaze. The ware is fired only once. Victoria and Albert Museum.

a slower rate. One additional precaution must be taken in glazing raw ware: soluble fluxes must first be fritted. If soluble fluxes are absorbed into the outer portion of the clay, they will likely react with the clay body and cause it to crack. Soluble fluxes may also cause overfluxing of the clay itself with resultant bloating or even slumping.

Clay in the Bisque State

After a clay body has been bisque fired, the major decorative techniques are associated with glazes and their methods of application. A few techniques, however, can be used for underglazing or even to replace a glaze.

Engobes Bisqued ware can be given applications of engobes to create a rough texture or to alter the color of the body. The engobes must contain sufficient fluxes to fuse with the body, but they should not be so fluid that they create a glossy surface.

Coloring Oxides and Underglazes Sometimes coloring oxides or underglazes (oxides mixed with flux or feldspar, see Appendix) can be used as brush decoration, bands of color, or an overall colorant on a bisqued body or a glazed surface as on this piece by Marj Peeler (Fig. 8-20). Groggy, textured clays or incised designs can be coated with an oxide-and-water solution and then the excess wiped off. This technique works well on large sculptural pieces where a glaze application is not necessary. Underglazes produce more uniform colors and are less likely to cause running than oxides mixed with only water.

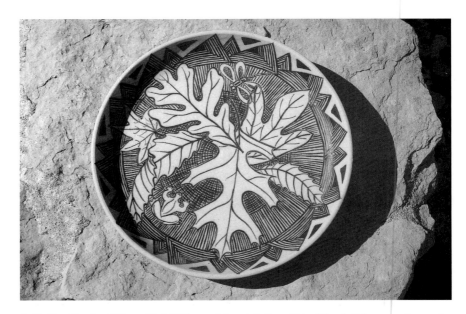

8-20 Marj Peeler, USA; untitled, 1990, porcelain, cobalt lines, 12 in. (30 cm). Colorant washes can be used for brushwork on a light colored glaze. If the glaze is stable and doesn't move or run during the firing, intricate drawings can be done.

Decorating Pencils Another technique requires the use of decorating or underglaze pencils, which are manufactured commercially in a variety of colors. These are actually oxides or stains in a pencil form. On a bisque surface the potter can draw fine lines not possible with brushes. The pencils are most successful on smooth, white clay bodies later to be glazed in a clear or translucent white. Wet-sanding the bisque ware with very fine silicon carbide auto body sandpaper will give a very smooth drawing surface. Be sure to rinse and dry the bisque ware thoroughly before drawing and glazing. The decoration can be very intricate, especially when used on porcelain under a thin clear glaze.

Wax- and Latex-Resist Decoration Wax can be brushed on bisque ware before glazing. The result is a strong contrasting pattern of clay surface texture with the smooth glaze color. Often the wax coating does not resist all the glaze so the droplets of glaze or colorant must be carefully sponged off. Latex frisket works in a similar manner, but is removable. (See earlier paragraphs concerning use on greenware.)

Glaze Inlay Glaze can be inlaid into lines or textures of bisque ware much in the same way slips are inlaid on greenware. Glaze is applied to the incised surface and the excess carefully removed from the rest of the clay surface. The teapot by Harris Deller shown in Figure 8-21 uses the stark contrast of a black glaze against the dry whiteness of the unglazed clay.

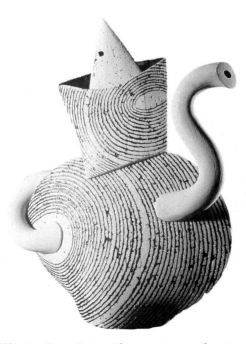

8-21 Harris Deller, USA; *Curvilinear Teapot* with concentric arcs and passive spout, 1994, porcelain, 12.5 × 11.5 × 3 in. (31 × 29 × 7 cm). Deller uses black glaze carefully inlaid into the linear textures inscribed into the clay in a way very much akin to the way one would draw two-dimensionally. His work also plays whimsically with the boundaries between two-dimensional and three-dimensional art.

GLAZING

Glazing in the raw clay state has a few advantages. By eliminating the bisque fire, there are savings not only in the labor needed for the extra stacking, unloading, and operation of the kiln but also in the fuel or power needed for the extra firing. But the disadvantages of once firing (see Slip Glazes) lead many modern potters to shy away from this procedure.

Glazing in the bisque state is the most common procedure. Normally, bisque ware is fired between cones 010 and 04 (1641°–1940°F, 894°–1060°C). Bisque for glazing should almost always be fired to the higher end of this range: cones 07–05 (1803°–1915°F, 984°–1046°C). At this stage the bisque is hard enough to be handled without mishap, yet sufficiently porous to absorb glaze readily. The higher bisque firing usually results in stronger ware, but the ware will be less porous and will absorb less glaze. The lower bisque temperatures may better withstand the rapid heating of raku firing and preserve the shine on burnished ware.

Bisque ware fired at too low a temperature will absorb too much glaze and may not burn out all organic materials and sulfates in the clay, leading to possible bloating. If the clay is fired to an extremely low bisque, the ware may still expand slightly with the moisture of glazing and crack. If the ware is bisque-fired too high, it is especially difficult to glaze, for the glaze tends to run off the less absorbent body.

An exception to the normal bisque firing is some high-fire chinaware. Such pieces as thin teacups, which are fragile and likely to warp, are often placed in the kiln with supporting fireclay rings inside their lips, or they are stacked upside down and then fired to their maximum temperature. Later, these chinaware pieces are glazed and fired on their own foot rims at a lower temperature where warpage losses are much less. Glazes for this type of ware are formulated with adhesives and binders to allow the glaze to adhere to the vitreous bisque clay surface without the need for the usual porosity.

How to Glaze

Before the actual glazing operation takes place, a few precautions must be taken. If bisque ware is not to be glazed immediately upon its removal from the kiln, it should be stored where dust and soot will not settle on it, or it should be covered with plastic. The bisque ware should not be handled excessively, especially if the hands are oily with perspiration, for this will deter the glaze from adhering properly.

All surfaces of the bisque ware should be wiped with a damp sponge or momentarily placed under a water tap to remove dust and loose particles of clay. The moisture added to the bisque ware by this procedure will prevent an excessive amount of glaze from soaking in and thus allow a little more time for glazing. Extra moisture also helps to reduce the number of air pockets and pinholes that form when the glaze dries too quickly on a very porous bisque. The amount of moisture required depends upon the absorbency of the bisque, the thickness of the piece, and the consistency of the glaze. Ware that is obviously wet from cleaning should be allowed to dry somewhat before glazing or the glaze will be too thin over the damp areas. Should the bisque-fire temperature accidentally rise much higher than cone 06 or 05, the ware should not be dampened at all.

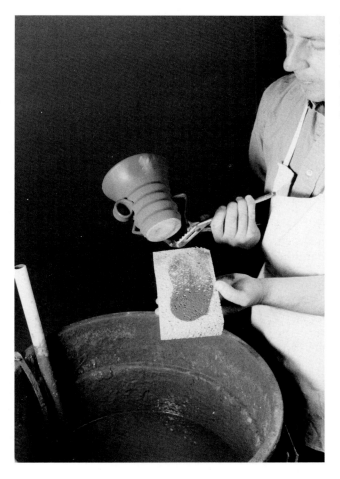

8-22 **Cleaning the foot** of a just-glazed piece. Glaze on the foot of a pot can be quickly removed using a large flat sponge which is kept fairly damp. With a light amount of pressure against the bottom of the pot, the sponge will also clean off glaze a short distance up the sides.

The glaze must be cleaned completely off the bottom of the pot and 1/4 inch (0.64 cm) up the side as soon as it is dry enough to handle. Excess glaze will always run, so it is never advisable to allow a heavy layer of glaze to remain near the foot rim. Wiping the foot of the glazed piece on a large flat sponge as in Figure 8-22 speeds cleaning off excess glaze. The cleaning operation can also be simplified by brushing wax emulsion on the bottoms of bisque pots or by dipping them in a shallow pan of hot paraffin before glazing.

Brushed Glazing A brushed glaze is an easy starting point for the beginner, although experience is needed to produce an even glaze coating. The technique is best suited for glazes that are formulated to flow easily from the brush during application and ones that melt fluidly enough during firing to hide brush strokes. Most commercially produced low-fire glazes have binders and additives that make brushing the best method for these products.

Brushing requires a flat brush, at least 1 inch (2.54 cm) in width and possibly larger. An ox hair bristle is preferred, for camel hair is much too soft and floppy. Some of the better artificial bristle watercolor brushes work well. Unless a considerable amount of clay is in the glaze, the addition of bentonite or a gum binder is necessary for proper adhesion. CMC gum adds both adhesive and good

brushing properties and may be useful. Some potters have found that formulating glazes with a substantial part of the water in the glaze replaced by the so-called "safe" antifreeze (propylene glycol) improves the brushability. For smaller quantities of glaze the addition of a few drops of glycerine may help the brushability. Glazes with large amounts of gerstley borate may brush easily with no additives. Heavily fritted glazes with little or no clay are almost impossible to brush evenly without additives.

The glaze should be applied rapidly, with a full brush, and the piece must be covered with a second and third coat before the bottom layer is completely dry, for otherwise blisters may develop. The glaze must be neither too watery nor so thick that it will dry quickly and cause uneven laps and ridges. Vary the direction of brush strokes for each coat to help obtain a more even glaze coat.

Dip Glazing The simplest glazing method is probably dip glazing. After the vessel has been cleaned and moistened with a damp sponge, it is plunged into a large pan of glaze. It should be withdrawn almost immediately and shaken gently to remove the excess glaze (Fig. 8-23). The object is then placed on a

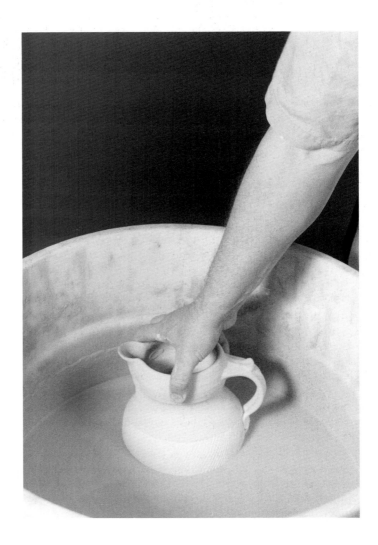

8-23 Glazing by dipping Dipping pots into a glaze is a quick way to apply glaze evenly.

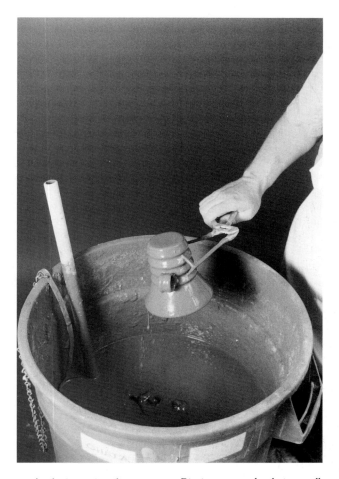

8-24 Glazing using dipping tongs Dipping tongs make glazing small pots much easier with less touch-up to the glazed surface. The entire pot can be plunged into the glaze, and agitated slightly to make sure all surfaces are glazed. It is then pulled from the glaze, quickly dumping out any glaze in the interior, and the pot is turned slowly as the glaze dries to minimize glaze drips.

rack to dry, and any finger marks are touched up with a brush. Small-size pots can be dip glazed with metal tongs (Fig. 8-24), which come in several shapes. The slight blemishes in the glaze caused by the pointed tips usually heal in firing. For the smoothest, most uniform application, dipping glazes must be kept mixed at optimum consistency. Glaze flocculation is an important factor for consistent and even dipped glaze application. (See "Flocculants" p. 299, Chapter 9.) Checking the specific gravity of the glaze periodically (see "Specific Gravity Measurements" in the Appendix) and keeping it within the range that you've found useful can help to minimize application problems and variations.

Interesting patterns and colors evolve when a piece is dipped in two or more different glazes that overlap. Take care when using multiple dips of glaze that the total application thickness is about the same as that used for a single glaze. Overly thick glaze application from multiple dips of glaze is a frequent cause of running and crawling glazes.

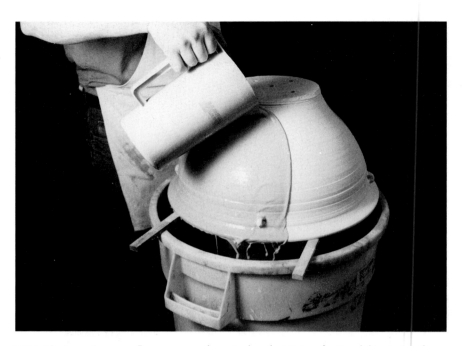

8-25 Glazing a large pot Pouring is a good way to glaze the interior of pots and the exterior of large and awkward shapes. Care and a large container are needed so as not to waste glaze. For the most even coating of glaze, use a large enough pouring container of glaze to cover the whole form in one continuous pour. Note the large bowl being supported by two wood slats while glazing. These will leave very small unglazed spots on the rim which are easily touched up with a brush.

Poured Glazes Pouring requires less glaze than dipping, and the technique can be applied to a greater variety of shapes (Fig. 8-25). For example, the insides of bottles and deep, vase-like forms can be glazed only in this manner.

If the object is a bottle with a narrow neck, the glaze is poured through a funnel, and then the vessel is rotated until all its surfaces are covered. The remainder is poured out and the bottle is given a final shake to distribute the glaze evenly and to remove the excess. Glazes that are poured or dipped must be a little thinner in consistency than those that are brushed on. The insides of bowls are glazed by pouring in a portion of the glaze, spreading it by rotating the bowl, and then pouring out the excess. This must be done rather quickly, or an over-abundance or uneven amount of glaze will accumulate. The potter often makes dance-like movements with the ware to achieve even glazing.

The exterior can also be glazed by grasping the bottle by either the upper rim or the foot rim and pouring the glaze from a pitcher, allowing the extra to run off into a pan beneath. Finger marks are then touched up with a brush, and the foot rim is cleaned when dry. The outside of a bowl is glazed in the same manner, provided the foot is large enough to grasp. Otherwise bowls or other large forms can be placed upside down on wooden dowels extending across a pan. It is generally better to glaze the interior of a vessel first and the exterior later.

Sprayed Glazes Spraying permits subtle variations of color and control over glaze thickness and coverage. A thin overall glaze coating over delicate designs

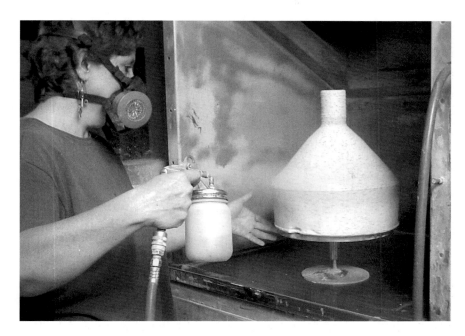

8-26 **Spraying a glaze** Spraying glazes is often the best way to glaze large forms. Spraying also allows subtle gradations when layering glazes or slips. Note the texture that is appearing on the surface of the pot as the glaze nears the proper thickness.

is most easily applied with the spray method. However, sprayed glazes are more common in commercial ceramics than among studio potters. Dipped and poured glazes are quicker to apply, less wasteful of glaze, and less liable to damage in loading. Another drawback is that brush and wax-resist decoration cannot be easily applied over a sprayed glaze (Fig. 8-26).

The glaze for spraying should be more fluid than the usual glaze for painting or dipping, and should be run through a fine mesh sieve. Alkaline compounds that tend to settle or become lumpy are best replaced by fritted substitutes. The small electrically powered spray units for paint work well for glazes. Airbrushes, commonly used by graphic artists, can produce overlapping color fields on a much smaller scale, but require very finely ground glaze materials.

The insides of deep bowls or closed forms may be glazed by pouring before spraying the outsides. To obtain an even layer, the glaze is sprayed slowly at a moderate distance from the pot. The pot is turned as the spraying progresses, building up a soft, "woolly," surface. If the application is too heavy, the glaze will run. When that happens, the glaze must be scraped off and the pot dried and then reglazed. When the spraying is completed, handle the pot as gently and as little as possible before firing, as the sprayed glaze can be somewhat more fragile than glaze applied in other ways. Waxing the foot before spraying will minimize the need to handle the pot while cleaning off the bottom, but some cleanup may still be necessary.

⚠ SAFETY CAUTION

Always spray glazes in a spray booth with adequate ventilation and spray control. Wear a NIOSH-approved mask rated for dusts and mists when spraying water-based glazes. Avoid spraying toxic materials and solvent-based materials.

Decorating with Glazes

The manner in which a glaze is applied can have a great impact on its fired appearance. A single glaze will vary in color if applied in layers of different thicknesses. Several glazes dipped or poured over each other will create contrasting color fields. An interesting design often results from brushing or spraying an oxide or second glaze over a dipped or poured surface. If the base glaze is completely dry, however, another glaze applied on top may crack or peel off.

A simple decorating technique consists of wiping away a portion of the glaze. On a textured surface, this will leave glaze in the rougher sections. If the glaze is wiped away from a smooth surface, the slight residue of flux from the glaze may alter the color of the clay body (Fig. 8-27). A variety of textures will also result from the glazes themselves—from a very dry through a smooth mat to a glossy finish.

When a glaze has dried to a firm coating, lines scratched through the glaze to the body will create a subtle relief pattern. Wax designs can also be applied to a firm coating of glaze, and lines can be incised through the wax. These lines can then be filled in with an oxide stain or a glaze of a different color to contrast with the body or base glaze. This technique is also used extensively on majolica glazed wares.

Majolica typically refers to a style of glazing and decorating where colorants are applied over a raw, unfired glaze. The typical majolica glaze fires white and opaque, and is quite viscous and will not move during the firing so that that

8-27 Finger wipes through a raw glaze.

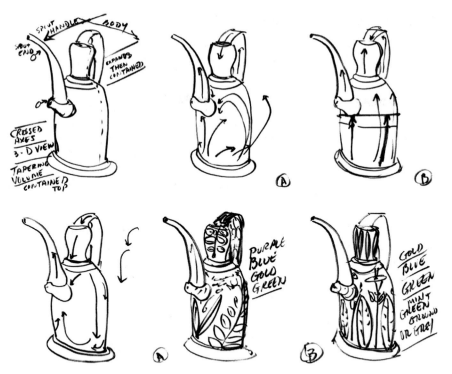

8-28 Linda Arbuckle, USA; Sketches for majolica decoration Arbuckle often sketches her pottery to help her consider how the movement of the decoration will interact with the form. Almost all of her work involves majolica glazes and decoration, often using complex floral designs. In this sketch she first thinks about the form itself and its attributes in the drawings on the left, then how the decoration can move about on its surface, and finally she sketches what the decoration may actually be (above and below—middle and right).

fine brushwork with the colorants is possible. When first popularized in Italian Renaissance wares (see Chapter 9, page 290), the glaze was largely made from lead and tin oxides. Now lead-free glazes are almost always used to eliminate the hazards of lead-containing glazes. Firing develops the colors as the colorants fuse with the glaze. Linda Arbuckle applies majolica glaze and colors to her ware, a complex process. In the sketches in Figure 8-28 she carefully considers the interaction of the decoration with the form in a variety of ways before commencing to paint. She often uses the wax-resist methods mentioned in the previous paragraph to build up a depth of color and image on her work. The result (see her work in Figures 1-9, 7-70, and 9-11) is a lively and colorful surface.

Paper stencils may also be placed on the bisque ware; after the ware is sprayed with glaze, the stencil is peeled off. Plain paper will temporarily adhere to bisque if it is dampened. The resulting decoration presents a contrast between the dry body surface under the stencil and the glaze. Latex frisket may also be used in this manner as a temporary mask (Fig. 8-29). Other materials that may be used for stenciling include masking tape, removable stickers, open-weave fabrics, lace, or any type of mesh. Stiff, thin plasticized paper makes a good stencil for spraying that can be washed off and reused.

Glaze-Fired Ware

Until recently, most hand potters were concerned with functional ware decorated with glazes formulated in the studio. Decorating techniques associated with commercially manufactured ceramics (or those that made the ware unsuitable for practical use) were largely neglected. Many contemporary potters now make

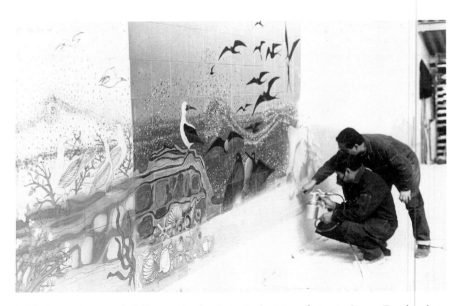

8-29 Decorating a mural, Cuenca, Ecuador. Artists in the Artessa factory in Cuenca, Ecuador, glaze a large tile mural. The center section has already been glazed and fired and is surrounded by unfired bisque tiles. Colors and colored glazes are being added to extend the image to the larger size. Much of the image here is being done by spraying glazes, using masking and frisket as needed.

use of low-fire and midrange commercial materials characterized by bright colors and sometimes metallic lusters. Health concerns limit the use of the brightest lead-containing commercial glazes to sculpture, but a wide variety of lead-free commercial glazes may be used on pottery.

One possibility for decoration on fired ware is the application of acrylic or oil-base paints onto the bisque or glazed surface. No firing can be done after paint or other nonceramic surfaces are applied. Although acrylic paints adhere best to bisqued ware, oil and enamel paints work well on both bisqued and many glazed surfaces. Christine Federighi uses oil paints to color her sculptural forms.

Overglaze Colors Overglaze colors (also called **china paints**) contain coloring oxides or stains, a flux (historically lead-based), and a binder, such as oil of lavender. Water-based, lead-free overglazes are now available. They are applied on top of an already fired glaze and then refired to a much lower temperature than the original glaze, typically to Orton cone 018–016.

Overglazes can be purchased in small bottles or tubes and applied directly from the container. Lavender oil-based overglazes must be fresh, for if the colors are too old, they will become gummy and form a jellylike mass. The manufacturer's instructions should be carefully followed, and note should be taken of which type of medium is recommended for thinning and cleaning purposes. Although it is possible to make your own overglazes and lusters, the ingredients are expensive and the process time-consuming. It is usually more profitable to choose from the commercially manufactured products.

Hard, glossy glazes are more reliable bases for these effects than rough or mat surfaces. The application and firing processes are exacting. Thin coats of color are applied with soft camel hair or sable brushes. The brushes should be

kept very clean and used only for overglazes. Mistakes can be wiped off with a cloth dipped in the proper thinner. A spray gun or airbrush will create subtle modeling details. The colors should be thinned to a more fluid consistency, however, to prevent the spraying mechanism from clogging.

If the design is complicated, the piece cannot be painted and fired in one operation. First, the broad color washes are applied; they can be intensified later if necessary. Then the finer details are painted. Many unusual color effects can be achieved by applying different colors over each other.

Most overglaze colors are fired between cones 020 and 015. The temperature is critical and should be controlled to the exact degree stated in the manufacturer's instructions. Overfiring will cause the colors to burn out; underfiring will prevent them from developing. The ware should always be handled with caution to avoid damaging the fragile surface. (See Chapter 9, p. 292.)

⚠ **SAFETY CAUTION**

Most older overglaze colors contain fritted lead fluxes and should not be used on ware used for food. Handle these with care. Oil of lavender and other solvents used in overglazes may be irritating. Spraying lusters creates even more vapor and flammability hazards. Use adequate ventilation when working with these materials. Make sure your kiln room is well ventilated when firing overglazes and lusters in order to rid the atmosphere of toxic fumes from the glazes.

Luster Glazes Metallic, iridescent, and pearlescent colors can be produced on glazed surfaces by means of luster glazes (Fig. 8-30). They are available in a large selection of hues and in such liquid metal colors as gold, silver, and bronze.

Like overglazes, lusters can be brushed or sprayed onto a glazed surface in thin, even coats. Lusters must be applied to very clean surfaces with clean brushes to avoid problems. Lusters will become increasingly brilliant with repeated firings; unusual effects result from applying colors over each other.

Firing should proceed slowly, with the kiln door or lid left open in the beginning to allow toxic fumes to escape. Most lusters mature between cones 020 and 018, although these temperatures may vary with the product.

Decals Several commercial firms produce decals, which are available from many ceramic supply houses. Water-mount decals are printed by either a lithographic or a silk-screen process onto a thin paper sheet coated with water-soluble film. Lacquer is then applied over the decal material.

To apply the decal, the desired design is cut from the sheet and soaked in room temperature until the paper has become saturated. (If it is left in the water for too long, the adhesive quality will be diminished.) When the backing paper has released the design, the decal is lifted from the water, drained, and slid from the backing onto the clean, glazed surface. The position is adjusted, and the excess water is patted away with a cotton pad. If the decal is large, a squeegee may be used to seal the decal to the surface. It is important to remove all water and air bubbles, or the decal will not adhere properly during the firing.

8-30 Karen Thuesen Massaro, USA; *Rockets,* 1994, cone 10 porcelain, lustre, china paint, 3.25 × 11.5 in. (8 × 29 cm). This thrown and altered bowl with delicate interior painting and drawing is a good example of how artists have found the interior space of bowls to be a wonderful place to draw. In this case, the drawing has been done over the cone 10 fired glaze with lusters and china paint (overglaze). The smooth white qualities of the porcelain are perfect for this and complement the most delicate lines.

Application on curved surfaces is facilitated by first heating the ware to about 85°F (29°C). This will cause the lacquer backing to stretch and conform to the surface when the decal is pressed onto the form.

The decal must dry completely before firing. Most decals mature between cones 020 and 018 (1323°F, 717°C) and should be fired in an electric kiln.

Photographic Silk-Screening The photographic silk-screen process may be used to make a decal, although the design may also be screened directly onto a vessel or a clay slab. The student in a school with a photographic and a print-making department should have no difficulty obtaining instruction in preparing a silk screen. The process is widely used commercially to produce advertising posters and T-shirts. Therefore, the potter in any urban area should be able to find a firm to furnish a photographic silk screen.

To make a silk-screen design, an image on a film negative is projected through a halftone (grid) screen to form a film positive. This positive image is in turn projected upon a silk screen coated with a light-sensitive emulsion. The coating on those portions of the screen receiving the greatest amounts of light is hardened by the light. The rest of the image is washed away when the image on the screen is developed. Ink, traditionally consisting of equal parts of turpentine, varnish, and linseed oil mixed with a colorant, is then brushed on the screen, penetrating the uncovered section directly onto the pot or onto transfer paper to make a decal. More recently, low-vapor solvent-based and water-based inks have been developed which eliminate the hazards of solvent vapors. Decals must be overcoated with a clear coat to hold the decal together. If screened directly, the pot which bears the design must then be fired to fuse the color to the surface. Firing will also burn off the binders in the ink if the pot is then to be overglazed.

Recently artists have been experimenting with using computers to manipulate digital images and photos for silk screens. Text and images can easily be added. Laser printers and copiers can print directly on decal paper leaving an iron-rich image in laser toner which will fire brown. The image can be overcoated with the normal clear lacquer overcoat used in making decals and then transferred to a glazed surface and fired just high enough to fuse the image to the glaze. Some experimentation may be necessary to obtain the optimum firing temperature.

The laser-printed image may also be transferred directly to the clay by placing the uncoated decal paper image against the wet clay or slip, and dampening the back of the paper to release it. Laser-printed images on ordinary paper may also be transferred to greenware or bisque ware by placing the image against the clay, then using a quick wipe of a solvent such as lacquer thinner or Dancolite (*caution:* these solvents may be highly flammable and toxic) on the back of the page to soften the toner and cause it to stick to the clay. Colorless blender pens that contain the solvent xylol, used to blend solvent-based felt marker colors, may also be used to transfer laser-printed images. Laser toner companies are reportedly working to make colored toners which contain ceramic colorants, making direct printing of ceramic decals a future possibility.

Glaze Defects

Opening the kiln and finding a runny, crawling, or rough glaze is one of the greatest disappointments faced by the potter. Because glaze chemicals vary

slightly in their composition and because potters are always tempted to experiment with new combinations of glazes, the problem of glaze defects is a continuing one.

There are usually several reasons, all logical, why a particular glaze fault occurs, but trying to deduce the cause from one piece may prove quite difficult. When there are a number of pots having the same glaze from a single kiln load or when there are several glazes on a single body, the problem of deduction is much easier. The following section outlines some of the factors that can cause glaze defects. Glaze faults may result not only from the composition of the glaze, but also from the improper selection or preparation of the clay body, faulty kiln operation, or, as happens most frequently, lack of skill and care in application.

Glaze Defects Caused by the Clay Body

◆ A body that is too porous because of improper wedging, kneading, **blunging** (mixing with paddles), or **pugging** (mixing in a pug mill) may cause small bubbles, beads, and pinholes to form in the glaze as the body contracts and the gases attempt to escape.

◆ Excessive water in the body can result in similar conditions.

◆ A large amount of manganese dioxide used as a colorant in a body or slip may cause blisters to form in both the body and the glaze.

◆ Soluble sulfates are contained in some clays and come to the surface in drying, forming a whitish scum. Pinholes and bubbles develop as these sulfates react with the glaze to form gases. This condition can be eliminated by adding up to 2 percent barium carbonate (toxic!) to the clay body. (See clay body recipes in the Appendix.) If glazes permit, a slight reduction fire at the point just before the glaze begins to melt, followed by a period of oxidation, will reduce the sulfates and allow the gas to pass off before the glaze develops a glassy retaining film. Using low-sulfur clays is often the best alternative, if possible.

◆ If the body is underfired in the bisque and therefore very porous, it may absorb too much glaze. Soluble fluxes in the glaze can cause the body to crack.

◆ A glaze applied to a very coarse clay body can have a rough, or even a sandpaper-like, surface.

⚠ SAFETY CAUTION

Sulfates and other contaminants in the clay and glaze may cause toxic and irritating gases to be given off during firing. Be sure to provide adequate ventilation for all kilns when firing.

Defects of Application

◆ Blisters or pinholes may result if the bisque ware has not been moistened slightly before glazing. The glaze traps air in the body's surface pores.

◆ Dust, wax, or oil on the surface of the bisque ware may cause pinholes, crawling, or a scaly surface in the glaze.

- If the glaze is applied too heavily, it will run and obscure the decoration, perhaps causing the pot to stick to the kiln shelves.

- In addition to flowing excessively, glazes that have been applied too thickly will usually crack in drying. When the piece is fired, these cracks will not heal and will pull farther apart and bead at the edges. If the drying contraction is great enough, the adhesion of the glaze to the body will be weak, causing portions to flake off during the initial **water-smoking** period of the cycle. This is the period early in the firing when moisture is being removed from the ware.

- On the other hand, a glaze application that is too thin will result in a poor, dry surface. This is especially true of mat glazes. Thinly applied glazes may not develop the desired color.

- If a second glaze coating is applied over a completely dry first coat, blisters will form. The wetting of the lower glaze layer causes it to expand and pull away from the body.

- If the bisque ware is considerably cooler than the glaze at the time of application, bubbles and blisters may develop later.

- Glazes high in colemanite should be applied immediately after mixing. If they are allowed to set, they thicken from the **thixotropic** effect of the colemanite. The extra water necessary to restore their consistency causes the glaze to separate and crawl in drying. A crude form of naturally occurring colemanite called gerstley borate should be used if possible, because it is less apt to settle and cause a number of glaze defects, notably the tendency for the glaze to crawl during firing. The addition of 0.5 to 1 percent soda ash or 3 percent Veegum T will retard the tendency of colemanite to thicken.

- **Bristol glazes** require perfect surface application. Because of their viscosity, thin areas will pull apart and crawl when fired. Many majolica-type glazes also require similar care in application.

- Using glazes that have settled and have not been thoroughly stirred will result in glazes with a changed composition that may not resemble the original recipe.

Defects Originating in Firing

- If freshly glazed ware is placed in the kiln and fired immediately, the hot moisture will loosen the glaze, causing blisters and crawling.

- Too-rapid firing will prevent gases from escaping normally. They will form tiny seeds and bubbles in the glaze. For some especially viscous glazes, a prolonged soaking period is needed to remove these bubbles.

- Excessive reduction will result in black and gray spots on the body and glaze and may produce a dull surface. Blistering, bloating and black coring of the body may also occur, especially if heavy reduction was started too early in the firing.

- Gas-fired kilns, especially those using manufactured gas, are troublesome to use with lead glazes. The sulfur content in the combustion gases will dull the glaze surfaces and possibly form blisters and wrinkles.

- Overfiring generally causes glazes to run excessively and clay bodies to distort and crack. Some glazes may also bubble and not smooth over

during cooling. Crazing is usually made worse with overfiring (see next section).

◆ Underfiring generally results in more mat glaze surfaces, and in severe cases pinholes, bubbles, or dry clay-like surfaces. Shivering may result from underfiring in some cases (see next section). **Dunting** (breaking of the ware) may also occur, especially if the glaze is thick and the clay thin, or if the ware is glazed only on the inside.

Defects in Glaze Composition

◆ Glazes that are not adjusted properly to the body are susceptible to stresses that may cause the glaze, and at times even the body, to crack. If the glaze contracts at a slower rate than the body does in cooling, it undergoes compression. This causes the glaze to crack and, in places, to buckle and separate from the body. This defect is commonly known as **shivering.** Dunting may also occur (see "underfiring" above).

◆ Crazing is also caused by unequal contraction rates in cooling, but with the opposite conditions from shivering. When this happens, the glaze contracts at a greater rate than the body, causing numerous cracks to form. When crazing is intentional such glazes are sometimes called crackle glazes.

◆ Glazes that run excessively at normal firing temperatures should be adjusted by the addition of kaolin to increase the refractory quality of the glaze or, if possible, by altering the base glaze.

◆ A dull surface will result if the proportion of silica to alumina or barium is too low.

◆ An excessive amount of tin, rutile, or colored spinels, which are relatively insoluble, will also cause a dull or rough-surfaced glaze.

◆ Bristol glazes not fitted properly to the body will tend to crawl or to crack. This may be due in part to an excess of zinc oxide usually contained in these glazes. Raw zinc oxide has a very high shrinkage rate. Use of calcined zinc oxide will usually lessen this problem.

◆ Colemanite is often implicated in problems with severe glaze crawling where the glaze seems to jump off the surface during firing. Recalculating the glaze to use a frit or gerstley borate instead may be the best answer.

◆ Glazes ground too finely—thus releasing soluble fluxes from the frits, feldspar, and so forth—will develop pinholes and bubbles or may show evidence of overfiring.

◆ Glazes that are allowed to stand too long may be affected by the decomposition of carbonates, organic matter in ball clay, or gum binders. Gases thus formed can result in pinholes and bubbles in the final glaze. In some instances, commercially available preservatives will help. If washed, dried, and reground (a fairly tedious process for a small studio pottery), the same glaze can be used again without difficulty.

Chapter 9

A ceramic glaze and its formulation are not as mysterious as they seem to most beginning pottery students. Basically, a glaze is nothing more than a thin, glasslike coating that is fused to a clay surface by the heat of a kiln. While some glaze compositions are quite elaborate and use a variety of chemical compounds, a glaze can be made from only three necessary components: silica, the glass former; a flux, or glass melter; and alumina, the stabilizer or refractory ingredient.

It should be noted here that the final form of all elements in a fired glaze is almost always that of an oxide, a molecular combination of an element with oxygen—for instance, sodium oxide, calcium oxide, aluminum oxide (or alumina) and silicon dioxide (silica). Occasionally it may be mentioned that a glaze contains an element without mentioning the word *oxide*. For instance, sodium may appear without the appended "oxide," but it should be remembered that this means that the fired glaze actually contains sodium oxide, not the pure element.

Silica　The essential glaze ingredient is silica, also called flint. Most glass and glaze is largely silica, which has the unique property that it does not easily recrystallize when cooled after melting. Instead it remains in the state of randomly arranged molecules that we call glass. Chemically, silica is silicon dioxide, SiO_2, and is one of the most common materials on earth. In its most common pure, crystalline state it is known as quartz. Were it not that the melting point of silica is so high—about 3100°F (1700°C)—this single material would suffice to form a glaze. Most earthenware clays, however, mature at about 2000°F (1093°C) and will seriously deform if fired higher, while most stoneware and porcelain bodies mature between 2250°F and 2400°F (1238–1315°C). Thus, pure silica cannot be used alone on these bodies.

Flux　A compound that lowers the melting point of another compound is called a flux. Fortunately, many chemicals will readily combine as fluxes with silica to form a glassy matrix that melts much lower than silica does alone. The types of materials that have been commonly used as fluxes in low-fire glazes are: lead compounds (lead carbonate, red lead, galena, and litharge), alkaline compounds (sodium, potassium and lithium oxides found in soda ash, bicarbonate of soda, pearl ash, lithium carbonate) and boron compounds (combinations of boron with alkalies: borax, gerstley borate). The alkaline compounds, with the exception of lithium carbonate, are usually used in the form of frits which also contain silica, as they are otherwise too soluble to be useful. Although these

categories of low-fire fluxes have comparable fluxing power, their effects on glaze colorants and many of their other qualities are different (see Chapter 10). Boron in glazes acts both as a flux and as a glass former, but in smaller amounts its chief role is as a flux. Because of the toxicity of lead compounds, lead oxide is rapidly disappearing from glaze use despite its once useful properties.

The alkaline fluxes (lithium, sodium, and potassium compounds, including most boron compounds) are also quite useful in high-fire glazes, but in smaller amounts than in low-fire glaze. The chief high-fire fluxes are the **alkaline earth** compounds that melt at higher temperatures: calcium carbonate (also called whiting), dolomite (containing both calcium and magnesium carbonates), strontium carbonate, and barium carbonate.

Refractory or stabilizer A **refractory** ingredient helps to form a stronger glaze that will better withstand the wear of normal use and stiffens the molten glaze. The glaze produced solely by a mixture of silica and many common fluxes would be somewhat soft and rather runny. A third ingredient, alumina, is therefore added to the glaze to stabilize it by making it harder when fired and more viscous as it melts, thus preventing excessive running. Silica and alumina unite to form tough, needle-like mullite crystals, creating a bond to the clay that is more resistant to abrasion and shock.

SIMPLE FORMULATION

In its final composition, then, a glaze includes its three necessary components: silica, the glass former; a flux, which lowers the fusion point of silica; and alumina, the stabilizer, to give increased hardness and viscosity to the glaze. Variations on the types of fluxes used, and the amounts of silica and alumina, will give a wide range of color response, surface types, and firing temperatures. Like a good cook, the potter should strive to learn the effect of these ingredients making these variations. Just as one adds spices to change the flavor of food, the glaze maker can add or change ingredients to enhance the glaze. Doing this knowledgeably and safely is the key.

Some simple glaze tests follow that focus on the learning of how glazes work experimentally. Chapter 10 focuses on using a more scientific approach to glaze calculation to understand and refine glazes.

It is not always economically practical or aesthetically desirable to use refined and pure ingredients to make up glazes. The compounds employed by the potter are often those minerals that are abundant in nature in a relatively pure state. Therefore, a simple, low-fire glaze might consist of the following:

kaolin ($Al_2O_3 \cdot 2SiO_2 \cdot 2H_2O$)
potash feldspar ($K_2O \cdot Al_2O_3 \cdot 6SiO_2$)
calcium borate frit ($Na_2O \cdot 2CaO \cdot 2B_2O_3 \cdot 5SiO_2$)

The silica content will be provided by both the clay (kaolin) and the feldspar. Alumina is also a constituent of both kaolin and feldspar. **Feldspars** are minerals that contain alumina, silica, and varying amounts of potash, sodium, and calcium. The predominant flux gives its name to the compound, such as soda feldspar. Potash feldspar, the more common type, is slightly cheaper and fires

harder and higher than soda feldspar. Feldspar should be considered only inci-dentally as a source of flux in the low-fire range, where it functions mostly as a source of silica and alumina. The calcium borate frit provides most of the fluxing power in this glaze. The combination of calcium and boron in the frit is a strong flux even at low firing temperatures. In addition to aiding the fusion of the glaze ingredients, a flux also combines with some of the silica and alu-mina on the surface layer of the clay body of the pot to form a bond uniting the body and the glaze. This union becomes stronger as the firing temperature increases. Occasionally, a very porous clay will react so readily with the flux that the glaze will become thin and rough and require adjustments to either the glaze or the body.

Glaze Testing

Glaze and clay testing is a necessity for potters. Glazes may react in varying ways on differing clay bodies. Materials vary from batch to batch. Most artists also want to develop a personal palette of glazes, whose colors and application they know well. The potter who expects a desired result without first testing and learn-ing how to use a particular glaze is likely to be sorely disappointed.

Health Hazards in the Studio All chemicals used in ceramics should be treated with respect, but some are notably hazardous and need special handling if used. Soluble chemicals, especially metal salts (chlorides, nitrates, and sulfates), present the possibility of absorption through the skin and should be handled with great care or avoided altogether in a school situation. While one can use only nontoxic or low-toxicity materials, this may result in a very limited palette of glazes. The following points are vital to safe glazing:

◆ Know what you are using, what hazards are presented, and how to protect oneself. For example, all chromates are now labeled as carcinogens, in addition to any innate toxicity. Cuts, or even sore, cracked skin present the distinct danger of absorption of otherwise reasonably safe materials such as borax. Some of the materials presented here are extremely toxic and not recommended for use, but may appear in older recipes. These are included so that the potter can be informed of the hazards which may be associated with them.

◆ Consult the *Material Safety Data Sheets* (MSDS) for more information on each chemical. These can be obtained at no cost from your ceramic supplier. Information about how to read an MSDS can be found in the appendices.

◆ *Always* wear proper protective equipment when preparing, handling, or spraying glazes. (See the section on Health and Safety in Chapter 5, Clay in the Studio.)

⚠ **SAFETY CAUTION—MIXING AND FIRING GLAZES**
You must observe certain precautions in using glaze chemicals and cer-tain glazes and in firing procedures. Some glaze chemicals are hazardous or toxic if ingested, inhaled, absorbed through the skin or cuts, or even given off as a gas or metal fumes during firing. Many other glaze chemicals are not a substantial hazard if handled sensibly. The degree of hazard depends on the chemical, *and*

on exposure—how long and what type of contact. **Don't smoke, eat or drink in glaze mixing or application areas. Wear an apron and/or change clothes to avoid taking hazardous materials with you when you leave.**

The fine particles of silica in clay and a number of other glaze ingredients are injurious when inhaled, causing a nonreversible lung condition called silicosis if inhaled over a long enough period of time. These effects are multiplied if you are a cigarette smoker. **You should wear an approved dust mask (see Appendix on safety equipment) when working with dry glazes or spraying glaze materials. Other protective equipment such as goggles or rubber gloves may be required when mixing glazes.** A well-ventilated spray booth is a must when spraying glazes. A firm knowledge of glaze ingredient hazards is a necessity. See Chapter 5 for more safety equipment information and the bibliography in the appendices for arts hazards publications.

Lead is well known today as a poison. The effects of lead poisoning are cumulative and can build up over a number of small exposures. Other fluxes such as barium carbonate, boric acid, borax, sodium, lithium carbonate, arsenic, and antimony are also potentially toxic, sometimes in minute amounts. Many colorants such as cadmium, chromium, copper sulfate, ferrous sulfate, iron chromate, manganese dioxide, vanadium pentoxide, and praseodymium are toxic or hazardous if misused. **Many of these materials are also damaging to the environment if disposed of improperly. Such disposal may also be illegal.** Thankfully, the bulk of ceramic materials are relatively safe for the potter if used properly. There are certainly many other more toxic chemicals in the world, but they are rarely used in ceramics.

You must not only protect yourself when mixing glazes, but you must also make certain that the glaze used is stable *after* **firing if it is to be used with food. Glazes that are improperly compounded or underfired and therefore rough and scaly should not be used for food containers.** There are many laws which regulate the use of lead and other toxic materials in glazes used on food containers. These regulations must be carefully followed.

While most potentially injurious gases pass out of the chimney during the firing of a fuel kiln, there is some leakage. **The gas kiln room must be especially well ventilated for the release of carbon monoxide (CO), which can cause asphyxiation. This is especially important during the reduction phase of firing gas kilns.** If the kiln is in the studio, drop panels from the ceiling should enclose the kiln area to localize the fumes and allow for an efficient use of the exhaust fan. Sufficient fresh air to replace that drawn out by the exhaust fan must also be supplied to kiln rooms. **Lead fumes commonly are released when lead glazes are fired, especially with raw lead glazes.** Salt kilns need special precautions since the hydrochloric acid released is toxic. Sodium bicarbonate is often used as a substitute for salt to eliminate the chlorine. Often such kilns are placed in an outside shed. An electric kiln should also have a hood and an exhaust fan, as hazardous gases and fumes seep out of the kiln during firing. **Commercially made electric kiln vents are available for individual kilns and should be used if no other form of ventilation is provided.** These draw air in through a very small hole in the kiln, usually at the top, and exhaust kiln fumes through a duct to the outside.

Low-Fire Glaze Tests In order to gain an understanding of the qualities imparted to the glaze by silica, alumina, and the flux, the beginner should make several tests with varying proportions of feldspar, kaolin, and a gerstley borate substitute or a boron frit fired to cone 04. Small clay tiles 2 by 4 inches (5.1 to 10.2 cm) and 0.25 inches (0.6 cm) thick make satisfactory tests. These should be made from the type of clay to be used with the glaze being tested, and bisque fired in the range of cone 08 to 06. The glaze samples should always be fired upright to detect a tendency in the glaze to run. The bottom quarter to half inch of each tile is left unglazed to catch the drips and evaluate the fluidity of the glaze. Other suggestions for test tiles are shown in Figure 9-1.

Before starting to weigh your glaze materials, be sure you are familiar with how a gram scale works. Many ceramists use a **triple beam balance** to weigh glaze ingredients accurately. This type of scale uses three separate sliding counterweights to set the amount to be weighed. One of the counterweights (which slides on its own "beam") is usually for 0- to 10-gram amounts in one-tenth-gram increments, one for 0- to 100-gram amounts in 10-gram increments, and one for 0- to 500-gram amounts in 100-gram increments. When the scale is balanced, with the pointer at the end of the beam pointing to level, the amount of material on the pan is equal to the settings shown by the position of the counterweights. Using a combination of all three sliding counterweights, any amount between one-tenth gram and 610 grams can be weighed. Larger amounts can be weighed by adding specially calibrated add-on weights to the pegs provided at the end of the beams. More and more common are small digital scales that make weighing materials even easier.

Most scales also have a **tare** weight or tare beam which can be used to compensate the scale (by balancing it) for the weight of the container in which the ingredients are to be weighed. It is *very* important to check for the correct tare setting for your container each time when starting to weigh out a glaze, as even similar containers weigh slightly different amounts, and some previous user may have used a different container. Digital scales usually will automatically compensate for the container by simply placing the empty container on the scale and pressing the tare button.

a. cone-shaped coil
with pinched texture

b. slab with hole for
hanging and texture

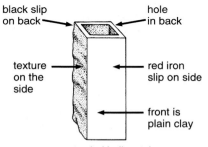
black slip on back
hole in back
texture on the side
red iron slip on side
front is plain clay
c. extruded hollow tube

d. cut from a thrown mug
(also could be extruded)

9-1 Several styles of test tiles are pictured. Test tiles which include aspects of your work will give you the best idea of how glazes will react to your own surfaces, rims, and decoration. The simple pinched tiles (a.) are quick to make and have typical hand-building surfaces. Slab tiles (b.) can also be made quickley. The square extruded tiles (c.) can show a variety of surfaces with one test. Thrown tiles (d.) may be best if you're going to use the glazes on wheel-thrown pottery.

A suggested beginning formula for a cone 04 glaze test is the following:

5 parts (by weight) Ferro Frit 3124 (or any calcium borate frit)
5 parts kaolin (clay)

A total batch of 100 grams (50 grams of each) is advisable as the likely error in weighing smaller amounts is quite high. After weighing, water is added until a consistency about that of thick cream is obtained, and the ingredients are run through a fine screen (30 to 50 mesh). Lumpy materials in a test glaze can also be ground in a mortar if needed. Modern ceramic materials are finely ground, so only a brief grinding or usually just a screening through a 30- to 50-mesh screen is all that is needed for a small sample. The glaze is brushed on a clean, dust-free tile in two or three coats. Try to leave a band of thinner glaze and one thicker to see what difference application thickness makes. Experience is the only guide to the proper thickness of application. Cracks may develop if a layer is too heavy. In succeeding tests the kaolin decreased by one part each time and the frit increased by one part to replace the kaolin. The total number of parts should be kept at 10, so that valid comparisons of recipes can be made. This process is repeated until the clay content is reduced to one part. The clay also functions as a binder to hold the nonplastic ingredients of a glaze together. Thus, if no clay is present, a small amount of methocel, CMC, bentonite, or another binder must be added to make a useful glaze.

The fired samples will show a gradual change from a clay-like white coating to one that becomes more fluid and glassy as the increased flux (from the frit) combines with the silica and alumina (from the clay). Finally, a point is reached at which the glaze runs excessively. This tendency can be retarded by substituting some feldspar for some of the frit.

At different firing temperatures the necessary proportions of flux, alumina, and silica will vary. When the temperature exceeds 2050°F (1130°C), the low-fire fluxes in the glaze must be replaced gradually by calcium carbonate (whiting), the principal high-fire flux. At temperatures above 2100°F (1150°C) alkaline and boron fluxes will tend to run immoderately and are used only in small quantities. A glaze can have a different crystalline surface structure by varying the proportion of alumina to silica, along with changes in the fluxes used. For example, an excess of alumina in the glaze often produces a matte instead of a glassy finish. Either too much or too little silica will result in a rough surface. Silica in its pure form can easily be added to a glaze if this should prove necessary.

After completing successful glaze tests with these two basic ingredients, the potter can substitute other frits for all or part of the frit to see what changes may ensue. Other materials such as feldspars, nepheline syenite, spodumene, or Cornwall stone may be substituted for a small portion (5–20%) of the frit in this low-fire test glaze. Further possibilities for additions or substitutions are talc, whiting, or dolomite, which will probably tend to matte the glaze somewhat when substituted for a small part of the frit. Testing will show how the addition affects the glaze melt. Although some of these compounds contain silica and alumina, their main purpose is in varying and increasing the proportion of flux. These additions can greatly affect the color response and surface quality of the glaze. The principal advantages of having several fluxes in a glaze are the extension of the firing range and the more complete fusion of the chemicals with fewer glaze defects. (See Chapter 11 for more specific details about these materials.)

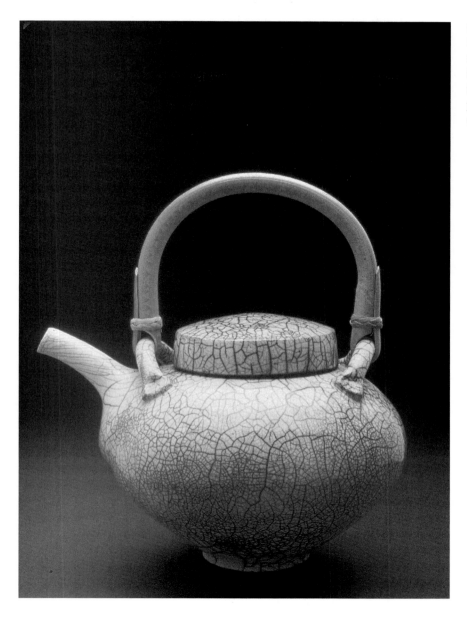

9-2 **Rick Berman,** USA; *T-pot,* 1993, raku, 10 × 10 × 10 in. (25 × 25 × 25 cm). This teapot shows a characteristic result of raku firing. The strong crackle pattern in the glaze is made visible when the smoke from the post-firing reduction penetrates the cracks and stains the porous clay underneath.

Strontium carbonate or barium carbonate additions may produce a matte glaze in situations where increasing the alumina content is not convenient and boron is not present (the test glaze above does contain boron in the frit).

⚠ **SAFETY CAUTION**

Barium carbonate is a toxic material and should be used with caution. Strontium carbonate is a safer alternative for many situations which call for barium carbonate. See pages 318 and 329 for more information on strontium.

It is essential that the glaze and the body cool and contract at the same rate after firing. If the body is weak and underfired, a contracting glaze may cause the clay and glaze to crack, which is called dunting. If the glaze contracts more than the clay underneath, it often results in **crazing,** which is the formation of a fine network of cracks in the glaze, leaving the clay intact. Even if the glaze initially looks unbroken, if sufficient tensions exist, the glaze will eventually craze, although this may not occur for days or even years. Slight expansion of the fired clay resulting from moisture collecting in a porous body may have a similar effect. On a decorative piece the crazed surface can add to the interest of the total design. If they are intentional, such effects are called **crackle glazes** to distinguish them from the unexpected and undesirable crazing.

Elimination of crazing is necessary in all functional ware to prevent seepage of moisture through the ware and to avoid bacterial growth resulting from food particles trapped in the cracks. Changes can sometimes be made in the clay body to increase or reduce contraction and thereby adjust it to the glaze. The addition of silica to either the body or the glaze is one method used to prevent crazing. In the body the crystal formation developed by excess silica usually increases cooling contraction, but in the glaze's glassy state silica is more likely to lessen the contraction of the glaze as it cools. Generally a potter has developed a satisfactory body with desired plasticity, vitrification, color, and so forth, and for this reason glazes are more often adjusted to fit the body, rather than the other way around.

Although gerstley borate and colemanite are roughly similar in composition, colemanite has a greater tendency to settle in the glaze and cause firing flaws, making gerstley borate the preferred low-fire flux for many potters for many years. A commercially available gerstley borate substitute may be used, because gerstley borate is no longer available. While frits are a more reliable glaze ingredient than gerstley borate, they also have a greater tendency to settle, which can usually be cured by the addition of bentonite or another suspending agent to the glaze.

High-Fire Glaze Tests

High-fire glaze tests differ from those in the low-fire range only in the substitution of calcium carbonate ($CaCO_3$—commonly called **whiting**) and feldspars for the low-melting lead and alkaline compounds. In this experiment, tiles must be made from a stoneware or porcelain body. A good starting formula for a cone 6 to 10 glaze would be the following:

4 *parts by weight*	kaolin
4 *parts*	potash feldspar
2 *parts*	whiting

This will produce a sample that is white and clay-like in character. In succeeding tests the whiting is held constant, the amount of feldspar gradually increased, and the proportion of the more refractory kaolin decreased. As the kaolin is lessened, the test glazes will become smoother and glassier. Depending upon the temperature, a satisfactory glaze should be achieved at the point when the kaolin content is between 10 and 20 percent (1 or 2 parts in the above recipe). Throughout this series of tests the fusion point of the glaze has been lowered by the addition of the active flux, potash, which is contained in the feldspar. Only at higher temperatures can feldspar be considered a flux, since it is also a major source of alumina and silica.

A successful stoneware glaze can be made using only feldspar, kaolin, and whiting. As mentioned earlier, however, it may be desirable to add small amounts of other chemicals to obtain a greater firing range, achieve a better adjustment to the body, provide a more varied color spectrum and interesting surfaces, and to develop a surface free from minor defects. Flint can easily be added to supply additional silica, if it should be needed.

The potter should attempt to vary the basic glaze to produce a glossy surface, a matte surface, and one that is fairly opaque (without the use of an opacifier such as tin oxide). Substitutions of some of the feldspar-like materials which contain different fluxes, such as spodumene or nepheline syenite, can be tried. Often small amounts of another flux will result in a great improvement in a glaze. Other suggested additions are zinc oxide, talc, and strontium carbonate. (See Chapter 10 for more detailed information on these and other chemicals, including colorants that will be used in further tests.)

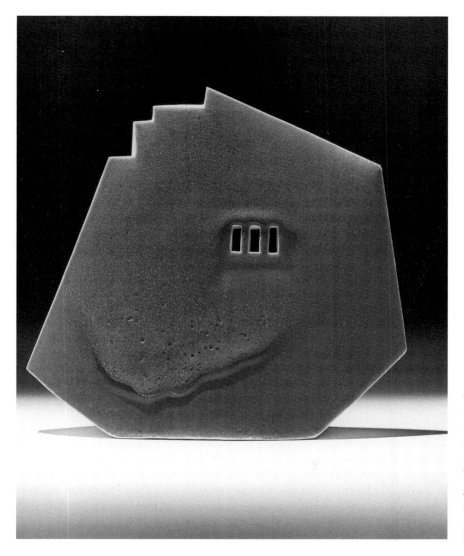

9-3 Yih-Wen Kuo, USA; *Eternal Home,* 1995, porcelain, 7 × 7 × 3 in. (17 × 17 × 7 cm). This sculptural form illustrates how the flowing qualities of a matte stoneware glaze can be used effectively. The rich texture and broken surface contrast and soften the geometric and architectural elements of the form. Note how the thin glaze at the edges shows the color of the clay and further highlights the form.

GLAZE TYPES

At the beginning of this chapter we stressed the simplicity of formulating a glaze. Indeed, a functional and attractive glaze can be made from only a few materials. Several glazes, however, use rather uncommon ingredients or require special firing techniques. The glaze recipes in the Appendix will clarify the general descriptions of the glazes that follow.

Glazes can be categorized in a number of ways: firing temperature, color, surface texture, composition, or application and use. The glaze types below have been grouped into two general categories—low fire and high fire. Low-fire glazes are those that fire generally between cone 020 and cone 01, including the popular cones 06 and 04. High-fire glazes mature between cones 6 and 10. Some identify a third classification—medium-fire or mid-range glazes, which mature between cones 01 and 6. Medium-fire glazes frequently exhibit some qualities of each of the other two popular categories.

Glazes can also be categorized by the major fluxes that are included in the glaze. The type of fluxes used can have a large effect on the color of the fired glaze. For instance, glazes high in the alkaline fluxes (soda, potash, and lithia) tend to produce bright colors from many colorants, with each of these flux oxides producing a somewhat different color from the same colorant. The use of glaze calculation (Chapter 10) to determine the oxide content of glazes can be helpful in understanding these variations.

In addition to these temperature categories, there are a number of special glazes formulated to give particular effects. Some of these fire predominantly in either the high or the low range, but others span the entire firing spectrum.

High-Fire Glazes

High-fire glazes generally are compounded to fire in a range from cone 6 to cone 14, or 2250°F to 2500°F (1230–1370°C). At these extreme temperatures, common low-fire fluxes, such as lead and borax, must be replaced with calcium carbonate, which has a higher melting point—about 2442°F (1339°C) and just begins to melt with silica at about 1500°F (816°C).

Porcelain and stoneware glazes are identical, except in situations where adjustments must be made to accommodate a difference in firing shrinkage. Because feldspar is a major ingredient in such glazes, the term **feldspathic glaze** is often applied to most stoneware glazes. Because of the high temperature, the union of glaze and body is quite complete. The interlocking mullite crystals which are formed prevent detection of the line of junction that is easily visible between a glassy glaze and a porous earthenware body. Feldspathic glazes are very hard (they cannot be scratched by steel), and they resist most acids, the exceptions being hydrofluoric, phosphoric, and hot sulfuric acids. The surfaces may be either matte or smooth, but they seldom reveal the extremely high gloss of many low-fire glazes.

Medium-Fire Glazes

Glazes firing between cones 02 and 5 or 6 contain both high- and low-fire fluxes in order to adjust to these temperature limits. (See Appendix for glaze recipes.) Generally, they combine the smooth, glossy surface and potential for

bright colors of low-fire glazes with the more durable heat and shock resistance of higher-firing glazes. There are also many commercially prepared glazes available in the medium-fire range providing a wide spectrum of colors—purples, yellows, reds, and oranges—difficult to achieve in the high-fire glazes and with harder surfaces than the lower-fire range due to the greater amount of silica that can be incorporated into the glaze. The recently developed zirconium inclusion stains which, though expensive, allow bright reds and oranges to be made which are quite stable at this temperature will even survive most reduction firings. Many hand potters and sculptors are working with the very stable glazes in this medium-fire range for the bright designs and details they make possible. Another desirable feature is the energy saving in firing to lower temperatures.

Low-Fire Glazes

Most low-fire glazes can be further subdivided into two distinct groups—lead-free or lead-containing—according to the major flux included in the glaze. Both fire in the range of cone 016 to cone 02, and both result in smooth, glossy surfaces. They often are characterized by the bright, shiny colors of commercial low-fire glazes, but matte surfaces, burnishing, and terra sigillata all can add variety. Lead-free glazes are generally of either the alkaline or calcium-borate types. New laws and regulations increasingly limit the availability and use of lead in glazes due to its toxicity. Lead glazes are discussed here for reference purposes only. Low-fire glazes are most often *fritted,* for the reasons discussed below.

Frits **Fritting** is a procedure by which a flux or combination of fluxes, and silica are melted completely into glass and ground into powder after cooling. The resulting frit is added to the glaze in place of the equivalent raw materials. This makes the lead glaze frits both less toxic and fritted alkaline glaze ingredients insoluble in water, posing fewer problems during application. Frit composition is complicated, for nontoxic or nonsoluble elements must be completely absorbed within a satisfactory firing range and without creating later glaze problems. Most frits now commonly available in the United States are lead-free. Frits can be used in both low- and high-fire glazes, but are most often seen in low-fire glazes. Feldspars, whiting, dolomite, and similar minerals are a good insoluble sources of most of the flux needed in high temperature glazes. Low-fire glazes need larger amounts of more powerful fluxes which don't readily occur as insoluble naturally occurring minerals.

 To produce a frit, lead or alkaline fluxes (soda ash, pearl ash, borax) are melted in a frit kiln with silica or with silica and a small amount of alumina. Other fluxes or even colorants can be added as desired. When the frit mixture becomes liquid, a plug is pulled in the bottom of the frit furnace, and the molten contents are discharged into a container filled with water. The fractured particles are then ground to the necessary fineness. Small amounts of frit can be made in the studio using a crucible. One disadvantage of studio manufacture is the extremely long grinding time necessary to pulverize the frit to adequate fineness. Frit is then washed to remove any soluble particles, and dried for use. Most potters buy the many types of commercially produced frits.

Fritted Glazes Fritted glazes may be little different chemically from other glazes, but utilize frit which renders raw-glaze materials either relatively nontoxic

to handle or insoluble. A frit by itself is seldom a complete glaze for several reasons. Since it is usually colorless, opacifiers or colorants must be added. The frit has little ability to adhere to the bisque, so it is usually necessary to add a small amount of clay, most often kaolin or bentonite. A typical starting point for fritted low-fire glaze is:

> 9 parts low-fire frit
> 1 part kaolin

A fritted glaze with no kaolin may include up to 3 percent bentonite as an adhesive and suspension agent without noticeably changing the fired glaze. Other additives like Epsom salts may also be used to help keep the glaze in suspension and make application easier. Heavily fritted glazes like this have a tendency to settle badly. See the section on glaze additives on pages 297–299. Adjustments for the final firing range and fit to the clay body of the fritted glaze must also be made by altering the amount of clay and silica added to the glaze.

Fritted glazes have extensive commercial use where large amounts of a standard glaze are employed. For the studio potter, frits are of the most value in making dependable low-fire glazes and in eliminating the negative qualities of borax (lumpiness, solubility) needed in crystalline, copper reds, and similar glazes. Frits are also useful as a more reliable substitute for natural sources of boron such as gerstley borate. Purchased in 100-pound (45.36-kg) lots, low-fire frits might well be used in schools to replace the small and expensive colored glaze packets or premixed glazes often purchased. The addition of a few color oxides or commercially available stains and kaolin would not raise the cost substantially.

Alkaline Glazes Alkaline glazes are high in the alkalies sodium, potassium, or lithium and encourage bright color effects, particularly turquoise-blues from copper. These glazes are almost always formulated as a frit or use frits for a large portion of the glaze. Because of their extreme solubility, alkaline glazes should never be applied to raw ware unless fritted. When absorbed into the clay, the fluxing action of soluble alkaline compounds with the clay may cause the body to crack during firing and cooling.

A very soft bisque ware also reacts poorly to an alkaline glaze, for it will absorb a portion of the flux, leaving an incomplete and usually rough-textured glaze after firing. Because of their solubility and tendency to become lumpy in the glaze solution, the alkaline compounds (and others such as borax) are often fritted into a nonsoluble silicate form. Boron-containing materials like gerstley borate or substitutes often give a milky blue tinge to the glaze. Alkaline glazes are generally more successful when used on a body fairly high in silica. Highly alkaline glazes have an almost incurable tendency to craze. Their surface is also somewhat soft, more easily etched by acids, and easily scratched. These factors limit their usefulness on ware for food.

Lithium is the odd member of the alkaline glaze ingredients, as it has very low thermal expansion when used in small quantities, so it is useful to correct the tendency of alkaline glazes to craze. Large amounts of lithium oxide in glazes may have just the opposite effect, however, but this is a rare occurrence as lithium is a very strong flux and will cause extremely fluid glazes in fairly small amounts. Lithium is also useful to make flowing alkaline matte glazes.

Lead Glazes In the past the most common fluxes for many low-fire glazes were the lead compounds lead carbonate and red lead; indeed, some of the

earliest glazes were probably largely made from powdered galena, a lead mineral. A very active flux that melts at about 950°F (510°C), lead gives glazes a bright and glossy surface, and can support some of the brightest colors in glazes. Historically it has been one of the most dependable and flexible glaze materials for low-fire glazes.

The extreme toxicity of raw lead has made it seldom used in glazes in recent years. Ceramic engineers have worked hard at formulating lead-free alternatives to many of the popular low-fire colors. Lead, if used at all in glazes for sculptural work, should be in a fritted form for safer handling before firing. Because of the toxicity of raw lead compounds, lead is usually converted into a somewhat less hazardous lead bisilicate form by fritting.

Given recent legislation, even fritted lead glazes should not be used for ware that could be used for food. The risk to the potter may be less in handling and firing fritted lead glazes, but is not to be ignored. Improperly formulated or fired lead glazes may constitute a hazard even after firing, especially if they are used with acidic food and drink. Lead-glazed coffee cups are now said to be one of the main environmental sources of dietary lead intake in the United States. Obviously the use of lead glazes on such wares should be avoided.

The addition of other materials, notably copper colorants, to lead-containing glazes can render them unsafe for use with food. The laws governing lead use in all parts of society, including the production of lead-containing frits, are growing stricter, so it is likely that we'll soon see the disappearance of this once popular and valuable glaze flux.

In spite of there being a potential health hazard, lead glazes might rarely be considered for sculptural work if handled responsibly, although increasing restrictions on lead use and production may soon make this impossible as well. Kilns used for firing lead glazes also should not be used for firing functional lead-free wares, especially in the same firing, as there is a slight danger of lead contamination of the lead-free wares by lead fumes in the kiln.

The attraction of lead glazes is that they produce uniquely soft and shiny surfaces, and bright colors. There are many historical examples with beautiful lead glazes. In the past, lead glazes made opaque and whitish by the addition of tin to the glaze were commonly used on Spanish and Italian earthenware called majolica, but lead is no longer used in modern majolica wares, having been replaced by calcium borate frits.

SAFETY CAUTION
You should handle even fritted lead glazes carefully to avoid breathing the poison dust or getting particles in your mouth. Do not use lead-glazed vessels to store or serve food. Variations in firing may also cause an otherwise "safe" lead glaze to be unsafe. Lead glazes used on food wares *must* be tested for lead release.

LEGAL NOTE: In many parts of the United States, recent changes in the laws which govern lead-glazed ware have made it largely illegal to make any such wares which could be used for food. Ware with lead glazes usually must be permanently labeled as such. Check the laws that govern your area carefully.

Special Glazes and Effects

Ash Glazes Ash glazes were probably among the earliest glazes used to apply to pottery. At present they have no commercial industrial application, but they are of interest to the studio potter. The ash can derive from any wood, grass, or straw. Depending upon the specific source, the chemical composition can vary considerably: it is often very high in silica and contains some alumina and calcium; moderate amounts of fluxes, such as potash, soda, and magnesia; plus iron and small quantities of numerous other compounds. Because of the high silica content, ash can seldom be used in low-fire glazes in amounts over 15 to 20 percent. This is not sufficient to make much change in the basic glaze.

A suggested starting point for a stoneware ash-glaze test would be the following:

 4 parts ash
 4 parts feldspar
 2 parts whiting

or this simple recipe which may yield a somewhat runny glaze:

 5 parts wood ash
 5 parts earthenware clay

Other clays might be tried in the latter glaze. Materials added to the ash may be varied in the former recipe, in much the same way as the stoneware glaze test described earlier in this chapter.

Fireplace ashes should be collected in a fairly large quantity and then mixed thoroughly to ensure uniformity. The ash is first run through a coarse sieve to remove unburned particles. It can then be soaked in water that is decanted several times to remove soluble portions. Many potters, however, prefer to run the dry ash through a medium to fine sieve without washing (taking special care not to inhale the fine ash particles or get them in their eyes), and thus retain the soluble fluxes. The latter procedure will allow a larger percentage of ash to be used in the final glaze. Using a coarser sieve to screen the ash may give an interesting broken texture to the glaze, due to the variations of the larger particle sizes.

⚠ **SAFETY CAUTION**
Because ash glazes are quite caustic, do not stir them with a bare hand. Unwashed ash can be especially caustic! Wear protective clothing, rubber gloves, and eye protection when handling dry or wet ash. Also wear a dust mask when handling powdered dry ash.

While wood ash can be incorporated into a glaze and fired in an electric, oil, or gas kiln, an ash glaze can also be the result of a long firing in a wood-burning kiln. Results are not predictable, because much depends upon the placement in the kiln, the path of the flame, and the length of firing. These factors cause the ash to be deposited on the ware in an uneven fashion, much like the effects of salt or soda vapor glazes. (See Figure 9-4 and also Figures 4-4, 4-27, and 4-40.) One can even sift dry wood ash onto a freshly glazed pot before

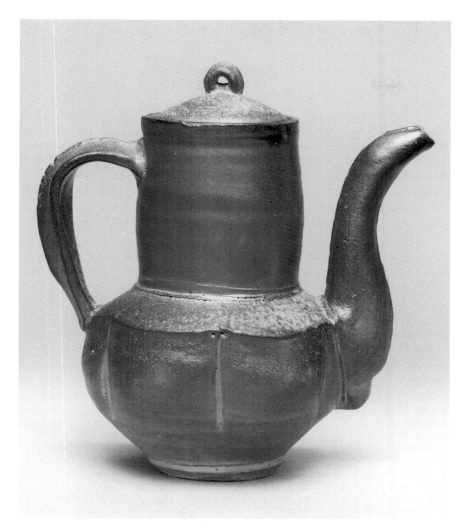

9-4 Randy J. Johnston, USA. Wood firing enriches the surface of this elegant teapot, but does so in a very naturalistic way. The glaze, formed only from ash deposited during the wood firing, is subtle, earthy, and appealing in both the amount of surface detail that it reveals and in its warm reddish-brown glow.

firing, but the results will not be exactly the same as wood ash glaze formed in a wood firing.

Salt and Soda Vapor Glazes Salt glazes have enjoyed a revival in recent years after a long period of neglect by the studio potter. This type of firing is sometimes called vapor glazing as the primary glaze on the outside of the ware is formed by sodium vapors blowing through the kiln. From the twelfth to the mid-nineteenth century, such glazes were common in Germany and England and, in the seventeenth and eighteenth centuries, in Colonial America. Little commercial salt glazing is done today because of the chlorine emitted from the kiln during the glazing procedure.

Salt glazing is a simple procedure, but it requires a dedicated fuel-fired kiln as the glazing process glazes the entire inside of the kiln at the same time as the ware. The ware is fired to its body-maturing temperature (most commonly in the stoneware range), at which time common salt (sodium chloride) is thrown into the firebox or through ports entering the kiln chamber. This sodium combines

with the silica in the clay to form a glassy silicate. Adding a small amount of borax will reduce the firing temperature, but often results in a shiny glaze.

⚠️ **SAFETY CAUTION**
Since some hydrochloric acid vapor is released at the moment of salting, you should have a well-ventilated outdoor kiln. Soda firing (below) offers a safer alternative. Either type of firing demands protective equipment because of the intense heat of working so close to the kiln, and good ventilation. A proper respirator rated for organic acid vapors (*not* just a dust mask) is advisable.

The toxic hydrochloric acid fumes released from salt glazing (formed from the chlorine that makes up part of the salt) have caused potters to search for alternatives to sodium chloride. Of these, sodium bicarbonate seems the most successful and easiest to use. This is now often referred to as **soda firing.** Because of its higher melting point and lower vapor pressure, you should spray the sodium bicarbonate slowly into the burner port or special ports near the burners to ensure its distribution throughout the kiln. Simply dumping sodium bicarbonate into the kiln, as one might salt, results only in a mass of soda glass on the floor of the kiln. One method that works well is to use an inexpensive portable sandblaster to blow the carefully screened sodium bicarbonate into the hottest part of the kiln near the burners. Avoid spraying the sodium bicarbonate directly on pots or kiln shelves, as it may cause bubbly, eroded surfaces and damage to the shelves. An alternate method is to dissolve soda ash (sodium carbonate) in hot water, then slowly spray it into the kiln using a garden sprayer (be careful: soda ash solution is somewhat caustic). In either case only 3–6 pounds of baking soda or soda ash is usually required for a 20- to 30-cubic-foot kiln.

For salt glazing, the usual stoneware or porcelain body is often satisfactory. Additions of silica and feldspar to the clay may be necessary to obtain a good glaze coating, as a nearly vitreous, glassy body greatly aids soda glaze formation. Under reducing conditions (incomplete combustion to introduce carbon monoxide and hydrogen into the kiln atmosphere), buff or red clays will develop a pebbly brown or black glaze. A more oxidizing firing may produce lighter tans and grays. Other colors can be obtained only by using colored slips or body stains. See the Appendix for stain and clay recipes for salt and soda firing.

Unique copper-red salt glazes have been achieved by reducing the ware after copper carbonate has been introduced into the kiln during the salting. Other color oxides can also be thrown into the kiln during the salting procedure, causing flashes of color where the vapors strike the ware. Unfortunately some of these colorants will stay in the kiln and many continue to color the ware for many future firings, so this should be carefully considered before throwing colorants into the kiln with the salt. Using colored slips or engobes on the ware may be a better option, and one which is more kind to the environment.

Whatever coloring devices are employed, the glaze will more than likely have a mottled and pebbly surface, often called **orange peel.** The salt glaze runs off the sharper edges of plastic additions and does not penetrate far into incised

decoration, so that a natural contrast develops between fully and thinly glazed areas. Because the salt does not reach the insides of closed forms or tall bottles, the insides should be glazed in the normal manner. Once fired wares may be slip-glazed inside.

The major disadvantage of the salt or soda glaze is that it coats the whole interior of the kiln. This makes the kiln unsuitable for normal bisque and other types of glaze firing. The firing range of salt glazes is wide, from cones 04 to 12, but the most common firings are between cones 5 and 10. (See Chapter 11 for more specifics on salt and soda firing techniques.)

Fuming Iridescent effects much like lusters can be produced by fuming glazed ware in the kiln with metallic salts. At the end of the glaze firing, the kiln is cooled to a low red heat (about cone 020—barely above 1000°F [538°C]). With the draft and burner ports open, very small amounts (a few grams at most) of metal salts such as stannous chloride, ferric chloride, bismuth nitrate, or silver nitrate are introduced into the kiln through the burner ports. This process should only be done with proper ventilation. Proper eye protection and a vapor mask are required for safety. Follow chemical handling procedures. Fuming may result in carnival glass-like lusters on the ware, much like coating the pieces with pearl luster. The coating left by the fuming is extremely thin, and depends on a smooth glaze surface to develop iridescence. If done at too high or low temperature, the ware may instead be covered with a scummy white coating that is difficult to remove.

SAFETY CAUTION

Metallic nitrates and chlorides pose a much larger hazard than most of their oxide counterparts. Many of these materials are soluble and may be absorbed through the skin. Silver nitrate is particularly hazardous, as it is photosensitive and binds with human tissue. Wearing appropriate protective equipment, including eye protection, is vital when handling these materials. Fuming with these materials will release volatile chlorine and nitrate compounds, along with the metals involved. A respirator with filtration for fumes, organic vapors, and dusts is required for safety.

Raku Glazes Raku glazes are usually applied to stoneware bodies containing a high proportion of grog, usually 30 percent of the body, in order to withstand the rapid heating and cooling involved in the firing process. (See Chapter 11 for raku firing techniques.) Finer grained bodies may work, but need to be able to withstand the intense strains of the rapid firing. Because the firing temperature may be as low as 1750°F (955°C) or cone 09, the glaze can consist of 80 percent gerstley borate substitute and 20 percent potash feldspar or nepheline syenite. Using a high amount of gerstley borate will tend to make these glazes thixotropic, but usually a quick stir will liquefy them before use. Low-firing borosilicate frits can also be used and will eliminate the lumpiness resulting from the borax or the unpredictability of gerstley borate. As frits tend to settle badly (unlike the thixotropic qualities of glazes with gerstley borate), a small amount of bentonite and flocculant like epsom salts may be needed. Gerstley borate substitutes may also require similar cures for settling problems.

Raku glaze is best applied to bisque ware because the rapid firing would cause greenware to explode. Because of the low firing temperature, the clay body remains underfired and porous, and the glaze is not waterproof. Because of this, raku is generally not suitable for utilitarian ware meant for foods, especially liquids which will soak into the porous clay. An exception is when used for tea, as the tea soaking into the clay body gradually seals the porous ware.

The speed of the firing, the exposure to open flame, and the reducing atmosphere and smoking result in a great variety of unusual and unpredictable glaze effects. Copper oxides tend to develop reds and lusters, red iron oxide becomes black, and deep crackle patterns occur in all glazes. The popular rainbow raku matte colors caused by the flashing of glazes containing high amounts of copper are not stable, however, and will fade over time.

Raku ware is associated with the Japanese tea ceremony as described in Chapter 3. Classic Raku tea bowls are usually hand-built and irregular, allowing the effects of the firing to complete the decorative design. The high grog content and rapid firing process somewhat limit the size and shapes of raku forms, although many contemporary potters have greatly expanded the scope of raku ware. Raku has been greatly Americanized from its original Japanese roots, with the process being used for a wide range of decorative and sculptural work.

Reduction Glazes Reduction glazes are those especially compounded to develop their unique color characteristics only if fired in a kiln capable of maintaining a reducing atmosphere during certain portions of the firing cycle. Fuel-fired kilns are most often used for reduction firing. A typical electric kiln almost always has an oxidizing fire, since there is nothing in the kiln atmosphere to consume the oxygen which is always present as air moves through the kiln. This oxygen is thus free to react with any materials in the glaze, a process called **oxidation.**

To produce a reducing atmosphere there must be sufficient fuel of some type to both consume any free oxygen gas in the kiln, and to provide reducing gasses like hydrogen and carbon monoxide to react with oxygen in the glaze and clay materials. Remember that the fired form of all ceramic materials is largely that of an oxide—a compound that contains oxygen. Hydrogen and carbon monoxide are highly reactive in the high temperatures of the kiln and seek to combine with any oxygen they can find, ultimately forming water vapor and carbon dioxide. This can happen most effectively while the clay and glaze are not fully vitrified or melted, respectively, so reduction usually is begun just as the glazes first start to melt. Prior to this point, the firing is done in oxidation.

As the reducing gases take oxygen from the oxides in the clay and glaze, the molecular structure is changed, leaving the clay and glaze with less oxygen. This molecular change both alters the hue of many oxides we use as colorants, and affects the way many glazes melt. Matte glazes in particular seem to benefit from firing in a reducing atmosphere, acquiring a silky matte quality that is not present if the same glaze is fired in oxidation.

In a gas or oil kiln, reduction is accomplished by increasing the fuel while decreasing the air intake slightly, resulting in an incomplete combustion that releases hydrogen and carbon monoxide into the kiln interior. Some electric kilns have been devised to allow the introduction of small amounts of solid fuel to enable reduction firing, but gas kilns are usually preferred for this type of firing. See Chapter 11 for more details on reduction firing.

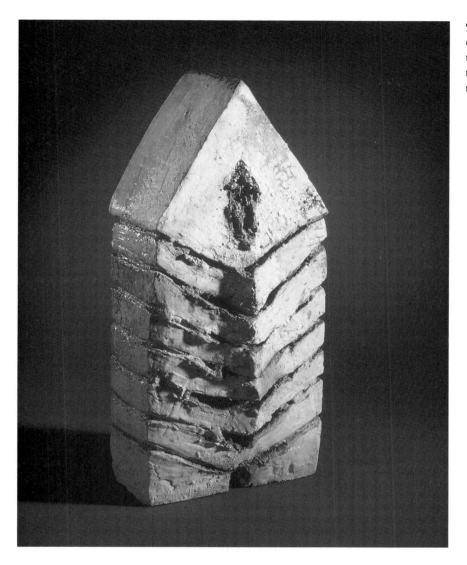

9-5 Nina Hole, Denmark; *Secret;* raku-fired clay. Many low-fire glazes used for raku use the simple recipes like the one described in the text. The plain white, crazed surface of this glaze helps to keep this piece integrated.

⚠ **SAFETY CAUTION**
 Reduction firing must always be done in a well-ventilated space. Carbon monoxide generated during the firing can be toxic. Avoid spending unnecessary time near kilns which are being fired.

 Iron and copper coloring oxides in glazes are particularly affected by reduction firing. It was in this manner that the Chinese produced their famous copper-reds (*sang-de-boeuf*) and gray-greens (celadons). When either copper or iron oxide is deprived of its oxygen, it is reduced in the glaze to a less oxygen-rich molecule or even the pure colloidal metal within the glaze. Thus a normal green copper glaze becomes a beautiful ruby red with occasional blue or purple tints. The iron oxide loses its customary brownish-red tone and takes on a variety

of soft gray-green hues of a celadon glaze. Temmoku glazes with larger amounts of iron oxide turn a rich black broken with reddish brown.

Reduction can also affect the color of a stoneware body. Stoneware that is buff or tan in oxidation becomes gray to rich shades of brown under reducing conditions. The iron oxide particles contained in most stoneware become darker and melt into the glaze, making it speckled. At the end of the firing with fuel no longer flowing into the kiln, the kiln reoxidizes as it cools. The glazes, being dense and glassy, are resistant to reoxidation and retain much of their reduced color. The iron-containing clay sealed under a clear glaze stays a reduced gray color from black iron oxide (FeO), yet where the clay is not glaze-covered it will reoxidize to the warm brown of the more oxidized red iron oxide (Fe_2O_3).

A local copper reduction can sometimes be achieved by using a small amount (about 0.5 percent) of silicon carbide (carborundum) in the glaze. The effects are slightly different from the standard reduction, for the color is concentrated in little spots around the silicon carbide particles, often with variable and mixed results. But this technique has an advantage in that it can be used in an electric kiln, since the heating elements are in no way affected. The firing range of copper-red and celadon reduction glazes is quite wide, from about cone 08 all the way up through the more commonly seen copper reds at porcelain temperatures of cone 10–11. Iron is somewhat more difficult to reduce in the low-fire range than is copper, and the most classic iron reduction colors can be obtained in the cone 7 to 12 range.

Matte Glazes Matte glazes commonly are formed either by adding an excess of alumina or by adding a sufficient amount of an alkaline earth flux like barium carbonate (toxic), strontium carbonate, calcium carbonate (whiting), or magnesium carbonate (from dolomite) to the glaze. Glazes matted primarily with large amounts of alumina are called alumina mattes and tend toward a dry, stony surface. Barium mattes were once quite popular because of the intense colors produced by colorants in association with barium, especially the rich aqua blues that are possible using copper as a colorant. Because of barium carbonate's toxicity, strontium carbonate is now often used instead, although this results in slightly different hues and less intense colors. The substitution is usually in the ratio of 0.75 parts by weight of strontium carbonate for every 1.0 part of barium carbonate in the recipe. Barium or strontium mattes may be difficult or impossible to make if there is a substantial amount of boron in the glaze, as these react with boron, which often results in a very glossy glaze. Magnesia (magnesium oxide) makes satin mattes that have a particularly smooth waxy feel, and also affects colorants. Magnesia dulls some colors, but turns cobalt noticeably more purple than blue. Additional alumina (usually supplied by clay) may need to be added along with the alkaline earth to assure that the glaze will indeed be matte.

A matte glaze should not be confused with a thin, rough, or underfired glaze. It should be smooth to the touch, with neither gloss nor transparency. The matte effects sometimes observed on an underfired glaze are caused by incompletely dissolved particles, whereas a true matte develops a different crystalline structure on its surface upon cooling. A long cooling time will encourage the formation of matte textures. One test for a true matte is to cool the glaze quickly to see if it will develop a shiny surface. A matte surface caused by the incomplete fusion of particles, as in an underfired glaze, will continue to have

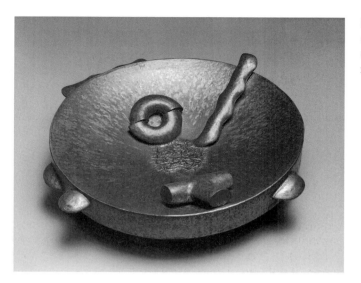

9-6 Patrick Horsley, USA; *Basin*, stoneware, 18 in. (45 cm). A saturation of colorant is partly responsible for the metallic matte surface of this piece.

a matte surface, regardless of the cooling time. It is generally a bit rough to the touch and lacks the smoothness of a true matte glaze.

Mattes can be calculated for all temperatures, but they are particularly attractive in the stoneware ranges, with soft waxy matte surfaces easily achieved. Matte low-fire glazes are more difficult to achieve, but worth the effort as the extreme gloss of many low-fire glazes can sometimes obscure decoration and form. Matte glazes are related to the crystalline group, because both depend upon the surface structure of the glaze for their effects. Therefore, mattes can also be made with iron, zinc, and titanium (rutile) when properly compounded and cooled slowly.

Crackle Glazes Crackle glazes cannot be characterized by their composition, for they are merely the result of tensions that arise when a glaze and a body expand and contract at different rates. In most glazes, except perhaps some mattes, a visible crackle can be produced. The simplest way is to substitute similar-acting fluxes for others having a different contraction rate. The reverse is true if a noncrackling glaze is desired. Sodium has the highest expansion rate, followed by potassium. Calcium has about half the rate of expansion of these, lead and barium follow, with boron and magnesium having the lowest expansion rates of commonly used fluxes.

A crackle is a network of fine cracks in the glaze. It must be used on a light body to be seen properly. To strengthen the effect, a coloring oxide or strong black tea is often applied to the crackled area. The Chinese were able to achieve, by successive firings, a network of both large and fine crackles, each stained with a different coloring oxide. A crackle glaze is more practical on a vitreous stoneware or porcelain body because a crackle on a porous earthenware pot will allow liquids to seep through.

Crystalline Glazes There are two types of crystalline glazes. The more common, macrocrystalline, has large crystal clusters embedded in or on the surface of the glaze; the second type, called aventurine, has single crystals, often small, suspended in the glaze, which catch and reflect the light. These are interesting

9-7 Adrian Saxe, USA; *Explosive Decompression*, 1990, porcelain, lusters, faceted cubic zirconia, and quartz crystal, 19.5 × 10 × 8 in. (49 × 25 × 20 cm). The crazing lines in the glaze have been stained so that they become more apparent.

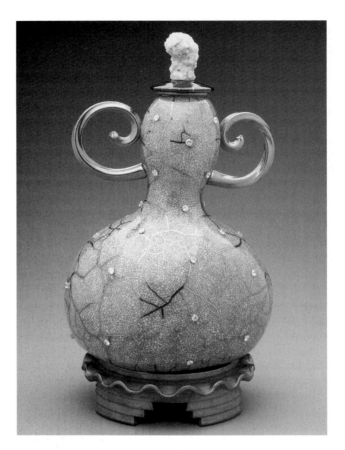

glazes technically, but they must be very carefully related to the pot shape for best effect. The jewel-like qualities seem to float off the surface of all but the most simple and reserved forms.

The crystalline formation is encouraged by additions of zinc oxide, with iron oxide or titanium dioxide (rutile). Borax and soda can also be used as fluxes, preferably in a fritted form, but lead is not advisable. The alumina content must be very low and is in fact largely absent from many crystalline formulas. The silica content is also lower than in most glazes of the same temperature. Besides having a fairly narrow range of formulas, crystalline glazes demand special and careful firing, particularly for the more spectacular crystals to develop.

A matte glaze is actually an example of a microscopic aventurine-type glaze. Possible firing ranges are wide, and, as with matte formations, the rate of cooling is most important. In order to allow the crystals to develop properly, the temperature of the kiln should be permitted to drop only about 100°F (38°C) after maturity, and it must be held at this level for several hours before slow cooling. Crystalline glazes are quite runny, so a pedestal of insulating brick should be cut to the foot size and placed under the ware. The piece can be set in a shallow bisque bowl that will collect any excess glaze that might run off the sides. The potter can also throw a separate foot ring with catch basin, coat it with kiln wash, and place it under the ware.

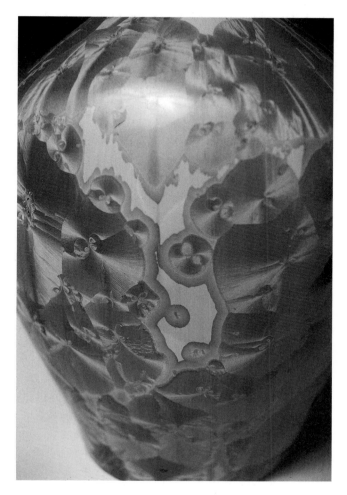

9-8 Crystalline glaze on porcelain The rich visual texture of crystalline glazes suggests their use on simple forms. Crystals are almost flower-like and can get quite large if given enough time to grow in the kiln. The color of the crystal is often strikingly different from the background glaze color. The pot in this photo has bright blue crystals on a yellow background.

Luster Glazes Historically, lusters consisted of a thin, decorative metallic coating fired over a tin-lead glaze, and are not exactly one of the true glazes. This coating was a solution of pine resin, bismuth nitrate, and a metallic salt dissolved in oil of lavender. The luster was then fired to a low red heat in a reducing atmosphere sufficient to fuse the metal and burn off the resin, but not to melt the original glaze. This procedure made possible a variety of colors as well as iridescent sheens. The metals employed were lead and zinc acetates; copper, manganese, and cobalt sulfates; uranium nitrate; and even silver and gold compounds. Bismuth generally served as the flux. The luster was rarely an overall coating; rather, it was applied in the form of a decorative design. This is especially true in Islamic ceramics, which featured intricate, interlocking decorative motifs, as described in Chapter 3. Glazes that fire with a luster-like surface are also possible.

Whereas the lusters of the Islamic potter contained impurities that softened their brilliance, commercial lusters used today are bright and strident. The lusters usually are fired in an electric kiln between cone 020 and cone 014 and are

9-9 Adrian Saxe, USA; *Untitled Ewer,* *(Clearface Gothic Extra Bold Ampersand)* 1989, porcelain and lusters, 8.5 × 9 × 2.5 in. (21 × 22 × 6 cm). The gold luster used on this piece adds an air of richness and elegance to the form. Saxe draws inpiration for his work from a variety of sources, including the opulent decoration and gold common to much European porcelain of the eighteenth and nineteenth centuries.

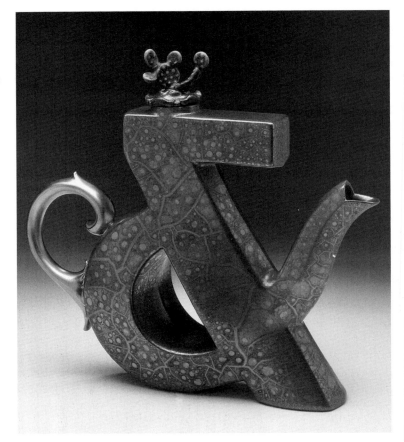

available in pearl-like iridescent hues and various colors—turquoise, blue, pink, red, gold, and silver. They can be brushed or drawn with special pens onto nearly any low-fire or stoneware glaze.

⚠ SAFETY CAUTION

Lusters carry several possible hazards. The medium typically used is oil of lavender. This is a material whose vapors are a respiratory irritant to many people. Good ventilation is a must. An organic vapor mask is recommended. Firing produces additional noxious gases.

Bristol Glazes Bristol glazes are very similar, in most respects, to the typical porcelain glaze, except that a relatively large amount of zinc oxide is added. In most instances, this tends to lower the melting point and to add a certain opacity to the glaze. Calcium and barium should be included in the fluxes. Most Bristol glazes fall into the cone 5 to 9 range, although formulas have been successfully developed for cones 3 to 14. The most common use of the Bristol glaze is for architectural tile and bricks.

Since a large amount of clay is normally used, the ware is generally given a single firing, and there is no problem of shrinkage. However, by calcining part of the clay, the glaze can be fitted to double firings. The commercial single fire usually takes 50 to 60 hours, not only because of the thickness of the ware being fired, but also because of the extremely viscous nature of the Bristol glaze. It is this quality of the glaze that makes it valuable to the studio potter. Interesting effects can be achieved by using a Bristol glaze over a more fluid glaze that breaks through in spots. The application of the glaze must be perfect because its viscosity prevents any cracks that may occur from healing. Moreover, in firing, the edges of the cracks will pull farther apart and bead. In general, Bristol glazes are shiny, but they can be given a matte surface by increasing the amount of calcium while reducing the silica content.

Slip Glazes Slip glazes are made from raw natural clays that contain sufficient fluxes to function as glazes without further preparation beyond washing and sieving. In practice, additions are often made to enable the slip glaze to fit the body or to modify the maturing temperature, but these changes are minor.

Slip glazes were commonly used by early American stoneware potteries that produced such utilitarian objects as storage crocks, bowls, mugs, and pitchers. Albany slip clay was once the primary commercial variety and used widely on a variety of wares. It is no longer available, but substitutes such as Alberta slip have appeared to replace it. Albany slip fired reliably to a glossy brown-black at cones 6 to 10. Many slip clay deposits are not always recognized as such. They are particularly common in the Great Lakes region—Indiana, Michigan, Minnesota, Wisconsin—and, like those in New York, are probably of glacial origin.

Barnard slip clay is somewhat similar to Albany slip clay, but it is lower in alumina and silica and has a much higher iron content. Red Dalton is higher in alumina and silica, but lower in fluxes. All fire to a brownish black and can be used in a combination or, depending upon the firing temperature, with added fluxes. Because of the natural contraction of slip clay during drying, the ware is best glazed and decorated in the leather-hard stage. The addition of 2 percent cobalt to slip clays like Albany or Barnard will result in a beautiful, semigloss jet black.

Frequently, earthenware clays can be used as slip clays when fired high enough and with the addition of small amounts of flux. Most slip clays fire from cone 4 to cone 12. Slip clay fluxes are generally the alkaline earth compounds, plus iron oxide in varying amounts. A high iron content serves also to produce a color ranging from tan to dark brown.

The potter must be careful in using slip clays, for they are generally mined in small pits, and their composition will vary slightly from batch to batch. Each new shipment of material should be tested before being used in quantity. Studio potters should pay more attention to this group of glazes. Slip clays are easy to apply, adhere well, and fire with few, if any, defects. The composition, chemically, is most durable, and, since additions are few, much time can be saved in glaze preparation. Slip clays are particularly well suited for single-fire glazes.

Terra Sigillata Terra sigillata is not actually a glaze, but rather a thin slip made of extremely fine particled clay, fired to somewhat low temperatures so that the surface was somewhat easily scratched and not completely waterproof. (See Terra Sigillata, Chapter 8.)

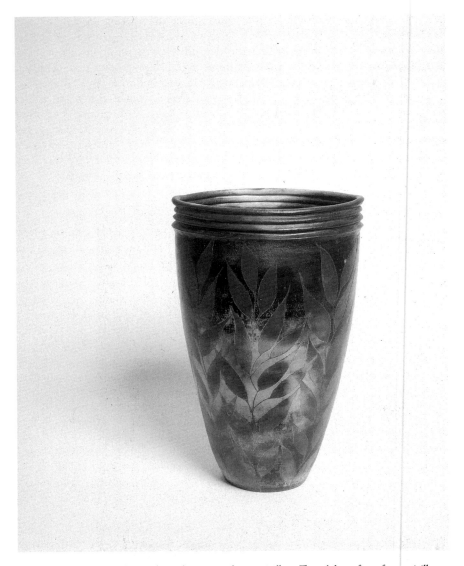

9-10 Aase Haugaard, Denmark; earthenware with terra sigillata. The subtle surface of terra sigillata goes well with the primitive firing techniques and simple, naturalistic decoration of this piece. Terra sigillata never attains the high gloss of many low-fire and raku glazes, but instead maintains a satin luster if burnished and fired to low temperatures.

Majolica Glaze Majolica (or sometimes **maiolica**) is the name often used for the technique of applying colorant washes over an unfired opaque white glaze. The colorant washes fuse into the stiff, white glaze when it is fired. Flux in the form of gerstley borate or frit is usually added in the amount of up to 50 percent to the colorant wash to aid the fusion with the glaze. Originally this was a tin-opacified lead glaze, but now lead-free glazes are used. The style is thought to have Moorish-influenced origins in Spain; from there it spread across Europe becoming majolica in Italy, delftware in the Netherlands, and

faïence in France. Italian majolica had great popularity during the Renaissance, with majolica painters often copying the works of major painters of the era onto plates and shallow bowls. As the desired result is usually a painterly effect, the glaze used must be quite stable and not run or even move much in the firing or the painted colorants will be obliterated. The typical majolica glaze is fired at about cone 04, but potters have experimented in recent years with majolica painting techniques using cone 3–6 glazes for greater durability and fewer problems with glaze fit to the clay body. See Chapter 8 and the Appendix for additional majolica information, and glaze and colorant recipes.

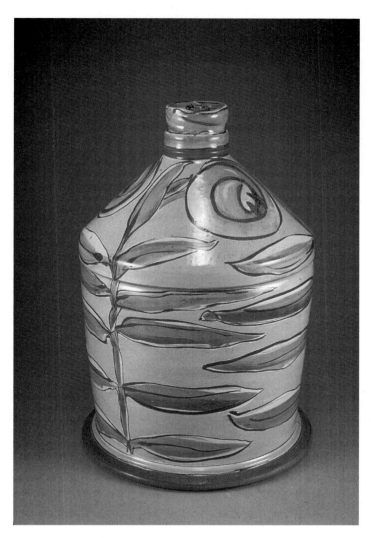

9-11 Linda Arbuckle, USA; *Biscuit Jar: Lateral Leaves,* 1994, terra cotta with majolica glaze, 13.5 × 8.5 in. (34 × 21 cm). Arbuckle's painterly decoration of this jar utilizes the qualities of majolica to the fullest. By wrapping the horizontal leaves around the vertical jar she sets up a pleasing visual tension.

9-12 William Brouillard, USA; *Platter,* 1993, terra cotta with majolica glaze, 6 × 26 × 26 in. (15 × 66 × 66 cm). Brouillard uses the smooth white surface of the majolica glaze like a canvas. The content of his platter includes references to historical pottery decoration and also to the area of the country where he lives—the part of the industrial Midwest sometimes known as "the Rust Belt."

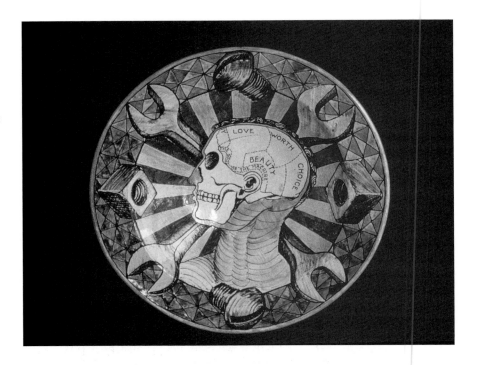

Texture Glazes Glazes are sometimes used for texture, especially on sculptural work. Possibilities include glazes that crawl or bubble, and that would be considered defective if used on utilitarian pottery. Crawl glazes can be made to look like peeling paint, lichen on rocks, or pebbled surfaces. Crawling can be induced by including high shrinkage materials in the raw glaze. Magnesium carbonate is a fluffy material that is commonly used to induce crawling. Amounts up to 30–40 percent will almost certainly cause almost any glaze to crawl. Large amounts of zinc oxide in a glaze will also promote crawling, especially if uncalcined zinc oxide is used.

Glazes that leave bubbled surfaces after firing are sometimes called crater glazes. These glazes are produced by including materials in the glaze that will release gases late in the firing, causing the molten glaze surface to bubble. The most common addition for this is 1 to 5 percent powdered silicon carbide which decomposes late in the firing, causing the glaze to bubble profusely. (Silicon carbide may also cause some local reduction effects within the glaze.) Fluorspar and cryolite, materials that release fluorine gas as they melt, have also been used, but the hazards of fluorine gas have limited their use in recent years. The bubbles are usually razor edged if broken and must be ground off to expose the crater surface. Refiring to a somewhat lower temperature may smooth and anneal the sharp edges. A colorant or lower temperature glaze can be wiped into the ground-off bubbled surface before refiring to enhance color or contrast.

Colorants for Glazes and Decoration

Coloring Oxides Most studio potters obtain their glaze colors from the oxides or carbonates of the more common metals, such as iron, copper, nickel,

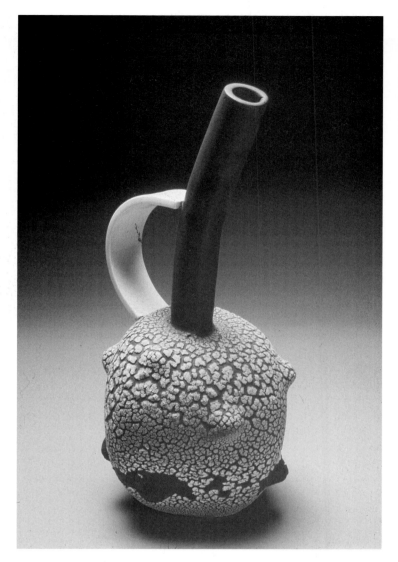

9-13 Joseph Molinaro, USA; Pitcher form, 1990, porcelain, 14 × 8 × 6 in. (30 × 20 × 15 cm). Molinaro's intentional use of a glaze that crawls (breaks apart upon firing) adds a lively texture which works well with the energetic form of this thrown and hand-built pitcher, and provides a strong contrast to the smooth surfaces of the spout and handle.

tin, zinc, and manganese. Other oxides, such as cobalt, although rarer and more expensive, are extensively used because of a lack of cheaper substitutes. The accompanying list of major colorants indicates the oxide necessary and the amount generally used to produce a particular color. However, just because an oxide is listed as producing a green does not mean that it will produce a green in every situation or glaze. A study of the section on ceramic materials in Chapter 10 will reveal that the particular color that develops from an oxide depends upon the type of flux used, the proportions of alumina or silica, and the firing temperature and type. Often very specific recipes are needed to get a particular color. In some instances, even the rate of cooling will have an effect upon the glaze. Therefore, the list of oxides and colors is merely for convenience in determining some basic color possibilities. Before using the oxide, the potter should be aware of its characteristics and the characteristics of the glaze to which it is added.

Guide to Use of Colorants

Color	Oxide	Percentage	Temperature	Atmosphere
black				
	cobalt oxide	1–2	any	either
	use these: manganese dioxide	2–4		
	cobalt oxide	1		
	black iron oxide	8	any	either
	or these: manganese dioxide	3		
	chrome oxide	2		
	iron oxide	10–12	high	reducing
	commercial black stain	8–12%	any	either
blue				
	cobalt carbonate	0.5–2	any	either
turquoise	copper carbonate (alkaline flux)	3–5	low	oxidizing
slate-blue	nickel oxide (with zinc)	1–3	low	oxidizing
	iron oxide & rutile (each)	4	high	reducing
brown				
	rutile	5	any	reducing
	chromium oxide (with MgO, ZnO)	2–5	low	either
	iron oxide	3–7	any	oxidizing
	manganese dioxide	5	any	either
	nickel oxide (with ZnO)	2–4	any	either
green				
	copper oxide (transparent)	1–5	any	oxidizing
gray-green	iron oxide	1–4	any	reducing
	nickel oxide–magnesia	3–5	low	oxidizing
light green	chrome oxide	0.25–1	any	either(1)
dark green	chrome oxide	3–5	any	either(1)
reds				
	copper carbonate (alkaline flux)	0.5–1	any	reducing
	iron oxide (high SiO_2, KNaO), CaO	2–5	low	oxidizing
	inclusion stains	5–12	any	either
pink	chrome oxide and tin oxide (1 to 18)	5	any	oxidizing(1)
coral	chrome oxide (with high PbO)	5	low	oxidizing
purple	manganese dioxide (with KNaO)	4–6	any	oxidizing
purple, pink	cobalt carbonate (with MgO)	1–2	high	either
tan				
	iron oxide	2	any	either
	manganese dioxide	2	any	either
	rutile	2	any	either
yellow				
	praseodymium yellow stain	5–12	any	either
	zirconium-vanadium stain	5–12	any	either
	tin-vanadium stain	4–12	any	oxidizing
white	(see opacifiers in chart, page 297)			

Notes: (1): zinc-free glazes only

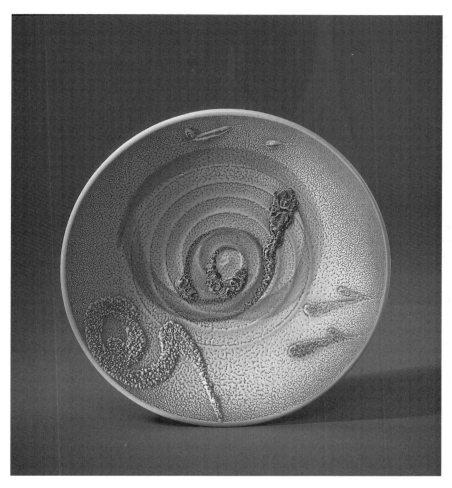

9-14 James Watkins, USA; *Painted Desert,* 1992, stoneware, 20 in. (50 cm). Watkins' use of highly textured glazes, such as the crawled surface of the orange-white glaze that covers most of this platter, adds to the landscape feel of the piece.

Commercially prepared stains are available that produce a wide range of colors in glazes. These stains are generally used in the amounts of 5–12 percent, depending on the intensity of color desired. Many stains work in a wide variety of glazes, but some stains need a particular formulation of glaze to support their specified color. The temperature at which stains can be used also varies considerably, with many being useful only in the low-fire range. Most, but not all, require an oxidizing firing to maintain their specified color. Of particular note are the new inclusion stains which provide red and orange colors that are stable in oxidation and reduction firings up to cone 8 or above. Stain manufacturers provide this information. (See also section on stains in Chapter 10.)

It is common practice to use two or more colorants in order to soften harsh colors and to obtain subtle variations or mottled color effects. One colorant is

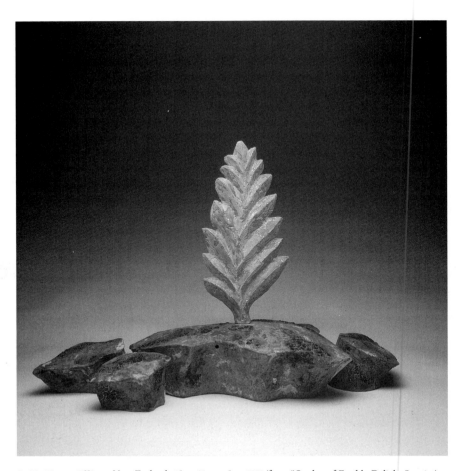

9-15 Moyra Elliott, New Zealand; *Plant/Transplant XIII* (from "Garden of Earthly Delights" series), porcelain, terra cotta, and bronze, 27 × 33 × 16 in. (68 × 83 × 40 cm). Elliott used multiple firings of engobes and low-fire glazes on this piece to develop the rich surfaces resembling leaves, rocks, and lichens. The series cites the grounded, transplanted, indigenous/exotic, permanent/transient nature of society on the edge of the South Pacific.

often used to create the main color, with smaller amounts of other colorants modifying it. For instance, copper, manganese, iron, or nickel are often added to soften powerful cobalt hues. Opacifiers added with colorants will tend to brighten colors, but may make the glaze more paint-like as it becomes opaque. Rutile is a popular addition, since it contributes a textured speckled quality as well as slightly matting a glaze in larger amounts.

Line Blends Line blends and triaxial blends can be used to find the best combination of colorants. Blends are done by mixing two (or three for a triaxial blend) small test batches of glaze, each with a different colorant amount or colorant combination. These small batches are carefully combined in a series of varying combinations, creating a set of glaze tests, each with a slightly different combination of colorants. For example a simple five-step line blend would create these five combinations of the two glazes, **A** and **B** in parts by weight: 5A + 1B, 4A + 2B, 3A + 3B, 2A + 4B, and 1A + 5B. Don't forget to test glazes

A and **B** by themselves, too. For example, if glaze **A** contains 2 percent cobalt carbonate, and glaze **B** contains 5 percent iron oxide, the middle test (3A + 3B) would be half of one, half of the other and contain 1 percent cobalt carbonate and 2.5 percent iron oxide. Be sure to keep good notes of the percentage of each glaze in each combination so that when the test tiles are fired you can calculate the exact combination of colorants.

Opacifiers Opacifiers are, for the most part, relatively insoluble in the glaze melt. Tin oxide and zirconium oxide are the chief examples of this type. As such, they remain suspended in the glaze and, if dense enough, prevent light from penetrating through to the body. Most opacifiers, and of course those of the greatest value, are white. Some, however, give a slight yellow, pink, or bluish cast to the glaze.

Opacifiers

Color	Oxide	Percentage	Temperature	Atmosphere
pure white	tin oxide	5	any	either
weak blue white*	titanium dioxide	8–12	any	either
white	zirconium silicate	8–15	any	either
weak yellow white	antimony oxide (toxic)	10–12	low	oxidizing
white	Zircopax (or zirconium opacifier)	10–15	any	either

*a yellowish coloration with lead or barium/strontium flux

Another type of opacifier is titanium (or zinc under some conditions), which tends to form minute crystalline structures within the glaze. Having a different index of refraction from the major portion of the glaze, it thus breaks up and prevents much light penetration. This is the type of crystal formation associated with matte glazes. It is the reason why all matte glazes must be, necessarily, either wholly or partially opaque.

Binders and Suspending Agents

Various materials can be added to either a clay body or a glaze to increase the green or dry strength of the ceramic form, to aid glaze adhesion, and to lessen injury to the fragile glaze coating during the kiln loading. The several binders and waxes used in industrial production to increase the body strength are not really needed by the studio potter, since a plastic clay body is usually adequate in this regard.

Clay If the glaze contains 10 percent kaolin or more, additional binders may not be needed. However, if the clay content is low, the inclusion of 1 to 3 percent bentonite will increase adhesion and improve any glaze settling problems, but may require flocculation to work properly (also see Flocculants, page 298). Too much bentonite may make the glaze shrink excessively in drying and crack or crawl. Bentonite should be thoroughly mixed with the dry ingredients, or better, completely slaked in water before it is added to the glaze. An old blender is useful for doing this quickly, adding the bentonite slowing to the water while the blender runs.

Macaloid and Veegum™ are both refined colloidal magnesium aluminum silicate clays. Macaloid is similar to bentonite as a plasticizer of both clay bodies and glazes. Veegum is useful both as a plasticizer and as an aid in suspending chemicals that tend to settle in the glaze. The addition of 2 or 3 percent to the glaze will prove helpful. Veegum should be soaked in hot water prior to adding it to the glaze. Veegum CER also includes methylcellulose binders.

Gums Traditionally, gum Arabic or gum Tragacanth has been used as a glaze binder. The granular gum crystals are soaked overnight in water and stirred vigorously the following day. Heating in a double boiler will speed up the process. Straining may be necessary. About 0.25 ounces (7.5 g) will make a quart (0.95 liters) of cream-like mucilage binder. A couple of drops of carbolic acid are needed to prevent decomposition. One or two teaspoons of this solution per quart (0.95 liters) of glaze is usually adequate. Natural gums are not used as much today because of their increasing expense and tendency to decompose in the glaze batch.

Gelatin Gelatin, another glaze binder, is an animal glue dissolved in 4 parts water and added to the glaze in a proportion of 1 to 6. The gelatin solution may also be brushed onto either a vitreous or a very porous bisqued surface for better adhesion of the glaze. Gelatin is best used in glazes that will be used up immediately and not stored, as it will spoil and rot.

Methocel and CMC Methocel and CMC are synthetic methylcellulose binders that will not deteriorate as the natural gums will and that also serve as an agent to prevent settling. The latter is a problem to which colemanite and some types of nepheline syenite, in particular, are susceptible. Normally 1 to 2 percent methocel by dry weight is sufficient. The dry powder should not, however, be added to a liquid glaze. Instead, the powder should be sifted into hot water in a double boiler, the mixture soaked overnight, and then the resultant jellylike mass poured into a large container of hot water. When all the methocel is dissolved, it can be added to the glaze ingredients. An old blender (no longer used for food!) is useful for this step, since it greatly speeds up the combining of ingredients.

Temporary Binders and Preservatives In an emergency, sugar, syrup, or wheat flour can be used as a binder. Of course, all of these will ferment and therefore must not be stored without adding a few drops of preservative to the glaze. In the past formaldehyde was used but other less hazardous alternatives such as Agent A and Vancide are now commercially available from most clay suppliers. The medium used in painting to produce acrylic pigments can also be used as a binder. Because it is a plastic, it does not decompose, although it may cause the glaze to settle.

Flocculants Glazes may need additions that will help to flocculate any clay in the glaze. Flocculating the clay will increase its ability to keep all the other particulate components of the glaze in suspension. Even glazes that contain bentonite may need to have a flocculant added, especially if the glaze contains materials like nepheline syenite that may release alkalies into the glaze batch. Free alkalies will deflocculate the clay in the glaze batch and cause greater settling. A common addition is 0.1–0.2% Epsom salts (magnesium sulfate). This is best

added by dissolving the Epsom salts first in a little warm water, then adding this solution slowly while stirring the glaze. Add only enough of the solution to cause the glaze to thicken the desired amount. A few drops of concentrated calcium chloride in a water solution may also work, but the results may not be as long lasting. The small amounts needed of either of these chemicals should have little or no effect on most glazes, but keep in mind what you're adding and watch for changes in fired glaze qualities when making any addition to a glaze. Commercially available glaze flocculants are also available.

Chapter 10

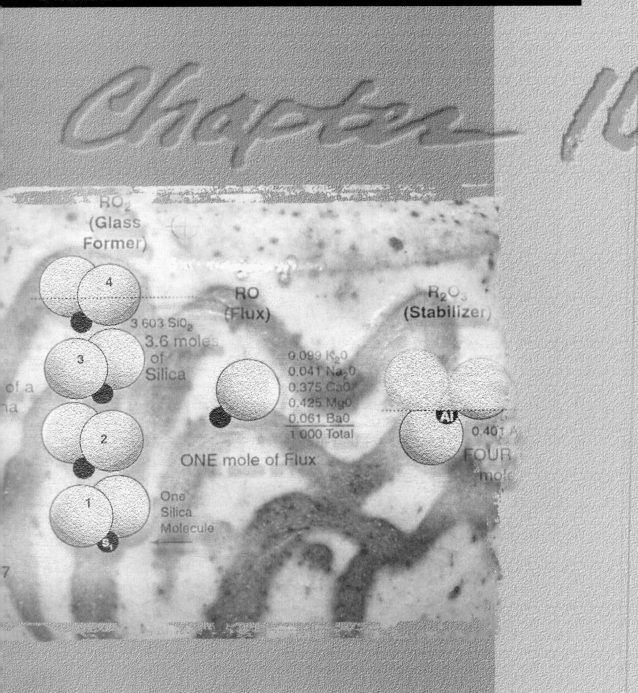

RO₂
(Glass
Former)

RO
(Flux)

R₂O₃
(Stabilizer)

3.603 SiO₂
3.6 moles
of
Silica

0.099 K₂O
0.041 Na₂O
0.375 CaO
0.425 MgO
0.061 BaO
1.000 Total

ONE mole of Flux

One
Silica
Molecule

0.401 A

FOUR
mol

One of the greatest frustrations facing the ceramist is often that of formulating glazes. Most potters strive to find a unique, individual palette of glazes. This requires a good deal of careful measuring, mixing, and firing of tests. One can approach this process in several ways. Perhaps the oldest method is to test variations of randomly chosen mixtures of glaze materials while keeping good notes. This method offers the possibility of wonderful new chance discoveries and more frequently, horrifyingly awful failures. It is also perhaps the most time-consuming method. A more efficient approach might be to develop a knowledge of the properties that each type of glaze material brings to a glaze, and then to focus on tests that will most likely give the desired result. This is the method most often used by potters.

A further refinement, one used frequently by ceramic engineers, is to use a knowledge of glaze calculation to calculate glazes on a molecular basis. Glaze calculation, a discussion of which follows later in this chapter, can allow the potter to better understand the exact makeup of a glaze or to substitute materials more reliably in a recipe. As helpful as they are, these hand calculations are often limited in their usefulness by simplifications necessary to minimize the difficulty of the operation. For example, feldspar is usually classified as only soda or potash feldspar. Yet, a look at the table in the Appendix reveals a great variety among the feldspars, including many elements not included in the basic formula used. The same is true of other complex compounds such as Cornwall stone, nepheline syenite, plastic vitrox, spodumene, and most clays. The trace elements in a material may markedly change the way the glaze melts or reacts to colorants. Simplifying the analysis too much may render calculations less than useful.

Computers have now made the math-intensive process of glaze calculation easy to do, far faster, and often more accurate. Computer calculation alone is not sufficient, as careful testing of the actual glazes is still a definite necessity. Glaze materials are often quite complex and ever-changing, and the analyses obtained from manufacturers are usually only an approximation of the analysis of the materials you actually have at hand. Many ceramic chemicals are not like

10-1 **Mining feldspar** at the Sullins-Wiseman mine in Spruce Pine, North Carolina.

the pure compounds that chemists prefer, but rather are raw minerals dug from the earth and pulverized. The composition varies from mine to mine and even from year to year in the same mine. Up-to-date average analyses of materials can often be obtained from manufacturers' Web sites.

However, a much clearer understanding of glazes can be gained by the potter who can handle the bit of chemistry and math needed to master glaze calculation. For example, the previous chapter mentioned the three parts of a glaze: silica, the glass former; flux, such as borates or potash; and alumina, the refractory agent. Most glaze recipes are merely a list of complex chemicals, which makes it impossible to see at a glance exactly the true proportions of silica, flux, and alumina contained in the glaze. Silica and alumina are likely to be present in more than one of the glaze ingredients. Calculating the glaze makes it immediately clear how much silica and alumina are present throughout the recipe. Comparing the amounts of silica and alumina to the total amount and type of flux can give the potter a good idea of the type and temperature of the glaze. Simply looking at a recipe doesn't reveal as much detail about the workings of the glaze.

Glaze calculation makes it much easier to compare one glaze with another and to the "normal" amounts of silica, flux, and alumina in a particular type of glaze. There are rough limits to the proportion of silica, flux, and alumina needed

to produce a satisfactory glaze at a specific temperature. By reducing a problem glaze to an empirical molecular glaze formula, potters can better see and correct any deficiencies, glazes can be adjusted and fine-tuned, and substitutions for unavailable materials made (see Figure 9-7).

CALCULATIONS

A glaze may be written as a batch glaze recipe consisting of the weights of the raw chemicals making up the glaze. This is the recipe used to actually weigh out the ingredients when mixing the glaze. Or it may be shown in the form of an empirical glaze formula in which the active ingredients are expressed in molecular proportions. This is essentially a way to count the number of molecules of each oxide contained in the glaze. The empirical formula can tell you more about how the glaze will melt and how it will react chemically if you're willing to learn just a little about what these chemical formulas mean.

EPK	10.00
Whiting	20.00
Flint	30.00
Potash Feldspar	40.00
Totals:	100.00 %

Molecular Formula

All matter is made up of approximately one hundred chemical elements in the form of atoms. These elements seldom occur in nature in a pure form, but instead they form compounds, which are groups of atoms held together by an electro-chemical attraction known as a chemical bond. Each atom is much too small to be easily weighed, but it is possible to determine the relative weights of atoms to each other. They are assigned weights corresponding to their weights in relation to that of hydrogen, the lightest atom, rather than use measures which are far too large, such as ounces or grams. For example, oxygen, symbolized by the letter O, has been given the atomic weight of 16 because each atom of oxygen is sixteen times heavier than an atom of hydrogen.

0.165 K_2O
0.402 Al_2O_3
3.906 SiO_2
0.075 Na_2O
0.759 CaO

Silica (silicon dioxide—a major ingredient of all clays and glazes) has the **molecular formula** of SiO_2 (Fig. 10-2). This molecular formula is read as including one atom of the element silicon combined chemically with two atoms of oxygen. The subscript numbers that follow the abbreviation for an element in the molecular formula tell you how many atoms of that element are included. Sometimes for clarity formulas are written like this one for clay: $Al_2O_3 \cdot 2SiO_2 \cdot 2H_2O$, with numbers before a group of elements and bullets between each group. This entire formula represents one molecule of clay, but is

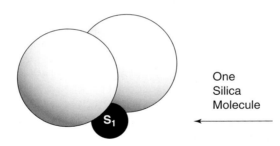

One
Silica
Molecule

10-2 A diagram of a silica molecule made up of two oxygen atoms and one silicon atom.

broken into oxide groups to make it easier to understand in ceramic terms when melted into a glaze. The clay formula represents one molecule of alumina (Al_2O_3), two molecules of silica (SiO_2), and two molecules of water (H_2O), all chemically combined into one larger molecule of clay. This is more useful to a ceramist than to see the formula for clay written as $Al_2Si_2H_2O_9$ which tells us little about the structure of clay in terms of ceramic oxides. The chemical formulas of other complex materials like feldspars are also written using this format.

To get back to the molecular formula of silica, SiO_2, the atomic weight table in the Appendix lists the weight of silicon as 28. Since the two oxygen atoms weigh 32, the total molecular weight of the compound silicon dioxide is 60, the combined weight of the one atom of silicon and two of oxygen. Silica can be easily added to a clay or glaze as quartz or flint (both forms of pure silicon dioxide), but it is also commonly found in a more complex compound such as kaolin ($Al_2O_3 \cdot 2SiO_2 \cdot 2H_2O$) with a molecular weight of 258, or potash feldspar ($K_2O \cdot Al_2O_3 \cdot 6SiO_2$) with a molecular weight of 557. A large variety of ceramic glaze ingredients also contain silica. A more detailed description of how to calculate molecular weights is shown on page 307.

The Batch Recipe

A batch recipe consists of a list of the ceramic raw materials needed to form the glaze, along with the weight of each ingredient. Take, for example, the following simple glaze, which is a blue gloss glaze maturing at cone 6. The recipe is as follows:

Raw Materials		Parts by Weight	
		Percentage	**Batch**
soda feldspar		15.5	775
gerstley borate		20.7	1035
whiting		19.7	985
kaolin		11.0	550
flint		33.1	1655
	Totals	100.0 %	5000 gm
cobalt carbonate		1.5	75

This recipe shows the two ways that potters often write a batch recipe. The first column of numbers gives the percentage amounts by weight. The second column is a batch recipe to make a usable amount of glaze (about 2–3 gallons). Ideally the percentage total should always be exactly 100, but sometimes it may be one-tenth off, the case due to rounding errors (for example 99.9%, unless the fractions are taken to three places, which makes weighing the materials unnecessarily complicated and precise). Percentage and batch recipes can both be used to weigh out a glaze, with the only difference being that the percentage recipe for the base glaze (the recipe without colorants) always totals 100.

Colorants are almost always added as a percentage *addition* to the base recipe (the list of ingredients needed for the glaze to melt as expected) and usually follow below the base glaze recipe when written (as above). For instance, adding 1.5 percent cobalt carbonate to the above recipe for the 5000-gram batch would require $0.015 \times 5000 = 75$ grams of cobalt carbonate. Colorants are sometimes given in the actual amount in a batch recipe, so be careful when reading or

writing recipes to note whether the amount of each colorant is a percentage addition to the batch or an actual amount to be weighed.

The RO, R$_2$O$_3$, RO$_2$ System

Since ceramic glazes are often complex, it is difficult to compare one to another. They may, however, be compared in terms of their three major components— the flux, the refractory element, and the glass former. Fortunately for us, most ceramic oxides bearing the same chemical structure have a similar function in a glaze. The three glaze components, therefore, have been symbolized as RO, R$_2$O$_3$, and RO$_2$ where "R" stands for the element which is combining with oxygen in each case.

The symbol RO refers to the fluxing agents, metallic or alkaline earth elements (bases), which form their oxide by combining with one atom of oxygen. The exceptions are lithium (Li$_2$O), sodium (Na$_2$O), and potassium (K$_2$O) where two atoms of these elements combine with one oxygen atom.

The symbol R$_2$O$_3$ refers to the refractory elements (neutrals), the chief of which is alumina (Al$_2$O$_3$). Alumina acts to stiffen or stabilize the glaze as it melts, hence another occasional name for this group: stabilizers. This group is also sometimes called the **amphoteric** oxides as some members of this group can act in several ways in the glaze. Boric acid (B$_2$O$_3$), however, unlike other refractory elements, can react either as a base (flux) or an acid (glass former). Red iron oxide (Fe$_2$O$_3$) can be a flux as well as a colorant, and works as a more powerful flux in its reduced state FeO. Other colorants like cobalt oxide (CoO when melted in glazes) and copper oxide (CuO) are also fluxes, but not used as a main flux because of their strong color effect on the glaze even in very small percentages.

The symbol RO$_2$ refers to the glass formers (acids). Silica (SiO$_2$) is practically the sole element in this category since TiO$_2$, ZrO$_2$ and SnO$_2$ are used only in small quantities in a glaze as opacifiers (Fig. 10-3).

With these exceptions the RO, R$_2$O$_3$, RO$_2$ system is effective as a method to separate a glaze into its three components. A glance at the table of common ceramic oxides on page 306 will illustrate this more clearly.

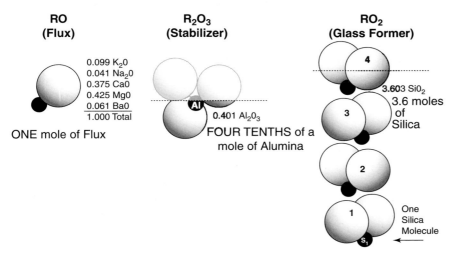

RO
(Flux)

0.099 K$_2$0
0.041 Na$_2$0
0.375 Ca0
0.425 Mg0
0.061 Ba0
1.000 Total

ONE mole of Flux

R$_2$O$_3$
(Stabilizer)

Al

0.401 Al$_2$0$_3$

FOUR TENTHS of a mole of Alumina

RO$_2$
(Glass Former)

4

3.60 3 SiO$_2$
3.6 moles of Silica

3

2

1

One Silica Molecule

S$_1$

10-3 A simple way of looking at the idea of a molecular glaze formula. Obviously there are no partial molecules in the real glaze, but this drawing represents the ratios of the millions of molecules which are present in even a small amount of the actual glaze.

RO (Bases)	R$_2$O$_3$ (Neutrals)	RO$_2$ (Acids)
Fluxing Agents	Refractory Elements (Amphoteric oxides)	Glass Formers (and opacifiers)
Li$_2$O	Al$_2$O$_3$	SiO$_2$
Na$_2$O	B$_2$O$_3$	TiO$_2$
K$_2$O	Fe$_2$O$_3$	ZrO$_2$
CaO	Sb$_2$O$_3$	SnO$_2$
MgO	Cr$_2$O$_3$	
BaO		
ZnO		
FeO		
PbO		

Converting a Batch Recipe to an Empirical Glaze Formula

In order to establish the RO, R$_2$O$_3$, RO$_2$ proportions of a glaze and thus be able to compare one glaze to another, it is necessary to reduce the batch glaze recipe to an empirical glaze formula. In such a formula the active ingredients are expressed in molecular proportions based on the numbers of molecules of each ingredient. Remember that this is essentially like counting the number of molecules of each oxide in the glaze, but simplified to much smaller numbers of molecules than actually exist. Actually, the molecular formula is a ratio of the numbers of molecules of all the oxides in the glaze.

Commonly a **unity molecular formula** (often called simply a unity formula) is used where there is always one unit of RO (unity—you may want to think of this as being like one molecule of flux), with the other oxides in the glaze (R$_2$O$_3$, RO$_2$) in proportion. This makes it easy to see how the glaze may melt, as the RO (flux, melter) is always one, and the amounts other oxides (R$_2$O$_3$, RO$_2$) vary with the intended firing temperature.

By contrast, in the batch recipe, proportions are expressed by the actual weights of the raw ingredients making up the glaze. In order to convert a batch recipe to an empirical glaze formula it is first necessary to know the chemical formulas of the individual raw materials as well as their molecular weights. A table with this information on all commonly used ceramic chemicals is found in the Appendix.

Molecular Weights

The molecular weight of a compound is the sum of the atomic weights of its constituent elements. This can be calculated by finding the molecular weights of each element in the raw material. Knowing these, the molecular weight of each oxide can be calculated.

For example, potash (K$_2$O) contains two atoms of potassium (K) and one atom of oxygen (O).

Element	Atoms in Oxide		x			Molecular Weight
K$_2$	2	\times	39.1	=		78.2
O	1	\times	16.0	=		16.0
Total molecular weight of potash (K$_2$O)				=		**94.2**

Next, multiply the molecular weight of each oxide times the number of molecules of each oxide contained in the material. In the feldspar example below there is one molecule of potash (K_2O), one molecule of alumina (Al_2O_3), and six molecules of silica (SiO_2).

Calculating the Molecular Weight of Feldspar

Raw Material	Formula		Molecular Weights
feldspar (potash)	$K_2O \cdot Al_2O_3 \cdot 6SiO_2$		
1 × molecular weight of potash	(K_2O)	=	94.2
1 × molecular weight of alumina	(Al_2O_3)	=	102.0
6 × molecular weight of silica	(SiO_2) 6 × 60	=	360.0
Total molecular weight of feldspar		=	**556.2**

To convert a glaze batch to an empirical formula the needed information must be put in table form to make the calculations easier. If the cone 6 gloss glaze previously mentioned is used, the materials and weights are shown in a table as follows:

Raw Materials	Parts by Weight
soda feldspar	471.6
gerstley borate	630.4
whiting	600.0
kaolin	335.4
flint	1008.0
Total	3045.4

This is a typical recipe used to weigh out an actual batch of the glaze. The amounts are proportioned to make the needed amount of glaze. It is easier to compare glaze recipes and to do glaze calculations if the recipe is converted to a percentage batch recipe where the ingredient amounts total 100. This conversion is shown in the table below. First, the weights of all ingredients are totaled (3045.4). Next, the weight of each ingredient is divided by this total, then finally multiplied by 100 to obtain the percentage recipe. When this is done we can see that this is indeed the same recipe that appeared earlier in this chapter.

Conversion of Batch Recipe to a Percentage Batch Recipe
Typical Shop Recipe Converted to a Percentage Recipe

	Individual Amount	Divided by Total × 100	=	Percentage
soda feldspar	471.6	/ 3045.4 × 100	=	15.5
gerstley borate	630.4	/ 3045.4 × 100	=	20.7
whiting	600.0	/ 3045.4 × 100	=	19.7
kaolin	335.4	/ 3045.4 × 100	=	11.0
flint	1008.0	/ 3045.4 × 100	=	33.1
	3045.4			100.0

The numbers from this preliminary calculation are used to make up the more complex conversion table that follows. In the first column are the raw materials along with their molecular formulas, which are found in the Appendix. In the second column are batch weights of the materials used. On the same pages of the Appendix are also found the molecular weights of the material, which are placed in the third column. The next five columns have the headings of the various oxides found in the glaze materials. The batch weights of the raw materials are first divided by the molecular weights to find the molecular equivalent of the particular ingredient. This molecular equivalent is then multiplied by the number of molecules of each oxide contained in that ingredient (from the chemical formula), which gives the molecular proportions in the form of single oxides listed under each oxide. A chart can be found in the Appendix which will make doing this calculation by hand much simpler.

Note that only oxides that end up in the final fired glaze are calculated in the table. The water (H_2O) contained in some of the materials is included when calculating the molecular weight of the raw materials because it is there when we weigh out the batch, but NOT included in the fired glaze formula because the water evaporates during the firing.

Calculating the Molecular Unity Formula from a Batch Recipe

Raw Materials	Parts by Weight		Molecular Weight		Molecular Equivalents		Na_2O		CaO	B_2O_3	Al_2O_3	SiO_2
gerstley borate	20.7	÷	**412**	=	0.050							
($2CaO \cdot 3B_2O_3 \cdot 5H_2O$)					2(RO)	×	0.050	=			0.100	
(mol. wt. = 412)			$3(R_2O_3)$	×	0.050	=				0.150		
			(water, H_2O, is driven off in firing)									
soda feldspar	15.5	÷	**524**	=	0.030							
($Na_2O \cdot Al_2O_3 \cdot 6SiO_2$)			1(RO)	×	0.030	=	0.030					
(mol. wt. = 524)			$1(R_2O_3)$	×	0.030	=					0.030	
			$6(RO_2)$	×	0.030	=						0.187
kaolin	11.00	÷	**258**	=	0.043							
($Al_2O_3 \cdot 2SiO_2 \cdot 2H_2O$)			$1(R_2O_3)$	×					0.043	=		0.043
(mol. wt. = 258)			$2(RO_2)$	×	0.043	=						0.086
			(water, H_2O, is driven off in firing)									
whiting	19.7	÷	**100**	=	0.197							
($CaCO_3$ mol. wt. = 100)			1RO	×	0.197	=			0.197			
flint (silica)	33.1	÷	**60**	=	0.552							
(SiO_2 mol. wt. = 60)			$1(RO_2)$	×	0.552	=						0.552
Totals	100.0						0.030		0.297	0.150	0.073	0.825
							Na_2O		CaO	B_2O_3	Al_2O_3	SiO_2

Remember that what we are doing here is roughly equivalent to counting the number of molecules of each oxide in the glaze. The calculation above is simply converting the actual weights of each glaze ingredient to the number of

molecules of each oxide. It may help to think of molecules in this case as essentially the number of molecules, even though we could never have a fraction of a real molecule. The result is really a *ratio* of the relative number of molecules of each oxide in the glaze. In the previous example the ratio is that for every 0.825 molecules of silica (SiO_2) we also have 0.073 molecules of alumina (Al_2O_3), 0.150 molecules of boria (B_2O_3), 0.297 molecules of calcium oxide (CaO), and 0.030 molecules of soda (Na_2O) in the *fired* glaze. We'll try to convert this into a more standardized format where the total of all the fluxes is one, with the number of molecules of alumina, boria, and silica all in ratio to the one unit total of all the flux oxides.

Arranging these oxides into their appropriate RO, R_2O_3 and RO_2 groups reveals that the batch glaze has the following empirical formula:

RO	R_2O_3	RO_2
.030 Na_2O	0.073 Al_2O_3	0.825 SiO_2
.297 CaO	0.150 B_2O_3	
.327 Total RO (flux)		

The total of the RO oxides comes to 0.327 instead of the desired unit of one. Dividing each of the oxide amounts above by 0.327 (the flux total) yields the following empirical formula. The RO total is now 1.000 or **unity.**

RO	R_2O_3	RO_2
0.092 Na_2O	0.223 Al_2O_3	2.52 SiO_2
0.908 CaO	0.459 B_2O_3	
1.0000 Total RO (flux)		

By calculating the unity molecular formula so that the RO (flux) total is 1.00, glazes can be easily compared in terms of the relative amounts of RO_2 (glass former) and R_2O_3 (refractory). This allows rough estimates to be more easily made for various glaze properties.

Considerable research has been done on the properties of ceramic materials, and some reasonable predictions can be made about the probable change that a particular chemical will cause in a known type of glaze. There are, however, many variables, such as how finely the glaze is ground, the thickness of application, the reactions between glaze and body, other glazes in the kiln, the kiln atmosphere, and the rate of temperature rise and fall. Since each or all of these conditions can markedly affect a particular glaze, glaze experimentation is something less than a true science. Successful work depends largely upon the overall experience and care of the operator in controlling these factors as they interact with one another.

Converting an Empirical Glaze Formula to a Batch Recipe

To convert an empirical formula to a batch recipe, it is necessary to reverse the procedure explained in the previous section. As before, the easiest method is to draw up a chart on which to compile the information. This type of conversion will require slightly greater familiarity with raw chemical compounds, because it is necessary to select those compounds containing the proper oxides without adding any unwanted elements. The parts of compounds that pass off in the kiln as gases or water vapor are ignored. To make the process clearer, the previous empirical glaze formula will be converted back into a batch recipe.

RO	R_2O_3	RO_2
0.092 Na_2O	0.223 Al_2O_3	2.52 SiO_2
0.908 CaO	0.459 B_2O_3	
1.000 Total RO (flux)		

Hints for Successful Glaze Calculation

◆ Add materials that supply only the necessary oxides, but do so in order of their complexity. This means, in general, adding materials which supply two or more necessary oxides first (feldspars, frits, clays, dolomite, talc, etc.), then moving toward adding materials which supply only a single oxide (whiting, flint, zinc oxide, etc.).

◆ Start with materials which supply fluxes to the glaze. In addition, if any boron is needed one should try to include it by first adding as much boron frit or gerstley borate as possible before other ingredients are added. Frits are often the best source of boron, but may be expensive. Gerstley borate substitutes are a cheaper source of boron flux, but may be less reliable from batch to batch. Both frits and gerstley borate substitutes are less soluble and not as likely to become lumpy or soluble in a glaze as other sources such as borax.

◆ Next, if alkaline (RO) fluxes are present (Na_2O or K_2O) and still needed, it is best to include as much as possible in the form of a soda or potash feldspar, or from spodumene if lithium (Li_2O) is needed.

◆ Clay can be added next, if desired.

◆ Add other materials that contain more than one oxide next. These are materials such as bone ash, dolomite, wollastonite, and others.

◆ Lastly, fill any needs for the other single oxides, adding the silica at the end. Alumina and silica are often included in other compounds, and the balance can easily be added in the form of either kaolin or silica after the fluxes are satisfied. Since silica is always present in larger amounts than alumina and is available in a cheap, pure form, if it is still needed it can safely be saved for the final addition.

Empirical Formula to Batch Recipe

Raw Material	Oxides in Formula:				
	Na_2O	CaO	B_2O_3	Al_2O_3	SiO_2
and the molecular equivalents needed for each oxide in the formula:	0.09	0.91	0.46	0.22	2.52
ADD: **soda feldspar** ($Na_2O \cdot Al_2O_3 \cdot 6SiO_2$)					
0.09 equivalents	($\times 1$) = 0.09			($\times 1$) = 0.09	($\times 6$) = 0.54
remainder	0.0	0.91	0.46	0.13	1.98
ADD: **gerstley borate** ($2CaO \cdot 3B_2O_3 \cdot 5H_2O$)					
0.153 equivalents (0.46 ÷ $3B_2O_3$)		($\times 2$) = 0.31	($\times 3$) = 0.46		
remainder		0.60	0.0	0.13	1.94
ADD: **whiting** (calcium carbonate) ($CaCO_3$)					
0.60 equivalents		($\times 1$) = 0.60			
remainder		0.0		0.13	1.94
ADD: **kaolin** ($Al_2O_3 \cdot 2SiO_2 \cdot 2H_2O$)					
0.13 equivalents				($\times 1$) = 0.13	($\times 2$) = 0.26
remainder				0.0	1.68
silica (flint) (SiO_2)					
1.68 equivalents					($\times 1$) = 1.68
remainder					0.0

Several of the calculations in the "Empirical Formula to Batch Recipe" table may seem incorrect at first, so perhaps a few of these seeming inconsistencies should be pointed out. In the first addition, taking 0.09 equivalents of soda feldspar gives six times as much SiO_2 as either Na_2O or Al_2O_3, because the formula for soda feldspar is $Na_2O \cdot Al_2O_3 \cdot 6SiO_2$. Similarly, gerstley borate has two units of CaO and three units of B_2O_3 for each equivalent of the compound, so the actual equivalent added is one third of the amount of B_2O_3 added.

Now that the needed molecular equivalent of the chemical compounds are set out, the gram (or pound) batch weights can be found by multiplying each equivalent by the molecular weights of the chemical compound.

The following set of calculations results in a batch recipe (using the amounts from the previous calculation):

Raw Material	Molecular Equivalents		Molecular Weights		Batch Weights
soda feldspar	0.09	×	524	=	47.16
gerstley borate	0.153	×	412	=	63.04
whiting	.60	×	100	=	60.00
kaolin	.13	×	258	=	33.54
silica	1.68	×	60	=	100.80
		TOTAL		=	304.54

Dividing the individual batch weights by 304.54 and then multiplying each amount by 100 produces a batch recipe expressed in percentages (see this

calculation earlier in this chapter). This is essentially the original glaze recipe, although slight rounding errors were introduced in simplifying the recipe for this example. Carrying one or more extra decimal places through all of these calculations would make a more accurate result, something that computer glaze calculation does with ease.

Original Batch Recipe

Raw Material	Batch Amount *divided by* TOTAL × 100 =		Percentage (parts by weight)
soda feldspar	47.16	/ 304.54 × 100 =	15.5
gerstley borate	63.04	/ 304.54 × 100 =	20.7
whiting	60.00	/ 304.54 × 100 =	19.7
kaolin	33.54	/ 304.54 × 100 =	11.0
silica	100.80	/ 304.54 × 100 =	33.1
	304.54		100.0

Limit Formulas

In the glaze experiments described in Chapter 9, no definite limits were mentioned regarding the ratio between the RO, R_2O_3, and RO_2 parts in a glaze. This is because the major purpose of these glaze tests was to gain familiarity with the qualities of the various glaze chemicals. However, previous research has shown that there are general limits to the amounts of alumina and silica that can be used successfully in relation to a single unit of flux for a given temperature of firing. The types of fluxes used are also important factors in establishing limits.

In the several limit formulas that follow, a number of possible fluxes are indicated; however, the total amount used must add up to a unit of one. In general, a higher proportion of alumina will result in a matte surface, provided the kiln is cooled slowly. Barium or strontium will also tend to create a matte surface if boron is not present. A study of these formulas indicates how the ratio of alumina and silica rises as the temperature increases. While not intended to take the place of glaze formulas, the listing should be a helpful guide to those seeking to change the temperature range of a favorite glaze. Some glaze chemicals are quite complex, and under certain conditions an addition to a glaze will not have the desired effect. By converting the batch recipes to empirical formulas and comparing them with the suggested limits, it ought to be possible to detect the direction of the error.

Limit Formulas: Typical Molecular Amounts of Oxides for Lead-Free Glazes

Surface	Cone	$K_2O + Na_2O$	Li_2O	CaO	$BaO + SrO$	MgO	ZnO	B_2O_3	Al_2O_3	SiO_2
Raku	08	0.12–0.60	0.0–0.13	0.35–0.72	0.0–0.06	0.0–0.03	0.0–0.03	0.3–1.0	0.05–0.25	0.8–2.0
Gloss	06-04	0.17–0.60	0.00–0.30	0.15–0.50	0.00–0.10	0.00–0.07	0.00–0.05	0.25–0.70	0.10–0.30	1.00–3.00
Matte	06-04	0.05–0.26	0.00–0.35	0.25–0.75	0.00–0.40	0.00–0.30	0.00–0.15	0.10–0.40	0.15–0.40	1.15–3.00
Gloss	5-6	0.05–0.40	0.0–0.20	0.35–0.70	0.0–0.10	0.0–0.14	0.0–0.10	0.1–0.6	0.3–0.45	2.5–3.6
Satin	5-6	0.05–0.30	0.0–0.08	0.35–0.60	0.0–0.15	0.0–0.20	0.0–0.2	0.0–0.25	0.3–0.45	1.8–3.0
Matte	5-6	0.05–0.25	0.0–0.14	0.20–0.60	0.0–0.30	0.0–0.22	0.0–0.3	0.0–0.12	0.35–0.5	1.8–2.5
Gloss	10	0.05–0.30	0.0–0.05	0.3–0.7	0.0–0.10	0.0–0.20	0.0–0.07	0.0–0.12	0.30–0.55	2.5–4.4
Satin	10	0.05–0.20	0.0–0.05	0.3–0.6	0.00–0.25	0.06–0.35	0.0–0.10	0.0–0.08	0.35–0.65	2.0–3.5
Matte	10	0.05–0.10	0.0–0.0	0.3–0.5	0.0–0.50	0.15–0.45	0.0–0.15	0.0–0.0	0.4–0.7	2.0–3.2

Variables in Glaze Formulation

Potters are frequently disappointed when a glaze obtained from a friend or from a textbook produces quite unexpected results. Several factors may be involved in this problem. Ingredients that are more finely ground than usual will melt at a slightly lower temperature. In the same way, fritted glaze additions melt more quickly than do raw compounds of a similar composition. Occasionally the thickness of application or reaction with the clay body will produce slightly different results. More distressing and troublesome is the variable nature of such major glaze ingredients as gerstley borate, Cornwall stone, and the feldspars, as these come from natural sources.

In attempting to alter a glaze that has proved unsatisfactory, the potter has several simple remedies. If the glaze is too runny, the addition of flint or kaolin usually will raise the melting point; if it is too dry, an increase of flux will develop a more fluid glaze. Sometimes, however, the effect is quite the opposite, and in such situations the student, quite justifiably, may feel that the instructor who suggested the change does not know a great deal about glaze chemistry.

The real culprit in many glaze failures is the chemical phenomenon known as a **eutectic.** A eutectic is the lowest melting point combination of two or more chemicals. It is also a lower melting temperature than the melting point of any of the individual chemicals. For example, calcium oxide has a melting point of 4676°F (2580°C), and silica melts at 3119°F (1715°C). One might expect that an approximately half-and-half mixture of calcium and silica would melt at temperature somewhat higher than that of silica, yet the actual melting point is much lower. Calcium oxide and silica have a eutectic point at about 2617°F (1436°C), with a mixture of approximately 40 percent calcium oxide and 60 percent silica. The line diagram in Figure 10-4 illustrates the idea of this interaction, using lead oxide (a strong flux) and silica, with the eutectic point marked at E.

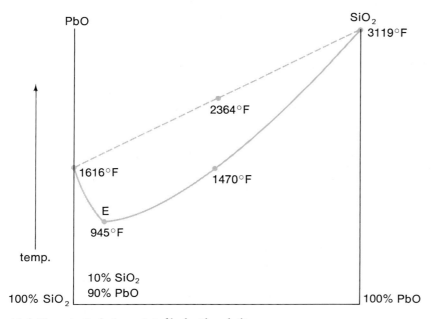

10-4 The eutectic fusion point of lead oxide and silica.

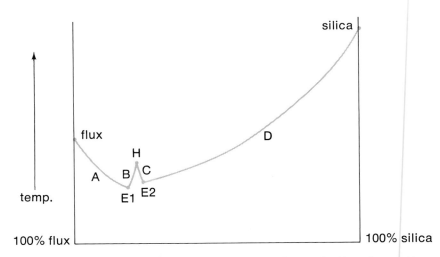

10-5 Although exaggerated, this line drawing demonstrates the unpredictable results caused by eutectic points in a glaze.

In an actual glaze—compounded of complex minerals and containing several fluxes, alumina, and even different types of silica—the firing reaction is much more complicated. It is quite possible for there to be two and even more eutectic points.

Figure 10-5 shows a hypothetical reaction, with two eutectic points, between several fluxes and silica. The vertical movement represents the changing temperature of fusion as a portion of flux is replaced with a like amount of silica. Glazes that fall in areas B and C are more troublesome to potters, since a slight change in composition or temperature will greatly alter the fired result. These are generally high-gloss glazes. In area B a small increase in silica will increase the gloss and raise the melting temperature, but in area C an increase in silica will lower the melting temperature and create a very runny glaze. The points E1, H, and E2 are especially troublesome, for a very slight temperature rise will change the character of the glaze. The most satisfactory glazes fall in the lower ranges of A and D. Because of the flattened curve in these areas, a slight change in temperature or silica is not likely to cause a great variation in the fired glaze. The alumina, calcium, zinc, and dolomite matte glazes fall in the lower area of A. As the silica is decreased in area A, the glazes become more matte and finally become rough and incomplete with a very low proportion of silica. Transparent and majolica glazes fall in the lower area of D; these become less glossy as the ratio of silica and the temperature are raised. Although the area D glazes can be glossy like the unpredictable glazes in B and C, they are quite stable and little affected by slight changes in silica or temperature. Ash glazes fall in all areas; those in areas B and C are runny and unpredictable.

Figure 10-5 is a purely theoretical attempt to visualize the reactions between the fluxes and silica. It does not represent an actual glaze, since the function of alumina is ignored. The more usual method of diagramming a glaze is shown in Figure 10-6. Here are the three major components of a glaze: fluxes, silica, and clay (alumina-silica). The small triangle at each apex represents the use of 100 percent of the compound in that corner. Moving along the base line of the silica-clay axis, the ratio becomes 90 percent silica to 10 percent clay (kaolin), then

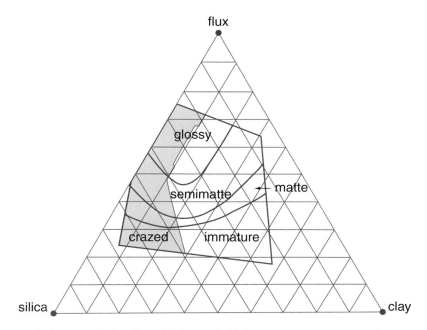

10-6 This triaxial chart shows the glaze results likely at stoneware temperatures with varying amounts of silica, clay, and flux.

80 percent silica to 20 percent clay, and so forth. Progressing vertically, the triangles contain an increasing amount of the first glaze components, the fluxes. The roughly square section in the center covers those glaze tests that at cone 10 (2426°F, 1330°C) fuse to form a glaze. As the gradient indicates, there is a change from matte to glossy as the fluxes are increased, and an area of crazed glazes where the silica content is low. The clay content also has a decisive effect upon whether a glaze is to be glossy or matte. As indicated in both Figures 10-5 and 10-6, the matte and semi-matte glazes cover a much wider range of possible combinations at a given temperature. The sharp gradient of the glossy area in Figure 10-6 would suggest that the eutectic points for this particular glaze would fall in this range.

The use of a triaxial diagram for planning experiments has many applications in ceramics. It takes a lot of time to complete the entire sequence, and considerable effort can be saved by concentrating on those areas in which meaningful results can be expected. This system is especially helpful in gaining knowledge about the relative fluxing power of various compounds, their effects on colorants, and blending of colorants and opacifiers.

CHEMICALS

The chemicals used by the potter are generally not pure single oxides but more complex compounds that are available for industrial uses in a moderately refined form at low cost. Because of differences either in the original mineral or in refining methods, the ceramic chemicals available from different dealers can vary slightly. Even items from the same supplier can change from year to year. Commercial potteries constantly check new shipments of chemicals, but while this is seldom done to the same extent in the small studio, new batches of raw

materials should be tested before mixing large quantities of glaze. If a favorite glaze reacts strangely, the potter should consider this factor, provided, of course, there was no deviation from the normal glazing and firing procedure. The feldspars, in particular, vary in their fluxing power. It is for this reason that the author has not stressed the importance of a specific glaze formula, but rather the experimental knowledge of the properties in glaze ingredients. The batch glazes listed in the Appendix are mainly for purposes of illustration, and they may have to be adjusted slightly to fit the materials available, and one's own clay and firings.

For the convenience of students converting an empirical glaze formula into a batch recipe, a listing follows that gives the major sources of the various oxides in the RO, R_2O_3, and RO_2 groups. A more complete chemical description will be found in the alphabetized list at the end of this chapter.

Sources of Fluxes—Base (RO) Oxides

The basic ingredients in glazes can be grouped in additional ways besides their three major functions in a glaze. The fluxes that follow have been arranged to group them by their effect on the glaze, especially on colorants added to the glaze: alkaline fluxes, alkaline earth fluxes, and metallic fluxes. Boron usually functions as a flux in most pottery glazes, but is listed in the amphoteric (neutral) oxides, following, as it also functions as a glass former.

Alkaline Fluxes

This group of fluxes tends to cause glossy, fluid glazes and bright, intense colors from added colorants. Highly alkaline glazes tend to be somewhat soft and easily scratched.

Lithium Oxide Lithium oxide (Li_2O) is more commonly used by glass manufacturers, but it has several important qualities that make its occasional use in glazes valuable. Lithium (the oxide or carbonate) is expensive, because it is present in very small quantities (3 to 8 percent) in the producing ores. Lithium carbonate can also be toxic in its raw form. It has a much lower atomic weight than does either sodium or potassium (ratio of 1:3 and 1:5); therefore, a smaller amount of material can be used without lessening the fluxing action. This has the effect of decreasing tensions caused by thermal expansions and contractions and thus promoting a more durable glaze. Larger amounts of lithium can lower the thermal expansion of the glaze to the point where it may shiver. Excessive amounts of lithium may cause matte glazes and increase thermal expansion making crazing worse. Sources of lithium are

> *spodumene* ($Li_2O \cdot Al_2O_3 \cdot 4SiO_2$)
> *lithium carbonate* (Li_2CO_3)
> *lepidolite* ($LiF \cdot KF \cdot Al_2O_3 \cdot 3SiO_2$)
> *petalite* ($Li_2O \cdot Al_2O_3 \cdot 8SiO_2$)
> *amblygonite* ($2LiF \cdot Al_2O_3 \cdot P_2O_5$)

Potassium Oxide Potassium oxide (K_2O) is similar in fluxing action to sodium. It has a lower coefficient of thermal expansion, thus increasing the hardness and brilliance of a piece and lowering the fluidity of the glaze. Sources of potassium are

> *potassium carbonate* (K_2CO_3), more commonly known as pearl ash (soluble)
> *potash feldspar* ($K_2O \cdot Al_2O_3 \cdot 6SiO_2$)

Cornwall stone ($1RO \cdot 1.16Al_2O_3 \cdot 8.95SiO_2$), a complex compound of variable composition, roughly similar to a feldspar and having fluxes of calcium, sodium, and potassium

plastic vitrox ($1RO \cdot 1.69Al_2O_3 \cdot 14.64SiO_2$)

Carolina stone, a domestic product similar to Cornwall stone

volcanic ash (variable—see approximate analysis in Appendix)

Sodium Oxide

Sodium oxide (Na_2O) is one of the more common low-fire fluxes. It has the highest coefficient of expansion of all the bases and generally gives a lower tensile strength and elasticity to the silicates formed than do most other fluxes. It has a notable effect on some colorants. The usual ceramic sources of sodium are

soda feldspar ($Na_2O \cdot Al_2O_3 \cdot 6SiO_2$)

nepheline syenite ($K_2O \cdot 3Na_2O \cdot 4Al_2O_3 \cdot 9SiO_2$)

alkaline frits, sodium is often fritted to lessen its solubility

sodium carbonate (Na_2CO_3), more frequently called soda ash or washing soda

sodium bicarbonate ($NaHCO_3$) common baking soda

borax ($Na_2O \cdot 2B_2O_3 \cdot 10H_2O$)

cryolite (Na_3AlF_6), little used because it gives off fluorine when fired.

sodium chloride ($NaCl$) table salt (not often used in glazes because of the chlorine)

Alkaline Earth Fluxes

Barium Oxide

Barium oxide (BaO) is a very active flux under some conditions. It has a notable eutectic with boron oxide which can cause very fluid melts. Barium in larger amounts may intensify some colors. Its glass formation has a brilliancy second only to that of the lead silicates. Barium's effect on the thermal expansion of the glaze is less than that of the alkalies and calcia. Its fumes are toxic and it can leach from improperly formulated glazes. It is one of the alkaline earth minerals, a category that also includes calcium, strontium, and magnesium. The best source for barium is

barium carbonate ($BaCO_3$)—(TOXIC!)

Calcium Oxide

Calcium oxide (CaO), in comparison with the alkaline oxides, produces a hard, nontoxic glaze that is resistant to abrasion, mild acids, and weathering. These characteristics make it a good choice for use in glazes for tableware. Calcium oxide has a moderate effect on most colorants. It also lowers the coefficient of thermal expansion, thereby increasing tensile strength. Although it is often used in small amounts with other fluxes in low-fire glazes, calcium should not be used as the sole flux at temperatures below cone 3. As with other alkaline earth oxides, an excess of calcium tends to produce matte textures. Sources of calcium are

calcium carbonate ($CaCO_3$), also called whiting—this is the most common source

dolomite [$CaMg(CO_3)_2$]

calcium fluoride (CaF_2), better known as the mineral fluorspar

bone ash, refined [$Ca_3(PO_4)_2$]

wollastonite ($CaSiO_3$)

calcium borate ($2CaO \cdot 3B_2O_3 \cdot 5H_2O$), more commonly known as colemanite—adds boron

gerstley borate ($2CaO \cdot 2B_2O_3 \cdot SiO_2 \cdot 8H_2O$, plus small amounts of Na_2O and MgO)—adds boron

Magnesium Oxide Magnesium oxide (MgO) is frequently found combined with the feldspars and limestones. It lowers the thermal expansion more than do other bases, and it is as satisfactory as the alkaline fluxes in developing a durable glaze. In some combinations it will produce a slight opacity. In high amounts it produces waxy, opaque magnesia mattes at stoneware temperatures, especially in reduction firings. It is primarily a high temperature flux. Used with low-fire glazes, magnesium has a refractory effect and lends opacity and a matte quality; it fluxes easily at stoneware temperatures and becomes quite fluid. Cobalt added to high magnesia glazes produces a pink to purple color. Sources of magnesium are

> *dolomite* [CaMg(CO_3)_2]
> *talc* (varies from 3MgO•4SiO_2•H_2O to 4MgO•5SiO_2•H_2O), in the solid and more impure form it is also known as steatite or soapstone
> *magnesium carbonate* (MgCO_3), a high shrinkage rate limits its usefulness
> *diopside* (CaO•MgO•2SiO_2)

Strontium oxide Strontium Carbonate (SrCO_3) is more expensive than barium carbonate, but provides a nontoxic alternative. To substitute for barium in glazes use 0.75 parts by weight of strontium carbonate for each 1.0 part by weight of barium carbonate. This substitution results in little change in most glazes, although glazes with larger amounts of barium (in the 20–40% range) will be noticeably different. Strontium is almost always used in the carbonate form.

Metallic Fluxes

Lead Oxide Lead oxide (PbO) has long been one of the major low-fire fluxes, but its toxicity has caused it to be banned from use in many areas in recent years. The use of lead in glazes is not recommended. There are several reasons for lead's previous popularity. It combines readily with all other fluxes and has a lower coefficient of expansion than do the alkaline fluxes. Lead gives greater brilliancy to the glaze, although at times this can be a disadvantage. Lead glazes melt and flow well and thus tend to reduce pinholes and other defects of the more viscous type of glaze. The chief drawbacks are the poisonous nature of lead compounds (and the associated environmental drawbacks) and their susceptibility to attack by strong food acids in improperly formulated or fired glazes. Lead-containing materials must be handled with great care, and disposed of as toxic waste. Lead tends to blacken or develop a film if even slightly reduced during firing. The surface of a lead glaze will scratch easily unless an alkaline flux is added. There are many forms of lead. ALL ARE TOXIC! Common forms are:

> *litharge* (PbO), a lead oxide (TOXIC!)
> *red lead* (Pb_3O_4), a lead oxide (TOXIC!)
> *white lead* [2PbCO_3•Pb(OH_2)], also called lead carbonate (TOXIC!)
> *lead sulfide* (PbS), also called galena (TOXIC!)

Fritted forms of lead are somewhat safer for the potter to handle before firing, but still must be used with care. These include:

> *lead monosilicate,* the fritted lead silicate composed of approximately 16 percent SiO_2 and 84 percent PbO
> *lead bisilicate,* another commercial lead silicate, with the approximate composition of 65 percent PbO, 33 percent SiO_2, and 2 percent Al_2O_3

Zinc Oxide Zinc oxide (ZnO) can contribute several different qualities to a glaze. It can be used to replace some of the more soluble alkaline fluxes. Zinc is second only to magnesium in reducing thermal expansion and to calcium in increasing the strength and resistance of a glaze. It contributes some opacity to the glaze and is helpful in reducing crazing defects. Large amounts of zinc in glazes can lead to problems with crawling, especially if uncalcined zinc oxide is used. Small amounts of zinc in glazes may help some colors, such as copper reds. The major zinc compound used in ceramics is

 zinc oxide (ZnO)

Sources of Amphoterics—Neutral (R_2O_3) Oxides

Unlike the RO group, which has numerous similar compounds, the R_2O_3 group is almost limited to alumina (Al_2O_3) and a few oxides that have the same oxygen ratio. The greatest difference between a typical glass and most glazes is the presence of alumina in the glaze. The alumina content is one of the most important factors in a successful glaze. It controls the fluidity of the melting glaze and enables it to withstand the temperatures needed to mature the body. Greater amounts of alumina increase the hardness of the glaze and its resistance to abrasions and acids. Crystalline glazes must necessarily be low in alumina, since alumina prevents the devitrification that accompanies the crystal formation. Unlike alumina, most of the other members of this group can act in varied ways in glazes, most notably boron compounds which may act as both fluxes and glass formers.

Alumina Alumina (Al_2O_3) in a glaze can vary from 0.1 to 0.9 molecular equivalents, depending upon the firing temperatures. The equivalent ratios between the alumina and the silica groups can be from 1:4 to 1:20. For most glossy glazes the ratio is about 1:8 or 1:10. As mentioned before, an increase of alumina will tend to produce matte textures. A glossy porcelain glaze firing from cones 10 to 12 will have an alumina-silica ratio of between 1:7 and 1:8, whereas matte glazes will have a ratio of between 1:3 to 1:4. The refractory properties of alumina are more like those of the acid silica than any of the bases. Alumina also has an effect on the colors developed. The normal blue of cobalt oxide will become a rose pink in the absence of alumina. Alumina is used to produce manganese-alumina pinks. Chromium oxide, which usually gives various green tones, will tend to become reddish in the presence of excess alumina. Clay and feldspars usually provide most or all of the alumina needed in glazes, as they combine more easily into the melt than do purer forms of alumina. Common sources of alumina are:

 alumina hydrate ($Al(OH)_3$)
 feldspar and Cornwall stone, see sections under RO oxides
 kaolin or china clay ($Al_2O_3 \cdot 2SiO_2 \cdot 2H_2O$), see sections under clay
 nepheline syenite ($K_2O \cdot 3Na_2O \cdot 4Al_2O_3 \cdot 9SiO_2$)
 plastic vitrox ($1RO \cdot 1.69Al_2O_3 \cdot 14.64SiO_2$)
 pyrophyllite ($Al_2O_3 \cdot 4SiO_2 \cdot H_2O$)

Boric Oxide Boric oxide (B_2O_3) is one of the neutral oxides (R_2O_3). As previously noted, it can react either as a base (flux) or an acid (glass former). On the whole, however, boric oxide functions as a flux. Boric oxide has a number of characteristics similar to alumina: the alumina of matte glazes can be

satisfactorily replaced by boric oxide; color effects do not change by this substitution, but the surface will; both alumina and boric oxide harm underglaze red and green colors; and both can form mixed crystals. In comparison with silica it increases elasticity, lowers tensile strength, and, in limited quantities, lowers the thermal coefficient of expansion. Like lead, it increases the gloss and refractive index. Boron forms a very fluid eutectic with barium or strontium which may make it difficult to matte glazes containing these oxides. Major compounds containing boric oxide are

boric acid ($B_2O_3 \cdot 2H_2O$) (TOXIC!)
borax ($Na_2O \cdot 2B_2O_3 \cdot 10H_2O$) (TOXIC!)
colemanite ($2CaO \cdot 3B_2O_3 \cdot 5H_2O$), also called calcium borate
gerstley borate ($2CaO \cdot 2B_2O_3 \cdot SiO_2 \cdot 8H_2O$, plus small amounts of Na_2O and MgO)
 (Gerstley borate is no longer produced, but several commercially produced
 substitutes with similar formulas are available.)

Sources of Glass Formers—Acid (RO$_2$) Oxides

The important oxide in this group, silica, has a refractory effect on glaze, while the others function largely as opacifiers or coloring agents. Boric oxide (an amphoteric material, above) functions as a glass former in glazes, and also as a flux.

Silica Silica (SiO_2), also called flint or quartz, combines readily with the bases to form glassy silicates. It is the most common element in glazes, where it acts as the glass former. In a glaze an increase in silica usually has the effect of raising the melting point, decreasing fluidity, increasing resistance of the glaze to water and chemicals, increasing hardness and tensile strength, and reducing the coefficients of thermal expansion. The amounts of silica used depend upon the flux and the maturing point of the glaze, but it is generally between 1 and 6 molecular equivalents.

Silica is commonly obtained from sandstone, quartz sands, or flint pebbles. Silica is also found combined with many ceramic materials. Below are listed a few of the more frequently used silica-containing compounds.

flint or quartz (SiO_2)—the primary source of pure silica
ball clay ($Al_2O_3 \cdot 2SiO_2 \cdot 2H_2O$)
kaolin ($Al_2O_3 \cdot 2SiO_2 \cdot 2H_2O$)
soda feldspar ($Na_2O \cdot Al_2O_3 \cdot 6SiO_2$)
potash feldspar ($K_2O \cdot Al_2O_3 \cdot 6SiO_2$)
nepheline syenite ($K_2O \cdot 3Na_2O \cdot 4Al_2O_3 \cdot 6SiO_2$)
Cornwall stone ($1RO \cdot 1.16Al_2O_3 \cdot 8.95SiO_2$)
wollastonite ($CaSiO_3$)
talc (typically $3MgO \cdot 4SiO_2 \cdot H_2O$)
petalite ($Li_2O \cdot Al_2O_3 \cdot 8SiO_2$)

Characteristics of Chemicals

(*Note:* Only the most dangerous compounds are labeled for their hazards here. Many chemicals can be toxic or otherwise hazardous if ingested or inhaled. Read labels carefully, and understand safe handling of chemical and glaze materials before compounding your own glazes.)

GLOSSARY

Albany Slip Albany slip is a slip clay, which is a natural clay containing silica, alumina, and fluxes in the correct proportions to function as a glaze. It was mined in the vicinity of Albany, New York, but is no longer commercially produced. Since it occurred in small pits, its composition and color varied. Usually, it fired to a glossy brown-black at temperatures between cones 4 and 12. Occasionally, it fired to a pale, nearly transparent tan. Recent substitutes include Alberta slip from Canada and various synthetic recipes. (see Appendix). Slip clays are very easy to apply, and they fire with few, if any, defects.

Alumina Hydrate Alumina hydrate ($Al[OH]_3$) is preferred to the calcined form of alumina (Al_2O_3) for glaze uses, since it has better adhesive qualities and remains suspended in the glaze longer. Introduction of alumina for matte effects is considered to be more effective in the hydrate form than in such compounds as clay or feldspar which also contain silica and/or fluxes.

Antimoniate of Lead (TOXIC!) Antimoniate of lead ($Pb_3[SbO_4]_2$), also known as Naples yellow, has been used primarily as a permanent paint pigment. It was once used as a source of low-fire yellows. Now seldom used due to the toxicity of lead. The presence of lead in Naples yellow helps form the color, since antimony will not produce a yellow unless combined with lead or iron.

Antimonious Oxide (TOXIC!) Antimonious oxide (Sb_2O_3) is poisonous and slightly soluble in water. For a satisfactory effect as an opacifier, it must be used in glazes fired below cone 1. Antimony will also produce yellow and orange colors for glazes. Yellow commercially produced stains made from praseodymium or vanadium have largely replaced antimony as a colorant in glazes.

Barium Carbonate (TOXIC!) Barium carbonate ($BaCO_3$) is usually used in combination with other fluxes, since at low temperatures it combines very slowly and acts as a refractory element to form matte textures. At higher temperatures it reacts strongly as a flux. Barium forms a strong eutectic with boron. While barium can be introduced fairly safely into many glazes in the form of a frit, strontium carbonate has gained popularity as a nontoxic substitute for barium carbonate (use 0.75 parts by weight of strontium carbonate for each 1.0 part of the barium in glazes). Barium carbonate is the only material that can be added to clay to stop scumming.

Barium Chromate (TOXIC! carcinogen) Barium chromate ($BaCrO_4$) will produce colors in the pale yellow to light green range. It is generally used in overglaze decoration, since it is fugitive (the color is not stable) at temperatures above cone 04. All chromates should be considered carcinogens.

Bentonite Bentonite ($Al_2O_3 \cdot 4SiO_2 \cdot 9H_2O$) is of volcanic origin. The formula is not quite correct, since bentonite contains other impurities (see the analysis of South Dakota bentonite in the Appendix). Bentonite generally fires to a light cream color and fuses at about 2400°F (1300°C), although purer white bentonites are available. Its chief value is as a plasticizer for short clays (those lacking plasticity) and as a glaze additive to glazes to help stop settling in the batch. As such it is about five times as effective as ball clay. Bentonite also adds dry strength to greenware. Purified bentonite will make a stronger glaze covering and if properly flocculated will help prevent settling in the glaze. An addition of about 2 or 3 percent is sufficient in glazes. Because bentonite is so plastic it must be slaked thoroughly in water before being added to glazes, or alternately dry mixed thoroughly with other materials before water is added to the glaze.

Bicarbonate of Soda (see sodium bicarbonate)

Bismuth Subnitrate (TOXIC!) Bismuth subnitrate ($BiONO_2 \cdot H_2O$) generally contains impurities such as arsenic, lead, and silver carbonates. It melts at a low temperature and will produce pearly metallic lusters under reducing conditions.

Bone Ash Bone ash in the unrefined state has a formula of $4Ca_3(PO_4)_2 \cdot CaCO_3$ with a molecular weight of 1340, although the actual analysis will vary slightly. Natural bone ash is not used much. The material generally available today is the refined calcium phosphate $Ca_3(PO_4)_2$ (or $3CaO \cdot P_2O_5$) with a molecular weight of 310. It sometimes serves as a glaze flux, chiefly in chun-type glazes and iron reds at stoneware temperatures. Phosphorus pentoxide forms a glass which does not dissolve into the silica-based glaze, but stays as tiny globules of phosphorus pentoxide glass within the silica glass, which sometimes imparts a bluish-white opalescence to glazes. Large amounts of bone ash may contribute to pinholing in glazes. It is more commonly used as a body ingredient in bone china, chiefly in the kind produced in England. It lowers the firing temperatures required and increases translucency.

Borax (TOXIC!) Borax ($Na_2O \cdot 2B_2O_3 \cdot 10H_2O$) is a main a source of boria (B_2O_3) which is, next to lead, the major low-fire flux. It has a strong action on all ceramic compounds and may even be used in small amounts in the high-fire glazes that tend to be overly viscous in nature. Borax has an effect on coloring oxides different from that of lead; for this reason it is often combined with lead. Borax absorbs moisture and should therefore be kept dry, or weight calculations will be inaccurate. As mentioned earlier, borax is very soluble in water and should not be applied to raw ware. Boron frit or gerstley borate are less soluble sources of boron in glazes.

Boric Acid (TOXIC!) Boric acid ($B_2O_3 \cdot 2H_2O$) is a flaky material soluble in water. It is available in a fairly pure state at low cost and most often used as a source of boron in frits. Although boric acid is one of the neutral oxides (R_2O_3), it functions more as a flux, since it increases the gloss in glazes. Unlike silica, an acid, in small percentages boric acid lowers the expansion coefficient and helps to increase elasticity.

Cadmium Sulfide (TOXIC!) Cadmium sulfide (CdS) is a low-fire yellow colorant. It is usually combined in a stain made of cadmium, selenium, and sulfur frits. Unfortunately, it is fugitive above cone 010 and can be used only for over-glaze decorations.

Calcium Borate (see colemanite and gerstley borate)

Calcium Carbonate (see whiting)

Calcium Fluoride (see fluorspar)

Calcium Phosphate (see bone ash)

Calcium Zirconium Silicate Calcium zirconium silicate is a commercially produced opacifier with the composition of ZrO_2, 41.12 percent; SiO_2, 25.41 percent; CaO, 22.23 percent. It does not have the opacifying strength of tin but is considerably cheaper. It will reduce slightly the maturing temperatures of the lower-fire glazes.

Carolina Stone Carolina stone is similar in composition to imported Cornwall stone, but is mined domestically. However, it is not commonly available.

China Clay (see kaolin)

Chromic Oxide (suspected carcinogen) Chromic oxide (Cr_2O_3—commonly called chrome oxide) and other chromium compounds are often used in glazes to produce green colors. Chrome in smaller amounts makes a bright grass green, but saturates in glazes in fairly low percentages and produces dark, paint-like greens. Chrome oxide is quite refractory (like alumina—note that chrome oxide is an R_2O_3 group member) and may raise the melting point of a glaze. All chromate compounds are now labeled as carcinogens and should be handled carefully. Chromic oxide is a suspected carcinogen. Dichromates were once preferred for colorants because of the greater amounts of chromium per weight. Care must be

taken in the glaze composition, for, when chromic oxide is combined with tin, a pink color results. Zinc and chrome will form a brown, and high-lead glazes may develop a yellow-lead chromate. Reducing conditions in the kiln will blacken the color. In fact, even adjacent tin-glazed and chrome-glazed pieces may affect each other in the kiln. Bright, low-temperature reds (below cone 010) can be produced by chrome oxide in a high-lead and low-alumina glaze.

Clay Clay is a decomposed feldspathic-type rock consisting chiefly of silicates of aluminum, but often containing numerous other impurities such as quartz, micas, feldspar, iron oxides, carbonates of calcium and magnesium, and organic matter (see Chapter 1).

Cobalt Carbonate Cobalt carbonate ($CoCO_3$) is used to introduce a blue color in glazes. It is often preferred over the oxide as it tends to melt into the glaze with less speckling, as it chemically decomposes to cobalt oxide when fired. When combined with manganese, iron oxide, and chrome oxide it will produce colors ranging from gray to black. Additions of nickel oxide or manganese dioxide will give a grayer, less intense blue (see cobalt oxide, below, for more color information).

Cobalt Oxide Cobalt oxide (Co_2O_3) has long been the major blue colorant. It is extremely strong and therefore is often fritted with alumina and lime for lower-temperature underglaze colors. The frit allows a lighter and more even color dispersion and limits cobalt's fluxing action. Color stains made of cobalt, alumina, and zinc are uniform at all temperature ranges. Small amounts of cobalt in glazes containing magnesia, silica, and boria will produce a variety of hues in the pink and lavender-purple range.

Cobalt Sulfate (TOXIC!) Cobalt sulfate ($CoSO_4 \cdot 7H_2O$), unlike the other cobalt compounds mentioned, is very soluble in water and this increases its hazards in handling greatly. It melts at a low temperature and is primarily used in decorative work or lusterware.

Colemanite Colemanite ($2CaO \cdot 3B_2O_3 \cdot 5H_2O$) is a natural hydrated calcium borate, which has the advantage of being only slightly soluble in water. Therefore, it does not develop the granular lumps in the glaze so characteristic of borax. Colemanite serves as low-fire flux, since the boron present melts at a fairly low temperature. In smaller amounts it tends to help prevent crazing. Colemanite can be substituted for calcium in some glazes where calcium would harm the pink or red colors desired. In both high- and low-fire glazes, colemanite tends to develop a milky-blue opalescent color. Colemanite is now little used in raw glaze batches as it may cause the glaze to come off the clay surface early in the firing. Gerstley borate, a boron mineral similar to colemanite, is preferred by many potters because it has less tendency to settle in the glaze and causes fewer glaze faults. Either material will be much more variable in analysis and less dependable than a commercially prepared frit, although these natural materials are usually considerably cheaper than frit.

Copper Carbonate Copper carbonate ($CuCO_3$) is a major green colorant in glazes. The carbonate form is preferred to the oxide form in the production of blue-greens or copper reds under reducing conditions, as it mixes easily into glazes and disperses well into the glaze melt when the carbonate portion decomposes, leaving finely divided copper oxide in the fired glaze.

Copper Oxides Copper oxide is available in two forms: cupric, or black, copper oxide (CuO), or cuprous, or red, copper oxide (Cu_2O). The red form is somewhat difficult to mix with water. Copper is one of the few colorants that does not change greatly under normal oxidizing conditions. Additions of 2 percent or more of copper will decrease markedly the acid resistance of lead glazes. Lead fluxes tend to produce a blackish green. When copper are combined with an alkaline flux, a turquoise will result in oxidation, with reds possible in reduction if a small amount of tin is included. Potash will induce a yellowish green, while zinc and copper

with fluxes of sodium, lithium, and barium will develop a blue tinge.

Cornwall Stone Cornwall stone is a complex mixture derived from a deposit of partially decomposed granite rock in England. It is composed of quartz (flint), feldspar, lepidolite, tourmaline, fluorspar, and small quantities of other minerals. Cornwall stone has characteristics that lie between those of kaolin and feldspar. It is a major ingredient of many English glazes and bodies and is subject to less firing strains than kaolin and feldspar. Because of the more intimate mixture of naturally occurring minerals, a smaller amount of alkali flux is necessary than would otherwise be needed. Since less bulk is required, there is less shrinkage of both the unfired and the fired glaze, thus minimizing glaze defects. Cornwall stone is roughly similar to petuntze, the feldspathic rock used for centuries by the Chinese as a major ingredient in their porcelain bodies and glazes. Like feldspar, Cornwall stone has variable composition; samples differ in the percentages of silica, potassium, sodium, and so on. If Cornwall stone is not available, a substitution of 70 parts by weight of soda feldspar, 24 parts flint, 2 parts wollastonite, and 4 parts kaolin can be made for 100 units of Cornwall stone. However, as previously noted, the new glaze will not have identical characteristics. The analysis of Cornwall stone is found in the Appendix.

Crocus Martis A naturally occurring iron sulfate mineral, usually used in its calcined form where it is less soluble. Often used to color terra sigillatas, giving a purplish brown.

Cryolite (HAZARDOUS!) Cryolite (Na_3AlF_6) is used primarily as a flux and an opacifier for enamels and glasses. It has a limited application in glazes and bodies as a source of fluxes and alumina. In some glazes, an addition of cryolite will promote crazing. Cryolite releases fluorine gas during firing and should be used only with caution. The fluorine gases released are corrosive to the kiln and elements, and hazardous to the potter and environment, so cryolite is little used now. It is sometimes used in so-called "crater" glazes because the gases released during firing may cause glaze bubbling.

Dolomite Dolomite [$CaMg(CO_3)_2$] is a double carbonate of calcia and magnesia. Its inclusion in a glaze is a good method of introducing both calcia and magnesia, since glazes with magnesia usually have a large proportion of calcium. Dolomite contains the equivalent of 44 percent magnesium carbonate and 56 percent calcium carbonate. Glazes containing large quantities of dolomite will shift the color of cobalt toward pinks and purples, and often result in waxy matte surfaces. Dolomite will also promote a longer and lower-firing range in clay bodies. Below cone 4, the addition of a small amount of a lower-firing alkaline flux to the dolomite will greatly increase this effect.

Epsom Salts (see magnesium sulfate)

Feldspar Feldspar is a crystalline mineral composed of the aluminum silicates of potassium, sodium, and calcium. These silicates are never found in a pure state, but in a mixture with one or the other predominating. For convenience in ceramic calculations, their formulas are usually given as follows:

> *potash feldspar* (microcline)
> $K_2O \cdot Al_2O_3 \cdot 6SiO_2$
> *soda feldspar* (albite)
> $Na_2O \cdot Al_2O_3 \cdot 6SiO_2$
> *lime feldspar* (anorthite)
> $CaO \cdot Al_2O_3 \cdot 6SiO_2$

Other feldspathoids (feldspar-like minerals) include the lithium minerals spodumene, lepidolite, and petalite.

The feldspars are a major component of porcelain and whiteware bodies and are often the only source of body flux. If the feldspar content of the body is high, the substitution of soda spar for potash feldspar will reduce the vitrification point by as much as 100°F (38°C). Feldspars are a cheap source of glaze flux and have the additional advantage of being insoluble. Because of the presence of Al_2O_3 and SiO_2, feldspars are not a good source of flux at low-temperature ranges, even though some flux is contributed to the glaze.

Grinding feldspar to a finer particle size may lower its melting point somewhat. Potash forms a harder glaze than does soda and decreases the thermal expansion. Thus, unless soda is desired for color purposes, potash feldspar should be preferred in the glaze composition. (See Appendix for a comparative analysis of feldspars.)

Ferric Chloride (TOXIC!) Ferric chloride ($FeCl_3 \cdot 6H_2O$) is more commonly called chloride of iron. It is very soluble in water and must be stored in airtight containers. Ferric chloride serves as a luster decoration on glass or glazes and produces an iridescent gold-colored film under proper conditions.

Ferric Oxide (see iron oxides)

Ferrous Oxide (see iron oxides)

Flint (see silica)

Fluorspar Fluorspar (CaF_2), also called calcium fluoride, may serve as a source of flux in glaze and body compositions. The particle size must be less than 100 mesh when used in the body, or pinholes are likely to form in the glaze. Fluorspar fluxes at a lower temperature than do other calcia compounds. When it is combined in a glaze with copper oxides, some unusual blue-green hues can be developed. Fluorspar is not much used in current glaze practice due to the toxic fluorine gas which may be produced during firing.

Galena (see lead sulfide)

Gerstley Borate Gerstley borate (approximately $2CaO \cdot 2B_2O_3 \cdot SiO_2 \cdot 8H_2O$) is often given the same formula as colemanite, but it contains somewhat less boron and also contains a small amount of sodium and other impurities. Most dealers now supply gerstley borate when colemanite is ordered, since the latter is quite variable in quality and may cause serious glaze flaws. Gerstley borate is an excellent source of calcium and boron and gives a slight opalescent color in most glazes, but as a natural material is also quite variable in analysis. Frit may be a more reliable source for boron in glazes.

Ilmenite Ilmenite ($TiO_2 \cdot FeO$) is the mineral source of titanium and its compounds. When coarsely ground into a powder-like sand, it produces dark specks in the glaze.

Iron Chromate (CARCINOGENIC!) Iron chromate ($FeCrO_4$) combined with manganese and zinc oxide will produce underglaze brown colors; combined with cobalt it will form a black stain. Used alone, it is fugitive above cone 04.

Iron Oxides Iron oxides have three forms: ferrous oxide (FeO), ferric oxide, rust, or hematite (Fe_2O_3), and ferrous-ferric oxide, or magnetite (Fe_3O_4). Iron is the oxide most frequently used to produce tan or brown bodies and glazes. Were it not for its pronounced color, it could serve as a flux. Black iron oxide (the reduced form) is a much stronger flux at lower temperatures than is red iron oxide. Iron is responsible for most of the low-firing characteristics and the red color of many earthenware clays. A pink stain can be made with a smaller amount of iron, plus alumina, calcium, and flint. When fired in reduction in a suitable glaze, $1-2$ percent iron oxide will form the blue-gray to light greens characteristic of the Chinese celadons. Saturated iron glazes (often called tenmoku) contain $9-12$ percent red iron oxide, which results in an opaque, brown to black stoneware glaze when fired in reduction.

Kaolin Kaolin ($Al_2O_3 \cdot 2SiO_2 \cdot 2H_2O$) is also called china clay or pure clay. Because of its composition and relative purity, kaolin is the highest-firing clay. It is an important ingredient of all whiteware and china bodies, since it fires to pure white. For glazes, kaolin constitutes a major source of Al_2O_3 and SiO_2. The chief residual deposits in the United States are in North Carolina, and sedimentary deposits are found in Florida, South Carolina and Georgia. For bodies, the more plastic sedimentary types are preferred. The sedimentary kaolin deposits of Florida are even more plastic and are often termed ball kaolin or EPK (see Chapter 1).

Lead Antimoniate (TOXIC!—see lead warning) (see antimoniate of lead)

Lead Bisilicate (TOXIC!—see lead warning) (see lead silicate)

Health Hazards in the Studio

Unless properly compounded, lead glazes can be poisonous because the harmful lead may be released when the fired ware comes in contact with tea, citric-acid fruit juices, salad dressings containing vinegar, or other food acids. *Government legislation greatly restricts or prohibits the use of lead in glazes, especially ware meant for food.* **Use with great caution. Lead fumes may be released from the glazes during firing and may contaminate other wares and the studio. Kilns should be properly vented if used to fire lead glazes.**

You should handle lead only when it is fritted. Otherwise, you may absorb the lead powder into the body through the skin or by inhalation. Lead is released from the body very, very slowly, so any exposure tends to add to the cumulative load. Even low levels of lead in the body have been shown to have marked effects such as lowered intelligence in children.

Copper oxide and combinations of iron oxide and manganese dioxide can greatly increase the potentially toxic release of lead from fired glazes when exposed to acid foods. Larger amounts of alumina, silica, calcium, and zirconium increase the acid resistance of lead glazes. Additions of sodium, potassium, and barium all decrease acid resistance.

Lead Carbonate (TOXIC!—see lead warning) Lead carbonate [$2PbCO_3 \cdot Pb(OH)_2$], more commonly called white lead, has long been a major low-fire flux that imparts a lower surface tension and viscosity over a wide temperature range. This results in a smooth, brilliant glaze with few surface defects. Lead may comprise all the flux in the low-temperature range, or a lesser amount at cone 4–5. Glazes which contain unfritted lead are called **raw lead** glazes. Government restrictions have made the use of lead in glazes much less common. Lead glazes should be avoided on any type of ware for use with food.

Lead Oxide (TOXIC!—see lead warning) Lead oxides occur in two types: litharge (lead monoxide–PbO), and red lead (minimum–Pb_3O_4). Litharge is a yellow powder that has a greater use in Europe than in the United States. Since litharge occasionally contains impurities and has larger particles than does the carbonate form, the latter is the preferred lead compound. Because of the greater amount of oxygen, red lead often replaces litharge. Ceramic grades of red lead are seldom pure but usually contain 75 percent red lead and about 25 percent litharge. Red lead contains more PbO by weight than does the carbonate form.

Lead Silicate (TOXIC!—see lead warning) Lead silicate is a frit made of lead and silica to lessen the toxic effects of the lead compounds. The two most common types are lead monosilicate, with a composition of 15 percent SiO_2 and 85 percent PbO; and lead bisilicate, which has a formula of 65 percent PbO, 34 percent SiO_2, and 1 percent Al_2O_3.

Lead Silicate, Hydrous (TOXIC!—see lead warning) [$2PbSiO_2 \cdot Pb(OH)_2$] has a molecular weight of 807. This material is the basic silicate of white lead. It is used as a substitute for lead carbonate when the CO_2 released by the carbonate forms pinholes or is otherwise objectionable in the glaze.

Lead Sulfide (TOXIC!—see lead warning) Lead sulfide (PbS), also called galena, is the black powder that is the raw source of all lead compounds. Some of the earliest glazes may have consisted of a dusting of galena on the wet clay surface, a process that no doubt lead to the early death of more than a few potters. Lead sulfide now has little use in glazes.

Lepidolite Lepidolite (LiF·KF·Al_2O_3·$3SiO_2$), also called lithium mica, contains from 3 to 6 percent lithia. It has some use as a body ingredient in chinaware and is a source of flux, Al_2O_3, and SiO_2 in higher-temperature glazes. It will tend to brighten most glazes, lower thermal expansions, and reduce brittleness (see lithium carbonate). Sources of this mineral have been hard to find in recent years.

Lime (see whiting)

Litharge (TOXIC!) (see lead oxides)

Lithium Carbonate (TOXIC!) Lithium carbonate (Li_2CO_3) is a common source of lithia. With lithia, greater amounts of Al_2O_3, SiO_2, and CaO can be used in alkaline glazes, thus producing a more durable glaze while retaining the unusual copper blues characteristic of the alkaline glazes. It can be used in place of lead in the medium-temperature ranges where volatilization is a problem. When substituted for sodium or potassium, it reduces glaze expansion and promotes crystallization. Moderate amounts may cause shivering as lithium tends to lower the thermal expansion. Large amounts of lithium may have the opposite effect, however, and promote crazing. Lithium carbonate may tend to deflocculate glazes, leading to problems with ingredients settling out of suspension in the batch, and application problems from thin, runny raw glaze. Other sources of lithia are lepidolite, petalite, and spodumene.

Magnesium Carbonate Magnesium carbonate ($MgCO_3$), also called magnesite, acts as a refractory element at lower temperatures, changing to a flux at higher temperatures. It is valuable for slowing down the fluid qualities of crystalline and other runny glazes. It also improves glaze adhesion. Because magnesium carbonate has some solubility in water that causes drying and firing

shrinkage, it is best added to glazes in the form of dolomite $[CaMg(CO_3)_2]$. It has a slight tendency to promote opacity in glazes. Magnesium carbonate is often supplied as a fluffy, lightweight powder which shrinks a great deal in drying and firing, and may cause crawling of glazes. This is the form used to make intentional "crawl" glazes which break up into chunks or stiff droplets during the firing.

Magnesium Sulfate Magnesium sulfate $(MgSO_4 \cdot 7H_2O)$ is better known as Epsom salts. It serves to flocculate (thicken) glazes which contain clay or bentonite, countering settling and improving application by dipping or pouring. Usually 1/2 to 1 percent, dissolved in hot water, will be sufficient and will have no apparent effect on the fired glaze. It is very useful for thickening glazes when used in this manner in combination with 1–2% bentonite in the glaze. A spoonful or two of Epsom salts dissolved in hot water can also be added to a bucket of already mixed glaze which is settling badly.

Magnetite (see iron oxides)

Manganese Dioxide (TOXIC!) (see manganese oxide)

Manganese Oxide (TOXIC!) Manganese oxide (MnO_2) is primarily a colorant. It should not be used in concentrations greater than 5 percent in either body or glaze, because blisters may develop. The usual colors produced are in the brown range. With cobalt, a black results; with the proper alkaline fluxes, purple and dark reddish hues can be produced. When it is fritted with alumina, a pink colorant will be formed.

Naples Yellow (TOXIC!) (see antimoniate of lead)

Nepheline Syenite Nepheline syenite $(K_2O \cdot 3Na_2O \cdot 4Al_2O_3 \cdot 9SiO_2)$ is a material roughly similar to feldspar (see Appendix for composition). In glazes, nepheline syenite can substitute for potash feldspar, but will lower the maturing point as much as a cone or two. It also produces a greater firing range and increased thermal expansion, which in turn will increase crazing tendencies in the glaze.

Nickel Oxide Nickel oxide is used in two forms, green nickel oxide, or nickelous oxide (NiO), and black nickel oxide, or nickelic oxide (Ni_2O_3). The function of nickel in a glaze is almost solely as a colorant. Depending upon the flux used and the ratio of alumina, a variety of colors can be produced: with zinc, a blue; with lime, a tan; with barium, a brown; and with magnesia, a green. None of these hues is particularly brilliant. In general, nickel will soften and alter other coloring oxides. In addition, 5 to 10 percent nickel in a suitable glaze promotes the formation of a crystalline structure.

Ocher Ocher is a term given to clays containing varying amounts of red iron or manganese oxides. Their primary function is in paint manufacturing. However, they can be used as glaze or slip colorants to impart tan, brown, or brick-red hues. When used in glazes or clay bodies ochers may give a smoother, more subtle color than purer forms of iron oxide, but more will be required to obtain an equivalent color.

Opax Opax is a standard, commercially produced zirconium silicate opacifier. The composition is listed in the Appendix. Opax does not have the power of tin oxide (1.5 times as much as tin oxide is required for similar opacity), but it is considerably cheaper, and for this reason it often replaces part of the tin oxide in glaze recipes.

Pearl Ash (see potassium carbonate)

Petalite Petalite $(Li_2O \cdot Al_2O_3 \cdot 8SiO_2)$, lithium-aluminum silicate, is chiefly used as an auxiliary body flux to reduce thermal expansions and increase shock resistance in ovenware bodies. At about cone 6 it converts into beta spodumene, which has almost no volume change when heated or cooled. It serves as a source of lithia and silica primarily for medium- and high-temperature glazes.

Plastic Vitrox Plastic vitrox $(1RO \cdot 1.69Al_2O_3 \cdot 14.64SiO_2)$ is a complex mineral mined in California that is a source of silica, alumina, and potash in both glaze and body formulas. It resembles potash feldspar and Cornwall

Health Hazards in the Studio

Because potassium dichromate is very poisonous and also a known carcinogen (as are all chromates), you should handle it with caution or avoid its use.

stone in composition. (See Appendix for comparative analysis.)

Potash Feldspar (see feldspar)

Potassium Carbonate (CAUSTIC!) Potassium carbonate (K_2CO_3) is more commonly called pearl ash. It is used primarily to modify color effects. When pearl ash is substituted for lead, sodium, or calcium content in a glaze, the colors resulting from copper oxide can be changed from the usual green to either a yellow-green or a bright blue.

Potassium Dichromate (TOXIC! carcenogenic!) Potassium dichromate ($K_2Cr_2O_7$) is used in glazes as a green colorant, and can produce bright red and orange colors in certain lead glazes. When it is calcined with tin, low-fire stains developing pink and red hues are formed (see chromic oxide).

Praseodymium Oxide Praseodymium oxide (Pr_6O_{11}), a black oxide, is a rare earth compound used in ceramics as a yellow colorant. It is commonly combined with zirconium oxide and silica to form a glaze stain that is stable at all normal firing temperatures.

Pyrophyllite Pyrophyllite ($Al_2O_3 \cdot 4SiO_2 \cdot H_2O$) is used primarily in wall tile bodies, where it decreases thermal expansions, crazing, and moisture expansions to which tile is subjected. Since it is nonplastic, it has limited use in throwing or hand-building bodies. It may be substituted for some of the silica in porcelain bodies to gain more stability in firing.

Red Lead (see lead oxide)

Rutile Rutile (TiO_2) is an impure form of titanium dioxide containing small amounts of iron and vanadium. It serves as a tan colorant in glazes and imparts a mottled or streaky effect. It tends to promote crystalline surfaces. It is popular in slips for soda and salt firing where it produces pearly colors.

Selenium Selenium (Se) is a glass colorant. It has a limited application in ceramic glazes and overglaze colors, primarily as cadmium-selenium red frits which require a lead glaze base. These frits, unfortunately, are fugitive at higher temperatures.

Silica Silica (SiO_2) is called flint or sometimes quartz. It is commonly obtained from sandstone, quartz sands, or flint pebbles. True flint is obtained from England, France, and Denmark. This cryptocrystalline flint has a different specific gravity (2.33) from that prepared from quartz sand or sandstone (2.65). For glaze purposes, the silica (silicon dioxide) derived from flint is important.

When used alone, silica melts at the extremely high temperature of 3119°F (1700°C) and forms an unusually hard and stable crystal. It combines under heat, however, with a variety of fluxes at much lower temperatures to form a glass, and with the alumina compounds to form the more refractory body structure. An increase in the silica content of a glaze has the effect of raising the maturing temperature as well as increasing hardness and resistance to wear. In a glaze, an addition of silica decreases its thermal expansions (reduces crazing); in a body it increases thermal expansion (increases crazing in the glaze).

Silicon Carbide Silicon carbide (SiC) has many industrial uses. Its value in ceramics is as the sole or major ingredient in high-temperature kiln furniture and muffles (a type of kiln lining). When added to an alkaline glaze in small amounts (0.5 percent), the carbon will reduce the copper oxides to form localized copper reds. Larger amounts of silicon carbide can be used to produce **crater** glazes which bubble with lava-like surfaces when the silicon carbide decomposes as the glaze melts.

Silver Chloride (HAZARDOUS!) Silver chloride (AgCl) is the major silver compound used in luster overglaze preparations (see the section on lusters later in this chapter.) When silver chloride is combined with bismuth and with a resin or fat oil as a binder, an overglaze metallic luster with greenish or yellow tints will form.

Soda Ash (CAUSTIC!) (see sodium carbonate)

Sodium Aluminate Sodium aluminate ($Na_2O \cdot Al_2O_3$) is used to prevent casting

slips from settling and to increase the strength of dry ware.

Sodium Bicarbonate Sodium bicarbonate ($NaHCO_3$), also called bicarbonate of soda or baking soda, has some use in casting slips and in forming stains with cobalt sulfate. Sodium carbonate ($NaCO_3$) is the sodium form more commonly used as a flux. Many potters are experimenting with sodium bicarbonate for salt glazing, as a less toxic alternative to sodium chloride (common salt). See Chapter 11, Kilns and Firing.

Sodium Carbonate (CAUSTIC!) Sodium carbonate (Na_2CO_3) is commonly called soda ash or washing soda. It is a very active flux, but because of its solubility it is more often used in glazes as a frit ingredient. Soda ash is often included in raw form in Shino glazes. Small quantities of soda ash, functioning as a deflocculant, will reduce the water of plasticity required in a clay body. Sodium carbonate is usually used in combination with sodium silicate to deflocculate clays, as by itself it tends to have a thixotropic effect on the slip. Deflocculation decreases plastic workability and strength of the clay body, but greatly reduces shrinkage from the wet to the dry state making slip casting possible. See sodium silicate, below.

Sodium Silicate (CAUSTIC!) Sodium silicate is a compound that can vary from $1Na_2O \cdot 1.6SiO_2$ to $1Na_2O \cdot 3.75SiO_2$. It usually comes in liquid form and is a major *deflocculant*.

Sodium Uranate (TOXIC! radioactive!) Sodium uranate ($Na_2O \cdot UO_3$), more commonly called uranium yellow, has not been available in the United States since World War II because of government restrictions placed on uranium. Uranium yellows may still be available, however, outside the United States. Uranium compounds formerly were the best source of yellow colorants. When uranium compounds are combined with various fluxes or with tin and zirconium oxide, a variety of hues from bright yellow through orange to vermilion red can be developed (see

uranium oxide). Ware glazed with uranium colors will become radioactive and could pose a risk to the user. Prewar Fiesta ware in the dark orange colors gives off low-level radiation.

Spodumene Spodumene ($Li_2O \cdot Al_2O_3 \cdot 4SiO_2$) is an important source of lithia. The use of lithia, which is an active flux, helps to develop unusual copper-blue hues. Spodumene is also added to whiteware and porcelain bodies. As a replacement for feldspar, it will reduce the vitrification temperature as well as lower the thermal expansion. Strange as it may seem, the crystalline form of spodumene expands, instead of shrinking, at about 1700°F (927°C).

Stannic Oxide (see tin oxide)

Steatite Steatite, a hydrous magnesium silicate, is a variety of talc. Most steatite is used in powdered form for electrical insulators. It has very little shrinkage, and occasionally the rock-like nuggets are turned down on a lathe for special projects. Steatite was used by the Egyptians almost 5000 years ago for the creation of beads and small figurines. These were generally covered with a turquoise alkaline copper glaze (see talc).

Strontium Carbonate Strontium carbonate ($SrCO_3$) is the main source for strontium oxide in glazes. Strontium carbonate, while somewhat expensive, is a safer alternative for barium carbonate which is quite poisonous if ingested. Most glazes which call for barium carbonate can be made safer by replacing it entirely with strontium carbonate. Use strontium carbonate in the amount of 0.75 parts by weight of strontium carbonate for each 1.0 part by weight of barium in the recipe. Many glazes will show little change when this substitution is made, although glazes high in barium carbonate (30–40%) will show some noticeable shifts in surface and colorant reactions.

Talc Talc varies from $3MgO \cdot 4SiO_2 \cdot H_2O$ to $4MgO \cdot 5SiO_2 \cdot H_2O$. In the solid and more impure form, it is also known as steatite or soapstone. Talc is occasionally used in glazes, but it is more frequently employed as a major ingredient

in whiteware bodies firing at moderate temperatures (cones 4 to 6). A favorite low-fire whiteware clay body for artists is half talc and half ball clay which fires to about cone 04–03. Like dolomite, it will lower the firing temperatures of the other body ingredients, usually kaolin, ball clays, and feldspars. Talc will promote a slight opacity in glazes. Only asbestos-free talcs should be used.

Tin Oxide Tin oxide (SnO_2), also called stannic oxide, is the most effective of all opacifiers. From 5 to 7 percent will produce a completely opaque white glaze. An excess will create a dull surface and increase the chance of crawling. Tin also has wide use in stains, since it has considerable effect on the color qualities of most color-forming oxides. Because of its relatively high price, tin substitutes (usually zirconium silicate opacifiers) are frequently used for simple opacification, but about 1.5 times the amount of tin is needed to achieve the same opacity when using zirconium-based opacifiers. Tin oxide is required (no substitutes) for chrome-tin pinks and reds, and in reduction copper reds where adding about 1 percent tin oxide helps to produce the red color.

Titanium Oxide Titanium oxide (TiO_2), or more correctly titanium dioxide, is a major opacifier when used either alone or in a frit. Like rutile, which is an impure form containing iron, titanium will encourage a semi-matte surface texture by promoting crystal growth. Combined with cobalt it can produce blue-green to green colors in glazes. Like most opacifiers, it tends to have a somewhat refractory effect on the glaze, stiffening it and making a more viscous melt.

Uranium Oxide (TOXIC! radioactive!) Uranium oxide (U_3O_8[black]), is a depleted nuclear fuel that was used formerly as a yellow colorant in low-fire lead glazes. Bright orange-red dinnerware produced before World War II in the United States was often made with uranium as the colorant, and this ware is now radioactive. The tin-vanadium, zirconium-vanadium, and praseodymium yellow stains have greater flexibility and no radiation hazard. They are more readily available and are preferred by most potters. Uranium initially loses its radioactivity upon firing, but slowly regains radioactivity over a period of years.

Vanadium Pentoxide (HAZARDOUS!) Vanadium pentoxide (V_2O_5) is a rather weak yellow colorant when used alone. When fritted in the proper composition with tin, it produces a strong yellow color. This stain, known commercially as tin-vanadium stain, has largely replaced the uranium yellows, which are no longer available. It has a wide firing range (cones 06 to 14), is transparent, and is not affected by a reduction firing.

Volcanic Ash Volcanic ash occurs in many regions of the western United States. It was formed from the dust of volcanic glass erupted in prehistoric times. Since the material often floated through the air many miles before being deposited, it is extremely fine and can be used with little preparation. Its composition is highly variable, but is roughly similar to that of a granite-type rock (see the formula in the Appendix). In most glazes volcanic ash can be substituted for roughly 70 parts of feldspar and 30 parts of flint, with about 1 percent of iron oxide added if desired.

White Lead (TOXIC!—see lead warning under lead) (see lead carbonate)

Whiting Whiting ($CaCO_3$) is a calcium carbonate produced domestically by processing marble or limestone. European whiting is generally obtained from chalk deposits, such as those at the famous cliffs of Dover. Whiting is the major high-fire glaze flux, although it has a limited use in bodies where a small amount will lower vitrification temperatures and reduce porosity. The calcium oxide provided by whiting adds hardness and durability to glazes, and in large amounts may cause matte glazes. As a flux, it produces much harder and tougher silicates than will either the lead or alkaline compounds. For this reason, small amounts of whiting are often added to lower-fire glazes, although it is most effective at cone 4

and above. As with other fluxes, calcium has an effect upon the coloring oxides, particularly chrome greens.

Wollastonite Wollastonite ($CaSiO_3$) is a natural calcium silicate. As a replacement for both flint and whiting, it reduces firing shrinkage and improves heat shock. It is used in both bodies and glazes. In glazes, it reduces the amount of gases released by the melting glaze compared to whiting, and may help to produce more clear transparent glazes.

Zinc Oxide Zinc oxide (ZnO) is a difficult compound to classify. At high temperatures it is an active flux. When used to excess in a glaze low in alumina and cooled very slowly, zinc will produce crystalline structures. Opacity will develop if zinc is used in a high-alumina, low-calcium glaze, with no boro-silicate fluxes, at cone 1 or higher. In general, zinc increases the maturing range of a glaze and promotes a higher gloss, brighter colors, reduced expansions, and, under some conditions, an opacity. Zinc oxide is almost always used in the calcined form, as uncalcined zinc oxide has a high amount of shrinkage and promotes crawling. The presence of zinc oxide in a glaze will cause chrome oxide to produce brown colors.

Zirconium Oxide Zirconium oxide (ZrO_2) is seldom used alone as an opacifier in ceramics but is generally combined with other oxides and fritted into a more stable silicate form. Below are listed a few commercial zirconium silicates. None has the strength of tin oxide (see tin oxide), but they are considerably cheaper.

calcium zirconium silicate: 51.12 percent ZrO_2, 25.41 percent SiO_2, and 22.23 percent CaO

magnesium zirconium silicate: 53.75 percent ZrO_2, 29.92 percent SiO_2, and 18.54 percent MgO

zinc zirconium silicate: 45.78 percent ZrO_2, 23.08 percent SiO_2, and 30.52 percent ZnO

zirconium spinel: 39.94 percent ZrO_2, 25.25 percent SiO_2, 19.47 percent ZnO, and 19.41 percent Al_2O_3

Most of these compounds are used in combination with other opacifiers, such as tin or titanium compounds (see also Opax and Zircopax).

Zircopax Zircopax is a standard commercially produced zirconium silicate opacifier with the composition of 64.88 percent ZrO_2, 0.22 percent TiO_2, 34.28 percent SiO_2 (see zirconium oxide, above).

OTHER CERAMIC MATERIALS

Spinel Stains

Under certain circumstances, the use of a raw coloring oxide may be objectionable. For example, most metallic oxides are quite soluble in the melting glaze, leading to a change in color from the raw to fired form, and occasionally color bleeding. Colorants that dissolve into the glaze are known as **solution colors.** To avoid solution of the colors into the glaze, a special type of colorant known as a **spinel** is used. Overglaze and underglaze decoration with any degree of precision or control is impossible with colorants that diffuse into, react with, or flow with, the glaze. The previous section noted that the fluxes and other elements of the glaze had considerable effect upon color quality, often changing colors markedly.

A spinel stain is a colored crystal that is highly resistant to attack by fluxes in the glazes and to the effects of kiln temperatures. In this way spinels function more like a pigment in the glaze, remaining as distinct particles of color. In strict chemical terms, spinel refers to the mineral magnesium aluminate $(MgOAl_2O_3)$. However, manganese, iron, and chromium may be present by replacement. The crystal is an octahedron variety of extreme hardness. The ruby gem is a red spinel. By calcining certain oxides together, some very stable colored spinels can be formed. In general, these follow the formula $RO \cdot R_2O_3$. The RO member can be MgO, ZnO, NiO, CaO, MnO, or FeO, and the R_2O_3 can be Cr_2O_3, Al_2O_3, or Fe_2O_3.

Preparation of a spinel stain is a long procedure, and it is not recommended unless it is necessary for advanced experimental work. A wide range of commercial stains, expertly prepared, are available at reasonable cost. However, the general idea of the preparation should be understood. Detailed information can be found in the reference texts listed in the Bibliography.

It is extremely necessary that the chemicals involved be very finely ground and mixed completely. To this end the raw chemicals should first be passed through an 80-mesh sieve. It is preferable that they be in the form of soluble salts, that is, the nitrates or sulfates of the oxides listed above. These are thoroughly mixed in a liquid solution. After the water has been evaporated, the dry mixture is placed in a crucible or a kiln and calcined. The temperature will vary with the mixture. If the mixture melts into a solid mass, it should be calcined in a pot furnace so that the crucible can be removed with tongs and the contents poured into water, thus preventing the spinel from hardening into a solid crystalline block. Afterwards, the material is broken up with an iron mortar and pestle into a coarse powder, which is then ball milled. For a uniform color without specks, the particle size of the spinel must be extremely small. This may necessitate grinding in the ball mill for well over a hundred hours. When it is sufficiently fine, the stain should be washed several times with hot water to remove any remaining soluble salts. Filters may be necessary at this point in the process to prevent the loss of fine particles.

Other Colored Stains

Besides the spinels, a number of other chemical compounds are calcined to produce stable colorants at certain temperatures. A discussion of a few of the better-known examples will serve to illustrate some of the numerous possibilities in the preparation of colorants.

An ultramarine blue can be formed by a silicate of cobalt. It is made by calcining cobalt oxide and flint, plus a flux such as feldspar.

Green stains can be developed by calcining fluorspar and chromium oxide.

Yellow stains, such as Naples yellow and yellow base, are made from antimony, lead, and tin, and should not be used in food service ware. Calcium and sodium uranate have been used in the past, to form various yellow and orange colorants, but pose radiation hazards. Vanadium with tin is also used to make a yellow stain, but more recently praseodymium yellow has gained popularity as the least hazardous of all the yellow stains.

Pink and red stains are made by a number of methods. One of the most unusual is the precipitation of colloidal gold upon kaolin, which is then calcined and ground to form the stain. Other red stains are formed from a mixture of tin, calcium, flint, and chromium. (For further information and specific details, consult the reference texts by Parmelee, Norton, and Koenig and Earhart listed in the Bibliography.)

Recently a new form of red and orange inclusion stains has become available. These stains, made by encapsulating the cadmium-selenium red color within a zirconium oxide crystal, are stable up to cone 8 (2305°F or 1263°C) or above. These stains allow strong red colors to be used on sculptural forms at higher temperatures than previously possible. Note that these stains should *not* be ball milled, as that may break down the encapsulating zirconium that protects the color.

Health Hazards in the Studio

Because of the toxicity and other hazards associated with many of the raw ingredients used in spinels and stains, it is best to leave the production of many of these materials to professional manufacturers. Commercially produced stains may still pose definite health hazards, but they are generally safer (and provide more stable color in glazes) than most of the raw forms of colorants.

Underglaze Colors

Underglaze colors were mentioned before briefly in Chapter 9. As the term indicates, they are colors used under the glaze. Since they will eventually be fired at the same temperature as the glaze, the variety of colors available is less than for overglaze colors. For example, at the hard porcelain range of cone 14 (2548°F, 1398°C), most, if not all, of the delicate hues available in overglaze colors will burn out completely. This leaves only the blues, browns, grays, gold-pinks, reduction reds, and celadon hues available for use at these higher temperatures. It is advisable to run a series of firing tests before attempting any amount of decorative work at such temperatures. The basic reason for employing underglaze rather than overglaze colors is durability.

Underglaze colors are made up of a colorant (either a raw oxide or a spinel), a flux such as feldspar to allow the color to adhere to the body, and a diluent like silica, calcined kaolin, or ground bisque ware. The purpose of these last materials is either to lighten the color or to equalize shrinkage. It is rather important that the mixture be adjusted properly to the bisque ware and the final glaze. The glazed surface should show no change in gloss over the decoration.

Overglaze Colors

The major differences between overglaze colors and underglaze colors are the use of a lower melting flux and a wider range of colors. Since the overglaze decoration is to be applied to a previously fired glaze, the final firing need be only high enough to allow the flux to melt into the glaze and seal the color. This is usually about cone 020 to cone 015, approximately 1231° to 1549°F (666°–843°C). The flux is made of varying proportions of lead, borax, and flint, depending upon the color to be used with it. Lead-free overglazes are becoming more available, but with a somewhat limited palette. The mixture is calcined

lightly, ground, and washed. The colorant, and if necessary, an opacifier, is then added, and the whole mixture is ball milled to an adequate fineness. A vehicle such as gum or oil is used to help the mixture adhere to the glazed surface. In commercial production, where decoration is standardized, printing methods are used. The colors of both types of decoration are applied by decals or silk screen. (See Chapter 9 for application methods.)

Luster Formulation

As was noted earlier in the discussion of glaze types (Chapters 8 and 9), a luster is nothing more than a thin layer of metal that is deposited and fused upon the surface of the glaze. It is not actually a glaze, although certain glazes may develop a luster surface.

Lusters are now commonly available in a variety of commercially produced colors. The hazards and complexity of their manufacture leads most artists to use commercially prepared lusters.

There are various methods by which a lustered surface can be accomplished, some of them outlined below. Luster can give a variety of effects, depending upon the transparency or color of the composition and the type of glaze upon which it is applied. In Persian and Hispano-Moresque pieces it is very effectively combined with underglaze decoration. In fact, luster really comes into its own when it is used to enrich other types of decoration. The colors available in lusters are a transparent iridescent, a nacreous silver white, and metallic hues in a variety of yellows, greens, browns, and reds. (See references in the Bibliography.)

Preparation of lusters will vary according to the specific method of firing to be employed. There are three types of preparation, the first being the most common.

1. A mixture composed of a resin, oil of lavender, and a metallic salt is brushed on the glazed ware. The ware is then fired in an oxidizing kiln to a low temperature of between 1100° and 1300°F (593°–704°C), at which point the carbon in the resin reduces the metallic salt to its metal form. Most lusters contain bismuth nitrate, an active flux, as well as the other metal salts. This is used in combination with zinc acetate, lead acetate, and alumina to produce a clear, iridescent luster. The various metal colorants are always used in the form of a salt that decomposes at the lower temperatures needed to form the luster coating. Yellows can be made with chrome alum and bismuth nitrate. Nickel nitrate, cobalt sulfate, manganese sulfate, and iron chloride will produce a variety of browns, shading from yellowish to reddish hues. Uranium nitrate, when it was available, developed a greenish yellow. Gold is commonly used to produce red hues and platinum to create silvery lusters. Many combinations of these colorants are used and results will be varied, depending in part upon the basic glaze and the firing schedule. In general, the luster mixture will consist of 1 part metallic salt, 3 to 5 parts resin, and 7 to 10 parts oil of lavender. The resin, usually gum dammar, is heated; when it becomes liquid, the nitrate or chloride is added. When the nitrate dissolves, the oil is slowly poured in. The solution is then filtered or cooled and decanted. The experiments in *Literature Abstracts of Ceramic Glazes* by J. H. Koenig and W. H. Earhart (see Bibliography) will help in creating formulas.

2. Another type of preparation is similar to that employed many centuries ago by Egyptian and other Middle Eastern potters, although it is seldom used today. These Islamic craftsmen developed luster and carried it to a high level of sophistication. The chief difference between their method and that described earlier is the use of a reduction fire to reduce the metal rather than having a reducing agent contained in the resin. The mixture, which is brushed on the glazed ware, consists of 3 parts metal, usually in a carbonate form, 7 parts red ocher, and an adhesive, such as gum tragacanth. Old recipes call for vinegar or wine, but gum is doubtless more efficient. In the firing cycle, the atmosphere is oxidizing until a low red heat is reached, whereupon reduction is started and continued to the temperature necessary to reduce the metal, usually from 1200° to 1300°F (649°–704°C).

3. The third method of developing a luster is also seldom used, but in rare instances it occurs by accident. The color is incorporated into the glaze, preferably in the form of a metallic salt. Various combinations can be used in proportions ranging from 0.5 to 8 percent of the total glaze. As in the resinate type of luster glaze, the use of bismuth, in addition to the other metallic salts, will aid luster development. The kiln is fired, oxidizing to the maturity point of the glaze, then cooled to between 1200° and 1300°F (649°–704°C). At this point the kiln is relit and fired for about fifteen minutes with a reducing atmosphere. Accurate records should be kept on reduction firings, since variations of temperature and reduction periods will produce quite different results.

Chapter 11

Much like the fisherman, the potter has in his work many elements of chance and failure. This is especially true of the final firing, in which pots may crack, glazes run, and other mishaps occur. It is no wonder that ancient potters were superstitious; they placed a votive figure over the kiln door and made supplications prior to firing. The following quotation is from a life of Homer purportedly by the fifth-century-B.C. Greek historian Herodotus but actually an imitation from a much later period (c. 130–80 B.C.). It is a "begging song" attributed to Homer, who, while visiting the island of Samos, was offered several pots by some potters in exchange for a song.

If you will pay me for my song, O potters,
then come, Athena, and hold thy hand above the kiln!
May the kotyloi and all the kanastra turn a good black,
may they be well fired and fetch the price asked,
many being sold in the marketplace and many on the roads,
and bring in much money, and may my song be pleasing.
But if you (potters) turn shameless and deceitful,
then do I summon the ravagers of kilns,
both Snytrips (Smasher) and Smaragos (Crasher) and Asbetos (Unquenchable) too,
* and Sabaktes (Shake-to-Pieces)*
and Omodamos (Conqueror of the Unbaked), who makes much trouble for this craft.
Stamping on stoking tunnel and chambers, and may the whole kiln
be thrown into confusion, while the potters loudly wail.
As he grinds a horse's jaw so may the kiln grind
to powder all the pots within it.
[Come, too, daughter of the sun, Circe of many spells,
cast cruel spells, do evil to them and their handiwork.
Here too let Cheiron lead many Centaurs,
both those that escaped the hands of Herakles and those that perished.
May they hit these pots hard, and may the kiln collapse.
And may the potters wail as they see the mischief.
But I shall rejoice at the sight of their luckless craft.]
And if anyone bends over to look into the spy-hole, may his whole face
be scorched, so that all may learn to deal justly.

* From Joseph Veach Noble, *The Techniques of Painted Attic Pottery* (New York: Watson-Guptill, 1965), p. 107. Based on the text reproduced in Wilamowitz, *Vitae Homeri et Hesiodi*, trans. by Marjorie J. Milne (Bonn, 1916), pp. 17–18.

EARLY KILNS

Kiln design technology has played an important role in the development of ceramics, along with such other factors as function, cultural influences, and general innovations in form, decoration, and glaze. It is helpful to understand the role that the firing process plays in determining ceramic form and surface. Innovations in kilns often were necessary for innovations in glaze and clay to occur. Contemporary potters often look to the past to rediscover older ways of firing and use them in new ways.

Pit Firing

The first pots and figurines were fired in what was little more than a bonfire (Fig. 11-1). Usually a shallow pit was dug and filled with a layer of dry twigs or even coarse grass. On this bed the sun-dried ware was placed and covered with more twigs and dry wood, then a layer of broken shards was often added to protect the ware. After the pile was lit and burning, more small pieces of wood were added until the ware was covered with a glowing layer of red-hot coals. After a couple of hours the fire bed was covered with a layer of ash, broken pottery shards, and earth to contain the heat and allow the ware to cool slowly.

Only a porous, low-firing clay could be used in such a procedure. The ware, fired to only about 1500°F (800°C) was not really mature but was able to serve a useful purpose. Finer-grained clay slips were often applied to the surface of these pots before firing to help to seal the porous surface. Since the body was still quite porous, the surface was often rubbed with the leaves of gummy plants or tree sap resins while still hot, which gave it a slight waterproof coating.

Most low-firing clays have a high iron content. When the fire is smothered with ashes, some of the normal red iron (Fe_2O_3) in the clay body is converted by the lack of oxygen into the black oxide form (FeO) turning the clay gray. Carbon impregnated into the surface of the ware also contributes a large part to the dark color of pit-fired pottery. While it's possible to fire pieces in oxidation in a bonfire, it's often a hit-or-miss affair, with black fire-marks a common occurrence. Some cultures, such as the Egyptian Baderian ware (Fig. 2-34) made beautiful use of the tendency for the ash-covered portion of the pot to turn black, while the portion left exposed to the air is fired red.

Long after kilns capable of oxidization were developed, many cultures continued to make blackware by firing with a nearly oxygen-free atmosphere. These pieces were first coated with a decanted, fine-particled slip and burnished to produce a glossy surface. The Chinese **Lung-Shan** ware and the Etruscan **bucchero** ware, discussed in Chapter 2, are examples of the advanced blackware tradition.

Bank Kilns

In an effort to fire clay at a higher temperature in order to produce a more durable ware, early potters developed the bank kiln (Fig. 11-2). Dug into the side of a bank or hill, it provided a fuel port for the fire at the bottom, an enclosed heat-retaining chamber next to it, and a vent-like chimney opening farther up

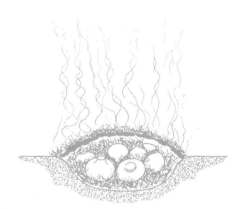

11-1 A primitive bonfire firing in a shallow pit.

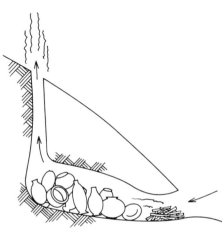

11-2 An early bank kiln, showing firebox and chimney.

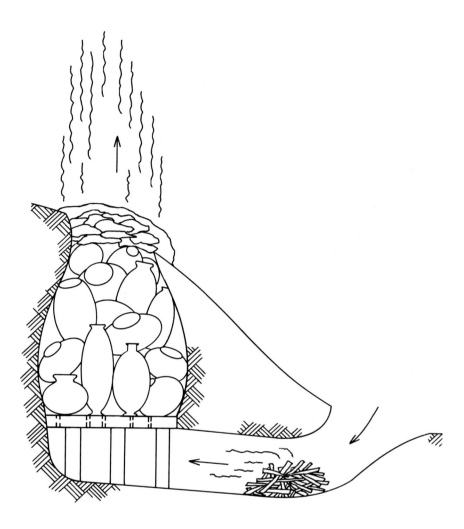

11-3 Top-loading bank kiln with firebox construction.

the hill. This arrangement created an updraft that contributed to higher temperatures. In time a slotted kiln floor was added and the chamber enlarged (Fig. 11-3). In addition to attaining higher temperatures, the bank kiln made it possible for the potter to control the firing atmosphere for either a reducing or an oxidizing state, making possible a wider range of predictable colors.

Freestanding Kilns

Eventually potters evolved a freestanding kiln made of clay bricks with a firebox on the bottom separated by a slotted floor from the kiln chamber above. Unlike the preceding bank kiln, the simple, freestanding updraft kiln could be built near any source of clay. This type of kiln (Fig. 11-4) is still used today in many areas of the world. It is a simple design to build and can burn a wide variety of fuels. The change from pit-fired ware to kiln-fired ware can be distinguished by the appearance of wares with red bodies, since these kilns offered greater control over the firing and more uniform oxidation of the ware. The ware was often decorated with brushed slip decorations that would have been obscured by the blackened clay of a smoky firing. This shift occurred as early as 5700 B.C. in

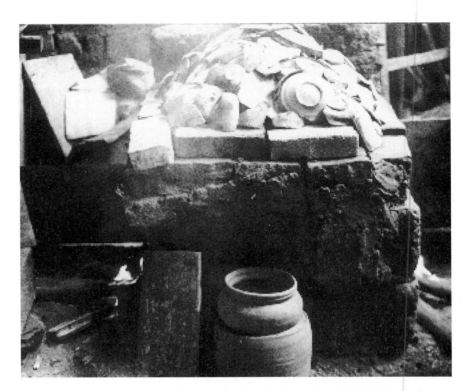

11-4 Simple kiln in Cuenca, Ecuador. Pottery has been fired in simple updraft kilns like this for millennia. The pottery is carefully piled up inside the simple clay and brick box. It is held slightly above the firepit at the bottom by a few bricks placed in the floor of the kiln. The top of the kiln is "sealed" with a layer or two of broken pottery shards which help to hold the heat in the kiln. The two fire mouths are just visible on the sides of the kiln. Such kilns are still used to fire low-fire slipware and lead-glazed pieces in many countries.

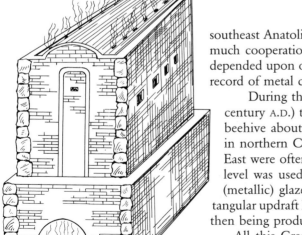

11-5 Rectangular Renaissance updraft kiln.

southeast Anatolia and slightly later in Iraq and China. It is likely that there was much cooperation between the early metalsmith and the potter because both depended upon obtaining high temperatures to make their product. There is no record of metal casting in a culture without a developed pottery tradition.

During the Classical Greek and Roman periods (fifth century B.C.–fifth century A.D.) the typical kiln in the Mediterranean region was shaped like a beehive about 6 feet (1.8 m) in diameter. Beehive kilns were also common in northern China. By the eighth century A.D., kilns in the Islamic Middle East were often built with an upper and a lower chamber. The cooler upper level was used either to fire ware to the bisque state or to give it a **luster** (metallic) glaze. By the fifteenth century in Renaissance Italy, a larger, rectangular updraft kiln had evolved in order to fire the greater quantities of pottery then being produced (Fig.11-5).

All this Greco-Roman and Islamic pottery and most pottery in medieval and Renaissance Europe was earthenware, fired at a temperature seldom exceeding 2000°F (1093°C). Only in the Rhine Valley, where stoneware clays were discovered and there was plenty of wood to keep up a hot fire, did potters, in about the fourteenth century, begin to make higher-fired stoneware in rectangular downdraft kilns.

Bank-Climbing Kilns

As early as 1000 B.C. potters in southern China were producing a few high-fired proto-stoneware pieces. Stoneware became fairly common by the Han Dynasty (206 B.C.–A.D. 220) and porcelains during the Sung Dynasty (960–1279). This early development of higher-fired ware is explained partly by the fact that China had plentiful supplies of stoneware clays, and of kaolin and feldspathic rock for porcelain. Equally important was the bank-climbing, or sloping, kiln, which was constructed up a bank or hillside in mountainous southern China (Fig. 11-6).

By the Sung period the sloping kiln had developed from a single large chamber often 15 feet (4.57 m) high into a series of large chambers rising in steps up the hillside from the firebox at the base. Heat from a wood fire rose from chamber to chamber and escaped through a vent higher up the slope. Separate fuel ports allowed extra wood to be added to keep the heat even in the upper chambers. The wares were enclosed in **saggars,** round containers of fireclay serving to protect the glazed surface from kiln fumes and the falling ash such as that which had accidentally glazed unprotected Han period stoneware. The kiln construction and careful placement of the saggars created a downdraft in the kiln, in which the heat was deflected up one side of the lowest chamber by the wall of stacked saggars. The flame was then drawn down through the ware by the suction of the draft and through the opening at the bottom of the chamber wall to pass into the next higher chamber. This design permitted an efficient use of fuel and evenly high temperatures. More pottery could be fired, as the heat that would be lost out the vent in a single-chamber kiln was used to heat the upper chambers. As each chamber was heated, the firing progressed up the hillside, chamber by chamber.

Korean kilns, or **anagama,** were similar to Chinese sloping kilns, but with more numerous auxiliary fuel ports to obtain better control of the heat in the single long chambers. Japanese kilns were based on Chinese and Korean models. By the seventeenth century, Japanese climbing kilns, or **noborigama,**

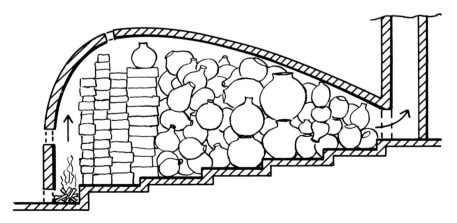

11-6 Large single-chamber climbing-bank kiln similar to those used at Ching-Te-Chen. Many contemporary potters have been variations on this design, often called an anagama kiln, for wood firing pottery. All the flame and ash is forced through the ware, resulting in large amounts of ash-glazed pottery.

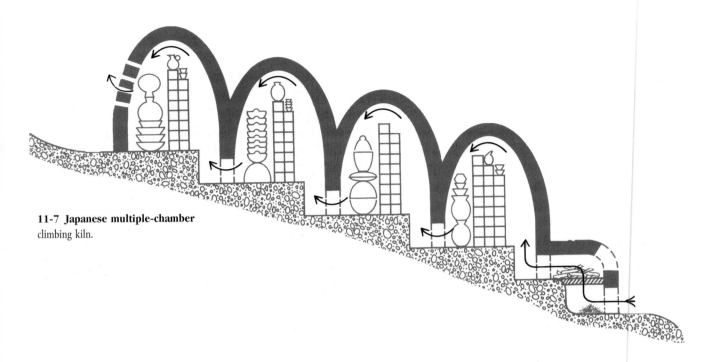

11-7 Japanese multiple-chamber climbing kiln.

consisted of as many as twenty connecting small chambers about 6 feet high and 8 feet wide (1.83 by 2.44 m), an arrangement that greatly improved efficiency (Figs. 11-7).

MODERN KILNS

Many of the kiln types employed by the ancients are still in use today, but more modern kilns have been modified to accommodate new fuels, new materials, and in the ceramic industry, the need for expanded and efficient large-scale production (Fig. 11-8). Perhaps the most drastic change in kiln design in recent times was caused by the development of a new source of power—electricity. Since the electric kiln needs no chimney or fuel lines and is comparatively portable, simple, and safe to operate, it has played a large part in the current popularity of ceramics. It is especially convenient for the potter whose studio might be relatively temporary or for the school in which the facility provided for neither a chimney nor a source of fuel.

Increases in the cost of oil, gas, and electricity, combined with an increasing need to conserve resources, present a real challenge to the potter. Kilns *must* be designed to operate as efficiently as possible. When fuel was relatively cheap, the potter building a new kiln often scrimped on materials, using inexpensive but not the most effective firebrick. New products now on the market are both light and convenient, as well as efficient in firing. Combined with traditional materials, they provide savings in fuel. Although the price of refractory and insulating materials has also risen, the most efficient materials will doubtless pay for their cost over the long run.

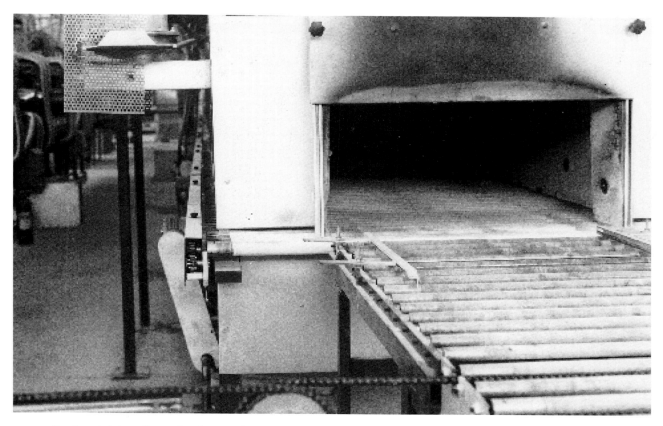

11-8 Roller hearth kiln in Cuenca, Ecuador. A modern roller kiln features a floor made from refractory rollers which allow the individual shelves filled with pottery to be rolled through the kiln at a constant speed, slowly warming them at one end, reaching full firing temperature toward the middle of the kiln tunnel, and cooling slowly as they move toward the exit. Such kilns allow very efficient use of fuel, as they run constantly and use the heat of the cooling pottery to preheat the unfired ware as it enters the kiln.

Fuel Kilns

Whether wood, coal, oil, or gas is used as a fuel, the basic kiln design is much the same. A combustion area is needed either below or to the side of the kiln chamber. Wood or coal requires a larger firebox area equipped with a grate and an ash pit. When wood or coal were the only available fuel, saggars were often used to protect the glazed ware from flying ash. Fuel oil and manufactured gas, more recent fuels that contain sulfur which often causes dullness and blistering on the glaze surface, also required saggars for many glazes. As they take up much space, saggars were often replaced with an inner muffle chamber that serves the same purpose. The updraft muffle kiln shown in Figure 11-9 was designed to eliminate this problem. The design, however, creates extra heat in the floor area, making an even firing difficult. Placing burners closer to the side wall will alleviate the problem to some extent. Modern studio gas kilns usually lack muffles, as they are not needed. Many small commercially made gas kilns are of the updraft type, with small vertical burners spaced across the floor area. These also tend to be hot at the bottom.

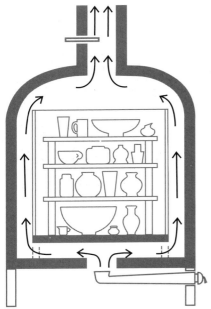

11-9 Gas-fired updraft muffle kiln.

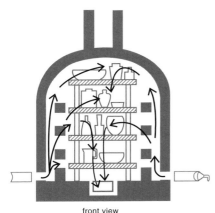

front view

11-10 Standard design for a gas-fired downdraft kiln.

11-11 Crossdraft kiln with the burners on one side.

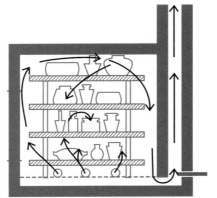

side view

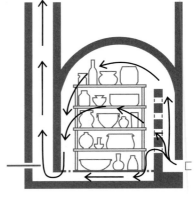

The downdraft kiln illustrated in Figure 11-10 provides a more even heat distribution and has come to be the standard design preferred by most potters. This is especially true since the advent of clean-burning natural gas, which has eliminated the need for a muffle. In this downdraft kiln the heat enters from multiple burners on each side, is deflected upward by the bag wall (a low wall of bricks within the kilns which directs the flame away from the ware). The flame then is drawn down by the suction of the chimney through the ware to a channel under the floor. If the fuel supply and draft are adequate, it will ensure a heat deviation of no more than one cone from top to bottom, and usually much less.

For a smaller-size kiln, a layout such as that illustrated in Figure 11-11, with the burners placed to one side, may prove equally satisfactory. Numerous other burner arrangements have been tried, but the design sketched in Figure 11-11 remains one of the most popular and useful.

A kiln fired with fuel oil requires a slightly larger combustion area than one fired with natural gas. The catenary arch kiln shown in Figure 11-12 is ideal for fuel oil or a salt/soda kiln, since the flare at the bottom provides the extra combustion area needed. Except for the arch construction, the design is similar to that of a typical rectangular gas kiln. The curve is established by suspending a chain from two points, thus forming a natural self-supporting arch. A proportion in which the base width equals the height is the most stable and provides excellent heat distribution. Although the arch is self-supporting, tie rods are desirable from front to back, and even from side to side across the floor, since some movement occurs during repeated firing. Templates cut to this curve and faced with 1/8-inch (0.33-cm) Masonite will form a mold for the brick construction.

Oil is a satisfactory fuel, cheaper than gas, but it has some drawbacks. A separate shed-like installation is desirable, since the fumes that are given off, together with the noisy blowers, make an oil-burning kiln impractical for use inside the potter's studio or the classroom. Natural gas is usually much preferred.

Kilns with a cubic shape are more likely to fire evenly than ones with a more elongated rectangular profile. Kilns are easier to load, too, if the door width is as large or slightly larger than the depth of the chamber. It is assumed that the chambers of the kilns discussed have a loading area of about 10 to 20 cubic feet (3.05 to 6.1 m³), a convenient size for a small one-person studio. However, many artists and schools need a larger capacity. The physical strain incurred in stretching to load the heavy shelves and ware at the far end of a 30-cubic-foot

more elongated rectangular profile. Kilns are easier to load, too, if the door width is as large or slightly larger than the depth of the chamber. It is assumed that the chambers of the kilns discussed have a loading area of about 10 to 20 cubic feet (3.05 to 6.1 m³), a convenient size for a small one-person studio. However, many artists and schools need a larger capacity. The physical strain incurred in stretching to load the heavy shelves and ware at the far end of a 30-cubic-foot (9.14 m³) or larger chamber is too much for many people. In such situations a car kiln (Fig. 11-13) may be a good solution. This, again, is essentially the Figure 11-10 design, but the floor section is built on a steel frame and wheels, so that it can be rolled in and out of the kiln on a track. The door often becomes an integral part of the car, instead of swinging or being bricked up in the usual fashion. There must be a close fit between the floor and the side walls, often with a channel iron in the floor extending into a sand trough in the side wall to form a heat seal. In the car kiln the ware can be loaded from either side without undue strain to the ceramist. Car kilns are also quite useful in production situations where ware is a consistent size and must be loaded and unloaded quickly and efficiently as in Figure 11-14.

In a large kiln, more burners may be needed than the illustrations show. As a rule, a more even firing results from several smaller burners rather than two extremely large burners. In a long kiln, openings in the bag wall will need to be varied from front to back, because the draft, and the heat, may be greater at the rear, near the chimney.

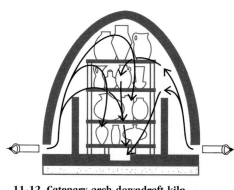

11-12 Catenary-arch downdraft kiln with side burners.

Electric Kilns

The electric kiln has many advantages. In areas where electricity is relatively cheap or gas is not easily obtained, the electric kiln is almost universally used by the studio potter. Results from electric firing are generally quite consistent. It is almost

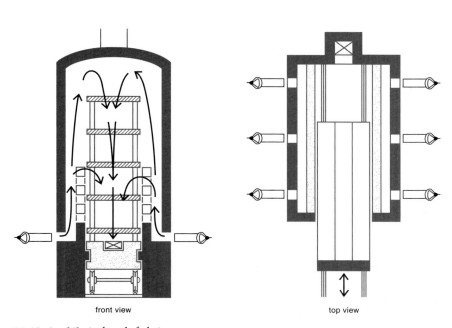

front view top view

11-13 Car kiln in downdraft design.

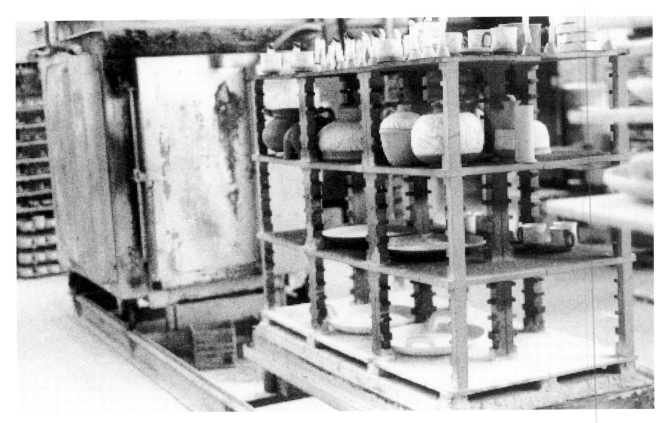

11-14 Electric car kiln in a factory in Cuenca, Ecuador. This partially loaded car kiln is about to be rolled into the kiln for firing. Often the shelves are left in a permanent configuration in such kilns to make stacking and unstacking faster.

The kiln room, even for an electric kiln, *must* be well ventilated and should be fitted with an exhaust system venting to the outside. In firing, most clays give off carbon monoxide and often some sulfurous gases. There are very few glazes that do not release some noxious fumes, all of which seep into the room atmosphere from the expanding pressure of the heated kiln chamber.

The electric kiln comes in two basic styles—the top loader (Fig. 11-15) and the front loader. In either type, a kiln with less than an 18-by-18-inch (45.72–by–45.72-cm) interior should not be considered except as a test kiln, for it is too

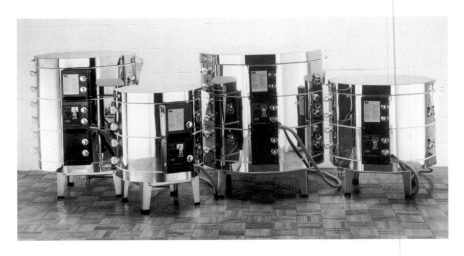

11-15 Typical studio-size electric kilns. Round electric kilns built in stackable sections or rings allow a lot of flexibility for the studio artist. Some models allow extra blank rings with no heating elements to be added to increase size, or sections can be taken off for smaller firings. This type of kiln is also more and more commonly found in schools.

small to fire most pieces. The coiled elements recessed in the side walls radiate heat; therefore, a kiln chamber bigger than about 24 by 24 inches (60.96 by 60.96 cm) requires a large coil or strip element, which greatly increases the cost of the kiln. Because they must have a stand and a heavy frame to carry the door, plus flexible connections to the door elements, front-loading kilns are much more expensive. The top loader is cheaper to purchase and fairly easy to load for most things, so it is a more logical choice for many studio potters.

More recent top-loading electric kilns are made in a circular form with eight or ten insulating bricks cut at an angle to ensure a tight fit. The side wall is usually only 2.5 inches (6.35 cm) thick. although some thicker versions are available. The brick structure is wrapped first with a layer of high temperature fiber insulation, then in a thin stainless steel sheet, which holds the bricks in place. As shown in Figure 11-15, the controls are usually mounted on the side wall of the kiln. The top lid of the kiln is hinged for ease of opening. Occasionally additional sections may be added to fire unusually tall pieces. The construction of a circular kiln is lighter as well as cheaper than that of the usual square kiln. More or heavier elements are needed to compensate for the greater heat loss. As a result circular kilns sometime fire and cool off faster than the usual square kiln. Some glazes react slightly differently in a shorter firing cycle, especially matte glazes. Increasingly popular are oval top-loading kilns which allow pieces of somewhat larger scale.

There are three types of electric heating elements. Suitable for low-fire temperatures (up to 2000°F or 1098°C) are those made of coiled Nichrome wire. This type of element is seldom found on current models, but may limit usefulness of older kilns. The Kanthol A-1 and similar element types commonly found today are constructed of a different alloy and will produce temperatures up to cone 8 (2305°F or 1263°C) or above. Larger and higher-firing industrial Globar kilns use silicon carbide or other similar carbon compounds in the form of a rod from 0.25 inches to 2 inches (0.64 to 5.08 cm) in diameter. Globar kilns are capable of very high temperatures well in excess of the typical stoneware range. Unfortunately, the elements and the special electrical transformers needed for them are more expensive than the structure of the kiln itself, which makes globar kilns more costly than gas or other types of electric kilns.

Kiln Loading and Firing

The final step in the potter's art—the loading and firing of the kiln—is most important, for carelessness can easily ruin the potter's best efforts. It can also do permanent damage to the kiln. With the exception of some salt-glaze ware and commercial high-fire porcelain, most pottery is fired twice, first in a lower temperature bisque firing, then in a glaze firing. Some clay bodies can be glazed successfully in the raw state, but the fragility of unfired clay and the difficulty of glazing some shapes make a double firing desirable, especially in schools, where techniques of glazing and loading are being taught.

Front-loading kilns are generally easy to fill, but care must be taken to avoid back injury leaning into the kiln with heavy work or kiln shelves. Placing large, heavy work down into top-loading kilns can be difficult. Kilns that are made with multiple stacking rings, each with an element and control may make loading such work easier. The rings can be taken off, the work loaded onto the floor of the kiln, then the rings are replaced by lowering them over the work.

The shelves and supports used in a kiln are collectively called kiln furniture. Shelves are typically made from fireclay for low-fire to midrange (cheapest), or

silicon carbide for higher temperatures (more expensive). Shelves are quite heavy, easily broken and expensive, so care in handling them is needed. Newer materials like nitride-bonded silicon carbide shelves are much lighter and stable at stoneware temperatures, but more expensive yet and easily broken if abused. High alumina or mullite shelves may be serviceable in many situations, too, and can afford some savings in cost over silicon carbide shelves.

Support posts can be purchased pre-made in a variety of sizes, but many potters choose to use firebrick **soaps** (a half brick cut the long way) or other firebrick shapes as a long-lasting and somewhat cheaper alternative.

A uniform load without tight or open areas will produce an even firing (Fig. 11-16). The potter should not ordinarily try to fire a half load, since uneven temperatures are almost certain to occur, especially in gas kilns. Staggering the shelves in a large kiln may help to create a more even heat flow. In the typical electric kiln, shelves should not be placed close to the bottom or the top, for a cold spot will develop in the center area of these shelves. Glaze test tiles should always be stacked near the middle of the kiln near cones, since there is usually some temperature variation from top to bottom.

Shelves should always be supported by only three posts each in a triangular arrangement (Fig. 11-17). A shelf will sit firmly on three posts, as three points determine a plane, but with four it seems one post is always a bit short or long. The uneven support of four posts puts the shelf in a twist which may break or warp it during the firing. The combined weight of a stack of heavy shelves loaded with ware can put a tremendous load on the bottom shelves, so they must be

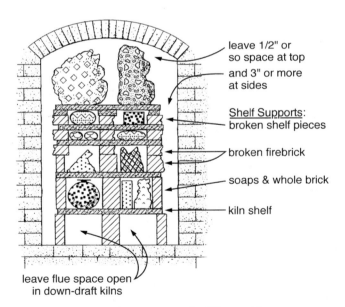

leave 1/2" or so space at top and 3" or more at sides

Shelf Supports:
broken shelf pieces

broken firebrick

soaps & whole brick

kiln shelf

leave flue space open in down-draft kilns

11-16 Kiln loading—front view. Ware should be sorted by size as it is loaded and placed in the kiln to use the shelf space efficiently. Note how the posts are all directly one above another. Small pieces of broken kiln shelf or firebrick have been added to increase the height just slightly to accommodate the ware on some shelves. The lowest shelf or kiln floor is often left more open to help the flames circulate more evenly. Sometimes the floor of the kiln is left empty, as in the drawing above.

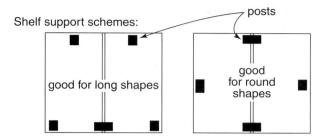

Shelf support schemes:

posts

good for long shapes

good for round shapes

Both of these arrangements use only 3 posts per shelf.
Use one or the other of these schemes, NEVER both
in the same stack of shelves!

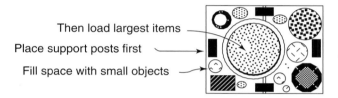

Then load largest items

Place support posts first

Fill space with small objects

11-17 Kiln loading—top view. Three posts should be used for each shelf, as a tripod arrangement makes the most stable structure. Make sure shelves are even and level if large pots are placed across two separate shelves, or warping may occur.

Shelves should always be supported by only three posts each in a triangular arrangement (Fig. 11-17). A shelf will sit firmly on three posts, as three points determine a plane, but with four it seems one post is always a bit short or long. The uneven support of four posts puts the shelf in a twist which may break or warp it during the firing. The combined weight of a stack of heavy shelves loaded with ware can put a tremendous load on the bottom shelves, so they must be loaded carefully. Posts must be placed one right above another from one shelf to the one above it, especially at the bottom of the setting.

Long shelves may need one of the three posts to be placed in the center of the long side to avoid warping. Small damp clay pads used to level uneven posts should be dusted first with dry alumina hydrate to avoid sticking, or wadding can be made especially for this purpose.

General Tips for Kiln Loading

◆ Use only three support posts per shelf. Using four posts can crack or break shelves during the firing.

◆ Place kiln posts directly above the posts on the previous layer.

◆ Space the posts so as to evenly distribute the load on the shelf.

◆ Washing the ends of kiln support posts with a small amount of kiln wash may make them less likely to stick to the kiln shelves in high temperature firings.

◆ Keep shelves level and stable by using uniform heights of support posts and

Pyrometric Cones and Other Temperature Gauges

Pyrometric cones provide the most accurate method of measuring the **heat work** in the kiln. The name is inaccurate, for the pyrometric "cone" is actually a tall tetrahedron or pyramid shape. Large cones are 2.375 inches (6.03 cm) high, with a base 0.5 inches (1.27 cm) across; small cones are 1.13 inches (2.87 cm) high and 0.25 inches (0.64 cm) wide at the base. In the United States pyrometric cones are made by the Edward Orton Jr. Ceramic Foundation (a nonprofit foundation), and usually called simply Orton cones in many references. Pyrometric cones were invented by Hermann Seger in Germany in the 1800s, and cones in Europe still bear his name, Seger cones. In Great Britain Harrison cones are often used. Seger, Orton, and Harrison cones have a slightly different end point, even though the numbering is similar, which should be noted when testing recipes from another country. Also available in the United States from Orton are 2.5-inch (6.35-cm) high, self-supporting cones which don't need a separate supporting base, and pyrometric bars, 1-inch (2.54-cm) rectangular pyrometric bars intended for use in automatic kiln shut-off devices such as the Dawson Kiln-Sitter.

Cones are compounded of a material similar to a glaze. When softened by heat, they bend; when the cone forms a half circle, the temperature in the kiln is approximately that given for the cone number (see Appendix). As cones measure the effects of the firing (the combination of time and temperature) on the ware, the actual temperature in the kiln at a particular cone may differ greatly from that listed. Cone charts commonly give the specified heat rise per hour for a given end temperature for a particular cone number.

The cone base is beveled to indicate the proper angle at which to press it into a pad of clay, 8 degrees off vertical for Orton cones. The cone should be placed so that the flat side is toward the angled direction in which the cone will bend. Several cones are often assembled into one finger-sized coil of clay, called a **cone pack.** The cones should be inserted into the base so that exactly 2 inches of the cone extends out of the base. It is important that the cone pack be placed on a level spot in the kiln, away from immediate contact with flame, so that they can accurately measure the effect of the firing on the ware.

Pyrometric cones are numbered in an orderly, if a bit odd, manner. Orton cones are commonly available in numbers ranging from cone 022 (a dull red glow in the kiln) to cone 20 (brilliant white hot), the latter being well above the temperatures typically used by potters. The zero at the start of a cone number is very important, as it differentiates the low-fire cones, 022 (the lowest temperature cone) to 01, from the rest of the higher temperature cone numbers which start with cone 1 and go upward in temperature to at least cone 20. One might think of the leading zero in a cone number as being like the minus sign of a negative number, with cone 022 being the lowest-temperature cone. A cone chart for Orton cones is provided in the appendices for reference.

The cone numbering system looks like this (Fig. 11-18):

Pyrometric cone numbers and typical firings:

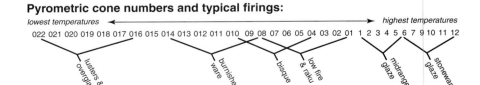

11-18 Pyrometric cone ranges and typical firings.

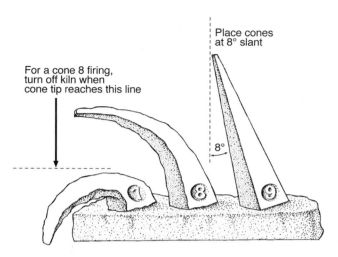

For a cone 8 firing,
turn off kiln when
cone tip reaches this line

Place cones
at 8° slant

8°

11-19 Pyrometric cones are placed in a cone pack. The proper angle is quite important for accurate, repeatable firings. Orton cones should be placed at an 8-degree angle.

A common practice is to use three cones, a guide cone, a firing cone, and a guard cone. For example, one would use cones 7, 8, and 9 if the firing is to reach cone 8 (Figure 11-19). The bending of cone 7 warns that the kiln is approaching the proper temperature, and the potter should make burner or damper adjustments to stabilize and even the heat as the kiln nears the end of the firing. In a large kiln the cones are placed near both top and bottom, not too close to the door, burners, or kiln walls. As cone 8 bends, the burners can be cut back for a **soaking** period (holding the kiln at the same temperature). A softening of cone 9 indicates an overfiring. For the initial firing of a new kiln, cones can be placed throughout the kiln to find hot and cold spots. Gas kilns often fire slightly hotter at the bottom near the burners, so a less fluid glaze can be used there. If the cones are difficult to see, quickly inserting a steel rod near the cones will reveal them more clearly as the rod cools the cones slightly. Green-colored kiln or welding glasses may also help to see the cones.

A slower rise in temperature, and the resulting longer period of chemical reaction, will permit a glaze to mature at a lower temperature than if the heat rise is rapid. This relationship between time and temperature is called the **work heat ratio,** and it is recorded by the pyrometric cone, but not by the **pyrometer.** The pyrometer consists of a pair of welded wires of dissimilar metals, called a **thermocouple,** which is inserted into the kiln. When the kiln is heated, a minute electrical voltage is generated which varies with the temperature. A millivolt meter calibrated in degrees Fahrenheit (F) or centigrade (C) indicates the temperature. A pyrometer is convenient for making adjustments to produce the most efficient heat rise or to determine the proper time to begin a reduction. However, unless the potter has an exact and unvarying firing schedule, it is not completely accurate. In time, corrosion of the thermocouple tips affects the accuracy of the reading, but this can be adjusted to more closely correspond to the cone by recalibrating the pyrometer.

Pyrometers are available in both low- and high-fire models. The rather inexpensive ones (which have type K thermocouples) used by potters are seldom reliable over a wide range of temperatures; that is, if the cone 8 reading is correct, the cone 04 may be inaccurate. More expensive analog meter or digital pyrometers may offer a bit more reliability. The more expensive pyrometers have a thermocouple with wire tips completely enclosed in a porcelain or high temperature metal jacket. This instrument is recommended for larger kilns in frequent use, for it is less apt to be damaged in kiln loading or by slight chemical reactions during firing. Pyrometers which use a type R thermocouple are the most dependable for stoneware firing, but are quite expensive due to the cost of the platinum thermocouple. Optical pyrometers are also available; these are quite accurate, but rather expensive. Draw rings, which were common before the introduction of cones, can also be used to measure kiln temperature. When made from the same clay and glaze being fired, such rings are a convenient method of determining glaze buildup in a salt- or soda-vapor-glazing kiln.

Many small electric kilns have a Dawson Kiln-Sitter, a mechanical arrangement which holds a small cone which can automatically shut off the electricity at the end of the firing. When the cone bends, a lever trips a switch turning the kiln off. These automatic shutoffs are a great convenience provided they work consistently. Even though the cone numbers are the same, a small cone placed in a cone shutoff device will bend at a slightly lower temperature than the large cones placed in the kiln with the ware. This difference is often about one whole cone number lower. Safe use of these automatic cone shutoff devices requires careful inspection and loading of the kiln for each firing. The use of a timer along with the cone shutoff device makes a much safer arrangement. It must be noted that only the small-size cones (or pyrometric bars made specially for this) which have a different temperature range than the standard cones (see Appendix), can be used.

While many potters use these cutoff devices, they must be used with care. The working parts tend to corrode and accumulate glaze from the melted cone. Some potters advise coating the pins with a small amount of kiln wash, but *only* where they touch the cone. Keep the ceramic channel through the kiln wall free of corroded pieces from the metal parts. Although their design has improved over the years, one should *never* leave the studio and depend solely on the automatic cutoff to turn off the kiln. Visual cones are always recommended, at least as a backup.

A more recent innovation is the computer kiln controller (Fig. 11-20), which measures both the temperature in the kiln (using a thermocouple) and the passage of time. By combining time and temperature measurements computer controllers can closely approximate pyrometric cones in the ability to accurately measure the heat effects on the ware. Computer controllers are generally more accurate, and have a longer life, if kept as far away from the heat of the kiln as possible. Because controllers depend on a thermocouple for temperature measurement (usually placed near the kiln wall), they are still prone to slight inaccuracies due to variations in the density of loading of the kiln. The use of visual cones placed alongside the ware is still highly advised to ensure that firings go as planned, especially for critical glaze firings. There is a tendency to give complete control of kiln firing over to such technological marvels as the kiln controller or cone shutoff device, but the wise potter will also be observant and attentive to the firing, watching for overfiring and electronic or mechanical failure of the controller.

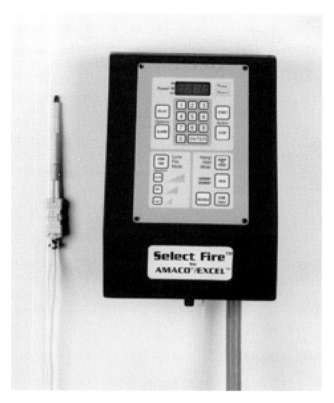

11-20 Computer Kiln Controller This is a typical computer kiln controller which consists of two main parts: the programmable power controller in the box at right which turns the electricity to the kiln on and off, and a thermocouple at the left which is inserted in a small hole in the kiln wall to measure the temperature of the firing. The electrical power for the kiln is connected through the controller.

The most useful aspect of computer kiln controllers is their ability to control the whole firing, from how fast the kiln heats, to how fast it cools. Less expensive controllers come with only preset programs for firing. The better controllers allow the ceramist to easily program custom firings for such specialized firings as those for crystalline glazes, thick sculptural work, or anything which needs a unique firing. Programming these controllers is not difficult, but requires a knowledge of proper firing rates for all parts of the firing. Kiln controllers can be bought already installed on new kilns, or as separate units which can be installed on existing kilns. Most controllers are built to control a single kiln, but industrial models are available which will control several kilns at once. Some of these more sophisticated controllers use a personal computer to log and control the firings through an interface box which adds the thermocouple inputs and the control circuit outputs. While computer controllers are most commonly found on electric kilns, they can be made to control gas kilns as well. As computer kiln controllers become less expensive and more accurate, they are becoming increasingly popular and no doubt will be quite common in future years.

The Bisque Fire

The bisque firing temperature is generally between cone 010 and cone 05, depending upon the clay body used. Fired bisque ware must be hard enough to endure normal handling in the glazing operation, yet sufficiently absorbent to permit glaze adhesion. Ware bisqued below cone 012 may crack during the glaze fire if too much flux is absorbed into the porous clay body. The stacking of a bisque kiln is quite different from that required for a glaze fire. In each situation, however, at least 1 inch (2.54 cm) of free space must be left between the electrical heating elements and the ware. In a gas kiln a minimum of 3 inches (7.62 cm) between the kiln wall and the ware is a desirable margin to allow free passage of heat and gases, and to avoid hot and cold spots.

Raw ware must be completely dry before it is loaded in the bisque kiln. The common test for dryness is to hold the greenware piece against the cheek or wrist. If it feels cold, there is still excess moisture in the clay. The bottom and any thick areas especially should be carefully checked.

Since there is no problem of glaze sticking, kiln wash is not needed on the shelves for bisque, and pieces may touch one another. It is possible to stack one piece inside or on top of another, building to a considerable height if the ware is strong enough. The potter must take care to make the rims coincide for support and to avoid placing heavy pieces on more fragile ones.

Loading Hints for Bisque Firing

◆ Work can often be stacked for more efficient loading. Stacking the work rim to rim, or foot to foot is usually best.

◆ When stacking one piece inside another, be careful that they aren't wedged into one another. The weight of the piece should be on the foot, or the rim if stacked rim to rim.

◆ Avoid placing smaller objects in the center of relatively flat objects such as plates. Large platters can sometimes be stacked rim to rim, if the rims are the same diameter and strong enough to safely support the weight.

◆ Large, shallow bowls, which might warp, can be fired upside down on their rims if the kiln shelf is very even and flat. Smaller size bowls can be placed underneath.

◆ Lids should be fired in place to prevent warping, and tall knobbed covers can sometimes be turned upside down to save space.

◆ To get more work in the kiln, load larger diameter pieces first, then fill around them with smaller work of about the same height.

Starting the Bisque Firing

Raw clay contains much moisture, even though it seems to be dry, so firing should proceed at a low heat for several hours. Kiln doors should be left ajar or peepholes left open for an hour or so to allow this moisture to escape. Large, heavy pots or sculptural pieces must be fired more slowly to prevent the moisture contained in the clay or in hidden air pockets from being converted into steam, which would cause the piece to explode. Figure 11-21 shows a pot that bloated during the glaze firing, possibly as the result of a too-rapid bisque fire that didn't burn out the excess organic matter in the clay.

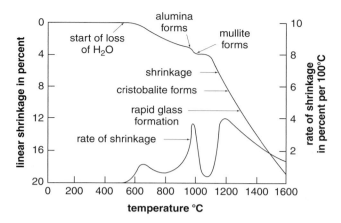

11-21 Clay shrinkage and mineral changes during firing.

Chemical Changes Chemical changes in the clay body during firing are slight at first (Fig. 11-21). When the temperature reaches 350° to 400°F (178°–204°C), all atmospheric moisture should have left the ware, causing little or no shrinkage. The ware should be heated very slowly through this range as water forms steam at 212°F (100°C). If large amounts of steam form suddenly inside the ware, the clay will explode into tiny fragments.

Most of the chemically combined water will leave the ware at temperatures between 950° and 1300°F (510°–705°C). During this "water smoking" period both the chemically combined water and gases from organic material leave the body. The firing should not be too rapid, for the body is very weak. As the temperature approaches 1750°F (955°C) and continues to the typical bisque firing temperature of 1850°F (1010°C), tough, needle-like crystals of alumina-silica $(3Al_2O_3 \cdot SiO_2)$, called **mullite,** begin to form, but they are not fully developed in stoneware clays until much higher temperatures are reached in the glaze firing. These crystals give toughness to the body, and as the temperature increases, additional free silica combines with fluxes in the clay to form a glass around them. Because of impurities and varying composition, clay bodies achieve maximum hardness at different temperatures. Earthenware clay typically matures at about 2000°F (1090°C), stoneware at about 2370° F(1300°C), and pure clay (kaolin) at about 3000°F (1650°C). Porcelain fires in the same range as stoneware, normally between cones 8 and 12, although higher temperatures are possible for specialized porcelains.

Quartz Inversion A major problem in the successful firing of ceramic bodies is quartz inversion. During the firing of a ceramic body, silica (quartz) changes its crystalline structure several times. This is the free crystalline silica that is not in a chemical bond with other body components or fused into glass. The most pronounced change occurs when the firing temperature reaches 1063°F (573°C). At this point the quartz crystals change from alpha to beta quartz, with a resultant sudden expansion in size. In the cooling process the situation is reversed. When the kiln temperature drops to 1063°F (573°C), any free silica in the body in the form of quartz crystal contracts. Quartz inversion is one of the reasons why a slow cycle of firing and cooling is essential.

If a ceramic piece is heated or cooled too quickly, or if the distribution of heat is uneven, the piece will crack.

A second inversion of crystal structure occurs with any silica that has taken the form of cristobalite. Like quartz inversion, cristobalite inversion is accompanied by a sudden expansion on heating or contraction on cooling. This expansion is larger than that which occurs with quartz. The cristobalite inversion occurs at a much lower temperature than quartz inversion, at just over 400°F (204°C). Clearly this can be a very serious problem for ovenware and similar wares subjected repeatedly to heat, or even as a dunting problem in the initial cooling of the ware. During the firing of clay, free silica is formed from parts of what started as the kaolin mineral as the clay changes its mineral form. The cristobalite form of silica develops from any free silica in the clay (silica which is not part of the glassy structure of the clay), primarily in the stoneware temperature range, cone 8–10. It is good practice to include just enough flux (usually in the form of potash feldspar) in a clay body to dissolve into the glassy matrix any cristobalite which forms.

All studio clay bodies will slowly expand and contract upon any heating and cooling, in addition to the more sudden cristobalite and quartz inversions. The amount of this movement, called the **coefficient of thermal expansion,** is determined by the formulation of the clay body and how it has been fired. Special precautions are required for such things as ovenware which must be able to withstand the repeated heating and cooling of baking. Ovenware bodies are often formulated to have a relatively low thermal expansion. Glazes must also be formulated to match these clay bodies.

Cooling Procedures

Cooling procedures are important both to firing of ware and to the maintenance of kilns. When the correct temperature has been reached, the electric kiln can simply be turned off and allowed to cool. In the fuel-burning kiln, the chimney damper must be closed immediately to prevent a cold draft of air from being sucked into the burner pots, which might crack both the ware and the shelves, and even shorten the life of the brickwork of the kiln. Just as the kiln must be fired slowly, so must it be allowed to cool gradually. The damper can be opened slightly after the kiln has cooled overnight to a temperature below about 1000°F (538°C), so that the temperature in the kiln is safely below quartz inversion. The peephole plugs can also be removed at this point, but the door must not be opened more than a crack until the temperature has dropped to 400°F (204°C), which is below the cristobalite inversion temperature. It might be noted that paper burns at about 450°F (232°C), so a small slip of paper can be carefully inserted into a peephole as a test for kiln temperature if no pyrometer is available. Even slower cooling may be desirable for extremely large or heavy pieces. With programmable computer-controlled kilns, the cooling rate can be adjusted to match the needs of the work, with the kiln firing continued in a minimal way to slow the cooling. This can also be done manually, if careful attention is paid to the cooling. An expensive kiln, which should give at least ten years' service or more before major repairs are needed, may be ruined after a short time by careless firing and cooling.

The Glaze Fire

The glaze fire differs in several respects from the bisque fire: the loading is different, the kiln atmosphere may be varied, and the final temperature must be controlled even more carefully. Since mishaps may occur from runny glazes, all kiln shelves should be coated with a **kiln wash.** Kiln wash often consists of equal parts by weight of silica (flint) and kaolin in a creamy mixture, although equal parts of kaolin and alumina hydrate are also a popular mix (and good for wood and soda/salt kiln use). Several coats may be needed, with each coat applied before the last is completely dry. Kiln wash can be brushed on, or applied more quickly with an inexpensive paint roller. Take care not to allow the kiln wash to drip onto the edges or back of the shelves where it could flake off and land on the glazed ware. Dusting on a thin layer of coarse alumina gives additional protection if needed. The shelf edges must be cleaned to prevent any of the powder from sifting down on the ware below. Silica sand is not recommended for this use as it tends to fuse to the ware and to the shelf.

All stoneware glazed ware should be **dry footed**—that is, all glaze cleaned off the base and about one quarter of an inch (0.64 cm) or more up the side of the foot rim. Low-fire and midrange glazed ware may sometimes be fired with a glazed foot by placing the ware on **stilts,** small pointed clay or clay and high-temperature wire props which hold the work well away from the kiln shelf. The small flaws left in the glazed foot from the points of the stilts can easily be ground off after firing. Glazes that are runny, such as crystalline glazes and even copper-reds, can be placed on a pedestal made from high-firing insulating brick coated with kiln wash. This will facilitate any later grinding of the excess glaze.

As in the bisque fire, lids are best fired in place, but the potter must make certain that the contact areas are clear of glaze. Porcelain lids, because of the glassiness of this type of clay body, may need to have a dusting of alumina hydrate on the rims to keep the clay from sticking to itself. Waxed rims can be rubbed in a little alumina so that a thin layer sticks in the wax where the rim touches, or a small amount of alumina hydrate can be added to a special batch of wax resist (dyed with some food coloring to keep it apart from regular wax resist) which is used to wax porcelain lids and rims only.

Placing glazed ware too close to the upper bag wall often results in overfired spots from the intense heat in this part of the kiln, although gaps in the bricks may even out the heat in this area somewhat. Glazed pieces should be at least one-quarter inch (0.64 cm) apart because colors may also vaporize from one pot to another, so keeping a one-quarter to one-half inch (1.28 cm) gap between all pieces is a wise choice. When you are loading, this can be quickly gauged as about a finger width apart. A smaller gap may be possible with high-shrinkage bodies.

Reduction Firing

Reduction firing, sometimes called reducing the kiln, means that part of the firing cycle is conducted with an inadequate amount of oxygen in the kiln to burn up all the fuel. As a result, the free hydrogen and carbon monoxide in the kiln atmosphere unite with, and thus reduce, the oxygen content of the metallic

oxides in both the body and the glaze. The reducing atmosphere in the kiln alters glaze color and even alters the surface in some cases. With a forced-draft burner system this process is accomplished by increasing the gas pressure to the burner while keeping the air constant or just slightly less, adjusting the damper for neutral pressure at the burners. For a natural-draft burner system gas pressure is increased and the flue damper is cut back slightly, so that less secondary air will be sucked into the kiln. Primary air may also have to be adjusted if that adjustment is possible on the burners.

Excessive reduction is almost always undesirable and can be seen by black soot or smoke coming from the kiln. Not only does the temperature drop rapidly while fuel is being wasted, but the body may erupt with blisters or even crack, and the glaze becomes a dirty gray. In any gas kiln a slight back pressure will cause flame at all the spy holes in normal reduction. The flue at the damper should be evenly filled with flame, but no smoke or soot should be generated. This is all that is necessary for a reduction, not the gas-wasting belching of flame and smoke that some people seem to enjoy—until the blistered pots are unloaded.

⚠ SAFETY CAUTION

Because of the increased atmospheric pressure within the kiln during reduction, you should pull out the peephole plugs cautiously, with your face turned well away from the kiln, for the flame may shoot out a foot (30.05 cm) or more. Keep hair and loose clothing well away from the hot kiln. Wear heat-proof gloves, and kiln glasses or goggles to protect your eyes from the intense infrared light.

Be careful also when pulling out peephole plugs from a tall bricked-up door. Some type of rod or bar holding the door against the kiln near the top is helpful, since the door bricks may lean outward and become unstable due to the expansion of the brick on the inside hot face.

The atmosphere should be an oxidizing one during the first part of the firing cycle, in order to ensure the most efficient heat rise and to remove (by oxidizing them) any remaining contaminants from the clay. Removing a contaminant like the sulfur, which in some clays requires a slight reduction followed by a brief oxidizing period, can be done around cone 010 or 09 (approximately 1750°F or 955°C), to cone 08 as long as reduction is not so heavy as to drive carbon into the clay. The kiln should be reduced for at least a half an hour to an hour, then reoxidized for a similar time period or longer before reduction is started for the glazes and clay color at about cone 06 (approximately 1830°F or 1000°C). The reduction needed to produce a rich body color is effective only at the temperatures below which the glaze begins to melt and seals the surface of the clay. For a cone 10 firing, most glazes begin to melt at around cone 07 or 06. The clay is still relatively porous at this point, too, and this aids the reduction of iron colorants in the clay body and the resulting rich brown clay colors typical of stoneware reduction firing.

Many of the classic glazes for reduction firings need to be melted under reducing conditions to develop their expected color and surface. Some glazes may need a bit earlier start for the reduction portion of the firing. Copper-red

and shino glazes fall in that category and may produce better results if reduction is started as early as cone 08 or 010. Shino glazes will sometimes produce **carbon trapping** (the actual retention of particles of carbon within the glassy melt of the glaze) if reduction is started as early as cone 010, giving the glaze a beautiful smoky gray to black color where thick. A neutral fire is acceptable from about cone 5 or 6 upward if needed to adjust the kiln to achieve even temperatures throughout or maintain an adequate rate of temperature climb. When the maximum temperature has nearly been reached (a half cone or so before the end is usually fine), the damper can be adjusted to provide a neutral or just slightly oxidizing fire. The usual practice is to cut back the burners slightly after the cones begin to bend to allow a half hour or so of an oxidizing **soaking** during which temperatures can stabilize and glazes become smoother as the temperature climb in the kiln is slowed. This period of oxidation will improve many glaze colors as well, and is especially beneficial to iron-red glazes.

Glazes which must be fired in a reduction firing in order to develop their proper color are called **reduction glazes.** Two of these are glazes especially compounded to produce copper-red and celadon colors (see Chapter 9). Thus, the blue-green of copper oxide becomes a rich red, and the brown-red of iron oxide is transformed into a gray-green or even a pale shade of blue. Too heavy reduction or accidental oxidation while the glaze melts may spoil these sensitive colors. Copper-red color variations range from a mottled blue, green, and red to a deep purple-red or a pale pink, depending upon the reduction sequence, the glaze thickness, clay body color, and speed of cooling. In both copper-red and celadon glazes the color is most intense over the whiteness of a porcelain body, especially the more transparent reds and the more delicate blue-green celadons. However, the celadon body may have 1 or 2 percent iron. This slightly gray body sometimes improves the darker green celadon colors.

A **localized reduction** can be obtained by adding 0.5 percent of silicon carbide (Carborundum, 40-mesh or finer) to a suitable copper-alkaline glaze. The result is usually a speckled red-and-purple color. Its only real advantage is its adaptability to the electric kiln, as the result will not likely be at all similar to a true reduction firing. The atmosphere in an electric kiln can be reduced by adding a combustible material into the kiln. In the past this has been accomplished by popping a few charcoal briquets or splints of wood through the peephole or other opening. The kiln should have heavy elements, which have a good oxidized coating from several previous firings. Continuous reduction firings may shorten the life of the elements and corrode and eventually destroy the electrical connections, but an occasional one will do little harm to the kiln. Safe ventilation of the kiln is a must.

⚠ SAFETY CAUTION

Any type of reduction firing will generate carbon monoxide and possibly other toxic gases. Adequate ventilation is a must. Introducing materials other than the gas used to fire the kiln may produce unknown hazards, especially if partially burned gaseous by-products of the material escape from the kiln. Materials such as mothballs, exotic woods, treated lumber, plastics, and so forth should be avoided.

Raku Firing

In the last thirty or more years raku ware has developed in an entirely different direction from its Japanese origin (see Chapter 3). While it still requires a low-temperature (usually below cone 04) rapid-fire process, the infusion of contemporary images and the availability of lightweight insulating materials for kilns have directed the attention of potters away from the Japanese tea ware tradition. As a demonstration technique, raku firing can be very useful because it compresses the amount of time needed to take a pot through the entire ceramic process. It is a wonderfully expressive medium which offers a variety of glaze and surface techniques. Raku is not, however, well suited for functional pottery meant for food or liquids of any kind as the clay remains porous and the glazes are heavily crazed.

At first it would seem that most of the raku firing results are accidental, but in time the experienced potter can learn to control many of the effects which seem so unpredictable, and still be rewarded with some unexpected results. The potter should look for variations in the clay body formula that might affect the fired density and crackle patterns. The range of glaze, terra sigillata, and engobe possibilities are immense and affect the ability of the ware to form reduction lusters and accept carbon from the intense smoking into the porous clay. The cooling cycle and related reduction and smoking affect body color, luster and crackle formation. Many of the copper luster colors, especially the currently popular matte lusters will not last, however, as the bright iridescent colors soon reoxidize to a much duller color. Sealing the surface of these copper matte lusters may somewhat prolong their life, but eventually they'll be less colorful.

The raku body is usually formulated as a white or light-colored body, which remains porous after both bisque and glaze firing. A largely fireclay clay body with from 10 percent to 30 percent grog is a good place to begin. Additions of more plastic clays or shock-resistant materials such as kyanite and wollastonite may be tried to facilitate larger pots. Even low-temperature talc bodies have been used successfully for intricate forms. Bisque firing to only about cone 010 to 08 may also make it possible to raku fire larger forms without cracking, as the more porous ware from the low bisque better resists the intense heat shock of the rapid firing.

Raku pots *must* be bisque fired and should be glazed a day in advance of firing to allow all glaze water to evaporate. Prior to placing them into the hot kiln the pots **should** be preheated to as high as about 400°F (200°C) if possible to drive any remaining water from the ware. This is often done by placing the next pots to be fired quite near the hot raku kiln. Clearly care must be taken both in loading preheated pots, and in placing pots into a very hot kiln. Gloves, face masks, tongs, and other protective gear are required.

The melting glaze can be observed through a small peephole in the kiln. As it nears the proper melt an area should be prepared for "working" the pot during the cooling cycle. While raku can be fired without cones simply by watching the glaze until it has melted to the proper degree, cones may be used to determine a very approximate end point for the firing. Typically, a cone is laid on its side extending over the side of a brick. When the cone melts and bends against the side of the brick the firing is done. This is a *very* inaccurate use of cones, but may aid in firing raku somewhat more consistently. Because the firing is so rapid, cones *cannot* be placed in a raw clay base for support, as it will explode.

⚠ **SAFETY CAUTION**

Safety is an important consideration when handling hot raku pots. Equipment such as tongs, nonasbestos heat-proof gloves, a face shield, cap, leather jacket and chaps, and leather shoes should all be used as protection from heat, flame, and smoke. Long hair should be tied back and loose clothing avoided. Shoes are a must to protect feet from hot pots or fragments that may be dropped.

Care should also be taken loading the kiln when it is still hot from a previous firing, as any dampness in a pot, or even excessive amounts of wax resist may cause it to crack, flame, or even explode.

Reduction in a raku firing generally takes place outside the kiln in a separate metal container using combustibles such as sawdust, shredded paper, excelsior, or dry leaves (Fig. 11-22). The quick cooling and random smoking of the pot produces color patterns in the open clay, crackle in the glaze, and lusters from certain metallic oxides (copper being the most common).

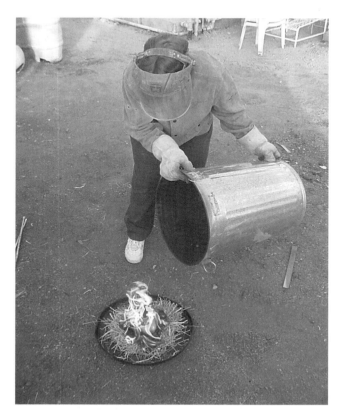

11-22 A typical post-firing reduction for raku. The pots are taken red hot from the kiln and placed in a barrel with paper, straw, or other combustible materials.

The raku kiln need not be a complex piece of equipment. A mortarless construction of 2300 °F insulation firebrick with a corbeled arch and portable door will work well. In building a corbeled arch the bricks are laid progressively into the archway until the arch is closed. The introduction of ceramic-fiber blanket has made simple, lightweight kilns possible, and many potters have used it for raku kilns. Unfortunately, refractory fiber is now considered extremely hazardous due to the fine particles which break off in handling after the kiln has been fired. Inhalation of these fibers is a serious potential health risk. Whichever approach to kiln construction is used, the interior should be designed slightly larger than the largest pot to be fired. Empty space does not heat up efficiently. The burner should be aimed in such a way as to use the space under the shelf as a firebox to avoid playing the flame directly on the pot.

Firing Lead Glazes

Lead glazes require extra care in formulation (see Chapter 9) and also precautions in firing. Federal and state regulations now generally prohibit the use of lead in glazes for use with food. Because of these factors, the use of lead as a glaze material can no longer be recommended. Lead melts at a relatively low temperature, so a portion of the lead volatilizes into the kiln atmosphere. Raw lead glazes release much more volatile lead than properly fritted glazes, but all give off some lead fumes. In cooling, this free lead settles back onto the glaze surface and the interior of the kiln. This unstable lead film easily breaks down under normal use, thus increasing the danger of lead poisoning. The problem is limited to electric kilns because in a fuel kiln all gaseous impurities are drawn off by the chimney draft. A small hole drilled in the lower and upper peephole plugs will allow the lead particles to be drawn off by the natural movement of the heated air. The important time for this to be done is during the end of the firing cycle. Commercially made kiln ventilation is a better option, as this will vent all lead fumes out of the kiln area during the entire firing.

Proper ventilation is a must, for otherwise the potter will inhale the lead-bearing air. A hood with an exhaust fan can be installed over the electric kiln. Commercially produced kiln vents are also available which provide a small but constant flow of air through the kiln and out an exhaust duct. As mentioned earlier, gas kilns must also be carefully vented. There are always cracks that open up in the firing and allow potentially hazardous gases to escape into the studio, especially during reduction cycles. Remember that merely venting toxic lead fumes to the outdoors may contaminate another area of the environment—another good reason not to use lead glazes.

Vapor Glazing

Vapor glazes, such as those on salt- and soda-fired wares, are unusual from several standpoints. Decorative pieces, or those glazed raw on the inside, can be fired in a single firing. Salt (sodium chloride) is not applied directly to the ware to form the glaze, but is inserted in the hot kiln when the maturity of the clay body has been reached. This procedure causes the salt to volatilize and combine with the silica and alumina in the clay body to form the glaze. The color of the glaze is clear unless there is color on the surface of the clay (Fig. 11-23). As the glaze is made directly from the clay surface, it preserves and highlights many of

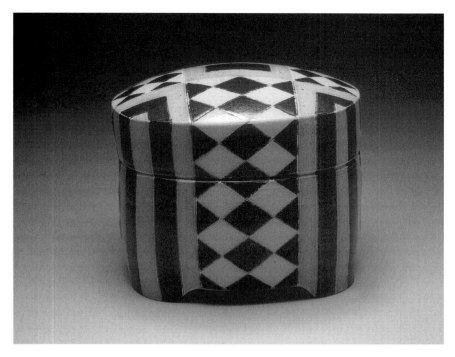

11-23 Donna Anderegg, USA; *Box,* salt-fired porcelain, $8 \times 7 \times 7$ in. $(20 \times 17 \times 17$ cm). Salt glaze has no color itself, but instead takes on any color that is present on the surface of the clay or in the clay itself. The salt- or soda-fired surface often looks like it is really a part of the clay without obscuring the surface. The crisp qualities of the decoration of this piece becomes integral with the form after salt glazing.

the surface details. Salt glaze is sometimes the closest thing possible to the wonderfully fresh look of wet clay.

Typically salt and soda firing is done in the cone 8–10 stoneware range, but salt glazing can be done as low as cone 04 if a proper clay body is used and borax is added to the salt as an additional flux. To obtain a good glaze in salt or soda firing the clay body must be quite dense and glassy, very nearly vitreous. Many ceramists now use sodium bicarbonate ($NaHCO_3$) or soda ash (Na_2CO_3) instead of salt (NaCl) to do **soda firing.** Soda firing eliminates the hazardous chlorine compounds (mostly hydrochloric acid) which are created during the salt-glazing process.

The clay body should have a high silica content and should be fairly dense and glassy when the salt is introduced to the kiln at nearly the peak firing temperature. If silica is added to the body, it should be finely ground, because coarse silica particles will not unite with the vaporous sodium to form a glaze, although silica sand may be useful as a filler. Including a small amount of potash feldspar in the clay body (5–15 percent typically in a stoneware body) will help to make it denser and more glassy, thus making it easier for the sodium to produce a glaze.

The interior of any kiln used for salt glazing must be lined with either a hard refractory firebrick or a dense castable (a type of refractory that can be poured or rammed into place), because insulating firebrick will soak up the sodium and deteriorate rapidly. Traditionally, salt kilns were made of hard firebrick. The salt

was permitted to build up in a coating on the brick surface. During the first firings in a new kiln a great deal of salt was needed. In effect, the kiln was being glazed along with the ware. Much less salt was needed in subsequent firings as the glaze coating slowly built up over the surface of the brick. A kiln used for soda or salt is generally considered unsuitable for normal glaze or bisque firings, as even without adding more there will be soda vaporizing from the kiln fireboxes and walls which will affect the ware. Potters sometimes use this effect intentionally, however as a **salt bisque** or **residual salt** glaze firing. And, in time, the interior surfaces deteriorate as the salt reacts with the silica contained in the refractory firebrick and literally eats into it.

Some potters try to prevent this corrosion by either coating the interior of the kiln with alumina compounds (similar to a high-alumina kiln wash) or using a high-alumina cement to cast the interior and the kiln roof. Commercially available calcium-aluminate cements and tabular-aluminate (a high alumina grog) will produce a refractory wall that can withstand temperatures higher than 3000°F (1650°C). The usual mixture for this refractory material is 15 parts cement, 85 parts tabular-aluminate, plus 10 percent water. Larger amounts of water will result in a weaker bond. Since the mixture sets up in an hour, all forms must be ready. It is possible to pour in sections if the joints are left rough or keyed together. The roof arch, however, must be completed at once.

Salting begins when the body has matured. Cones are not completely accurate in determining the body maturation temperature because the sodium vapor from the kiln walls will react on the cones. Coarse rock salt is the preferred material; about 5 ounces per cubic foot (141.75 g per 30.48 cm^3) of kiln space will be needed, less if the salt kiln is well coated. The salt is typically moistened slightly with water and divided into eight equal portions. Many potters use a long steel angle iron as a trough to introduce the salt into the kiln. The salt-filled end of the angle iron is inserted into the salting port and quickly inverted and withdrawn. The salt ports are typically open into the hottest part of the kiln, directly in front of the burners, so that the salt is vaporized rapidly. Or the portions of salt can be placed in small paper condiment cups (purchased from a restaurant supply house) or wrapped in newspaper packets. The salt packets can be inserted through the salting ports into the firebox area. In a Rhineland downdraft salt kiln the ports are located in the arch of the roof. It's best to design the kiln to allow for these special salting ports.

⚠ SAFETY CAUTION

The coarse, damp rock salt will explode and scatter through the kiln. Eye and face protection are a must when introducing salt into the kiln. At this point toxic vapors of hydrochloric acid are given off, so the entire kiln area must be well ventilated. Salt kilns constructed in outside sheds are highly advisable. These sheds should be constructed so that they can be opened during salting to dissipate the fumes. The hydrochloric acid and salt vapors are also highly corrosive to most metal, so metal kiln sheds will have a limited lifetime. Salt glazing is restricted or prohibited in many areas because of the pollutants emitted. Soda glazing may be an acceptable alternative.

Soda firing requires a slightly different approach from that of salt glazing when introducing sodium bicarbonate into the kiln. Sodium bicarbonate will simply form a sticky, glassy mass if dumped on the kiln floor as one would add salt. The bicarbonate form does not disperse as readily in the kiln as does the rock salt when inserted through the burner ports, so it is helpful to blow it into the kiln bit by bit. Many ceramists blow the dry sodium bicarbonate into the kiln through salting ports with a small, inexpensive portable sandblaster. Some ceramists have found that sodium bicarbonate or soda ash dissolved in warm water and sprayed into the kiln with a simple garden sprayer works well. It is best to spray the soda into the midst of the flames in the bag wall area of the kiln. Avoid blowing the soda directly on the ware as this will tend to cause severe glaze runs and kiln shelf deterioration.

The atmosphere during the introduction of soda can be neutral or slightly reducing. The draft must be cut back slightly (closing the damper somewhat) when the soda or salt is introduced in order to prevent the soda from being drawn out through the stack. As in the customary salting procedure, the soda is introduced into the kiln over an extended period of time, up to several hours.

A recommended soda or salting procedure requires one or two hours, with the eight portions of material introduced at ten- to fifteen-minute intervals. Because the draft is cut back, a slight reduction will occur. After about five minutes the draft can be adjusted to a neutral fire so that the heat loss during reduction can build up again. The potter may want to develop a slightly different salting procedure to account for variations in kiln design, materials, and clay body, but the two-hour sequence is recommended as a starting point. Too short a salting sequence will not allow for a proper buildup of the glaze. Heavy reduction is usually not advised, but once again the potter should experiment to find what works best in the range of possibilities for oxidation and reduction.

Along with the cones normally used to gauge the firing, several draw rings or small clay doughnuts should be placed in the areas of the kiln where cones would usually be placed. After about half the salt or soda has been introduced, one or more test clay rings should be hooked out of the kiln with a steel rod so that the potter can observe the glaze buildup. The glaze on the draw rings should be judged for amount and not for color, as the quick cooling of the draw rings does not allow them to develop the same color as will a normal slow cooling. Care should be taken in placing and removing the clay rings, or they may be knocked down into the kiln or onto the ware. When the draw rings show sufficient glaze buildup, soda/salting is stopped, and the kiln is usually allowed to run a few more minutes to clear out some of the residual soda vapors. Salt kilns will show evidence of vaporizing salt for quite a long time, while soda kilns will stop much more quickly.

A characteristic of the salt glaze is its pebbly appearance. Potters who prefer a smoother glaze surface sometimes add about 5 percent borax to the salt. Borax can also be added to sodium bicarbonate. Feldspar and other semi-fluxes can be used as slip decoration before firing to obtain sections of still glossier glaze. Slips containing less flux and more alumina will tend to favor drier surfaces, which can give both interesting crusty surfaces and delicate signs of flashing of the soda and flame. Thus the potter can develop a range of slips and textures beyond the classic glossy orange-peel glaze surface that is typical of salt. As in normal kiln firings, the body must be reduction-fired if desired for color

(vapor glazing works fine for oxidation-fire ware, too) before any appreciable glaze buildup occurs.

Since the salt glaze alone is colorless, any color in the glaze must come from the body or from coloring oxides applied in engobes on the raw ware. Soluble forms of oxides, such as nitrates or chlorides, can also be brushed onto the ware. Deep forms must be glazed inside, for little vaporous salt or soda will reach the interior to form a glaze. The kiln load must be uniform and not too tight if an even glaze coating is desired. Many potters prefer the uneven glaze **flashing** that occurs when pots are stacked close together, almost touching. This can be an especially nice effect on ware that has a thin kaolin wash on the surface of the clay. Incised or pressed designs will be accentuated by uneven amounts of glaze buildup, a factor that adds to the interest of the salt glaze.

Some potters fume their ware to produce an iridescent sheen on portions of the glaze. The general technique is to cool the salted kiln to a low dull red heat barely above 1000°F (538°C), just before the kiln goes dark. Fuming at too hot or cool a temperature may result in undesirable or nonexistent effects. Then, water-soluble colorants (such as chlorides or nitrates) are sprayed into the kiln in a thin mist. Often the sole chemical used is the chloride form of tin. This will form an extremely thin transparent layer of varied iridescent hues over the other colors in the clay and engobes. Dry chlorides (including tin chloride) that volatilize under the heat can also be used and introduced in a somewhat more localized fashion using a stainless steel spoon wired to an iron rod. Only very small amounts of these chemicals are needed to produce iridescence on the ware.

Safety Caution

Metallic chlorides and nitrates are usually soluble and may be absorbed through the skin. These materials are much more hazardous to handle than the insoluble oxide forms of the same colorants. Skin and eye protection are advised. Heating these chlorides to high temperatures will release toxic chlorine and hydrochloric acid vapors, accompanied by metallic fumes. Adequate safe ventilation is a must if fuming techniques are attempted.

Saggar Firing

While **saggars** once were used as pristine chambers which protected pottery from the ravages of wood and coal ash, they are now often used to contain organic matter and colorants in a semi-sealed chamber so that they can have a greater effect on pottery being fired in the saggar (Fig. 11-24). At its most basic, a saggar is simply a clay box with a lid which is used inside a kiln to hold pottery.

In **saggar firing** the pots are piled into a container within the kiln. The actual saggar (the container) can be made as simply as a loosely stacked firebrick box, sealed at the top with shards or pieces of broken kiln shelves. Actual saggars can also be constructed as sturdy slab-built vessels formed of heavily grogged clay, with a few small openings cut randomly in the sides to let in small amounts of air and flame. Some air movement into the box is often good during the firing to leave lighter-colored areas on the pots, so for most firings the saggar is not sealed too tightly.

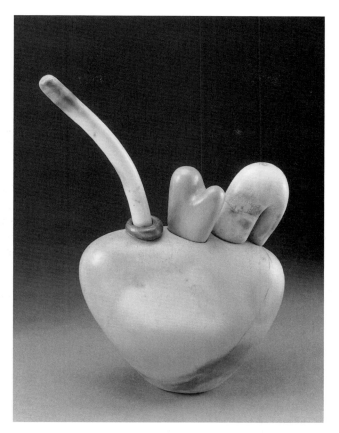

11-24 Susie Duncan, USA; *T-Pot Form;* earthenware with burnished terra sigillata; saggar fired, 12 × 13 × 6 in. (30 × 33 × 15 cm). Saggar firing is essential in producing the delicately mottled surfaces of Duncan's work. She often fires parts of these sculptural teapots separately, then assembles them with epoxy after firing.

matter and colorants in a semi-sealed chamber so that they can have a greater effect on pottery being fired in the saggar (Fig. 11-24). At its most basic, a saggar is simply a clay box with a lid which is used inside a kiln to hold pottery.

In **saggar firing** the pots are piled into a container within the kiln. The actual saggar (the container) can be made as simply as a loosely stacked firebrick box, sealed at the top with shards or pieces of broken kiln shelves. Actual saggars can also be constructed as sturdy slab-built vessels formed of heavily grogged clay, with a few small openings cut randomly in the sides to let in small amounts of air and flame. Some air movement into the box is often good during the firing to leave lighter-colored areas on the pots, so for most firings the saggar is not sealed too tightly.

The following suggestions are most commonly used with low temperature saggar firings in the cone 08–06 range. At this low temperature the unglazed ware can be stacked and piled with little or no danger of it sticking together. Saggar firing is possible at stoneware temperatures (cone 8–10), but as the ware may stick together or warp as the clay softens at such high temperatures, the ware is usually not piled up in the saggar. As the saggars are loaded they are usually layered with organic materials chosen to have an effect on the clay (Fig. 11-25). Materials such as sawdust, charcoal, pieces of wood, seaweed, banana and orange peels, and even such things as dry dog food are commonly used. Seaweed is popular because the small amount of salt that it contains will often give strong

11-25 Susie Duncan, USA. Saggar kiln being unloaded, 1993. Loaded saggared kiln showing how a brick and kiln-shelf box (the saggar) is built around the pieces. The organic materials placed around the work affect the color and surface of the clay. The ware in low-temperature saggar firing is often cushioned with vermiculite. This kiln has already been fired.

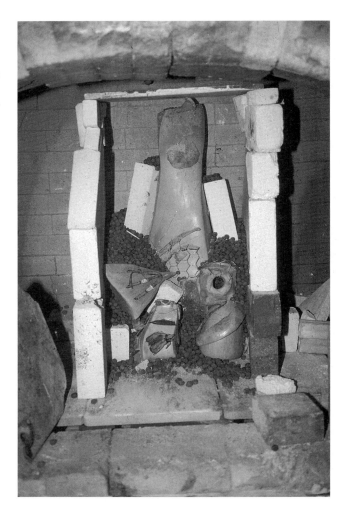

Terra sigillata surfaces work well for saggar firing. Glazes are generally not used at all on the pots as glazed areas would stick together and to all the debris piled upon the ware. Adding a teaspoon or two of copper carbonate per quart of liquid terra sigillata made from ball clay will also enhance the colors possible in saggar firing. Other colors of terra sigillata will also work.

NOTE: *If you are firing to temperatures higher than about cone 08–06, care should be taken to use copper wire and materials containing salt sparingly, as both are very strong fluxes at higher temperatures. Vermiculite will also melt at stoneware temperatures and cannot be used.*

Other Primitive Firing Techniques

The richly varied surfaces often left by flame and smoke in primitive firings have led to a resurgence of popularity in these simple techniques. The effects are often similar to low-temperature saggar firing. Known by a variety of terms like saw-dust firing, smoke firing, pit firing, bonfire firing, the one thing primitive firings

have in common is that little in the way of a kiln is needed to do this type of firing. The temperatures involved are rather low, in ceramic terms, and no glazes are used. Burnished or terra sigillata surfaces can be used to give a bright sheen to the clay surface if desired. The surfaces can also be waxed after firing to add to the sheen. As the ware is usually stacked and piled for firing, pottery forms which are sturdy and have no delicate protrusions usually survive the firing best.

While this type of firing was originally done with green, unfired pots, the chance of breakage is *much* decreased by bisquing the ware to a low temperature first. Primitive firing greenware requires both great care to increase the heat *very* slowly at first to warm and dry the pots, and also more porous clay bodies than commonly used in studio clay work. Warming the pots first overnight in an oven, increasing the temperature slowly to 250–350°F (approx. 150°–180°C), will greatly increase the chance of success if you want to try greenware in a primitive firing. Usually a cone 014 to 012 bisque will make the work strong enough to withstand the rigors of the firing and yet preserve the primitive qualities of the firing. Higher bisque firing may diminish any burnishing and lessen the natural effects of the firing.

The bonfire is the simplest, as only a clear area where an open wood fire can be built is needed. The work is stacked in a pile surrounded by firewood. Wood, straw or other combustibles may be placed among the pots. Take care not to place large combustible chunks under the ware so that it might cause the pile to shift and collapse during the firing, possibly breaking the ware. Placing shards of broken pots or old broken kiln shelves around the pottery before adding the rest of the wood will lessen the chance of breakage by firewood. The fire is lit and allowed to burn to completion and the pottery is removed when cool. Additional firewood or bundles of straw or other quickly burning material are often added carefully during the firing to attain slightly higher temperatures (Fig. 11-26).

Sawdust, pit, and smoke firing have more in common in that they usually utilize some type of container for the firing. Sawdust and smoke firings are often done in a metal drum or large can with an open top and a number of small air holes drilled around the sides to aid combustion. The work is stacked in layers in the can, covering each in a thick layer of sawdust. When all the pots are in the container, the top of the sawdust is ignited and allowed to burn until the entire top is glowing. A partial lid (often a sheet of thin metal) is placed over the top of the container to allow only enough air to allow combustion to continue slowly without open flame. Sawdust firings usually take 12–24 hours to complete. The pots can be safely removed when the fire has burned out. Pieces buried deeply in the ash are often a rich black, while those exposed to more air are more likely to be gray or the natural color of the clay surface.

Pit firing is much like sawdust firing, except that it is usually done in a small excavated hole in the ground. Sometimes a few bricks are used to build up slightly taller sides if needed. A small firemouth for additional stoking may be built on the upwind side of the pit if a hotter firing is needed. This approximates some of the earliest kiln designs known. A bed of wood, straw or sawdust is put into the pit first, often with a few bricks or potsherds upon which to pile the pottery and raise it slightly from the floor of the pit kiln. This is followed by the pottery surrounded with more combustible materials. The "kiln" is then topped with either broken shards of pots or a few old broken kiln shelves. The fire is lit, at the bottom if a firemouth is provided, or at one side if not. As the fire reaches its peak heat, more wood can be stoked at the firemouth to attain slightly higher temperatures.

11-26 Firing a Chicha jar in Jatun Molino, Ecuador. Simple open firing techniques are still used by potters in some parts of the world. While the firing temperatures are limited and fairly low, the results of the firing on burnished vessels such as this one are often beautiful. The jar is held above the groud by a framework of green wood sticks which will not burn in the rapid firing. A tiny fire is made below the pot for several hours to slowly warm and dry it, then a bonfire of quick-burning wood is built around the pot. The main part of the firing is completed in about 30 to 45 minutes.

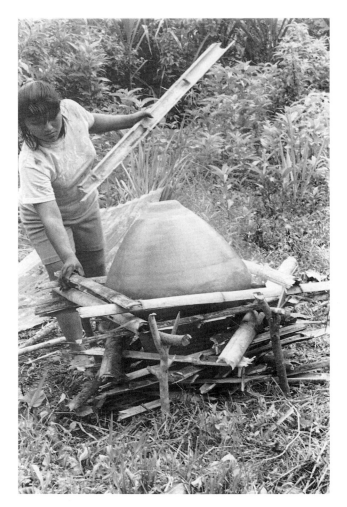

KILN MATERIALS

Thanks to the industrial market, most kiln materials are available in any large city, but prices may vary. Even in a small town a building-supply dealer can generally provide dense, high-heat-duty firebrick and other basic supplies.

Firebrick

Firebrick is made in a number of special compositions and shapes, but the common alumina-silica **superduty refractory firebrick** is satisfactory for many purposes (Fig. 11-27). These dense heavy bricks, sometimes called **hard firebricks** by potters, do not provide much insulation. A kiln constructed entirely of hard firebrick will consume a great deal of fuel, since the bricks absorb and conduct a considerable amount of heat. Fuel costs can be quite high for a hard firebrick kiln. Fortunately, porous **insulating** or **soft firebrick** is also made, which has an insulating value from three to five times as great as that of the

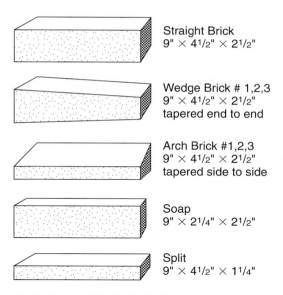

Straight Brick
9" × 4¹/2" × 2¹/2"

Wedge Brick # 1,2,3
9" × 4¹/2" × 2¹/2"
tapered end to end

Arch Brick #1,2,3
9" × 4¹/2" × 2¹/2"
tapered side to side

Soap
9" × 2¹/4" × 2¹/2"

Split
9" × 4¹/2" × 1¹/4"

11-27 **Standard U.S. firebrick** shapes and sizes.

hard brick. Insulating firebrick is available in a temperature range similar to that of hard brick, but the cost is somewhat higher. The higher initial cost of the insulating firebrick will soon be recovered through fuel savings. Different grades of insulating firebrick are produced for operating temperatures of 1600°, 2000°, 2300°, 2600°, and 2800°F (870°, 1093°, 1260°, 1427°, and 1538°C), and some can be used at temperatures as high as 3000° and 3200°F (1650° and 1760°C).

Insulating firebrick is often used as a backup layer in kilns which must be made from hard brick (soda, salt, and wood kilns typically), although kilns made entirely of insulating bricks are common. Insulating firebrick can also be cut easily with a coarse-tooth saw, such as an inexpensive pruning or bow saw, making kiln construction much easier than if hard firebrick were used.

The bricks used for higher operating temperatures are denser and lose much of their insulating ability. They are also more expensive. Therefore, a potter should not purchase a higher-grade brick than is needed. A 2600°F (1427°C) brick is generally used for the interior layer of brick in kilns firing from cone 8 to cone 10. Two-thousand-degree-Fahrenheit (1093°C) insulating brick can then be used for the outer course of a 9-inch-thick kiln wall. Special arch- and wedge-shaped bricks can be ordered for the curve of the kiln roof.

Ceramic-Fiber Insulation

Research in new, lightweight, high-temperature insulating materials for the space program resulted in the development of ceramic-fiber insulation. While initially these fiber materials seemed to show much promise for kilns, serious questions have now been raised about their safety, especially when used to line the interior of kilns where the fired fiber can break off and become airborne and inhaled (see the safety caution), but fiber may be appropriate for limited uses. Ceramic fiber refractories are, for the most part, extruded,

extremely thin fibers of alumina and silica and this is where their danger lies. They have a purer composition than the denser, heavier firebrick. Ceramic-fiber insulation comes in several forms: 0.75- and 1-inch (1.91- and 2.54-cm) rigid panels, 24 by 36 inches (60.96 by 91.44 cm) in area; 1-inch (2.54-cm) lightweight, ceramic-fiber blankets, in a roll 2 feet wide by 25 feet (0.61 by 7.62 m) long; loose granular materials; a lightweight, ceramic-fiber castable mixture; and even a form that comes in a caulking gun tube. These materials are compounded for operating temperatures between 2300° and 2600°F (1260°–1427°C). Ceramic-fiber cements are available for joining sections and filling cracks. Ceramic studs can be used to tie inner rigid panels to the outer kiln structure. When these products first appeared on the market, they had a number of flaws. Considerable shrinkage occurred in the rigid panels, and cracks appeared in the castable mixture when it was exposed to long firing cycles. However, improvements in both materials and construction techniques have been made in recent years.

The fiber insulation, although costlier than firebrick, is much lighter. Firing costs for ceramic-fiber kilns are generally less than even kilns made from insulating firebrick, thanks to the highly efficient insulating abilities of refractory fiber. Ceramic fiber insulation can also serve as a sandwich layer or a backup layer with conventional firebrick, and perhaps this is the safest use of it.

⚠ SAFETY CAUTION

Ceramic fiber does have one serious drawback, in that the tiny pieces of fiber that easily break off the blanket are extremely irritating both to the skin and respiratory tract. Handling the fiber safely during construction or repair requires one to follow the safety advice of the manufacturer carefully. After it has been fired several times ceramic-fiber refractory is even more brittle and prone to breaking off fibers, which greatly increases the hazard of inhaling these dangerous microscopic crystalline particles. Ceramic-fiber refractories are currently under review by the government for possible long-term health hazards. Check for the latest status and health warnings before working with these materials.

Castable Refractories

Castable refractories of varying compositions for several operating temperatures are also available. These can be mixed and poured like cement. Although more expensive than brick, castable refractories are useful for forming odd shapes, such as burner ports or small arches. They are dense and conduct heat much as hard brick does. A castable calcium-alumina refractory can serve as the liner for a dual-purpose salt kiln, so that salt will not accumulate on the firebrick interior. With this arrangement, a gas kiln can be used for the occasional light salt-glaze firing with only slight effects from residual sodium in the kiln. Over a long period the door bricks will have to be replaced several times, and the combustion area near the burner ports will require chipping out and recasting as a result of the salt action, but the rest of the kiln will remain largely unaltered.

Other Insulating Materials

Insulating materials of a lower heat tolerance but with great insulating value can also be used for a backup layer. Even common soft red brick will serve this purpose (Fig. 11-28). Kilns of more than 30 cubic feet (9.14 m^3) at one time were commonly built with a hard firebrick inner lining, a middle portion of insulating firebrick, and an outer layer of red brick. Contemporary kilns are more often built with a skin of shiny stainless steel over the exterior, which provides some additional insulation due to its reflectivity.

When the outer walls rise to a height of several courses, loose granular vermiculite poured to a depth of 6 to 8 inches (15.24 to 20.32 cm) will give further insulation to the roof crown. To further insulate a high curved brick roof, such as a catenary arch, vermiculite can be mixed with clay, Portland cement, or mortar and troweled on. Chicken wire embedded in the mixture will provide additional support, as expansions and cracks occur during firing.

Kiln Furniture

The shelves, posts, and other props used in the kiln comprise the kiln furniture. Heavy fireclay shelves have been replaced by newer materials. Mullite shelves are suitable for earthenware temperatures, but the more expensive silicon carbide shelves give longer service and are compounded for higher temperatures. A 0.75-inch (1.91-cm) thickness is adequate for standard loads. To avoid sagging and possible breakage in spans of 24 inches (60.96 cm) or more, a center post on the long edge is necessary. Rectangular shelves are less subject to strain in cooling and heating, so they give longer service than square ones.

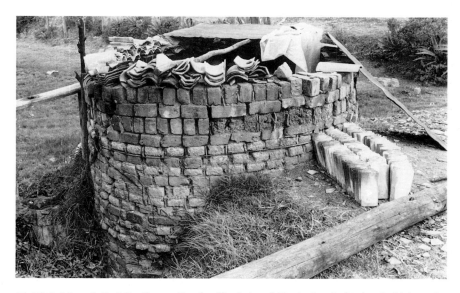

11-28 Brick and tile kiln, Cuenca, Ecuador. The design of this simple cylindrical updraft kiln made of locally fired low-temperature brick goes back thousands of years, yet it still works effectively for firing roof tile and brick at this village pottery near Cuenca, Ecuador. The firebox is slightly below ground level. The kiln is built into a small hill to facilitate loading from the top.

A slower heating and cooling cycle not only minimizes damage to the pots but will prolong the life of the kiln furniture, especially the shelves. Salt or soda glazing eat away at normal kiln shelves, although some silicon carbide formulations seem more resistant to the salt effects. Coating all surfaces with alumina hydrate mixed with a binder will help, but with the danger of alumina flaking onto the work below. More often the shelves in salt kilns are kiln washed only on the upper surface and scraped free of the pebbly glass buildup on the underside after each firing.

Posts made of fireclay are available in various sizes. They often have a center opening to promote a more even expansion. High-temperature insulating bricks can be cut to make satisfactory posts for a couple of shelves in a small kiln, but lack the strength to support a tall stacking of shelves and ware. Hard firebrick soaps (a half of a full-sized brick, split lengthwise) make good posts, and may be cut with a brick saw to a variety of lengths. Dipping the ends of the fireclay or hard brick posts into thin kiln wash made of kaolin and alumina hydrate will lessen their tendency to stick to silicon carbide shelves at stoneware temperatures. This problem does not arise in bisque firings or low temperature glaze firings.

Triangular porcelain stilts having pointed contact areas, and sometimes a Nichrome wire insert, can be used for some lids or for small pieces that must be glazed overall. The small contact blemishes are not very noticeable and can be ground off after firing if needed. This type of stilt is generally most effective at temperatures below cone 6–8. Higher temperatures will greatly shorten the life of many stilts or even cause collapse.

KILN CONSTRUCTION AND MAINTENANCE

Twenty-five years ago few potters were building their own kilns, but with the burgeoning interest in ceramics and with increased knowledge this practice is now quite common. While there is not space here to cover all the details of kiln building, the potter should be familiar with how kilns are constructed. The construction of simple small kilns, such as descriptions of those that follow, are well within the grasp of most potters. In addition, the proper care and maintenance of kilns will extend their life greatly.

Large fuel-fired kilns are more often constructed on site, but there are a number of smaller commercially made gas kilns available. While larger ready-made heavy-duty gas kilns are available, they are expensive and costly to ship. Not counting the value of labor, the potter may often save 50 percent over the cost of a prefabricated model by building kilns, especially larger kilns. Such kilns can be difficult to install into many locations because of their size and weight, which makes on-site construction more desirable. One should, however, factor labor and ultimate reliability into the cost of building a kiln and take this into consideration when choosing whether to buy or build.

The beginner, who has little experience in the principles of kiln design, would be advised to duplicate a proven design, rather than to experiment. Permits and zoning variances may be necessary for the urban potter. Gas connections and burners should be designed and plumbed by a competent technician, as the hazards of gas explosions are well known. Kiln kits are available which can make

construction by the novice kiln builder much easier. The novice might want to build a small raku kiln or two first before attempting to construct a larger gas-fired model.

Electric Kilns

Most ceramists choose to purchase electric kilns from one of the many commercially produced models available, but it is possible for potters to build such kilns. The electric kiln, which needs no chimney or gas lines, eliminates these challenges to the novice. However, unless the student potter is technically inclined, he or she will best forego the problems of calculating length of element wire, size, resistance, and ohms necessary to obtain the desired heat in the kiln chamber and other steps necessary to build an electric kiln. Many excellent models are available, and can often be purchased used.

Elements and switches may need to be replaced from time to time (Fig. 11-29). Both of these may be purchased from almost any kiln manufacturer and from many ceramic suppliers. Replacement elements come already coiled, like a screen-door spring. They must be stretched to fit the kiln. It is important to do this very evenly over the length of the element. This is best done by pulling on the elements from both ends. Great care must be taken not to kink or unnecessarily bend the elements, as areas thus weakened will fail sooner. The length of the element slot may be measured using a piece of string, then the element stretched to that length. Most elements go twice around the kiln and through a diagonal slot to complete the circle. The element should be stretched just slightly longer than necessary to just fit into the slot, as elements contract after several firings. By placing the element into the kiln under slight compression it is less likely to come out of its groove. The Kanthol A-1 brand elements become brittle after use, but their tendency to contract is diminished if they are first fired to cone 8, even though subsequent firings are lower. Kanthol elements which come out of their groove will break if stretched or bent when cold. Old sagging elements may be heated to red heat with a gas torch in problem areas and safely stretched or compressed as necessary to fit back into the element groove. The

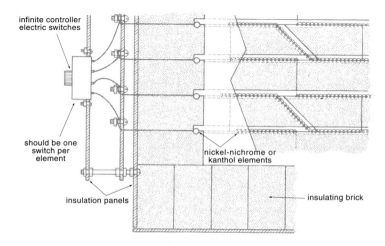

11-29 Detail of electric kiln showing brick, element, and wiring placement.

coils must not touch at any point, or a hot spot will develop, eventually causing the element to fail.

Unless the potter has some electrical experience, it is advisable to hire an electrician to hook up the wiring for the electric kiln. Larger electric kilns may require wiring heavier than that commonly available in many homes. An electrician or kiln repairman should also be called for switch and element replacement unless the ceramist is knowledgeable in these repairs. Buying an electric kiln that is wired for the electrical voltage in your area is critical. In the United States most electric kilns are wired for either 208 volts or 240 volts, and can be specially ordered for three-phase power.

Gas-Fired Raku Kilns

Thanks to the uniformity in size of insulating firebrick, a small gas kiln can be built with no kiln cement between the bricks. This is particularly true of raku kilns, which are small and temporary in nature. A single burner can be placed in a simple brick box, with the pots set on a few bricks. A flat roof with a small hole for exhaust is sufficient. Either a bolted-together top or a similar side door can be used, since the ware is inserted and removed from the hot kiln with tongs. On a small kiln like this the top of the kiln may even be closed with a **corbeled** arch (Fig. 11-30).

A portable raku kiln can be constructed by cutting a 55-gallon (208.2-liter) steel drum about 3 inches (7.62 cm) from the top to make a cover. The remaining drum is too deep to load conveniently, so an additional 10 inches (25.4 cm) can be cut off and discarded. A 4-inch (10.16-cm) hole is cut in the cover section to serve as an exhaust; a 3-inch (7.62-cm) hole is cut into the base section about 4 inches (10.16 cm) from the bottom to serve as the burner inlet.

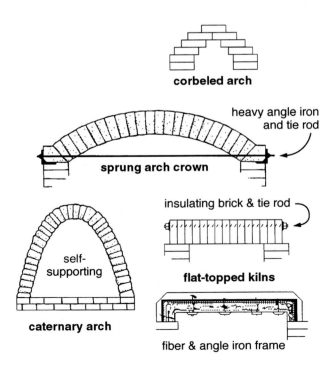

11-30 A variety of possibilities for kiln arches.

The inside of such a steel drum could be lined with insulating fire brick or even a lightweight castable. Iron rods shaped and welded to the cover and base for handles facilitate loading and make the kiln portable. A much lighter weight but somewhat more delicate kiln can be made by substituting a welded angle iron framework for the barrel. About two dozen insulating firebricks can be arranged for a base. A few firebrick posts and a small kiln shelf form the combustion chamber and loading floor. The raku kiln sits on the base covering the shelf and posts. Since the heat can be raised quickly, a small burner and blower unit works well, although a regular atmospheric burner can also be used.

Other Gas Kilns

For a small gas kiln a single 4.5-inch (11.43-cm) wall of insulating firebrick may be adequate, as in the single-bag-wall design illustrated in Figure 11-11. A 4- or 5-cubic-foot (1.21- or 1.52-m³) kiln can be fired easily with two atmospheric burners. A kiln that is square in all dimensions is most likely to have a uniform heat. Deep kilns are hard to load, and a tall chamber will often cause a noticeable temperature variation from top to bottom. Insulating firebricks are not hard to cut, but it is easier to plan a design based on the uncut shape of the brick.

In planning a kiln, the desired size should be established first. It should be as close to a cube form as possible and based on the dimensions of available kiln shelves. A calculation should then be made to determine the burner capacity needed. Manufacturers supply information on the BTU (British thermal units) of their various burners. Unless the kiln is quite small, several burners are preferable to one large unit, in order to avoid a concentration of heat near the burner. Generally about 6000 to 7000 BTU are required in a stoneware kiln for each cubic foot (0.31 m³) of capacity, including the combustion area. For the average atmospheric or aspirating burner, a 3-inch-square (7.62-cm) opening is sufficient. The chimney size should be at least equal to the area of all burner ports, even slightly larger if possible, especially if there are angles in the flue connection or if the chimney has an unusually horizontal run (both of which circumstances result in friction loss in the draft).

The opening through which the depressed flue in the floor sends exhaust into the chimney should be smaller than the chimney itself to prevent a too-rapid heat loss. It should be constructed in such a way, however, as to allow easy enlargement, if necessary. Unless the kiln is unusually large, a bag wall constructed of firebrick laid on edge is sufficient. After the first course of brick, the bag wall can usually be laid up without mortar to allow adjustments later. The function of the bag wall is to force the flames and heat upward in the kiln. Its height will depend upon the kiln size, the chimney draft, and other factors. Additional bricks can be laid without cement if more heat is needed in the upper kiln area. Openings may be desirable in the upper bag wall. About 4 or 5 inches (10.16 or 12.7 cm) of combustion area between the kiln and the bag wall is sufficient in the average gas kiln. A slightly larger area is needed if oil is used for fuel.

Refractory mortar cements, in either dry or wet form, are available for bonding the bricks. A cheaper and essentially similar material can be mixed from 2 parts fireclay and 1 part fine grog. An even stronger bond can be made by adding 1 gallon (3.79 liters) of sodium silicate to 100 pounds (45.36 kg) of the dry weight of clay and grog. Unless the bricks are first moistened, they will soak

up too much moisture from the mortar resulting in too thick a coating, so it is best to first immerse them in water and then allow them to drain. Only the thinnest layer of mortar is needed, since the bricks are very uniform and do not require a thick layer of cement for leveling purposes. The best method is to dip the brick edges to be joined into a soupy mix of mortar and tap them into place immediately with a hammer and a wood block. Because of their porosity, insulating bricks expand very little in heating and can be placed very close together. The dense firebricks, however, expand considerably under heat; therefore, about 0.25 inches (0.64 cm) of space with no mortar should be left in every third or fourth space between bricks, for otherwise the outside layer of cooler brick will be forced open in firing.

It is especially advisable to plan on a unit brick size when using hard bricks, as cutting is time- and labor-intensive. Hard bricks can be cut by hand by tapping a groove on each side with a mason's hammer, then hitting a solid blow to the groove with a mason's chisel struck by a heavy hammer. The lucky potter will have a power saw with a brick-cutting diamond blade. The wedge-shaped bricks needed for the kiln arch can be cut in half, but shaping of the actual wedge shape from a hard firebrick is nearly impossible by hand. These bricks are best purchased in the shapes needed. The usual arch rises at the rate of 1.5 inches per foot (3.81 cm per 30.48 cm). Placing the bricks on edge for a 4.5-inch (11.43-cm) thickness provides sufficient strength for the average-size kiln. The #1 arch brick tapers from 2.5 to 2.13 inches (6.35 to 5.41 cm). By drawing two curves 4.5 inches (11.43 cm) apart on a large board and using a 1.5-inch rise per foot (3.81 cm per 30.48 cm) over the desired span, the potter can calculate the required number of #1 arch bricks. Some straight bricks will be needed, but they should be kept to a minimum and placed toward the sides of the kiln if at all possible to lessen the tendency for them to slide out during firing. Keep the mortar only as thick as needed to bond the brick. Thick mortar joints may later rain crumbs of mortar on the ware in the kiln during the firing.

Calculating the arch presents no problem in an insulating firebrick kiln, since the softer bricks can be trimmed to a wooden pattern using a coarse rasp or even cut using an old or disposable handsaw in a jig. A sharply angled skewback brick is needed where the arch meets the side wall. Special skew shapes are available in hard firebrick, but can be cut to custom angles easily for insulating firebrick arches The kiln will require a 2.5-inch (6.35-cm) angle-iron support at each corner, with 0.5-inch (1.27-cm) take-up rods at top and bottom. While these give a slight rigidity to the kiln, their main purpose is to hold the heavy angle-iron brace, which is needed on the outer wall to take up the thrust along the length of the kiln arch. A very heavy spring (such as a valve lifter spring from an automobile engine) is sometimes used under the nut, since some expansion takes place while firing.

A supporting form to hold the arch can be made easily by cutting several boards to the arch curve and covering them with a thin plywood or Masonite sheet. It is wise to leave a bit of slack at the sides and to place wedges under the uprights so that the form can be lowered and removed easily after the steel angles and rods are in place and holding the weight of the arch. The catenary-arch kiln is self-supporting and needs no metal bracing for the arch, but angle irons across the front and rear secured with a tie rod are still desirable. Metal bracing on a catenary arch kiln will also help to keep the front and back walls tight against the arch. The catenary curve can be established by suspending a lightweight chain from two nails on a horizontal line which are separated by the

desired floor width of the interior of the kiln. The result will be a somewhat pointed curve. The structure will be most stable if the height approximates the width of the base. This design is perhaps ideal for an oil-burning kiln, since the flare at the base provides the extra combustion area needed for oil fuel. Soda and salt, and even wood kilns are often built with catenary arches, as these kilns also profit from the large, open firebox.

The weight of a kiln is considerable, and it requires at least a 4-inch (10.16-cm) or thicker reinforced concrete base. In order to avoid leaning over and bumping the head in loading, it is a good idea to build the kiln on a reinforced concrete slab elevated to the necessary height with concrete blocks. Such a kiln can be moved later, if necessary, with little or no damage if it is not too large, and is well braced. The brick structure should always be arranged so that the joints are staggered and there is an occasional tie brick to bind two courses together. The corner bricks should be laid first, after it is certain that the plan is perfectly square. A level and a guide line are essential tools, since the eye is not dependable. Common red bricks can be used as backup for that part of the floor area not depressed for the exhaust channel. The kind of brick to be used and the wall thickness are determined by the size and general use of the kiln. For the salt kiln or oil-fueled kiln an inner course of 4.5-inch (11.43-cm) hard firebrick is necessary, backed up by 2000°F (1090°C) insulating firebrick. If the size reaches 30 cubic feet (9.14 m^3), an extra outer layer of red brick is often desirable, but somewhat expensive, especially in locations subject to abuse or weather. Sheet steel (preferably stainless) is another option for weatherproofing the exterior surface of the kiln. Kilns that are covered by only a simple roof are often used in summer schools and camps. These should be covered with plastic during the winter to keep out moisture that can freeze and cause severe damage.

A properly constructed kiln will give many years of service and require few repairs. A smaller stoneware kiln with a 15- to 25-cubic-foot (4.57- to 7.62-m^3) capacity can be built with 2600°F (1427°C) insulating brick on edge and 2000°F (1090°C) brick on the flat, thus creating a 7-inch (17.78-cm) wall. If one can afford the cost, it is more stable and fuel efficient in the long run to build such kilns with both layers of brick laid flat in the normal fashion with a 9-inch (22.9-cm) wall. Although the initial cost is high, insulating brick construction is easier to do and the fuel cost lower. However, insulating bricks retain little heat and the kiln may cool more rapidly if there is the usual air flow through the kiln after the firing is completed. Sealing the kiln more tightly at the end of the firing may lessen this effect. The kiln door jambs should be built of the same brick as the inner liner, whatever the type used.

It should be obvious from all these examples that there is no one way to build a kiln. The illustrations show a variety of burner placements. Most potters find the downdraft layout (Fig.11-31) to be the most satisfactory for the 15- to 30-cubic-foot (4.57- to 9.14-m^3) size. Updraft kilns are not recommended for construction by the potter, because the downdraft design usually fires more uniformly and reduces more efficiently.

Oil Kilns

In locations where natural gas is not available and propane or butane (L.P.G., liquid petroleum gas) are difficult to obtain, the potter should consider the use of #2 fuel oil. Oil is slightly cheaper than gas, and it produces a hotter flame. However, there are several disadvantages. Except with the most sophisticated and

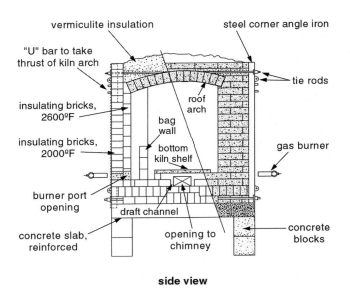

side view

11-31 A few construction details for a typical gas kiln.

expensive burner types, fuel oil tends to be very smoky in the early stages of firing. This will be objectionable to neighbors, unless the potter lives in an isolated location. Some potters have solved this problem by preheating the kiln with portable gas burners before starting the oil fire. During the early stages of firing an oil burner, there is a greater chance of soot building up and causing a malfunction, so the firing must be carefully supervised.

Since fuel oil contains many impurities not found in natural or propane gas, the inner lining of the kiln must be made of hard refractory brick or a castable. The usual soft insulating firebrick will deteriorate under these conditions. There is also a greater volume expansion of volatilized oil gases, and this mandates a slightly larger combustion chamber such as found in the catenary-arch kiln illustrated in Figure 11-33. Otherwise, the basic design of the oil-burning kiln is little different from the gas kiln illustrated in Figure 11-31. Oil-burning units, especially those with forced air, are often placed in the front of the kiln, where the flame can run down the length of the combustion area without immediately impinging against the bag wall.

Wood Kilns

Many potters are especially attracted to the accidental glaze effects afforded by wood-fired kilns. These effects result from ashes settling on the pots in a random fashion (Fig. 11-32). The increasing cost of electricity, gas, and oil fuels has added to the interest in the wood-burning kiln as an alternative source of fuel. Delicate glazes can also be fired without the ash effects in wood-burning kilns if the pots are placed in saggers or placed in protected areas of the kiln where less ash lands.

There are, however, several drawbacks to the wood kiln. For one thing, the actual process of stoking the kiln is a long and demanding affair. There is no such thing as taking a dinner break or trimming pots while the kiln automatically goes up to temperature. The usual firing cycle of the wood kiln takes about

11-32 Peter Voulkos, USA; untitled plate, 1994, wood-fired stoneware, 22 in. (55 cm). Voulkos' rugged wood-fired plates draw heavily from the process and material qualities of the clay and firing. The chance aspect of the wood-fired glaze is perfect to complete the expressively handled clay.

16–24 hours and often much longer (up to a week or more) for large kilns. It begins with a tiny fire made with a small amount of split wood in the ash pit. The fire is deliberately kept at a low heat for several hours as moisture leaves the ware and the kiln gradually warms up. Then wood is placed on the grate, and the actual firing begins. Relatively large pieces of wood are needed in this beginning stage because they burn slowly.

Although hard woods—oak, maple, birch, or ash—have potentially more heat value, soft woods such as pine, fir, and hemlock burn faster and may result in a faster heat rise. The resin in soft woods volatilizes and produces a long flame that extends throughout the kiln. The drawback to pine and similar resinous wood is that they are much harder to burn without creating large volumes of smoke—a definite drawback in environmentally sensitive areas. Carefully stoked hardwood, burned as small pieces in a well-designed kiln, can result in very little smoke being emitted. The type of wood used also affects the type of glaze formed when the ash lands on the ware. Some woods such as pine usually give a more fluid glaze, while the ash of other woods may give only a dry, rough glaze. Some hardwoods may require a higher temperature firing than pine to create a fluid glaze.

It is essential that the wood be perfectly dry—cut, split, and placed under cover for a period of about two years if cut green. Damp wood will expend a

large proportion of its heat value in the process of drying out, making it impossible to reach the required temperature in the kiln.

The firing progresses from a stoking of relatively large split pieces every hour or so, to a rate of several 1- or 2-inch-by-2-foot (2.54- or 5.08-by-60.97-cm) sticks every five minutes. These thin pieces explode in the heat of the firebox and send a long flame through the kiln and up the chimney. The stoke and ash pit holes usually remain closed so that excessive drafts will not cool the chamber, but this varies with the kiln design. Air vents in the ash pit and the grate area must be regulated carefully as the firing progresses. Raking the ashes occasionally may cause more of them to be deposited on the ware. The ashes should not be removed as this may cause a heat loss from opening the ash pit door, except when it is absolutely necessary to rake them away from the grate. If the ash is allowed to build up on the bottom side of a metal grate, the grate will overheat and fail much more quickly.

Timing the stoking is critical to maintain a rise in temperature. Usually wood is added only when the previous load has nearly burned down to a bed of coals on the grate. The grate must not be overloaded, for if there is not enough oxygen to keep the wood burning brightly, there will be a drop in temperature. Normally, there is a slight reduction after stoking, which changes to an oxidation firing as the fuel is consumed.

A somewhat remote location is also desirable for wood firing. The li___r colored smoke given off early in the firing is largely water vapor. T___ smoke after a heavy stoking is carbon, and should generally be a___ a sign of wasted heat. The smoke may disturb neighbors, as ma____es t__ shoot out of the chimney when higher temperatures are ____ st__les__ steel screen may be required on the chimney to contain ____wood s____s, but should not overly restrict the draft. An open, w____ed kiln___ a safe distance from buildings or trees would be a wise____ __ny __ __nay have restrictions on solid fuel kilns like wood kilns, bec____ __sm___e a___ spark hazards.

The average wood kiln of 30 to 60 cubic feet (9.14 to ____ ___ from 1 to 2 cords of wood for each firing (a cord is a stack of ____ __ y 4 by 8 feet, or 1.22 by 1.22 by 2.44 m), so a good source of fuel __ __ntial. Woodworking factories often have a quantity of kiln-dried wood scraps available. Slabs from a sawmill (bark-covered first cuts from a log) are another good prospect. The considerable labor of cutting timber with a chain saw, then hauling and splitting it into small sizes, followed by the long firing, may not be justified unless one desires the effects of the wood kiln on the ware. To eliminate part of the arduous firing schedule, some potters fire their kilns overnight to a low red heat on portable gas burners and then complete the firing with wood during daylight hours. The use of gas burners for the initial heating also makes it easier to fire greenware safely.

The catenary-arch design is especially well suited to the wood kiln because the expanded base can contain a large portion of the firebox (Fig. 11-33). For the typical well-insulated stoneware kiln about 1 square foot (0.30 m^2) of grate space is needed for each 6 square feet (1.82 m^2) of floor area. A firing chamber on each side of the kiln generally provides a more even heat, but many successful designs have also utilized a single firebox opposite the chimney. The single firebox design saves space, because only one bag wall is needed and a single grate need not be as wide as the combined width of two grates. If wood ash effects

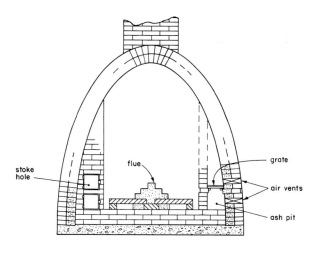
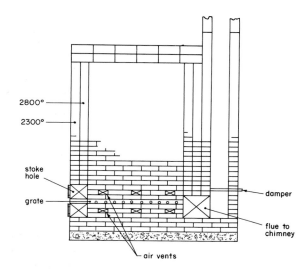

11-33 Front and side veiws of a catenary-arch wood-burning kiln.

are desired, a cross-draft design with one firebox opposite the flue is good in that it forces all the ash to move through the ware.

The floor and firebox area must be of hard refractory firebrick, while the inner kiln lining is usually of 2800°F (1538°C) firebrick backed up by 2300°F (1260°C) insulating firebrick. Wood ash does not do great damage to insulating brick, and the upper kiln area can be made of insulating firebrick for heat efficiency. Hard refractory firebrick should be used for the entire kiln interior if salt or soda will be used in conjunction with wood.

Various materials have been used for the fire grates, ranging from old cast-iron sash weights to scrap-iron rods. The most durable—although expensive—choice would be 1-inch (2.54-cm) stainless steel rods of one of the more heat-resistant alloys. These can be placed at 1.5- to 2-inch (3.81- to 5.08-cm) intervals. A greater width between rods is possible if a second grate is used below to catch the smaller embers. The bricks should be laid to form an indentation of 0.5 inches (1.27 cm) at the grate level, to provide a supporting ledge. The grate rods should be cut 0.25 inches (0.64 cm) shorter to allow for heat expansion. Two 0.5-inch (1.28-cm) rods welded to the heavier grates will prevent shifting or the rods can be wadded in place with a bit of fireclay and grog. The ash pit should be 8 or 9 inches (20.32 or 22.86 cm) deep to allow some buildup during the firing. Three air intakes each 2.5 by 4.5 inches (6.35 by 11.43 cm) in the ash pit area and three more intakes immediately above the grate or the equivalent are recommended. Doors for the ash pit and stoke holes should be made of sheet steel on heavy hinges or swung from a chain, because the chore of removing firebricks is too time consuming when stoking rapidly.

For convenience in loading, the reinforced slab foundation can be raised and cast on a foundation of concrete blocks. The outer 9 inches (22.86 cm) of slab floor should incline inward at a pitch of 1 inch to 10 inches (2.54 to 25.4 cm) for a catenary-arch kiln. Otherwise, a #1 arch brick must be used for the base brick in order to obtain the proper angle between the foundation and the rising side wall of the catenary arch. Afterward, the usual 2800°F (1538°C) hard firebrick

straights can be used for the inner wall until the approach to the crown of the arch, where several rows of #1 arch brick will be needed. The exact number and shape of brick needed can be determined using the brick shapes and a full-sized drawing of the arch. A thin mortar of one-half fireclay and one-half fine grog can be used to fill gaps if needed. A 0.25-inch (0.64-cm) space with no mortar should be left between bricks at three- or four-brick intervals to allow for heat expansion. Because the brick courses must be staggered, a number of half bricks will also be necessary.

The large volume of hot gases in a wood kiln means that the opening from the chamber to the chimney must be about twice that for the usual gas kiln, and the chimney itself must be larger—about 12 by 12 inches (30.48 by 30.48 cm) for a 30- to 40-cubic-foot (9.14- to 12.19-m^3) kiln. A rule of thumb is to have 1 foot (0.30 m) of height for each inch (2.54 cm) in diameter, and more if there is any horizontal run from the kiln to the chimney. A kiln shelf that slides into a slot at the base of the chimney makes a suitable damper. A firebrick and red-brick combination is suitable for the lower chimney section with fireclay tile and red brick for the upper chimney. See the next section for other chimney options.

CHIMNEYS

Because of the extreme temperatures involved, a kiln cannot emit exhaust into an ordinary household chimney. For an open-air kiln or a metal-roofed shed-like studio a simple refractory brick chimney may be sufficient to carry the exhaust. A tube rolled out of heavy-gauge sheet stainless steel is another option for the upper chimney above the top of the kiln arch. Watch out for electrical wires overhead when installing metal chimneys!

Care must be taken to keep flammable building materials well away from the chimney as it goes through the roof, as the chimney will get quite hot, especially in wood and reduction firings. In the classroom, however, an insulated fireclay Van Packer unit may be necessary, especially for the portion within the building. The exterior section can have the usual fireclay liner and brick construction. Small kilns can emit exhaust into a metal hood above the kiln, thus sucking the cooler room air into the hood and eliminating some of the extreme temperature problem. Such hoods need to be carefully designed so that sufficient cooling air from the room is drawn in with the hot kiln flue gases. Adequate supplies of fresh air into the room must be provided to replace that lost through firing and venting. Stainless steel flue sections with an insulated inner core are commonly available and used for this type of vent. They should be used only with a hood to reduce the temperature of flue gases. It is wise to consult with both an engineer and local fire officials before designing and constructing a kiln indoors.

A short, direct connection from kiln to chimney is just as important for a proper draft as is the height of the stack. If needed, overhead connections can be made with a metal fireclay-lined pipe. Undue length or angles in this connection will require a much higher and larger stack size than normal. Tall stacks with unusual connections will probably need a burner or a blower into the stack base to induce an initial draft. If there are no surrounding buildings to cause a downdraft, a 15- to 20-foot (4.57- to 6.1-m) chimney should be sufficient. A 6-by-6-inch (15.24-by-15.24-cm) flue is usually adequate for a 10-cubic-foot (3.05-m^3) kiln, and a 9-by-9-inch (22.86-by-22.86-cm) flue for a

20-cubic-foot (6.1-m^3) gas kiln. However, an even larger size is recommended, especially in a taller stack which has some friction loss. A slot for a damper to control the draft must be left in the flue near the point where it leaves the kiln. The damper can be a small or broken kiln shelf.

BURNERS

The proper burner size and type are of critical importance to the success or failure of a kiln. In the past many potters were forced to construct their own burners because the small sizes they needed were not always available on the market. Increased interest in kilns has changed this situation. The manufacturers listed in the Appendix produce a wide variety of burners and will recommend the type most suitable to individual kilns. Although burners can be improvised to duplicate commercial designs, the anticipated savings are not worth the potential of unsatisfactory firings.

Gas Burners

Natural-draft gas burners are easy to install and quiet in operation. The Bunsen-type atmospheric burner pictured in Figure 11-34 typically has a rating of about 25,000–30,000 BTU. Six or more of these burners are needed for a downdraft gas kiln with a loading area of about 20 cubic feet (6.1 m^3). The burner ports should be about 3 inches (7.62 cm) in diameter, with the burner installed about 1 inch (2.54 cm) behind the opening to allow additional air to be sucked into the kiln. The burner has a brass valve to control the flow of gas, as well as an adjustment on the tip to regulate the length of the flame during firing. An average kiln will need a 2-inch (5.08 cm) gas line direct from the natural gas main unless high pressure gas and a regulator are available. If propane gas is used, a 500-gallon (1893-liter) tank or larger is recommended. Several smaller tanks can be hooked up together with a manifold, but will need frequent filling. The amount of gas generated by the liquid propane decreases in cold weather and when the tank is less than a quarter full. There should be 10 pounds (4.54 kg) of pressure from the tank to a regulator at the kiln that reduces the pressure to 6 to 8 ounces (170.1 to 226.8 g) for most burners, although high pressure propane burners are available. A T-fitting at the rear of the kiln will distribute equal pressure to the burners on each side. A thermocouple or flame sensor unit connected to a solenoid safety valve should be installed on burners. If thermocouple safety valves are used, heavy-duty thermocouples are highly recommended to withstand the intense heat of ceramic kilns. Safety regulations often require a solenoid valve and flame detection on each burner.

Larger kilns, such as car kilns (Fig. 11-13), will need larger burners with a BTU rating of 75,000 or more. Large car kilns, because they tend to be somewhat long and rectangular, may require six or more such burners for a uniform heat distribution. This type of burner can often be installed vertically or horizontally with 90-degree elbows directing the flame into the kiln to conserve space (see Figure 11-35).

Forced-draft gas burners like that illustrated in Figure 11-35 typically provide from 200,000 to 800,000 BTU per hour. A large kiln will require at least two of these units. The burners can be located at either the front or the rear of

11-34 Simple venturi burners
Small kilns like those often used for raku may not require complex burner systems, as they are fired quickly with constant attention by the potter. These simple atmospheric burners have an air shutter at the rear which screws in and out to control the air gas mixture. Only the addition of a gas control valve and supply line is needed to complete the setup.

11-35 A forced air burner with attached blower. Burners come in many configurations and types and can often be customized extensively to fit the particular needs of a kiln or kiln location. This is a Ward Burner Systems MB300 with electric solenoid, Ransome piggyback Venturi Pilot, water column gauge, and 90-degree head that directs the flame at a right angle to the burner, all mounted on an adjustable height stand. Pilot burners and safety shutoff equipment are usually required by most fire codes, especially for indoor use.

the kiln; the blower will cause the flame to travel the length of the firing chamber. A target brick is often placed partway down the kiln to deflect the flame upward for a more even firing. A single blower unit can be fitted with a *T*-joint to service two units placed on the same side of the kiln, but some type of air shutter or valve will be needed to even out the air supplied to each burner.

Smaller forced-draft burners, although somewhat more expensive than venturi-type burners, provide a quick and portable means for a raku firing. A single venturi burner will also work well for raku kilns. Small, inexpensive squirrel cage blowers can also be used with a simple burner to provide more control over the atmosphere and faster heating.

Oil Burners

Oil burners range from simple to very complex devices. A rudimentary burner consists of a cast-iron pan placed beneath a 4-inch (10.16-cm) hole leading into a chamber below the kiln floor. A small metal pipe running from a 55-gallon (208.2-liter) drum to the pan should have a valve to control the flow of oil. To begin firing, an oily rag is placed in the pan and ignited. The valve is adjusted so that oil drips slowly into the pan, resulting in a very smoky flame. When a

red heat is reached, the oil will volatilize sufficiently to produce an efficient use of the oil. A slightly more practical device consists of a square steel port with a series of ladder-like angled plates. The oil drips down these plates and is volatilized with a better air mixture. Both these methods produce a very sooty chimney exhaust until a red heat develops.

A forced-air unit that disperses the oil and provides a greater amount of oxygen for oil combustion is a more desirable solution. The blower must be a heavy-duty type capable of continuous operation with a 1/3—horsepower motor. Two burners can be run from a single blower. The burner should be preheated before the blower is started. This can be done by igniting some oily rags as mentioned earlier. When a good blaze develops, a little oil should be allowed to trickle in to maintain the fire. To eliminate this smoky period some potters preheat with a small portable gas unit or a gas line connected to the oil line. It is preferable to begin the firing with a light oil (such as kerosene), which has a lower flash point. Later, the oil can be switched to #2 fuel oil.

Even more efficient are the commercial burners that inject oil under pressure into a mixing chamber and blow it into the kiln in a gaseous mixture. This provides a cleaner and more complete combustion which is highly recommended. Some burners are even equipped with ignition and safety cutoff devices. In view of the increasing cost of all fuels, the expensive but efficient burner may be a bargain in the long run.

The operation of a simple oil burner is not automatic, since the oil and air supply must be monitored constantly. Too much air will cool the kiln, while excessive oil will result in incomplete combustion, reduction, and a lowering of temperature. Air and oil input both will be smaller in the early stages of firing and must be increased gradually as higher temperatures are reached.

Other Fuels and Firings

While coal was at one time a common fuel for kilns, it is now little used. The sulfur and fly ash from a coal fire will often react unpleasantly with many glazes. Stoking is also required with coal, which means it is a more laborious process. In many Third World countries other secondhand carbonaceous materials like old automobile tires provide a viable source of heat. Sawdust and wood chips from mills may be used as a fuel if a convenient method of stoking it can be devised. Any fuel that produces ash may require protecting the glazes from the ash if the ash/glaze interaction is undesirable.

Solar kilns have been built on a small scale, but are still highly experimental and quite limited, as the intense heat needed over a long period of time makes solar firing of larger kilns impractical.

APPENDICES

REFERENCE TABLES

Atomic Weights of Common Elements

Element	Symbol	Atomic Number	Atomic Weight	Element	Symbol	Atomic Number	Atomic Weight
aluminum	Al	13	26.97	molybdenum	Mo	42	95.98
antimony	Sb	51	121.76	neon	Ne	10	20.183
barium	Ba	56	137.36	nickel	Ni	28	58.69
bismuth	Bi	83	209.00	nitrogen	N	7	14.008
boron	B	5	10.82	oxygen	O	8	16.00
cadmium	Cd	48	112.41	palladium	Pd	46	106.70
calcium	Ca	20	40.08	phosphorus	P	15	30.98
carbon	C	6	12.01	platinum	Pt	78	195.23
chlorine	Cl	17	35.457	potassium	P	19	39.096
chromium	Cr	24	52.01	silicon	Si	14	28.06
cobalt	Co	27	58.94	silver	Ag	47	107.88
copper	Cu	29	63.54	sodium	Na	11	22.997
fluorine	F	9	19.00	strontium	Sr	38	87.62
gold	Au	79	197.20	sulfur	S	16	32.066
hydrogen	H	1	1.008	tin	Sn	50	118.70
iridium	Ir	77	193.10	titanium	Ti	22	47.90
iron	Fe	26	55.84	uranium	U	92	238.07
lead	Pb	82	207.21	vanadium	V	23	50.95
lithium	Li	3	6.94	zinc	Zn	30	65.38
magnesium	Mg	12	24.32	zirconium	Zr	40	91.22
manganese	Mn	25	54.93				

Common Ceramic Raw Materials

Material	Raw Formula	Compound Molecular Weight	Equivalent Weight	Fired Formula
aluminum hydroxide	$Al_2(OH)_6$	156	156	Al_2O_3
antimony oxide	Sb_2O_3	292	292	Sb_2O_3
barium carbonate	$BaCO_3$	197	197	BaO
bone ash (calcium phosphate)	$Ca_3(PO_4)_2$	310	103	CaO
boric acid	$B_2O_3 \cdot 3H_2O$	124	124	B_2O_3
borax	$Na_2O \cdot 2B_2O_3 \cdot 10H_2O$	382	382	$Na_2O \cdot 2B_2O_3$
calcium borate (colemanite, gerstley borate)	$2CaO \cdot 3B_2O_3 \cdot 5H_2O$	412	206	$2CaO \cdot 3B_2O_3$
calcium carbonate (whiting)	$CaCO_3$	100	100	CaO
chromic oxide	Cr_2O_3	152	152	Cr_2O_3
cobalt carbonate	$CoCO_3$	119	119	CoO
cobalt oxide, black	Co_3O_4	241	80	CoO

Common Ceramic Raw Materials *continued*

Material	Raw Formula	Compound Molecular Weight	Equivalent Weight	Fired Formula
copper carbonate	$CuCO_3$	124	124	CuO
copper oxide, green (cupric)	CuO	80	80	CuO
copper oxide, red (cuprous)	Cu_2O	143	80	CuO
Cornwall stone[a]	$(1RO•1.16Al_2O_3•8.95SiO_2)$	652	652	same
cryolite	$Na_3•AlF_6$	210	420	$3Na_2O•Al_2O_3$
dolomite	$CaCO_3•MgCO_3$	184	184	$CaO•MgO$
feldspar, potash	$K_2O•Al_2O_3•6SiO_2$	557	557	same
feldspar, soda	$Na_2O•Al_2O_3•6SiO_2$	524	524	same
kaolin (china clay)	$Al_2O_3•2SiO_2•2H_2O$	258	258	$Al_2O_3•2SiO_2$
kaolin (calcined)	$Al_2O_3•2SiO_2$	222	222	$Al_2O_3•2SiO_2$
iron chromate	$FeCrO_4$	172	172	$FeCrO_4$
iron, oxide, red (ferric)	Fe_2O_3	160	160	Fe_2O_3
iron oxide, black (ferrous)	FeO	72	72	FeO
flint (quartz, silica)	SiO_2	60	60	SiO_2
fluorspar (calcium fluoride)	CaF_2	78	78	CaO
lead carbonate (white lead)	$2PbCO_3•Pb(OH)_2$	775	258	PbO
lead monosilicate	$3PbO•2 SiO_2$	789	263	same
lead oxide (litharge)	PbO	223	223	PbO
lepidolite	$LiF•KF•Al_2O_3•3SiO_2$	356	356	same
lithium carbonate	Li_2CO_3	74	74	Li_2O
magnesium carbonate	$MgCO_3$	84	84	MgO
manganese carbonate	$MnCO_3$	115	115	MnO
manganese dioxide (black)	MnO_2	87	87	MnO
manganese oxide (greenish)	MnO	71	71	MnO
nepheline syenite[b]	$1RO•1.04Al_2O_3•4.53SiO_2$	447	447	same
nickel oxide, green	NiO	75	75	NiO
nickel oxide, black	Ni_2O_3	166	83	NiO
petalite	$Li_2O•Al_2O_3•8SiO_2$	197	197	same
plastic vitrox[c]	$1RO•1.69Al_2O_3•14.64SiO_2$	1139	1139	same
potassium carbonate (pearl ash)	K_2CO_3	138	138	K_2O
pyrophyllite	$Al_2O_3•4SiO_2•H_2O$	360	360	$Al_2O_3•4SiO_2$
sodium bicarbonate	$NaHCO_3$	84	168	Na_2O
sodium carbonate (soda ash)	Na_2CO_3	106	106	Na_2O
spodumene	$Li_2O•Al_2O_3•4SiO_2$	372	372	same
strontium carbonate	$SrCO_3$	148	148	SrO
talc (steatite)	$3MgO•4SiO_2•H_2O$	379	126	$3MgO•4SiO_2$
tin oxide (stannic oxide)	SnO_2	151	151	SnO_2
titanium dioxide (rutile impure TiO_2)	TiO_2	80	80	TiO_2
wollastonite	$Ca•SiO_3$	116	116	same

(continued)

Common Ceramic Raw Materials *continued*

Material	Raw Formula		Compound Molecular Weight		Equivalent Weight	Fired Formula
zinc oxide	ZnO		81		81	ZnO
zirconium oxide	ZrO_2		123		123	ZrO_2

[a]formula for Cornwall stone:

K_2O	0.4453	Al_2O_3	1.0847	SiO_2 7.796
Na_2O	0.2427	Fe_2O_3	0.0065	
CaO	0.1873			
MgO	0.0821	*Mol. weight 652*		
CaF_2	0.0421			

[b]formula for nepheline syenite:

Na_2O	0.713	Al_2O_3	1.04	SiO_2 4.53
K_2O	0.220			
CaO	0.056	*Mol. weight 447*		
MgO	0.011			

[c]formula for plastic vitrox:

CaO	0.045	Al_2O_3	1.693	SiO_2 14.634
MgO	0.058	Fe_2O_3	0.005	
Na_2O	0.054			
K_2O	0.842	*Mol. weight 1139.40*		

Analysis of Common Clays and Chemicals

Note: The analyses of all ceramic materials vary widely from batch to batch—consider these analyses approximate. Obtain current analyses of your specific type of material from the manufacturer or supplier. Older clays are included as an aid in converting recipes which may use them. **All amounts are percentage by weight.**

Material	SiO_2	Al_2O_3	Fe_2O_3	TiO_2	CaO	MgO	K_2O	Na_2O	Li_2O	Ignition Loss
red Dalton clay	63.2	18.3	6.3	1.3	0.3	0.5	1.6	1.2		6.4
Barnard clay	41.4	6.7	29.9	0.2	0.5	0.6	1.0	0.5		8.4
Monmouth stoneware	56.8	28.5			0.3	0.3	0.3	1.3		12.2
Jordan stoneware	69.4	17.7	1.6	1.3	0.1	0.5	1.5	1.39		6.4
Albany slip	57.6	14.6	5.2	0.4	5.8	2.7	3.2	0.8		9.5
ball clay	51.9	31.7	0.8	1.5	0.2	0.2	0.9	0.4		12.3
sagger clay	59.4	27.2	0.7	1.6	0.6	0.2	0.7	0.3		9.4
fireclay	58.1	23.1	2.4	1.4	0.8	1.1	1.9	0.3		10.5
Georgia kaolin	44.9	38.9	0.4	1.3	0.1	0.1	0.2	0.2		14.21
Florida kaolin	45.7	37.4	0.8	0.4	0.18	0.1	0.06	0.33		13.91
English kaolin	47.25	37.29	0.84	0.05	0.03	0.28	1.8	0.04		12.21
petalite	77.0	17.5					(0.5)	4.3		0.7
pyrophyllite	73.5	20.0	0.5		0.1		1.4	1.2		3.3
bentonite	64.32	20.7	3.47	0.11	0.46	2.26	2.9			5.15
volcanic ash	72.51	11.55	1.21	0.54	0.68	0.07	7.87	1.79		3.81
plastic vitrox	75.56	14.87	0.09		0.22	0.20	6.81	0.29		2.04
feldspar, potash	68.3	17.9	0.08		0.4		10.1	3.1		0.32
feldspar, soda	66.8	19.6	0.04		1.7	trace	4.8	6.9		0.2
Cornwall stone	72.6	16.1	0.23	0.06	1.4	0.1	4.56	3.67		2.54
nepheline syenite	60.4	23.6	0.08		0.7	0.1	9.8	4.6		0.7
lepidolite	55.0	25.0	0.08				9.0	1.0	4.0	0.92[a]
spodumene	62.91	28.42	0.53		0.11	0.13	0.69	0.46	6.78	0.28

[a]plus 5 percent fluorine.

Analysis of Several Feldspars[a]

Material	SiO$_2$	Al$_2$O$_3$	Fe$_2$O$_3$	CaO	MgO	K$_2$O	Na$_2$O	Ignition Loss
Soda spars								
Spruce Pine #4	67.9	19.01	0.05	1.54	trace	4.98	6.22	0.08
NC-4	68.2	18.9	0.07	1.4	trace	4.1	6.82	0.09
Kona F-4	66.8	19.6	0.04	1.7	trace	4.8	6.9	0.2
Potash spars								
Bell	68.3	17.9	0.08	0.4	trace	10.1	3.1	0.32
Buckingham	65.58	19.54	trace	0.16	0.2	12.44	2.56	0.32
Chesterfield	70.6	16.33	0.08	0.3		8.5	3.75	0.4
Custer	68.5	17.0	0.15	0.3	trace	10.0	3.0	
Eureka	69.8	17.11	0.1	trace		9.4	3.5	0.2
Kingman	66.0	18.7	0.1	0.1		12.0	2.8	0.2
Kona A-3	71.5	16.3	0.08	0.4	trace	7.5	4.0	0.2
Oxford	69.4	17.04	0.09	0.38		7.92	3.22	0.3

[a]The variable quality of the feldspar fluxes is a major reason why glaze recipes may need alteration unless materials are identical. Several older feldspars which are no longer available are shown to aid in making substitutions of currently available feldspars in older recipes.

Oxide Equivalents of Selected Commercial Frits[a]

Supplier	Frit No.	Molecular Formula							Molecular Weight
		K$_2$O	Na$_2$O	CaO	ZnO	Al$_2$O$_3$	B$_2$O$_3$	SiO$_2$	
Pemco	25	0.18	0.76	0.03	0.03	0.38	0.78	2.63	319
	54		0.32	0.68			0.64	1.47	191
Ferro	3124	0.02	0.28	0.70		0.27	0.55	2.56	279
	3134		0.32	0.68			0.63	1.47	191
	3110	0.06	0.64	0.29		0.10	0.10	3.00	259
for comparison:		K$_2$O	Na$_2$O	CaO	MgO	Al$_2$O$_3$	B$_2$O$_3$	SiO$_2$	Molecular Weight
Gerstley borate[b]			0.16	0.68	0.16	0.02	0.742	0.293	179

[a] In most cases the above frits will constitute a complete glaze at cone 06.
[b] Gerstley borate, a natural material with a fluxing effect similar to frits, was sometimes unavailable at this writing and is quite variable in analysis. Various commercial replacements may be available—test carefully. Analyses should be available from the manufacturers.

Water of Plasticity of Various Clays

washed kaolin	44.48–47.50
white sedimentary kaolin	28.60–56.25
ball clays	25.00–53.30
plastic fireclays	12.90–37.40
flint fireclays	8.89–19.04
sagger clays	18.40–28.56
stoneware clays	19.16–34.80
brick clays	13.20–40.70

$$\textit{water of plasticity} = \frac{\textit{weight of plastic sample} - \textit{weight of dry sample}}{\textit{weight of dry sample}} \times 100$$

Average Temperatures to Which Various Ceramic Products Are Fired

Products	Degrees F	Degrees C
Heavy clay products		
common brick–surface clay	1600–1800	870–982
common brick–shale	1800–2000	982–1093
face brick–fireclay	2100–2300	1150–1260
enamel brick	2100–2300	1150–1260
drain tile	1700–1900	927–1038
sewer pipe	2030–2320	1110–1271
roofing tile	1960–2140	1071–1171
terra cotta	2070–2320	1021–1271
Pottery		
flowerpots	1580–1850	860–1010
stoneware (chemical)	2650–2700	1455–1482
stoneware (once fired)	2318–2426	1270–1330
semivitreous ware	2282–2354	1250–1290
pottery decalcomanias	1400–1500	760–816
Refractories		
firebrick–clay	2300–2500	1260–1371
firebrick–silica	2650–2750	1455–1510
silicon carbide	3236–3992	1769–2200
Whitewares		
electrical porcelain	2390–2500	1310–1371
hotel china–bisque	2390–2436	1310–1336
hotel china–glaze	2210–2282	1210–1250
floor tile	2318–2498	1270–1370
wall tile–bisque	1886–2354	1030–1290
wall tile–glaze	1186–2246	641–1230

Color Scale for Temperatures

Color	Degrees C	Degrees F
lowest visible red	475	885
lowest visible red to dark red	475–650	885–1200
dark red to cherry red	650–750	1200–1380
cherry red to bright cherry red	750–815	1380–1500
bright cherry red to orange	815–900	1500–1650
orange to yellow	900–1090	1650–2000
yellow to light yellow	1090–1315	2000–2400
light yellow to white	1315–1540	2400–2804
white to dazzling white	1540 and higher	2804 and higher

Melting Points of Selected Compounds and Minerals

Material	Degrees C	Degrees F
alumina	2050	3722
barium carbonate	1360	2480
bauxite	2035	3695
borax	741	1365
calcium oxide	2570	4658
cobaltic oxide	905	1661
copper oxide (CuO)	1064	1947
corundum	2035	3695
cryolite	998	1830
dolomite	2570–2800	4658–5072
ferric oxide	1548	2818
fireclay	1660–1720	3020–3128
fluorspar	1300	2372
kaolin	1740–1785	3164–3245
lead oxide (litharge)	880	1616
magnesium carbonate (dissociates)	350	662
magnesium oxide (approx.)	2800	5072
mullite	1810	3290
nepheline syenite	1223	2232
nickel oxide	400	752
orthoclase feldspar (potash)	1220	2228
potassium oxide	red heat	
rutile	1900	3452
silica	1715	3119
silicon carbide (decomposed)	2220	3992
sillimanite	1816	3301
sodium oxide	red heat	
tin oxide	1130	2066
titanium oxide	1900	3452
whiting (dissociates)	825	1517
zircon	2550	4622

Temperature Equivalents for Orton Standard Pyrometric Cones[a]

Cone Number	Large Cones		Small Cones		Seger Cones (used in Europe) Degrees C
	150°C[b]	270°F/hr[b]	300°C/hr[b]	540°F/hr[b]	
020	638	1180	666	1231	670
019	693	1279	723	1333	690
018	732	1350	752	1386	710
017	761	1402	784	1443	730
016	794	1461	825	1517	750
015	816	1501	843	1549	790
014	836	1537	870	1598	815
013	859	1578	880	1616	835
012	880	1616	900	1652	855
011	892	1638	915	1679	880
010	913	1675	919	1686	900
09	928	1702	955	1751	920
08	954	1749	983	1801	940
07	985	1805	1008	1846	960
06	1101	1852	1023	1873	980
05	1046	1915	1062	1944	1000
04	1070	1958	1098	2008	1020
03	1101	2014	1131	2068	1040
02	1120	2048	1148	2098	1060
01	1137	2079	1178	2152	1080
1	1154	2109	1184	2163	1100
2	1162	2124	1190	2174	1120
3	1168	2134	1196	2185	1140
4	1181	2158	1209	2208	1160
5	1205	2201	1221	2230	1180
6	1241	2266	1255	2291	1200
7	1255	2291	1264	2307	1230
8	1269	2316	1300	2372	1250
9	1278	2332	1317	2403	1280
10	1303	2377	1330	2426	1300
11	1312	2394	1336	2437	1320
12	1324	2415	1355	2471	1350
13	1346	2455			1380
14	1366	2491			1410
15	1431	2608			1430

[a]From the Edward Orton, Jr., Ceramic Foundation, Westerville, Ohio. Visit their Web site (www.ortonceramic.com) for a wealth of information on pyrometric cones and their proper use, including tables of bending temperatures for various heating rates, and for self-supporting and iron-free cones.
[b]Temperature rise per hour for the last 180°F (100°C) of the firing.

CONVERSION TABLES

Temperature Conversion Formula

Centigrade to Fahrenheit

example: 100°C $\times \dfrac{9}{5}$ = 180 180 + 32 = 212°F

Fahrenheit to Centigrade

example: 212°F − 32 = 180 180 $\times \dfrac{5}{9}$ = 100°C

Metric Conversion Tables

When dealing with foreign suppliers or consulting references printed abroad, the potter should be able to convert readily from the American system of weights and measures to the metric system, employed by virtually every country outside the United States. The following tables provide multipliers for converting from metric to U.S. and the reverse; the multipliers have been rounded to the third decimal place and thus yield an approximate equivalent.

Metric to U.S.			U.S. to Metric		
to convert from	to	multiply the metric unit by	to convert from	to	multiply the U.S. unit by
Length:					
meters	yards	1.093	yards	meters	.914
meters	feet	3.280	feet	meters	.305
meters	inches	39.370	inches	meters	.025
centimeters	inches	.394	inches	centimeters	2.540
millimeters	inches	.039	inches	millimeters	25.400
Area and volume:					
square meters	square yards	1.196	square yards	square meters	.836
square meters	square feet	10.764	square feet	square meters	.093
square centimeters	square inches	.155	square inches	square centimeters	6.451
cubic centimeters	cubic inches	.061	cubic inches	cubic centimeters	16.387
Liquid measure:					
liters	cubic inches	61.020	cubic inches	liters	.016
liters	cubic feet	.035	cubic feet	liters	28.339
liters	*U.S. gallons	.264	*U.S. gallons	liters	3.785
liters	*U.S. quarts	1.057	*U.S. quarts	liters	.946
Weight and mass:					
kilograms	pounds	2.205	pounds	kilograms	.453
grams	ounces	.035	ounces	grams	28.349
grams	grains	15.430	grains	grams	.065
grams per meter	ounces per yard	.032	ounces per yard	grams per meter	31.250
grams per square meter	ounces per square yard	.030	ounces per square yard	grams per square meter	33.333

*The British imperial gallon equals approximately 1.2 U.S. gallons or 4.54 liters. Similarly, the British imperial quart equals 1.2 U.S. quarts, and so on.

Specific Gravity Measurement

One of the big problems of glaze mixing and application is the need to keep the raw glaze at a constant liquid consistency. One check that can be easily done is to find the *specific gravity* of the glaze. This measurement will give you an idea of how much water there is in the glaze slip. This is also important with terra sigillata, which typically has a specific gravity of between 1.15 and 1.2 for the best results.

The specific gravity is a ratio of volume to mass (in practical terms mass equals weight). Water at room temperature has a specific gravity of 1.0, with 1 liter of water weighing 1 kilogram. Since a glaze slip contains both water and ground-up minerals which are heavier than water, a liter of glaze will weigh more than a liter of water. As the amount of water in the glaze varies, so will its specific gravity. Hydrometers are sometimes used to measure specific gravity of liquids, but the viscosity of a glaze slip makes the use of a hydrometer less than accurate.

To measure the specific gravity of a glaze:

1. Find a clear plastic container (a cut-off soft one-liter drink bottle or large plastic cup will work well).

2. Place this empty container on a gram scale and set the tare to zero on the scale (it is balanced with nothing in the container).

3. Set the gram scale to weigh 100 grams (or 500 g if you have a large enough amount of glaze) and carefully fill the container with room-temperature water until the scale balances exactly.

4. Mark the level of the water accurately on the side of the container using a permanent marker. Also write the weight of the water on the side for future reference.

5. Dump out the water, dry the container, and refill it with glaze *exactly to the line you just marked*. Leave the scale tare set to the container weight (you did this in step 2).

6. Weigh the container filled with glaze and record the weight.

7. The specific gravity is the weight of the glaze divided by the weight of the water.

For instance, if the water weighed 100 grams and the glaze weighed 140 the calculation would be:

$$\text{specific gravity} = 140/100 = 1.4$$

If your ideal specific gravity is for example 1.3 (determine this experimentally for each glaze you use), then you need to add a little water to the glaze to lower its specific gravity. If the ideal specific gravity of the glaze or slip was higher, say, 1.6, then you need to let some of the water evaporate or let the glaze settle and remove some water, or add more dry glaze mix to the batch. Keeping the glaze to a constant specific gravity, along with keeping the glaze flocculation and viscosity as constant as possible, will help you get more consistent and repeatable glaze results.

GLUES AND ADHESIVES FOR CERAMICS

Pottery and sculpture may come out of the kiln in perfect condition, fired and complete, but this is not always the result, especially with complex sculptural forms. For most pottery the best and most permanent method of assembling multiple parts is to make the form entirely of clay, completing all the joinery in the leather-hard stage. For sculptural pieces or large-scale pots this may not always be possible and the work must be fired in sections. Another scenario is that a piece may be broken after firing and need repairs. For such things the ceramist often turns to modern adhesives.

There are many types of adhesives available that will work with fired clay. Many are quite strong, durable and waterproof. However, if the work is being assembled from separate fired pieces, making some provision for strong glue joints *before* firing is important. One of the simplest things that will add great strength when gluing ceramics fired in separate parts is to provide a mechanical connection between the two parts in addition to the bond provided by the glue. This may be as simple as inserting a small metal pin or two into matching holes drilled into the two ceramic parts being glued. Boring holes in clay is best done before firing for dense or nearly vitreous clays, as after firing the clay will likely be too hard to be easily drilled even with a masonry bit. Drilling holes is easiest and has the least risk of breakage when the clay is leather hard. Care in making sure that the clay parts are made so that the glue joint fits tightly will also help. See the suggestions for types of glue to use and other hints below.

Epoxy is one of the most commonly used glues for ceramics. It is extremely strong and fills gaps well. Epoxies come in two parts, a resin and a hardener. Once the hardener has been added to the resin it's just a matter of time before the glue sets. Epoxies are available in a variety of types, from quick setting (not as strong, yellows badly and weakens in a few years), to slower setting types with more strength (strong, may take up to 24 hours to fully set). Epoxies are also available in consistencies ranging from thin syrup to putties that are thick and shapable before the epoxy has set. Most epoxies yellow with age. Non-yellowing varieties are available, but more expensive. One possible hazard of epoxies is that some people are allergic to skin contact with them. Such allergies can crop up suddenly, so carefully avoid contact with the uncured resin and hardener.

Some glues may have noxious fumes and require good ventilation or an organic vapor mask. Some adhesives may be flammable. READ THE LABEL carefully before using any glue.

General gluing tips

- Use gravity as much as possible to keep parts together while gluing. Ceramic parts are often hard to clamp, and hand holding the parts even with quick-setting glues may result in a weaker joint.
- A bed of sand allows parts to be held at any angle for gravity connections, but be very careful to keep sand out of joints.
- Work in a clean, cleared area with newspaper, cardboard or plastic underneath to catch glue drips and spills. Most glues won't stick to polyethylene.
- Practice putting the parts together before applying glue, especially if using a quick setting glue.
- Masking tape can be useful to hold parts together or keep glue off delicate surfaces, but be careful not to glue the tape to the pot, too. Remove tape as soon as safely possible. Test the tape first on hidden surface to make sure it won't damage the clay or glaze surface.

Tips for gluing parts fired separately

- Make careful, tight-fitting joints if possible when creating the piece. Leave some allowances for warping, uneven shrinkage, and the thickness of the glue.
- Keep in mind that it is often difficult to hide glue joints in pieces built in sections. Build the ceramic parts to fit together so that the glue joint is incorporated visually into the piece.
- Leave as much of the area being glued unglazed as possible especially if it will be hidden by the glue joint.

- Make a mechanical connection, too, if at all possible. This can be wire pins or wooden dowels that are glued into the joint, or even bolts.
- Epoxy is one of the strongest glues for joints that have gaps—even small gaps—which are almost always present in assembled work. (See earlier note on types of epoxies in the text.)
- Silicone adhesives (including caulking and bathtub sealers) are useful for elastic joints which don't have to hold much weight.
- Auto body fillers may be useful for filling large gaps or missing pieces, but are generally not as strong as epoxies for the actually bonding of the joint.
- Plaster can be used after gluing to fill small cracks, then painted.

Tips for gluing pieces broken after firing

- Cyanoacrylate adhesives ("super" type glues) work well for fixing breaks that fit together perfectly. This type of glue sets very rapidly (in seconds) so one must work quickly and keep the glue off hands and skin to avoid gluing oneself to other objects. (Use liquid-type cyanoacrylate for dense, vitreous clay, and gel-type for more porous clays.)
- Epoxies will fill gaps of missing or ill-fitting parts, but most are too thick and viscous to squeeze out and make a thin, invisible joint. Epoxy putty (such as that used by plumbers) may be useful in filling large gaps.
- White glue and other woodworking type glues will work well on more porous clays like raku bodies or some lowfire clays, if the pieces fit tightly together and the result doesn't have to be completely water resistant.

GLAZE RECIPES

Far too often ceramists look for the easy answer to that glaze that does everything, or that special recipe with the celebrity potter's name on it, thinking that if they only can find the right recipe their work will suddenly be more wonderful. This is seldom the case. It is far better to work toward developing a personal palette of slips and glazes and learn how to use them effectively.

The glaze recipes listed below are intentionally generically named, and intended only as a starting point for glaze investigation by the potter. Thousands of recipes are available in other books and on the Internet. The recipes here are chosen for both variety of temperature and effect. Some are transparent and others opaque, shiny and mat, runny and viscous, smooth and textured. Glazes with specific colorants listed can be altered and the colorants changed. As mentioned before, the type of flux has a great effect upon the colorants. Many variations of color are possible starting with these simple recipes. Rarely will one find an existing glaze that does exactly what is wanted with the very first use. Testing subtle variations in colors and surface, finding the best ways of applying the glaze, and discovering what other glazes, slips and clays are most appropriate to use with it are the keys to success.

Before using these or any other new glazes the potter should always run some tests. Gerstley borate was again available as of this writing, along with many new commercially formulated substitutes for this interesting but highly variable material. Substantial testing should always be done with any new batch of material or substitute. Feldspars and other naturally occuring chemicals also contain impurities and vary from batch to batch and mine to mine. More finely ground chemicals will lower slightly the maturity of the glaze. The rate of heat rise or fall, as a result of kiln construction or of its size, also plays a part. A difference will sometimes be found if the same glaze is fired in a gas or an electric kiln, even if both are oxidation firings. Changes to the glaze occur due to the type of clay body, with more pronounced effects at the higher temperatures and especially under reducing conditions. Some glazes must be fired to a very exact temperature (see the discussion on eutectics in the section on variables of glaze formulation in

Chapter 10), while others can tolerate a couple of cones' difference with only slight changes in surface appearance and color.

There has been a noted increase in awareness of the food-use safety of pottery glazes. In particular, the possibility of leaching of metal oxides (colorants and fluxes) from the glaze has come under growing scrutiny. The following glazes have been chosen for relative stability and safety. However, not all are appropriate for pottery surfaces to be used for food. Many contain chemicals which are potentially hazardous to the potter before they are fired. Knowledge of safe glaze handling and use is a necessity.

Lowfire glazes should be carefully formulated, fired, and tested, but high-fire stoneware glazes are generally much more stable, thanks to the larger amount of silica that can be melted into the glaze at high temperatures. Even then, the potter might want to consider having leach tests done, especially for glazes with high or saturated amounts of colorants, especially copper (metallic or metallic black surfaces are often a sign of high colorants being present), glazes which have unusual formulas to attain a particular unique color, glazes containing barium carbonate, glazes which are underfired or dry, and the like if these glazes are to be used on food-contact surfaces. If in doubt, use stable, glossy, non-crazing glazes with low amounts of colorants on the food contact surfaces.

While it is important for the potter to have an understanding of glazes and chemicals, this knowledge is not a panacea. Some potters use only a few glazes with which they are completely familiar. Others use dozens of glazes to attain the results they want. It takes a lot of trial and error to discover that certain forms, glazes, and decoration have an affinity and seem to naturally go together. Keep good notes and an experimental attitude!

Note: Many of the following recipes contain gerstley borate. If gerstley borate is unavailable, test these recipes with some of the commercially available substitutes or try substituting lowfire leadless frits, or other boron-containing materials. While this type of substitution is best done using glaze calculation, experimental testing may render satisfactory results, especially in higher temperature glazes where the amount of gerstley borate is small and the substitution less critical.

Terra Sigillata
Basic Terra Sigillata

Cone: 018–08

clay	1000
water	3000
sodium silicate	3

This is not a glaze, but rather an extremely fine-particled clay coating that seals the clay body, and ideally attains an almost wax-like sheen when buffed before firing.

process:

Choose a clay first. Almost any clay will make a terra sigillata, but finer grained clays like ball clays will give a higher yield from the batch. Red earthenware clays will give a red to orange-red terra sigillata. Test the finished terra sigillata carefully with your clay body to make sure it does not flake off after application and firing.

Mix sodium silicate with warm to hot water. Slowly mix in clay, blunging constantly. Mix well. Let sit for an hour or so, then remix. Place the mixture in a container where it can remain undisturbed for about 18–24 hours. After this settling time you should have three distinct layers: a water layer at the top (siphon this off and throw away), a terra sigillata layer in the middle which you will save, and a sludge-like layer of clay at the bottom. Siphon the middle layer off carefully using a hose, being careful not to disturb or siphon any of the heavier sludge-like clay at the bottom. If you hold the siphon hose near the end with your hand as you lower it into the terra sigillata, you can feel the sludge-like layer with your fingers and keep the hose from siphoning that layer. The terra sigillata will probably be too thin to use immediately. Allow some of the water to evaporate until the specific gravity is between 1.15 and 1.2 (see the appendices for determining specific gravity).

application:

Apply to greenware in 3–5 thin coats. If the terra sigillata is too thick (or dense—too high of a specific gravity), it may peel from the clay surface after firing. Multiple thin coats are always better than one or two thicker coats. Buff the terra sigillata when it is almost dry (just damp, but not wet) with a soft cloth, chamois, or for the best shine: a piece of crinkly plastic grocery bag. If needed you can lightly spray the surface of the terra sigillata with water to re-dampen, let it just soak in (no wet spots), then buff.

colors:

Terra sigillatas are best when made with clays that provide a natural color. Kaolins provide a range of whites, ball clays usually are creamier white to beige, stoneware clays somewhat darker cream colors, and red earthenware clays give red to orange colors.

Other colorants or stains can be added to terra sigillatas after they are made, but adding too much colorant will result in a lowered ability to buff the surface to a high sheen. Adding a small amount of gerstley borate (or a similar low-temperature flux-containing material) to the terra sigillata when you add stains, to get a slightly harder surface after firing. Ball milling the colorant with the finished terra sigillata may help to incorporate the colorant into the mix more smoothly.

firing:

Terra sigillatas need to be fired to a fairly low temperature (usually cone 010–08 maximum) to keep their full lustrous sheen. They can be fired higher, to cone 04 on the feet of majolica pieces for instance, and have a wonderful smoothness that seals the clay surface without looking glazed. Many sigillatas can be fired even higher, but they progressively look more and more like a smooth clay slip as the temperature increases.

other variations:

Powdered graphite added to terra sigillata (about 4 grams per 1/2 cup) will reduce iron-rich earthenware terra sigillatas to black, especially if fired fairly quickly or fired in a sagger. Firing to a very low temperature (cone 018-16) may also be necessary to keep the full black color from the graphite addition, but this will result in fairly soft and fragile ware—test it carefully with your clay. The result of adding graphite is often a nice sparkle to the surface.

Adding 1 tablespoon of copper carbonate to one pint of ball clay terra sigillata makes an interesting surface for low-temperature sagger-fired pieces which reacts well to the variations inherent to sagger firing.

Lowfire Glazes

Basic Lowfire Starter Glazes

For cone: 06

Leadless lowfire frit	90
Clay	10

For cone: 04

Leadless lowfire frit	80
Clay	20

Comments:

Try using different frits to vary glaze fit, transparency, surface, melting, and color response. Adding 5% increments of silica, strontium carbonate, or feldspars will further modify the glaze (see the glazes which follow for examples). While kaolin is usually the best clay to add for clarity of glaze with minimal added color, other clays can be tried, sometimes with interesting results. Add commercial stains (3–12%), oxides, or opacifiers for color if desired.

Amber Clear

Cone: 04–03

Color: transparent yellow
Surface: shiny or glossy
Firing: oxidation

Ferro frit 3124	86.8
Florida kaolin	10.5
Strontium carbonate	2.7
Total:	100.0%

Also add:

Bentonite	2.0
Burnt umber	7.0

Comments:

Should resemble the yellow color of an antique lead glaze for earthenware. Clear without the burnt umber.

Deep Alkaline Turquoise

Cone: 04–03

Color: translucent blue green
Surface: glossy or shiny
Firing: oxidation

Ferro frit 3195	18.1
Ferro frit 3110	54.3
Gerstley borate	9.5
Florida kaolin	8.6
Flint	9.5
Total:	100.0%

Also add:

Copper carbonate	4.5
Bentonite	2.0

Comments:

May run if very thick.

Blue Raku

Cone: 08–06

Color: clear turquoise blue
Surface: shiny
Firing: raku or oxidation

Ferro frit 3110	75.2
Gerstley borate	10.8
Soda ash	10.8
Florida kaolin	3.2
Total:	100.0%

Also add:

Copper carbonate	3.0

Comments:

Apply medium to thin coat. Crawls during raku firing if too thick. May turn metallic if reduced heavily. Also good in oxidation firings.

Clear

Cone: 04

Color: transparent clear
Surface: shiny or glossy
Firing: oxidation

Ferro frit 3124	70.0
Strontium carbonate	10.0
Florida kaolin	10.0
Nepheline syenite	10.0
Total:	100.0%

Also add:

Bentonite	2.0
Epsom salts	0.2

Shiny Black

Cone: 04

Color: opaque black
Surface: shiny or glossy
Firing: oxidation

Ferro frit 3124	45.0
Ferro frit 3289	45.0
Florida kaolin	10.0
Total:	100.0%

Also add:
Bentonite	2.0
Mason 6600 black stain	10.0
Epsom salts	0.2

Strontium Frosty Matte

Cone: 04

Color: opaque white base
Surface texture: matte
Firing: oxidation

Ferro frit 3124	27.50
Nepheline syenite	39.00
Florida kaolin	7.50
Wollastonite	6.25
Strontium carbonate	10.50
Whiting	7.75
Flint	1.50
Totals:	100.00%

Comments:
Nice with colors and stains. Sugary stiff
matte white base.

Majolica

Cone: 04–03

Color: opaque white
Surface: glossy or shiny
Firing: oxidation

Ferro frit 3124	65.7
Kona F-4 soda feldspar	17.2
Florida kaolin	10.8
Nepheline syenite	6.3
Total:	100.0%

Also add:
Tin oxide	5.0
Zircopax	10.0
Bentonite	2.0

Comments:
From Linda Arbuckle.
Majolica colorant suggestions:
Mix by VOLUME with Gerstley borate:

Turquoise green: 1 copper
carbonate 1 1 Gerstley borate

Blue: 1 cobalt carbonate. + 1 Gerst-
ley borate

Brown: 1 red iron oxide + 1 Gerstley
borate

All others mix 1 part colorant with 3
to 4 parts of Gerstley borate:

Green opaque: 1 chrome + 3–4 Ger-
stley borate

Rusty orange: 1 rutile + 3–4 Gerst-
ley borate

Yellow: 1 Mason stain 6404 + 3–4
Gerstley borate

Pin: 1 Mason stain 6001 + 3–4 Ger-
stley borate

Black: 1 Mason stain 6600 + 3–4
Gerstley borate

(or use black oxide mix, below)

Black Oxide mix: (by weight)

20 black iron oxide

15 cobalt carbonate

10 manganese dioxide

5 chrome oxide

Lowfire Texture Glazes and Raku

Crawl/Lichen Glaze

Cone: 06, 05, 04

Color: white
Surface: crawl texture
Firing: oxidation

Gerstley borate	46.5
Magnesium carbonate	31.0
Florida kaolin	18.6
Borax	3.9
Total:	100.0%

Also add:
Zircopax	5.5

Comments:
This is a nice, dependable crawl glaze
with lots of texture. It is not a good choice
for food-use surfaces. Fine to almost no
crawling when applied very thinly. Large
platelets of glaze form when applied very
thickly, but they may flake off. Fired to
cone 04 this glaze becomes more glassy,
giving beads of glaze. For a more crusty
surface on flatter objects, sift the dry glaze
onto the clay surface, then fire.

Red Trailing Glaze

Cone: 08, 07, 06

Color: opaque brick red
Surface: semi-gloss
Firing: oxidation

RedArt clay	50.0
Lowfire leadless frit	50.0
Total:	100.0%

Comments:
This glaze is not meant to be used as an
overall glaze on the surface, but rather
as a thin line of glaze either on the clay
or over another glaze. Use a hypodermic
syringe to trail a fine line of glaze. You
can substitute other clays for the RedArt
clay, such as XX Sagger Clay for a white
trailing glaze.

Vitreous Engobe

Cone: 08, 07, 06

Color: white, base
Surface: slip or engobe
Firing: oxidation

Kentucky ball clay	20.0
Flint	30.0
Ferro frit 3110	30.0
Talc	5.0
Borax	5.0
Zircopax	10.0
Total:	100.0%

Comments:
Vitreous enough to resist smoking in raku firing, but will still leave a matte clay-like surface after firing, unless over-fired, in which case it can get glossy. To lower the drying shrinkage even more, use Florida kaolin or Georgia kaolin instead of the ball clay. Increase the frit for a more vitreous surface at lower temperatures. Add colorants as desired.

Copper Luster Raku

Cone: 08, 07, 06

Color: multicolor metallic
Surface: shiny
Firing: Raku

Gerstley borate	65.5
Custer potash feldspar	12.0
Flint	12.0
Ball clay	6.0
Strontium carbonate	4.5
Total:	100.0%

Also add:
Copper carbonate	12.0

Comments:
Not for use on food-contact surfaces.

Dry Copper Luster

Cone: 08, 07, 06

Color: iridescent rainbow luster
Surface: texture
Firing: Raku

Gerstley borate	80.0
Bone ash	20.0
Total:	100.0%

Also add:
Copper carbonate	5.0
Cobalt carbonate	5.0
Tin Oxide	2.0

Comments:
The classic raku dry pebble-textured luster surface, often with wildly colorful flame markings after firing in raku. Note that this type of metallic surface-only coloration from copper is not permanent and will slowly fade and tarnish. Not for use on food-contact surfaces.

White Crackle

Cone: 06

Color: white
Surface: shiny
Firing: Raku

Gerstley borate	80.0
Nepheline syenite	15.0
Florida kaolin	5.0
Total:	100.0%

Also add:
Zircopax	1.0

Comments:
Thicker application will yield larger crackle pattern, thinner application yields finer. Zircopax gives a whiter, more opaque glaze, will cover pink bisque better. This glaze has a tendency to crawl.

Clear Crackle

Cone: 08

Color: clear
Surface: shiny, crackle
Firing: Raku

Gerstley borate	80.0
Nepheline syenite	20.0
Total:	100.0%

Comments:
A classic American raku glaze. Can be opacified with 5–10% Zircopax for crackle white or colorants can be added.

Medium-Fire Glazes: Cones 5–6

Polished Matte

Cone: 5–6

Color: opaque creamy white
Surface: satin matte
Firing: oxidation or reduction

Kona F-4 soda feldspar	20.0
Custer potash feldspar	20.0
Spodumene	20.0
Dolomite	20.0
Whiting	5.0
Kaolin	15.0
Total:	100.0%

Also add:
Tin oxide	6.00

Comments:
Slightly drier in oxidation, very smooth in reduction and a bit grayer. Good color response for a matte glaze to stains brushed over the raw glaze—only somewhat pastel. Without the tin oxide it is somewhat translucent and dark colorants or slips will show through easily.

Strontium Matte

Cone: 6–8

Color: various—good color response
Surface: matte
Firing: oxidation or reduction

Nepheline syenite	60.0
Kentucky ball clay	10.0
Strontium carbonate	20.0
Lithium carbonate	1.0
Flint	9.0
Total:	100.0%

Comments:

Increasing the lithium carbonate to 3% makes this glaze slightly more fluid.

Cream white: 5% Titanium dioxide

Aqua-green: 5% Titanium dioxide + 5% Copper carbonate

Light blue: 0.15% Cobalt carbonate + 4.0% Copper carbonate

Dark green: 8% Copper carbonate

Creamy tan: 6% Rutile

Gray: 2% Manganese dioxide + 5% Copper carbonate

Various colors in oxidation: 5–12% commercial stain.

Satin Base

Cone: 6

Color: translucent base
Surface: satin
Firing: oxidation or reduction

Ferro frit 3110	9.0
Ferro frit 3134	20.9
Nepheline syenite	24.9
Whiting	13.5
Flint	31.7
Total:	100.0%

Also add:	
Bentonite	3.0
Epsom salts	0.15

Texture/Crawl

Cone: 6

Color: white
Surface: crawling texture
Firing: oxidation or reduction

Nepheline syenite	70.0
Magnesium carbonate	25.0
Ball clay	5.0
Total:	100.0%

Comments:

Works well over slips. Colorants: Beige 10% Rutile. Brown 10% Mason 6134. Yellow 7% Mason 6485. When sprayed it develops a finely pebbled surface even when fairly thin. When brushed it breaks into a more platelet-like crawl. Can be fired to a higher temperature to get a glossier surface and more rounded globs of glaze. Good response to colored stains brushed or sprayed over. Try this glaze over dark slips or engobes for a dramatic effect.

You can make this glaze bead up just by spraying it on thickly or at least somewhat drier than normal (step back from the piece while spraying so that the droplets of sprayed glaze dry out a bit before they get to the piece), so that the surface is very pebbly BEFORE firing. You can control whether it is a fine pebble or large beads this way—Thicker = glassy beads, thinner = fine pebble. Brushing or pouring it tends to make it break into more flat platelets, although firing a bit higher will usually convert a thickly crawl glazed piece to more bead-like droplets. Adding additional flux in the form of 5–10% leadless lowfire frit will make this glaze more glossy and bead-like, too.

Buttery Matte

Cone: 6

Color: white opaque
Surface: matte
Firing: oxidation

Talc	45.5
Petalite	54.5
Total:	100.00%

Also add:	
Bentonite	2.0

Midrange Majolica 1

Cone: 6

Color: opaque white
Surface: shiny or glossy
Firing: oxidation

Ferro frit 3124	33.3
Custer potash feldspar	56.4
Florida kaolin	10.3
Total:	100.00%

Also add:	
Zircopax	12.0

Comments:

Add 1 Tbsp. liquid CMC syrup per 500 gram batch to harden raw glaze surface (syrup is 1 Tbsp. dry CMC to a pint of hot water—shake, let sit overnight).

Use with commercial translucent underglaze colors or commercial stains mixed with this glaze (40% stain, 60% glaze base) watered down to a thin color wash and brushed over raw glaze.

Midrange Majolica 2

Cone: 6

Color: opaque white
Surface: shiny or glossy
Firing: oxidation or reduction

Gerstley borate	5.3
Nepheline syenite	33.1
Florida kaolin	4.6
Dolomite	2.3
Whiting	9.4
Flint	45.3
Totals:	100.0%

Also add:
Zircopax	12.0
Bentonite	3.0
Epsom salts	0.2

Comments:
Add 1/2 cup of CMC gum solution per 5-gallon bucket of glaze to make the surface harder and less prone to scuffing and powdering off when painting. CMC gum solution: put 1 heaping Tbsp. of CMC powder into about a pint of hot water in a jar with a tight-fitting lid. Shake well and let stand overnight to hydrate the CMC. Shake again before using.

Almost boron free and good for stain colors that are subject to dissolving in boron glazes. Very stable, does not move during firing unless quite thick. Will crawl slightly if very thick. Applies well either by dipping or brushing. Use with commercial translucent underglaze colors or commercial stains mixed with this glaze (40% stain, 60% glaze base) watered down to a thin color wash and brushed over raw glaze.

Other color possibilities, added directly to the glaze for solid colors:

Dark blue green: 2% cobalt carbonate + 3% chrome oxide + 2% black iron oxide
Various colors: 3–12% commercial stain

Iron Red Glaze

Cone: 6

Color: semi-opaque red brown
Surface texture: shiny or glossy
Firing: oxidation

Laguna borate	34.5
Kona F-4 soda feldspar	18.3
Talc	15.7
Silica	30.7
Whiting	0.8
Totals:	100.0%

Also add:
Red iron oxide	15.0
Bentonite	2.0

Clear

Cone: 5–6

Color: transparent clear
Surface texture: shiny glossy
Firing: oxidation

Laguna borate	51.8
Florida kaolin	23.6
Flint	22.2
Dolomite	2.1
Magnesium carbonate	0.3
Totals:	100.0%

Porcelain and Stoneware Glazes: Cones 8–11

Satin Black

Cone: 10

Color: opaque black
Surface: satin matte
Firing: reduction

RedArt clay	46.8
Nepheline syenite	13.6
Talc	18.8
Strontium carbonate	7.8
Florida kaolin	3.6
Whiting	6.6
Flint	2.8
Total	100.0%

Also add:
Red iron oxide	1.0
Cobalt oxide	2.0
Chrome oxide	2.0

Comments:
This is a great black glaze, very smooth and satiny. Putting clear over results in a beautiful dark blue green. Ball milling may be necessary if the strontium is grainy—mill 2 to 4 hours for a smoother glaze—avoid overmilling. This glaze also works well in salt or soda firings.

Blue Celadon

Cone: 10–11

Color: transparent blue green
Surface: shiny or glossy
Firing: reduction

Potash feldspar	43.9
Grolleg	13.0
Whiting	15.6
Flint	25.1
Magnesium carbonate	2.4
Total	100.0%

Also add:
Red iron oxide	1.0

Comments:
Very blue if made with Grolleg kaolin as specified. May craze over some clays.

Celadon

Cone: 10

Color: translucent light green
Surface: shiny or glossy
Firing: reduction

Custer potash feldspar	30.4
Tennessee ball clay	6.9
Florida kaolin	12.0
Talc	3.3
Whiting	17.0
Flint	30.4
Total	100.0%

Also add:
Red iron oxide	0.5
Bentonite	1.0
Epsom salts	0.15

Comments:
Could be made with 1% red iron oxide for a slightly darker green. Use Grolleg kaolin for all the clay for a bluer celadon.

Clear

Cone: 9–10

Color: transparent clear
Surface: shiny or glossy
Firing: oxidation or reduction

Custer potash feldspar	39.9
Whiting	16.5
Florida kaolin	11.8
Flint	31.8
Total	100.0%

Also add:
Bentonite	1.0
Epsom salts	0.15

Comments:
This glaze is stable, clear and light gray over white stoneware with no appreciable greenish hue.

Matte White

Cone: 9–10

Color: white
Surface: matte
Firing: reduction

Custer potash feldspar	48.2
Florida kaolin	25.6
Dolomite	22.7
Whiting	3.5
Total	100.0%

Chrome Green

Cone: 10

Color: very, very green
Surface: shiny
Firing: oxidation or reduction

Custer potash feldspar	75.0
Whiting	15.0
Silica	5.0
Florida kaolin	5.0
Total	100.0%

Also add:
Chrome oxide	4.0
Bentonite	2.0

Comments:
Intense green—use sparingly. This glaze can be applied quite thickly or slip trailed over another glaze without much danger of running. Trailed in a thin line over an iron red glaze, it leaves a line with a green center, black edges, and causes silvery crystals to form nearby in the iron red. Without the chrome it is much more fluid.

Magnesia Matte Purple

Cone: 10

Color: white base/purple with cobalt added
Surface: waxy semi-matte
Firing: reduction

Potash feldspar	43.8
Gerstley borate	12.8
Talc	15.0
Flint	21.4
Dolomite	7.0
Total	100.0%

Also add:
Cobalt carbonate	1.5

Comments:
This glaze is a nice waxy matte white without the cobalt carbonate. The glaze turns lavender to purple with a cobalt carbonate over-spray or with the addition of 1–2% cobalt carbonate to the glaze.

Iron Red

Cone: 9–10

Color: reddish brown
Surface: shiny to semi-gloss
Firing: reduction

Potash feldspar	48.7
Silica	21.7
Kaolin	6.3
Talc	6.3
Whiting	7.1
Bone ash	9.9
Total	100.0%

Also add:
Red iron oxide	10.8
Bentonite	1.5

Comments:
This is a nice, stable iron red glaze, really dependable. Oxidizing the kiln for the last half hour or more may help this glaze to turn red. Slight underfiring (cone 9) may result in a better red as well, along with somewhat lighter reduction (heavy reduction may favor darker red brown with black flecks).

Cranberry Red

Cone: 9, 10, 11

Color: translucent copper red
Surface: shiny or glossy
Firing: reduction

Custer potash feldspar	73.8
Gerstley borate	10.2
Whiting	11.1
Flint	4.9
Total	100.0%

Also add:

Bentonite	1.0
Copper carbonate	0.3
Tin oxide	1.0
Epsom salts	0.15

Comments:
Pete Pinnell says: "This glaze works best if it's reduced early, beginning at cone 012 and continuing until cone 04. From then until cone 10 keep it in a light reduction. The exact color seems to depend primarily on how heavily it's reduced. Its different colors are distinct enough that one can use it as a measuring stick after the firing to judge the intensity of reduction."

Oxidation: glossy, crazed, very light green.

Neutral: clear (no color) crazed, slight pigskin (dimpling) on surface

Light reduction: very dark burgundy, almost black-heavy pig skinning on surface

Medium to heavy reduction: bright cherry red, semi-transparent, smooth glossy surface. Beautiful!

Heavy reduction: some blue appears, surface can mottle, or begin to take on a matte appearance – also quite nice.

Extremely heavy reduction: matte surface some bubbling, lots of blue mixed with the red.

Powder Blue

Cone: 9–10

Color: light blue–greenish when thin
Surface: shiny, glossy to mat when thin
Firing: reduction

Custer potash feldspar	63.5
Whiting	19.7
Kaolin	16.8
Total	100.0%

Also add:

Rutile	3.8
Cobalt carbonate	0.7
Bentonite	2.

Copper Green

Cone: 10

Color: green
Surface: glossy or shiny
Firing: reduction

Silica	17.5
Kentucky ball clay	10.9
Whiting	9.5
Custer potash feldspar	22.8
Dolomite	6.6
Barium carbonate	13.6
Kona F-4 soda feldspar	19.1
Total	100.0%

Also add:

Zircopax	8.0
Copper carbonate	2.7
Tin oxide	2.0

Comments:
This glaze runs badly if applied thickly. Try this glaze under a coat of clear for copper reds. In salt or soda firings it will go green and red, depending on the reduction. Also try with up to 6% copper carbonate for more black/green combination. Try adding more opacifier as well. A strontium carbonate substitution can be done (use 10.2% instead of the 13.6% barium carbonate), but the color will be greener, with less blue green.

Barium carbonate is highly toxic; avoid ingestion. Do not use on ware intended for use with food.

Fake Ash Drip

Cone: 10

Color: translucent
Surface: semi-mat, runny
Firing: oxidation or reduction

Custer potash feldspar	21.5
Florida kaolin	24.7
Silica	8.1
Talc	2.7
Whiting	43.0
Total	100.0%

Comments:
This glaze runs a lot! This is a rivulet, fake ash glaze – apply VERY thinly. Glaze should be mixed nearly as thin as milk for dipping. Good for accenting texture, over slip or slip trailing. Color variations: (Blue Drip: 1% cobalt carbonate, 1% nickel carbonate; or Yellow Drip: 1% red iron oxide, 5% rutile; or commercial stains if used in oxidation). Good on porcelain. Made up with ball clay this would work well as a once-fired slip glaze on greenware. Earthenware clays could also be used as part of the clay batch to add a greenish iron color to the glaze.

Shino

Cone: 9, 10, 11

Color: semi-opaque white to orange brown
Surface: shiny glossy
Firing: reduction

Spodumene, Australian	10.9
Soda feldspar	42.9
Nepheline syenite	14.7
Kentucky ball clay	8.2
Florida kaolin	16.7
Soda ash	6.6
Total:	100.0%

Comments:
DO NOT APPLY OVER MOST GLAZES – it bubbles badly. Okay under

other glazes. Apply thin for orange/brown, medium to thick for white. Fire in heavy reduction starting early in the firing to get carbon-trapping effects. This glaze melts early in the firing, so reduction must start by 08-07 or earlier for classic Shino color and surface.

Temmoku

Cone: 10–11

Color: brown/black
Surface: shiny
Firing: reduction

Custer potash feldspar	47.9
Whiting	13.7
Silica	26.7
Kaolin	11.7
Total	100.0%

Also add:
Red iron oxide	8.5

Comments:
This is a really dependable temmoku glaze. Black when thick, brown when thinner. Works well in salt and soda, where it turns runny yellow-green where it gets more of the vapor glaze hitting it.

Rutile Blue

Cone: 10

Color: blue/brown
Surface: shiny
Firing: reduction

Potash feldspar	41.6
Flint	26.7
Kentucky ball clay	12.9
Whiting	17.8
Bentonite	1.0
Total	100.0%

Also add:
Red iron oxide	4.0
Rutile	4.0

Comments:
A classic iron blue glaze. This glaze is brown if very thin, orange-brown if thin, blue with purplish overtones when thicker. Runs badly if very thick.

Yellow Salt

Cone: 9, 10, 11

Color: opaque light yellow
Surface: glossy to matte
Firing: reduction and Salt/Soda

Nepheline syenite	60.5
Dolomite	20.1
Zircopax	15.3
Kentucky ball clay	4.1
Total	100.0%

Also add:
Red iron oxide	1.0
Bentonite	3.5

Comments:
This glaze works well as a liner glaze in salt or soda firings. Add approximately a tablespoon or two of Epsom salts dissolved in a little warm water to each bucket of glaze to help keep the glaze suspended.

Very nice on stoneware clays, too, in reduction Firing: (no salt) where it goes a beautiful yellow matte with medium to thin application. Too thick and it goes shiny! Without the iron it makes a nice gloss white.

Stable Base Glaze

Cone: 10

Color: semi-opaque
Surface: semi-gloss
Firing: reduction

Custer potash feldspar	35.0
Florida kaolin	28.3
Wollastonite	24.6
Flint	12.1
Total	100.0%

Comments:
This is a very stable, industrial-type base glaze, useful for a liner glaze or for a variety of colors.

Color variations to try are:

Blue-green: chrome oxide 0.6% + cobalt oxide 0.6%
Translucent blue: 1% cobalt carbonate
Cranberry red: 0.5% copper carbonate + 1% tin oxide
Black/brown: 8–10% red iron oxide
White: 7–10% zirconium opacifier

Slips and Special Glazes

Trailing Glaze

Cone: 10

Color: translucent white
Surface: shiny or glossy
Firing: oxidation or reduction

Custer potash feldspar	80.0
Florida kaolin	20.0
Total	100.0%

Comments:
This glaze is meant to be used as a trailed line of glaze rather than for application to an entire surface.

The glaze should be made up to the thickness of heavy cream to slightly thinner than yogurt to use as a trailing glaze over another glaze or by itself. It can be applied quite thickly and is stable, leaving a sharply defined line of glaze. Works best under a glaze, or over a stable glaze so the glaze line doesn't move, although interesting results could occur if it did.

If you use a syringe to apply this glaze, draw the liquid glaze into the syringe through the tip, rather than by pouring it into the plunger end. This way any glaze going into the syringe through the needle will also come out.

Colorants:
7% Rutile gives a nice peach color.
1% Cobalt carbonate gives a bright blue.

A combination of 1% cobalt oxide + 3% black iron oxide + 3% chrome oxide + 2% manganese dioxide gives a nice black.

4–6% Iron oxide gives a brown, but the lines will soften a bit more with the fluxing effect of the iron.

Large amounts of Chrome may matte the surface. Try Chrome Green (above) for a better dark green for glaze trailing.

Other Variations:
Try this same glaze with any other clay instead of the Florida kaolin. Some good possibilities are:

Neuman Red Clay (a red earthenware) gives a nice red-brown over a glaze and a great red orange line under Shino.

Barnard Clay gives a Mashiko slip type brown—this might even make an interesting brown glaze.

Albany Slip gives a light green celadon colored glaze.

Using soda spar or nepheline syenite instead of Custer feldspar works fine, but the result is more opaque. Soda spar might be preferable to potash in some cases.

By formulating it with 85% Nepheline syenite + 5% talc + 10% Florida kaolin it works at cone 6 in oxidation.

Crawl/Texture glaze

Cone: 8–10

Color: white
Surface: textured crawl/lichen
Firing: oxidation or reduction

Nepheline syenite	55.0
Magnesium carbonate	45.0
Total	100.0%

Comments:
Use over a contrasting color slip or stiff glaze for texture effects. Especially good over textured clay surfaces.

Base Slip

Cone: 9–10

Color: opaque white, add colors
Surface: slip or engobe
Firing: oxidation or reduction

Florida kaolin	20.0
Ball clay	35.0
Custer potash feldspar	25.0
Flint	10.0
Whiting	5.0
Ferro Frit 3124	5.0
Total	100.0%

Also add:
Zircopax	5.0
Bentonite	2.0

White Slip

Cone: 9–10

Color: white
Surface: slip
Firing: oxidation or reduction

Kentucky ball clay	35.0
Florida kaolin	20.0
Nepheline syenite	15.0
Whiting	5.0
Silica	25.0
Total	100.0%

Also add:
Borax	5.0

Comments:
For lower temperatures (midrange, lowfire) substitute a calcium-borate frit for part or all of the nepheline syenite.

Slip Colors:
Additions for color in the above slips/engobes. Colors will vary with glazes used, firing types, and temperatures.

Iron Red/Black—
15% red iron oxide
Honey—
15% rutile
Green-to-red—
5% copper carbonate

(Note: for green-red slip omit the zircopax in base and add 3% tin oxide)

Green—
4% chrome oxide
(Note: adding 5% leadless lowfire frit may help color with chrome green)
Blue-Green—
3% chrome
+2% cobalt carbonate
Blue—
3% cobalt carbonate
Black—
omit Zircopax in base and add
1% manganese Dioxide
+7% black iron oxide
+2% cobalt carbonate
+3% chrome oxide
or 15% commercial black stain
White—
add 10% MORE Zircopax to base
In oxidation only:
Various colors—
commercial body stain 5–15%

Crackle Slip

Cone: 10

Color: white
Surface: crackle slip texture
Firing: oxidation or reduction

Florida kaolin	20.0
Calcined kaolin	20.0
Kentucky ball clay	20.0
Custer potash feldspar	26.6
Zircopax	6.7
Borax	6.7
Total	100.0 %

Comments:
Apply to bisqueware or on top of raw glaze for crackle texture. If used over glazes, works best with thick, viscous glazes that contain a lot of clay. May flake off or cause crawling—if so try rebisquing the piece after applying slip.

Flashing Slip

Cone: 8, 9, 10

Color: opaque red orange brown
Surface: engobe
Firing: salt—soda or wood

Nepheline syenite	24.0
Florida kaolin	44.0
Calcined kaolin	30.0
Red earthenware clay	2.0
Total	100.0%

Comments:

A useful slip to apply on the unglazed areas of ware to be fired in a soda, salt, or wood kiln. It can be applied to green-ware, or very thinly to dampened bisque. Where the flame and fluxes from soda or wood firing hit the slip it gets slightly darker and turns a lovely orange-red color. In other firings it will be very dry and off-white. Make it darker or lighter by varying the amount of red earthenware clay. Higher firing (higher alumina) red earthenware clays are best.

Crystalline Glazes

These glazes require a special firing and cooling cycle to fully attain their crystalline surfaces. Cooling is especially important, as the temperature in the kiln must be held for up to several hours at a point 100–300°F (56–167°C) below the final firing temperature to allow the crystals to form. This type of glaze is also very fluid, so special bases must be made to catch the excess glaze as it runs off the pottery. (See the section on crystalline glazes in Chapter 9.)

Aventurine

Cone: 07–05

Color: red-brown with crystals
Surface: crystalline
Firing: oxidation

Borax	45.7
Barium carbonate	2.6
Boric acid	3.3
Kaolin	1.7
Flint	46.7
Red iron oxide	17.7
Total	100.0%

(Contains soluble ingredients: grind and use immediately or frit without the clay.)

Zinc Crystal

Cone: 3–4

Surface: crystalline
Firing: oxidation

Soda ash	13.4
Boric acid	15.5
Zinc oxide	22.2
Flint	42.8
Ball clay	6.1
Rutile	6.7
Total	100.0%

(Contains soluble ingredients: grind and use immediately or frit without the clay.)

Crystalline Glaze Base

Cone: 9

Color: base white, various
Surface: Crystalline
Firing: oxidation

Frit 3110	49.5
Flint	17.8
Titanium dioxide	7.9
Zinc oxide	24.8
Total	100.0%

Colors:
Light green—2% copper carbonate; Darker greenish blue—2% copper carbonate + 0.5% cobalt carbonate; White with yellowish crystals—3% Rutile; Blue crystals on beige background—1% nickel carbonate; Blue gray crystals on an orange background—3% manganese dioxide + 0.5% cobalt carbonate; Purply brown—5% manganese dioxide.

Comments:
This glaze runs! Use typical crystal glaze catch basins under each piece. Fire quickly to cone 9, cool 300°F to approximately 2100°F and soak for 3–4 hours at this temperature, then let kiln cool normally.

CLAY BODIES

The clay body preferred by the studio potter is often quite different from that used by an industrial ceramics manufacturer. For slip casting or jiggering, a uniformity of texture is necessary, for obvious technical reasons. Similarly, any impurities imparting color to the body are undesirable. Therefore, bodies used in commercial production are carefully selected, ground, and refined. Plasticity is of minor importance, and, since it is associated with high shrinkage rates, it is often avoided.

Because the volume of clay used in the school studio will normally be measured in tons per year, both the initial cost and the shipping charges are important. Thus, clay that can be bought locally has a decided advantage in cost if it meets your needs, even if it needs small additions. For the potter willing to do a little more work, and one with the proper equipment, a truckload of raw clay can sometimes be purchased reasonably from a local brick or tile works. Local supplies of earthenware and plastic fire-clays are easily available in the United States, particularly in the Midwest where many clays are mined. Since clays are widely used in cement, plaster, and mortar mixtures, they are competitively priced and generally quite reasonable.

Many clays will not be very plastic unless they are aged. Adding 4 to 5 percent bentonite, which is extremely plastic, will usually render a short clay more workable. Often two or more clays that alone are not suitable can be mixed together to form a good body. Only experimentation will indicate the necessary changes. Cream-colored clays can be rendered more plastic by the addition of ball clays. Adding a half cup (0.1 liter) or more of vinegar (a mild acid) per 100 lbs. (45.4 kg) to the clay batch with the water may temporarily counteract the slight deflocculation that can come from sodium leaching from feldspars, nepheline syenite, or frits.

Many contemporary potters prefer to buy prepackaged, ready-to-use wet clay, leaving the processing to the clay supplier. The trade off for the savings in time spent processing clay is a higher cost of clay and less ability to vary the clay body to fit ones exact needs.

With any source of clay, glazes must be carefully adjusted to fit the body. Testing one's glazes with each new batch of clay is highly advisable, especially if you buy plastic clay in ready-to-use form.

Earthenware Bodies

Earthenware clays are plentiful over much of the earth's surface, and there are many brick and tile factories that also sell bagged earthenware clays. Shale clays with coarse particles will cause trouble unless they are run through a sieve of from 15 to 20 meshes per inch (2.54 cm). Some earthenware clays contain soluble sulfates, which will form a whitish scum on the fired ware; however, the addition of 0.25 to 2 percent barium carbonate will eliminate this fault. Barium carbonate is the only material that really cures this problem. Unfortunately barium carbonate is toxic and may also cause a skin rash with prolonged contact. Luckily very little is needed to cure scumming, and once the barium has reacted with the soluble sulfates it forms barium sulfate which is not toxic and less hazardous. Obviously only enough barium carbonate should be added to just cure the scumming problem. An excess is not advisable. A better cure might be to locate sources of earthenware clays which are not prone to scumming.

Talc is often used in low-fire whiteware bodies as a source of both flux and silica, as it has less of a negative effect on plasticity than other flux sources like frits. Feldspar, nepheline syenite, frits, and plastic vitrox are also added to various bodies to contribute fluxing qualities. Earthenware can be made very dense and strong with careful formulation and testing. Consistent clay composition and firing, and careful testing of glazes may be needed to produce uncrazed functional ware in the earthenware range.

Stoneware and Porcelain Bodies

Stoneware and porcelain bodies are usually compounded from several ingredients. In fact, it is quite rare for a single clay to satisfy all throwing and firing requirements. There is no clay that, by itself, will make a porcelain body. Oriental porcelain is made from one or two clay-like minerals that are fairly plastic. Since nothing in the Western world compares with Chinese petuntze, porcelain bodies in the rest of the world must be compounded from clay and various minerals. Ball clays will add plasticity to porcelains, but usually make a very white porcelain less white and less translucent.

Both stoneware and porcelain will typically form hard, vitrified or nearly vitreous bodies at about cone 10. The major difference between the two is that stoneware contains some impurities, chiefly iron, which give it a gray or tan color. Porcelain is more vitreous, white, and glassy. Both stoneware and porcelain bodies are compounded for varying temperatures and, in the case of porcelain, for different degrees of translucency and whiteness. Greater translucency is usually obtained by increasing the feldspar, which has the accompanying disadvantage of an increase in warpage when the ware is fired. Porcelain bodies with large amounts of ball clay may have reduced translucence. Adding fine porcelain grog (molochite) may help minimize the problems inherent in producing large porcelain forms.

Fireclay and stoneware clays differ from pure clay (kaolin) chiefly in that they contain various fluxes and impurities that lower the fusion point and impart a gray, tan, or buff color. Fireclays, which have a more universal industrial use, can be often substituted for stoneware. Some fireclays are very plastic and fine enough for throwing. However, fireclays often contain some iron impurities, which give the body a flecked appearance, and this can sometimes create unwanted glaze flaws. Earthenware clays may even be added to some stoneware bodies in small quantities to add color, but they need to be carefully blended into the clays to avoid firing problems from the inclusion of these low temperature clays.

Casting Slips

Most clays can be deflocculated to use for slip casting, although some red earthenware clays can present problems or require special deflocculants. A few recipes for white clays and porcelains are included hereafter as examples.

Suggested Clay Bodies

The following recipes for clay bodies are included merely as recommendations, since it usually will be necessary to vary these recipes depending upon the raw materials available locally. Substitutions of similar clays (a local plastic kaolin for EPK, a local fireclay for Hawthorn Bond or Greenstripe, etc.) will usually work well as a starting point. Test all new clay bodies with your glazes to make sure they work together favorably.

White Earthenware Clay

Cone: 06–04

Color: white
Uses: hand-building & throwing
Firing: oxidation

OM-4 ball clay	50.0
Talc	50.0
Total:	100.0%

Comments:
Adding more ball clay yields a higher firing temperature – try a 60% ball clay/40% talc combination for up to about cone 1. Adding a handful of chopped nylon fiber to a 100–200 lb. (45.4–90.7 kg) batch helps in hand-building with this clay.

Red Earthenware 1

Cone: 04

Color: red
Uses: hand-building & throwing
Firing: oxidation or reduction

Ranger Red clay	40.0
RedArt clay	25.0
Hawthorne Bond clay	20.0
OM-4 ball clay	10.0
Talc	5.0
Total:	100.0%

Also add:
Bentonite	1.0
Barium carbonate	0.5

Comments:
This is a smooth, plastic throwing body.

Red Earthenware 2

Cone: 04–01

Color: red to red brown
Uses: hand-building & throwing
Firing: oxidation

RedArt clay	44.0
Fireclay	44.0
Talc	8.0
Red iron oxide	4.0
Total:	100.0%

Also add:
Silica sand or grog	8.0
Barium carbonate	0.5

Comments:
For heavy sculpture add more grog using a mixture of fine, medium and coarse sizes. Add barium carbonate to prevent scumming. If barium carbonate is not added for safety reasons there is a high probability of scumming.

Egyptian Paste

Cone: 06–05

Color: turquoise
Uses: hand-building
Firing: oxidation

Kona F-4 feldspar	37.4
Soda ash	6.1
Sodium bicarbonate	6.1
EPK	11.5
Flint	37.4
Bentonite	1.5
Total:	100.0%

Colorants for Egyptian Paste

purple-blue:	0.7% cobalt carbonate
light green:	0.5% copper carbonate
turquoise:	3.0% copper carbonate
yellow:	7.0% yellow stain

Comments:
For other colors: add various colorants or glaze/body stains in amounts typical for slip or engobe colors. Dry slowly on screen wire to allow a crust of soda to build up on all surfaces. Speed of drying may affect glaze. Avoid handling during drying process. Load carefully into kiln to avoid scraping off crust of soda that forms the glaze. Fire on stilts or place beads on Nichrome wire.

Raku

Cone: 08–06

Color: white
Uses: hand-building & throwing
Firing: Raku

Kentucky ball clay	20.0
Fireclay	62.0
Talc	18.0
Total:	100.0%

Also add:
Silica sand	10.0

Comments:
Bisque firing Raku bodies to only cone 010-08 will keep them more porous and minimize breakage when Raku firing larger forms.

Midrange Porcelain

Cone: 6

Color: white
Uses: hand-building & throwing
Firing: oxidation or reduction

#6 tile clay	48.60
Custer potash feldspar	30.70
Silica	13.80
Pyrophyllite	4.60
Bentonite	2.30
Total:	100.00%

Throwing Body

Cone: 6

Color: light to medium warm brown
Uses: throwing
Firing: reduction

Goldart clay	42.2
Kentucky ball clay	31.5
Ocmulgee clay	15.8
Nepheline syenite	10.5
Total:	100.0%

Also add:

30 mesh grog	5.5

Comments:
Throws well, dense. RedArt can be substituted for Ocmulgee, but will give a darker color and lower plasticity.

White Stoneware

Cone: 6

Color: off white
Uses: hand-building & throwing
Firing: oxidation or reduction

#6 tile clay	20.0
EPK	15.0
Kentucky ball clay	20.0
Goldart clay	25.0
Nepheline syenite	10.0
Flint	10.0
Total:	100.0%

Also add:

Bentonite	2.0

Comments:
Throws well, plastic, dense, smooth.

Midrange Casting Slip

Cone: 5–6

Color: white porcelain
Uses: slip casting
Firing: oxidation or reduction

Grolleg kaolin	15.0
Tile #6 clay	15.0
EPK	3.5
OM-4 ball clay	10.0
Flint	20.0
Ferro Frit 3124	1.5
Pyrophyllite	5.0
Nepheline syenite	30.0
Total:	100.0%

Also add:

water	35.0
Darvan #7	0.35

Comments:
Substitute Velvacast kaolin instead of Tile #6 for a less plastic body. Mix the Darvan into hot water before adding dry clays.

Midrange Casting Slip 2

Cone: 3–6

Color: white
Uses: slip casting
Firing: oxidation

EPK	33.4
Ball clay	23.8
Potash feldspar	19.0
Flint	19.0
Nepheline syenite	4.8
Total:	100.0%

Also add:

Sodium silicate	0.5
Water	35.0

Stoneware 1

Cone: 9, 10, 11

Color: tan in reduction, beige in oxidation.
Uses: hand-building & throwing
Firing: all firings

Cedar Heights GoldArt	42.5
AP Green fireclay	42.5
OM-4 ball clay	10.0
Potash feldspar	5.0
Total:	100.0%

Also add:

Grog, fine to medium	3.0

Comments:
Good throwing body. Glazes nicely at cone 8 to 10 in salt or soda. Reasonably good as a raku body if bisque fired to cone 010. Otherwise bisque fire to cone 05 to eliminate the sulfur problems such as pinholing in glazes. For large sculpture add 20–30% more grog using a mixture of fine, medium and coarse sizes.

Stoneware 2

Cone: 9–10

Color: tan to toasty brown
Uses: hand-building & throwing
Firing: oxidation or reduction

Greenstripe fireclay	40.0
Lincoln 60 fireclay	40.0
OM-4 ball clay	10.0
Neuman Red clay	4.0
Potash feldspar	6.0
Total:	100.0%

Also add:

Grog, fine to medium	5.0

Comments:
Good all-around clay body. Leave out the red clay for a lighter color.

White Stoneware

Cone: 10–11

Color: off white, light gray
Uses: hand-building & throwing
Firing: oxidation or reduction

#6 tile clay	20.0
EPK	20.0
OM-4 ball clay	20.0
Flint	8.0
Potash feldspar	24.0
Pyrax pyrophyllite	8.0
Total:	100.0%

Comments:
Compatible with some stoneware bodies
for laminated clay, etc.

Grolleg Porcelain

Cone: 9–10

Color: very white
Uses: hand-building & throwing
Firing: oxidation or reduction

Grolleg kaolin	50.0
Potash feldspar	25.0
Flint, 325 mesh	25.0
Total:	100.0%

Also add:
Bentonite	4.0

Comments:
This clay is very white and translucent at
cone 10 if thin and a white bentonite is
used. It is a very plastic porcelain with
high shrinkage: around 18% at cone 10.
Slake bentonite in warm/hot water be-
fore adding to mix or mix thoroughly
with dry powdered clay to avoid lumps
of bentonite. Substituting pyrophyllite
for about half of the silica may help to
minimize warping and slumping.

Tile Clay Porcelain

Cone: 10–11

Color: off white, light gray
Uses: hand-building & throwing
Firing: oxidation or reduction

#6 tile clay	38.0
OM-4 ball clay	20.0
Flint	19.0
Potash feldspar	23.0
Total:	100.0%

Comments:
This clay is compatible with some
stoneware bodies for laminated clay, etc.
Not nearly as white or as plastic as the
Grolleg porcelain, but the shrinkage is a
lot lower and the clay more forgiving if
overfired.

Wood-fire Body

Cone: 10–11

Color: off white, light gray
Uses: hand-building & throwing
Firing: oxidation or reduction

#6 tile clay	18.0
EPK	18.0
Kentucky ball clay	18.0
Flint, 325 mesh	5.0
Custer potash feldspar	22.0
Pyrophyllite	14.0
Neuman Red clay	5.0
Total:	100.0%

Also add:
Fine grog or molochite	10.0

Comments:
Shows tan to orange-red flashing from
flame in soda/salt or wood firing. Will
go light gray in salt/soda if it gets much
glaze.

Wood-Soda Firing Clay

Cone: 10–11

Color: off white, light gray
Uses: throwing
Firing: wood/soda/salt

#6 tile clay	25.0
OM-4 ball clay	20.0
Grolleg kaolin	25.0
G-200 potash feldspar	15.0
Pyrophyllite	5.0
Ocmulgee	2.0
Flint	8.0
Total:	100.0%

Also add:
200m molochite grog	2.0
30m molochite grog	3.0

Comments
Works well. Doubling the amount of
Ocmulgee will give a bit richer color and
darker flashing.

Basic Porcelain Casting Slip

Cone: 6–10

Color: white to light gray
Uses: slip casting
Firing: oxidation or reduction

Florida kaolin (EPK)	25.0
Kentucky ball clay	25.0
Potash feldspar	25.0
Silica	24.0
Whiting	1.0
Total:	100.0%

Also add:
Darvan #7	0.4
Soda ash	0.1
HOT water	48.0

Comments:
A dependable casting slip, not very
white, but plastic enough to allow some
manipulation after the cast comes out of
the mold. If the slip is a little thick when
mixed, add small amounts of water to
which Darvan has been added in the
same ratio as above. Depending on the
water and/or clay more water and/or de-
flocculant may be needed.

Works as a cone 6 body, but does not become vitreous at that temperature. Use nepheline syenite instead of feldspar to lower the firing temperature for use at the lower part of the temperature range. Always test the amount of deflocculant needed, as changes in materials and even the water used will affect the amount required.

Substituting Velvacast kaolin for some of the EPK will make a slip that comes out of the molds much easier, but which is much less plastic after casting.

Colorants for Clay Bodies and Slips

The oxides should be added to dry white stoneware or porcelain body ingredients, the mixture sieved, and enough water added to make a thick slurry. After the mixture has set up (or dried out slightly on a plaster bat) it should be wedged very well. As with other formulas, these should be tested in small batches.

A wide variety of clay body and slip colors are possible with commercial stains. Check that the stains are suitable for use as body stains. Not all commercial ceramic stains work well in a clay body, although many stains will work as both glaze and body stains. Most stains require firing in oxidation to hold their true color, but some may withstand light reduction, especially after the glaze has melted and sealed the surface.

Note that putting colorants into the clay body is an expensive option as the color is dispersed all the way through the clay. Applying color to the clay surface with a slip or engobe may be both a more affordable and safer method. Carefully read colorant safety information before preparing and handling colored clays. Rubber gloves may be appropriate when handling colored clays, especially when using raw colorants.

red	5–15% zirconium-encapsulated red stain
orange	5–15% zirconium-encapsulated orange stain
pink	8–10% commercial pink body stain
yellow	8–10% commercial yellow stain
yellow-tan	6–8% powdered rutile
black	8–10% commercial black stain
green	1–5% commercial green stain
lavender	5% commercial pink body stain
	0.5% cobalt carbonate
light blue	0.5–1% cobalt carbonate
dark blue	1–2% cobalt carbonate
brown	3–5% red iron oxide

SOURCES OF EQUIPMENT AND MATERIALS

Ceramic materials and tools are quite widely available in the United States, and indeed worldwide through the many suppliers who offer their products on the Internet. Quite frequently a discount will be allowed by the dealers to schools. The shipping costs of heavy ceramic materials can add greatly to the total price, so bargain prices far from home may not be as cost-effective once the shipping bill is paid. In case of damage, errors, or needed repairs, a local dealer is often of much greater assistance than a more distant source.

The price of clay, which seems so cheap by the pound or kilogram, mounts alarmingly for the enormous quantities used in the classroom. The shipping costs often total as much as three times the actual cost of the clay at the mine. Considerable savings result from quantity purchases. Several potters or even nearby schools can share in a large shipment, since the relative shipping cost for a single ton is much more than for twenty tons (18.04 metric tons). Fireclays have many industrial applications and are available at building-supply houses. Plastic fireclay is a suitable base for some types of stoneware body. Earthenware clays are often used commercially to make concrete more dense and waterproof. They may be sold under a trade name, but they are essentially clays suitable for both earthenware and stoneware bodies. Many earthenware clays are of a shale origin and need sieving (as may some fireclays to remove large chunks of contaminants), but if they are relatively inexpensive it may be worth the effort.

The public school teacher, often limited by time, cannot arrange the usual studio procedures, especially complex glaze formulation. It is expensive to buy the small packets or bottles of commercially pre-mixed lead-free glaze, but some of these glazes are available in larger sizes. These glazes usually have the added advantage of being certified nontoxic, which is an important factor in the public schools, especially for the early grades.

Frits in 100-pound (45.36-kg) lots are much more economical than buying small quantities of lowfire glazes, but there are advantages to the testing and formulation that have gone into a good commercial product, especially with low-fire glazes. Most frits fire to about cone 06, but the addition of 10 percent kaolin will increase adhesive properties and raise the maturing temperature to cone 04. Coloring oxides and stains can be purchased in 1- to 10-pound (0.45- to 4.54-kg) lots. Since these are used in relatively small amounts, the total cost per pound (kilogram) of mixing your own fritted glaze will be small. Because of the dangers resulting from lead in glazes, lead-free borosilicate frits must be used.

The suppliers which follow are listed by type of goods offered, although many will have a variety of supplies. No endorsement of any of these dealers is intended, and no warranty offered. Ask other local potters for their recommendations of the most reliable sources of materials for a reasonable price. As with many things, the cheapest source is not always the best. Given the relatively low price of the raw materials used for making pottery, and the large investment in time and firing costs, paying a little more for reliable clays and glazes is often well worth the small additional outlay.

Web sites and e-mail addresses are listed where available. Many more suppliers may now have their catalogs on Web sites. A simple Web search can save time in finding supplies and materials, or current addresses for businesses that have moved.

General Ceramic Supplies

(clays, chemicals, books, kilns, wheels, tools, equipment)

Aardvark Clay & Supplies, Inc.
1400 E. Pomona St.,
Santa Ana, CA 92705-4812
714-541-4157, FAX: 714-541-2021
www.ceramics.com/aardvark/

**American Art Clay Co., Inc.
(AMACO/Brent)**
4717 W. 16th Street,
Indianapolis, IN 46222-2598
800-374-1600, FAX: 317-248-9300
www.amaco.com

Annie's Mud Pie Shop
3130 Wasson Road,
Cincinnati, OH 45209
513-871-2529, FAX: 513-871-5576
annie@anniesmudpieshop.com
www.anniesmudpieshop.com

A.R.T. Studio Clay Co., Inc.
9320 Michigan Avenue,
Sturtevant, WI 53117-2425
800-323-0212, FAX: 262-884-4343
www.artclay.com

Axner Pottery
P.O. Box 621484,
Oviedo, FL 32762
800-843-7057, FAX: 407-365-5573
www.axner.com

Bracker's Good Earth Clays, Inc.
1831 E. 1450 Road,
Lawrence, KS 66044
888-822-1982, FAX: 785-841-8142
bracker-mail@brackers.com
www.brackers.com

Brickyard Ceramics & Crafts
4721 W. 16th Street,
Speedway, IN 46222
800-677-3289, FAX: 317-248-9300
www.brickyardceramics.com

Columbus Clay
1080 Chambers Rd.,
Columbus, OH 43212
614-488-9600, FAX: 614-488-9849
columbusclay@aol.com

Continental Clay Company
1101 Stinson Boulevard N.E.,
Minneapolis, MN 55413
800-432-CLAY, FAX: 612-331-9332
www.continentalclay.com

Corey Ceramic Supply
87 Messina Drive Dept. CM,
Braintree, MA 02184
781-848-2772

Cornell Studio Supply
8290 N. Dixie Drive,
Dayton, OH 45414
937-454-0357

Davens Ceramic Center
5076 Peachtree Road,
Atlanta, GA 30341
800-695-4805, FAX: 770-455-7012
davens@mindspring.com
davensceramiccenter.com

Del Val Potters Supply Co.
1230 East Mermaid Lane,
Wyndmoor, PA 19038
215-233-0655, FAX: 215-836-1740
delval@gateway.net

Georgies Ceramic and Clay Co.
756 NE Lombard,
Portland, OR 97211
800-999-2529, FAX: 503-283-1387
www.georgies.com

Great Lakes Clay and Supply Co.
120 South Lincoln Ave.,
Carpentersville, IL 60110
800-258-8796, FAX: 847-551-1083
greatclay@Greatclay.com
www.greatclay.com

Highwater Clays
236 Clingman Avenue,
Asheville, NC 28814
828-252-6033, FAX: 828-253-3853
clay@highwaterclays.com
www.highwaterclays.com

Kickwheel Pottery Supply, Inc.
6477 Peachtree Industrial Boulevard,
Atlanta, GA 30360
800-241-1895
kickwheel@aol.com
www.kickwheel.com

Laguna Clay Company
14400 Lomitas Avenue,
City of Industry, CA 91746
800-4-LAGUNA, FAX: 626-333-7694
info@lagunaclay.com
www.lagunaclay.com

Miami Clay Company
270 N.E. 183 Street,
Miami, FL 33179
800-651-4695 In FL, FAX: 305-652-8498
MiamiClayCo@aol.com
www.MiamiClay.com

Mid-South Ceramic Supply Co.
1230 4th Avenue North,
Nashville, TN 37208
615-242-0300, FAX: 615-244-3191
www.opulenceglaze.com

Mile Hi Ceramics
77 Lipan Street,
Denver, CO 80223
303-825-4570
www.milehiceramics.com

Minnesota Clay, USA
8001 Grand Avenue South,
Bloomington, MN 55420
800-CLAYUSA, FAX: 952-884-1820
www.mm.com/mnclayus

Plainsman Clays, Ltd
Box 1266, 702 Wood Street,
Medicine Hat, Alberta T1A 7M9 Canada
03-527-8535, FAX: 403-527-7508
plainsman@digitalfire.com
www.plainsmanclays.com

Sheffield Pottery, Inc.
U.S. Route 7 Box 399,
Sheffield, MA 01257
888-SPI-CLAY
www.sheffield-pottery.com

Standard Ceramic Supply Co.
P.O. Box 4435,
Pittsburgh, PA 15205
412-276-6333, FAX: 412-276-7124
www.standardceramic.com

Trinity Ceramic Supply, Inc.
9016 Diplomacy Row,
Dallas, TX 75247
214-631-0540, FAX: 214-637-6463
trincer@aol.com

Jack D. Wolfe Co.
2130 Bergen Street,
Brooklyn, NY 11233
718-495-2065

Kilns

Alpine
9320 Michigan Avenue,
Sturtevant, WI 53117
800-323-0212
www.artclay.com

Bailey Pottery Equipment Corp.
P.O. Box 1577,
Kingston, NY 12402
800-431-6067, FAX: 845-339-5530
BaileyPottery@earthlink.com
www.BaileyPottery.com

Bennett's Pottery Supply
431 Enterprise Street,
Ocoee, FL 34761
800-432-0074, FAX: 407-877-3559

Contemporary Kiln, Inc.
24C Galli Drive,
Novato, CA 94949
415-883-8921, FAX: 415-883-2435

Euclid's Elements
1120 Speers Road,
Oakville, Ontario L6L 2X4 Canada
800-296-5456, FAX: 905-849-0001
www.euclids.com

Geil Kilns Co.
1601 West Rosecrans Avenue,
Gardena, CA 90249
800-887-4345, FAX: 310-532-2471
geil@kilns.com
www.kilns.com

L&L Kiln Manufacturing, Inc.
P.O. Box 1898,
Boothwyn, PA 19061
888-684-3232, FAX: 610-558-3698
sales@hotkilns.com
www.hotkilns.com

Olsen Kiln Kits
60520 Manzanita #205,
Mountain Center, CA 92561
760-349-3291

Olympic Kilns
P.O. Box 1347,
4225 Thurmond Tanner Road,
Flowery Branch, GA 30542
800-241-4400, FAX: 770-967-1196
www.kilns-kilns.com

Paragon Industries, Inc.
2011 South Town East Blvd.,
Mesquite, TX 75149-1122
800-876-4328, FAX: 888-222-6450
paragonind@worldnet.att.net
www.paragonweb.com

Ward Burner Systems
P.O. Box 1086,
Dandridge, TN 37725
865-397-2914, FAX: 865-397-1253
wardnbrner@aol.com
www.wardburner.com

Kiln Elements

Duralite, Inc.
P.O. Box 188, 15 School Street,
Riverton, CT 06065
860-379-3113, FAX: 860-379-5879
heat@duralite.com
www.duralite.com

Euclid's Elements
1120 Speers Road,
Oakville, Ontario L6L 2X4 Canada
800-296-5456, FAX: 905-849-0001
www.euclids.com

Potters Wheels

Aardvark Clay & Supplies, Inc.
1400 E. Pomona St.,
Santa Ana, CA 92705-4812
714-541-4157

**American Art Clay Co., Inc.
(AMACO/Brent)**
4717 W. 16th Street,
Indianapolis, IN 46222-2598
800-374-1600, FAX: 317-248-9300
www.amaco.com

A.R.T. Studio Clay Co., Inc.
9320 Michigan Avenue,
Sturtevant, WI 53117-2425
800-323-0212, FAX: 262-884-4343
www.artclay.com

Axner Pottery
P.O. Box 621484,
Oviedo, FL 32762
800-843-7057, FAX: 407-365-5573
www.axner.com

Bailey Pottery Equipment Corp.
P.O. Box 1577,
Kingston, NY 12402
800-431-6067, FAX: 845-339-5530
BaileyPottery@earthlink.com
www.BaileyPottery.com

Bluebird Manufacturing, Inc.
P.O. Box 2307,
Fort Collins, CO 80522-2307
970-484-3243, FAX: 970-493-1408
info@bluebird-mfg.com
www.bluebird-mfg.com

Bracker's Good Earth Clays, Inc.
1831 E. 1450 Road,
Lawrence, KS 66044
888-822-1982, FAX: 785-841-8142
bracker-mail@brackers.com
www.brackers.com

Brickyard Ceramics & Crafts
4721 W. 16th Street,
Speedway, IN 46222
800-677-3289, FAX: 317-248-9300
www.brickyardceramics.com

Clayworld
Memphis, TN
800-242-6885
bpalmer@clayworld.com
www.clayworld.com

Columbus Clay
1080 Chambers Rd.,
Columbus, OH 43212
614-488-9600, FAX: 614-488-9849
columbusclay@aol.com

Continental Clay Company
1101 Stinson Boulevard N.E.,
Minneapolis, MN 55413
800-432-CLAY, FAX: 612-331-9332
www.continentalclay.com

Creative Industries
1946 John Towers Avenue,
El Cajon, CA 92020
800-748-5530, FAX: 619-449-1854
potwheel@creative-ind.com
www.creative-ind.com

Edmunds Design & Mfg.
315 North Lake Avenue Suite 403,
Duluth, MN 55806
218-723-4059
info@edmfg.com
www.edmfg.com

Georgies Ceramic and Clay Co.
756 NE Lombard,
Portland, OR 97211
800-999-2529, FAX: 503-283-1387
www.georgies.com

Great Lakes Clay and Supply Co.
120 South Lincoln Ave.,
Carpentersville, IL 60110
800-258-8796, FAX: 847-551-1083
greatclay@Greatclay.com
www.greatclay.com

Highwater Clays
236 Clingman Avenue,
Asheville, NC 28814
828-252-6033, FAX: 828-253-3853
clay@highwaterclays.com
www.highwaterclays.com

Kickwheel Pottery Supply, Inc.
6477 Peachtree Industrial Boulevard,
Atlanta, GA 30360
800-241-1895
kickwheel@aol.com
www.kickwheel.com

Laguna Clay Company
14400 Lomitas Avenue,
City of Industry, CA 91746
800-4-LAGUNA, FAX: 626-333-7694
info@lagunaclay.com
www.lagunaclay.com

Lockerbie Manufacturing Co.
P.O. Box 695,
Beaumont, CA 92223
800-350-5855, FAX: 909-845-4125
www.lockerbie.com

Mid-South Ceramic Supply Co.
1230 4th Avenue North,
Nashville, TN 37208
615-242-0300, FAX: 615-244-3191
www.opulenceglaze.com

Mile Hi Ceramics
77 Lipan Street,
Denver, CO 80223
303-825-4570
www.milehiceramics.com

Minnesota Clay, USA
8001 Grand Avenue South,
Bloomington, MN 55420
800-CLAYUSA, FAX: 952-884-1820
www.mm.com/mnclayus/

Nidec-Shimpo America Corp.
1701 Glenlake Avenue,
Itasca, IL 60143
800-237-7079, FAX: 630-924-0340
info@shimpoceramics.com
www.shimpoceramics.com

Soldner Pottery Equipment, Inc.
P.O. Box 90,
Aspen, CO 81612
970-925-3742

Thomas Stuart Wheels
P.O. Box 9699,
Denver, CO 80209
800-848-9565
www.thomasstuart.com

Trinity Ceramic Supply, Inc.
9016 Diplomacy Row,
Dallas, TX 75247
214-631-0540, FAX: 214-637-6463
trincer@aol.com

Jack D. Wolfe Co.
2130 Bergen Street,
Brooklyn, NY 11233
718-495-2065

Equipment and Tools

Aardvark Clay & Supplies, Inc.
1400 E. Pomona St.,
Santa Ana, CA 92705-4812
714-541-4157

Aftosa
1034 Ohio Avenue,
Richmond, CA 94804
800-231-0397, FAX: 510-233-3569
customerservice@aftosa.com
www.aftosa.com

**American Art Clay Co., Inc.
(AMACO/Brent)**
4717 W. 16th Street,
Indianapolis, IN 46222-2598
800-374-1600, FAX: 317-248-9300
www.amaco.com

A.R.T. Studio Clay Co., Inc.
9320 Michigan Avenue,
Sturtevant, WI 53117-2425
800-323-0212, FAX: 262-884-4343
www.artclay.com

Axner Pottery
P.O. Box 621484,
Oviedo, FL 32762
800-843-7057, FAX: 407-365-5573
www.axner.com

Bailey Pottery Equipment Corp.
P.O. Box 1577,
Kingston, NY 12402
800-431-6067, FAX: 845-339-5530
BaileyPottery@earthlink.com
www.BaileyPottery.com

Bluebird Manufacturing, Inc.
P.O. Box 2307,
Fort Collins, CO 80522-2307
970-484-3243, FAX: 970-493-1408
info@bluebird-mfg.com
www.bluebird-mfg.com

Bracker's Good Earth Clays, Inc.
1831 E. 1450 Road,
Lawrence, KS 66044
888-822-1982, FAX: 785-841-8142
bracker-mail@brackers.com
www.brackers.com

Brickyard Ceramics & Crafts
4721 W. 16th Street,
Speedway, IN 46222
800-677-3289, FAX: 317-248-9300
www.brickyardceramics.com

Clayworld
Memphis, TN
800-242-6885
bpalmer@clayworld.com
www.clayworld.com

Columbus Clay
1080 Chambers Rd.,
Columbus, OH 43212
614-488-9600, FAX: 614-488-9849
columbusclay@aol.com

Continental Clay Company
1101 Stinson Boulevard N.E.,
Minneapolis, MN 55413
800-432-CLAY, FAX: 612-331-9332
www.continentalclay.com

Dolan Tools
P.O. BOX 15161,
Scottsdale, AZ 85260
800-624-3127, FAX: 480-991-4509

Georgies Ceramic and Clay Co.
756 NE Lombard,
Portland, OR 97211
800-999-2529, FAX: 503-283-1387
www.georgies.com

Giffen Tec, Inc.
P.O. Box 4057,
629 Dixon Road,
Boulder, CO 80306
303-449-9142, FAX: 303-442-2997

Great Lakes Clay and Supply Co.
120 South Lincoln Ave.,
Carpentersville, IL 60110
800-258-8796, FAX: 847-551-1083
greatclay@Greatclay.com
www.greatclay.com

Highwater Clays
236 Clingman Avenue,
Asheville, NC 28814
828-252-6033, FAX: 828-253-3853
clay@highwaterclays.com
www.highwaterclays.com

Jiffy Mixer
4120 Tigris Way,
Riverside, CA 92503
800-560-2903
www.jiffymixer.com

Kickwheel Pottery Supply, Inc.
6477 Peachtree Industrial Boulevard,
Atlanta, GA 30360
800-241-1895
kickwheel@aol.com
www.kickwheel.com

Laguna Clay Company
14400 Lomitas Avenue,
City of Industry, CA 91746
800-4-LAGUNA, FAX: 626-333-7694
info@lagunaclay.com
www.lagunaclay.com

Miami Clay Company
270 N.E. 183 Street,
Miami, FL 33179
800-651-4695 In FL, FAX: 305-652-8498
MiamiClayCo@aol.com
www.MiamiClay.com

Mile Hi Ceramics
77 Lipan Street,
Denver, CO 80223
303-825-4570
www.milehiceramics.com

Minnesota Clay, USA
8001 Grand Avenue South,
Bloomington, MN 55420
800-CLAYUSA, FAX: 952-884-1820
www.mm.com/mnclayus/

North Star Equipment, Inc.
P.O. Box 189,
Cheney, WA 99004
800-231-7896, FAX: 800-447-3293
www.northstarequipment.com

Peter Pugger Manufacturing
12501 Orr Springs Road,
Ukiah, CA 95482
707-463-1333, FAX: 707-463-1333
www.peterpugger.com

Scott Creek Pottery
2636 Pioneer Way East,
Tacoma, WA 98404
800-939-8783
clayextruder@scottcreekpottery.com
www.scottcreekpottery.com

Soldner Pottery Equipment, Inc.
P.O. Box 90,
Aspen, CO 81612
970-925-3742

Trinity Ceramic Supply, Inc.
9016 Diplomacy Row,
Dallas, TX 75247
214-631-0540, FAX: 214-637-6463
trincer@aol.com

Jack D. Wolfe Co.
2130 Bergen Street,
Brooklyn, NY 11233
718-495-2065

Chemicals, Clays, and Refractories

Check these Web sites for current product information.

**Cedar Heights Clay Company
(a RESCO company)**
POB 295
Oak Hill, OH 45656
614-682-7794
www.rescoprod.com

**Feldspar Corporation–feldspars
and EPK**
www.zemex.com/minerals/

Ferro Corporation–frits and stains
www.ferro.com

**GerstleyBorate–information on this
changing product**
www.gerstleyborate.com

**Kentucky-Tennessee Clay Company–ball
clays**
www.ktclay.com

**Pacer Corporation–makers of
Custer Feldspar**
www.pacerminerals.com

**R. T. Vanderbilt–a variety of
ceramic minerals**
www.rtvanderbilt.com

United Clays–a variety of clays
www.unitedclays.com

**Searchable database of refractories
suppliers at:**
Refractoryonline.com

International Suppliers

These suppliers are all on the Web for easy access:

Clayworks Australia
Dandenong, Victoria, Australia
www.ozemail.com.au/~claywork

Colorantes Ceramicos Lahuerta, S.L.
Valencia, Spain
www.lahuerta.com

Potterycrafts Ltd
Stoke on Trent, Staffordshire,
United Kingdom
www.potterycrafts.co.uk

Scarva Pottery Supplies
Banbridge Northern Ireland
www.scarvapottery.com

Clayman UK
Chichester, West Sussex United Kingdom
www.the-clayman.co.uk

Walker Ceramics
Croydon, Victoria, Australia
www.walkerceramics.com.au

Glazes

Duncan Enterprises
5673 East Shields Avenue,
Fresno, CA 93727
800-237-2642
www.duncanceramics.com

Campbell's Ceramic Supply, Inc.
4231 Carolina Avenue,
Richmond, VA 23222
800-657-7222, FAX: 804-329-1439
www.claysupply.com

Gare Incorporated
165 Rosemont Street,
Haverhill, MA 1830 USA
978-373-9131, FAX: 978-372-9432
www.gare.com

Mayco Colors
Coloramics, 4077 Weaver Court South,
Hilliard, OH 43026 USA
www.maycocolors.com

Spectrum Glazes
P.O. Box 874,
Lewiston, NY 14092
800-970-1970
info@spectrumglazes.com
www.spectrumglazes.com

Decals

Ceramic Decals Inc
515 E Washington St,
Colorado Springs, CO 80907
719-391-4821, FAX: 719-471-2932
www.fineartweb.com/klm

Har-Bon Ceramics & Decals
24475 US 23 South,
Presque Isle, MI 49777 USA
989-595-2463, FAX: 989-595-2326
www.harbon.com

Wise Screenprint, Inc.
1009 Valley Street,
Dayton, OH 45404
888-660-WISE, FAX: 937-223-1115

Glaze Software

There are several programs available. Some are easier to use than others. More information about all of those listed is available on their Web sites. A few of the best programs are:

Ceramis
USA, Windows shareware.
www.ceramis.com

Glaze Workbook
Great Britain, glaze calculation templates for Microsoft Excel for Macintosh and PCs.
www.dhpot.demon.co.uk

HyperGlaze™
USA, easy-to-use, but powerful glaze software for Macintosh computers.
HyperGlaze@aol.com
members.aol.com/hyperglaze/

Matrix
New Zealand, Glaze calculation software for Windows on PCs.
www.matrix2000.co.nz

GlazChem
USA, shareware glaze calculation software for Windows on PCs
www.dinoclay.com

Books

American Ceramic Society
P.O. Box 6136,
Westerville, OH 43086-6136
614-794-5890, FAX: 614-794-5892
www.ceramics.org

The Potters Shop
31 Thorpe Road,
Needham, MA 02494
781-449-7687, FAX: 781-449-9098
Search the Web for new and used books:
www.bookfinder.com can find books from many vendors.

Organizations

American Ceramic Society
P.O. Box 6136,
Westerville, OH 43086-6136
614-794-5890, FAX: 614-794-5892
www.ceramics.org

American Crafts Council
72 Spring St.,
New York, NY 10012-4019
212-274-0630, FAX: 212-274-0650
www.craftcouncil.org

CERF
(Craft Emergency Relief Fund),
P.O. Box 838,
Montpelier, VT 05601
802-229-2306
info@craftemergency.org
www.craftemergency.org
Provides funding for artists with emergencies (flood, fire, health, etc.).

National Council on Education for the Ceramic Arts (NCECA)
77 Erie Village Square,
Erie, CO 80516
303-828-2811
office@nceca.net
www.nceca.net

Web Links and Portals for Ceramics

These sites are good starting places for exploring the Web for ceramics. Most have lots of links to other ceramics sites, and some, notably the CeramicsWeb, have educational materials and searchable databases of glaze recipes, material analyses, and Web links. In addition, most of the manufacturers and suppliers' Web sites (above) have lots of information on safety and how to use their products.

CeramicsWeb
San Diego, California USA
art.sdsu.edu/ceramicsweb/

Critical Ceramics
(an online ceramics magazine)
www.criticalceramics.org

Ceramic and More
Verona, Italy
www.ceramicandmore.com

Ceramics and Industrial Minerals
www.ceramics.com

www.ceramique.com
France
www.ceramique.com

ceramics.about.com
ceramics.about.com

BIBLIOGRAPHY

The past few years have seen an explosion in the number of books on ceramics, far too many to list even all of the best ones here. Only a selected few are listed below along with many classics. Some may be out of print, but are still available through libraries. Even with the advent of the Internet and its wealth of information, much of the best information is still available in books.

References on Technique

Baird, Daryl E. *The Extruder Book*. American Ceramic Society, 2000. A thorough exploration of extruded ceramics and extruder techniques.

Birks, Tony. *The Complete Potter's Companion*. Revised ed. Little, Brown, and Co. 1993. Full-color handbook covering the processes behind the potter's art.

Burleson, Mark. *The Ceramic Glaze Handbook: Materials, Techniques, Formulas*, Lark Books, 2001. A wide range of useful information on glazes. Well illustrated.

Chapell, James. *The Potter's Complete Book of Clay and Glazes*. New York: Watson-Guptill, 1977. Detailed material on a wide range of bodies and glazes.

Colson, Frank. *Kiln Building with Space Age Materials*. New York: Van Nostrand Reinhold, 1975.

Conrad, John W.: *Contemporary Ceramic Formulas*. New York: Macmillan, 1980. Chemicals, glazes, and other ceramic materials, toxic qualities.

Cooper, Emmanuel, and Royle, Derek. *Glazes for the Potter*. New York: Scribner, 1978. Glaze types, formulas, and their historical development.

Currie, Ian. *Revealing Glazes: Using the Grid Method*. Bootstrap Press, Australia, 2000. A well-organized guide to learning more about glazes and developing your own.

———. *Stoneware Glazes: A Systemic Approach*. Bootstrap Press, Australia, 1985. A self-directed course in understanding stoneware glaze formulation.

Daly, Greg. *Glazes and Glazing Techniques: A Glaze Journey*. Gentle Breeze Pub. Co., 1995. A good source of recipes and glazing ideas from this Australian author.

Eppler, Richard A, and Douglas R. Eppler. *Glazes and Glass Coatings*. American Ceramic Society, 2000. An exhaustive treatise on almost every aspect of glaze making.

Fraser, Harry. *Ceramic Faults and Their Remedies*. A & C Black, 1886. An incredible resource for finding a cause and a cure for almost any ceramic problem.

Frith, Donald. *Mold Making for Ceramics*. Krause Publications, 1999. The complete manual of how to make plaster molds for clay—a wonderful resource.

Gault, Rosette. *Paper Clay*. University of Pennsylvania Press, 1998. A good handbook on working with this unique material.

Greabnier, Joseph. *Chinese Stoneware Glazes*. New York: Watson-Guptill, 1975. An excellent treatment of Chinese glazes with formulas.

Hamer, Frank and Janet. *The Potter's Dictionary of Materials and Techniques*. 4th ed. University of Pennsylvania Press, 1997. Absolutely the best resource for the answers to all those hard-to-find questions about any ceramics topic.

Hamilton, David. *Architectural Ceramics*. New York: Thames & Hudson, 1977. Techniques of forming and decorating ceramic elements used in architecture. Historical and modern examples.

Hopper, Robin. *The Ceramic Spectrum: A Simplified Approach to Glaze and Color Development, 2nd ed.* Krause Publications, 2001. Lots of information on glazes with several useful approaches to developing a personal palette.

Kingery, W. David and Pamela B. Vandiver. *Ceramic Masterpieces: Art, Structure and Technology*. Free Press, New York City, 1986. A fascinating look at the science behind some famous ceramics.

Koenig, J.H., and Earhart, W.H. *Literature Abstracts of Ceramic Glazes*. Ellenton, Fla., College Institute, 1951. Formulas from many technical sources, although somewhat dated at present.

Lawrence, W.G, and R. R. West. *Ceramic Science for the Potter*. 2nd ed. Chilton Book Company, 1982. A well-written book that carefully explains the science behind clay and glaze in practical terms.

Leach, Bernard. *A Potter's Book*. Levitton, N.Y.: Transatlantic Arts, 1965. Continues to be the "bible" of the potter interested in functional ware.

Lou, Nils. *The Art of Firing*. Gentle Breeze Pub. Co. 1998. One of the best discussions of how to fire gas kilns.

McCann, Michael. *Artist Beware: The Hazards of Working With All Art and Craft Materials and the Precautions Every Artist and Photographer Should Take.* 2nd ed. The Lyons Press, 2001. A good source of health and safety information for potters, with a good bibliography and resource guide.

———. *Health Hazards Manual for Artists*. 4th revision. The Lyons Press, 1994. A small handbook on safe studio practice in the arts.

Obstler, Mimi. *Out of the Earth and into the Fire: A Course on Ceramic Materials for the Studio Potter*. American Ceramic Society, 1996. This is a great book to get to know the materials used in clay and glazes, and their sources.

Olsen, Frederick. *The Kiln Book, Materials, Specifications and Construction*. 2nd ed. Chilton, 2001. A comprehensive guide to kiln construction, from bricks to burners.

Pancioli, Diana. *Extruded Ceramics : Techniques, Projects, Inspirations*. Lark Books, 2000. A good exploration of work made using extrusion techniques with clay.

Parmalee, Cullen W., and Harman, Cameron G. *Ceramic Glazes*. Boston: Cahners, 1973. A revised edition of the standard text on chemicals and glazes.

Riegger, Hal. *Raku: Art and Technique*. New York: Van Nostrand Reinhold,

1970. A short but fairly complete treatment of raku procedures and kilns, but avoid the lead glazes.

Rhodes, Daniel and Robin Hopper. *Clay and Glazes for the Potter.* 3rd ed. Krause Publications, 2000. An updated edition of this classic book, a complete and well-illustrated treatment of clay, glazes, and calculations.

Rhodes, Daniel. *Kilns, Design, Construction and Operation.* Rev. ed. Radnor, Pa.: Chilton, 1980. A standard text on kilns, their operation, and their historical development.

———. *Pottery Form.* Radnor, Pa.: Chilton, 1977. Ceramic form as it evolves from imagination and tradition, as well as technique.

———. *Stoneware and Porcelain: The Art of High-Fired Pottery.* Radnor, Pa.: Chilton, 1959. A companion book to *Clay and Glazes for the Potter* with an emphasis on high-fire glazes and bodies.

Sanders, Herbert H. *How to Make Pottery.* New York: Watson-Guptill, 1974. A short but complete and well-illustrated text 'on forming techniques.

———. *Glazes for Special Effects.* New York: Watson-Guptill, 1974. A beautifully illustrated text dealing primarily with iron and copper reduction, crystalline, luster, and raku glazes.

———. *The World of Japanese Ceramics.* Palo Alto, Calif.: Kodansha International, 1967. The many techniques shown will be of interest to all potters, as will the many illustrations.

Scott, Paul. *Ceramics and Print.* University of Pennsylvania Press, 1995. The handbook for combining photo and printmaking techniques with clay.

Shaw, Kenneth. *Ceramic Colors and Pottery Decoration.* Frederick A. Praeger, Publishers, 1969. This book contains a lot of information about ceramic colorants and stains and how color is produced in glazes.

Storr-Britz, Hildegard. *Ornaments and Surfaces on Ceramics.* Dortmund, West Germany: Verlagsanstalt Handberk GMBH, 1977. An international selection of works displaying a wide range of decorative techniques.

Tichane, Robert. *Ash Glazes.* Rev. ed. Krause Publications, 1998. More than you'll ever need to know about ash and ash glazes.

———. *Celadon Blues.* Krause Publications, 1999. A thorough treatise on this classic type of glaze.

———. *Copper Red Glazes.* Krause Publications, 1998. Everything you need to know about copper red glazes.

Troy, Jack. *Salt Glazed Ceramics.* New York: Watson-Guptill, 1977. Origin, kilns, and methods of salt glazing.

———. *Wood-Fired Stoneware and Porcelain.* Chilton, 1995. Kilns, clays, and glazes for wood firing. Well illustrated.

Williams, Gerry; Sabin, Peter; and Bodine, Sarah, eds. *Studio Potters Book.* Warner, N.H.: Daniel Clark Books, 1978. Major articles selected from six years of the *Studio Potter* magazine.

Wood, Nigel. *Chinese Glazes: Their Origins, Chemistry and Recreation.* University of Pennsylvania Press, 1999. A wonderful resource on the classic glazes from China.

Zakin, Richard. *Electric Kiln Ceramics,* 2nd ed. Krause Publications, 1994. Clays, glazes, and decorative techniques in oxidation.

———. *Hand-Formed Ceramics : Creating Form and Surface.* Chilton Book Co., 1995. A wide range of techniques and recipes for hand-builders. Well illustrated.

Zakin, Richard and Val M. Cushing *Ceramics: Mastering the Craft,* 2nd ed. Krause Publications, 2001.

Supplemental Texts

Birks, Tony. *The Art of the Modern Potter.* New York: Van Nostrand Reinhold, 1977. Some of the experimental British potters.

Cardew, Michael. *Pioneer Pottery.* New York: St. Martin's, 1976. Use of simple materials, local clays, wood kilns.

Casson, Michael. *Pottery in Britain Today.* New York: Transatlantic Arts, 1967.

Charleston, Robert L. *World Ceramics.* New York: McGraw-Hill, 1968. A historical survey of the ceramics of the major world cultures.

Clark, Garth. *American Ceramics: 1876 to the Present.* Abbeville Press, 1987. One of the few histories of American ceramics.

———. *The Potter's Art: A Complete History of Pottery in Britain.* Phaidon Press, Ltd, 1995. A good survey of British pottery from neolithic times to the present.

Cox, Warren E. *The Book of Pottery and Porcelain.* New York: Crown, 1953. A historical survey of world ceramics.

Coyne, John, ed. *The Penland School of Crafts Book of Pottery.* New York: Bobbs-Merrill, 1975. The step-by-step process of the hand-building, throwing, and glazing techniques of eight of Penland's potters.

Ferrin, Leslie. *Teapots Transformed: Exploration of an Object.* North Light Books, 2000. An examination of work from ceramists using the teapot form.

Lauria, Jo. *Color and Fire: Defining Moments in Studio Ceramics, 1950–2000.* Rizzoli and Los Angeles County Museum of Art, 2000. A good survey of the modern era of ceramics.

Levin, Elaine. *The History of American Ceramics.* Harry N. Abrams, Inc, 1988. One of the better histories of American clay work.

Lowell, Susan, with Walter Parks, et al. *The Many Faces of Mata Ortiz.* Rio Nuevo Publishers, Tucson, AZ, 1999. A good survey of work from this amazing village of potters.

Lewenstein Eileen, and Cooper, Emmanuel. *New Ceramics.* New York: Van Nostrand Reinhold, 1974.

Ramie, Georges. *Picasso's Ceramics.* New York: Viking, 1976.

Rice, Prudence M. *The Prehistory and History of Ceramic Kilns.* American Ceramic Society, 1997.

Watson, Oliver. *Studio Pottery: Twentieth Century British Ceramics in the Victoria and Albert Museum Collection.* Phaidon Press, Ltd, 1993. A wonderful resource of modern British pottery from this amazing collection.

Woodhouse, Charles P. *The World's Master Potters.* New York: Pitman, 1975. Discussion of historical ceramics with an emphasis on the evolution of materials and techniques.

Selected Historical Texts

Ancient Middle Eastern and Ancient Mediterranean Ceramics.

Alexion, Styliaros; Platon, Nicolaos; and Gunanella, Hanni. *Ancient Crete.* New York: Praeger, 1968.

Arias, P. E. *Greek Vase Painting.* New York: Abrams, 1961.

Boardman, John. *Pre-Classical, from Crete to Archaic Greek.* Baltimore: Penguin, 1967.

Chamoux, François. *Greek Art.* Greenwich, Conn.: New York Graphic Society, 1966.

Hambridge, Jay. *Dynamic Symmetry: The Greek Vase.* New York: Dover, 1967. Reprint of the 1920 edition.

Hutchinson, R. W. *Prehistoric Crete.* Baltimore: Penguin, 1962.

Martinatos, Spyridon. *Crete and Mycenae.* New York: Abrams, 1960.

Noble, Joseph Veach. *The Techniques of Painted Attic Pottery.* New York: Watson-Guptill, 1965.

Petrie, Flinders. *The Making of Egypt.* London: Sheldon Press, 1939.

Platon, Nicolaos. *Crete.* Cleveland, Ohio: World Publishing, 1966.

Raphael, Max. *Civilization in Egypt.* New York: Pantheon, 1947.

——. *Prehistoric Pottery.* New York: Pantheon, 1947.

Richardson, Emeline Hill. *The Etruscans.* Chicago: University of Chicago Press, 1964.

Richter, Gisela M., and Milne, Marjorie. *Shapes and Names of Greek Vases.* New York: Metropolitan Museum of Art, 1935.

Swedish Institute in Rome. *Etruscan Culture.* New York: Columbia University Press, 1962.

Oriental Ceramics

Beurdeley, Michel. *Chinese Trade Porcelain.* Rutland, Vt.: Tuttle, 1966.

Bushell, Stephen W. *Chinese Pottery and Porcelain.* 1910. Reprint. New York: Oxford University Press. A translation of *T'ao Shuo,* written by Chu Yen in 1774.

Chang, K.C. *The Archaeology of Ancient China.* New Haven: Yale University Press, 1977.

Egami, Namio. *The Beginnings of Japanese Art.* New York: Weatherhill/Heibonsha, 1973.

Griffing, Robert P. *The Art of the Korean Potter.* New York: Asia Society, 1968.

Hayashiya, Seizo, and Hasebe, Gakuji. *Chinese Ceramics.* Rutland, Vt.: Tuttle, 1966.

Ho, Ping-Ti. *The Cradle of the East.* Chicago: University of Chicago Press, 1975.

Hobson, R. L. *Chinese Pottery and Porcelain.* 1915. Reprint. New York: Dover, 1976.

Honey, William Bowyer. *The Ceramic Art of China.* London: Faber and Faber, 1944.

——. *Japanese Pottery.* New York: Praeger, 1970.

Jenyns, Soame. *Later Chinese Porcelain.* New York: Yoseloff, 1965.

Kidder, J. Edward. *Prehistoric Japanese Arts: Jomon Pottery.* New York: Kodansha International, 1969.

Kim, Chewon, and Kim, Won-Yong. *Treasures of Korean Art.* New York: Abrams, 1966.

Koyama, Fugio, and Figgess, John. *Two Thousand Years of Oriental Ceramics.* New York: Abrams, 1960.

Leach, Bernard. *Hamada, Potter.* New York: Kodansha International, 1975.

——. *Kenzan and His Tradition.* London: Faber and Faber, 1966.

Medley, Margaret. *Yuan Porcelain and Stoneware.* London: Pitman, 1974.

Mikami, Tsugio. *The Art of Japanese Ceramics.* New York: Weatherhill/Heibonsha, 1972.

Miki, Fumio. *Haniwa.* New York: Weatherhill/Shibundo, 1974.

Munsterberg, Hugo. *The Ceramic Art of Japan.* Rutland, Vt.: Tuttle, 1964.

Peterson, Susan Harnly. *Shoji Hamada: His Way and Work.* New York: Kodansha International, 1974.

Prodan, Mario. *The Art of the T'ang Potter.* London: Thames & Hudson, 1960.

Islamic, Hispano-Moresque, and African Ceramics

Frothingham, Alice Wilson. *Lusterware of Spain.* New York: Hispanic Society of America, 1951.

Grube, Ernest J. *The World of Islam.* London: Hamlyn, 1966.

Lane, Arthur. *Early Islamic Pottery.* New York: Van Nostrand, 1948.

——. *Later Islamic Pottery.* London: Faber and Faber, 1957.

Meauzé, Pierre. *African Art.* Cleveland: World Publishing, 1967.

Mellaart, James. *The Neolithic of the Near East.* New York: Scribner, 1976.

Newman, Thelma. *Contemporary African Arts and Crafts: On-Site Working with Forms and Processes.* New York: Crown, 1974.

Wassing, René S. *African Art.* New York: Abrams, 1968.

Wilkinson, Charles K. *Iranian Ceramics.* New York: Abrams, 1963.

Wilson, Ralph Pinder. *Islamic Art.* New York: Macmillan, 1957.

Yoshida, Mitsukuni. *In Search of Persian Pottery.* New York: Weatherhill/Tankosha, 1972.

Medieval Through Nineteenth-Century Western Ceramics

Barrett, Richard Carter. *Bennington Pottery and Porcelain.* New York: Bonanza, 1958.

Berendson, Anne. *Tiles, General History.* New York: Viking, 1967.

Evans, Paul. *Art and Pottery of the United States.* New York: Scribner, 1974.

Hiller, Bevis. *Pottery and Porcelain, 1700–1914.* New York: Meredith, 1968.

Honey, William B. *European Ceramic Art.* London: Faber and Faber, 1949.

Ketchum, William C., Jr. *Early Potters and Potteries of New York State.* New York: Funk and Wagnalls, 1970.

Lane, Arthur. *Italian Porcelain.* London: Faber and Faber, 1954.

Liverani, Giuseppe. *Five Centuries of Italian Majolica.* New York: McGraw-Hill, 1960.

Mountford, Arnold R. *Staffordshire Salt-Glazed Stoneware.* London: Barrie & Jenkins, 1971.

Quilland, Harold. *Early American Folk Pottery.* Radnor, Pa.: Chilton, 1971.

Rackham, Bernard. *Medieval English Pottery.* New York: Van Nostrand, 1949.

Ramsay, John. *American Potters and Pottery.* New York: Tudor, 1947.

Savage, George. *Eighteenth Century German Porcelain.* New York: Tudor, 1968.

Spargo, John. *Early American Pottery and China.* New York: Century Library of American Antiques, 1926.

Watkins, Jura W. *Early New England Potters and Their Wares.* Hamden, Conn.: Anchron, 1968.

Webster, Donald Blake. *Decorated Stoneware Pottery of North America.* Rutland, Vt.: Tuttle, 1970.

Pre-Columbian Ceramics

Anton, Ferdinand, and Dockstader, Frederick J. *Pre-Columbian Art.* New York: Abrams, 1968.

Brody, J. J. *Mimbres Pottery, Ancient Art of the American Southwest.* New York: Hudson Hills Press, 1983.

Bushnell, G. H. S. *Ancient American Pottery.* New York: Pitman, 1955.

Disselhoff H.D., and Linne, S. *The Art of Ancient America.* New York: Crown, 1960.

Dockstader, Frederick J. *Indian Art in South America.* Greenwich, Conn.: New York Graphic Society, 1967.

Donnan, Christopher B. *Moche Art of Peru: Pre-Columbian Symbolic Communication.* Revised ed. Regents of the University of California, 1976.

———. *Ceramics of Ancient Peru.* Regents of the University of California, 1992.

Haberland, Wolfgang. *The Art of North America.* New York: Crown, 1964.

Kubler, George. *The Art and Architecture of Ancient America.* Baltimore: Penguin, 1962.

Lehmann, Henri. *Pre-Columbian Ceramics.* New York: Viking, 1962.

Litto, Gergrude. *South American Folk Pottery.* New York: Watson-Guptill, 1976.

Peterson, Susan. *The Living Tradition of Maria Martinez.* New York: Kodansha International, 1977.

von Hagen, Victor W. *The Desert Kingdoms of Peru.* Greenwich, Conn.: New York Graphic Society, 1964.

Willey, Gordon R. *An Introduction to American Archaeology.* Englewood Cliffs, N. J.: Prentice-Hall, 1966.

Magazines and Periodicals

Australia

Ceramics: Art And Perception
35 William St, Paddington,
Sydney NSW, 2021
AUSTRALIA
61.(0)2.9361.5286 or
Fax 61.(0)2.9361.5402
http://www.ceramicart.com.au

Ceramics Technical
35 William St, Paddington,
Sydney NSW, 2021
AUSTRALIA
61.(0)2.9361.5286 or
Fax 61.(0)2.9361.5402
http://www.ceramicart.com.au

Pottery In Australia
PO Box 937 Crows Nest,
Sydney NSW
AUSTRALIA 2065
(02)9901-3353 Fax (02)436-1681
http://www.ozemail.com.au/~potinaus/

France

La Ceramique Moderne
22 rue Le Brun
75013 Paris
FRANCE

Germany

Keramik Magazin
Steinfelder Strasse 10
W-8770 Lohr am Main
GERMANY

Neue Keramik (New Ceramics)
(In German with English subtitles
and summaries)
Unter den Eichen 90
W-1000 Berlin 45
GERMANY
30 8312953 Fax 30 8316281
http://www.ceramics.de

Great Britain

Crafts
Crafts Council
44a Pentonville Rd
London N1 9BY, UK

Ceramic Review
25 Foubert's Place
London, W1F 7QF
England, UK.
Tel: 020 7439 3377
http://www.ceramic-review.co.uk/

Greece

Keramik Techni
(now available in English)
PO Box 80653
Piraeus 185 10
GREECE
phone/fax 1-411-4322
http://www.starcard.com/keramieki

Italy

Ceramica Italiana Nell'Edilizia
Via Firenze 276
48018 Faenza,
ITALY

Japan

Honoho Geijitsu
Abe Corporation
4-30-12 Kamimeguro
Meguro-ku
Tokyo, 153,
JAPAN

Korea

Ceramic Art Monthly
1502-12 Seocho 3dong,
Seocho-ku.
Seoul,
KOREA
Phone (02)597-8261-2
Fax (02)597-8039

Netherlands

Keramiek
Poeldijk 8
3646 AW Waverveen
The NETHERLANDS
*Klei (*until 7/96 called
"Klei & Hobby")
Marterlaan 13
6705 CK Wageningen
The NETHERLANDS

New Zealand

New Zealand Potter
PO Box 881
Auckland
NEW ZEALAND
(09)415-9817
Fax (09)309-3247

Spain

Ceramica
Apartado 708
Paseo de Acacias 9
28005 Madrid
SPAIN

Taiwan

Ceramic Art
PO Box 47-74
Taipei
TAIWAN

United States

American Ceramics
9 East 45 St
New York, NY 10017
USA
212/661-4397 Fax 212/661-2389

American Craft
American Crafts Council
72 Spring St
New York, NY, 10012
USA
800/562-1973 for subscription info

Ceramic Industry
P.O. Box 3215
Northbrook, IL 60065
USA
http://www.ceramicindustry.com

Ceramics Monthly
735 Ceramic Place
PO Box 6102
Westerville, OH 43086
USA
614/523-1660 Fax 614/891-8960
http://www.ceramicsmonthly.org/

Clay Times
PO Box 365
Waterford, VA 20197
USA
800/356-2529
http://www.claytimes.com

Pottery Making Illustrated
735 Ceramic Place
P.O. Box 6136
Columbus, OH 43086-6136
USA
phone: 614.794.5890
fax: 614.794.5892
http://www.potterymaking.org/

Studio Potter
PO Box 70
Goffstown, NH 03045
USA
603/774-3542
http://www.studiopotter.org/

Studio Potter Network Newsletter
PO Box 70
Goffstown, NH 03045
USA
603/774-3542

CREDITS

Black & White Figures

Figure 1.1: San Diego State University Electron Microscope Facility. **Figure 1.2:** Photo by Chris Staley. **Figure 1.4:** Photo by Herbert Lotz. **Figure 1.6:** Photo © Studio LaGonda. **Figure 1.7:** Photo by Geoff Carr. **Figure 1.8:** Photo by David Browne. **Figure 2.1:** Photo by Jean Dieuzaide. **Figure 2.2:** Metropolitan Museum of Art, New York (gift of George D. Pratt, 1933). **Figure 2.3:** British Museum, London. **Figure 2.5:** V & A Picture Library, London. **Figure 2.6:** Metropolitan Museum of Art, New York (Harris Brisbane Dick Fund, 1950). **Figure 2.7:** Courtesy of the Cultural Relics Bureau, Peking, and the Metropolitan Museum of Art, New York. **Figure 2.8:** V & A Picture Library, London. **Figure 2.9:** Museum of Far Eastern Antiquities, Stockholm. **Figure 2.10:** Los Angeles County Museum (William Randolph Hearst Collection). Museum No. 46.16.22. Photograph © 2002 Museum Associates / LACMA. **Figure 2.11:** Seattle Art Museum (Eugene Fuller Memorial Collection). Museum #58.122. Photo by Susan Dirk. **Figure 2.12:** Metropolitan Museum of Art, New York. **Figure 2.13:** Seattle Museum of Art (Eugene Fuller Memorial Collection). Museum #58.63. **Figure 2.14:** Tokyo National Museum (gift of Sugihara Sosuke). **Figure 2.15:** Metropolitan Museum of Art, New York (gift of Mrs. John D. Rockefeller, III, 1958). **Figure 2.16:** Tokyo National Museum. **Figure 2.17:** Metropolitan Museum of Art, New York (The Michael C. Rockefeller Collection, bequest of Nelson A. Rockefeller, 1979). **Figure 2.18:** Metropolitan Museum of Art, New York. **Figure 2.19:** Metropolitan Museum of Art, New York (bequest of Nelson A. Rockefeller, 1979). **Figure 2.22:** Metropolitan Museum of Art, New York (The Michael C. Rockefeller Collection, gift of Nelson A. Rockefeller, 1978). **Figure 2.23:** National Museum of the American Indian, Smithsonian Institution (exchange from R. L. Stolper). NMAI Photo No. 23/2572. Photo by Carmelo Guadagno. **Figure 2.24:** Anonymous gift to the Bowers Museum Foundation. Images of Power P22, BMCA F81.23.1. Photo by Don Wiechec, © 1994 Bowers Museum. **Figure 2.25:** Metropolitan Museum of Art, New York (bequest of Nelson A. Rockefeller, 1979). **Figure 2.26:** Arizona State Museum, University of Arizona. Photo © Helga Teines. **Figure 2.27:** National Museum of the American Indian, Smithsonian Institution (Clarence B. Moore Collection). NMAI Photo No. 17/3260. Photo by Carmelo Guadagno. **Figure 2.28:** The Art Institute of Chicago (Kate S. Buckingham Endowment, 1955.2349). **Figure 2.29:** The Art Institute of Chicago (Kate S. Buckingham Endowment, 1955.2310). **Figure 2.30:** The Art Institute of Chicago (Kate S. Buckingham Endowment, 1955.2128, 3/4 view). **Figure 2.31:** Metropolitan Museum of Art, New York (gift of Tehran Museum, 1939). **Figure 2.32:** Metropolitan Museum of Art, New York (Rogers Fund, 1955). **Figure 2.33:** Metropolitan Museum of Art, New York (Fletcher Fund, 1931). **Figure 2.34:** V & A Picture Library, London. **Figure 2.35:** Metropolitan Museum of Art, New York (Rogers Fund, 1920). **Figure 2.36:** Metropolitan Museum of Art, New York (Carnavon Collection, gift of Edward S. Harkness, 1926). **Figure 2.37:** Metropolitan Museum of Art, New York (Gift of Edward S. Harkness, 1917). **Figure 2.38:** Herakleion Museum, Crete. **Figure 2.39:** British Museum, London. **Figure 2.40:** Metropolitan Museum of Art, New York (Louisa Eldridge McBurney Gift Fund, 1953). **Figure 2.41:** Cyprus Museum, Nicosia, Cyprus. **Figure 2.42:** Metropolitan Museum of Art, New York (Cesnola Collection). **Figure 2.43:** Metropolitan Museum of Art, New York (Fletcher Fund, 1925). **Figure 2.44:** Metropolitan Museum of Art, New York (Rogers Fund, 1921). **Figure 2.45:** Metropolitan Museum of Art, New York (Rogers Fund, 1918). **Figure 2.46:** Metropolitan Museum of Art, New York (Rogers Fund). **Figure 2.47:** Villa Guilia Etruscan Museum, Rome. **Figure 2.48:** The Art Institute of Chicago (gift of Philip D. Armour and C. L. Hutchinson, 1889.19). **Figure 2.49:** Metropolitan Museum of Art, New York (Subscription, 1896). **Figure 2.50:** Metropolitan Museum of Art, New York (Mr. and Mrs. Isaac D. Fletcher Collection, bequest of Isaac D. Fletcher, 1917). **Figure 2.51:** Metropolitan Museum of Art, New York (Rogers Fund, 1910). **Figure 2.52:** Metropolitan Museum of Art, New York (Rogers Fund, 1919). **Figure 3.1:** Cleveland Museum of Art. **Figure 3.2:** V & A Picture Library, London. **Figure 3.3:** V & A Picture Library, London. **Figure 3.4:** Metropolitan Museum of Art, New York (gift of Robert E. Tod, 1937). **Figure 3.5:** V & A Picture Library, London. **Figure 3.6:** National Palace Museum, Taipei, Taiwan, Republic of China. **Figure 3.7:** Seattle Art Museum (Thomas D. Stimson Memorial Collection, gift of Frank Bayley III). Museum #81.92. Photo by Paul Macapia. **Figure 3.8:** V & A Picture Library, London. **Figure 3.9:** Seattle Art Museum (Eugene Fuller Memorial Collection). Museum #58.12. Photo by Paul Macapia. **Figure 3.10:** Metropolitan Museum of Art, New York (Fletcher Fund, 1925). **Figure 3.11:** Seattle Art Museum (Eugene Fuller Memorial Collection). Museum #58.11. Photo by Paul Macapia. **Figure 3.12:** Seattle Art Museum (Eugene Fuller Memorial Collection). Museum #59.14. Photo by Paul Macapia. **Figure 3.13:** Seattle Art Museum (gift of Mrs. Charles E. Stuart). Museum #61.56. **Figure 3.14:** Metropolitan Museum of Art, New York (gift of John D. Rockefeller, 1938). **Figure 3.15:** Metropolitan Museum of Art, New York (bequest of Edward C. Moore, 1891). **Figure 3.16:** Metropolitan Museum of Art, New York (Rogers Fund 1920). **Figure 3.17:** V & A Picture Library,

London. **Figure 3.18:** The Art Institute of Chicago (gift of Martin A. Ryerson, 1925.25). **Figures 3.19–3.26:** V & A Picture Library, London. **Figure 3.27:** Courtesy Department of Library Services, American Museum of Natural History, New York. Neg. No. 325343. Cat No. 90.2/249. **Figure 3.28:** Metropolitan Museum of Art, New York (The Michael C. Rockefeller Memorial Collection, bequest of Nelson A. Rockefeller, 1979). **Figure 3.29:** Metropolitan Museum of Art, New York (bequest of Nelson A. Rockefeller, 1979). **Figure 3.30:** Metropolitan Museum of Art, New York (The Michael C. Rockefeller Memorial Collection, gift of Nelson A. Rockefeller, 1961). **Figure 3.31:** The Museum of London. **Figure 3.32:** The Museum of London. **Figure 3.33:** V & A Picture Library, London. **Figure 3.34:** V & A Picture Library, London. **Figure 3.35:** V & A Picture Library, London. **Figure 3.36:** V & A Picture Library, London. **Figure 3.37:** Metropolitan Museum of Art, New York. **Figure 3.38:** Metropolitan Museum of Art, New York (Rogers Fund, 1924). **Figure 3.39:** Metropolitan Museum of Art, New York (Rogers Fund, 1917). **Figure 3.40:** Metropolitan Museum of Art, New York (gift of Mrs. George B. McClellan, 1942). **Figure 3.41:** Metropolitan Museum of Art, New York (bequest of Alfred Duane Pell, 1925). **Figure 3.42:** V & A Picture Library, London. **Figure 3.43:** Brooklyn Museum of Art, New York (gift of Mrs. Huddah Cail Lorimer in memory of George Burford Lorimer, 56.5.2). **Figure 3.44:** Brooklyn Museum of Art, New York (gift of Arthur W. Clement, 43.128.19). **Figure 3.45:** Brooklyn Museum of Art, New York (gift of Arthur W. Clement, 43.128.59). **Figure 3.46:** Metropolitan Museum of Art, New York (Edward C. Moore, Jr. Gift Fund, 1926). **Figure 3.47:** Metropolitan Museum of Art, New York (gift of Edward C. Moore, 1922). **Figure 3.48:** Everson Museum of Art, Syracuse, NY; Museum purchase, 1916. **Figure 3.49:** Photo by Bob Brooks, courtesy of the Ohr-O'Keefe Museum of Art, Biloxi, MS. **Figure 3.50:** Everson Museum of Art,

Syracuse, NY, Purchase Prize given by Onondaga Pottery Company; 7th Ceramic National, 1938 (P.C. 39.42). **Figure 3.52:** V & A Picture Library, London. **Figure 3.53:** V & A Picture Library, London. **Figure 4.1:** Everson Museum of Art, Syracuse, NY (gift of John Pentland, 76.98). **Figure 4.2:** Schein-Joseph International Museum of Ceramic Art (gift of Winslow Anderson, 1993.57). Photo by Brian Oglesbee. **Figure 4.3:** San Diego Museum of Man (1997-2-91). **Figure 4.4:** Photo by Schopplein Studio. **Figure 4.5:** Art © Estate of Robert Arneson / Licensed by VAGA, New York, NY. **Figure 4.7:** Scripps College, Claremont, CA (gift of Mr. and Mrs. Fred Marer). Photo by Susan Einstein. **Figure 4.8:** Photo by Jarvis Grant. **Figure 4.9:** Photo by Louis Katz. **Figure 4.10:** Photo by Mark Johnson. **Figure 4.11:** Photo by Phyllis Kloda. **Figure 4.12:** Photo by Richard Notkin. **Figure 4.13:** Photo © Studio LaGonda. **Figure 4.14:** Crafts Council Picture Library, London. **Figure 4.15:** Scripps College, Claremont, CA (gift of Mr. and Mrs. Fred Marer). Photo by Susan Einstein. **Figure 4.16:** Photo by Judith Salomon. **Figure 4.17:** Photo by Bruce Mayer. **Figure 4.18:** Photo by John Dixon. **Figure 4.19:** Photo by Walker Montgomery. **Figure 4.21:** Photo by Herb Lotz. **Figure 4.22:** Photo by Brook, Rose, Cooper and Sheperd LeVan. **Figure 4.23:** Crafts Council Picture Library, London. **Figure 4.26:** Crafts Council Picture Library, London. **Figure 4.27:** Crafts Council Picture Library, London. **Figure 5.3:** Everson Museum of Art, Syracuse, NY; gift of Mr. and Mrs. Joseph Caldwell III (85.59). **Figure 5.4:** Photo by Linda C. Mueller. **Figure 6.2:** Photo by Ira Block. *Science*, v.246 (1989) pp. 102–108. **Figure 6.13:** © Antony Gormley. Photo courtesy Jay Jopling / White Cube, London. **Figure 6.37:** Photo by James Evans. Collection: Archie Bray Foundation. **Figure 6.41:** Los Angeles County Museum of Art (gift of Howard and Gwen Laurie Smits). Museum No. M.87.1.77. Photograph © 2002 Museum Associates / LACMA. **Figure 6.44:** Photo by Elizabeth

Ellington. **Figure 6.45:** Photo by Kathryn Inskeep. **Figure 6.66:** Photo by E. G. Schempf. **Figure 6.67:** Photo by Chuck Sharbaugh. **Figure 6.68:** Photo by Peter Lenzo. **Figure 6.70:** Photo by Patricia Williams, 1991. **Figure 6.71:** Photo by Joseph Schopplein. **Figure 6.72:** Courtesy of Garth Clark Gallery, New York and Los Angeles. **Figure 6.73:** Photo by Stefano Massoli, Italy. **Figure 6.74:** Photo by Kathryn Wetzel. **Figure 6.75:** Photo by John Glick. **Figure 7.14:** Photo by Geoffrey Carr. **Figure 7.26:** Photo by Michelle Coakes. **Figure 7.47:** Photo by Peter Lee. **Figure 7.50:** Photo by Peter Lee. **Figure 7.52:** Photo by Dan Milner. Collection: Leslie Nichol. **Figure 7.58:** Photo by Lee Rexrode. **Figure 7.60:** Photo by Jim Connell. **Figures 7.61–7.68:** Photos by Peter Lee. **Figure 7.69:** Photo by Larime Photographic. **Figure 7.71:** Photo by Tom Mills. **Figure 7.72:** Photo by Tracey Hicks. **Figure 7.74:** Photo by Ginny Marsh. **Figure 7.75:** Photo by Rebekah Marsh. **Figure 8.2:** Photo by Chuck Johnson. **Figure 8.4:** Photo by Bobby Silverman. **Figure 8.8:** V & A Picture Library, London. **Figure 8.14:** Photo by Ian Thomas / V & A Picture Library, London. **Figure 8.21:** Photo by Harris Deller. **Figure 8.30:** Photo by Lee Hocker. **Figure 9.2:** Photo by Bart Kasten. **Figure 9.4:** Photo by Peter Lee. **Figure 9.5:** Photo by Kristian Krogh. **Figure 9.6:** Photo by Rick Paulson. **Figure 9.7:** Photo by Anthony Cuñha. **Figure 9.9:** Photo by Anthony Cuñha. **Figure 9.10:** Photo by Erik Balle. **Figure 9.15:** Photo by Haru Sameshima. **Figure 10.1:** © Feldspar Corporation. Photo by Alex Glover. **Figure 11.23:** Photo by Donna Anderegg. **Figure 11.24:** Photo by Anderson Flewellen. **Figure 11.25:** Photo by Anderson Flewellen. **Figure 11.32:** Photo by Schopplein Studio.

Color Plates

Plate 2: Photo by Peter Hogan. **Plate 3:** Photo by R. Bruhn. **Plate 4:** Photo by Bobby Silverman. **Plate 5:** Photo by Ron Roy. **Plate 6:** Photo by David L. Gamble.

Plate 7: Crafts Council Picture Library, London. **Plate 8:** Crafts Council Picture Library, London. **Plate 9:** Photo by Will Ruggles. **Plate 10:** Photo by Tim Barnwell. **Plate 11:** Photo by Barbara Tipton. **Plate 12:** Photo by Derek Smith. **Plate 15:** Crafts Council Picture Library, London. **Plate 16:** Philip Cornelius. **Plate 17:** Photo by Dean Powell, Lowell, MA. **Plate 19:** Photo by Wesley Anderegg. **Plate 20:** Photo by Kelly Bugden. **Plate 21:** Photo by Anthony Cuñha. **Plate 23:** Photo by Kevin Montague & Michael Cavangh. **Plate 24:** Everson Museum of Art, Syracuse, NY; Museum Purchase (93.24). **Plate 26:** Photo by Chris Autio. **Plate 27:** Photo by Don Tuttle. **Plate 28:** Photo by Suzanne Coles. **Plate 30:** Photo by Barbara Tipton. **Plate 31:** Photo by Berry Matthews. **Plate 32:** Photo by Soldner. **Plate 36:** Photo by Charles Frizzell. **Plate 37:** Photo by Susan Coles. **Plate 40:** Photo by William Owen. **Plate 45:** Photo by Paul W. Leathers. **Plate 47:** Photo by John Wilson White. **Plate 48:** Photo by Fareed Mashat. **Plate 49:** Photo by William Triesch Voelker. **Plate 50:** Photo by Jack Ramsdale, Philadelphia. **Plate 51:** Photo by Allen Cheuvront. **Plate 52:** Photo by Jeanne Otis. **Plate 53:** Photo by Oyo Studio. **Plate 54:** Collection: Jane Korman. Photo by Malcom Varon. **Plate 55:** Photo by Joyce Kohl. **Plate 56:** Photo by Robert Harrison. **Plate 57:** Photo by Christopher Zaleski. **Plate 58:** Photo by Gerald Gustafson. **Plate 59:** Photo by Tim Barnwell.